A SURVEY OF MANUSCRIPTS
ILLUMINATED IN THE BRITISH ISLES
VOLUME FOUR
EARLY GOTHIC MANUSCRIPTS [I]
1190–1250

BY NIGEL MORGAN

Frontispiece: David harping before Saul.
New York, Pierpont Morgan Library, Glazier 25, f. 3v (cat. 50)

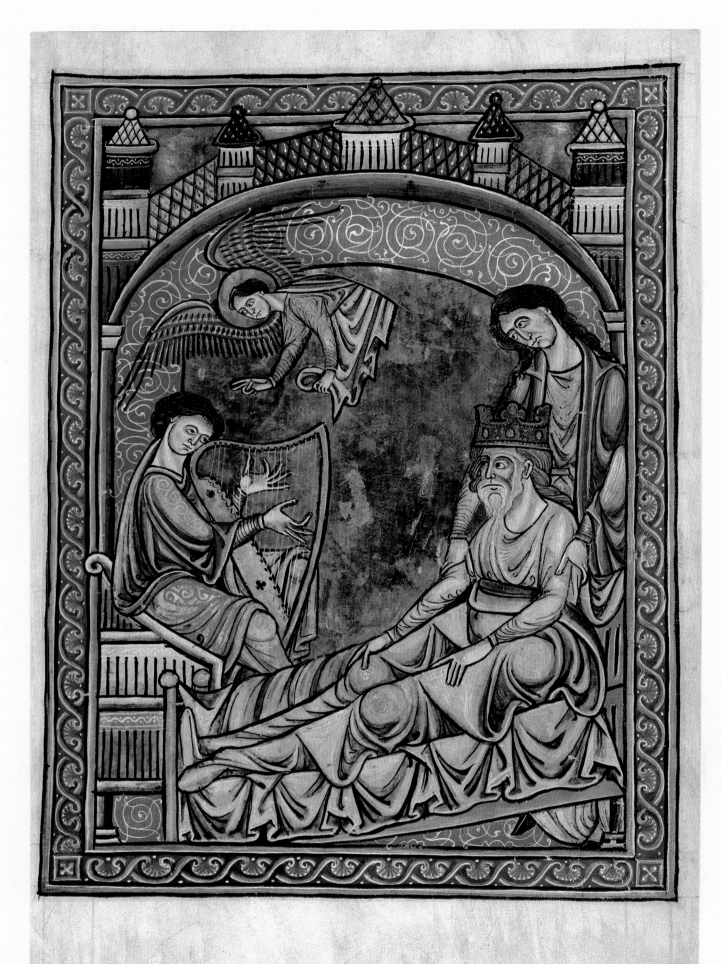

A SURVEY OF MANUSCRIPTS ILLUMINATED IN THE
BRITISH ISLES~GENERAL EDITOR: J·J·G·ALEXANDER

EARLY GOTHIC MANUSCRIPTS [I]
1190~1250

BY NIGEL MORGAN

WITH 330 ILLUSTRATIONS

HARVEY MILLER PUBLISHERS
~ OXFORD UNIVERSITY PRESS

A SURVEY OF MANUSCRIPTS
ILLUMINATED IN THE BRITISH ISLES

General Editor J. J. G. Alexander

Volume One: INSULAR MANUSCRIPTS FROM THE 6TH TO THE 9TH CENTURY

Volume Two: ANGLO-SAXON MANUSCRIPTS 900–1066

Volume Three: ROMANESQUE MANUSCRIPTS 1066–1190

Volume Four: EARLY GOTHIC MANUSCRIPTS (in two parts) 1190–1285

Volume Five: GOTHIC MANUSCRIPTS 1285–1400

Volume Six: LATER GOTHIC MANUSCRIPTS

Originating Publisher HARVEY MILLER · 20 Marryat Road · London SW19 5BD

Published in conjunction with OXFORD UNIVERSITY PRESS · Walton Street · Oxford OX2 6DP

Published in the United States by OXFORD UNIVERSITY PRESS, New York

ISBN 019 921026 8

Designed by Elly Miller

Text Printed by Clark Constable Ltd · Edinburgh · Scotland
Illustrations printed at the University Press, Oxford

CONTENTS

In Memory of my Father

EDITOR'S PREFACE

THE AMOUNT of English book painting of the thirteenth century surviving will come as a surprise, I think, even to specialists and it has necessitated dividing this volume in our series into two parts. As Nigel Morgan points out, earlier scholars, in sifting through this mass of material and concentrating either on particular texts or on what they considered to be the outstanding manuscripts, have missed a number of important connections. But as we move away from a period in which monastic production predominated to one of professional workshops, such stylistic and iconographic connections provide often the only evidence of where a book was made. The other evidence, calendars and liturgical usage, is also vital and here too the author's expertise has resulted in fresh conclusions. So in this book much new light is shed on provincial and metropolitan workshops and their interrelationships. Comparisons across a broader field have also resulted in a much more coherent dating than has been available hitherto.

In architecture Gothic was an imported style and English architects evolved their own variations on it. In painting, however, it is by no means always a case of English dependence. In the early thirteenth century, for example, evidence is beginning to emerge that English models were used by Parisian illuminators. This book demonstrates the range, the inventiveness and the quality of English painting of the period.

J. J. G. Alexander

Hoopoe. Oxford, St. John's College, 61, f 45ᵛ (cat. 42)

FOREWORD

VOLUME FOUR OF THE SURVEY covers the beginnings and early development of the Gothic style. It is the period of the rise to predominance of the workshops of lay artists and of the first well-documented individuals to whom a personal style can be attributed, William de Brailes and Matthew Paris. The quantity of surviving material, even after selection from a still greater amount, has had to be presented in two parts. This first part covers the period from the late twelfth century up to *c.* 1250, and Part 2 covers the years from *c.* 1250–85. There will of course be some overlap in the period 1240–60. For the great series of illustrated Apocalypses beginning in the 1240s it seemed most sensible to include them as a whole in Part 2. Conversely the work of Matthew Paris beginning *c.* 1240 and continuing into the 1250s is all contained in Part 1.

Not only is the number of manuscripts greater than in earlier Survey volumes but also the subject matter differs much in range and quantity from the earlier periods. In the cases of Bibles and Bestiaries, both more profusely illustrated than their twelfth-century predecessors, there have been inevitable difficulties in making catalogue descriptions. Certain subjects in the Bibles remain as tentative identifications, and for the Bestiaries the approach has been always to describe the creature of the accompanying text passage rather than to attempt to assess the correctness of the depiction in its closeness to, or more usually remoteness from, nature. In both these classes of manuscripts more research is required on text and iconography than I have been able to devote without delaying even further the writing of this book. Another apology in matters of description is due to musicologists for my failure to particularise the musical instruments in most of the illustrations of musicians.

In many cases arguments have been presented for major alterations in date and provenance to those which have stood without dispute for the past fifty years or more. These revisions have been the result of the advantage gained from an overall view, in contrast to the emphasis in earlier studies on manuscripts of a particular text or on single books. There has also been a tendency in general accounts of the period to trace lines of development between a handful of masterpieces without placing such exceptional works in the context of the abundant contemporary material. Above all this has been the case for Bestiaries, Bibles and Psalters, and for these new dating and provenance have frequently been proposed.

The bibliographies at the end of each entry, as in previous volumes, draw attention to publications on aspects of text and script as well as to purely art historical accounts. The prime aim of the catalogue entries is to describe and analyse the illuminated decoration, but they are not intended to provide full descriptions of text contents or those aspects of the text which have no bearing on the decoration, provenance or the dating of the manuscript.

The selection of the material would have been an even longer task had not much of it already been sifted and described by the great efforts of past scholars, above all M. R. James, Sir George Warner, Sir Sydney Cockerell, Eric Millar, and in more recent times by Francis Wormald, Fritz Saxl, Margaret Rickert and Neil Ker. To all of these anybody working in the field will always owe a special debt.

Many friends and colleagues have helped me in the past ten years of research. First I should record special thanks to Adelaide Bennett for generous help and encouragement, and most particularly for permission to use her pioneering thesis on English thirteenth-century

Bible illustration which made possible the daunting task of selecting Bibles for inclusion. I am most grateful to Xenia Muratova for providing an account of the Leningrad Bestiary (no. 11), and to Harvey Stahl for the entry on the Bible in the Huntington Library (no. 77), neither of which manuscripts I was able to study in the original myself. I owe a great debt to Derek Turner and Christopher Hohler for initiating me over the years into the problems of manuscript studies. In addition I would particularly like to thank François Avril, Larry Ayres, Janet Backhouse, Rosalind Brooke, Christopher de Hamel, Tilly de la Mare, Michael Evans, Tessa Garton, Joan Gibbs, George Henderson, Sandy Heslop, John Higgitt, Michael Kauffmann, Suzanne Lewis, Maura O'Carroll, John Plummer, Ian Short, Alison Stones, Jenny Stratford and Elizabeth Temple, who in various ways have shared their knowledge and given assistance. Also thanks is due to those research students who have given me help and criticism in past years: Claire Baker, Peter Barnet, Elizabeth Black, Lynda Dennison, the late Richard Forward, James Golob, Michael Michael, William Monroe and Nicholas Rogers. My fellow collaborators on the Gothic volumes of this series, Lucy Sandler and Kathleen Scott, have been a constant support in our discussions of mutual problems.

Kindness and tolerance have been shown to me by numerous librarians and their assistants who have brought me the treasures in their care. Without their co-operation the book could never have been written.

I would particularly like to thank Isabel Hariades for her help to an author who committed the double sin of producing a text long overdue and considerably greater in length than expected. A special acknowledgment is due to my publisher, Elly Miller, for her constant interest, admirable arrangement of my illustrations, and for her patience in waiting for my text.

Finally my thanks to Jonathan Alexander, initiator and editor of this series, for asking me to do a volume, and for encouragement and friendship at all stages of the work.

INTRODUCTION

THE YEARS AROUND 1200 open this volume of the Survey; it is a time when a host of major changes were occurring in many aspects of cultural and social life, and these had lasting effects on the world of books and art. These changes had begun in the 12th century, and although difficult to see as directly affecting the work of artists and scribes they came in various ways to condition the themes and forms of their works, and the circumstances of their production.[1]

The English Church in the earlier part of the 12th century had, as elsewhere in Europe, been much dominated in its intellectual life by the great monasteries. In the later 12th and in the 13th century an increasingly important role is played by the secular and conventual rather than the monastic side of the church; the secular cathedrals, the Augustinian canons, and from the 1220s the new orders of friars, came to be sources of innovations and influences in patronage and art.[2] In the illuminated manuscripts discussed in the previous volume of the Survey the intellectual content of both text and illustration contrast markedly with the simpler types of those described in this book, and this contrast reflects the increasing provision for the tastes of a more worldly audience. The laity in the later 12th and the 13th century were more active in financing foundations of establishments for the regular canons and friars than for the monastic orders. Their personal contacts with these canons and friars who often acted as their chaplains or confessors were probably more direct than with the monastic institutions they patronised. A chaplain could, for example, have a major influence on the reading matter of his patron, and doubtless was often involved in the provision of such books, particularly those of a devotional nature. It is this more personal link between the lay patron and the church which seems an important and relevant element in the period. Needless to say benefactions to the older monastic foundations still continued but by 1250 they were merely one of several alternatives for the investment of the laity, and patronage inevitably became more diversified.[3]

In 1215 the Fourth Lateran Council, perhaps the most important of all the medieval Councils of the Church, had initiated many reforms which the English bishops constantly enforced throughout Henry III's reign. The organisation of religious life in the secular church, from the cathedral to the parish church, became better ordered and more stable.[4] One aspect of this reform of the organisation of the church was the standardisation of the liturgy according to the practices of the cathedral church of Salisbury (the Use of Sarum) which seems to have been considered the best model to follow. During the 13th century the new Sarum texts are gradually adopted by all the dioceses of the province of Canterbury excepting that of Hereford.[5] The province of York retained its own Use although it seems some process of standardisation was also attempted involving some introduction of Sarum practices.[6] As almost half the manuscripts discussed in this volume of the Survey are liturgical books, the introduction of Sarum Use during the period of transition in the 13th century is of considerable importance in the analysis of their texts.

Another aspect of reform following Lateran IV concerned the pastoral activity of the clergy. In an indirect way this doubtless had some effect in encouraging more regular devotions among the laity which is reflected in the rapid increase in the production of devotional texts such as Psalters and, later in the century, Books of Hours. The rising taste for such books may, however, equally be a direct result of increasing literacy.

The Church had always played the predominant role in education, and throughout the period we are considering all education was in the hands of those in some form of religious orders. In the earlier Middle Ages and in the first half of the 12th century the monastery and cathedral schools were the centres of intellectual life, but in the later 12th century the University as an independent institution arises. This appearance of the universities is another of the major changes in the years around 1200. In England, at Oxford by the late 12th century, and at Cambridge after a migration of Oxford masters there in 1209, university systems were instituted following the model created at Paris a few years earlier.[7] Inevitably these centres of scholarship required books and these came to be produced at the university towns themselves. The new orders of friars established some of their earliest foundations in Oxford and Cambridge at almost the same time as these embryo universities were forming, and played a fundamentally important role in the new educational institutions.

In lay society there were also major changes between the late 12th and the mid 13th century. Those relevant to book production took place however only in the small minority of aristocratic and court circles. The age of the Crusades had made a mark on northern European society bringing it into contact with the sophisticated aspects of domestic life of the Byzantine and Islamic world. Domestic architecture in the 13th century became more suited to comfort and private leisure activities as is best seen in the palaces of Henry III. Although no substantial part of any of these remains, detailed accounts of their building and decorations survive.[8] As literacy rapidly improved during the period those of the higher ranks of society became interested in acquiring certain types of books for their own private reading.[9] Women in these aristocratic circles had patronised literature in the 12th century, and their role in popularizing illuminated books of a devotional nature is not to be underestimated, although difficult to document.[10]

PATRONAGE OF BOOK PRODUCTION

Illuminated books are the luxury élite of medieval manuscript production. They were richly decorated either because they played an honoured role in the liturgy (e.g. a Missal) or alternatively because they were the private commission of those ranks of society who could afford luxury objects (e.g. Psalters and Bestiaries). It is the latter category which predominates in the 13th century. In the earlier Middle Ages the patronage of book illumination by the richer classes of the laity was to provide gifts for public use in the liturgy in churches and monastic houses. The Gospel Book is the best example of such a gift. In the 13th century illuminated books were in general much more exclusively intended for personal private use, and texts for devotional reading like the Psalter and the Book of Hours are prime examples of this class.[11] Even Psalters made for monastic patrons like the Westminster Psalter (no. 2), the Psalter of Robert de Lindesey (no. 47) and no. 49, Oxford, Magdalen College MS 100 seem to have been made for the personal use of the Abbot or Prior rather than for any general use by members of the community, as is suggested by the large number of private prayers appended to the text of the Psalms.

A fair proportion of illuminated and illustrated texts were still produced for Benedictine patrons (nos. 1–4, 5 [Cluniac], 12, 22, 26 and 27 [Order of Fontevrault], 32[?], 33, 34, 36, 41, 42, 45, 47–9, 51[?], 52, 56, 59a, 63, 64). These nearly all fall into the period before 1230: more than half are Psalters, two are Lives of Saints, one is a Bible and two are Bestiaries. For most of these books the evidence points strongly to ownership contemporary with their production. In addition to those listed there is the special group of books illustrated with tinted drawings provided by Matthew Paris for St. Albans (nos. 85–9, 91–3).

Production of illustrated texts for the monastic orders other than the Benedictines is minimal. A fine Bestiary, Cambridge, Univ. Lib. Ii. 4. 26 (no. 21) was possibly for a Cistercian house, and a copy of *De similitudinibus* of St. Anselm (no. 60) also belonged to Cistercians. In both these cases the evidence for ownership is of much later date than the books and the Cistercians could have acquired them long after their production. From the plainness of its decoration and stylistic similarity with the Anselm, the Bible (no. 58) may also be a Cistercian book although there is no evidence of provenance.

Several manuscripts, almost all Psalters, show marks of ownership or have textual contents suggesting a contact with the Augustinian Canons (nos. 8[?], 14, 23, 24, 26[?], 27[?], 29, 31, 35, 39, 51[?], 54). Some of these may not have been intended for an Augustinian patron but rather their production was in some way supervised by Augustinians possibly for lay people. Such a situation would probably have resulted when laymen had these canons as chaplain or spiritual director.[12]

The Franciscans and Dominicans became established in England during the 1220s and few books of their ownership have survived from the pre-1250 period.[13] A Bible, Oxford, Bodl. Lib. lat. bibl. e. 7 (no. 69) and a set of miscellaneous texts including a Bestiary, London, B.L., Harley 3244 (no. 80), belonged to Dominicans, and a copy of Alexander Neckham, Cambridge, Univ. Lib. Gg. 6. 42 (no. 84), probably to a Franciscan.

Only one book, the Leiden Psalter (no. 14), can definitely be identified as belonging to a member of the cathedral clergy. Its first owner was Geoffrey Plantagenet, Archbishop of York, who, as a member of the royal family, was naturally in a very special position. It is rather surprising that although several 13th-century illuminated books have survived which were owned by Abbots and Priors this Psalter is the only extant illustrated manuscript made for a Bishop.[14]

Almost half the manuscripts catalogued have been ascribed to ecclesiastical patronage and very probably some of those without evidence were intended for ecclesiastical destinations. For the remaining books it is difficult to be certain of their ownership. They include several Psalters, Bestiaries, Bibles, a Book of Hours, two Herbals, two books of romances and several miscellaneous texts. In the case of one Bible (no. 75) it is clear that it belonged to a bailiff of Norwich later in the 13th century. For several Psalters and the Book of Hours lay ownership is suggested by donor portraits, and in three cases (nos. 30, 35, 68) the contemporary or near-contemporary owners can be tentatively identified.

Evidence of illuminated books for those associated with the court circle is slight in the period before 1250 but from that time on during the last twenty years or so of Henry III's reign, such patronage flourishes. Undoubtedly there was some indication of court patronage in the earlier part of the reign although it must be remembered that the King's own expenditure was some-what restricted until he had ended his minority in 1227.[15] Possibly the motivation for an interest in richly illuminated books in the court circle followed the fashion set by the court of France. Blanche of Castile and her son St. Louis (Louis IX) had by the 1240s shown a consistent interest in patronising rich book production.[16] King John, Henry's father, evidently had an interest in books although only one Psalter (Margarete Skulesdatter's Psalter, no. 35) can controversially be ascribed to the ownership of his family.[17] Three others, the Leiden, Imola and Glazier Psalters (nos. 14, 26 and 50) have ownership or textual evidence suggesting patronage by members of the court circle; of these the Leiden Psalter is as early as the late 12th century.

In the period before 1250 there is no clear evidence for any taste or style which can be associated with court or aristrocratic patronage. It is of course artificial to make too significant a distinction between luxury devotional books such as Psalters produced for the private ownership of the aristocratic laity and those for high ecclesiastics. The division between the intellectual world of increasing numbers of educated laity and that of the clergy had become less marked. In general in the thirteenth century there is what has been called a 'laicisation' of all society.[18]

THE CIRCUMSTANCES OF BOOK PRODUCTION

The way in which books were made and ordered in the 13th century is still almost unknown. Documentary evidence is for the most part lacking although some probably remains to be discovered. As was apparent in the discussion of patronage our information even in that field is very obscure and is an additional barrier to any investigation of the manner and circumstances which led to the production of illuminated books.

Only in the case of Oxford has some picture been presented of the activity of scribes and illuminators living in the area around Catte Street, now the site of the Radcliffe Camera. This has been traced in various records from as early as the closing years of the 12th century.[19] In the case of one workshop, that of William de Brailes, sufficient documentation and manuscripts (nos. 69–74) survive to enable some general assessment.[20]

Two groups of manuscripts (nos. 23, 24, 28–32) earlier in date than the de Brailes workshop have liturgical or iconographic evidence pointing to Oxford production. These and the de Brailes books provide an almost continuous series during the first half of the 13th century. The detailed study of both illuminated and non-illuminated Oxford manuscripts from the standpoint of palaeography and codicology as well as of their painted decoration has been beyond the scope of this book but would be an interesting task for further research. The complex problems of the relationship between scribes and illuminators cannot be assessed in our present state of knowledge, but a study of these Oxford manuscripts would certainly prove most valuable. For the moment only a few general points can be made.

Up to the end of the 12th century most evidence suggests fairly continuous traditions of production in certain monastic scriptoria such as Canterbury, Durham, St. Albans and Winchester. In several cases lay artists and scribes may have been employed for a period of time to assist the monks, and then moved on to another place. In the late 12th and the early 13th century this system seems to be changing. Book production at the monastic centres now appears to lack continuity in a figure and ornamental style, or in script and format, which suggests the ceasing of any continuous tradition. In those cases in the 13th century where the same illuminators work on a group of books, the scripts, formats and eventual destinations of the books are often diverse, as for example the Berlin Psalter group (nos. 35–37) and the de Brailes manuscripts (nos. 68–74).

A prelude to this development is seen in the work of the 'Abbot Simon Master' who seems to have been a lay artist working on a variety of books for diverse patrons in the 1170s and 80s (see *Survey*, III, nos. 90, 91, 96). The artist works in England for the Benedictines of St. Albans and for a house of Augustinian Canons in Yorkshire. In France he produces books for patrons in the Champagne region.[21] Around 1200 the group of the Munich and Imola Psalters presents an analogous case (nos. 23–29). This 'workshop' may have started as a number of independent artists working in the West Midlands and in the Winchester region, who eventually joined forces in Oxford.

These examples provide a possible picture of the situation in the period of transition *c.* 1170–1210 in which illuminators change their working pattern from being itinerant between monastic houses to forming an association with a group, probably also involving scribes, which could in a loose sense be called a workshop. This is only a hypothesis which future research may disprove or corroborate.

The production of books doubtless often involved collaboration between clerics and scholars on the one hand, and scribes and illuminators on the other. The devotional contents in the form of special prayers added to the Psalms in a Psalter, or an up-to-date text of the Bible, would have to be provided if the patrons or their advisers wished them to be copied. Whether many patrons were sufficiently discerning over such matters is an open question. We know very little of how books were ordered in this period or of their cost, and if more of such information existed, or could be discovered, patronage and the organisation of scribes and

illuminators could be discussed with greater confidence. It is evident from the few published household accounts of the 13th century that books and materials were purchased in the three most likely centres, Oxford, Cambridge and London.[22]

BOOK TYPES: THEIR ICONOGRAPHY, RELATIONSHIP OF ILLUSTRATION TO TEXT, AND ORNAMENTAL DECORATION

(a) *Psalters*

A quick glance at the catalogue and plates will instantly reveal that the Psalter was the text most commonly found with elaborate illumination. Richly decorated Psalters had during the 12th century become increasingly common and by 1200 the fashion had been established.[23] There seems little doubt that this reflects the rise of the psalter text as the most popular luxury private devotional book; in the later Middle Ages this came eventually to be supplanted by the Book of Hours. The laity seem to have used the Psalter as a form of prayer book, and the clergy for private devotional reading as well as for the psalmody of their daily offices. Unfortunately the extant texts giving directions for lay devotion all date from a period when the saying of the Hours of the Virgin Mary had become the chief form of private prayer, so we are not well informed as to exactly how the Psalter was used in this context.[24] Many of the Psalters include the Office of the Dead which later became an essential part of the Book of Hours, and many also have the Creed, Pater Noster and private prayers.[25] Almost all also contain the daily Canticles and the Litany.

The Psalters of the 12th century had given special ornamental or historiated initials to the psalms which began the series sung at daily Matins and Sunday Vespers.[26] This decoration was supplemented in the most luxurious Psalters by a set of prefatory miniatures of the Old and New Testaments, of the Tree of Jesse, of King David, of the Virgin and Child and of Christ in Majesty. Apart from David, the author of the Psalms, these subjects had no direct relevance to the text of the Psalter but functioned rather as a sort of picture book. This illustrated section may have originated in laymen's Psalters, but it should not be assumed that learned ecclesiastics would not also gain pleasure and devotional stimulus from such pictures.[27] Few of the scenes can be classified as devotional images but are essentially narrative pictures of Bible stories. During the 13th century single full-page miniatures of the Crucifixion and the Virgin and Child come to be presented in a manner in which their sentimental and devotional aspects appeal to the onlooker. They then become pictures which assist through contemplation in the private prayer and meditation of the owner, and are a prelude to the mature forms of devotional image of the 14th and 15th centuries.

The decoration of the text pages of the Psalter becomes elaborated in this period by the use of line endings (or line fillers) which fill the space between the last word of each Psalm verse and the edge of the text block. These, at their simplest, are merely ornamental patterns in coloured pen, and at their richest are fully illuminated and gilded blocks incorporating animals, grotesques and even human figures. The initials to the psalms other than those of the liturgical divisions can also range in decoration from simple penwork to fully illuminated ornament or figure scenes. Even the individual verse initials vary in the degree of ornamentation according to the richness of the book. The decoration of these text pages is often completed by extensions in the form of dragons or foliage from the initials into the margins. In the late 13th and the 14th century these extensions are used to form border bars to frame the whole text block. The degree of richness of illumination in the decorative

systems of the Psalter text pages no doubt directly reflect the cost and importance of the book.

The extent of illumination varies in the products of the various workshops and is clearly evident in the group around the Munich and Imola Psalters (nos. 23–9). There seems in some cases to have been division of labour between the artists working on the figure scenes and on certain categories of ornamentation, although often one artist paints almost everything. This 'workshop' situation, where several artists are involved, presents an interesting field for further investigation which could assist in establishing a better chronology for the manuscripts produced by a particular group of artists. The same 'workshop' system can be seen also in several groups to be discussed in Part 2 of this volume: e.g. the group of the Sarum Master (nos. 99–103) and that of the Bible of William of Devon artists (nos. 159–164).

There is a continuous production of Psalters throughout the period considered in this volume so that developments in iconographic repertoire can be traced. In the 12th century the fashion had begun for cycles of richly illuminated and gilded full-page miniatures to be set at the beginning of the text after or before the Calendar. These varied in number from three or four to a series of twenty or more. The culmination of this trend is in the Munich Psalter (no. 23) which has ninety full-page miniatures. Other extensive cycles occur in nos. 1, 14, 24, 28, 30, 51, 72 and shorter series are to be found in nos. 2, 35–7, 50, 52, 86. The two Peterborough Psalters (nos. 45, 47) have one and two full-page miniatures exclusively of the devotional subjects of the Crucifixion and Christ in Majesty. The large picture cycles undoubtedly had an appeal through their richness and also their educative function, probably for teaching children the stories of the Old Testament and the events of Christ's life (as in the case of no. 14).

The very extensive Old Testament cycles in the great Canterbury Psalter, the Munich and Huntingfield Psalters and in the Trinity College, Cambridge Psalter (nos. 1, 23, 30, 51) and in the set of single leaves by the de Brailes workshop (no. 71) have many scenes and iconographic features in common. They all derive from a series of scenes known in the 12th century and perhaps originating in the late Anglo-Saxon period.[28] The smaller cycles of pictures show almost entirely the scenes of the main events of the life of Christ and devotional images of Christ in Majesty, the Crucifixion and of the Virgin and Child. The Glazier Psalter (no. 50) unusually includes two full-page miniatures of the life of David which very probably had some special significance for the owner. The Huntingfield Psalter (no. 30) and the St. Albans Psalter (no. 86) are exceptional in having scenes of the lives of the saints.

The cycle of prefatory miniatures in the Munich Psalter (no. 23), Cambridge, Trinity College MS B. 11. 4 (no. 51) and the de Brailes Psalter leaves (no. 72) is terminated by scenes of the Last Judgement. The inclusion of this subject in miniatures before a Psalter occurs in the 10th century in the Athelstan Psalter (*Survey*, II, no. 5) and in the 12th century in the Psalter of Henry of Blois (*Survey*, III, no. 78). Under English influence around 1200 it is also found in French Psalter illustration in the Ingeborg Psalter (Chantilly, Musée Condé, MS 1695).

The historiated initials of the liturgical divisions in the period up to 1250 have in most cases subjects distinct from those in contemporary French manuscripts which were later to influence English Psalter iconography.[29] The various workshops have individual iconographic features for these initials which confirm the stylistic groupings and often point to regional traditions.[30] The Canticles, Creed and prayers very rarely have figure initials although the Munich Psalter and London, B.L., Arundel 157 (nos. 23, 24) have a very full series.

Certain groups of artists seem to have specialised in Psalter illustrations (e.g. nos. 23–9, 35–7, 49–52), for their surviving products are almost exclusively of that text. There was indeed a great fashion in the period for luxury Psalters and doubtless it was profitable for workshops to concentrate their activities on producing these books.

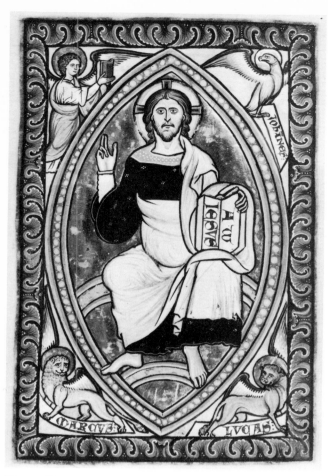

Fig. 1. Christ in Majesty.
London, B.L., Royal 2. A. XXII, f. 14 (cat. 2)

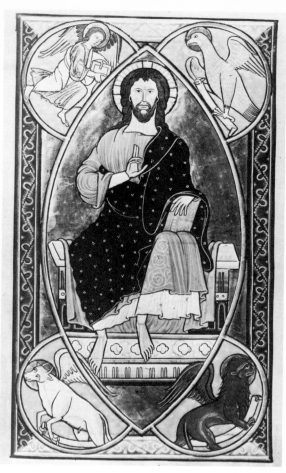

Fig. 2. Christ in Majesty.
London, B.L., Royal 1. D. X, f. 8ᵛ (cat. 28)

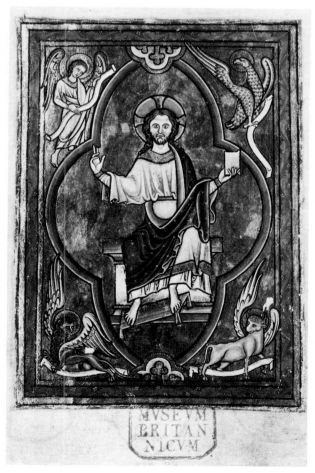

Fig. 3. Christ in Majesty.
London, B.L., Cotton Vespasian A. 1, f. 1 (cat. 46)

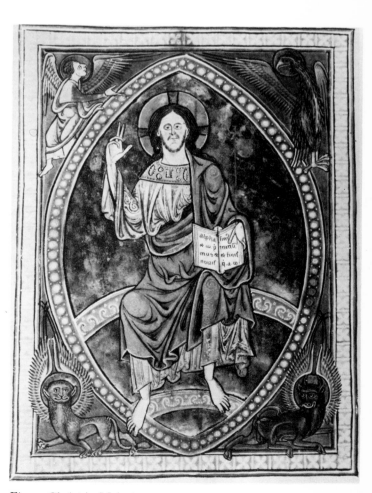

Fig. 4. Christ in Majesty.
New York, Pierpont Morgan Lib., Glazier 25, f. 3 (cat. 50)

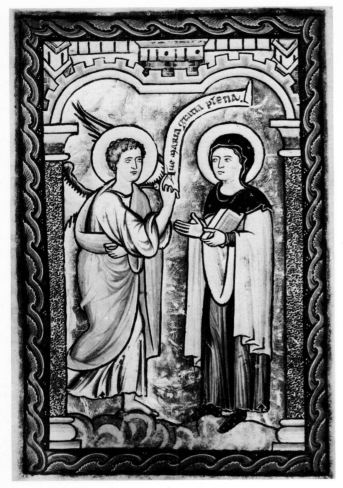

Fig. 5. Annunciation. London, B.L.,
Royal 2. A. XXII, f. 12ᵛ (cat. 2)

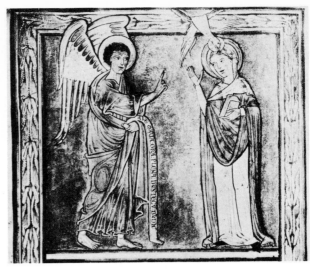

Fig. 6. Annunciation. London, B.L.,
Royal 1. D. X, f. 1 (cat. 28)

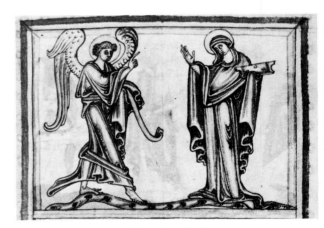

Fig. 7. Annunciation. London, Society
of Antiquaries, 59, f. 33 (cat. 47)

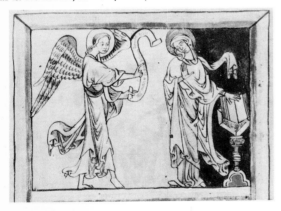

Fig. 8. Annunciation. Cambridge, Emmanuel
College, 252 (3.3.21), f. 7 (cat. 52)

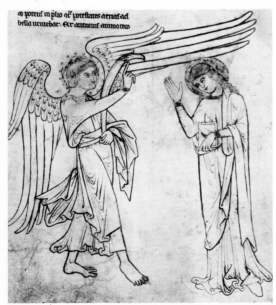

Fig. 9. Annunciation. Cambridge,
University Lib., Kk. 4. 25, f. 47ᵛ (cat. 53)

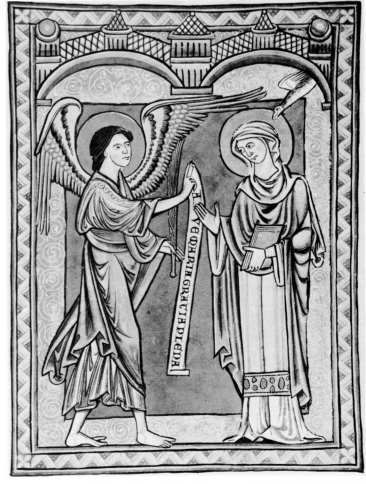

Fig. 10. Annunciation. New York, Pierpont
Morgan Lib., Glazier 25, f. 1ᵛ (cat. 50)

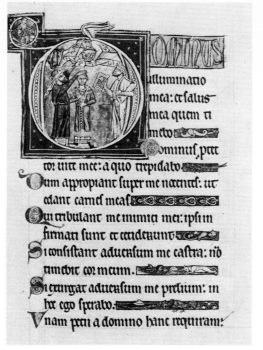

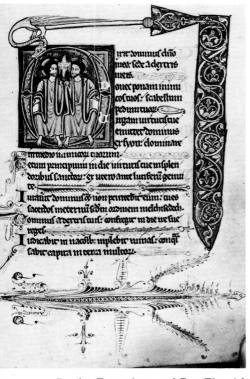

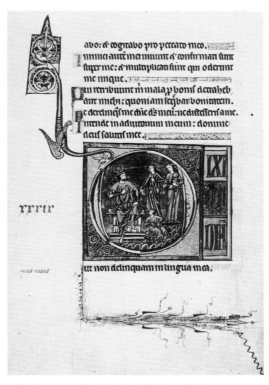

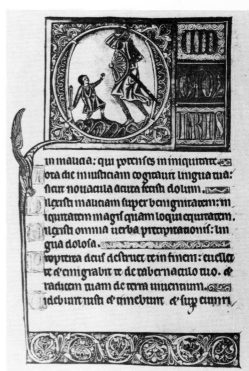

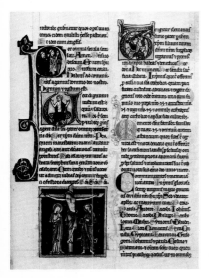

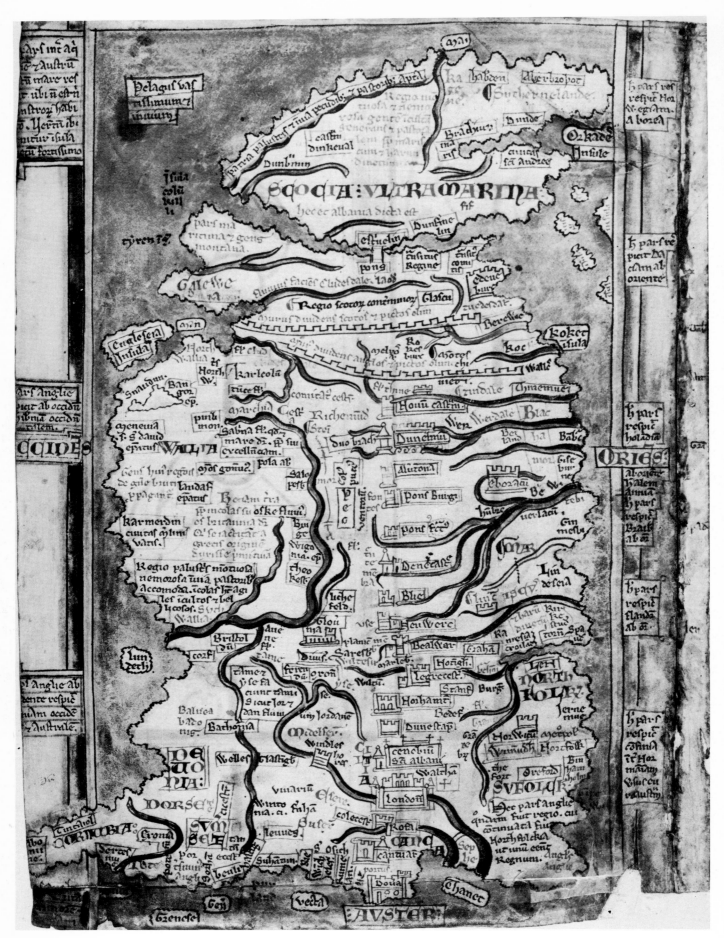

Fig. 18. Map of England and Scotland.
London, B.L., Cotton Claudius D. VI, f. 12ᵛ (cat. 93)

(b) *Other liturgical and devotional texts*

There is a remarkable lack of illuminated copies of books for the public services of the Church, above all of the Missal.[31] Only a single leaf (no. 57) and three partial Missals containing only a few select masses attached to Bibles (Oxford, Bodl. Lib., lat. bibl. e. 7, San Marino, Huntington Lib. HM 26061, nos. 69, 77 and Paris, B.N. lat. 10431) survive from the first half of the 13th century. The main decoration of a Missal seems to have been a full-page Crucifixion miniature facing the beginning of the Canon Prayer (nos. 57, 77), and this iconography and placing was traditional for the text throughout the Middle Ages.

No other illuminated books for the public liturgy, except a few very coarsely decorated examples, have survived. Of devotional texts other than the Psalter there is only a single Book of Hours, (London, B.L., Add. 49999, no. 73) from this period. This text only appears in illustrated form from around the middle of the 13th century and the de Brailes Hours (no. 73) is exceptional for its elaborate decoration at such an early date.[32]

The Hours of the Virgin Mary and various other forms of Hours (e.g. of the Holy Ghost) offered a structured devotional programme of reasonable brevity over the liturgical hours of the day, and it is not surprising that it became very popular amongst the laity. Its text combined psalmody with Biblical readings, hymns and prayers to the Virgin. The Hours of the Virgin first appears attached to the Psalter with little or no illustration (nos. 24, 35, 36). In addition to these Hours the most usual contents are the Office of the Dead, the seven Penitential Psalms and the fifteen Gradual Psalms. These elements also were first included or indicated in the text of Psalters before the Book of Hours appeared as an independent text. The beginning of the series of Gradual Psalms in the Psalter would, for example, occasionally be given a large illuminated initial (e.g. Part 2, nos. 166, 184, Venice, Bibl. Marciana MS lat. I., 77 and Křivoklat, Castle Lib. I. b. 23). Little attempt was made to develop the illustration of the text within the Psalter except to provide one historiated and a few ornamental initials (e.g. nos. 35, 36) in the Hours of the Virgin and the Office of the Dead. The de Brailes Hours presents a great range of subject matter in full-page miniatures and historiated initials and makes an exceptionally worthy beginning to the illustration of the text which later in the Middle Ages was to become the chief concern for the skills of illuminators.[33]

(c) *Lives of the Saints*

A form of book illustrated with full-page miniatures devoted to the life of a single saint had begun in the 11th century and flourished in the 12th.[34] The small format of such books which had characterised the earliest examples led to them being called *libelli*. The texts contained the lives and posthumous miracles of the saint and occasionally also prayers. The Life of St. Cuthbert (no. 12) is in this tradition and is the last English example of it. Most of these books were intended for the use of the religious houses or cathedrals where the relics of the saints were kept.

In the 13th century illustrated copies of saints' lives in the vernacular became fashionable The writing of such lives in Anglo-Norman French was often nothing more than a slightly elaborated translation from an earlier Latin life although some were of greater originality.[35] Throughout the century Anglo-Norman was still the main language of the higher ranks of society and only in the 14th century was it eventually supplanted by English. All the 13th-century Anglo-Norman saints' lives have the pictures as framed tinted drawings set at the head of the page above the columns of text (nos. 61, 85, Part 2, no. 123). All have, albeit controversially, been linked with Matthew Paris the monk and chronicler of St. Albans either as author or illustrator or both, and detailed arguments for these attributions are presented in the respective catalogue entries. Matthew was certainly involved in lending copies of such books

to aristocratic ladies (see The Life of St. Alban, no. 85). The extent to which the illustrations closely follow the text or alternatively in some cases use conventional compositions from representations in the monumental arts of wall painting, tapestry or stained glass should be questioned. The Lives of the Saints in the 13th century were depicted in monumental art, above all stained glass, more frequently than in manuscripts.[36] The investigation of such picture cycles is made difficult by the existence of several versions both in Latin and in Anglo-Norman of the lives of the more famous saints.

The Guthlac Roll (no. 22) has a series of roundels illustrating the Life of St. Guthlac as tinted drawings. The use of roundels, commonly found in contemporary stained-glass windows, has led to the suggestion that the roll was a model for a window.

General collections of lives of saints, often intended for reading in the refectory in religious houses, had existed from an early period.[37] They were hardly ever given much decoration and no. 5 (Cambridge, Corpus Christi College, MS 161) with its one miniature, made probably for a Cluniac house, is typical of such a book.

(d) *Bibles*

Thirteenth-century Bibles are much smaller than their 12th-century predecessors although a few from the early years of the century keep to the old format (nos. 32, 44). The remaining Bibles are about half the size or less, and some are small enough to be termed portable or pocket Bibles because they are of such a size that they could easily be carried about (nos. 66, 69).[38] This change reflects the rise in personal rather than corporate ownership of these books which seem almost all to have been for private study with only two showing evidence of use for reading in the refectory (nos. 65, 69). The monumental 12th-century Bibles (*Survey*, III, nos. 56, 69, 70, 83, 98, 103) were intended as major creations of the monastic scriptoria on whose text and decoration no time or effort was spared. They stand as the most magnificent products of English 12th-century illumination. Fine as the 13th-century examples are they cannot be claimed as major products of their time in comparison for example with the luxury Psalters. Their decoration consists of small historiated or ornamental initials at the beginning of each book often elaborated by having ornamental extensions into the borders. A much larger initial, usually with a series of Creation scenes, is given to the Book of Genesis.

The Lothian Bible (no. 32) in its size and degree of illustration is still in the tradition of 12th-century Bibles, although in placing several small crowded scenes all together within the initials and in fussy decorative features it shows a scaling down of the monumental presentation of its predecessors.

The Bible of Robert de Bello (no. 63) of the second quarter of the century is intermediary in size and its initials are large in relation to the dimensions of the book. It is rather an isolated product. More typical of the appearance of English Bibles of the period from *c.* 1230 until the end of the century are nos. 65, 66, 69, 70, 75, with those from the de Brailes workshop as the best examples. They all have relatively small finely illuminated initials, some with figure subjects and others only ornament. The degree of decoration ranges from an almost complete set of historiated initials to the books, with ornamental initials to their prologues, down to the simplest form with only an illuminated initial at the beginning of Genesis. This range is well seen in the products of the de Brailes workshop.

Bibles with the most up-to-date texts were of course in great demand in the universities with their heavy emphasis on theological studies. It is therefore hardly surprising that many of the illuminated examples before 1250 seem to have been produced in Oxford. The revision of the Bible text in Paris in the first half of the 13th century had an impact on the text used in England.[39]

The iconography of the initials in the smaller Bibles is often difficult to determine because

the small size of the initials necessitated abbreviation of scenes to two or three figures. In some cases the identification of the subjects given here may with further research be proved wrong, but it has seemed best not to litter the text with too many question marks even though many cases perhaps merited them. Influences on the subjects used come from France, as would be expected in view of the interest in the new Paris text, but until the French material has been better published, an assessment of these is not possible. The historiated initials to the book of Psalms in most cases follow English traditions and this feature combined with the stylistic evidence enables attribution of these books to England.[40]

(e) *Bestiaries*

After the Psalter the finest products of English illumination of the first half of the 13th century are found in the books of animal lore, the Bestiaries.[41] In the older literature, many of these have been dated rather too early, to the late years of the 12th century, whereas most of them were produced at a date well into the 13th century.[42]

The earliest illustrated Bestiaries had been given only simple drawings set within the text (*Survey*, III, nos. 36, 104–5). In the closing years of the 12th century the fashion began for fully painted framed pictures, also set within the text, in the Radford Bestiary (*Survey*, III, no. 106) and the slightly later companion copy in Leningrad (no. 11). Although Bestiaries with plain or tinted drawings continue to be produced (nos. 21, 53, 54, 80) the majority are fully painted and gilded. The format of placing the miniature, now framed, within the text rather than on a separate leaf is retained although occasionally a whole page is devoted to a picture (e.g. in the Ashmole Bestiary, and the St. John's, Oxford, Bestiary (nos. 19, 42)).

Only in a few cases are the animals in any way naturalistic, which is hardly surprising since the majority of them are either fantastic or not native to England. Most of the Bestiaries were made before even the famous Elephant arrived for Henry III in 1255. In a period in which sculptors in both figure and leaf forms were coming closer to nature it could perhaps have been expected that domestic animals, birds and insects indigenous to England would be painted with greater fidelity to their actual appearance and yet the traditions of formalised stereotypes still persisted.[43] The snake shedding its skin is a revealing example. In some Bestiaries (e.g. no. 21) it is shown as a dragon symbolically passing through a tower as an indication of a crack in the rocks through which the text tells us the snake passes to facilitate the removal of its skin. In others (e.g. nos. 53, 55) a proper snake is shown with its skin peeling off. Naturalism is introduced only by means of genre elements like the presentation of some of the animals in a narrative context such as a hunting scene (e.g. nos. 53, 76).

The text of the Bestiary was amplified in the late 12th and early 13th century by additions derived from the *Hexaëmoron* of St. Ambrose, the *Topographia Hibernica* of Giraldus Cambrensis (e.g. the Barnacle Geese), and the *Pantheologus* of Peter of Cornwall.[44] These interpolations sometimes result in repetitious accounts of the same creature and in varying orders of the many sections of the text.[45]

(f) *Herbals, Treatises on Medicine and Fortune-telling*

These can be considered as books of science and must have been destined for specialist practitioners in the case of medicine although possibly for amateurs in the case of fortune-telling. Understandably richly illuminated copies of such texts are few in number, for luxury books would hardly be necessary for those wishing to acquire the practical skills described. The Herbal is essentially a medical book and both copies, Oxford, Ashmole 1462 (no. 9) and London, B.L., Sloane 1975 (no. 10) also have pictures of medical operations. The copy of

Roger of Salerno's *Chirurgia* in Trinity College, Cambridge (no. 78) is concerned with descriptions of operations and of the preparation of medicines. It is rare to find such a full series of illustrations of these activities at such an early date and they provide valuable documentation for the study of 13th-century medical practice.[46]

In the Herbals the set of illustrations of both the herbs and the medical operations depend on 12th-century models and in particular have links with a supposedly Mosan manuscript (London, British Library, MS Harley 1585). The herbs are very stylised and are much more so than in 11th- and early 12th-century copies (*Survey*, II, no. 63; *Survey*, III, nos. 10, 11).[47]

The single fortune-telling text is from the hand of Matthew Paris (Oxford, Ashmole 304, no. 89) and the good chance that it has illustrations is the result of his ever inventive capacity to accompany a text with pictures.

(g) *Theological texts*

Copies with illumination of the various books of the Bible with commentaries (glosses) by contemporary theologians had been popular in the second half of the 12th century in the climate of great activity of Biblical scholarship (*Survey*, III, nos. 90, 99–101).[48] This type of book continues in the 13th century (nos. 3, 8, 25, 31, 36, 38) but becomes less common after *c.* 1220. Their decoration with historiated initials is in its iconography modelled on contemporary Bible or Psalter initial illustration.

Other illustrated theological works are collected or single works of near-contemporary theologians (nos. 4, 43, 53, 60, 79, 80, 84, 90), St. Anselm, Hugh and Richard of St. Victor, Peter of Poitiers, Peter of Riga and Peraldus (Guillaume Peyraut). In contrast to the 12th century there are no illustrated copies of any importance of the work of the Church Fathers, Saints Augustine, Gregory and Jerome, but the emphasis is on comparatively recent theological works. This was almost certainly a result of the ample supply of texts of the Church Fathers which had been produced in the period between the Conquest and the end of the 12th century. The works of Anselm and Peraldus are moral treatises and the popular Peter of Poitiers text is on the genealogy of Christ.[49] Apart from the Hugh of St. Victor which has a framed full-page author portrait, the others have simple illustrations in tinted drawing and are far from being luxury books.[50]

(h) *Legal texts*

Only a single copy with substantial illumination survives from the period before 1250 of the book of Canon Law, the Decretals of Gratian (no. 6). This is probably so because such books were usually prepared in France or Italy and sent to England; this explains why the iconography and style of no. 6 derives much from North French examples.[51] The standard decoration was to have historiated initials at the beginning of each of the cases (*causa*) illustrating the offence or dispute. A late 12th-century copy possibly produced at Durham has illuminated ornamental initials (Durham, Cathedral Library MS C. II. I) and represents a simpler form of decoration.[52]

(i) *Chronicles*

A notable feature of the period is the richness of illustration to chronicles which both before and since then were texts illustrated either sparsely or not at all.[53] The finest examples are those produced at St. Albans by Matthew Paris (nos. 87, 88, 91, 92, 93).[54] In these not only the

historical characters but also a great diversity of the events of the text are represented. The idiosyncratic choice of subject and the execution of the tinted marginal drawings are almost entirely due to Matthew Paris himself.[55]

The format of marginal illustrations in this technique for chronicle material had existed earlier in the works of Giraldus Cambrensis (nos. 59a, b) describing his journey in Ireland and Wales, which are strictly speaking topographical works rather than chronicles. The anecdotal and often bizarre choice of subject by Gerald is very similar to that of Matthew.

The Genealogy of Christ by Peter of Poitiers was often extended by combination with a Universal Chronicle (nos. 43b, 90) attempting to fuse sacred and profane history into a whole.[56] The illustrations are almost exclusively busts or heads of the personages of the chronicle, set in roundels within the text. As in the case of both the Matthew Paris and Giraldus Cambrensis material, these are also in tinted drawing.

A particular interest of the time, evident in the Chronicle of Abingdon (no. 41), the Universal Chronicle (no. 43b) and the works of Matthew Paris (nos. 92, 93), is a series of illustrations of the Kings of England. Later in the 13th and 14th centuries genealogies of kings become more common in sculpture and wall painting as well as in manuscripts.[57]

(j) *Romances*

Only two illustrated texts survive (nos. 81, 82). Although chivalric literature had been much read since the 12th century it was not apparently considered as a text for rich illustration.[58] The Romance of Alexander (no. 81) has numerous framed tinted drawings set within columns of the text. It is a form of illustration in which, as in the Bestiaries and Herbals, the picture is close to the passage of text which describes the event represented. The Chanson d'Aspremont (no. 82) is illustrated in the same manner but is distinguished neither by the abilities of its scribe nor by those of its illuminator and is a poor product.

The relatively modest appearance of these books (probably for aristocratic patrons who could certainly have afforded better) is worthy of note. It seems they did not become luxury books until much later, although it is always possible that better examples existed. By analogy with France it is however unlikely that this would be the case until relatively late in the 13th century.[59]

STYLISTIC DEVELOPMENTS

In the older literature the discussion of the styles of the period has been rather simplified with general descriptions of broad changes which were based on the consideration of a few of the major manuscripts. Closer investigation of evidence for dating and provenance over a wider range of material has enabled a rather more detailed account to be presented here, but much remains to be done on relative chronology among the various manuscripts of the individual workshops. Also in matters concerning the development of ornament in initials and line endings future work may reveal interrelationships and significant changes.[60]

(a) *The Transitional Period c. 1180–1220 (nos. 1–48)*

At the beginning of the period a number of major manuscripts were produced at Winchester, St. Albans, Durham (*Survey*, III, nos. 82–4, 89, 96, 98) and at some monastic West Midlands

centres (*Survey*, III, no. 103). The various styles of the artists who had produced these books are the basic source for almost all the major illuminated books for the period *c.* 1190–1210. There appears to have been a dissemination of styles from these monastic centres which may reflect a breaking up of the system in which artists were closely linked with the book production of the monastic scriptorium. The manuscripts of this period of stylistic development are only in one or two cases for the same Benedictine patrons as their predecessors. The remainder are for Augustinian canons, an archbishop of York and various unspecified, perhaps lay, patrons.

The late artists of the Winchester Bible (*Survey*, III, nos. 82–4) had, under strong Byzantine influence, developed a figure style with relatively naturalistic poses and draperies and with heavily modelled Byzantine-derived head types. This style was in great contrast to the abstract linear patterning and distorted figure poses of Romanesque painting. Figures in the new Winchester styles were not only more balanced in pose but more three-dimensional in form.[61] In the most advanced of these painters, the so-called Master of the Gothic Majesty, there was a move away from the heavy modelling and stern features of the Byzantine-derived head types towards more gentle expressions and paler modelling. A direct following or parallel of this style, possibly works of this same artist, are the Westminster Psalter (no. 2) and the St. Albans Glossed Gospels (no. 3). Probably also directly derived from another of the Winchester painters is the style of the last copy of the Utrecht Psalter made at Canterbury (no. 1).

In these three works a type of painting originating at Winchester is seen spreading to London, St. Albans and Canterbury. At Winchester itself, in the first decade of the 13th century, two Psalters were probably produced for the nearby nunnery of Amesbury in Wiltshire (the Imola Psalter, no. 26 and the Psalter in the Bodleian Library, lit. 407, no. 27). The developed style of these artists is best seen in a Psalter with many full-page miniatures (no. 28) made for an Oxford patron probably after the workshop had moved to Oxford. The late 12th-century interest in full rounded figure forms shown in the late artists of the Winchester Bible and their direct followers (e.g. the Westminster Psalter, no. 2) has in these miniatures changed to preoccupation with flatter forms, tendencies towards angularity in outline and gesture and more emphasis on linear drapery folds. The painting of the heads with pale modelling shows a definite move away from any imitation of Byzantine types in appearance and technique.

Parallel with these derivations from painting at Winchester is a similar development in the North of England. At Durham in the 1170s the manuscripts produced (*Survey*, III, nos. 98–101) were under strong influence from North France or the Champagne region and some of the artists involved may well have been French.[62] The figures are compact in form with smooth flowing folds tending to be arranged in parallel lines or splaying from a point. The style of one of the artists of Bishop Hugh de Puiset's Bible is followed directly in the two Herbals, Oxford, Bodleian, Ashmole 1462 (no. 9) and London, B.L. Sloane 1975 (no. 10) for which a North England provenance has been suggested. The style of the Durham manuscripts is taken up in the Gough Psalter (*Survey*, III, no. 97) with larger-scale figure compositions. In both its style and iconography this Psalter was the model for a series of Bestiaries (*Survey*, III, no. 106 and this volume no. 11) and Psalters (nos. 14–16). In the Bestiaries are found the same solemn, almost surly, facial types, and the drapery style in a drier linear version. The artist of the miniature of David and his musicians in the Gough Psalter (f. 32), probably a different hand from that of the main series of pictures, has a distinctive painterly style. It is this that is followed in the Psalters (nos. 14–15) and the set of Bible pictures (no. 16) whose iconography provides further evidence of the derivation.

The Life of St. Cuthbert (no. 12) and a Bestiary (no. 13), both in the British Library, are further removed from the Durham work of Bishop Hugh de Puiset's time although the Life still shows links with such painting. The figures in these have softer, more fluid forms and groupings, and the faces no longer have the severity of the earlier work.

Possibly also from the North or North Midlands is a group of luxury Bestiaries: the Ashmole Bestiary (no. 19), the Aberdeen Bestiary (no. 17), and the Cambridge Bestiary (no. 21). Their quality is extremely high and although their iconography is linked to two earlier Bestiaries from this region (*Survey*, III, no. 106) and the Leningrad Bestiary (no. 11) their style is very different. Several pieces of evidence for provenance suggest the possibility of Lincoln as their centre of production.[63] The Guthlac Roll (no. 22) in view of the inclusion of a picture of the benefactors of Croyland Abbey (Lincolnshire) seems to have been destined for that place. It is very probably by the same artist as the Cambridge Bestiary (no. 21) and is the prime piece of evidence for localising the group in that region. Further evidence is provided by stylistic similarity with the North Rose window (the Last Judgement) of Lincoln Cathedral.[64]

The origins of the early style of the group of the Munich Psalter (nos. 23, 24) seem to be from the West Midlands centre which produced a richly decorated Bible in the closing years of the 12th century (*Survey*, III, no. 103). The provenance of the Bible is far from certain but the Gloucester connections of the Munich Psalter itself give some support for links with this region. These artists eventually form a workshop at Oxford (nos. 24, 28, 29) in combination with those who had originated at Winchester (nos. 25–7). The Munich Psalter itself probably predates this link with the Winchester artists.[65] Its figure style is characterised by bright colours rather heavily applied, full rounded forms with some figures in dynamic poses but without much understanding of the natural contours of the bodies. In this last feature the style is still very much in the tradition of Romanesque painting and is parallel, even possibly in some way linked, to the manner of the Copenhagen Psalter (*Survey*, III, no. 96). The same features of patterned rinceaux designs on the highlight areas of the draperies, and the flowing sweeps of folds are common to both works. Although the Copenhagen Psalter was destined for an Augustinian house in the diocese of York several elements in the style of the main artist suggest origins in the southern half of England.[66]

In the second decade of the 13th century most artists show definite moves away from the interest in plastic three-dimensional figures in calm balanced compositions which distinguished works of the years around 1200 like the Westminster Psalter (no. 2) and the Life of St. Cuthbert (no. 12). The figures become angular and insubstantial in form with lively gesticulation of hands and arms. Some of the monumental sobriety of composition survives from the earlier period in varying degrees in some artists. In the Huntingfield Psalter group (nos. 30–32) both aspects are evident, whereas in the Berlin Psalter group (nos. 35–7) monumental solidity of figures is still a major interest.

Other manuscripts of the time (e.g. nos. 33, 34, 38–41) have a smaller-scale, livelier style. The best example of this almost Early Gothic style is the Lindesey Psalter group (nos. 45–7). Painterly modelling, although retained, is in some figures combined with a reassertion of linearism in fold patterns. This, combined with a nervous preciosity of figure pose also evident in the Lindesey group, will be the main feature to characterise the fully developed Early Gothic style.

(b) *The Early Gothic Style (nos. 49–68)*

One of the problems in applying the term Gothic to painting is that very different definitions are required for the dates and phases of developments from that used for the style in architecture or in sculpture. Like so many of the terms first used to describe architecture it rests rather uneasily on the shoulders of the figure arts. Early Gothic as applied to architecture means the 12th-century development of the style, to be followed by High Gothic in the first third of the 13th century. Controversially and much less satisfactorily the same periodisation can be applied to sculpture. For painting, the period of transition *c*. 1180–1220 shows much diversity

of styles amongst which it is difficult to single out any as distinctly Early Gothic, or in any sense in the mature style implied by the term High Gothic.

In the 20s and 30s of the 13th century more uniformity and clearer lines of development in English painting justify the use of the term Early Gothic. Tendencies were evident in the first twenty years of the century towards angular mannered poses with the beginnings of an emphasis on linear fold patterns. In the fully developed Early Gothic, systems of strongly delineated troughed folds are used to define the form of rather thin delicate bodies. A variant of this 'trough' fold is the so-called '*Muldenfaltenstil*' in French painting *c.* 1200–40 which had originated in late 12th-century goldsmiths' work. Very probably in England also this fold style originated in some three-dimensional art either that of the goldsmith or of the sculptor.[67] The best early examples of the style are the Glazier Psalter (no. 50), the Trinity College Psalter (no. 51), and a Bestiary (no. 53), all of which may have originated in London.

Other artists using rather different figure and drapery styles show the same tendency to emphasise linear folds in strong black lines. The artist of the Rochester Bestiary (no. 64) to whom a number of other works can be ascribed (nos. 65–68) is a good example. In his work small-scale effects are achieved with delicately posed figures in small initials (e.g. nos. 65, 66, 68). Similar features characterise two contemporary Bibles (nos. 62, 63). In the popular tinted drawing technique of the time the linear aspects can of course be easily emphasised (nos. 52–61).

The full development of the Early Gothic style occurs in a group of manuscripts perhaps produced at Salisbury (the Sarum Master group) and in the works of the artists of the earliest Apocalypses. This will be discussed in Part 2 of this volume.

(c) Tinted Drawings c. 1200–50 (nos. 21, 22, 43, 47, 51–61, 78–94)

Although the works in tinted drawing have been included in the general discussion of style in the previous two sections they deserve special consideration apart from the fully painted work. In a sense this technique may represent a simpler, less expensive form of decoration, although many of the manuscripts in this manner contain work of the highest quality (e.g. nos. 21, 22, 51, 53).

Perhaps a distinction can be made between the use of light tinting along the outlines and fold lines of the figures and architectural features, and the rarer technique of overall colour wash used for some parts of the drawing (e.g. nos. 51, 53). The former technique, practised in England since the 10th century (e.g. *Survey*, II, nos. 41, 64) had used light colour washes along contours to define three-dimensionality. The plain vellum serves as a sort of highlight area and thus the figure can be given plastic form. In the first half of the 13th century the use of the technique to convey modelling is relatively poorly understood. But in the tinted drawing Apocalypses of the 1250s and 60s to be considered in Part 2 it is used by some artists in a very sophisticated way.

Above all it must be emphasised that the popularity of tinted drawing in 13th-century England is hardly at all connected with any influence from the St. Albans monk, chronicler and artist, Matthew Paris. It had been used by some artists at all times, from the 10th century onwards. In the early 13th century it is used in the Guthlac Roll (no. 22) which, even allowing for the possibility of a date as late as the 1220s, considerably precedes the artistic activity of Matthew Paris.

The technique is however more predominant in the 13th century than it had been in the 12th. In the first half of the century many of the tinted drawing manuscripts are of monastic provenance (nos. 21[?], 22, 47, 52, 56, 59a, 60[?], 85–93), although perhaps it would be unwise to draw any definite conclusion from this. Simpler books for which there is no tradition of luxury copies have this technique (e.g. no. 43) whereas some texts such as Bestiaries occur both as tinted drawing or with full painting and gilding.

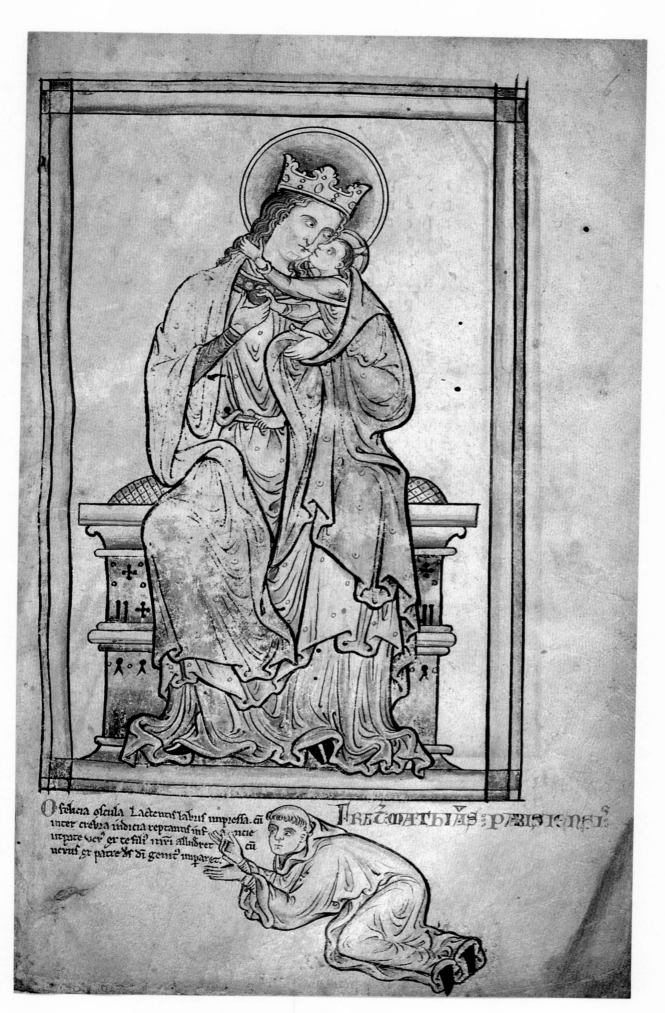

Virgin and Child. London, B.L., Royal 14. C. VII, f. 6 (cat. 92)

(d) William de Brailes (nos. 69-74)

Fortunately one professional artist of the period can be reasonably well documented and a fair number of works can be ascribed to him and his workshop. Very probably several artists are involved working in the 'de Brailes style' and it has not been possible in the scope of this volume to differentiate the hands.

The documents of the activities of scribes and illuminators all living in the vicinity of Catte Street in Oxford mention a William de Brailes.[68] The signature W. de Brailes is found on one of a set of single leaves once prefatory to a Psalter (no. 72) and in a Book of Hours (no. 73). In the latter he is designated as a painter although it seems the rubric titles to his illustrations may be by his hand showing that he was also a competent scribe. The signature is accompanied by a figure of a tonsured man. As the documents reveal that he had a wife Celena the tonsure must signify that he was only in minor orders.[69]

The style of de Brailes is characterised by lively figures, rather stiff in their movements but as group compositions very active as a result of mannered postures and gesticulating hands. The range of expression in the heads is restricted but always alert and conveying a life-like energy to the narrative. The wide range of subject matter in his work is presented with a great concern for telling the story. The origins of this style are indisputably in the Huntingfield Psalter workshop (nos. 30-32) which also provides parallels in iconography and use of ornament. The mistaken early dating of the Huntingfield Psalter in the older literature and insufficient emphasis on the link between the artists of this book and those of the Lothian Bible has obscured any assessment of the relevance of these works for the de Brailes workshop.

The use of ornamental extensions as border bars to frame the text is an important aspect of the de Brailes workshop and is used in its most mature form in the New College Psalter (no. 74). This achieves a linking of the illumination of the historiated initial with the whole page of text and in the second half of the 13th century and in the 14th and 15th centuries becomes widespread.

(e) Matthew Paris (nos. 85-93)

Matthew Paris, the monk and chronicler of St. Albans, stands out as an exception among the artists of the 13th century: exceptional not only in the individuality of his art but also in his status as a monk, for he stands apart from the predominantly lay production of book illustration suggested by all the circumstantial evidence. The extensive documentation on Matthew Paris contrasts with the negligible documentation on the lay artists and this has naturally led to some overemphasis on his role in 13th-century art. This assessment of his position and influence becomes crucial in the discussion of the Lives of the Saints and Apocalypses ascribed to the School of St. Albans. As the production of many of these extends after Matthew's death in 1259 it has seemed best to discuss the whole group in Part 2 of this volume.

Matthew's use of tinted drawing for the marginal illustrations of the Chronicles which seem to be his earliest works is in no way exceptional. In the works of Giraldus Cambrensis (no. 59a, b) and in the copy of Anselm's *De similitudinibus* (no. 60) marginal scenes were executed in this technique. His figure style shows roundness of contour and in most cases also a solidity of form, and these features, characteristic of the Transitional period, suggest that Matthew formulated his style from works of the years around 1200 like the St. Albans Glossed Gospels (no. 3) by the artist of the Westminster Psalter (no. 2). It is this essentially early 13th-century style rather than the angular thin figure forms of the art of his contemporaries which predominates in his work. In certain later works (e.g. nos. 87, 92) he was undoubtedly influenced by the elaboration of linear fold patterns which is characteristic of much art of the period. In the characterisation of head types he conveys a lively sense of involvement in the narrative

although the wide-eyed expressions give a certain naïveté to the faces. In the smaller drawings in the Chronicles the style is much freer and sketchier than in the large formal pictures in the Life of St. Alban and Lives of the Offas (nos. 85, 87).

The art of Matthew Paris seems best considered as that of a very talented amateur in contrast to the professional artists of the time. This judgement is not meant to imply that it is in any way inferior to their work for indeed in many aspects it is considerably more interesting than that of all but the best of his contemporaries. The range of subject matter is very wide and always presented in an interesting way. The lack of any established models for most of the scenes necessitated considerable invention and observation of unusual detail.

The influence of his art seems to have been much more restricted than has been suggested in the older literature. In the case of the Life of St. Thomas (no. 61) arguments are presented in the catalogue entry for dissociating it from any involvement of Matthew Paris. Similar arguments are presented in Part 2 for other manuscripts which have been seen to have been influenced by him. Quite possibly other artists, perhaps laymen, worked at St. Albans in the tinted drawing style. In the autograph works of Matthew Paris, however, the evidence for any collaboration is slight.

TECHNIQUES AND COLOUR

Our present state of knowledge does not allow anything very definite to be said about the techniques of illumination in the period. The processes described by Theophilus in his treatise *De diversis artibus* of the first half of the 12th century seem to have been the basic techniques as far as can be judged from the appearance of the paintings.[70] The substances in which the coloured pigments were mixed for manuscript painting were either a preparation from egg white called glair, or a water solution of a type of soluble resin.[71] In the case of tinted drawing water-colour seems to have been used.

The contacts with Byzantine painting during the 12th century must have resulted in greater understanding of the use of colour for painterly modelling and shading. These painterly techniques were to a large degree abandoned in the early 13th century as can well be seen from the changes in the way faces are modelled. Similarly in the draperies there is a flatter application of colour with the folds delineated as black lines and hardly any use of painterly shading and highlighting. Some artists, for example the painter of the Psalter of Robert de Lindesey (no. 47), still use very sophisticated means of highlighting in some of their figures.

The study of the colours used in the period is also a relatively unexplored field. In full painting there is a clear trend during the first half of the 13th century towards a predominance of blue and orange-red over all other colours. The same tendency is evident in contemporary French illumination.[72] The purples, yellows and greens which had been common in 12th-century work are used more sparingly and in particular the purple is seldom used. In tinted drawing, green, brown and yellow are the most favoured colours although some artists, notably Matthew Paris, use much blue and red-orange or red-pink. The green, brown, blue, yellow combination with hardly any red or orange as used in tinted drawing is occasionally found in full painting, as in Margarete Skulesdatter's Psalter (no. 35) and the Psalter in St. John's College, Cambridge (no. 36). The normal procedure for a fully painted and gilded miniature began with an underdrawing in silver point or lead point. The drawing was then worked in ink and the gilding and burnishing done in the areas required. Then the colour was applied, and as a final stage stronger ink outlines and foldlines were made, with white paint often used for highlights and details. Gold is extensively used for the backgrounds in full painting and in rare cases for details in tinted drawing. It is in most cases applied thickly with

high burnish although the heaviest examples tend to be of the early part of the century (e.g. nos. 1, 2, 28).

During the period the fashion develops for incised punch marks or linear or foliate patterns incised on the gold.[73] The technique ranges in elaboration and is widely found (e.g. nos. 12–15, 19, 37, 40, 42, 44, 45, 47, 51, 62, 70, 72, 73, 75). The finest example of the early period of this patterning of the gold is undoubtedly the Psalter of Robert de Lindesey (no. 47) in which very detailed foliate designs are used in the Crucifixion and Christ in Majesty miniatures. No detailed study of these incised patterns has been possible but they may perhaps be a useful pointer to workshop traditions.

EVIDENCE FOR LOCALISATION AND DATING

The situation in the 13th century is complicated firstly by lack of information on contemporary ownership in the form of library pressmarks or inscriptions, and secondly by the change from book production in established monastic scriptoria to the lay workshop. It is still unclear whether lay scribes or artists were peripatetic or whether they were almost entirely based in major towns such as Oxford, Cambridge and London. Circumstantial evidence in civic archives for the existence of scribes and illuminators has of course to be supported by evidence of provenance from the books themselves either from their textual features or their decoration.

The liturgical texts are the main source of information. In the case of the large number of Psalters their calendars and litanies give many indications of possible localisation. In groups of Psalters by the same artists there is the additional advantage of combining the calendar/litany information for all the manuscripts.[74] In some cases the result of this analysis is conflicting because quite often the calendar gives different information from the litany, or a workshop has totally different texts for its various products. More usually there is a clear localisation to a diocese or association with a particular religious order. Most workshops in the 13th century seem to have produced for relatively local consumption. As an example books in Oxford might be produced for the neighbouring dioceses of Worcester, Winchester and London as well as the southern part of the diocese of Lincoln at whose southernmost extremity Oxford was located. It would be odd, however, for a diocese of Norwich or Durham book to be produced there.

The production of very high-class books should perhaps be distinguished from more mass-produced texts like the smaller Bibles. Very rich people could undoubtedly afford to maintain scribes and illuminators in their employ either at or close to their main residences.[75] The patronage of the Court would be a case in point and *a priori* one might expect some luxury books to be produced in the locality of the palaces of Westminster, Winchester and Clarendon, near Salisbury.[76] Combined textual, stylistic, iconographic evidence and, if it exists, contemporary ownership would of course be needed to locate any particular book to these centres. In no sense can either the text or the style or the iconography alone be used for localisation but must always contribute together to a solution. Further evidence from script, page ruling and size may eventually give more information.[77] It should, however, be said that lay scribes using conventional book hands are much more difficult to identify than a script developed in a particular monastic scriptorium.

The analysis of calendars and litanies is particularly complicated in the period before the introduction of Sarum Use with which this volume, excepting the latter period of Part 2, is concerned.[78] If calendar or litany is for a Benedictine house there is little problem in identification.[79] If it is for an Augustinian house it is very difficult to be precise since such places hardly ever had relics of sufficient importance to lead to a liturgical cult. If the calendar is of diocesan

use the problem of regional location is usually simply solved by identifying the local saints whose cults were limited to that part of England. This is complicated by what seems to be a diversity of liturgical observance within most dioceses until the introduction of Sarum Use eventually put an end to this chaos.[80] It is also complicated by the use of monastic text models containing many non-local elements which in modified form are used as secular calendars. This is probably a survival from the 12th-century situation in which a manuscript like the Shaftesbury Psalter (*Survey*, III, no. 48), probably made for a laywoman, was produced under the supervision of Shaftesbury and provided with a simplified Shaftesbury calendar. Thirteenth-century Psalters with Augustinian calendars may similarly in some cases have been intended for lay patrons rather than the canons themselves. But in this latter case the calendar may simply be a diocesan calendar with the added feasts of St. Augustine particular to the Augustinians.

The conclusion from the combined evidence of text and decoration is that one centre, Oxford, is producing illuminated manuscripts throughout the period *c.* 1200–50 as well as during the second half of the century, as will indeed be seen in Part 2. In the years around 1200 the old monastic centres of Winchester, Canterbury and Durham were probably still producing finely decorated books. Up to around 1220 there were perhaps centres in the North Midlands or the North but after that date there seems to be a decline in production. Throughout the period there is evidence for production in London which seems often to be linked with Winchester and Salisbury. The interconnections between the art of these three centres will become clearer in the manuscripts of Part 2 of this volume: it is very probably explained by high aristocratic patronage in association with the favourite places of residence of the court, and the consequent transference of artists. In addition to the lay centres mentioned, monastic production is still to be found at St. Albans in the middle years of the century as a result of the activity of Matthew Paris.

Dating of manuscripts is very tentative for so few have a firm date. Liturgical evidence from the introduction of a new feast only provides a *terminus post quem* if the saint is included in the calendar or litany. The absence of a feast can never provide a *terminus ante quem* because there was often considerable delay in a newly introduced observance finding its way into the texts.[81] Inevitably much dating depends on the view of developments in figure and ornamental style. In both these aspects of style there is of course additional evidence from developments in the sometimes better dated arts of wall painting, stained glass and architectural and tomb sculpture. In combining all these pieces of information, a dating in the 13th century within a period of about twenty years (i.e. ± 10 years from a *circa* date) is in most cases possible. Conservative artists may persist over a long period in a similar style but usually some aspect will reveal earlier and later works.

In proposing provenances and dates the use of as many of the diverse aspects of the illuminated book as possible, rather than placing too much emphasis on any one feature, has seemed the best approach. The results are however only tentative hypotheses according to our present state of knowledge, and it is hoped that the information and evidence presented here will provide a firmer basis for further investigation and so establish a more confident understanding of the period.

NOTES

1. A major exhibition held in New York in 1970 'The Year 1200' attempted an overall presentation of the arts and intellectual life of the period: ed. K. Hoffmann, *The Year 1200, I, Catalogue, New York, Metropolitan Museum of Art*, 1970; ed. F. Deuchler, *The Year 1200, II, A Background Survey*, New York, 1970; ed. J. Hoffeld, *The Year 1200: a Symposium*, New York, 1975. The term 'The Style 1200' proposed at the exhibition is not very satisfactory. The period is above all characterised by diversity and experiment rather than uniformity.

2. The distinctions between the monastic, the conventual and the secular church are between the monks of enclosed communities (e.g. Benedictines and Cistercians), the conventual but not enclosed orders of regular canons (e.g. Augustinians), and of friars (e.g. Franciscans, Dominicans), and secular priests and canons serving cathedrals, parish churches and chapels. The term secular applies to those in religious orders, whereas lay describes that bulk of the population (the laity) which was not. Some cathedrals (e.g. Canterbury, Worcester) had, since Anglo-Saxon times, been served by monks rather than secular canons which is a situation almost unique to England. P. Brieger, *English Art 1216–1307*, Oxford, 1968, 2–4 emphasises the role of the secular clergy in establishing English Early Gothic art.

3. On the English church in the 13th century see J. R. H. Moorman, *Church Life in England in the Thirteenth Century*, Cambridge, 1945, and J. C. Dickinson, *An Ecclesiastical History of England: the Later Middle Ages*, London, 1979, pt. III. For aspects of patronage see S. Wood, *English Monasteries and their Patrons in the Thirteenth Century*, Oxford, 1955. For the Augustinian Canons: J. C. Dickinson, *The Origins of the Austin Canons and their Introduction into England*, London, 1950. For the 'pastoral' element in Augustinian spirituality contrasted with monastic views see C. W. Bynum, 'The spirituality of regular canons in the twelfth century: a new approach', *Medievalia et Humanistica*, N. S. 4, 1973, 3–24.

4. On this aspect see M. Gibbs, J. Lang, *Bishops and Reform 1215–72*, Oxford, 1934, and C. R. Cheney, *English Synodalia of the Thirteenth Century*, 2nd ed., Oxford, 1968. Although primarily concerned with the 14th century K. Edwards, *The English Secular Cathedrals in the Middle Ages*, 2nd ed., Manchester, 1967, has much material relevant to the 13th century. For the organisation of the diocese of Lincoln by Robert Grosseteste, Bishop (1235–53) see D. A. Callus (ed.), *Robert Grosseteste*, Oxford, 1955, 146–77.

5. The detailed study of this process has not been made although W. H. Frere, *The Use of Sarum*, I, Cambridge, 1898, xxi–xxxvii; II, Cambridge, 1901, xxvii–xxxii provides an excellent basis.

6. A brief account of the Use of York is given by W. H. Frere, 'York Service Books', in *Walter Howard Frere: a Collection of his Papers on Liturgical and Historical Subjects*, Alcuin Club Collections, XXXV, 1940, 159–69. Hardly any York texts survive from the 13th century.

7. For the most recent account of the rise of Oxford and Cambridge see A. B. Cobban, *The Medieval Universities*, London, 1975, 96–115.

8. T. Hudson Turner, *Some Account of Domestic Architecture in England from the Conquest to the end of the Thirteenth Century*, Oxford, 1851, 181–263 gives in translation the texts from the Liberate and Close Rolls on the work done on the domestic buildings under Henry III's patronage. These extracts give a good impression of the concern for privacy and comfort. The painted decorations in these buildings are discussed by T. Borenius, 'The cycle of images in the Palaces and Castles of Henry III', *J.W.C.I.*, VI, 1943, 40–50, and E. W. Tristram, *English Medieval Wall Painting. The Thirteenth Century*, Oxford, 1950.

9. On literacy see the excellent essay by M. B. Parkes, 'The Literacy of the Laity', in *Literature and Western Civilisation: the Medieval Period*, ed. D. Daiches, A. K. Thorlby, London, 1973, 555–77, where further references are provided.

10. For patronage of literature and music by Eleanor of Aquitaine (wife of Henry II) see M. Lazar, 'Cupid, the Lady and the Poet: modes at Eleanor of Aquitaine's Court', and R. A. Baltzer, 'Music in the Life and Times of Eleanor of Aquitaine'. Both essays are contained in ed. W. W. Kibler, *Eleanor of Aquitaine*, Austin, 1976. The direct evidence for 12th-century ownership of illuminated books by lay women in England is slight; a possible example which could be cited is the 'Shaftesbury Psalter' (*Survey*, III, no, 48). The donor depicted before the Virgin and Child usually considered as a Benedictine abbess is hardly dressed as such and may be a lay woman. The sensible description of this donor as 'a lady connected with Shaftesbury Abbey' is given by D. H. Turner, *Romanesque Illuminated Manuscripts in the British Museum*, London, 1966, 8, pl. I. In the present volume nos. 14, 30, 35 of the period *c*. 1200–30 belonged to lay women at a time shortly after their production.

11. The Psalter is essentially an Office Book for the recitation of the Psalms which is the central part of the daily offices for the hours. The richly decorated Psalter could of course be taken to church to use at the offices of the hours but its main use seems to have been for private devotional reading.

12. Texts like the Ancrene Riwle although intended for anchoresses were doubtless also of interest to the devout laity. It has recently been shown by E. J. Dobson, *The Origins of Ancrene Wisse*, Oxford, 1976, that this text was produced by an Augustinian canon probably of Wigmore. See on the devotional programme R. W. Ackerman, 'The Liturgical Day in Ancrene Riwle', *Speculum*, 53, 1978, 734–44 which gives further references.

13. For books of the mendicant orders see K. W. Humphreys, *The Provision of Books by the Mendicant Orders in the Thirteenth and Fourteenth Centuries*, B.Litt., Oxford, 1949.

14. An interesting discussion of the evidence for book ownership by 13th-century Bishops is given by R. H. Bartle, *A Study of Private Book Collections in England between c. 1200 and the early years of the 16th century*, B.Litt. Oxford, 1959, 13–29.

15. I am much indebted to the unpublished thesis by R. Kent Lancaster, *King Henry III and the Patronage of*

Religious Art, Ph.D. Johns Hopkins University 1967, for an illuminating account of the King's patronage. Dr. Lancaster has published 'Artists, Suppliers and Clerks: the human factors in the art patronage of Henry III', *J.W.C.I.*, XXXV, 1972, 81–107. It is to be hoped that more of this interesting thesis will be presented in published form. The building patronage of the King is exhaustively discussed in H. M. Colvin, *Building Accounts of King Henry III*, Oxford, 1971, and by the same author in the *History of the King's Works*, I, II, London, 1963.

16. See R. Branner, *Manuscript Painting in Paris during the reign of St. Louis*, Berkeley, 1977, 3–6.

17. For King John's borrowing of theological books from the Abbot of Reading see W. L. Warren, *King John*, London, 1966, 190 and V. H. Galbraith, 'The Literacy of the earliest English Kings', *Proceedings of the British Academy*, XXI, 1936, 214.

18. R. Strayer, 'The Laicisation of French and English Society in the Thirteenth Century', *Speculum*, XV, 1940, 76–86.

19. G. Pollard, 'The University and the Book Trade in Medieval Oxford', *Miscellanea Medievalia*, III, 1964, 336–44. For names of illuminators see H. E. Salter, *Medieval Archives of the University of Oxford*, I, Oxford, 1920, 290, 292, 296, and O. Lehmann-Brockhaus, *Lateinische Schriftquellen zur Kunst in England, Wales und Schottland vom Jahre 901 bis zum Jahre 1307*, Munich, 1960, II, nos. 3404, 3422; III, nos. 5232, 5268, 5298, 5320, 5335.

20. G. Pollard, 'William de Brailes', *Bodleian Library Record*, V, 1955, 202–9.

21. The activities of the Simon Master are discussed by W. Cahn, 'St. Albans and the Channel Style in England', *The Year 1200: a Symposium, Metropolitan Museum of Art, New York*, 1975, 189–97. See *Survey*, III, 15–16 for discussion of lay illuminators in 12th-century England.

22. A very few examples on costs in the 13th century are cited by H. E. Bell, 'The price of books in Medieval England', *The Library*, XVII, 1936/7, 312–13. The ordering in 1265 of two Breviaries involving payment for vellum and writing in London and Oxford is recorded in the Household Roll of Eleanor, Countess of Leicester: B. Botfield, T. Turner, *Manners and Household Expenses in England in the Thirteenth and Fifteenth Centuries*, Roxburghe Club, 1841, 9, 24. Probably other examples remain to be discovered in unpublished Wardrobe and Household accounts. For a discussion of these documents see T. F. Tout, *Chapters in the Administrative History of Medieval England*, Manchester, 1920, Vols. I, II. In the late 13th century Queen Eleanor of Castile regularly employed an illuminator named Godfrey and two scribes Roger and Philip. The purchases of pigments, gold, ink and vellum are recorded in her wardrobe account: J. C. Parsons, *The Court and Household of Eleanor of Castile in 1290*, Toronto, 1977, 13, 28, 84, 86, 87, 92, 95, 101, 104, 110, 131. The Queen also purchased Psalters and Books of Hours in Cambridge, J. C. Parsons, *op. cit*, 63–4.

23. See *Survey*, III, nos. 29, 48, 78, 89, 94–7.

24. See n. 12 for devotions described in the Ancrene Riwle. For later medieval directories see W. A. Pantin, 'Instructions for a Devout and Literate Layman', *Medieval learning and literature: essays presented to Richard William Hunt* (eds. J. J. G. Alexander, M. T.

Gibson), Oxford, 1976, 398–422, where other references are given. The private use of the Psalter for devotions in monastic circles is discussed from the point of view of its early medieval development by J.-B. Molin, 'Les manuscrits de la "Deprecatio Gelasii": usage privé des Psaumes et devotion aux Litanies', *Ephemerides Liturgicae*, XC, 1976, 113–48. The general use of the Psalms in the Western Church is discussed in J. A. Lamb, *The Psalms in Christian Worship*, London, 1962, 80 ff.

25. The Office of the Dead consists only of First Vespers, Matins and Lauds. In medieval wills stipulating its recitation it is usually referred to by the opening words of the antiphons for Vespers and Matins, *Placebo* and *Dirige*. Episcopal statutes in the 13th century stipulate the recitation of this office by the clergy: F. M. Powicke, C. R. Cheney, *Councils and Synods with other documents relating to the English Church*, II, *1205–1313*, Oxford, 1964, 79, 213, 301, 377, 1019.

26. G. Haseloff, *Die Psalterillustration im 13 Jahrhundert*, Kiel, 1938, 4–12 discusses the distribution of the psalms according to the liturgical divisions and the decorative initials used to indicate this in 12th-century Psalters.

27. The picture book aspect was first pointed out by L. Delisle, 'Livres d'Images destinés à l'instruction religieux et aux exercices de piété des laïques', *Histoire Littéraire de France*, XXXI, 1893. The Leiden Psalter (no. 14) passed from England to France early in the 13th century and an inscription records that St. Louis learned from it in his childhood. The pictures were evidently used for this instruction as well as the text and occasionally have titles in French (e.g. *Survey*, III, no. 78, and in the present volume these have been added to no. 30). The set of Bible pictures by the de Brailes workshop (no. 71) which may once have preceded a Psalter also have French titles. The use of the vernacular language as spoken by the higher ranks of the laity has suggested the theory of these luxury picture cycles originating in Psalters for laymen.

28. The discussion of these and other English 13th-century biblical cycles will be the subject of a forthcoming study by George Henderson. For the 12th-century cycles see *Survey*, III, 31–3. Scenes of the story of Joseph existed in several 13th-century monumental cycles: O. Lehmann-Brockhaus, *op. cit.*, I, nos. 931, 1657, and P. Z. Blum, 'The Middle English Romance "Jacob and Iosep" and the Joseph cycle in Salisbury Chapter House', *Gesta*, VIII, 1969, 18–34. Scenes of the Old and New Testaments were painted in the King's chamber at Winchester Castle in 1237, 1241; H. M. Colvin, *The History of the King's Works*, II, London, 1963, 861.

29. G. Haseloff, *op. cit.* for a study of these changes. Several other Psalters have come to light since this still-fundamental work.

30. N. J. Morgan, 'Psalter Illustration for the Diocese of Worcester in the Thirteenth Century', *Medieval Art and Architecture at Worcester Cathedral, British Archaeological Association Conference Transactions*, I, London, 1978, 91–104, for an account of some of these issues.

31. Even of undecorated 13th-century English Missals few survive. In the case of the secular church this could be explained by their destruction when the new Use of Sarum was introduced involving replacement by a Sarum text of the Missal. Although Bishops began to

introduce Sarum Use into their dioceses certainly from the mid century it was probably not until well into the 14th century that most churches had replaced all their old liturgical books with the new Sarum texts. The evidence from calendars of Psalters is that it is rare to find a proper Sarum calendar outside the diocese of Salisbury before the end of the 13th century.

32. For the early development of the text see E. Bishop, 'On the Origin of the Prymer', *Liturgica Historica. Papers on the Liturgy and Religious Life of the Western Church*, repr. Oxford, 1962, 211–37. There is, as yet, no study of the early forms of illustrated Books of Hours in the 13th century. A sparsely decorated mid 13th-century example is Yale, Univ. Lib. MS Marston 22.

33. See the catalogue entry (no. 73) for a full discussion of the iconography of the de Brailes Hours.

34. F. Wormald, 'Some illustrated manuscripts of the Lives of the Saints', *Bulletin of the John Rylands Library*, 35, 1952, 248–66. For English 12th-century examples see *Survey*, III, nos. 26, 34.

35. General discussions of Anglo-Norman lives of saints are given in M. D. Legge, *Anglo-Norman Literature and its background*, Oxford, 1963, 243–71 and M. D. Legge, *Anglo-Norman in the Cloisters*, Edinburgh, 1950, 19–31. An example with three historiated initials by the de Brailes workshop in Paris, Bibl. Nat. fr. 19525.

36. For general discussion of the iconographic series of the Life of St. Thomas Becket see T. Borenius, *St. Thomas Becket in Art*, London, 1932, 40–69, and M. Harrison Caviness, *The Early Stained Glass of Canterbury Cathedral*, Princeton, 1977, 140–50. The loss of the majority of English 13th-century stained glass hampers any discussion of the interrelationship between illustrations in manuscripts and those in this form of art. For textual references to lost works having cycles of the lives of Saints Alban and Thomas of Canterbury see O. Lehmann-Brockhaus, *op. cit.*, I, no. 934; II, nos. 3863, 3906, 4412. A general discussion of saints' lives in monumental decoration and models in the form of rolls is given by R. Branner, 'Le rouleau de Saint Eloi', *Information de l'Histoire de l'Art*, XII, no. 2, 1967, 65–8.

37. e.g. *Survey*, II, no. 36, *Survey*, III, nos. 17, 22, 85.

38. Production of small bibles in France is discussed by R. Branner, *Manuscript Painting in Paris, op. cit.*, 10 n. 45, 16–19. Much discussion of the 'pocket Bible' can be found in J. C. Schnurman, *Studies in the Medieval Book Trade from the late 12th to the mid 14th century with special reference to the copying of the Bible*, B.Litt., Oxford, 1960.

39. The excellent thesis A. L. Bennett, *The Place of Garrett 28 in Thirteenth Century English Illumination*, Ph.D., Columbia University, 1973, contains a fundamental discussion of the relationship of English Bibles to the Paris text. The standard account is H. H. Glunz, *History of the Vulgate in England from Alcuin to Roger Bacon*, Cambridge, 1933, 259–93.

40. I am much indebted to Dr. Bennett's thesis for the identification of English Bibles and their iconography. My great thanks to her for permission to consult this work and for her always-helpful advice have been appropriately acknowledged at the beginning of this book. The number of Bibles produced in England increases in the second half of the 13th century and they will be catalogued in Part 2 and subjected to more lengthy discussion than has been possible for the relatively few early examples. I have rejected two Bibles of the period before 1250 which have been described in some of the literature as English: London, Soane Museum, MS 9 and Yale, Univ. Lib., MS 387 ('The Ruskin Bible'). For an account of the latter see P. Barnet, 'A Pair of Thirteenth-Century Bibles: the Ruskin Bible at Yale and the Scripps Bible in the Detroit Institute of Arts', *Yale University Library Gazette*, 55, 1980, 1–13. The Soane and Yale Bibles seem to me to be North French.

41. A translation of the text of a typical Bestiary is given by T. H. White, *The Book of the Beasts*, London, 1954. The various versions are discussed by F. McCulloch, *Medieval Latin and French Bestiaries*, rev. ed. Chapel Hill, 1962. Much work is still required on the transmission of texts and pictures.

42. M. R. James, *The Bestiary*, Roxburghe Club, 1928, is the source of most of these erroneous datings. McCulloch, *op. cit.*, 25–40, has proposed modifications of James' groupings but did little to revise the chronology of the manuscripts.

43. W. B. Yapp, 'The Birds of English Medieval Manuscripts', *Journal of Medieval History*, 5, 1979, 315–49 discusses the extent of naturalistic representation of birds in English manuscripts of the 13th and 14th centuries.

44. McCulloch, *op. cit.*, 30–39, 199.

45. In the catalogue entries it has not been possible to give details on such matters of text repetition or variations in names of the creatures. I have not for example distinguished between the different types of Owl (*Nictorax, Bubo, Ulula, Noctua*) or Dove. For some creatures the English equivalent is uncertain and when in doubt I have either used the Latin name in the catalogue description or, in the iconographic index, have placed it in brackets after the proposed English translation. The creature is always titled according to the passage of text which is illustrated and I have not been able to draw attention to frequent misrepresentations of completely different species.

46. L. MacKinney, *Medical Illustrations in Medieval Manuscripts*, London, 1965 gives a comprehensive account of all European illustrated medical texts.

47. W. Blunt, S. Raphael, *The Illustrated Herbal*, London, 1979, 12–55, discusses in a general way the decoration of the Herbal from the earliest times to the 13th century with excellent illustrations. It is not clear as to why the authors have called the three late 12th-century manuscripts Anglo-Norman. If nos. 9, 10 are not English products they could perhaps have come from the northernmost part of France rather than Normandy.

48. B. Smalley, *The Study of the Bible in the Middle Ages*, Notre Dame, 1970, Chaps. III–V for the texts.

49. W. H. Monroe, 'A Roll-Manuscript of Peter of Poitiers' Compendium', *Bulletin of the Cleveland Museum of Art*, LXV, 1978, 92–105, discusses the Peter of Poitiers text and its illustration.

50. For comparable 12th-century author portraits see *Survey*, III, figs. 215, 256. It is unusual to show the author teaching, although in *Survey*, III, no. 19 St. Augustine is shown in this context. In 13th-century English manuscripts author portraits occur in nos. 12, 17, 19, 21, 53, 54, 81, 89.

51. See A. Melnikas, *The Corpus of the Miniatures in the Manuscripts of Decretum Gratiani, Studia Gratiana*, 16–18, Rome, 1975 for illustrations. The copies of the late 12th century are discussed by R. Schilling, 'The *Decretum Gratiani* formerly in the C. W. Dyson Perrins Collection', *Journal of the British Archaeological Association*, 26, 1963, 27–39.

52. R. A. B. Mynors, *Durham Cathedral Manuscripts to the end of the twelfth century*, Durham, 1939, 77, pl. 47. R. Schilling, *op. cit.*, considers this to be a French manuscript. The table on page 30 of her article enables a comparison between texts with or without figure decoration.

53. *Survey*, III, no. 55 for the sparsely illustrated chronicle of Florence of Worcester. The history of chronicle writing in England is the subject of the excellent detailed study by A. Gransden, *Historical Writing in England c. 550 to c. 1307*, London, 1974.

54. Gransden, *op. cit.*, 356–79 for a full account of Matthew's historical writings. The detailed discussion of the manuscripts from the point of view of chronology and compilation of text is given by R. Vaughan, *Matthew Paris*, Cambridge, 1958 to which reference is given in the catalogue entries.

55. A full study of these chronicle illustrations is shortly to be published by Professor Suzanne Lewis.

56. P. S. Moore, *The Works of Peter of Poitiers*, Notre Dame, 1936, 111–17.

57. In manuscripts: Oxford, Bodleian Library, MS Bodley Rolls 3 (late 13th century), Oxford, Bodleian Library, MS Ashmole Rolls 50 (*c.* 1300). These and other examples are discussed by W. H. Monroe, *Thirteenth and Fourteenth century illustrated roll-manuscripts: Peter of Poitiers Compendium and Chronicles of the Kings of England*, M.A. Report, Courtauld Institute, University of London, 1975. In sculpture a series (now destroyed) was set up in Henry III's reign on the pulpitum of Salisbury Cathedral: C. Wordsworth, 'List of Altars in Salisbury Cathedral and names of Kings of whom there were representations there about the year 1398', *Wiltshire Archaeological and Natural History Magazine*, 38, 1913/14, 566–71; C. Wordsworth, W. H. St. John Hope, *idem 39*, 1915/17, 504–6. In the time of Richard, abbot of Peterborough (1274–95) a series of Kings of England was painted in the chapel of St. Mary: O. Lehmann-Brockhaus, *op. cit.*, II no. 3500. In Edward II's time the refectory of Gloucester Abbey had a series of the kings of England: W. H. Hart, *Historia et Cartularium Monasterii Sancti Petri Gloucestriae*, I, *Rolls Series*, London, 1863, 44.

58. For romance literature in England M. D. Legge, *Anglo-Norman Literature and its Background*, Oxford, 1963, 44–59, 85–107, 108–34. For the reading of it by the laity see M. B. Parkes, *op. cit.*, 556–7.

59. M. A. Stones, 'Secular Manuscript Illumination in France' in ed. C. Kleinhenz, *Medieval Manuscripts and Textual Criticism (University of North Carolina Studies in Language and Literature)*, Chapel Hill, 1976, 83–102 for an excellent summary. The floor tiles of Chertsey Abbey, whose figure style would suggest a date around the middle of the century, show a series of scenes from the romance of Tristan: R. S. Loomis, *Illustrations of Medieval Romance on Tiles from Chertsey Abbey, University of Illinois Studies in Language and Literature*, 1916; R. S. Loomis, *Arthurian Legends in Medieval Art*, London, 1938, 44–8.

60. Under this heading of course also comes the necessary study of minor pen ornament and palaeographical investigation.

61. On this work at Winchester see L. M. Ayres, 'The work of the Morgan Master at Winchester and English Painting of the Early Gothic period', *Art Bulletin*, 56, 1974, 201–23. I prefer to call the painting of the period 'Transitional' rather than 'Early Gothic'.

62. On some of the Champagne region manuscripts of the period see R. Schilling, 'The *Decretum Gratiani* formerly in the C. W. Dyson Perrins Collection', *Journal of the British Archaeological Association*, 26, 1963, 27–39.

63. Illuminators certainly occur in Lincoln records: F. Hill, *Medieval Lincoln*, Cambridge, 1965, 161 cites Henry the illuminator.

64. The Rose now has many interpolations resulting from later restoration. Also most of the painting of drapery folds has deteriorated. The much better state in the mid-19th century is well recorded in some detailed watercolours by Charles Winston: London, British Library, MS Add. 35211, Vol. II, ff. 371–2, 379.

65. Arguments based on iconographic contacts put forward by H. B. Graham linking this also with Winchester are not entirely convincing: 'The Munich Psalter', *The Year 1200: a Symposium*, New York, Metropolitan Museum of Art, 1975, 301–12.

66. *Survey*, III, 119, points out links in some of the initials with St. Albans manuscript of Abbot Simon's period.

67. Such sculpture as the Virgin and Child and Coronation of the Virgin above the central west portal of Wells Cathedral shows this troughed fold style. Also at Wells the style is well seen in the Old and New Testament scenes in the quatrefoils of the lowest level. In works of ivory compare the Adoration of the Magi group in the British Museum (*The Year 1200*, New York, Metropolitan Museum of Art 1975, no. 66). Almost all contemporary goldsmiths' work has been lost, but for documentation see: C. Oman, 'The Goldsmiths at St. Albans Abbey during the 12th and 13th centuries', *Transactions of the St. Albans and Herts. Architectural and Archaeological Society*, 1930–2, 215–36, and R. Kent Lancaster, *op. cit.* (Ph.D. thesis).

68. G. Pollard, 'William de Brailes', *Bodleian Library Record*, V, 1955, 202–9. See also references given in n. 19. His name is in dated documents of 1238, 1246, 1252.

69. Although from the 12th century on those in minor orders were supposed to be celibate very probably many were not. Even priests in the 13th century were occasionally married although this was strictly condemned: J. R. H. Moorman, *op. cit.*, 63–7.

70. J. G. Hawthorne, C. S. Smith, *Theophilus, On Divers Arts*, New York, 1979, 34–43; H. Roosen-Runge, 'Die Buchmalereirezepte des Theophilus', *Münchener Jahrbuch*, 3/4, 1953, 159–71. For a general discussion of illuminators' techniques see D. V. Thompson, *The Materials and Techniques of Medieval Painting*, repr. London, 1956. For a recent detailed bibliography: F. Avril, *La technique de l'enluminure d'après les textes médiévaux. Essai de bibliographie*, Paris, 1967.

71. D. V. Thompson, *op. cit.*, 50–2 on the preparation of glair, and J. G. Hawthorne, C. S. Smith, *op. cit.*, 38 on the use of 'transparent resin' for a medium. A more detailed account of an 11th-century text on the preparation of glair in D. V. Thompson, 'The "De Clarea" of the so-called Anonymous Bernensis', *Technical Studies in the field of the Fine Arts*, I, 1932, 9–19, 70–81.

72. The treatise on the preparation of colours nearest in date to the period of this volume is a North French work of *c.* 1300 by a certain Peter of St. Omer: M. P. Merrifield, *Original Treatises on the Arts of Painting*, London, 1849, I, 116–65 for a translation; D. V. Thompson, 'The Liber Magistri Petri de Sancto Audemaro de coloribus faciendis', *Technical Studies in the field of the Fine Arts*, IV, 1935, 28–33. Colour in English 12th-century illumination is discussed by H. Roosen-Runge, *Farbgebung und Technik frühmittelalterlicher Buchmalerei*, I, Munich, 1967, 79–146.

73. The technique is discussed by M. S. Frinta, 'Punchmarks in the Ingeborg Psalter', *The Year 1200: a Symposium, New York, Metropolitan Museum of Art*, 1975, 251–60. In England these patterns on the gold first appear in late-12th-century manuscripts of North Country origin (e.g. *Survey*, III, nos. 95, 98).

74. The Munich/Imola Psalter group (nos. 23–9) is a very good example.

75. See n. 22 for Queen Eleanor of Castile's illuminator and scribes recorded in her household accounts for 1290.

76. In Henry's youth he was much at Winchester and was tutored by the Bishop: K. Norgate, *The Minority of Henry the Third*, London, 1912, 7. From the amounts spent on their building and decoration (H. M. Colvin, *op. cit.*) it seems that in the middle and late years of his reign his favourite residences were Westminster, Clarendon, Winchester, Windsor, Woodstock (near Oxford), and Guildford.

77. The use of above/below top line as a means of dating is, on present evidence, still not possible. See N. R. Ker, 'From "above top line" to "below top line": a change in scribal practice', *Celtica*, V, 1960, 13–16.

78. There is evidence from episcopal statutes that in some dioceses the Use of Sarum was being introduced from about the middle years of the 13th century: F. M. Powicke, C. R. Cheney, *Councils and Synods with other documents relating to the English Church*, II, A.D. 1205–1313, Oxford, 1964, 323. See also references in n. 5.

79. For the calendars see F. Wormald, *English Benedictine Kalendars after A.D. 1100*, LXXVII, LXXXI, 1939, 1946. The final volume of this series is being edited by me for the Henry Bradshaw Society from the late Professor Wormald's notes. Benedictine litanies are usually identifiable from the high placing or double invocation of St. Benedict in the list of Confessors.

80. The article on Worcester diocese Psalters cited in n. 30 discusses the diverse situation in that particular diocese. In Table Appendix II is presented an analysis of local entries of the period before and after the introduction of Sarum. See also N. Morgan, 'Notes on the Post-Conquest Calendar, Litany and Martyrology of the Cathedral Priory of Winchester with a consideration of Winchester diocese Calendars of the Pre-Sarum period', *The Vanishing Past: Medieval Studies presented to Christopher Hohler*, ed. A. Borg, A. Martindale, B.A.R., Oxford, 1981, 133–71.

81. In the period up to 1250 certain translations and canonisations occurred of saints which eventually become widely found in English calendars: the translations of Wulfstan (1218), Thomas of Canterbury (1220) and the canonisations of Hugh of Lincoln (1220) and Edmund of Abingdon (1247). All have been used for dating texts but in every case, even that of the popular Thomas of Canterbury, there are examples of calendars still lacking the feast and yet, on the basis of stylistic and other evidence, clearly produced years after its introduction. A particular problem in the use of calendars for dating is to distinguish between definitely later additions and those which were in the nature of corrections contemporary with the writing out of the text. Examples would be nos. 45, 49.

Caladrius. London, B.L., Harley 4751, f. 40 (cat. 76)

GLOSSARY

Apocalypse
The Revelation of St. John. This text occurs in various forms with or without a commentary. Translations into French and adaptations from the Latin were made in both verse and prose in some cases only giving excerpts from the full text.

Bestiary
A book about animals, birds and reptiles in which their habits are described and moralised. Many of the creatures are fantastic and mythological.

Breviary
The book containing all the offices for the daily hours of the public liturgy of the church. The daily offices are the system of prayers and readings arranged around the weekly recitation of the psalter. The day is divided into eight 'hours': Matins, Lauds, Prime, Terce, Sext, None, Vespers and Compline. The Breviary has these offices arranged according to the days of the Church year (Temporal) and those of the Saints (Sanctoral).

Byzantine blossom
A type of foliage deriving from Byzantine art introduced in the 12th century.

Calendar
Most liturgical manuscripts and occasionally other texts contain a calendar of the feast days and saints' days of the year. Regional cults existed for the lesser saints which sometimes enable localisation of the place for which the calendar was intended. See further under Sarum Use.

Canon Law
The laws of the Church relating to ecclesiastical discipline, faith and morality.

Canon Tables
Tables of passages of concordance between the various Gospels usually arranged as architectural systems of arcades.

Canticles
Certain recitations from the Old and New Testaments sung during the daily offices. Some canticles are not biblical text: the Te Deum, for example, was traditionally considered to be by St. Ambrose.

Capitula
Before the establishment of the Paris edition of the Vulgate in the mid 13th century various systems of chapter divisions (capitula) were used in Bibles.

Cartulary
A collection of transcriptions of various documents kept by owners of property and lands as evidence of their rights.

Consanguinity table
A table showing the family relationships between which marriage is not permitted.

Conventual Use
The liturgical practices of communities of regular canons (Augustinians, Premonstratensians) and friars (Dominicans, Franciscans). Their liturgy is much closer to that of the secular church than that of the monastic church, and increasingly in the later Middle Ages comes under its influence.

Decretals
A compilation of Canon Law.

Ecclesia
The church in medieval art was personified as a female figure usually crowned and holding such attributes as the cross, the chalice or a model of a church. The figure is often paired with *Synagoga*, a personification of the Synagogue.

Gatherings
The folded sections of leaves of variable number which are sewn together to form a book.

Gloss
A commentary on a text.

Gnadenstuhl Trinity
A form of the Trinity in which God the Father holds the Cross on which hangs the crucified Son with the Holy Spirit as a dove hovering above the Cross. There is no adequate term in English for this iconographic type. The older literature called it the Italian Trinity which is absurd because the type originated in France. Occasionally a translation of the German is found: the Mercy seat Trinity or more correctly the Throne of Grace Trinity.

Gradual Psalms

Psalms 119–33 (Vulgate numeration) mostly concerned with trust in God's aid. These were read daily before Matins in monastic use but only during Advent and Lent in secular use. The first of these psalms in the psalter is often given a large decorated or historiated initial.

Grotesques

Fantastic ornamental figures, often hybrid creatures.

Historiated initial

An initial containing a figure subject.

Hours, Book of

From the 11th century an addition to the daily monastic office, and from the 12th century also the secular office, were the Hours of the Blessed Virgin Mary. These came to form a separate book containing additional prayers, the office of the dead, the penitential psalms, the gradual psalms, and occasionally certain special Hours (e.g. the Trinity, the Holy Spirit, the Name of Jesus). It became in the later 13th and 14th century popular for the laity to possess Books of Hours for their private devotions although such books were also made for clerics and even monks.

Infills

The ornament or grotesque subject filling the inner space of an illuminated initial.

Invention

The discovery of the relics of a saint. The day of this occurrence is occasionally celebrated as a liturgical feast.

Line endings

The ornamental motifs which complete the space at the end of a line for lines that do not fill the text block. The term line fillers has been used by some recent writers.

Litany

A form of invocatory prayer in which are included invocations to various saints. Local saints enable some conclusions to be made concerning the area or place for which the litany might have been intended.

Mandorla

An almond shaped frame often placed around Christ or the Virgin when they are represented in Heaven or in some transfigured state.

Missal

The book containing the masses for the feast days and saints' days of the year and also other special votive masses.

Monastic Use

The liturgical practices of the enclosed monastic orders (Benedictines, Cluniacs, Cistercians and Carthusians).

Obituary Roll

A roll of prayers for the soul of a departed person (usually an ecclesiastic) sent around to various religious houses. Each place would add some further prayer to the roll.

Octave

Great festivals of the Church year and saints were celebrated in liturgical services until the eighth (octave) day following the feast day, the final day being celebrated with much elaboration.

Office of the Dead

First Vespers, Matins and Lauds for the dead.

Paschal tables

Tables for the computation of the date of Easter.

Penitential Psalms

Psalms 6, 31, 37, 50, 101, 129, 142 (Vulgate numeration) which express regrets for sin and desire for penitence. They were recited in the public liturgy daily after Prime in monastic use but only in Lent and on a few other occasions in secular use. Privately they could of course be said at any time.

Psalter

The book of psalms. All the psalms were recited during the week in the breviary offices of both monastic and secular use but according to different systems of distribution. They were also read extensively for private devotions by both clerics and laymen. The Psalter usually contained in addition to the psalms a calendar, litany and occasionally private prayers, the Hours of the Blessed Virgin Mary and Office of the Dead. The first psalms sung in secular use at Matins on each day and at Sunday Vespers (1, 26, 38, 52, 68, 80, 97, 109–Vulgate numeration, q.v.) were given larger decorated or historiated initials. Similarly such larger initials were given to the psalms of the three-fold division of the Psalter (1, 51, 101). The present catalogue uses the Vulgate numeration as this has always been used for the psalms of the breviary office.

Rinceaux

A pattern of coils of foliage.

Sarum Use

From the second quarter of the 13th century the various dioceses in the province of Canterbury adopted the calendar and the liturgical texts and practices of the Cathedral Church of Salisbury (Sarum Use) as they had finally come to be systematised under Bishop Richard Poore (1217–28). The exceptions to the adoption of Sarum Use were the

diocese of Hereford and the province of York. The period of transition to the new liturgical practices is at least fifty years and only in the 14th century do relatively pure Sarum texts become the norm. Most dioceses added to Sarum a few local feasts (supplements) sometimes called synodal feasts if officially declared by the synod of the diocese. The increasing appearance of the Sarum calendar is a marked feature in 13th-century calendars. The scant survival of Missals and Breviaries in the 13th century makes it very difficult to find sufficient evidence to document the change with any detail.

Secular Use

The liturgical practices of the non-monastic church: i.e. the secular cathedrals, the collegiate churches and chapels, and the parish churches. Sarum Use comes to be the standard liturgy of the secular church, although in the first half of the 13th century, and frequently in the second half, it seems that pre-Sarum local diocesan Uses were still widespread. The liturgy of the conventual orders of regular canons and friars occupies a position midway between that of the secular and monastic church although is rather closer to the former.

Synagoga

The personification of the Synagogue as a female figure. She is usually blindfolded and holds a spear (sometimes broken) and the tablets of the law. The figure in most cases is paired with *Ecclesia*.

Tinted Drawing

A technique in which light colour washes are applied to the lines of a drawing.

Translation

The moving of relics of a saint from one resting-place to a new one. The day on which this occurred is often celebrated as a liturgical feast.

Typology

The paralleling of episodes of the Life of Christ with incidents of the Old Testament.

Vulgate

The Latin text of the Bible as translated by St. Jerome. This was the text which with some revisions, notably in the 13th century in Paris, was the norm in the Middle Ages. The numbering of the Psalms is different in the Vulgate from the English Authorised Version of the Bible: 1–9 (the same), 10–113 (Vulgate) equivalent to 11–114 (Authorised Version), 114 (Vulgate) equivalent to 116 (Authorised Version), 116–146 (Vulgate) equivalent to 117–147 (Authorised Version), 148–150 (the same). This difference arises because certain psalms were divided into two parts in the two versions in different ways.

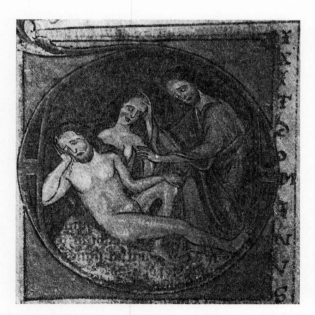

Creation of Eve. London, Lambeth Palace Lib., 563, f. 100 (cat. 48)

ABBREVIATIONS

Andersson, *English Influence*

A. Andersson, *English Influence in Norwegian and Swedish Figure sculpture in wood 1220–70*, Stockholm, 1950

Baltrušaitis, *Reveils et Prodiges*

J. Baltrušaitis, *Reveils et Prodiges, le gothique fantastique*, Paris, 1960

B.F.A.C.

Burlington Fine Arts Club

Bennett, *Thesis*

A. Bennett, *The place of Garrett 28 in thirteenth-century English illumination*, Ph.D. Dissertation, Columbia University, 1973

Boase, *English Art*

T. S. R. Boase, *English Art 1100–1216* (Oxford History of English Art, III), Oxford, 1953

Boeckler, *Abendländische Miniaturen*

A. Boeckler, *Abendländische Miniaturen bis zum Ausgang der romanischen Zeit*, Berlin, 1930

Brieger, *English Art*

P. Brieger, *English Art 1216–1307* (Oxford History of English Art, IV), 2nd ed., Oxford, 1968

British Museum, *Reproductions*, I–V

British Museum, *Reproductions from Illuminated Manuscripts*, Series I–V, London, 1907, 1908, 1928, 1965

Brussels, 1973

Bibliothèque royale, Brussels, *English illumination 700–1500*, 1973

B.S.F.R.M.P.

Bulletin de la Société Française de Reproductions de Manuscrits à Peintures

Cockerell, *W. de Brailes*

S. C. Cockerell, *The work of W. de Brailes*, Roxburghe Club, 1930

Coxe, *Catalogue*

H. O. Coxe, *Catalogi Codicum Manuscriptorum Bibliothecae Bodleianae*, 3 vols. Oxford, 1853–8

Deuchler, *Ingeborgpsalter*

F. Deuchler, *Der Ingeborgpsalter*, Berlin, 1967

Druce, 'Abnormal forms'

G. C. Druce, 'Some Abnormal and Composite Human Forms in English Church Architecture', *Archaeological Journal*, LXXII, 1915, 135–86

Druce, 'Amphisbaena'

G. C. Druce, 'The Amphisbaena and its connexions in Ecclesiastical Art and Architecture', *Archaeological Journal*, LXVII, 1910, 285–317

Druce, 'Ant-Lion'

G. C. Druce, 'An account of the Mirmocoleion or Ant-Lion', *Antiquaries Journal*, III, 1923, 347–64

Druce, 'Caladrius'

G. C. Druce, 'The Caladrius and its Legend', *Archaeological Journal*, LXIX, 1912, 381–416

Druce, 'Crocodile'

G. C. Druce, 'The Symbolism of the Crocodile in the Middle Ages', *Archaeological Journal*, LXIV, 1909, 311–38

Druce, 'Elephant'

G. C. Druce, 'The Elephant in Medieval Legend and Art', *Archaeological Journal*, LXXIV, 1919, 1–73

Druce, 'Medieval Bestiaries I, II'

G. C. Druce, 'The Medieval Bestiaries and their influence on Ecclesiastical Decorative art', *Journal of the British Archaeological Association*, XXV, 1919, 41–82; XXVI, 1920, 35–79

Druce, 'Serra'

G. C. Druce, 'Legend of the Serra or Saw-Fish', *Proceedings of the Society of Antiquaries of London*, 2nd Ser., XXXI, 1919, 20–35

Druce, 'Yale'	G. C. Druce, 'Notes on the History of the Heraldic Jall or Yale', *Archaeological Journal*, LXVIII, 1911, 173–99
Einhorn, *Spiritalis Unicornis*	J. W. Einhorn, *Spiritalis Unicornis*, Munich, 1976
Frere, *Bibliotheca Musico-Liturgica*	W. H. Frere, *Bibliotheca Musico-Liturgica. A descriptive handlist of the musical and Latin liturgical manuscripts preserved in the Libraries of Great Britain and Ireland*, London, 1894–1932, (repr. Hildesheim, 1967)
Freyhan, 'Joachism'	R. Freyhan, 'Joachism and the English Apocalypse', *Journal of the Warburg and Courtauld Institutes*, XVIII, 1955, 211 ff.
H.B.S.	*Henry Bradshaw Society*
Hardy, *Descriptive Catalogue*, I–III	T. D. Hardy, *Descriptive Catalogue of Materials for British History, I–III, Rolls Series*, London, 1862–71
Haseloff, 'Miniature'	A. Haseloff, 'La miniature dans les pays cisalpins depuis le commencement du XIIe jusqu'au milieu du XIVe siècle', ed. A. Michel, *Histoire de l'Art*, II, 1, Paris, 1906, 297 ff.
Haseloff, *Psalterillustration*	G. Haseloff, *Die Psalterillustration im 13. Jahrhundert. Studien zur Buchmalerei in England, Frankreich und den Niederländen*, Kiel, 1938
Henderson, 'Studies', I, II	G. Henderson, 'Studies in English manuscript illumination I, II', *Journal of the Warburg and Courtauld Institutes*, XXX, 1966, 71 ff., 104 ff.
Herbert, *Illuminated Manuscripts*	J. A. Herbert, *Illuminated Manuscripts*, London, 1911 (reprinted Bath, 1972)
James, *Apocalypse*	M. R. James, *The Apocalypse in Art*, London, 1931
James, *Bestiary*	M. R. James, *The Bestiary, (Cambridge, Univ. Lib. MS Ii. 4. 26)*, Roxburghe Club, 1928
James, *Catalogue*	M. R. James, *Descriptive catalogue of the manuscripts in the library of*: *Aberdeen University, 1932* *Corpus Christi College, Cambridge, 1912* *Emmanuel College, Cambridge, 1904* *Eton College, 1895* *Fitzwilliam Museum, Cambridge, 1895* *Gonville and Caius College, Cambridge, 1908* *Lambeth Palace, 1932* *St John's College, Cambridge, 1913* *Trinity College, Cambridge, 1900–4*
James, *Estoire de St. Aedward*	M. R. James, *La Estoire de Seint Aedward le Rei*, Roxburghe Club, 1920
James, 'Matthew Paris'	M. R. James, 'The Drawings of Matthew Paris', *Walpole Society*, XIV, 1925–6
J.W.C.I.	*Journal of the Warburg and Courtauld Institutes*
Ker, *Medieval Libraries*	N. R. Ker, *Medieval Libraries of Great Britain*, London, 1964
Ker, *Medieval Manuscripts*, I, II	N. R. Ker, *Medieval Manuscripts in British Libraries*: I *London*, Oxford, 1969 II *Abbotsford–Keele*, Oxford, 1977
Klingender, *Animals in art*	F. D. Klingender, *Animals in art and thought to the end of the Middle Ages*, London, 1971
Lindblom, *Peinture Gothique*	A. Lindblom, *La Peinture Gothique en Suède et Norvège*, Stockholm, 1916
Little, *Franciscan History and Legend*	A. G. Little, *Franciscan History and Legend in English Medieval Art*, Manchester, 1937

London, 1930 Victoria and Albert Museum, *Exhibition of English Medieval Art*, London, 1930

Maunde Thompson, 'Notes' E. Maunde Thompson, 'Notes on the illuminated manuscripts in the exhibition of English Medieval Paintings', *Proceedings of the Society of Antiquaries of London*, 2nd. Ser., XVI, 1895–7, 213 ff.

McCulloch, *Bestiaries* F. McCulloch, *Medieval Latin and French Bestiaries*, Chapel Hill, 1962

Millar, I E. G. Millar, *English Illuminated Manuscripts from the Xth to the XIIIth century*, Paris, 1926

Millar, 'Fresh Materials' E. G. Millar, 'Fresh Materials for the Study of English Illumination', *Studies in Art and Literature for Belle da Costa Greene*, Princeton, 1954, 286–94

Morison, *'Black-Letter' Text* S. Morison, *'Black-Letter' Text*, Cambridge, 1942

Munby, *Connoisseurs* A. N. L. Munby, *Connoisseurs and Medieval Miniatures 1790–1850*, Oxford, 1972

New Pal. Soc., I, II *New Palaeographical Society, Facsimiles of Ancient Manuscripts*, 1st and 2nd series, London, 1903–30

Nordenfalk, 'Psalterillustration' C. Nordenfalk, 'Insulare und Kontinentale Psalterillustration aus dem XIII Jahrhundert', *Acta Archaeologica*, X, 1939, 107 ff.

Pächt and Alexander, III O. Pächt, J. J. G. Alexander, *Illuminated Manuscripts in the Bodleian Library, Oxford*, III, *British School*, Oxford, 1972

Pal. Soc., I, II *Palaeographical Society, Facsimiles of Manuscripts and Inscriptions*, 1st and 2nd series, London, 1874–94

Pfaff, *New Liturgical Feasts* R. W. Pfaff, *New Liturgical Feasts in Later Medieval England*, Oxford, 1970

Ragusa, 'Lyre Psalter' I. Ragusa, 'An Illustrated Psalter from Lyre Abbey', *Speculum*, 46, 1971, 267 ff.

Rickert, *Miniatura*, I, II M. Rickert, *La Miniatura Inglese, I, Dalle origine alla fine del secolo XII*, Milan, 1959; II, *Dal XIII al XV secolo*, Milan, 1961

Rickert, *Painting in Britain* M. Rickert, *Painting in Britain. The Middle Ages* (Pelican History of Art), 2nd edn., 1965

S.C. *Summary Catalogue of Western Manuscripts in the Bodleian Library*, Oxford, 7 vols., 1895–1953

Saunders, *English Illumination* I, II O. E. Saunders, *English Illumination*, 2 vols., Florence and Paris, 1928 (repr. New York, 1969)

Saxl and Meier, III F. Saxl, H. Meier, *Verzeichnis astrologischer und mythologischer illustrierter Handschriften des lateinischen Mittelalters, III. Handschriften in Englischen Bibliotheken*, 2 vols, London, 1953

Schapiro, 'Glazier Psalter' M. Schapiro, 'An Illuminated English Psalter of the Early Thirteenth Century', *Journal of the Warburg and Courtauld Institutes*, XXIII, 1960, 179 ff. (Reprinted in M. Schapiro, *Late Antique, Early Christian and Medieval Art. Selected Papers*, London, 1980, 329–54)

Survey, I J. J. G. Alexander, *Insular Manuscripts 6th to 9th Century* (*A Survey of Manuscripts Illuminated in the British Isles*, I), London, 1978

Survey, II Elžbieta Temple, *Anglo-Saxon Manuscripts 900–1066* (*A Survey of Manuscripts Illuminated in the British Isles*, II), London, 1976

Survey, III C. M. Kauffmann, *Romanesque Manuscripts 1066–1190* (*A Survey of Manuscripts Illuminated in the British Isles*, III), London, 1975

Swarzenski, *Handschriften XIII Jh.* H. Swarzenski, *Die lateinische illuminierten Handschriften des XIII Jahrhunderts in den Ländern am Rhein, Main und Donau*, Berlin, 1936

Swarzenski, *Monuments* H. Swarzenski, *Monuments of Romanesque Art. The art of Church Treasures in north-western Europe*, 2nd ed., London, 1967

Swarzenski, 'Unknown Bible Pictures' H. Swarzenski, 'Unknown Bible Pictures by W. de Brailes and some notes on early English Bible illustrations', *Journal of the Walters Art Gallery*, I, 1938, 55 ff.

Tristram, *Wall Painting* E. W. Tristram, *English Medieval Wall Painting, II, The Thirteenth Century*, Oxford, 1950

Turner, *Early Gothic* D. H. Turner, *Early Gothic Illuminated Manuscripts in England*, London, 1965

Turner, 'Evesham Psalter' D. H. Turner, 'The Evesham Psalter', *Journal of the Warburg and Courtauld Institutes*, XXVII, 1964, 170 ff.

Turner, 'Manuscript Illumination' D. H. Turner, 'Manuscript Illumination', *The Year 1200*, II, ed. F. Deuchler, New York, 1970

Vaughan, 'Handwriting' R. Vaughan, 'The handwriting of Matthew Paris', *Transactions of the Cambridge Bibliographical Society*, I, 1953, 23 ff.

Vaughan, *Matthew Paris* R. Vaughan, *Matthew Paris*, Cambridge, 1958 (reprinted 1979)

Vitzthum, *Pariser Miniaturmalerei* G. von Vitzthum, *Die Pariser Miniaturmalerei von der Zeit des hl. Ludwig bis zu Philipp von Valois und ihr Verhältnis zur Malerei in Nordwesteuropa*, Leipzig, 1907

Warner and Gilson G. F. Warner, J. P. Gilson, *Catalogue of Western Manuscripts in the Old Royal and King's Collections*, 4 vols., London, British Museum, 1921

Watson, *Dated Manuscripts* A. G. Watson, *Catalogue of Dated and Datable Manuscripts c. 700–1600 in the Department of Manuscripts, the British Library*, London, 1979

Wormald, *Kalendars*, I, II F. Wormald, *English Benedictine Kalendars after A.D. 1100. I, II, Henry Bradshaw Society*, LXXVII, LXXXI, 1939, 1946

Yapp, 'Birds' W. B. Yapp, 'The birds of English medieval manuscripts', *Journal of Medieval History*, 5, 1979, 315–48

Zahlten, *Creatio Mundi* J. Zahlten, *Creatio Mundi. Darstellungen der sechs Schöpfungstage und naturwissenschaftliches Weltbild im Mittelalter*, Stuttgart, 1979

CATALOGUE

1. Paris, Bibliothèque Nationale MS lat. 8846

Psalter (The Great Canterbury Psalter)
480 × 325 mm., ff. 174
c. 1180–90. Canterbury, Christ Church

Ills. 1 (colour) 2–7

This is the last of the three English copies of the Carolingian Utrecht Psalter. The Psalter text is preceded by eight full-page miniatures each divided into twelve square compartments excepting f. 4 which is divided into eighteen medallions. There are forty-six scenes of the Old Testament and thirty-eight of the New with burnished gold grounds: 1. God creating light, 2. God creating the firmament, 3. God separating heaven and earth, 4. God creating the sun and moon, 5. God creating the birds and fishes, 6. God creating the animals and man, 7. The Creation of Eve, 8. God's instructions to Adam and Eve concerning the forbidden fruit, 9. The eating of the fruit, 10. Expulsion from Paradise, 11. Adam tilling the ground and Eve spinning with her children, 12. The offering of Cain and Abel (f. 1).

13. Murder of Abel, 14. God asks Cain 'Where is Abel your brother?', 15. Noah's Ark, 16. Noah leaving the Ark and planting vines, 17. Noah's drunkenness, 18. Melchisedech offers bread and wine to Abraham, 19. The Sacrifice of Abraham, 20. Jacob obtaining the blessing of Isaac, 21. Jacob's dream, 22. Joseph put in the pit, 23. Joseph sold by his brothers, 24. Joseph fills the storehouses of Pharaoh with corn (f. 1ᵛ).

25. Jacob and his family arrive in Egypt, 26. Joseph presents Jacob to Pharaoh, 27. Pharaoh orders the midwives to kill all male children, 28. Birth of Moses; his rescue from the Nile by the daughter of Pharaoh, 29. Moses and the Burning Bush, 30. The parting of the waters of the Red Sea, 31. Pharaoh's army submerged in the sea, 32. Moses and the Israelites praise the Lord for the triumph over Pharaoh, 33. Moses with the tablets of the Law; the Golden Calf, 34. The Tabernacle, 35. Moses and the Brazen Serpent, 36. Moses striking the rock (f. 2).

37. The carrying of the Ark, 38. The grapes brought back from the land of Canaan, 39. The taking of Jericho, 40. Saul anointed by Samuel, 41. Saul offers armour to David, 42. David fighting Goliath, 43. David cutting off Goliath's head, 44. David brings the head of Goliath to Saul, 45. Death of Saul, 46. Anointing of David by Samuel, 47. John the Baptist baptising a group of figures, 48. Beheading of John the Baptist; Salome carries off John the Baptist's head (f. 2ᵛ).

49. Baptism of Christ, 50. Wedding at Cana, 51. Christ told that there is no wine, 52. The changing of water into wine, 53. First temptation of Christ, 54. Second temptation, 55. Third temptation, 56. Four cities of the world with their riches, 57. Angels minister to Christ after his temptations, 58. Healing of the leper, 59. St. Peter's mother-in-law restored to health ministers to Christ, 60. Healing of St. Peter's mother-in-law (f. 3).

61. A scribe becomes a follower of Christ, 62. 'Foxes have holes and birds have their nests', 63. The calming of the storm, 64. The casting of devils into the Gadarene swine, 65. Healing of the paralytic, 66. The paralytic carrying his bed, 67. Christ eating with the publicans and sinners, 68. Healing of Jairus' daughter, 69. Healing of the two blind men, 70. Christ and his disciples plucking ears of corn on the sabbath, 71. The Pharisees reproach Christ for this violation of the sabbath, 72. Healing of the man with the withered arm (f. 3ᵛ).

A Tree of Jesse formed of eighteen round medallions has on each side six busts of Prophets and Apostles. The central series has, reading from the bottom, Jesse, three kings, the Virgin Mary and Christ. Luxuriant 'Byzantine blossom' foliage is interspersed with the medallions (f. 4).

73. Annunciation; Visitation, 74. Nativity, 75. Annunciation to the Shepherds, 76. Journey of the Magi, 77. Magi before Herod, 78. Herod consulting the priests and scribes, 79. Adoration of the Magi, 80. The dream of the Magi, 81. Presentation in the Temple, 82. Flight into Egypt, 83. Massacre of the Innocents, 84. Death of Herod (f. 4ᵛ).

The Psalter text also receives a miniature with burnished gold ground for each psalm following in the iconographic tradition of the Utrecht Psalter of the 9th century which had twice previously been copied (*Survey*, II, no. 64; *Survey*, III, no. 68) at Canterbury where it had come in the late 10th century. This present copy only has surviving text up to Psalm 98 v. 6, the decoration being of two widely separated periods. Ff. 5ᵛ–70 (Psalms 1–39), ff. 75–8ᵛ (Psalms 42–4), f. 84 (Psalm 48), ff. 88ᵛ–92 (Psalms 50–2) are by English artists of the late 12th century and the work was evidently abandoned. The remaining painting was done in the 14th century probably by a Catalan artist. The miniatures illustrate a selection of verses from the psalm they head and in iconography are closely dependent on the Utrecht Psalter and its copies. The elaborate contents of each scene are fully described by Leroquais listing the psalm verses used for each motif in the composition. Ornamental initials in gold and colours

are at the first verse of each of the psalms which are written in three textual versions, the Hebrew, the Roman and the Gallican.

The Hebrew version has a French interlinear gloss, the Roman has a small amount of Anglo-Saxon gloss (ff. 103v, 109v, 135v, 154v) and the Gallican version has a Latin gloss. The Gallican version, being the text of the Vulgate, is given prominence by being of greater width than the other two versions. Each psalm is followed by a collect, which is a rare feature, and the same series of prayers are found in the mid 12th-century copy of the Utrecht Psalter (*Survey*, III, no. 68).

The appearance of the miniatures differs radically from the Utrecht Psalter and the two previous copies in which the illustrations are as drawings or tinted drawings. In this final copy full painting with strong modelling of heads and limbs and heavily burnished gold grounds are used. In the Utrecht Psalter most of the scenes have very small figures often crowded together in groups. The late 12th-century artists have greatly increased the size of the figures and of the architectural features. This has necessitated some fundamental changes in composition and a reduction in the number of figures. There are two artists not greatly differing in figure style but showing a slightly different choice of colours and revealing different solutions to the necessary changes in composition. The first tends to retain the divisions of space by landscape contours used in the Utrecht Psalter whereas the second has a preference for divisions by rigid horizontal and vertical bar frames. Long flowing scrolls for text inscriptions held by the figures are a new feature not found in the Utrecht Psalter. These compositional changes are accompanied by an extraordinary wealth of invention of iconographic motifs. Many similar innovations are found in the Old and New Testament scenes and seem to derive partly from 12th-century Byzantine illumination and partly from rare English examples (Heimann).

The palette is distinguished by use of deep rich colours and by heavy black outlines to the figures. The faces and bodies are heavily modelled in the Byzantine manner using brown and grey-green shading. In the previous decade in the Winchester Bible (*Survey*, III, no. 83) in the work of the Master of the Genesis initial and the Morgan Master this modelling was very heavy whereas in the so-called Master of the Gothic Majesty a paler lighter effect was achieved. The artists of 'The Great Canterbury Psalter' fall midway between these two different approaches. This facial modelling and the way the draperies are shaded show such marked similarities with the Winchester artists that some direct link in the workshop training must be presumed. The figure forms are on the whole less substantial and natural in pose than in the work of the three late artists of the Winchester Bible. The style comes closest to a fourth Winchester artist who painted the Beatus initial in the second Winchester Bible (Oxford, Bodleian Library MS Auct. E. inf. 2; *Survey*, III, no. 82). The ovoid shapes in the drapery on the legs of many of the figures and also some of the facial types can

be paralleled with the Westminster Psalter-Hours (*Survey*, III, no. 89). Also these features can be paralleled in certain North French manuscripts like the third life of St. Amand (Valenciennes, Bibl. Mun. MS 500). Another French element is the initial ornament which is similar to that in a group of books containing commentaries on the Epistles and Gospels by Herbert of Bosham (e.g. Oxford, Bodleian Library MS Auct. E. inf. 6). Whatever the exact place of origin of the artists it seems fairly certain that since the Utrecht Psalter and its copies were at Canterbury the painting must have been done there. There are general parallels in style with the genealogy series in the stained glass in the Cathedral but the difference in technique results in only a vague resemblance.

The model or models used for the iconography is a controversial subject. The old theory (James) considered that both the text and illustration were copied from the mid 12th-century Eadwine Psalter (*Survey*, III, no. 68). In that manuscript certain new iconographic features differing from the Utrecht Psalter had been introduced and these are also found in the late 12th-century version. It was also suggested (Dodwell) that the mid 12th-century series of Old and New Testament scenes (*Survey*, III, no. 66) which in format and iconography are close to those preceding the late 12th-century copy were once prefatory to the Eadwine Psalter. Recently Heimann has demonstrated that the psalm illustrations cannot have derived directly from the Eadwine Psalter but from a common source, now lost, also available to the artist of the Eadwine copy. This copy had certain features not in Eadwine but which occur in the Utrecht Psalter itself, and are also found in the late 12th-century copy. Conversely there are certain innovations which were evidently made in the lost manuscript and which were followed in both Eadwine and by the late 12th-century artists. Features of both the French and Anglo-Saxon glosses support this theory of a lost intermediary copy.

Consequent on this theory is the idea that the mid 12th-century leaves with Old and New Testament scenes (*Survey*, III, no. 66) were prefatory to the lost copy. These scenes derive from a very old cycle originating perhaps in the 6th century or earlier. The grid framework with many small scenes can be paralleled in the 6th-century Italian Gospel Book, 'St. Augustine's Gospels' (Cambridge, Corpus Christi College MS 286) which was at Canterbury in the 12th century. Certain very rare scenes in the cycle in the 'Great Canterbury Psalter' such as the 'Foxes have holes' episode (f. 3v) are also found in the St. Augustine's Gospels. In some cases the titles written above the scenes do not correspond to what is represented. This mistake resulted from the elimination in the late 12th-century version of all scenes set in two registers within the same frame and the consequent absence of certain scenes. The scribe made the mistake of copying some of the titles from the scenes which had been omitted.

The Tree of Jesse arranged as a system of busts in roundels interspersed with foliage is unusual. A similar arrangement occurs in the English influenced

Lower-Saxon manuscript of the 1180s, the Gospels of Henry the Lion (originally at Gmunden, Schloss Cumberland and now lost or in an unknown private collection). The system of presenting a genealogy as a series of busts in roundels is used for the descendants of Anne in the Imola Psalter (no. 26). Such systems of busts seem to derive from Anglo-Saxon 11th-century models such as the Boulogne Gospels (*Survey*, II, no. 44, fig. 147). The setting of medallion scenes amidst luxuriant clumps of foliage occurs in slightly earlier English works of the 12th century: a series of enamel ciboria (M. Chamot, *English Medieval Enamels*, London, 1930, pls. 5–8) and in the English influenced wall paintings in the chapel at Le Petit Quévilly near Rouen.

The lavishness, quantity and consistently high quality of illumination in this splendid book place it in the highest rank amongst all medieval manuscripts. It forms a worthy climax to the tradition of copying the Utrecht Psalter and is perhaps the only one of the copies which in invention and artistic brilliance can be placed on the same exceptional level as the Utrecht Psalter itself.

PROVENANCE: The Cathedral Priory of Christ Church, Canterbury, which possessed the Utrecht Psalter and its copies at the time when this last version was made. At some time before the early 14th century the Psalter had been taken to the Continent where its decoration was completed by an Italianate, possibly Catalan artist. Possibly in the late 14th century it was in the library of the Duc de Berry but this lacks proof (Delisle, 1868, 1893). It came to the Bibliothèque Nationale from the library of Napoléon I.

LITERATURE: A. de Bastard, *Peintures et Ornements des Manuscrits*, Paris, 1832–69, II, pl. 248 bis; J. B. Silvestre, *Universal Palaeography*, II, London, 1850, 507–9, pl. 184; L. Delisle, *Le Cabinet des manuscrits de la Bibliothèque Impériale*, Paris, 1868, I, 65; F. Michel, *Le Livre des psaumes, ancienne traduction française*, Paris, 1876; S. Berger, *La Bible française au Moyen Age*, Paris, 1884, 322–3; L. Delisle, 'Livres d'Images destinés à l'instruction religieuse et aux exercices de piété des Laïques', *Histoire Littéraire de la France*, XXXI, 1893, 261–3; Haseloff, 'Miniature', 318–9, fig. 243; H. Omont, *Psautier illustré (XIIIe siècle). Reproduction des 107 miniatures du manuscrit latin 8846 de la Bibliothèque Nationale*, Paris, 1906 (facsimile ed.); Millar, I, 46, pl. 67; P. Lauer, *Les enluminures romanes des manuscrits de la Bibliothèque Nationale*, Paris, 1927, 89–90, pls. LXXXI–LXXXIII; Boeckler, *Abendländische Miniaturen*, 92 ff.; A. Watson, *The early iconography of the Tree of Jesse*, London, 1934, 55; M. R. James, *The Canterbury Psalter*, London, 1935, 4–5; Swarzenski, *Handschriften XIII Jh.*, 101 n. 2, 102 nn. 5, 8, 119 n. 2; M. R. James, 'Four leaves of an English Psalter', *Walpole Society*, 25, 1936–7, 1–21; Swarzenski, 'Unknown Bible Pictures', 65–9; V. Leroquais, *Les Psautiers manuscrits des bibliothèques publiques de France*, Mâcon, 1940–1, II, 78–91, pls. LX–LXII; M. Meiss, 'Italian Style in Catalonia and a Fourteenth-Century Catalan Workshop', *Journal of the Walters Art Gallery*, IV, 1941, 73–6, figs. 27–9, 31; Morison, *'Black-Letter' Text*, 33; D. Panofsky, 'The textual basis of the Utrecht Psalter illustrations', *Art Bulletin*, 25, 1943, 50–8; L. Brou, *Psalter Collects*, H.B.S., LXXXIII, 1949, 29–31, 39 n. 5, 68; Boase, *English Art*, 289 ff., pls. 94b, 95c, d, e, f, 96; Swarzenski, *Monuments*, fig. 5; C. R. Dodwell, *The Canterbury School of Illumination 1066–1200*, Cambridge, 1954, 98 ff., pls. 67, 69, 70a, 70c; Freyhan, 'Joachism', 211 n. 2; H. Buchthal, *Miniature Painting in the Latin Kingdom of Jerusalem*, Oxford, 1957, 55–6, 58n. 2, 58n. 4, 71, 80 n. 1, pl. 147a; D. Tselos, 'English manuscript illustration and the Utrecht Psalter', *Art Bulletin*, 41, 1959, 137, 142–7, figs. 4, 14; Rickert, *Miniatura* I, pl. 60; O. Pächt, C. R. Dodwell, F. Wormald, *The St. Albans Psalter*, London, 1960, 56, 158, pl. 104c; S. Dufrenne, 'Les copies anglaises du Psautier d'Utrecht', *Scriptorium*, 18, 1964, 186, 190–2, 197, pl. 20; B. Woledge, H. P. Clive, *Répertoire des plus anciens textes en prose française*, Geneva, 1964, 94–5; Rickert, *Painting in Britain*, 93–4, pl. 93; H. Hargreaves, C. Clark, 'An unpublished Old English Psalter-Gloss fragment', *Notes and Queries*, 210, n.s. 12, 1965, 443–6; Deuchler, *Ingeborgpsalter*, 19, 36, 37, 38, 39, 43, 53; E. Brayer, A.-M. Bouly de Lesdain, 'Les prières usuelles annexées aux anciennes traductions françaises du Psautier', *Bulletin d'Information de l'Institut de Recherches des Textes*, 15, 1967–8, 72–3; R. Mellinkoff, *The Horned Moses in Medieval Art and Thought*, London, 1970, 65, fig. 56; G. Henderson, *Early Medieval*, London, 1972, 185–9, fig. 122; A. Heimann, 'The Last Copy of the Utrecht Psalter', *The Year 1200: a Symposium*, New York, Metropolitan Museum of Art, 1975, 313–38; *Survey*, III, 32, 94, 96–7; S. Dufrenne, 'Les suites du Psautier d'Utrecht', *Les dossiers de l'archéologie*, 16, 1976, 50 ff., col. pls.; Einhorn, *Spiritalis Unicornis*, 383, 398; M. Harrison Caviness, *The Early Stained Glass of Canterbury Cathedral*, Princeton, 1977, 56, 57, 65, 69, 109, 113, 123, 124, 127, 150, 154, figs. 29, 57, 96, 102, 108; Zahlten, *Creatio Mundi*, 69, 154, 180, 267, figs. 123, 283.

EXHIBITED: Paris, Bibliothèque Nationale, *Le Livre anglais*, 1951, no. 11; Barcelona, *El Arte Romanico*, 1961, no. 171; Paris, Musée du Louvre, *L'Europe Gothique*, 1968, no. 234; New York, Metropolitan Museum, *The Year 1200*, 1970, no. 257; Brussels, 1973, no. 18.

2. London, British Library MS Royal 2. A. XXII
Psalter (Westminster Psalter)
230 × 158 mm., ff. 224
c. 1200. Westminster or St. Albans
(for later additions see no. 95, Part 2)

Ills. 8–13; figs. 1, 5

The Calendar at the beginning of the Psalter has roundels of the Signs of the Zodiac: Aquarius (f. 5);

Pisces (f. 5ᵛ); Aries (f. 6); Taurus (f. 6ᵛ); Gemini (f. 7); Cancer (f. 7ᵛ); Leo (f. 8); Virgo (f. 8ᵛ); Libra (f. 9); Scorpio-represented as a dragon (f. 9ᵛ); Sagittarius (f. 10); Capricorn (f. 10ᵛ). Five full-page miniatures with gold grounds precede the Psalter text: Annunciation (f. 12ᵛ); Visitation (f. 13); Seated Virgin and Child (f. 13ᵛ); Christ in Majesty with the symbols of the Evangelists (f. 14); King David playing a harp (f. 14ᵛ). Ten ornamental or historiated initials mark the liturgical divisions: Psalm 1, B with three medallions in the stem depicting David bringing the head of Goliath to Saul, David harping, and David beheading Goliath (f. 15); Psalm 26, D ornamental (f. 38ᵛ); Psalm 38, D ornamental (f. 53); Psalm 51, Q ornamental (f. 66); Psalm 52, D ornamental (f. 66ᵛ); Psalm 68, S with Jonah thrown from the ship and Jonah seated on the whale (f. 80ᵛ); Psalm 80, E ornamental (f. 98); Psalm 97, C ornamental (f. 114); Psalm 101, a monk in a grey-black habit kneeling before Christ (f. 116); Psalm 109, the Trinity (f. 132). The minor psalm initials are in red, blue and green with ornament in the same colours and the line endings have simple ornamental patterns in red and blue. Occasionally pen flourishes extend to form sprays in the margin. The full-page drawings added to the book in the middle of the 13th century (ff. 219ᵛ–221ᵛ) are discussed under no. 95.

There are three distinct styles in the book. The main artist does the full-page miniatures, another does the calendar roundels and the initials on ff. 15, 80ᵛ, 132, and a third the initial on f. 116. The figure style of the main artist owes much to the Byzantine influenced late work in the Winchester Bible (*Survey*, III, no. 83) particularly that of the so-called Master of the Gothic Majesty. The figure forms are very substantial, static and rounded with fairly natural fold patterns. The faces are of Byzantine type but with softer modelling in lighter shades of colour resulting in more gentle expressions. This development has gone one stage further than in the last copy of the Utrecht Psalter (no. 1). Parallels to the Westminster Psalter are the Glossed Gospels (no. 3) and the North French Ingeborg Psalter (Chantilly, Musée Condé MS 1695) probably based on an English model. The style of the late work of the Winchester Bible existed in wall painting as evidenced by the Chapel of the Holy Sepulchre in Winchester Cathedral and the cycle by English artists once in the Chapter House at Sigena in Spain. The monumental aspect of the figures of the Westminster Psalter suggest a possible derivation from wall painting.

The second artist who paints the Beatus page has a less sophisticated style with figures rather wooden in pose and a sketchy manner of drawing faces. The third artist who paints the monk kneeling before Christ for Psalm 101 has a related but even more archaic manner. The stiff fold patterns on the Christ and the blocky forms contrast with the much more relaxed poses of the main artist. It is possible that the two secondary artists may be monks of Westminster whereas the main artist is a visiting professional.

The tradition of prefacing a Psalter text with New Testament miniatures and occasionally also a portrait of David had existed earlier in the 12th century (*Survey*, III, nos. 29, 48, 78, 94, 95, 96, 97). The use of figure subjects for the initials of the liturgical divisions was becoming increasingly popular in the late 12th century, but in the Westminster Psalter this development is still at a stage where only some of these initials are historiated.

The dating of the Psalter is controversial and a date *c*. 1200 is often suggested. Bannister many years ago suggested that a mark by the year 1186 in the Paschal Tables contained in the text was significant for the dating. This occurrence of dots in Paschal Tables is however not proveable as an indication of date although the stylistic link with the Winchester Bible would make a date in the decade 1180–90 quite possible for the style. Recent opinion (Johnson) has suggested that the higher grading of certain feasts in the calendar was introduced by Ralph of Arundel who became Abbot in November 1200. This would perhaps give a terminus post for the production of the Psalter.

The intended Westminster provenance for the Psalter resulted in the special provision of large initials at most of the monastic divisions of the psalms (ff. 22, 29ᵛ, 51, 79ᵛ, 81ᵛ, 105ᵛ, 120ᵛ, 122ᵛ, 125ᵛ, 157ᵛ, 162, 163). This marking is fairly rare and was needed because in monastic use some psalms were divided into two parts for singing in the offices.

Although a Westminster destination was intended the style of the main artist is closest to works of Winchester and St. Albans provenance. A late 12th century strongly Byzantinising style related to that of Winchester had existed in London (*Survey*, III, no. 89) but it does not provide a direct source for the artist of the Psalter, whose Winchester training seems beyond doubt.

PROVENANCE: The Benedictine Abbey of Westminster on the evidence of the Calendar, Litany and special prayers to St. Edward the Confessor and St. Peter (f. 186). It is recorded in the inventories of 1388 and 1540. Later the book belonged to John Theyer (1597–1673) and *c*. 1678 was purchased for the Royal collection and passed into the British Museum in 1757.

LITERATURE: W. R. Tymms, M. D. Wyatt, *The Art of Illuminating*, London, 1860, XIIth-century plates no. 9; E. Maunde Thompson, *English Illuminated Manuscripts*, London, 1895, 34 ff., pl. 10; J. W. Legg, *Missale Westmonasteriensis*, III, H.B.S., XII, xiv–xv, 1385–98; G. Warner, *Illuminated Manuscripts in the British Museum*, London, 1899–1903, pl. 4; C. Wordsworth, H. Littlehales, *The Old Service Books of the English Church*, London, 1904, 111; Haseloff, 'Miniature', 317, fig. 241; British Museum, *Reproductions*, I, pls. IX, X; Herbert, *Illuminated Manuscripts*, 141–2; H. M. Bannister, 'Signs in Calendarial Tables', *Mélanges offerts à M. Emile Chatelain*, Paris, 1910, 148; British Museum, *Schools of Illumination*, pt. II, London, 1915, pl. 4; Warner and Gilson, 36–8, pl.

19a; Millar, I, 42–3, 90–1, pls. 62, 63; Saunders, *English Illumination*, I, 52, II, pls. 56, 57; Boeckler, *Abendländische Miniaturen*, 93–4; A. Wilmart, *Auteurs spirituels et textes dévots du moyen age latin*, Paris, 1932, 333 n. 3, 487, 572, 579 n. 5, 582 n. 1; Haseloff, *Psalterillustration*, 8 ff., Tab. 1; V. Lasareff, 'Studies in the Iconography of the Virgin', *Art Bulletin*, 20, 1938, 62, fig. 47; Wormald, *Kalendars*, II, 57; Morison, *'Black-letter' Text*, 19, 33; F. Wormald, 'Paintings in Westminster Abbey and contemporary paintings', *Proceedings of the British Academy*, XXXV, 1949, 162–3; Tristram, *Wall Painting*, 82, 84; Boase, *English Art*, 285 ff., pl. 85b; O. Homburger, 'Zur Stilbestimmung der figurlichen Kunst Deutschlands und des westlichen Europas im Zeitraum zwischen 1190 und 1250', *Formositas Romanica, Festschrift J. Gantner*, Frauenfeld, 1958, 33 ff., figs. 4, 5; Rickert, *Miniatura* II, pl. 2; L. Gjerløw, *Adoratio Crucis*, Oslo, 1961, 20, 22, 137, 142; O. Pächt, 'A cycle of English frescoes in Spain', *Burlington Magazine*, 103, 1961, 172; H. Barré, *Prières anciennes de l'Occident à la Mère du Sauveur*, Paris, 1963, 129 n. 10, 180 n. 3; G. Zarnecki, 'The transition from Romanesque to Gothic in English sculpture', *Acts of the XX International Congress of the History of Art*, Princeton, 1963, I, 157; Ker, *Medieval Libraries*, 196; Rickert, *Painting in Britain*, 92–3, pl. 91; E. Kitzinger, 'The Byzantine contribution to Western Art of the Twelfth and Thirteenth centuries', *Dumbarton Oaks Papers*, 20, 1966, 372–3; A. Martindale, *Gothic Art*, London, 1967, 72, pl. 50; Deuchler, *Ingeborgpsalter*, 164; D. H. Turner, *Illuminated Manuscripts exhibited in the Grenville Library*, British Museum, London, 1967, No. 12, pl. I; Turner, 'Manuscript Illumination', 135–6, figs. 177–9; W. Oakeshott, *Sigena*, London, 1972, 98, fig. 168; M. H. Caviness, 'The Canterbury Jesse Window', *The Year 1200: a Symposium, New York, Metropolitan Museum of Art*, 1975, 378, fig. 15; *Survey*, III, 114; N. Johnson, *The Westminster Psalter: some remarks on English illumination c. 1200*, M.A. Report, Courtauld Institute, University of London, 1975; Watson, *Dated Manuscripts*, no. 860, pl. 103; W. Oakeshott, *The Two Winchester Bibles*, Oxford, 1981, 70. Further bibliography relating specifically to the added drawings is given under no. 95, Part 2.

EXHIBITED: London, British Museum, *Illuminated Manuscripts and Bindings of Manuscripts exhibited in the Grenville Library*, 1923, no. 18, with pl.

3. Cambridge, Trinity College MS B. 5. 3
Gospels with Gloss
445 × 320 mm., ff. 236
c. 1190–1200. St. Albans *Ills. 15, 16*

The book begins with plain Canon Tables having columns partly in gold and partly marbled or decorated with pattern ornaments (ff. 1ᵛ, 2). At the beginning of each Gospel is an illuminated initial with burnished gold ground: Matthew, L, with foliage in stem and at base a seated figure with four heads of the Evangelist symbols (f. 4ᵛ); Mark, I, with four medallions containing the symbols of the Evangelists (f. 69ᵛ); Luke, F, with a bull with four heads of the Evangelist symbols and at the base of the initial a man seated on a heap of stones (f. 111ᵛ); John, I, with four medallions containing the Evangelist symbols (f. 187ᵛ). There are large ornamental illuminated initials for the prologues to Mark, Luke and John (ff. 68ᵛ, 111, 186ᵛ).

The figure style of the illumination is close to that of the Westminster Psalter (no. 2) main artist and is very probably by the same hand. The capitula have an unusual form also found in a St. Albans Bible (Cambridge, St. John's MS G. 15) suggesting the possibility that the Gospels were made there. This is the first manuscript to show links between St. Albans and Westminster which become frequent during the 13th century. The carefully modelled heads and the substantial proportions of the figures are features in common with the Westminster Psalter. The style is not the same as Trinity MS 0. 5. 8, as has been suggested by Rickert, which represents the St. Albans style of Abbot Simon's period (1167–83).

PROVENANCE: St. Albans on evidence of both the text and an inscription of ownership on f. 2ᵛ: '*Hic est liber St. Albani, quem qui ei abstulerit aut titulum deleverit anathema sit. Amen.*' Later in the 17th century it belonged to Thomas Nevile, Master of Trinity, who gave it to the College.

LITERATURE: James, *Catalogue*, no. 149, pl. XIII; Millar, I, 43; H. H. Glunz, *History of the Vulgate in England from Alcuin to Roger Bacon*, Cambridge, 1933, 178 n. 2, 236 ff.; Boase, *English Art*, 287, pl. 31 f; J. H. Plummer, *The Lothian Morgan Bible*, Ph.D. Dissertation, Columbia University, 1953, 13, 48, 50; Rickert, *Miniatura*, II, pl. 3; Ker, *Medieval Libraries*, 166; O. Homburger, 'Zur Stilbestimmung der figurlichen Kunst Deutschlands und des westlichen Europas im Zeitraum zwischen 1190 und 1250', *Formositas Romanica, Festschrift J. Gantner*, Frauenfeld, 1958, 34; Rickert, *Painting in Britain*, 92, pl. 92A; Henderson, 'Studies', I, 74; L. M. Ayres, 'A Tanner manuscript in the Bodleian Library and some notes on English painting of the late twelfth century', *J.W.C.I.*, XXXII, 1969, 48, pl. 7d; J. C. Higgitt, 'The Roman background to Medieval England', *Journal of the British Archaeological Association*, 36, 1973, 12, pl. III. 3; E. P. McLachlan, 'The Pembroke College New Testament and a group of unusual English Evangelist Symbols', *Gesta*, XIV/1, 1975, 10, fig. 10; W. Oakeshott, *The Two Winchester Bibles*, Oxford, 1981, 82, figs. 107, 108.

4. Oxford, Bodleian Library MS Laud Misc. 409
Hugh of St. Victor, De Archa Noe et al.; Richard of St. Victor, Benjamin Minor
243 × 164 mm., ff. 126
c. 1190–1200. St. Albans *Ill. 14*

One full-page miniature with a burnished gold ground shows Hugh of St. Victor teaching a group of Augustinian canons (f. 3ᵛ). There are two ornamental initials illuminated with gold at the beginning of the texts of Hugh (f. 4) and Richard (f. 64). The works of the School of St. Victor were evidently of interest at St. Albans in the late 12th century. A letter survives from Abbot Simon (1167–83) to Prior Richard of St. Victor asking for copies to be made of those texts by Hugh which were lacking in their library (*Gesta Abbatum S. Albani*, ed. T. Riley, London, 1867, I, 192). The copy made is probably Oxford, Bodleian Library MS Laud Misc. 370, and the text of this manuscript in part provided the model for that of Laud. Misc. 409. The figure style in Laud Misc. 409 develops out of St. Albans work of Abbot Simon's period and in contrast to no. 3 represents the indigenous style of the Abbey. The facial types are drier in appearance with less modelling than in the work of the 1180s, a general tendency in all English illumination of the years around 1200.

PROVENANCE: An inscription (f. 1) in a 13th-century hand records that the book was given by Abbot William (1214–35) and lists the text contents. Also on f. 1 is a 15th-century St. Albans pressmark. On f. 3 is recorded the ownership of Archbishop Laud in 1633 from whom it passed to the Bodleian Library.

LITERATURE: Coxe, *Catalogue*, II, col. 300; R. Baron, 'Hugues de Saint-Victor: contribution à un nouvel examen de son oeuvre', *Traditio*, XV, 1959, 251, 285; A. Squire, *Hugh of St. Victor. Selected spiritual writings*, New York, 1962, 19, pl. 1; G. Pollard, 'The construction of English twelfth century bindings', *The Library*, 5th ser. XVII, 1962, 3 n. 3; Ker, *Medieval Libraries*, 168; C. Brooke, *The twelfth century Renaissance*, London, 1969, pl. 17 (colour); G. Zarnecki, *The monastic achievement*, London, 1972, pl. 79 (colour); Pächt and Alexander, III, no. 255, pl. XXIV; W. Cahn, 'St. Albans and the Channel Style in England', *The Year 1200: a Symposium, New York, Metropolitan Museum of Art*, 1975, 195, 200, fig. 31; R. W. Hunt, 'The Library of the Abbey of St. Albans' in *Medieval Scribes, Manuscripts and Libraries. Essays presented to N. R. Ker*, M. B. Parkes, A. G. Watson, eds., London, 1978, 253 n. 10, 259 n. 38, 261 n. 51.

5. Cambridge, Corpus Christi College MS 161
Lives of Saints
302 × 202 mm., ff. 153
c. 1190–1200. (?) Canterbury or Faversham

Ill. 17

The only figure decoration in the manuscript is a full-page framed miniature of a standing Archbishop saint; possibly, in view of the Kent ownership, this is St. Dunstan (f. 1). The figure is set against a panelled ground of orange, red and grey-purple. An ornamental initial in red, blue and green penwork opens the text (f. 2).

The style of the figure is characterised by a dry linear fold system with little use of colour to give any modelling and three dimensionality. The face is slightly modelled in brown and white. This style is a sort of parallel to the dry manner evident in certain contemporary work from St. Albans (no. 4). The figure style in Corpus 161 could derive from Canterbury work of the 1170s such as London, British Library MS Royal 10. A. XIII (*Survey*, III, no. 92).

The likely presence of the book in Canterbury in the 16th century (see Provenance) and the very rare inclusion of a Life of St. Ithamar (relics at Rochester) suggests a Kent origin. Other unusual lives of saints included are Cluniac (Odo, Maiolus, Odilo, Hugh of Cluny). This evidence suggests the book was intended for a Cluniac house in the diocese of Rochester. A likely candidate would be Faversham, founded from Bermondsey, but having an unusual position in being outside the main order of Cluny. Sources in the 13th century do, however, describe the Abbey as Cluniac. The Bermondsey connection is supported by the inclusion of the Life of St. Erkenwald whose relics were in London.

PROVENANCE: A Cluniac house in Kent, possibly Faversham. On the flyleaf in red is the name Twyne. This is John Twyne, Mayor of Canterbury in 1554, who acquired manuscripts from religious houses, in particular St. Augustine's, Canterbury. Matthew Parker (1504–75), Archbishop of Canterbury (1559–75) acquired the book and bequeathed it with his other manuscripts to Corpus Christi College.

LITERATURE: Hardy, *Descriptive Catalogue*, I, 252, 294, 607; James, *Catalogue*, 358–63; D. Bethell, 'The miracles of St. Ithamar', *Analecta Bollandiana*, 89, 1971, 422, 427–37; H. E. S. Cowdrey, 'Two studies in Cluniac History', *Studi Gregoriani*, XI, 1978, 37, 119–39.

EXHIBITED: Cambridge, Corpus Christi College, *Matthew Parker's Legacy*, 1975, no. 18, pl. 18.

6. Cambridge, Corpus Christi College MS 10
Gratian, Decretals
433 × 287 mm., ff. 363
c. 1190–1200. Southern England *Ills. 18, 19*

This is an illustrated copy of the code of canon law compiled by Gratian at Bologna in the middle of the 12th century. The book is decorated with 39 ornamental and historiated initials, many having been painted on separate pieces of vellum and pasted in, and one full-page miniature: I, ornamental (f. 1); H, large ornamental with tight coils, Byzantine blossom and little white lions on a burnished gold ground (f. 12); Causa I, a seated Abbot with a man presenting a small boy and a bowl of silver (f. 92); Causae II, III, IV, V, ornamental (ff. 113, 130ᵛ, 138, 140);

Causa VI, a bishop between two disputing men (f. 142ᵛ); Causa VII, a bishop in bed surrounded by two men and another bishop (f. 145ᵛ); Causae VIII–XII, ornamental (ff. 152, 154ᵛ, 157, 160ᵛ, 171ᵛ); Causa XIII, dispute over church tithes (f. 181); Causa XIV, ornamental (f. 185); Causa XV, a cleric attacks a man with a club (f. 187ᵛ); Causa XVI, two secular clerics before an abbot and two monks (f. 192); Causae XVII–XIX, ornamental (ff. 204ᵛ, 208, 210ᵛ); Causa XX, two novices before an Abbot (f. 212); Causae XXI–XXVI, ornamental (ff. 214, 216, 224, 246, 257, 261); Causa XXVII, a dispute over a marriage (f. 268); Causae XXVIII–XXX, ornamental (ff. 275, 279, 280); Causa XXXI, a dispute over a marriage (f. 283ᵛ); Causae XXXII–XXXIV, ornamental (ff. 285, 294, 325ᵛ); Causa XXXV, marriage after the death of the first wife (f. 326ᵛ); a full-page miniature of a man with a superimposed tree of consanguinity (f. 330ᵛ); Causa XXXVI, a man and woman at table and in bed (f. 333ᵛ); ornamental (f. 335). The historiated initials have burnished gold, red, pink-red or blue grounds. The iconography of the initials is very close to a group of North French copies, Cambrai, Bibl. Mun. MS 967, Douai, Bibl. Mun. MS 590, Troyes, Bibl. Mun. MS 103, which suggest a common model was involved. The figure style of the Corpus Gratian has some connections with the French group and is a precursor of the style of the Munich Psalter (no. 23). The faces have strong modelling, a characteristic cream white ground colour is used in the draperies and highlighting is achieved by means of white hatching and ornamental rinceaux, all features found in the Munich Psalter. The origins of this type of painting seem to be in St. Albans work of Abbot Simon's period and its derivatives like the Copenhagen Psalter (*Survey*, III, no. 96). At this time there are many close similarities with North French painting and some painters worked on both sides of the Channel giving rise to the term 'Channel style'. The tree of consanguinity is a pictorial version of a table of kindred and affinity. The male figure on which the diagram is set is probably Isidore of Seville who devised the system. Another English 13th century example occurs in Oxford, Bodleian Library MS Rawl. A. 384 (no. 130, Part 2).

PROVENANCE: Bequeathed to the College by Matthew Parker, Archbishop of Canterbury (1504–75).

LITERATURE: James, *Catalogue*, no. 10; S. Kuttner, *Repertorium der Kanonistik* (*1140–1234*), Rome, 1937, 23; Boase, *English Art*, 280, pl. 92a; R. Schilling, 'The Decretum Gratiani formerly in the C. W. Dyson Perrins Collection', *Journal of the British Archaeological Association*, 26, 1963, 30, 32, 34–9, pls. XVII, XX–XXIII; A. Melnikas, *The Corpus of the Miniatures in the manuscripts of Decretum Gratiani*, Studia Gratiana, 16–18, Rome, 1975, 275, 435, 516, 1119, 1142, Causa I, fig. 13, Causa VI, fig. 16, Causa VII, fig. 11, Causa XIII, fig. 17, Causa XVI, fig. 15, Causa XX, fig. 12, Causa XXVII, fig.

10, Causa XXXI, fig. 10, Causa XXXV, fig. 12, Causa XXXVI, fig. 12.

EXHIBITED: Cambridge, Corpus Christi College, *Matthew Parker's Legacy*, 1975, No. 17, pl. 17.

7. Cambridge, Trinity College MS B. 10. 9
Psalter
248 × 174 mm., ff. 121
c. 1200. (?) London region *Ills. 20, 21*

The Calendar (ff. 2–7ᵛ) surrounded by a gold border for each month has roundels and squares containing Signs of the Zodiac. Each psalm has an illuminated ornamental initial using much gold and in some cases white backgrounds, with red and blue rinceaux on the white. The line endings are ornamental patterns in red, blue and green penwork. There are nine larger initials to the main liturgical divisions but that section containing Psalm 1 is missing: Psalm 26, D, Samuel anointing David (f. 25ᵛ); Psalm 38, D, ornamental with a knight fighting a lion, and a man (David?) with a club fighting another lion (f. 36ᵛ); Psalm 51, Q, ornamental containing the scene of Doeg killing Ahimelech (f. 45ᵛ); Psalm 52, D ornamental (f. 46); Psalm 67, S, ornamental (f. 55ᵛ); Psalm 80, E, ornamental (f. 66ᵛ); Psalm 97, C, ornamental with two small seated figures (f. 77); Psalm 101, D, ornamental (f. 78ᵛ); Psalm 109, D, ornamental (f. 88). Burnished gold grounds are much used and the faces of the figures are heavily modelled using browns and greens. There is some similarity to the figure style of the second artist of the Westminster Psalter (no. 2). The initial on f. 25ᵛ is by a different artist whose figures are rather stiff and have brown faces modelled with white. The main artist has more natural relaxed figures particularly evident in the initial on f. 77. The general page layout and ornamental initial types have some connections with the Copenhagen Psalter (*Survey*, III, no. 96). In view of St. Erkenwald (relics at St. Paul's) being highly graded in blue the calendar may point to London, as James has suggested, although it is not very close to Cambridge, St. John's MS D. 6 (no. 36) as he stated. There are the rare entries of Winchester – Hedda (7th Jul.), Transl. Ethelwold (10th Sept.), Ethelfleda (23rd Oct.); St. Albans – Simeon (18th Feb.), Inv. Alban (2nd Aug.); and the North Midlands – Transl. Wilfrid (24th Apr.), Rumwald (3rd Nov.), but these diverse elements offer no obvious location. The Calendar is very probably derived from a monastic model which would explain this diversity. At some time the Psalter was certainly in Benedictine hands because a later scribe has marked the monastic divisions of the psalms (e.g. ff. 63ᵛ, 81ᵛ, 82).

PROVENANCE: Probably given to the College by Sir Edward Stanhope (James).

LITERATURE: James, *Catalogue*, no. 220; Frere, *Bibliotheca Musico-Liturgica*, II, 157; Haseloff, *Psalterillustration*, 8 ff., 100, Tab. 1; W. Cahn, 'St.

Albans and the Channel Style in England', *The Year 1200: a Symposium, New York, Metropolitan Museum of Art*, 1975, 191 n. 24.

8. Oxford, Bodleian Library MS Auct. D. 2. 1
Psalter with Gloss
303 × 205 mm., ff. 223
c. 1190–1200. (?) West Midlands *Ills. 22, 23*

There are four fully illuminated initials to some of the psalms of the liturgical divisions, others, although large and elaborate, having only penwork ornament: Psalm 1, B ornamental (f. 8ᵛ); Psalm 51, Ahitobel brought by Doeg before Saul (f. 80); Psalm 101, seated Christ blessing (f. 147ᵛ); Psalm 109, D ornamental (f. 164ᵛ). The first of the Gradual psalms has an ornamental initial larger than for normal psalms. The figures show a style in which the compartmental fold patterns of the Romanesque are still to some degree evident but are being broken down into more natural sweeps of draperies. A similar attitude is seen in the slightly earlier Bible, Oxford, Bodl. MS Laud Misc. 752 (*Survey*, III, no. 103), with which there is some stylistic connection. Influences from Mosan or North French painting may have resulted in this development which is still best described by the term 'Channel style'. A marked feature of the technique of this manuscript is a heavy grey-green modelling of the faces.

As the earlier Bible in Oxford, Bodl. MS Laud Misc. 752, has connections with Buildwas (Shropshire), and as a text of Clement of Llanthony is added to the Psalter, there is some evidence, although rather weak, for connecting the book with the West Midlands. A book with similar decoration (Oxford, Trinity College MS 58) also has a Clement of Llanthony text.

PROVENANCE: The attribution to Llanthony on the basis of the inclusion of a text by Clement of Llanthony is not firm. A 15th-century inscription on f. 223ᵛ; 'Orate p(ro) a(n)i(m)a D(omi)ni Rob(ert)i Toff'.

LITERATURE: S.C., I, No. 2312; M.-T. D'Alverny, *Alain de Lille. Textes inédits*, Paris, 1965, 155; Pächt and Alexander, III, no. 226, pl. XXII; W. Cahn, 'St. Albans and the Channel Style in England', *The Year 1200: a Symposium, New York, Metropolitan Museum of Art*, 1975, 203 n. 24.

9. Oxford, Bodleian Library MS Ashmole 1462
Medical and Herbal texts. Pseudo-Apuleius, Herbarium; Sextus Placitus, De medicina ex animalibus; Pseudo-Dioscorides, De herbis feminis
304 × 206 mm., ff. 82 with six missing (76 extant)
c. 1190–1200. (?) Northern England
Ills. 24, 25, 27

The illustrations begin with three full-page miniatures: naked male figures showing cautery points for breathing problems, and diseases of the liver, spleen, stomach and kidneys (f. 9); similar naked figures and one seated clothed showing cautery points for elephantiasis, asthma, tertian fever and toothache (f. 9ᵛ); operations for cataract and nasal polyps (f. 10). Then follows the first part of the herbal with 138 pictures of the herbs and the complaints for which they are curative, some having frames, in various positions in the text: vetonica (f. 12); a man with a sword attacked by a rabid dog and bitten by a snake in the arm (f. 13ᵛ); plantago (f. 14); a man brandishing an axe at a serpent and a scorpion (f. 14ᵛ); pentaphyllos (f. 15); verminatia, a man holding the herb and piercing a serpent with a sword (f. 15ᵛ); simphoniaca, a doctor attending the wounded arm of a man (f. 16); pedeleonis, botration (f. 16ᵛ); botration staticen, artemisia monoglossos (f. 17); artemisia tagante (f. 17ᵛ); artemisia leptasillos, a centaur with the goddess Diana holding herbs, lapatium (f. 18); dracontea, satyrion (f. 18ᵛ); gentiana, cyclaminos (f. 19); polygonon (f. 19ᵛ); aristolochia, nasturtium (f. 20); hieribulbum, apollinaris (f. 20ᵛ); camaemilon, camedris, a man spearing a snake (f. 21); cameleia, camedaphne, ostriago (f. 21ᵛ); britannica, lactuca silvatica (f. 22); agrimonia (f. 22ᵛ); asphodel, oxilapatium, centauria maior held by a centaur (f. 23); centauria minor (f. 23ᵛ); personatia, a man wielding a sword at a dog-like creature, fraga (f. 24); hibiscus, ippiron, malva silvatica (f. 24ᵛ); buglossa, scilla (f. 25); gallicrus, cotyledon (f. 25ᵛ); marrubium, sciphion (f. 26); callitrichon, immolum, Mercury standing before Homer (f. 26ᵛ); heliotropium, cryas, polytrichum (f. 27); asularegia, papaver silvaticum, hynantes (f. 27ᵛ); narcissus, splenion, poleion (f. 28); victoriola, symphytum (f. 28ᵛ); asterion, leporis (f. 29); dyptannus, solago maior (f. 29ᵛ); solago minor, pionia, peristerion (f. 30); bryonia, nymphia (f. 30ᵛ); crision, isatis, scordeon (f. 31); verbascum, heraclea, strignos (f. 31ᵛ); celidonia, senecion (f. 32); felix, gramen (f. 32ᵛ); gladiolum, rosmarinum (f. 33); pasnatica silvatica (f. 33ᵛ); mercurialis, perdicalis, radiolus, asparagus (f. 34); savina, cynocephalus (f. 34ᵛ); erusca (f. 35); millefolium, ruta (f. 35ᵛ); a man drawing his sword at a dog, mentastrum (f. 36); ebulus, poleius (f. 36ᵛ); nepita, peucidanum, inula campana (f. 37ᵛ); cynoglossa, saxifraga, edera nigra (f. 38); serpillum, absinthium (f. 38ᵛ); salvia, coriander (f. 39); portulaca, cerfolium, sisymbrium (f. 39ᵛ); olisatrum, lilium, a man attacking a dragon with a sword, titimallos (f. 40); cardo silvaticus, lupinus (f. 40ᵛ); latiridis, lactuca leporina, sicidis agria (f. 41); cannabis, ruta montana (f. 41ᵛ); eptaphillos, ocymum (f. 42); apium, chrysocantis, hydiosmon (f. 42ᵛ); sempervivium, anetum (f. 43); feniculum, symphytum, exision (f. 43ᵛ); petrosilinum, brassica silvatica, basilisca (f. 44); mandragora, camepitium (f. 45).

Then follows a set of 24 illustrations of animals and birds to the text of Sextus Placitus: Badger (f. 45ᵛ); Stag (f. 49); Hare (f. 49ᵛ); Fox (f. 50ᵛ); Wild Goat (f. 50ᵛ); Wolf (f. 51ᵛ); Dog (f. 53); Ass (f. 53ᵛ); Mule, Horse (f. 54); Ram (f. 54ᵛ); Goat (f. 55); a boy urinating into a bowl beside a virgin girl holding

a palm (f. 56ᵛ); Cat, Crickets, Weasel, Mice (f. 57ᵛ); Partridge, Raven, Cock (f. 59); Hen (f. 59ᵛ); Dove, Goose (f. 60ᵛ); Swallow (f. 61).

Then the illustrations of the herbs begin again with 71 examples: buglossus, acantum (f. 64); helylysfacos, cyminon (f. 64ᵛ); cameleon alba, herpullos (f. 65); camerops, polyganos (f. 65ᵛ); sansucon, cestros (f. 66); aristolochia, sticas (f. 66ᵛ); adiantos, mandragora feminea (f. 67); thaspis, sisimbrion (f. 67ᵛ); celidonia, camemedros (f. 68); sideritis, flominos (f. 68ᵛ); linozostis, antherenon, britannica (f. 69); pusillios, melena (f. 69ᵛ); tribulosa, coniza (f. 70); strygnos, butalion (f. 70ᵛ); iffieritis, hipperis (f. 71); aizos, titimallos (f. 71ᵛ); eliotropis, scolymbos, achillea (f. 72); scaphisa, camelia (f. 72ᵛ); alcibiados, splenios (f. 73); titimallos, clitiriza (f. 73ᵛ); bulbus rufus, dracontea feminea (f. 74); meochon (f. 74ᵛ); colocinthios agria (f. 75); hypericon, lapatium (f. 75ᵛ); eliotropium, arnoglossos (f. 76); cameleuce, scylla (f. 76ᵛ); eringion (f. 77); tera (f. 77ᵛ); strucion, delphion (f. 78); centimorbia, viola aurosa (f. 78ᵛ); caparra, anchusa, cinobathos (f. 79); anagallus, panatia (f. 79ᵛ); viola purpurea, zamalention feminea, zamalention masculus, syon (f. 80); lycanis (f. 80ᵛ); abrotanus (f. 81); aparina (f. 81ᵛ); origanum (f. 82). Some leaves have been removed.

The illustrations of the herbs are not on the whole very close to the natural form of the plant and the artist seems to have had little or no interest in direct observation. They are represented as tree-like sprigs with symmetrical leaves. The scenes with human beings illustrate the snake and rabid dog bites against which the various herbs were said to be effective.

This copy is closely related in iconography to a supposedly Mosan manuscript, London, British Library MS Harley 1585. The series of pictures is based on a 6th-century archetype probably transmitted via an 11th-century Anglo-Saxon intermediary. A very conservative tradition existed for the illustrations of these medical and herbal texts (see *Survey*, III, nos. 10, 11 for two *c.* 1100 examples and *Survey*, II, no. 63 for an early 11th-century example). The painting is characterised by much use of bright red and blue. The figures are in lively poses with painterly sweeps of folds although some compartmental fold systems survive in certain figures. There are similarities with North French manuscripts such as Troyes, Bibl. Mun. MS 103 and Paris, Bibl. Nat. lat. 3884 and Durham manuscripts of the time of Bishop Puiset's Bible (*Survey*, III, nos. 98–100). The stylistic connection with Durham may suggest a North England provenance for this Herbal and its companion (no. 10). The Durham work of this period is heavily dependent on North French models and the term 'Channel style' is convenient for such art until relationships between England and France have been more precisely defined.

PROVENANCE: Edward Gravely written several times (ff. 3, 82ᵛ). Robert Flud 1612 written on f. 3. E. Ashmole also on f. 3 who gave his collection to Oxford University in 1677. In 1860 these were transferred from the Ashmolean to the Bodleian Library.

LITERATURE: W. H. Black, *Catalogue of the manuscripts bequeathed unto the University of Oxford by Elias Ashmole*, Oxford, 1845, cols. 1266–8; G. Swarzenski, 'Mittelalterliche Kopien einer antiken medizinischen Bilderhandschrift', *Jahrbuch des Kaiserlich-deutschen archäologischen Instituts*, XVII, 1902, 48; K. Sudhoff, 'Beiträge zur Geschichte der Chirurgie im Mittelalter', *Studien zur Geschichte der Medizin*, X, 1914, 15 ff., 81 ff., 94 ff., pl. I. 3; C. Singer, *Studies in the History and Method of Science*, Oxford, 1921, II, pls. V, XXIV; R. T. Gunther, *The Herbal of Apuleius Barbarus*, Roxburghe Club, 1925, 130, pls. 1, 5; C. Singer, 'The Herbal in Antiquity', *Journal of Hellenic Studies*, 47, 1927, 43, pl. IX; F. Saxl, R. Wittkower, *British Art and the Mediterranean*, London, 1948, pls. 31. 4, 31. 5; Boase, *English Art*, 86 n. 1; Saxl and Meier, III, 288, figs. 2, 3, 5; L. MacKinney, *Medical Illustrations in Medieval Manuscripts*, London, 1965, 49, 70, 160, figs. 43, 69; Bodleian Picture Book, *English Rural Life*, fig. 10b; Pächt and Alexander, III, no. 244, pl. XXIII; S. Rubin, *Medieval English Medicine*, London, 1974, pl. on 102; B. Rowland, *Birds with Human Souls*, Knoxville, 1978, fig. on 78; W. Blunt, S. Raphael, *The Illustrated Herbal*, New York, 1979, 45, 53, pls. 44, 46, 47.

EXHIBITED: New York, Metropolitan Museum, *The Year 1200*, 1970, no, 306.

10. London, British Library MS Sloane 1975

Medical and Herbal texts. Pseudo-Apuleius, Herbarium; Pseudo-Dioscorides, De herbis feminis; Sextus Placitus, De medicina ex animalibus
295 × 196 mm., ff. 95
c. 1190–1200. (?) Northern England

Ills. 26, 28

This is a slightly later version of no. 9, either directly based on it or on a common prototype. The titles or genders of the herbs occasionally vary between the two manuscripts and the order of the three texts differs. 246 miniatures of various sizes are set at various positions in the text: three ornamental initials (ff. 1ᵛ, 7ᵛ, 8); vetonica (f. 10ᵛ); a man with a sword attacked by a dog and bitten in the arm by a dragon-like creature (f. 12); plantago (f. 12ᵛ); a man brandishing a halberd at a scorpion and a dragon-like creature (f. 13); pentaphyllos (f. 13ᵛ); verminatia (columbaris) (f. 14); a man killing a serpent, a doctor attending a man (f. 14ᵛ); simphoniaca (f. 15); pedeleonis (viperina) (f. 15ᵛ); botration, botration straticem (f. 16); artemisia monoglossos, artemisia tagantes (f. 16ᵛ); artemisia leptasillos (f. 17); Diana giving the herb to Chiron the centaur, lapatium, dracontea (f. 17ᵛ); satyrion (f. 18); gentiana, cyclaminos (f. 18ᵛ); poligonon (proserpinatia)

(f. 19ᵛ); aristolathia (f. 19ᵛ); nasturtium, hieribulbum, apollinaris (f. 20); camemelum, camedris (f. 20ᵛ); a man spearing a serpent, camelia (f. 21); camedaphne, ostriago, britannica (f. 21ᵛ); lactuca silvatica (f. 22); agrimonia, asphodel (f. 22ᵛ); oxilapatium, centauria maior held by a centaur (f. 23); centauria minor (f. 23ᵛ); personantia, a man brandishing a sword at a red-faced dog (f. 24); fraga, hibiscus, ipporis (ippiron) (f. 24ᵛ); malva silvatica (f. 25); buglossa, scylla (f. 25ᵛ); gallitricus, cotyledon, marrubium (f. 26); xiphion (f. 26ᵛ); gallitrichum, immolum, Mercury standing before Homer, heliotropium (f. 27); cryas, politricus (f. 27ᵛ); astula regia, papaver silvaticum (f. 28); hinantes, narcissus, splenion (f. 28ᵛ); poleion, victoriola, symphytum (f. 29); asterion (f. 29ᵛ); leporis, dyptannus (f. 30); solago maior, solago minor (f. 30ᵛ); pionia, peterion (f. 31); bryonia, nymphia (f. 31ᵛ); crision, isatis (f. 32); scordeon, verbascum (f. 32ᵛ); heraclea, strignos (f. 33); celidonia, senecion (f. 33ᵛ); felix, gramen (f. 34); gladiolum (f. 34ᵛ); rosmarinum (f. 35); pasnatica silvatica, mercurialis (f. 35ᵛ); perdicalis, radiolus (f. 36); asparagus, savina (f. 36ᵛ); cinocephalus, erusca (f. 37); millefolium (f. 37ᵛ); ruta, a man drawing his sword against a dog with an orange head (f. 38); mentastrum, ebulus (f. 38ᵛ); poleius (f. 39); nepita, petucidanum (f. 40); enula campana, cynoglossa, saxifraga (f. 40ᵛ); edera nigra (f. 41); serpillum, absinthium (f. 41ᵛ); salvia, coliandrum (f. 42); portulaca, cerfolium, sisymbrium (f. 42ᵛ); olistratium, lilium, a man with a sword before a dragon belching flames (f. 43); titimallos, cardo silvaticus (f. 43ᵛ); lupinum muntanum, latiridis, lactuca leporina (f. 44); sicidis agria, cannabis (f. 44ᵛ); ruta muntana (f. 45); eptaphillos, ocymum, apium (f. 45ᵛ); chrysocantis, hydiosmon (f. 46); sempervivium, anetum (f. 46ᵛ); origanum, feniculum, symphytum (f. 47); erision, petrosilinum (f. 47ᵛ); brassica silvatica, basilisca (f. 48); mandragora (f. 49); campetum (f. 49ᵛ); panatia (f. 52ᵛ); buglossus, acantum (f. 53); helylysfacos (f. 53ᵛ); cyminon, cameleon alba (f. 54); herpullos, camerops (f. 54ᵛ); polyganos (f. 55); sansucon, cestros (f. 55ᵛ); aristolochia (f. 56); sticas, adiantos (f. 56ᵛ); mandragora feminea, thaspis (f. 57); sisymbrium, celidonia (f. 57ᵛ); camemedros (f. 58); sideritis, flominos (f. 58ᵛ); linozostis, antherenon, britannica (f. 59); pusillios, melena (f. 59ᵛ); tribulosa, coniza (f. 60); strignosa (f. 60ᵛ); bustalinon, iffieritis (f. 61); hipperis, aizos (f. 61ᵛ); titimallos, eliotropios (f. 62); scolymbos, achilleia (f. 62ᵛ); staphis agria, camelia (f. 63); alcibiados, splenios (f. 63ᵛ); titimallos (f. 64); clyziriza, bulbus rufus (f. 64ᵛ); dracontea feminea (f. 65); meothon (f. 65ᵛ); colochinthios agria (f. 66); hypericon, lapatium (f. 66ᵛ); eliotropium (f. 67); arnoglossos (f. 67ᵛ); cameleuce, scylla (f. 68); eringion (f. 68ᵛ); tera (vervena) (f. 69); strucion, delfion, centimorbia (f. 69ᵛ); viola aurosa (f. 70); capara, anchusa (f. 70ᵛ); cynosbassos, anagallus (f. 71); panatia, viola purpurea, zamalention feminea (f. 71ᵛ); zamalention masculus, syon, lycanis (f. 72); abrotanus (f. 72ᵛ); aparina (f. 73).
Then follows a set of illustrations to the text of

Sextus Placitus: Badger (f. 73); Stag (f. 77); Hare (f. 77ᵛ); Fox (f. 78ᵛ); Wild Goat (f. 79); Wild Boar (f. 79ᵛ); Bear, Wolf (f. 80); Lion, Lioness, Bull (f. 80ᵛ); Elephant, Dog (f. 81ᵛ); Ass (f. 82ᵛ); Mule, Horse (f. 83); Ram (f. 83ᵛ); Goat (f. 84); a boy urinating into a bowl beside a virgin girl (f. 85ᵛ); Cat (f. 86ᵛ); Cricket, Weasel, Mice (f. 87); Eagle, Vulture (f. 87ᵛ); Hawk, Crane (f. 88); Partridge, Raven (f. 88ᵛ); Cock (f. 89); Hen (f. 89ᵛ); Dove; Goose, Swallow (f. 90ᵛ).

Then follow three full pages and one half page of medical illustrations: preparation of medicines, an operation on the head, cautery points (f. 91ᵛ); cautery points (f. 92); cautery points, an operation on the foot (f. 92ᵛ); operations for haemorrhoids and nasal polyps (f. 93).

This manuscript is closely connected to no. 9, coming from the same workshop but showing a more developed fold style in the figure work. The mannerisms of pose and patterned fold forms are less evident. This move to more natural figures is typical of the closing decades of the 12th century as a breaking down of the abstract elements of the Romanesque style. The influence of Mosan art in this development occurs in many parts of North France and in England, and it seems to be an important element in the style of this workshop.

PROVENANCE: Sir Hans Sloane (1660–1753); his manuscripts were purchased by the nation in 1753 and passed to the British Museum.

LITERATURE: K. Sudhoff, 'Beiträge zur Geschichte der Chirurgie im Mittelalter', *Studien zur Geschichte der Medizin*, X, 1914, 11 ff., 81 ff., 93, 94, pl. I. 1; Druce, 'Elephant', 57 (pl.), 59, pl. IX; C. Singer, *Studies in the History and Method of Science*, Oxford, 1921, II, 72, pls. XVb, XXVa; E. S. Rohde, *The Old English Herbals*, London, 1922, pls. opp. 22, 30; R. T. Gunther, *The Herbal of Apuleius Barbarus*, Roxburghe Club, 1925, 130, 136, 138, pl. 6; C. Singer, 'The Herbal in Antiquity', *Journal of Hellenic Studies*, 47, 1927, 43, pl. X; Saxl and Meier, III, 245, fig. 6; K. Weitzmann, *Illustrations in Roll and Codex*, Princeton, 1970, 97 n. 37, 102, fig. 88; R. Herrlinger, *A History of Medical illustrations from Antiquity to A.D. 1600*, London, 1970, 32, pls. III, XIII, XIV; S. Rubin, *Medieval English Medicine*, London, 1974, pls. on 52, 101; J. Backhouse, *The Illuminated Manuscript*, Oxford, 1979, col. pl. 22; W. Blunt, S. Raphael, *The Illustrated Herbal*, New York, 1979, 41, 53, pls. 40, 41, 42.

11. Leningrad, State Public Library Saltykov-Shchedrin MS Lat. Q. v. V. I.
Bestiary
200 × 145 mm., ff. 91
c. 1190–1200. North Midlands *Ills. 29, 31–33*

The Bestiary is illustrated by 113 fully painted miniatures set in rectangular or circular frames. Gold rectangles or circles make up the central part

of the background usually set against red or green. These miniatures are of variable size set at various positions in the text, but four are full page: Adam naming the animals (f. 5); Whale (f. 71); and two miniatures of species of fish (ff. 72v and 73). At the beginning is a series of pictures of the Creation: God creating heaven and earth (f. 1); God creating the firmament (f. 1v); Creation of the birds and fishes (f. 2); Creation of Eve (f. 2v). These seem to originate from a different model than the other miniatures of the Bestiary. The main series of 109 illustrations follows: Adam naming the animals (f. 5); Lion (f. 9); Antelope (f. 10v); Onocentaur (f. 11v); Hedgehog (f. 11v); Fox (f. 12v); Unicorn (f. 13v); Beaver (f. 14v); Hyena (f. 15v); Hydrus (f. 16v); Hydra (f. 17); Sirens (f. 18); Wild Goat (f. 19); Wild Ass (f. 20); Apes (f. 20v); Satyr (f. 21v); Panther (f. 22); Elephant (f. 24); Wolf (f. 26); Dogs of King Garamantes, another scene of Dogs (f. 28); Dogs (f. 29); Stag (f. 31); Weasel (f. 31v); Ants (f. 32); Ibex (f. 34); Fire Stones (f. 34v); Ostrich (f. 35); Tiger (f. 36); Leopard (f. 36v); Lynx (f. 37); Griffin (f. 37v); Wild Boar (f. 37v); Bonnacon (f. 38); Bear (f. 38v); Manticora (f. 39v); Parandrus, Yale, (f. 40); Sheep (f. 40v); Ram, Lamb (f. 41); He-Goat (f. 41v); Bullock (f. 42); Ox (f. 42v); Camel (f. 43); the leaves with miniatures and texts on Dromedary, Ass, and the beginning of the chapter on the Horse are missing; Cat (f. 45v); Mouse, Mole (f. 46); Leucrota (f. 46v); Eagle (f. 47); Vulture (f. 47v); Swan (f. 48v); Cranes (f. 49); Parrot (f. 49v); Stork (f. 50); Halcyon (f. 50v); Cinnamolgus (f. 51); Ercinea (f. 51v); Partridge (f. 52); Hawk, Magpie (f. 52v); Nightingale (f. 53); Bat (f. 53v); Raven, Crow (f. 54); Swallow (f. 55); Quail (f. 55v); Peacock, Cock (f. 56); Duck (f. 56v); Bees (f. 57); Caladrius (f. 59v); Pelican (f. 60); Owl (f. 61); Phoenix (f. 61v); Hoopoe (f. 62); Ibis (f. 63); Coot (f. 64); Partridge (f. 64v); Turtledove (f. 65); Dove (f. 66); Perindeus Tree (f. 67); Amos, the prophet (f. 69); Sea Pigs (f. 69v); Serra (f. 70); Whale (f. 71); fishes and marine monsters (f. 72v); fishes (f. 73); Crocodile (f. 75); Dragon (f. 79); Basilisk, Scorpion, snakes (f. 80); Viper (f. 81); Asp (f. 82v); Emorroris (f. 84); Hydrus (f. 84v); Lizard, Salamander (f. 85v); Scitalis, Amphisbaena (f. 86v); Boas, Jaculus, Siren serpent (f. 87); Seps, Dipsa (f. 87v); Saura, Stellio (f. 88); snake shedding its skin (f. 88v).

The capital letters at the beginning of each section are simple red and blue pen initials. The only painted initial is at the very beginning of the text and has a figure of God-Creator set against a gold background.

The Leningrad Bestiary is the sister manuscript of New York, Pierpont Morgan Library MS 81 (*Survey*, III, no. 106). The figure style of the Bestiary pictures is almost identical to that of the Morgan manuscript although the Creation scenes by a different artist show a new more modern style suggesting a slightly later date. This second artist uses paint rather than line for his drapery systems and in this approach can be compared in a general sense with the artists of the Life of St. Cuthbert (no. 12) and the Leiden Psalter (no. 14) both also

working in the North of England. In spite of the close iconographic and stylistic identity with the Morgan Bestiary the two manuscripts are somewhat different in contents, in their approach to composition and colour and in their handling of forms. Both Bestiaries are transitional between the First and Second Families into which M. R. James classified these texts. A similar transitional manuscript is no. 13 which is stylistically closely related to the Life of St. Cuthbert (no. 12). The Morgan Bestiary belonged to Radford Priory (Lincolnshire) which suggests the possibility of a North Midlands origin for this type of illustrated Bestiary, possibly Lincoln itself. The artist of no. 13, probably from Durham, evidently knew this tradition of Bestiary illustration; this provides additional evidence for an association with the North.

PROVENANCE: There is an ownership inscription (17th-18th century) of Franciscus de la Moilière. It entered the Leningrad library in 1805 from the collection of Pierre Dubrowski, a Russian nobleman attached to the Embassy in Paris.

LITERATURE: N. Garelin, 'Dve rukopisi bestiarev Publitchnoj Biblioteki', *Sbornik Publitschnoj Biblioteki*, II, Leningrad, 1924, 248–76; A. Konstantinowa, *Ein Englisches Bestiar des zwölften Jahrhunderts in der Staatsbibliothek zu Leningrad*, Berlin, 1929; Millar, 'Fresh Materials', 287; H. W. Janson, *Apes and Ape Lore in the Middle Ages and the Renaissance*, London, 1952, 107, pl. XIIb; Boase, *English Art*, 195; E. G. Millar, *A thirteenth century Bestiary in the Library of Alnwick Castle*, Roxburghe Club, 1958, 15; McCulloch, *Bestiaries*, 34, 74 n. 15, 183; *Survey*, III, 126; Einhorn, *Spiritalis Unicornis*, 80, 81, 335; X. Muratova, 'L'iconografia medievale e l'ambiente storico', *Storia dell'Arte*, 28, 1976, 176, fig. 8; X. Muratova, 'Adam donne leurs noms aux animaux', *Studi Medievali*, XVIII. II, 1977, 375, pl. IX; Zahlten, *Creatio Mundi*, 74, 83, 255.

12 (a), (b). BEDE, LIFE OF ST. CUTHBERT

12 (a). London, British Library MS Yates Thompson 26 (Add. 39943)

Bede, Life of St. Cuthbert

135 × 98 mm., ff. 150

c. 1200. Durham *Ills. 38–43*

This small book contains 46 framed mostly full-page miniatures (one removed) illustrating Bede's Life of Cuthbert, the saint whose relics were in the care of the Benedictine Cathedral Priory of Durham to whom the book belonged. In addition to the miniatures there are ornamental initials with tight coil foliage on gold grounds on ff. 2v, 7v. The series of pictures probably lacks nine which have been removed: 1. A Benedictine monk kisses the feet of St. Cuthbert who is vested as Bishop with chasuble, mitre and crosier (f. 1v); 2. A tonsured seated scribe,

probably Bede (f. 2); 3. the miniature pasted in on a separate piece of vellum has been removed, only leaving the hind legs of a horse where the painting had overlapped onto the page – the subject intended was probably the angel riding on the horse coming to cure a tumour on Cuthbert's knee (f. 9); 4. St. Cuthbert praying beside the River Tyne (f. 10ᵛ); 5. Two monks praying at the monastery of Tynemouth (f. 11); 6. A horse discovers food for the saint in the straw roof of a shepherd's hut (f. 14); 7. Cuthbert received by Prior Boisil at Melrose Abbey (f. 16); 8. Cuthbert washes the feet of an angel (f. 17ᵛ); 9. The miraculous loaves sent from Paradise (f. 18); 10. The dying Boisil instructing Cuthbert (f. 21); 11. Cuthbert preaching (f. 22ᵛ); 12. Cuthbert praying in the sea and his feet wiped by otters (f. 24); 13. Cuthbert sailing to the land of the Picts (f. 26); 14. A fish miraculously provided as food for the saint and his companions (f. 26ᵛ); 15. They share a fish with an eagle (f. 28ᵛ); 16. Cuthbert drives away a demon (f. 30); 17. His prayers assist attempts to save a burning house (f. 31ᵛ); 18. He heals the wife of Hildmaer (f. 33ᵛ); 19. He teaches the monks at Lindisfarne (f. 35ᵛ); 20. An angel helps Cuthbert to build his hermitage on one of the Farne Islands (f. 39); 21. Cuthbert and his assistant dig for water (f. 41); 22. Cuthbert drives away birds from the freshly sown seed (f. 42ᵛ); 23. Crows pick the thatch and bring lard to Cuthbert (f. 44); 24. The miraculous appearance of a roof beam for Cuthbert's cell (f. 45ᵛ); 25. He admonishes a group of laymen (f. 47); 26. Abbess Elfleda cured by Cuthbert's girdle (f. 48ᵛ); 27. Elfleda meets Cuthbert (f. 50ᵛ); 28. King Ecgfrid visits Cuthbert (f. 51); 29. Monks urge Cuthbert to accept the bishopric (f. 53ᵛ); 30. A cure by water blessed by Cuthbert (f. 54); 31. He prophesies concerning the fate of Carlisle (f. 55ᵛ); 32. A monk sprinkles a sick woman with holy water sent by Cuthbert (f. 58ᵛ); 33. He cures a small girl (f. 60); 34. A Bishop gives a consecrated host to a sick man (f. 61); 35. Cuthbert vested as a bishop in mitre, cope, dalmatic and with a crosier, blesses a child sick of the plague (f. 62ᵛ); 36. Hadwold, a servant of Abbess Elfleda falling to his death from a tree (f. 63ᵛ); 37. Cuthbert, at table with the Abbess has a vision of the reception of Hadwold's soul into heaven (f. 64); 38. Cuthbert turns water into wine (f. 66); 39. He takes a monk on to his boat (f. 71ᵛ); 40. The death of Cuthbert (f. 73); 41. A torch signal from Farne island to the monks of Lindisfarne to announce Cuthbert's death (f. 74ᵛ); 42. Eleven years later the monks discover the saint's body uncorrupt in his tomb (f. 77); 43. A cripple with a crutch prays by the tomb (f. 79); 44. A paralytic cured by contact with one of the saint's shoes (f. 80); 45. Cuthbert's arm emerges from his tomb to cure a paralytic (f. 83); 46. A man healed by being touched with one of the saint's hairs (f. 84ᵛ). Most of the scenes are set against panels in the background, some gilded and some coloured. The gold grounds are occasionally given an incised diaper pattern, a feature which had occurred in earlier Durham manuscripts (e.g. *Survey*, III, no. 98).

The text contains the prose life by Bede plus additional material from his Ecclesiastical History and twenty-five additional miracles, the latter mostly not written until the early 12th century. Such a compilation of material relating to a saint combined with a set of illustrations became popular in the later 11th and 12th centuries.

The depiction of narrative in an intimate and emotional way is a remarkable feature of the illustrations. The compact calm figures are totally lacking the forced mannerisms of earlier painting at Durham (e.g. *Survey*, III, nos. 98–100) both in their poses and fold forms. A naïve simplicity of narrative presentation is combined with a concentration on single incidents involving a few figures above all centred on the dominant form of the saint himself. The style seems to evolve from earlier Durham work notably Durham, Cathedral Library MS A. II. 19, ff. 87ᵛ, 175, 218 (*Survey*, III, no. 99) by using more natural relaxed poses and soft painterly draperies. It has been suggested that there may be some influence from Winchester painting such as that of the Master of the Morgan leaf (*Survey*, III, no. 84) and by this means the indigenous Durham style was transformed into a more naturalistic manner. There is some stylistic connection with the wall painting of St. Cuthbert in the Durham Galilee Chapel and this provides additional evidence for production at Durham.

The cycle of illustrations has several resemblances to the earlier Life of St. Cuthbert, Oxford, University College MS 165 (*Survey*, III, no. 26) but the differences are sufficient to exclude any direct link and rather suggest derivation from a common model. The Yates Thompson version seems for certain to be a product of the Durham scriptorium in view of the closeness of the text to other copies owned by the Priory (e.g. Cambridge, Trinity College MS o. 3. 55). The same artist painted the initials of a copy of the sermons of Maurice de Sully (Oxford, Bodl. Lib. MS Douce 270) which contains a Durham calendar. This connection provides strong proof that the Life of Cuthbert in its painting is also a Durham product. Baker has argued persuasively for a prototype pictorial cycle of the late 11th century which lacked illustrations of the additional series of miracles whose texts were composed between 1100 and 1104. Although these are included in the text of the Yates Thompson manuscript and the closely related copy in Trinity College, Cambridge MS o. 1. 64, no. 12(b), they have no illustrations. This suggests that there was still an iconographic dependence on the pre-1100 cycle. The cycle was probably transmitted through a lost mid 12th-century intermediary. The relationship seems to be as shown in diagram overleaf.

The original set of pictures was adapted to express contemporary viewpoints. As the book was made for the internal use of the monks of Durham its pictures lay great emphasis on the monastic aspects of Cuthbert's story and adaptations of certain scenes reveal current attitudes to problems such as the respective rights of the monks and the bishop.

The book seems to have been an established model

Original Pictorial Cycle
(late 11th century)

Oxford, University College
MS 165
(*c.* 1100)

Lost intermediary cycle
(? mid 12th century)

Cambridge, Trinity College
MS o.1.64
(*c.* 1200)

London, British Library
MS Yates Thompson 26
(*c.* 1200)

for a set of scenes of Cuthbert's life and its influence can be seen in two extant later works of art in York and Carlisle. In the 1416 catalogue of the Priory library the book is recorded as having been lent to Richard Scrope, Archbishop of York (beheaded 1405) and perhaps in view of the violent circumstances of his death it had not been returned. While at York it was used with other material as a source for the series of Cuthbert scenes in the great stained glass window devoted to him in the Minster. The illustrations of the Yates Thompson life were followed with great fidelity by the late 15th-century painter of the Carlisle Cathedral choir stalls (1484–1507). The appearance of scene 3, lost from the manuscript, can be reconstructed from the version at Carlisle.

One parallel for the style, the seal of Prior Bertram (1189–1212), gives support to a *c.* 1200 date, possibly slightly before rather than after the turn of the century.

PROVENANCE: Durham Cathedral Priory on the evidence of a contemporary inscription on f. 2ᵛ 'Liber sancti cuthberti'. It was in the catalogue of the library in 1391 (*Surtees Society*, 1838, 29). Mary Cobb (17th century) written on f. 150ᵛ. On f. 95ᵛ is written Mary, and on f. 116ᵛ John, in a 17th-century hand. This is probably John Forcer of Harbour House, Durham (d. 1725). It then came into the possession of the Lawson family of Brough Hall. In 1906 it was put up for sale by Sir John Lawson and bought by Henry Yates Thompson. It was sold in 1920 and purchased by the British Museum.

LITERATURE: J. Raine, *St. Cuthbert*, Durham, 1828, IV, 15, 17, 20, 26, 28, 32, 38; *Catalogi veteres librorum Ecclesie Cathedralis Dunelmensis*, Surtees Society, 1838, 29, 107; J. T. Fowler, 'On the St. Cuthbert window in York Minster', *Yorkshire Archaeological and Topographical Journal*, IV, 1877, 249 ff.; W. Forbes-Leith, *The Life of St. Cuthbert*, Edinburgh, 1888 (facsimile); H. Yates Thompson, *A descriptive catalogue of twenty illuminated manuscripts in the collection of Henry Yates Thompson*, Cambridge, 1907, no. LXXXIV, 79–90; Herbert, *Illuminated Manuscripts*, 140; H. Yates Thompson, *Illustrations from 100 manuscripts in the collection of*

Henry Yates Thompson, London, 1914, vol. 4, 3–7, pls. IV–XV; Millar, I, 37, 87, pl. 52; Saunders, *English Illumination*, I, 54, II, pl. 59; British Museum, *Reproductions*, IV, pl. XIV; B. Colgrave, 'The St. Cuthbert paintings on the Carlisle Cathedral choir stalls', *Burlington Magazine*, 73, 1938, 17; B. Colgrave, 'The History of B.M. Add. MS 39943', *English Historical Review*, LIV, 1939, 673 ff; R. A. B. Mynors, *Durham Cathedral Manuscripts*, Oxford, 1939, 77, no. 132; M. S. Bunim, *Space in Medieval Painting and the Forerunners of Perspective*, New York, 1940 (repr. 1970), 103, 117, fig. 35; B. Colgrave, *Two Lives of St. Cuthbert*, Cambridge, 1940, 27, 31, 48, 50, 54–5, 339; Andersson, *English Influence*, 31–2, 266, fig. 159; F. Wormald, 'Some illustrated manuscripts of the lives of the saints', *Bulletin of the John Rylands Library*, 35, 1952–53, 260; Boase, *English Art*, 287, pl. 93 b; ed. C. F. Battiscombe, *The Relics of St. Cuthbert*, Oxford, 1956, 529; Rickert, *Miniatura*, I, pl. 57; O. Pächt, *The Rise of Pictorial Narrative in twelfth century England*, Oxford, 1962, 20–1; Rickert, *Painting in Britain*, 95, pl. 97A; D. H. Turner, *Illuminated Manuscripts exhibited in the Grenville Library*, British Museum, 1967, no. 10; Turner, 'Manuscript Illumination', fig. 176; W. Oakeshott, *Sigena*, London, 1972, 116; H. Farmer, 'Cuthbert von Lindisfarne', *Lexikon der christlichen Ikonographie*, VI, 1974, col. 9; C. Brooke, *The Monastic World 1000–1300*, London, 1974, figs. 50–1, 90–7, 216–19; *Survey*, III, 67; M. Baker, 'Medieval illustrations of Bede's Life of St. Cuthbert', *J.W.C.I.*, XLI, 1978, 16 ff., pls. 1a, b, 2b, 4c, 6a, 7c, d, 8c, d, 9a, b, c; R. Marks, N. Morgan, *The Golden Age of English Manuscript Painting 1200–1500*, New York, 1981, pls. 1, 2; W. Oakeshott, *The Two Winchester Bibles*, Oxford, 1981, 71, 123, fig. 173.

EXHIBITED: London, South Kensington Museum, *Catalogue of the Special Exhibition of Works of Art of the Medieval, Renaissance and more recent periods on Loan at the South Kensington Museum*, 1862, no. 6804; Leeds, *National Exhibition of Works of Art*, 1868, no. 521; B.F.A.C., *Illuminated Manuscripts*, 1908, no. 17; London, British Museum, *Illuminated Manuscripts and Bindings of Manuscripts exhibited in the Grenville Library*, 1923, no. 19.

12 (b). Cambridge, Trinity College MS o. 1. 64
Bede, Life of St. Cuthbert
158 × 108 mm., ff. 88
c. 1200. Durham *Ills. 44, 45*

A duplicate copy of the previous manuscript with a slightly different series of illustrations for which spaces have been left but the paintings never executed. From the position in the text it is evident that some scenes were included different from those in the Yates Thompson life. In two cases preliminary drawings were made: the first on f. 9ᵛ is scene 3. lost from the Yates Thompson book, an angel on a horse approaching the seated figure of Cuthbert to

cure his knee. The other on f. 10 shows the angel having dismounted approaching the saint, a scene also lacking in the previous manuscript. The first drawing seems to have been somewhat overdrawn at a later period.

PROVENANCE: Coventry Cathedral Priory as evidenced by the 13th-century inscription on f. 2, 'Liber eccl(es)ie cath. cove(n)trie'. A 15th-century note on the same page says it was 'ex dono domini Ric. Crossbey Prioris eiusdem'. Richard Crossby was prior 1398–1437. In the 17th or early 18th century the book was acquired by Thomas Gale or by his son Richard Gale who gave his manuscripts to Trinity College in 1738.

LITERATURE: James, *Catalogue*, no. 1088; Ker, *Medieval Libraries*, 54; Pächt and Alexander, III, note to no. 221; M. Baker, 'Medieval illustrations of Bede's Life of St. Cuthbert', *J.W.C.I.*, XLI, 1978, 24 ff., pl. 3a.

13. London, British Library MS Royal 12. C. XIX
Bestiary
223 × 157 mm., ff. 112
c. 1200–10. (?) Durham *Ills. 30, 34–37*

The 80 illustrations are framed miniatures of various sizes, many with gold grounds, having stamped decoration and systems of panels in the background, set in various positions in the text: Lion (f. 6); Antelope (f. 7v); Onocentaur, Hedgehog (f. 8v); Unicorn (f. 9v); Beaver (f. 10v); Hyena (f. 11v); Hydrus (f. 12v); Hydra (f. 13); Wild Goats (f. 14); Satyr (f. 15v); Panther (f. 16); Wolf (f. 19); Dog, story of King Garamantes (f. 21); Stag (f. 23); Weasel (f. 23v); Ants (f. 24v); Ibex (f. 26); Fire Stones (f. 26v); Ostriches (f. 27); Tiger (f. 28); Leopard (f. 28v); Manticora (f. 29v); Parandrus, Yale (f. 30); Sheep (f. 30v); Ram, Lamb (f. 31); He-Goat (f. 31v); Bullock (f. 32); Ox (f. 32v); Camel (f. 33); Horse (f. 34); Cats (f. 36v); Mouse, Mole (f. 37); Leucrota (f. 37v); Eagles (f. 38); Vultures (f. 38v); Swan (f. 39v); Cranes (f. 40); Parrot (f. 40v); Storks (f. 41); Halcyon (f. 41v); Partridge (f. 42); Hawk, Magpie (f. 42v); Raven, Crow (f. 43); Swallow (f. 44); Quail (f. 44v); Bees (f. 45); Caladrius (f. 47v); Pelicans (f. 48v); Nictorax (Owl) (f. 49); Phoenix (f. 49v); Hoopoe (f. 50v); Ibis (f. 51); Coot (f. 52); Partridge (f. 52v); Turtledoves (f. 53); Doves (f. 54); Dragon (f. 62); Basilisk, Regulus (f. 63); Anguis (f. 63v); Vipers (f. 64); Asp (f. 65v); Emorroris (f. 67); Hydrus (f. 67v); Lizard, Salamander (f. 68v); Boas, Jaculus, Siren serpent (f. 69); Seps, Lizard (f. 69v); Saura, Stellio (f. 70); a snake shedding its skin (f. 70v). Here the illustrations end but a space has been ruled out for a picture on f. 95v but has not been filled.

This book shows a stylistic development from the Life of St. Cuthbert (no. 12) in which the figure forms have become elegant and attenuated. This change in style is noticeable in several manuscripts of the early 13th century suggesting that the blocky compact figures of *c.* 1200 were no longer favoured. The colours and the small red and blue initials in the text are very similar to those in the Life of St. Cuthbert. The ornamental B (f. 6) is however of a different type.

The series of illustrations is transitional between the First and Second Families of Bestiaries as classified by M. R. James. The Second Family (e.g. nos. 17, 19, 21, 42, 76, 98) first appears in the late 12th century whereas the First Family represents an older tradition. The series of pictures is similar to New York, Pierpont Morgan Library MS 81 (*Survey*, III, no. 106), the Leningrad Bestiary (no. 11) and the mid 13th-century Alnwick Bestiary (no. 115, Part 2). The arrangement of framed miniatures which mostly extend across the whole width of the text, and the placing of the beasts against rectangular panels, are very similar to the Morgan and Leningrad Bestiaries. Doubtless such earlier manuscripts served as models but in figure style their linear elements are transformed into a more painterly version.

PROVENANCE: John Theyer of Cooper's Hill, nr. Brockworth (Glos.) (1597–1673). Purchased for the Royal Collection *c.* 1678, and from there passed into the British Museum in 1757.

LITERATURE: Druce, 'Crocodile', 316, 323; Druce, 'Yale', 177, 191, 195, pl. IV; Druce, 'Caladrius', 385, 407, pl. III; Druce, 'Abnormal forms', 169; Druce, 'Mediaeval Bestiaries, I', 74; Druce, 'Medieval Bestiaries, II', 40; Warner and Gilson, II, 33–4, pl. 70; Millar, I, 116; Saunders, *English Illumination*, I, 48, II, pl. 52; James, *Bestiary*, 11–12, 52, suppl. pls. 4, 5; British Museum, *Reproductions*, IV, pl. XIII; F. Saxl, R. Wittkower, *British Art and the Mediterranean*, London, 1948, pl. 29. 1; Saxl and Meier, III, 197; E. G. Millar, *A thirteenth century Bestiary in the library of Alnwick Castle*, Roxburghe Club, 1958, 2, 13, 14 ff., pls. LXXXII–XCII; McCulloch, *Bestiaries*, 34, 162; Rickert, *Painting in Britain*, 88; *Survey*, III, 126; Einhorn, *Spiritalis Unicornis*, 80, 81, 336; P. L. Armitage, J. A. Goodall, 'Medieval horned and polled sheep: the archaeological and iconographic evidence', *Antiquaries Journal*, LVII, 1977, 76; J. Backhouse, *The Illuminated Manuscript*, Oxford, 1979, pl. 23.

14. Leiden, Bibliotheek der Rijksuniversiteit MS lat. 76A.
Psalter (The St. Louis Psalter)
242 × 175 mm., ff. 185
c. 1190–1200. Northern England *Ills. 46–49*

The Calendar is illustrated with scenes of the Labours of the Months, almost identical to the set in no. 15, and the Signs of the Zodiac: January, a man feasting (f. 1); February, a man warming himself by the fire (f. 1v); March, a man digging (f. 2); April, a woman holding a flower (f. 2v); May, a man falconing (f. 3); June, a man weeding (f. 3v);

July, a man scything (f. 4); August, men cutting corn (f. 4v); September, a figure threshing (f. 5); October, a man sowing seed (f. 5v); November, a figure picking fruit (f. 6); December, the slaughter of a pig (f. 6v).

Then follow 23 full-page miniatures with gold grounds occasionally with punch-mark patterns most divided horizontally into two scenes and painted only on one side of the leaf leaving the reverse blank: 1. The seated figure of God blessing set in a mandorla held by angels surrounded by six round medallions with scenes of the six days of creation, God between two angels, God dividing the waters, Creation of the Trees, Creation of the Sun and Moon, Creation of the Birds, Creation of Eve (f. 7); 2. God's instructions to Adam and Eve, 3. The eating of the forbidden fruit, God's reprimand (f. 8v); 4. Expulsion from Paradise, 5. The angel instructing Adam to dig, Eve spinning (f. 9); 6. Offerings of Cain and Abel, Murder of Abel by Cain, 7. God instructs Noah to build the ark (f. 10v); 8. Noah in the ark receives the dove, 9. Noah's drunken sleep (f. 11); 10. God's promise to Abraham, Abraham and Hagar with their son Ishmael, 11. Abraham receives the three angels (f. 12v); 12. Sacrifice of Abraham, 13. Joseph sold by his brothers is carried off to Egypt (f. 13); 14. Samson and the lion, a group of figures with a small child (Samson's parents?), 15. Samson carries off the Gates of Gaza, his destruction of the Temple (f. 14v); 16. Annunciation, Visitation, 17. Nativity (f. 15); 18. Annunciation to the Shepherds, 19. Journey of the Magi (f. 16v); 20. Magi before Herod, 21. Adoration of the Magi (f. 17); 22. The Magi warned by the Angel to return by another way, 23. Presentation of Christ in the Temple (f. 18v); 24. Flight into Egypt, 25. Massacre of the Innocents (f. 19); 26. Marriage at Cana, 27. Baptism of Christ (f. 20v); 28. Temptations of Christ (f. 21); 29. Raising of Lazarus, 30. Entry into Jerusalem (f. 22v); 31. Last Supper, 32. Betrayal (f. 23); 33. Christ before Pilate, 34. The Flagellation, Way of the Cross (f. 24v); 35. Deposition, 36. Anointing of Christ's body (f. 25); 37. Holy Women at the Tomb, 38. Descent into Hell (f. 26v); 39. Noli me tangere, Meal at Emmaus, 40. Doubting of Thomas (f. 27); 41. Ascension, 42. Pentecost (f. 28v); 43. Christ in Majesty surrounded by Prophets with scrolls and symbols of the Evangelists (f. 29).

The Psalter text begins with a full-page decorative B for Psalm 1 (Beatus vir) which has figures of musicians in corner medallions and David harping at the middle point of the B (f. 30v). The frame to the initial has small nude figures in ornamental coils. Each psalm has small painted and gilded initials, mostly purely ornamental but some containing grotesque figures or heads. The Psalm 21 initial has a praying figure and Psalm 80 a bust of Synagoga referring to the first verse 'Deus stetit in Synagoga deorum'. Ornamental line endings are in red and blue ink. Nine large ornamental initials with tight concentric coils some containing grotesque figures or small white lions are to be found at the main liturgical divisions (ff. 52, 65v, 77, 78, 90v, 106, 120v, 122v, 136). The Psalter text ends on f. 167

and is followed by the Canticles, Creed and Litany, small ornamental initials decorating this part of the text.

The Calendar is based on an Augustinian model (Translation of Augustine, 11th October) of the province of York (Wilfrid on 24th April particularly emphasised in blue). Many luxury psalters of the late 12th and early 13th centuries on the evidence of their Calendars and Litanies have Augustinian connections. The Copenhagen and Glasgow Psalters (*Survey*, III, nos. 96, 95) are two examples of slightly earlier date than the Leiden Psalter, and both also have Calendars of Northern England.

Stylistically the Leiden Psalter is close to f. 32 of the Psalter, Oxford, Bodl. Lib. MS Gough lit. 2 (*Survey*, III, no. 97) which is by a different artist from the rest of that book. The style of this folio and that of the Leiden Psalter is a painterly version of that of the main artist of the Gough Psalter. This link gives further evidence of an origin in the North because the litany of the Gough Psalter is of that region. Final proof is provided by the companion book to the Leiden Psalter, another Psalter in Cambridge, St. John's K. 30 (no. 15), whose Calendar is of the North Midlands. A third member of the group is a set of New Testament pictures in a Private Collection (no. 16) in which both style and iconography are closely linked to the Leiden Psalter and also to the Gough Psalter.

The inclusion of a series of Old and New Testament scenes before the Psalter text was popular in England around 1200. A particular interest in including a substantial section from the Old Testament seems to have been prevalent at that time. The figure style is very painterly and has been quite unjustifiably condemned as coarse and undistinguished work (Boase, Rickert), a judgement which any examination of the original manuscript soon dispels. This mistaken evaluation has perhaps resulted in the neglect of this very important example of a style of North English painting parallel to the contemporary development at Durham (nos. 12, 13). The faces are heavily modelled using brown shading rather than the more Byzantine technique involving grey and green. The figure poses are in some cases lively, a feature enhanced by the fluid drapery systems of sweeping troughed folds, but in some compositions elements of stiffness appear. This style has been compared with relief metalwork on the English ciborium in the treasury of St. Maurice d'Agaune (Homburger).

In view of the stylistic connections the date of production is likely to be in the first half of the episcopacy of the first owner, Geoffrey Plantagenet, Archbishop of York (1191–1212). The Psalter passed into the possession of Blanche of Castile, Queen of France, possibly after his death. In this period French Psalters imitated such English examples, as was the case for the Ingeborg Psalter (Chantilly, Musée Condé MS 1695) which has a number of iconographic features in common with the Leiden Psalter.

PROVENANCE: Geoffrey Plantagenet, Archbishop of York (1191–1212). The obit of his father Henry II

is entered as an addition on the 7th July in the calendar. Blanche of Castile, Queen of France (1200–52). The obit of her father Alfonso is added to the calendar on 6th October. Louis IX (St. Louis), King of France (1215–70). A 14th-century inscription (ff. 30ᵛ, 185) records that he learned to read from this Psalter in his childhood. Later in the 13th and 14th centuries the book passed successively to Agnes, Duchess of Burgundy, Jeanne of Burgundy, Queen of France, Blanche of Navarre, Queen of France and Philippe le Hardi, Duke of Burgundy. The information concerning the ownership after the death of St. Louis comes from the will of Blanche of Navarre. From the library of the Dukes of Burgundy the book had passed by the 18th century to J. van den Bergh who offered it in 1741 to the library of the University of Leiden. The distinguished early ownership is doubtless due to the high value placed on the Psalter as a relic of St. Louis.

LITERATURE: Baron Kervyn de Lettenhove, 'Le psautier de Saint Louis conservé dans la bibliothèque de l'Université de Leyde', *Bulletins de l'Académie royale de Belgique*, 2nd. ser. XX, No. 7, 1865, 296–304; L. Delisle, *Mélanges de paléographie et de la bibliographie*, Paris, 1880, 167–72; A. Goldschmidt, *Der Albanipsalter in Hildesheim*, Berlin, 1895, 54, fig. 4; A. Haseloff, *Eine thüringisch-sächsische Malerschule des 13. Jahrhunderts*, Strasbourg, 1897 (repr. 1979), 122; L. Delisle, *Notice de douze livres royaux du XIIIe et XIVe siècle*, Paris, 1902, 19–26, 100–1, pls. IV–VII; H. Omont, *Miniatures du Psautier de St. Louis*, Leyden, 1902 (facsimile); Haseloff, 'Miniature', 345; Herbert, *Illuminated Manuscripts*, 141; S. Beissel, 'Die Handschriften des hl. Ludwig von Frankreich', *Stimmen der Zeit*, 88, 1914, 243; Millar, I, 118; Saunders, *English Illumination*, I, 40; Swarzenski, *Handschriften XIII Jh.*, 65, 85 n. 4, 91 n. 3, 142 n. 1; J. C. Webster, *The Labours of the Months in Antique and Medieval Art*, Evanston, 1938, 91, 172, pl. LXI; Boase, *English Art*, 280; O. Homburger, 'Früh- und hochmittelalterliche Stücke im Schatz des Augustinerchorherrenstifts von St. Maurice und in der Kathedrale zu Sitten', *Frühmittelalterliche Kunst in den Alpenländern, Akten zum 3 internationalen Kongress für Frühmittelalterforschung*, Olten-Lausanne, 1954, 353, fig. 168; J. Porcher, *French Miniatures*, London, 1960, 47; G. Henderson, 'Cain's Jaw-bone', *J.W.C.I.*, XXIV, 1961, 112 n. 26, pl. 16d; Rickert, *Painting in Britain*, 232; Deuchler, *Ingeborgpsalter*, 36, 37, 38, 45, 47, 51, 52, 58, 59, 61, 98 n. 87, 140 n. 195; ed. R. Pernoud, *Le siècle de St. Louis*, Paris, 1970, 112, col. pl.; H. B. Graham, 'The Munich Psalter', *The Year 1200: a Symposium. New York Metropolitan Museum of Art*, 1975, 306; G. Zarnecki, 'Deux reliefs de la fin du XIIe siècle à la Cathédrale d'York', *Revue de l'Art*, 30, 1975, 18; Zahlten, *Creatio Mundi*, 53, 111, 255, fig. 63.

EXHIBITED: Paris, Sainte Chapelle, *Saint Louis à la Sainte Chapelle*, 1960, no. 190; Utrecht, Aartsbisschoppelijk Museum, *Het Wonder, Miracula Christi*, 1962, no. 85, pl. 1; Paris, Salle des Gens d'Armes du Palais, *La France de Saint Louis*, 1970. no. 203; Brussels, 1973, no. 38.

15. Cambridge, St. John's College MS K. 30
Psalter
235 × 166 mm., ff. 134
c. 1190–1200. (?) North Midlands *Ills. 54, 55*

The Calendar preceding the Psalter text has rectangular panels with the Labours of the Months and circular medallions with the Signs of the Zodiac. The figures representing the Labours are set against panels of burnished gold as in the Leiden Psalter (no. 14). January, a Janus headed man at a table drinking from a horn (f. 1); February, a man having taken off his boot is warming his foot by the fire (f. 1ᵛ); March, a man digging (f. 2); April, a standing woman holding a flower (f. 2ᵛ); May, a man on a horse holding a falcon (f. 3); June, a man with hook and stick extracting weeds from the corn (f. 3ᵛ); July, a man scything (f. 4); August, two men cutting corn (f. 4ᵛ); September, a man with a flail and sheaves of corn (f. 5); October, a man sowing (f. 5ᵛ); November, a man picking grapes (f. 6); December, a man slaughtering a pig with an axe (f. 6ᵛ). These scenes are identical in almost all details to the less well preserved series in the Leiden Psalter (no. 14). The Psalter text begins on the verso of a blank leaf with a full page ornamental B of tight coils with Byzantine blossom foliage inhabited with white and orange lions (f. 7ᵛ). The gold ground has an incised rinceaux pattern. Each psalm has a small initial fully painted with human heads, animals or foliage with gold grounds. In a few cases there are standing figures (e.g. f. 57). At the liturgical divisions are nine large initials some having punch dot designs on the gold ground: Psalm 26, D ornamental (f. 26); Psalm 38, D ornamental (f. 38); Psalm 51, Q ornamental (f. 48ᵛ); Psalm 52, D ornamental with a figure of a juggler seated on it (f. 49); Psalm 68, S ornamental (f. 59ᵛ), Psalm 80, E ornamental (f. 72ᵛ); Psalm 97, C ornamental (f. 84ᵛ); Psalm 101, David harping with three musicians (f. 86); Psalm 109, D ornamental with a King with a scroll seated on it (f. 97ᵛ). There is a historiated initial with a bust of Christ blessing to Confitebor, the first of the Canticles (f. 123ᵛ). The Litany is lacking.

The style of painting is the same as the Leiden Psalter (no. 14) where it has been characterised. The St. John's Psalter gives further support to a Northern or Midlands provenance for this workshop. The Calendar has the feasts of SS. Guthlac (11th Apr.), Wilfrid (24th Apr.), Botulph (17th June), Paulinus (31st Aug.), Wilfrid (12th Oct.) and Rumwald (3rd Nov.) which suggest a text model connected with that region. Many entries in the Calendar are not normally found in English Calendars suggesting some connection perhaps with a religious house dependent on a French abbey.

PROVENANCE: On the fore-edges are faint remains of heraldic decoration, perhaps *or lions rampant gules*

and *gules a lion rampant sable*. The book was given to the College by Thomas Baker (f. 1).

LITERATURE: James, *Catalogue*, no. 233; J. C. Webster, *The Labours of the Months in Antique and Medieval Art*, Evanston, 1938, 92, 171, pl. LIX.

16. Private Collection
New Testament Picture Book
170 × 113 mm., ff. 106
c. 1200. Northern England *Ills. 50–53*

This set of New Testament scenes lacks any contemporary text. They could either once have been prefatory to a Psalter or were intended as an independent Picture Book; the same problem arises for the de Brailes manuscript (no. 71). In the 15th century text and additional miniatures were added to the blank versos which was possible as the 51 original pictures were painted only on one side of the leaf. Also some additional leaves with text and miniatures were added at various sections in this 15th-century adaptation. The late 12th-century full-page miniatures are: 1. Joachim and Anna before the High Priest (f. 18ᵛ); 2. The Angel appears to Joachim (f. 19); 3. Joachim meets Anna at the Temple (f. 20ᵛ); 4. Nativity of the Virgin (f. 21); 5. Presentation of the Virgin in the Temple (f. 22ᵛ); 6. The Virgin in the Temple (f. 24); 7. The Marriage of the Virgin (f. 25ᵛ); 8. Annunciation (f. 26); 9. Visitation (f. 28); 10. Nativity (f. 29ᵛ); 11. Annunciation to the Shepherds (f. 30); 12. Adoration of the Shepherds (f. 31ᵛ); 13. Journey of the Magi (f. 34); 14. The Magi before Herod (spread over two pages – ff. 35ᵛ, 36); 15. The Adoration of the Magi (spread over two pages – ff. 37ᵛ, 38); 16. Presentation in the Temple (f. 39ᵛ); 17. Herod orders the Massacre of the Innocents (f. 40ᵛ); 18. An Angel approaches the sleeping Herod (a misunderstanding based on the reference to Herod Antipas in Acts, XII v. 23) (f. 43); 19. Flight into Egypt with the idols falling from their pedestals (spread over two pages – ff. 44ᵛ, 45); 20. Massacre of the Innocents (f. 46ᵛ); 21. Herod's death (f. 47); 22. Christ goes with his parents to Jerusalem (f. 48ᵛ); 23. The Virgin and Joseph come to find Christ in the Temple (f. 49ᵛ); 24. Christ with the Virgin and St. Joseph (f. 52); 25. Baptism of Christ (f. 53); 26. First Temptation (f. 54ᵛ); 27. Second Temptation (f. 57); 28. Third Temptation (f. 58ᵛ); 29. Christ disputing with the Pharisees (f. 60); 30. Raising of Lazarus (f. 61); 31. Entry into Jerusalem (f. 62ᵛ); 32. Last Supper (f. 63); 33. The Betrayal (f. 64ᵛ); 34. Marriage at Cana (f. 65ᵛ); 35. The Flagellation (f. 68); 36. The Way of the Cross (f. 69ᵛ); 37. The Crucifixion (f. 78); 38. The Deposition (f. 79ᵛ); 39. Entombment (f. 81); 40. Descent into Hell (f. 82ᵛ); 41. Noli me Tangere (f. 84); 42. The meeting on the road to Emmaus (f. 85ᵛ); 43. The meal at Emmaus (f. 87); 44. Christ appears to the Apostles (f. 88ᵛ); 45. Doubting of Thomas (f. 89); 46. Ascension (f. 90ᵛ);

47. Pentecost (f. 91); 48. Death and Assumption of the Virgin (f. 92ᵛ).
The style of the miniatures is a more painterly version with freer figure forms of that of the Leiden Psalter (no. 14) and shows a development within the same workshop. The faces and architectural types have links with those in the Life of St. Cuthbert confirming the North England elements in the style of this workshop, which have been suggested for the Leiden Psalter. Iconographic features like the frontal Christ blessing in the Betrayal scene resemble those in the Leiden Psalter. Several scenes (e.g. Visitation, Annunciation to the Shepherds, Flagellation) indicate an iconographic prototype dating back to the Gough Psalter (*Survey*, III, no. 97).

PROVENANCE: In the 15th century in the region of Bury St. Edmunds because the additions have a miniature of the story of St. Robert of Bury (f. 44) whose relics were at the Abbey and whose cult was very local. Susan Flint and John Pinchbeck are names written in a 16th-century hand on the flyleaf. Robert Themilthorpe 1594 written on f. 4ᵛ probably the priest of that name at Themilthorpe (Norfolk). N. Roe, 1760. C. W. Dyson Perrins.

LITERATURE: G. Warner, *Descriptive Catalogue of Illuminated Manuscripts in the Library of C. W. Dyson Perrins*, Oxford, 1920, 1–8, No. 1, pl. I; H. Coppinger Hill, 'St. Robert of Bury St. Edmunds', *Suffolk Archaeology*, XXI, 1931, 98 ff.; Swarzenski, *Handschriften XIII Jh.*, 65, pl. 6 fig. 33; *Sotheby Sale Catalogue*, 1st Dec. 1959, lot 55, pl. C; J. Lafontaine-Dosogne, *Iconographie de l'Enfance de la Vierge dans l'Empire Byzantin et en Occident*, II, Brussels, 1965, 25, 64, 75, 82, 87, 106, 120, 161.

EXHIBITED: London, 1930, no. 32.

17. Aberdeen, University Library MS 24
Bestiary
300 × 205 mm., ff. i + 103
c. 1200. (?) North Midlands *Ills. 58–61*

The Bestiary is illustrated by 96 fully painted framed miniatures with burnished gold grounds. These are of variable size set within the text. The first four folios have large miniatures with scenes of the Creation: Creation of heaven and earth (f. 1); Creation of the waters and the firmament (f. 1ᵛ); a leaf lacking; Creation of the birds and fishes (f. 2); Creation of the animals (f. 2ᵛ); Creation of Eve (f. 3); a blank leaf showing prick marks for tracing around the figures of Adam and Eve (f. 3ᵛ); Christ in Majesty in a mandorla held by angels (f. 4ᵛ).
The Bestiary illustrations (some leaves are lacking) begin with Adam naming the animals (f. 5) and then follow those for the individual creatures: Tiger (f. 8); Leopard (f. 8ᵛ); Panther (f. 9); Beaver (f. 11); Ibex (f. 11); Hyena (f. 11ᵛ); Bonnacon (f. 12); Apes (f. 12ᵛ); Satyr (f. 13); Goat (f. 14); Wild Goats (f. 14ᵛ); Monoceros (f. 15); Bear (f. 15); Leucrota

(f. 15ᵛ); Fox (f. 16); Yale (f. 16ᵛ); Wolf (f. 16ᵛ); Dogs (f. 18); Dogs of King Garamantes (f. 18ᵛ); Dogs, their habits (f. 19); Ram, Lamb (f. 21); Pigs (f. 21ᵛ); Cats, Mouse, Weasel (f. 23ᵛ); Mole, Hedge-hogs (f. 24); Ants (f. 24ᵛ); Dove and Hawk (f. 26); Silver Dove (f. 27ᵛ); Hawk (f. 29ᵛ); Hawk (f. 30); Turtle Doves (ff. 31ᵛ, 32); a cross with a dove in the centre (f. 32ᵛ); the Virgin with seven doves symbol-ising the gifts of the Holy Spirit (f. 34); Pelicans (f. 35); Owl (f. 35ᵛ); Hoopoe (f. 36ᵛ); Magpies, Raven (f. 37); Ostriches (f. 41); Vultures (f. 44ᵛ); Cranes (f. 45ᵛ); Kite (f. 46ᵛ); Parrot, Ibis (f. 47); Swallow, (f. 47ᵛ); Storks (f. 49); Blackbird (f. 49ᵛ); Owl (f. 50); Hoopoe (f. 50ᵛ); Bat (f. 51ᵛ); Nightingale (f. 52ᵛ); Geese (f. 53); Herons (f. 53ᵛ); Partridge (f. 54); Halcyon (f. 54ᵛ), Coot (f. 55); Phoenix (f. 55ᵛ); Phoenix rising in flames (f. 56); Caladrius (f. 57); Quail (f. 57ᵛ); Crow (f. 58); Swan (f. 58ᵛ); Ducks (f. 59); Peacock (f. 59ᵛ); Eagles (f. 61ᵛ); Bees (f. 63); Perindeus tree (f. 65); Dragon (f. 65ᵛ); Basilisk (f. 66); Vipers (f. 66ᵛ); Asp (f. 67ᵛ); Scitalis, Amphisbaena, Hydrus (f. 68ᵛ); Boas, Jaculus (f. 69); Siren serpent, Seps, Lizard (f. 69ᵛ); Salaman-ders (f. 70); Saura, Stellio (f. 70ᵛ); snake shedding its skin (f. 71). Isidore of Seville, one of the authors of the Bestiary, is shown seated writing (f. 81). The Bestiary illustrations end with a miniature of Fire Stones (f. 93ᵛ). Illuminated ornamental initials with tight concentric coils inhabited by small white and red lions are on ff. 72, 72ᵛ, 77ᵛ, 80ᵛ.

The style of painting is characterised by forceful poses of both figures and animals. The figures are slightly elongated and have faces strongly modelled in browns and pinks. Although both the poses and facial types owe much to Byzantine models it is significant that the grey green modelling technique of Byzantine art is not used as it had been earlier in the 12th century. The whole book is by one artist but at the end some crude work of the 14th century has been added (ff. 94, 96).

The origins of the artist are not clear although some links in facial and figure type with the drawings of the Cambridge Bestiary (no. 21) suggest a common model in a 12th-century drawing style. Later work in the same manner probably by the same artist is in the Ashmole Bestiary (no. 19). In both Bestiaries the majority of the illustrations are only about half the width of the text. The location of the workshop of these two books is uncertain although the features in common with the Cambridge Bestiary and the related Guthlac Roll (no. 22) suggest perhaps the East or North Midlands.

The Aberdeen Bestiary is the earliest luxury copy of the Second Family of Bestiaries grouped by James and McCulloch (nos. 19, 21, 42, 76, 98). A slightly earlier copy having only small drawings is London, British Library MS Add. 11283 (Survey, III, no. 105). The series of pictures of the days of Creation is an unusual addition to the Bestiary and also occurs in two First Family Bestiaries (nos. 11, 115) and the Ashmole Bestiary (no. 19). The iconography of the Creation scenes in the Aberdeen book is close to the illustrated copy of Ambrose's Hexaëmoron from Regensburg (Munich, Bayerische Staatsbibliothek,

MS Clm. 14399). As the Second Family of Bes-tiaries incorporates material from the Hexaëmoron in the text it seems likely that the Creation scenes were derived from an illustrated copy similar to the Regensburg example.

PROVENANCE: In the Royal Library in 1542 where it is no. 518 in the inventory (f. 1). Thomas Reid secretary to James I. Given by him in 1624 to Marischal College, Aberdeen. From 1860 incor-porated in the University Library, Aberdeen.

LITERATURE: James, Bestiary, 55 ff.; M. R. James, 'The Bestiary in the University Library', Aberdeen University Library Bulletin, VI, 1928, 529ff., with pls.; James, Catalogue, 18–25 with pls.; Millar, Fresh Materials, 287, figs. 232–3; Boase, English Art, 295, pl. 89b; McCulloch, Bestiaries, 36 passim; Rickert, Painting in Britain, 88; K. Varty, Reynard the Fox, Leicester, 1967, 147; Klingender, Animals in art, 388, 392, 423; Einhorn, Spiritalis Unicornis, 277, fig. 23; X. Muratova, 'Adam donne leurs noms aux animaux', Studi Medievali, XVIII. II, 1977, 376; Zahlten, Creatio Mundi, 74, 82, 128, 137, 159, 188, 246, figs. 259, 300, 375.

EXHIBITED: B.F.A.C., British Medieval Art, 1939, no. 27; Manchester, City Art Gallery, Romanesque Art, 1959, no. 42; Brussels, 1973, no. 40.

18. London, British Library MS Arundel 104
Cuttings pasted into a Wycliffite Bible
62 × 68 mm. and 50 × 50 mm.
c. 1200–10. (?) North Midlands Ills. 56, 57

Historiated initials of various dates removed from other books have been pasted into a Bible of c. 1400 with the English text of John Wycliffe and his collaborators. In Volume I in the Psalter section are three initials close in style to the Aberdeen Bestiary: D, from Psalm 52, God casting down arrows from above on a group of fighting men (f. 350); S, from Psalm 68, the Crucifixion (f. 354); C, perhaps from the canticle, Confitebor, a figure seated at a desk inspired by the Holy Ghost (f. 364ᵛ). These initials must have come either from a Bible or a Psalter.

The subject with God casting down arrows at Antichrist is occasionally used for Psalm 52 (Ragusa, 'Lyre Psalter', 267). The Crucifixion combined with the Resurrection occurs for Psalm 68 in Cambridge, Trinity College, MS B. 11. 4 (no. 51).

The figure style with rather more relaxed forms than the Aberdeen Bestiary suggests a slightly later date.

PROVENANCE: Thomas Howard, Earl of Arundel (1585–1646). In 1681 presented by Henry Howard (ex dono on f. 1) to the Royal Society, and subse-quently bought by the British Museum in 1831.

LITERATURE: W. de Gray Birch, Early Drawings and Illuminations in the British Museum, London, 1879, 8.

19. Oxford, Bodleian Library MS Ashmole 1511
Bestiary

276 × 183 mm., ff. 105

c. 1210. (?) North Midlands

Ills. 62, 63 (colour), 64, 65

This is a companion book to the slightly earlier Aberdeen Bestiary (no. 17). The Bestiary miniatures are framed, of variable size, set within the text and have heavily burnished gold grounds. Like the Aberdeen Bestiary these are preceded by a series of eight Creation scenes: Creation of heaven and earth (f. 4); Creation of the waters and the firmament (f. 4ᵛ); Creation of the plants and trees (f. 5); Creation of the sun and moon (f. 5ᵛ); Creation of the birds and fishes (f. 6); Creation of the animals (f. 6ᵛ); Creation of Eve (f. 7); Christ in Majesty (f. 8ᵛ). Then follow the 121 Bestiary scenes: Adam naming the animals (f. 9); Lion in three scenes (f. 10); Lion in three scenes (f. 10ᵛ); Tiger (f. 12); Leopard (f. 12ᵛ); Panther (f. 13); Antelope (f. 14); Unicorn (f. 14ᵛ); Lynx (f. 15); Griffin (f. 15ᵛ); Elephant (f. 15ᵛ); Beaver, Ibex (f. 17); Hyena (f. 17ᵛ); Bonnacon (f. 18); Apes (f. 18ᵛ); Satyr, Stag (f. 19); Goat (f. 20); Wild Goats (f. 20ᵛ); Monoceros, Bear (f. 21); Leucrota, Crocodile (f. 22); Manticora (f. 22ᵛ); Parandrus, Fox (f. 23); Yale, Wolf (f. 23ᵛ); Dogs (f. 25); Dogs, the story of King Garamantes (f. 25ᵛ); Dogs, the story of Jason (f. 26); Dogs, identification of a murderer (f. 27ᵛ); Dogs, their habits in three scenes (f. 28); Sheep (f. 29ᵛ); Ram, Lamb, He-Goat (f. 30); Wild Boar, Bullock (f. 30ᵛ); Ox, Camel (f. 31); Dromedary (f. 31ᵛ); Donkey, Wild Ass (f. 32); Horse (f. 32ᵛ); Cats, Mouse, Weasel (f. 35ᵛ); Mole, Hedgehog (f. 36); Ants (f. 36ᵛ); Dove, Hawk (f. 38); three types of Dove (f. 39ᵛ); a symmetrical Eagle-like Bird (f. 41ᵛ); Hawk (f. 42); Turtledove (f. 43ᵛ); a Turtledove placed at the centre of a green cross (f. 44); the Virgin with seven doves symbolising the gifts of the Holy Spirit (f. 45ᵛ); Pelican (f. 46ᵛ); Owl (f. 47); Hoopoe (f. 48); Magpies (f. 48ᵛ); Raven (f. 49); Cockerel (f. 50ᵛ); Ostriches (f. 52ᵛ); Vultures (f. 56); Cranes (f. 57); Kite (f. 58); Parrot (f. 58ᵛ); Ibis (f. 59); Swallow (f. 59ᵛ); Stork (f. 60ᵛ); Blackbird (f. 61); Owl (f. 62); Hoopoe (f. 62ᵛ); Owl, Bat (f. 63); Jackdaw (f. 63ᵛ); Nightingale, Goose (f. 64ᵛ); Heron (f. 65); Siren (f. 65ᵛ); Cinnamolgus, Ercinea (f. 66); Partridge in two scenes (f. 66ᵛ); Halcyon (f. 67); Coot, Phoenix (f. 67ᵛ); Phoenix rising from the flames (f. 68); Caladrius (f. 69); Quail (f. 69ᵛ); Crow (f. 70ᵛ); Swan (f. 71); Ducks (f. 71ᵛ); Peacock (f. 72); Eagles (f. 74); Bees (f. 75ᵛ); Perindeus tree (f. 77ᵛ); Dragon (f. 78ᵛ); Basilisk (f. 79); Viper (f. 79ᵛ); Asp (f. 80ᵛ); Scitalis (f. 81); Amphisbaena, Hydrus (f. 81ᵛ); Boas (f. 82); Jaculus, Siren serpent, Seps, Lizard (f. 82ᵛ); Salamander (f. 83); Saura, Stellio (f. 83ᵛ); snake shedding its skin (f. 84); various fish (f. 86); Whale (f. 86ᵛ); Isidore seated writing (f. 95ᵛ); Fire Stones (f. 103ᵛ). There are three ornamental initials on ff. 85, 92, 95.

This luxury Bestiary is more complete than the Aberdeen example (no. 17) on which it is directly based. The figures have become more elongated in form and mannered in pose with small heads completely out of proportion. Both figures and animals have considerable vitality with dynamic contours and alert expressions. Characteristic white hatching systems are used for highlighting the draperies. The faces are well modelled using brown shadows. Punched patterns are occasionally used (e.g. ff. 8ᵛ, 45ᵛ, 52ᵛ) to ornament the highly burnished gold grounds and in some instances the name of the animal has been inscribed on the gold (e.g. f. 32).

This is a Bestiary of the Second Family with the added set of Creation scenes. It has recently been suggested (Muratova, 1977) that the early series of luxury Bestiaries (nos. 11, 17, 19, 21) have sufficient links to imply production in the same region, possibly at the same centre, perhaps Lincoln. There seems little doubt that evidence from both style and ownership of some members of the group indicates a North Midlands or Northern provenance.

PROVENANCE: William Wryght, vicar of Chepynge Wycombe (High Wycombe) owned the book in 1550 (f. 8). William Mann gave it in 1609 to Sir Peter Mancroft (d. 1625) as recorded on f. 1. In 1623 it had come into the possession of John Tradescant the Elder (d. 1637), the traveller and gardener and was seen in his Museum in Lambeth in 1638. His son was a friend of Elias Ashmole (1617–92) who obtained the Tradescant manuscripts in 1664. In 1677 Ashmole gave his manuscripts to Oxford University. In 1860 these were transferred from the Ashmolean to the Bodleian Library.

LITERATURE: T. F. Dibdin, *The Bibliographical Decameron*, London, 1817, I, lxxxvi–xc; W. H. Black, *Catalogue of the manuscripts bequeathed unto the University of Oxford by Elias Ashmole*, Oxford, 1845, cols. 1413–14; G. C. Druce, 'The Symbolism of the Goat on the Norman Font of Thames Ditton', *Surrey Archaeological Collections*, XXI, 1908, 110; Druce, 'Crocodile', 316, 318; Druce, 'Amphisbaena', 290; Druce, 'Caladrius', 408; Druce, 'Abnormal forms', 157, 175; Druce, 'Elephant', 35, 43; Druce, 'Medieval Bestiaries II', 39, 62; *New Pal. Soc.*, II, pls. 40–1; Millar, I, 39, pl. 58; Saunders, *English Illumination*, I, 47, pls. 49a, b, 50; James, *Bestiary*, 14–15, 53, suppl. pls. 15, 16; R. Poole, 'A manuscript from the Tradescant collection', *Bodleian Quarterly Record*, VI, 1931, 221 ff.; H. Swarzenski, *The Berthold Missal*, New York, 1943, 45 n. 70, 85, fig. 160; Bodleian Picture Book, *Scenes from the Life of Christ in English Manuscripts*, Oxford, 1951, pl. 1; Bodleian Picture Book, *English Romanesque Illumination*, Oxford, 1951, pl. 25; Boase, *English Art*, 295, pl. 89a; Saxl and Meier, III, 289; McCulloch, *Bestiaries*, 36; Rickert, *Miniatura*, II, pl. IV; Bodleian Picture Book, *English Rural Life in the Middle Ages*, Oxford, 1965, pls. 4b, 7c; Rickert, *Painting in Britain*, 88, pl. 90A; W. George, 'The Yale', *J.W.C.I.*, XXXI, 1968, 424; P. d'Ancona, E. Aeschlimann, *The Art of Illumination*, London, 1969, 216, pl. 69; Klingender, *Animals in art*, 392, 394, 396, figs. 218b, 223; Munby, *Con-*

noisseurs, 74; Pächt and Alexander, III, no. 334, pl. XXIX and frontispiece; B. Rowland, *Animals with Human Faces*, Knoxville, 1973, fig. on 137; A. G. and W. O. Hassall, *Treasures from the Bodleian Library*, London, 1976, 65ff., pl. 14; X. Muratova, 'L'iconografia medievale e l'ambiente storico', *Storia dell'Arte*, 28, 1976, 176, fig. 9; Einhorn, *Spiritalis Unicornis*, 79, 80, 81, 277, 336; W. O. Hassall, 'Bestiaires d'Oxford', *Les dossiers de l'archéologie*, 16, 1976, 73 ff.; X. Muratova, 'Adam donne leurs noms aux animaux', *Studi Medievali*, XVIII. II, 1977, 376, 377, 390–1, pl. X; B. Rowland, *Birds with Human Souls*, Knoxville, 1978, figs. on 33, 53, 80, 85, 91, 93, 102, 112, 131; Zahlten, *Creatio Mundi*, 74, 75, 83, 128, 137, 159, 179, 188, 263, figs. 151–4, 235, 350.

EXHIBITED: Manchester, City Art Gallery, *Romanesque Art*, 1959, no. 41.

20. Rome, Biblioteca Apostolica Vaticana MS Reg. Lat. 258
Bestiary and Lapidary
248 × 175 mm., ff. 48
c. 1200–10. (?) North Midlands *Ill. 71*

The 58 illustrations are unframed drawings with occasional tinting in yellow-brown and red. These are of varying size set within the text: Lion (f. 8ᵛ); Wolf (f. 10ᵛ); Antelope (f. 11ᵛ); Hyena (f. 12); Wild Ass (f. 12ᵛ); Wild Goat, Panther (f. 13); Dragon, Monoceros (f. 14ᵛ); Stag (f. 15ᵛ); Raven (f. 16ᵛ); Goat, Ape (f. 17); Fox (f. 18); Hedgehog, a man holding a hedgehog (f. 18ᵛ); Weasel, Asp (f. 19ᵛ); Viper, Salamander (f. 21); Ants (f. 22); Siren, Centaur (f. 22ᵛ); Whale (f. 23); Halcyon (f. 24); Crab, Polypus, Barnacle Geese (f. 25ᵛ); Barnacle Goose (f. 26); Eagle (f. 27ᵛ); Coot (f. 28); Pelican, Partridge (f. 28ᵛ); Phoenix (f. 29ᵛ); Turtledove (f. 30); Caladrius (f. 30ᵛ); Hoopoe (f. 31); Ibis (f. 31ᵛ); Doves, Perindeus Tree (f. 33); Vulture (f. 33ᵛ); Hawks, Owl (f. 34); Bat (f. 34ᵛ); Bees (f. 35); Crane, Stork (f. 36); Ostrich (f. 36ᵛ); Stellio (f. 37); Serra (f. 37ᵛ); Onocentaur, Ibex (f. 38); Lizard (f. 38ᵛ); Elephant, Mandrake (f. 39ᵛ); Crocodile (f. 40); Dog (f. 41); Hydrus (f. 41ᵛ). Several gaps are left for other drawings never executed. The Lapidary section, beginning on f. 42ᵛ, has simple sketchy geometrical shapes illustrating the various gems and stones.

The plain unframed illustrations in simple drawing without tinting link this Bestiary with the 12th-century English examples (*Survey*, III, nos. 36, 104, 105). The order of the texts on the various creatures differs from these and from other contemporary early 13th-century versions.

The style of drawing is distinguished by firm bare outlines with relatively few internal details. It has a clear relationship to the style of the Cambridge Bestiary (no. 21) and is either derivative from or transitional to the more confident and higher quality illustrations of that book. This link with the Cam-

bridge Bestiary suggests the Vatican example was perhaps also produced in the North Midlands.

PROVENANCE: In the 17th-century part of the Library of Queen Christina of Sweden. Her books passed to Cardinal Ottoboni and entered the Vatican Library after he became Pope Alexander VIII in 1689.

LITERATURE: A. Wilmart, *Codices Reginenses Latini*, II, Rome, 1945, 24–6; Einhorn, *Spiritalis Unicornis*, 280.

21. Cambridge, University Library MS Ii. 4. 26
Bestiary
282 × 192 mm., ff. 74
c. 1200–10. (?) North Midlands *Ills. 66–70*

The text is illustrated mainly by drawings with circular or rectangular frames but with a few scenes fully painted or tinted. The pictures begin with two of the fully painted miniatures for the Lion (ff. 1, 1ᵛ) with three registers for each. The remaining 97 illustrations are of varying size set within the text: Tiger, fully painted (f. 3ᵛ); Leopard, tinted (f. 4); Panther, tinted (f. 4ᵛ); Lynx, tinted (f. 6); from this point drawing only: Griffin (f. 6ᵛ); Elephant (f. 7); Beaver (f. 8ᵛ); Ibex, Hyena (f. 9); Bonnacon (f. 10); Apes (f. 10ᵛ); Satyr, Stag (f. 11); Goat (f. 12); Wild Goats (f. 13); Monoceros, Bear (f. 13ᵛ); Leucrota (f. 14ᵛ); Crocodile (f. 15); Manticora (f. 15ᵛ); Parandrus, Fox (f. 16); Yale (f. 16ᵛ); Wolf (f. 17); Dogs (f. 18ᵛ); Dogs, the story of King Garamantes (f. 19); Dogs, their habits in three registers (f. 20); Sheep, Ram (f. 22); Lamb, He-Goat (f. 22ᵛ); Wild Boars, Bullock (f. 23); Ox (f. 23ᵛ); Camel (f. 24); Dromedary (f. 24ᵛ); Donkey, Wild Ass (f. 25); Horse (f. 25ᵛ); Cats, Mouse, Weasel (f. 28); Mole, Hedgehog (f. 28ᵛ); Ants (f. 29); Eagles (f. 31); Vultures (f. 32); Cranes (f. 32ᵛ); Parrot (f. 33); Caladrius (f. 33ᵛ); Stork (f. 34); Swan, Ibis (f. 34ᵛ); Ostrich (f. 35); Coot (f. 35ᵛ); Halcyon, Phoenix (f. 36); Phoenix rising from the flames (f. 36ᵛ); Cinnamolgus, Ercinea (f. 37ᵛ); Hoopoe, Pelican (f. 38); Owl (f. 38ᵛ); Siren (f. 39); Partridge, two scenes (f. 39ᵛ); Magpie, Hawk (f. 40); Nightingale, Bat (f. 40ᵛ); Turtledove (f. 41); Swallow (f. 41ᵛ); Quail, Peacock, Hoopoe, Cockerel (f. 42ᵛ); Ducks (f. 43); Bees (f. 43ᵛ); Perindeus Tree (f. 45ᵛ); Dragon (f. 46ᵛ); Basilisk (f. 47); Viper (f. 47ᵛ); Asp (f. 48ᵛ); Scitalis, Amphisbaena, Hydrus (f. 49ᵛ); Boas (f. 50); Jaculus, Siren-serpent, Lizard (f. 50ᵛ); Salamander (f. 51); Saura, Stellio (f. 51ᵛ); snake shedding its skin (f. 52); various fish (f. 54); Whale (f. 54ᵛ); Isidore seated writing (f. 63ᵛ).

The drawings are superior in quality to the fully painted work and there seems to have been a decision to leave the drawings of a large part of the book without either painting or tinting. The absence of coloured tinting is unusual in the 13th century although there was a strong tradition of pure drawing in English 12th-century book illustration (e.g.

Survey, III, nos. 73, 85, 86, 105). It is particularly significant that this technique is used in the late 12th-century Bestiary, London, British Library MS Add. 11283, and in earlier 12th century Bestiaries. The Cambridge Bestiary thus seems to be in the tradition of the normal form of Bestiary illustration rather than the new luxury painted and gilded versions such as nos. 17, 19. If this Bestiary was made for the Cistercian Abbey of Revesby, to which it may have later belonged, the plain drawings may have been thought more suitable for the Cistercian requirement of lack of colour in manuscript decoration.

There are two manuscripts perhaps by the same artist as the Cambridge Bestiary. The first is a copy of Henry of Huntingdon's Historia Anglorum (Baltimore, Walters Art Gallery MS 793) which has textual and provenance evidence for a Winchester origin although, perhaps significantly for the artist's region of origin, the only event to receive illustration is the Battle of Lincoln (1141). The second work probably by the same hand is the Roll with scenes of the Life of St. Guthlac (no. 22). In view of this stylistic connection with the roll which was produced for Crowland and also stylistic links with the stained glass of the North Rose of Lincoln Cathedral it is tempting to suggest a Lincolnshire origin for the Bestiary. The almost totally illegible inscription on f. 73 was read by James as referring to Revesby Abbey which is near Lincoln. If this reading is acceptable (it seems quite unreadable now and the inscription has always been broken off at the edge of the page) then additional evidence for the Lincoln region is provided. The Cambridge Bestiary was closely copied in Oxford, St. John's MS 61 (no. 42) which belonged to Holy Trinity priory, York; this gives further support to a localisation in the northern part of England.

The firmness of contour for both figures and animals with dynamic forms and lively compositions is a feature found also in the Aberdeen Bestiary (no. 17). Although the figure style and facial types have changed, several compositions suggest that the artist knew the versions of the Aberdeen Bestiary or a similar manuscript. Ultimately many of these compositions seem to derive from the Morgan (*Survey*, III, no. 106) and Leningrad Bestiaries (no. 11). Since these two earlier Bestiaries, the text has developed into the full Second Family type.

PROVENANCE: On f. 73 there is an inscription of the 16th century: 'Jacobus Thomas Herison Thys ys ye abbaye of Rev . . .' where it is cut off as a result of cropping of the page: the last word was read by James as Revesby which was a Cistercian Abbey in Lincolnshire. On the front flyleaf is recorded the gift from Osbert Fowler, Registrar of King's College in 1655 when it entered the University Library.

LITERATURE: *A Catalogue of the Manuscripts preserved in the Library of the University of Cambridge*, 3, Cambridge, 1858, 463–4; Millar, I, 39, pl. 57; M. R. James, *The Bestiary (Cambridge, Univ. Lib. MS Ii. 4. 26)*, Roxburghe Club, 1928 (facsimile);

Saunders, *English Illumination*, I, 48, II, pl. 54; A. Watson, *The early iconography of the Tree of Jesse*, London, 1934, 49; Saxl and Meier, III, 419; Boase, *English Art*, 295, pl. 53b; T. H. White, *The Book of the Beasts*, London, 1954, (an English version of the text with complete reproduction of the illustrations); J. Morson, 'The English Cistercians and the Bestiary', *Bulletin of the John Rylands Library*, 39, 1956–7, 152–68; Rickert, *Miniatura*, I, pl. 54; G. Henderson, 'Giraldus Cambrensis: a note on his account of a painting in the King's Chamber at Winchester', *Archaeological Journal*, 118, 1961, 177, pl. XIII; McCulloch, *Bestiaries*, 36, passim; Rickert, *Painting in Britain*, 88; K. Varty, *Reynard the Fox*, Leicester, 1967, 147; W. George, 'The Yale', *J.W.C.I.*, XXXI, 1968, 424; M. W. Evans, *Medieval Drawings*, London, 1969, pl. 17; Klingender, *Animals in art*, 388, 389, 394, figs. 219b, 220b, c, 224; P. Zambon, *Il Bestiario di Cambridge*, Milan, 1974; J. Alexander, 'The Middle Ages', in *The Genius of British Painting*, ed. D. Piper, London, 1975, 36 with fig; Einhorn, *Spiritalis Unicornis*, 79, 278; X. Muratova, 'Adam donne leurs noms aux animaux', *Studi Medievali*, XVIII. II, 1977, 391–2; Yapp, 'Birds', 319.

EXHIBITED: B.F.A.C., *British Medieval Art*, 1939, no. 26; Manchester, City Art Gallery, *Romanesque Art*, 1959, no. 40; Brussels, 1973, no. 39, pl. 22.

22. London, British Library MS Harley Roll Y. 6
Life of St Guthlac (Guthlac Roll)
c. 1210. (?) Crowland *Ills. 72–75*

This is a roll 285 cm. long and 16 cm. wide with seventeen scenes from the Life of St. Guthlac in round medallions, and one scene showing the benefactors of Crowland. The illustrations are drawn in pen with ink wash and tinting in green and very occasionally also in yellow. The series of subjects are all from the 8th century life by Felix possibly through the intermediary text of the pseudo-Ingulph with the interpolation of the legend of the scourge given to Guthlac by St. Bartholomew: 1. The roll has been cut in such a way that only half the roundel remains. Guthlac on the night before a battle resolves to devote himself to the service of God, 2. He leaves his fellow warriors, 3. He receives the tonsure at Repton Abbey, 4. Tatwin takes him on a boat to Crowland, 5. Guthlac builds a chapel at Crowland, 6. An angel and St. Bartholomew appear to him 7. He is attacked by demons who carry him up in the air, 8. St. Bartholomew gives him a scourge to defend himself against the demons who are carrying him to the gate of hell, 9. He drives demons away from his house with the scourge, 10. He casts a demon out of Ecgga, 11. He is ordained as a priest by Bishop Hedda, 12. Ethelbald seeks the counsel of Guthlac, 13. The dying Guthlac gives instructions to Beccelm, 14. Angels receive the soul of the dying Guthlac, 15. Beccelm conveys the saint's dying wishes to his sister Pega, 16. Entombment of

Guthlac, 17. Guthlac appears in a vision to Ethelbald who is visiting his tomb, 18. Benefactors of Crowland holding scrolls beside Guthlac's altar and shrine with a cured man from whose mouth a demon is emerging. On the reverse of the roll are some drawings of the early 14th century illustrating the first book of Samuel.

The technique of tinted drawing used in the roll is an important early example of a manner of illustration frequently used in English 13th-century book decoration. The tinting in the Guthlac drawings is restricted almost entirely to the one colour, green. There are both squat and elongated figure types both with disproportionate heads often having expressions of incredulity. These head types are reminiscent of those in the Leningrad Bestiary (no. 11) although they are more carefully drawn, and in some cases both figure forms and heads are close to the Cambridge Bestiary (no. 21). The connections of the roll with Crowland, of the Cambridge Bestiary possibly with Revesby, and stylistic similarities with the early 13th-century glass of Lincoln Cathedral suggest a localisation of this particular style to the Lincolnshire region.

The dating of the Guthlac Roll to c. 1196 sometimes quoted is based solely on the suggestion that the roll was executed at the time of the translation of the saint's relics to a new shrine in 1196. All that can be said is that the shrine is probably depicted in subject no. 18 so that the translation may provide a terminus post quem. As the style of drawing is taken up in the second quarter of the 13th century in works like the two Bestiaries, Oxford, Bodleian Library MS Bodley 764 (no. 98, Part 2) and London, British Library MS Harley 4751 (no. 76) a date c. 1210 has been suggested for the Roll.

The Guthlac Roll was one of the earliest medieval illustrated manuscripts to attract antiquarian attention. It was displayed to the group who were to become the Society of Antiquaries on 23rd January 1708 at the Young Devill Tavern in London. The reason why these drawings are in the form of a roll is not clear. It has been suggested that they were designs for a stained glass window which would also explain the choice of roundels to frame the scenes. Another possible reason is that there appears to have been a textual tradition of the life of St. Guthlac presented in roll form. A roll of his life with Anglo-Saxon text was in the library of Leominster priory, a cell of Reading Abbey (J. B. Hurry, *Reading Abbey*, London, 1901, 113).

PROVENANCE: Crowland Abbey on the evidence of the pictures of the benefactors. Acquired either by Robert Harley, Earl of Oxford (1661–1724) or Edward (1689–1741) his successor, early in the 18th century. Bought by the British Museum in 1753.

LITERATURE: J. Schnebbelie, 'Account of St. Guthlac', *The Antiquaries Museum*, London, 1791–2, 1–32, pls. I–IX; W. de Gray Birch, *Memorials of St. Guthlac*, London, 1881; British Museum, *Reproductions*, I, pl. VIII; Herbert, *Illuminated Manuscripts*, 140; H. Vassall, 'The vignettes of St.

Guthlac as reproduced in the windows of Repton School Library', *Journal of the Derbyshire Archaeological and Natural History Society*, 35, 1913, 247 ff.; British Museum, *Schools of Illumination*, pt. II, London, 1915, pl. 3; Lindblom, *Peinture Gothique*, 122, 126, fig. 33; W. R. Lethaby, 'The Guthlac Roll', *Burlington Magazine*, 31, 1917, 147 ff.; Millar, I, 37, 87, pl. 53; Saunders, *English Illumination*, I, 54, II, pl. 60; G. Warner, *The Guthlac Roll*, Roxburghe Club, 1928 (facsimile); Boase, *English Art*, 288; J. Evans, *A History of the Society of Antiquaries*, Oxford, 1956, 37, 97; Rickert, *Miniatura*, I, pl. 58; Baltrušaitis, *Reveils et Prodiges*, 130 fig. 18B, 288 fig. 17; Rickert, *Painting in Britain*, 95, pl. 97B; R. Branner, 'Le rouleau de Saint Éloi', *Information de l'Histoire de l'Art*, XII, no. 2, 1967, 65; M. W. Evans, *Medieval Drawings*, London, 1969, 35, pl. 91; Turner, 'Manuscript Illumination', fig. 163; Munby, *Connoisseurs*, 20; D. H. Farmer, 'Guthlac von Crowland', *Lexikon der christlichen Ikonographie*, VI, 1974, col. 466; J. Alexander, 'The Middle Ages', in *The Genius of British Painting*, ed. D. Piper, London, 1975, 36.

EXHIBITED: London, British Museum, *Illuminated Manuscripts and Bindings of Manuscripts exhibited in the Grenville Library*, 1923, no. 17, with pls; London, British Library, *The Benedictines in Britain*, 1980, no. 35.

23. Munich, Bayerische Staatsbibliothek Clm. 835

Psalter (Munich Psalter)
277 × 195 mm., ff. 166 +3
c. 1200–10. (?) Oxford
Ills. 76–84, 85 (colour), 86, 87

This richly decorated Psalter has one of the most extensive picture cycles of the Old and New Testaments in 13th-century Psalter decoration. Following the Calendar (ff. 1–6ᵛ) one section of 46 full page miniatures (ff. 8–30) is followed by the Psalter text which has picture sections after Psalms 51, 100, 108 and 150. The Calendar has roundels with the Labours of the Months and Signs of the Zodiac: January, a servant presents a bowl to a man seated at a table (f. 1); February, a man warming himself by the fire (f. 1ᵛ); March, a man digging (f. 2); April, a knight with his horse (f. 2ᵛ); May, a man with a falcon and woman with a flower (f. 3); June, a man with a scythe (f. 3ᵛ); July, a man with a rake (f. 4); August, a man cutting corn (f. 4ᵛ); September, treading and gathering grapes (f. 5); October, a man sowing seed (f. 5ᵛ); November, a group of pigs (f. 6); December, a man killing a pig (f. 6ᵛ).

The Old Testament sequence begins on f. 8, the first two miniatures being divided into six compartments, the others into two with occasionally more than one scene combined within the same frame: 1. God creating heaven and earth, 2. God

creating the firmament, 3. God creating the plants, 4. God creating the sun, moon and stars, 5. God creating the birds and fishes. 6. God creating Eve (f. 8); 7. God resting on the seventh day, 8. His warning to Adam and Eve concerning the forbidden fruit, 9. The eating of the fruit, 10. God's rebuke to Adam and Eve, 11. Expulsion from Paradise, 12. Adam digging and Eve spinning (f. 8ᵛ); 13. Offering of Cain and Abel, 14. The murder of Abel with God rebuking Cain (f. 9); 15. Ascension of Enoch, 16. Lamech shooting Cain (f. 9ᵛ); 17. Building of the Tower of Babel, 18. God instructs Noah to build the Ark (f. 10); 19. The dove comes to Noah, 20. Noah's drunkenness (f. 10ᵛ); 21. Abraham's fight with the four kings, 22. Melchisedech offers bread and wine to Abraham (f. 11); 23. Abraham adores the three angels, 24. Lot's departure from Sodom (f. 11ᵛ); 25. Sacrifice of Abraham, 26. Isaac's meeting with Rebecca (f. 12); 27. Isaac blessing Jacob, 28. Esau brings food to Isaac (f. 12ᵛ); 29. Jacob's Dream, 30. Jacob wrestling with the angel (f. 13); 31. Jacob sends Joseph to visit his brothers at Shechem, 32. Joseph taken from the pit to be sold to the Ishmaelites (f. 13ᵛ); 33. The Ishmaelites sell Joseph to Potiphar, 34. Joseph fleeing from Potiphar's wife (f. 14); 35. Joseph in prison with the butler and baker, 36. The butler presents a cup to Pharoah, the baker is hanged (f. 14ᵛ); 37. Joseph interprets Pharaoh's dream, 38. Joseph riding in a chariot by the granaries (f. 15); 39. Joseph's brothers come to buy corn in Egypt, 40. Joseph's brothers charged with the theft of his cup (f. 15ᵛ); 41. Jacob is persuaded to send Benjamin to Egypt, 42. Joseph's farewell to Benjamin (f. 16); 43. Jacob comes to Egypt with his family, 44. Joseph presents Jacob to Pharoah (f. 16ᵛ); 45. Jacob blessing Ephraim and Manasseh, 46. Jacob blessing all his sons (f. 17); 47. The daughter of Pharaoh rescues Moses from the Nile, 48. Moses kills the Egyptian and hides him in the sand (f. 17ᵛ); 49. Moses and the Burning Bush, 50. Moses and Aaron before Pharaoh (f. 18); 51. The crossing of the Red Sea, 52. Moses receiving the tablets of the Law (f. 18ᵛ); 53. The slaying of the worshippers of the Golden calf, 54. Moses and Aaron in the Tabernacle (f. 19); 55. The punishment of the followers of Korah, Aaron's offering of incense and the rods of the tribes of Israel, 56. The return of the spies with the grapes of Eschol (f. 19ᵛ); 57. Moses striking the rock for water, 58. Moses and the Brazen Serpent (f. 20); 59. Balaam on the ass with the Angel of the Lord, 60. Phineas killing Zimri and Cozbi (f. 20ᵛ); 61. The priests carrying the Ark, 62. The Fall of Jericho (f. 21).

Then follows a cycle of the New Testament as nineteen full-page miniatures (ff. 21ᵛ–30ᵛ) to be described later.

The Old Testament cycle continues (ff. 104–111ᵛ) with sixteen full page miniatures each divided into six compartments: 63. Elimelech and Naomi, 64. The sons of Elimelech and Naomi take Moabite wives, 65. The tombs of Elimelech and his two sons, 66. Ruth and Orpah with Naomi, 67. Ruth brings grain to Naomi, 68. Ruth gleaning (f. 104); 69. Ruth

before Boaz, 70. Boaz makes a pact with his kinsmen, 71. Marriage of Ruth and Boaz, 72. They pray for God's blessing on the marriage, 73. Ruth nursing Obed, 74. Boaz, Obed and Jesse (f. 104ᵛ); 75. Elkanah with Hannah and Peninnah, 76. Hannah before Eli, 77. Birth of Samuel, 78. Presentation of Samuel in the temple at Shiloh, 79. Samuel anoints Saul, 80. Samuel anoints David (f. 105); 81. Nebuchadnezzar's dream, 82. Daniel's revelation, 83. Daniel interprets Nebuchadnezzar's dream, 84. Worship of the image of Nebuchadnezzar, 85. The three Hebrews in the furnace, 86. The three Hebrews before Nebuchadnezzar (f. 105ᵛ); 87. Joachim visited by the two elders, 88. The servants find the elders with Susanna, 89. Susanna accused, 90. Daniel rebukes the first elder, 91. Daniel rebukes the second elder, 92. The stoning of the elders (f. 106); 93. Belshazzar's feast, 94. Belshazzar speaks to the wise men, 95. The queen comes to Belshazzar, 96. Daniel interprets the writing on the wall, 97. Soldiers drive out Belshazzar, 98. Beheading of Belshazzar (f. 106ᵛ); 99. Daniel before Darius, 100. The princes and governors before Darius, 101. The princes and governors observe Daniel at prayer, 102. They complain against Daniel to Darius, 103. Daniel brought food in the lion's den, 104. The accusers of Daniel eaten by lions (f. 107); 105. Nebuchadnezzar sends Holofernes to war, 106. The army sets out, 107, 108. The soldiers of Holofernes destroy the images of the gods, 109. The soldiers of Holofernes, 110. The ambassadors kneel before Holofernes (f. 107ᵛ); 111. The Israelites and Eliakim pray in the temple on hearing of the destruction wrought by Holofernes, 112. They build walls around their city, 113. The princes of Moab and Ammon before Holofernes, 114. Achior tied to a tree, 115. The discovery of the springs at Bethulia, 116. Holofernes sets guards at the springs (f. 108); 117. Judith in her chamber, 118. Judith and her maid leave for the camp, 119. Judith comes before Holofernes, 120. Holofernes leads Judith to a chamber, 121. Judith prays at the fountain, 122. Holofernes at supper (f. 108ᵛ); 123. Judith beheads Holofernes, 124. She brings the head to Bethulia, 125. The discovery of the headless body of Holofernes, 126. The spoils brought to Bethulia, 127. The spoils given to Judith, 128. The people mourn at the burial of Judith (f. 109); 129. The feast of Ahasuerus, 130. The feast for the people of Susan, 131. Queen Vasthi's feast for the women, 132. The seven eunuchs go to Vasthi, 133. Ahasuerus consults the wise men, 134. The decree that husbands should be rulers over wives (f. 109ᵛ); 135. Egeus the eunuch with the virgins summoned to Ahasuerus, 136. Ahasuerus sleeping with one of the virgins, 137. Ahasuerus sleeping with Esther, 138. The marriage feast for Esther, 139. Bagathan and Thares plot against Ahasuerus, 140. They are hanged (f. 110); 141. The king's servants worship Haman, 142. Haman before Ahasuerus, 143. Haman instructs the scribes, 144. The Jews lamenting, 145. Mordecai gives the edict to Athach to take to Esther, 146. Esther's request to Ahasuerus (f. 110ᵛ); 147. Haman prepares the gibbet

for Mordecai, 148. Ahasuerus commands Haman to honour Mordecai, 149. Mordecai set on the king's horse, 150. Ahasuerus and Haman drink with Esther, 151. Haman on the gibbet, 152. The Jews slaughter their enemies (f. 111); 153. Jonah thrown to the whale, 154. Jonah comes out of the whale, 155. Jonah under the gourd, 156, 157, 158. The people of Nineveh in groups (f. 111ᵛ).

Preceding Psalm 109 are a Tree of Jesse (f. 121) and three full-page miniatures of more Old Testament scenes two to a page: 159. Ahimelech the priest gives the hallowed bread and the sword of Goliath to David, 160. Saul orders Doeg to slay the priests (f. 121ᵛ); 161. David harping walks before the ark, 162. The Ammonites shave the ambassadors of David (f. 122); 163. The prophecy of the birth of Josias and the destruction of Jeroboam's altar, 164. The prophet of Bethel told of the other prophet; a lion stands by the dead prophet (f. 122ᵛ). Twelve more scenes of the life of David are depicted on two full-page miniatures set at the end of the Psalter text immediately preceding the Canticles: 165. David instructs Joab to number the people, 166. Joab and the Captains number the people, 167. Joab tells the king of the number of the people, 168. The men of Israel and Judah, 169. David laments, 170. Gad speaks to David (f. 149); 171. David repents, 172. The pestilence of Israel, 173. God commands the angel of the Lord 'It is enough', 174. Gad instructs David to build an altar, 175. David and Araunah, 176. David sacrifices at the altar (f. 149ᵛ). The extensive Old Testament cycle here comes to an end. It is not only exceptional in its scope but in the odd distribution at various points in the Psalter, interspersed with sections of a large sequence of scenes of the New Testament. It has seemed best to list these New Testament scenes in the order they occur, although the section after Psalm 51 (ff. 65–72ᵛ) does not follow in sequence from the first section (ff. 21ᵛ–30) but supplements it with additional scenes.

The New Testament cycle begins on f. 21ᵛ with nineteen full-page miniatures and continues with a further sixteen in the section after Psalm 51. In most cases there are two miniatures to a page but occasionally only one: 1. Annunciation to the Virgin Mary, 2. Visitation (f. 21ᵛ); 3. The Nativity, 4. Annunciation to the shepherds (f. 22); 5. The Magi before Herod, 6. Adoration of the Magi (f. 22ᵛ); 7. Dream of the Magi, 8. Massacre of the Innocents (f. 23); 9. Flight into Egypt, 10. Presentation in the Temple (f. 23ᵛ); 11. Baptism of Christ, 12. Transfiguration (f. 24); 13. Entry into Jerusalem, 14. The Last Supper (f. 24ᵛ); 15. Judas receiving the pieces of silver, 16. Gethsemane (f. 25); 17. The Betrayal 18. Peter's denial before the fire, and Christ before the High Priest (f. 25ᵛ); 19. The Flagellation, 20. The Crucifixion (f. 26); 21. The Deposition, 22. Holy Women at the Tomb (f. 26ᵛ); 23. Descent into Hell, 24. 'Noli me tangere' (f. 27); 25. Meeting on the road to Emmaus, 26. Supper at Emmaus (f. 27ᵛ); 27. Doubting of Thomas, 28. Ascension (f. 28); 29. Pentecost (f. 28ᵛ); 30. Christ in Majesty trampling on the lion and the dragon (f. 29); 31.

Christ enthroned in Heaven with the Virgin Apostles and Saints (f. 29ᵛ); 32. The Last Judgement (f. 30); 33. The torments of Hell in twelve square compartments (f. 30ᵛ).

The scenes after Psalm 51 are: 34. The three temptations of Christ (f. 65); 35. Miracle at Cana, 36. Expulsion from the Temple (f. 65ᵛ); 37. Dance of Salome and Beheading of John the Baptist (f. 66); 38. Feeding of the five thousand (f. 66ᵛ); 39. Peter saved from the water, 40. Raising of Lazarus (f. 67); 41. Meal in the House of Simon with the anointing of Christ's feet, 42. The Washing of the Feet (f. 67ᵛ); 43. The Hanging of Judas (f. 68); 44. Healing of the young man of Nain, 45. Healing of the Paralytic (f. 68ᵛ); 46. Casting out of devils into the Gadarene swine, 47. Healing of the daughter of Jairus (f. 69); 48. Christ and the Samaritan woman at the well, 49. Healing of the blind man and the dumb man (f. 69ᵛ); 50. Healing of the woman with the issue of blood, 51. Christ and the Canaanite woman (f. 70); 52. Parable of Dives and Lazarus, 53. Lazarus in Abraham's bosom, Dives in Hell (f. 70ᵛ); 54. Healing of the ten lepers, 55. The tenth leper thanking Christ (f. 71); 56. The wise and foolish virgins with their lamps, 57. The virgins at the temple (f. 71ᵛ); 58. The calming of the storm, 59. 'I will render unto Caesar' (f. 72); 60. The woman in adultery, 61. Her accusers leave her alone with Christ (f. 72ᵛ).

After Psalm 150 there are five miniatures of the praise of God and one of the Judgement: Christ in Majesty surrounded by angels, the sun and moon, the elements, animals and plants (f. 146); the animals and groups of men in five circular medallions against a ground of foliage scrolls praising a seated figure of God (f. 146ᵛ); five groups of people under arches praising God (f. 147); scenes of Judgement (f. 147ᵛ); people and musicians praising God (f. 148); David harping in praise of God surrounded by four writing figures (f. 148ᵛ). These pages are literal illustrations of Psalms 148 (ff. 146, 146ᵛ), 149 (ff. 147, 147ᵛ) and 150 (ff. 148, 148ᵛ).

Ten historiated and large ornamental initials occur at the liturgical divisions of the Psalter, other psalms have small decorative initials occasionally containing figures and there are red and blue pen line endings with ornament and grotesques: Psalm 1, B, full page with ornamental concentric coils containing small lions and at corners and sides medallions of David rescuing the lamb from the bear, David killing the lion, David and Goliath, Anointing of David, David harping, David seated with a book (f. 31); Psalm 26, D, ornamental (f. 46); Psalm 38, D, ornamental (f. 55ᵛ); Psalm 51, Q, ornamental (f. 64ᵛ); Psalm 52, D, ornamental (f. 73); Psalm 68, S, ornamental (f. 81); Ps. 80, E, ornamental (f. 92ᵛ); Psalm 97, C, ornamental (f. 102ᵛ); Psalm 101, D, ornamental (f. 112); Psalm 109, D, ornamental (f. 123ᵛ). What is rarely found are historiated initials illustrating some of the Canticles, the Pater Noster, and the Apostles' and Athanasian Creeds: Confitebor, ornamental (f. 150); Ego dixi, ornamental (f. 150ᵛ); Exultavit cor meum, Hannah presents Samuel at the temple (f. 151); Cantemus domino, a group of

musicians (f. 151v); Domine audivi, the Nativity of Christ (f. 152v); Audite celi, Moses with a scroll (f. 153v); Te Deum, St. Ambrose, (f. 155v); Benedicite, the Three Hebrews in the Fiery Furnace (f. 156v); Benedictus, Zacharias with a scroll (f. 157); Magnificat, the Annunciation (f. 157v); Nunc Dimittis, Presentation of Christ to Simeon (f. 157v); Pater Noster, Christ and the Apostles (f. 158); Apostles' Creed, the Virgin and the Apostles (f. 158); Athanasian Creed, St. Athanasius (f. 158v); Gloria ornamental (f. 159v). The text ends with the Litany.

Three main artists are involved in the decoration of this sumptuous book, probably aided by one or two minor assistants. Hand A paints ff. 1–31, Hand B ff. 65–72v, 121–2v, 146–9v and the historiated initials to the Canticles, and Hand C ff. 104–111v. The highest quality work is by Hand A and is distinguished by a better understanding of poses and a greater range of facial expressions. Heavy modelling of flesh tones and much white hatching on both draperies and faces is used. These stylistic features give dramatic energy to the scenes which is enhanced by the use of dynamic figure poses. The origins of this artist are not clear although perhaps he knew the work of the Master of the Genesis Initial in the Winchester Bible (*Survey*, III, no. 83) where similar violent poses, exaggerated modelling and use of white hatching occurs. There are closer affinities with another Bible, Oxford, Bodl. MS Laud Misc. 752 (*Survey*, III, no. 103) in whose workshop Hand A must have studied. Several iconographic correspondences between the Psalter and this Bible support the connection. A third component in his stylistic origins is evidenced by his frequent use of rinceaux patterns on the folds which, together with certain facial features, links Hand A with the workshop of the Copenhagen Psalter (*Survey*, III, no. 96).

Hand B is the artist of the Psalter, London, British Library MS Arundel 157 (no. 24). His figures are static compared with Hand A and have weaker facial modelling, less precision in the outlining of the face and a tendency towards monotony of expression. He uses colours and drapery conventions similar to Hand A and is probably his pupil. Like Hand A he has links with the workshop of the Bible, Oxford, Bodl. MS Laud Misc. 752.

The last main artist, Hand C, is rather a coarse imitator of Hand B.

The iconographic cycle in the Munich Psalter is one of the most important in English medieval art. The painters must have had access to an extensive early cycle from which they excerpted sections and occasionally adapted the model with modern versions of the subjects. This cycle may have been transmitted through an 11th-century Anglo-Saxon exemplar, also perhaps known to the artists of the Winchester Psalter and Bible (*Survey*, III, nos. 78, 83), the Paris copy of the Utrecht Psalter (no. 1) and of the Sigena wall paintings now destroyed (W. Oakeshott, *Sigena*, London, 1972).

The choice of unusually full sets of pictures of the lives of heroic women of the Old Testament (Ruth, Judith, Esther) might suggest a female owner of the book; this is supported by the use of the female gender in some prayers following the Litany.

There are parallels in page arrangement and iconography with a mid 13th-century Bible made in the Kingdom of Jerusalem (Paris, Bibl. Arsenal MS 5211). In England the cycle is in part copied later in the Psalter in Cambridge (Trinity College MS B. 11. 4, no. 51), and the Huntingfield Psalter (no. 30) and it has many links with the Old Testament cycle known in the workshop of William de Brailes (no. 71).

The lack of historiated initials at the liturgical divisions of the psalms is unusual for the date, large ornamental tight coil initials on gilded grounds being used. The very unusual feature of figure initials to the Canticles already mentioned also occurs in another Psalter of the workshop (no. 24).

The place of production of all the books related to the Munich Psalter (nos. 24, 28, 29) seems to have been Oxford, but no obvious textual indication in the Psalter itself suggests Oxford. The Calendar (in which the scribe has forgotten to write in some of the entries in gold) has several very rare features which occur in that of the Benedictine Abbey of Gloucester: Blaise (15th Feb.), Paternus (15th Apr.), Karaunus (28th May) and Paternus (23rd Sept.). Although this is certainly not a pure Calendar of Gloucester some connection must be assumed. There is a single, very rare, entry normally found only in Cluniac Calendars of St. Robert of La Chaise Dieu (24th Apr.). The Litany is Augustinian, as Augustine heads the Confessors, and Osyth (whose relics were at the Augustinian nunnery of Chich) is the most senior to be listed among the English Virgins. An interpretation of this liturgical evidence might suggest a secular patron having links with the Gloucester region and the Augustinians. Most other books by the workshop have Augustinian textual features which suggests this order was in some way involved in directing the workshop or providing text models.

PROVENANCE: Maximilian I, Duke of Bavaria (1573–1651) whose bookplate is on the flyleaf. The Court Library of the Dukes of Bavaria into which the manuscript passed, eventually became the Bavarian State Library in Munich.

LITERATURE: A. Haseloff, *Eine thüringisch-sächsische Malerschule des 13. Jahrhunderts*, Strasbourg, 1897 (repr. 1979), 125, 160, 161–2, 182, 235, 239–40; Haseloff, 'Miniature', 320, fig. 244; Vitzthum, *Pariser Miniaturmalerei*, 16; J. A. Herbert, 'A Psalter in the British Museum Royal MS 1. D. X', *Walpole Society*, III, 1913–14, 48; G. Leidinger, *Meisterwerke der Buchmalerei*, Munich, 1920, pl. 19; Millar, I, 119; Saunders, *English Illumination*, I, 55, 57; R. Ligtenberg, 'De Genealogie van Christus', *Oudheidkundig Jaarboek*, IX, 1929, 41; Boeckler, *Abendländische Miniaturen*, 93ff., pls. 91, 92; A. Watson, *The early iconography of the Tree of Jesse*, Oxford, 1934, 91 n. 1; Swarzenski, *Handschriften*

XIII Jh., 73, 74, 85 n. 4, 94 n. 44, 102 n. 10, 146 n. 4; Swarzenski, 'Unknown Bible Pictures', 64 ff.; Boase, *English Art*, 278 ff., pl. 90; F. Saxl, *English Sculptures of the twelfth century*, London, 1954, 52, 55, 57, fig. 38; H. Buchthal, *Miniature Painting in the Latin Kingdom of Jerusalem*, Oxford, 1957, 55 ff., 57 n. 1, 58 n. 2, n. 5, n. 7, pl. 148 a, b, c; Ker, *Medieval Libraries*, 92; Baltrušaitis, *Reveils et Prodiges*, 129, fig. 17; A. Heimann, 'A twelfth century MS from Winchcombe', *J.W.C.I.*, XVIII, 1965, 99; Rickert, *Painting in Britain*, 98, pl. 98B; A. Martindale, *Gothic Art*, London, 1967, 72, pls. 47, 49; Deuchler, *Ingeborgpsalter*, 164 n. 284; Turner, 'Manuscript Illumination', 136, figs. 168, 172-4; R. Mellinkoff, *The Horned Moses in Medieval Art and Thought*, London, 1970, 66, figs. 59, 60; F. Bucher, *The Pamplona Bibles*, Yale, 1970, 82, 88, 147 n. 151; G. Schiller, *Ikonographie der christlichen Kunst*, 3, Gütersloh, 1971, fig. 91; Ragusa, 'Lyre Psalter', 268 n. 8, fig. 6; R. Hammerstein, *Diabolus in Musica*, Bern, 1974, 71, fig. 83; H. B. Graham, *Old Testament Cycles in the English Psalter in Munich*, Ph.D. Dissertation, Princeton University, 1975; H. B. Graham, 'The Munich Psalter', *The Year 1200: a Symposium, New York, Metropolitan Museum of Art*, 1975, 301-12, figs. 1, 2, 3, 4, 6, 8, 9; *Survey*, III, 124; J. J. G. Alexander, *The Decorated Letter*, New York, 1978, 15, pl. 20; Zahlten, *Creatio Mundi*, 53, 68, 137, 158, 165, 178, 260, figs. 64, 117, 261.

EXHIBITED: Bern, Kunstmuseum, *Kunst des frühen Mittelalters*, 1949, no. 321.

24. London, British Library MS Arundel 157
Psalter and Hours of the Virgin
294 × 195 mm., ff. 185
c. 1200-10. Oxford *Ills. 88-92*

This is the earliest richly illuminated manuscript with fairly definite evidence of Oxford provenance. Before the Calendar and the Psalter text is a series of twenty full-page miniatures. Added at the beginning is a *c.* 1240 half-page miniature of the Veronica head of Christ (f. 2) with an accompanying prayer. On f. 1ᵛ is a rubricated inscription describing the image. The main picture cycle has two scenes to a page set in heavy ornamental frames: 1. Annunciation, 2. Visitation (f. 3); 3. Nativity, 4. Annunciation to the shepherds (f. 3ᵛ); 5. The Magi before Herod, 6. Adoration of the Magi (f. 4); 7. The dream of the Magi, 8. Presentation in the Temple (f. 4ᵛ); 9. Flight into Egypt, 10. Massacre of the Innocents (f. 5); 11. Baptism, 12. First Temptation (f. 5ᵛ); 13. Second Temptation, 14. Third Temptation (f. 6); 15. Wedding at Cana, 16. Expulsion from the Temple (f. 6ᵛ); 17. Herod's Feast, the Beheading of John the Baptist, 18. The Feeding of the Five Thousand (f. 7); 19. Peter saved from the water, 20. Transfiguration (f. 7ᵛ); 21. Raising of Lazarus, 22. Meal at the house of Lazarus (f. 8); 23. Entry into Jerusalem, 24. The Last Supper (f. 8ᵛ); 25. The Washing of the feet, 26. Gethsemane (f. 9); 27. The

Betrayal, 28. Peter's Denial, Trial of Christ (f. 9ᵛ); 29. Judas leaves the High Priest and hangs himself, 30. The Flagellation (f. 10); 31. The Crucifixion, 32. The Deposition (f. 10ᵛ); 33. Descent into Hell, 34. Holy Women at the Tomb (f. 11); 35. 'Noli me tangere', 36. Supper at Emmaus (f. 11ᵛ); 37. Doubting of Thomas, 38. Ascension (f. 12); 39. Pentecost, 40. Christ in Majesty (f. 12ᵛ).

Then follows the Calendar with roundels illustrating the Labours of the Months and Signs of the Zodiac: January, feasting (f. 13); February, a man warming his feet by the fire (f. 13ᵛ); March, two men digging (f. 14); April, a knight with his horse (f. 14ᵛ); May, a man with a falcon and a woman with a flower (f. 15); June, a man scything (f. 15ᵛ); July, a man cutting out weeds (f. 16); August, a man cutting wheat (f. 16ᵛ); September, a man treading grapes (f. 17); October, a man sowing seed (f. 17ᵛ); November, pigs feeding (f. 18); December, a man killing a pig (f. 18ᵛ).

The Psalter text opens with a full-page B for Psalm 1 (f. 19) filled with tight coils inhabited by small white lions. There are four historiated medallions at the corners: David rescuing the lamb from the lion, Anointing of David, David casting his sling at Goliath, David beheading Goliath. Each psalm has a small illuminated initial some having foliage ornament, others grotesques, heads, standing figures and occasionally groups of figures. There are red and blue penwork ornamental line endings. The nine initials of the liturgical divisions are larger and historiated: Psalm 26, D, Anointing of David (f. 34ᵛ); Psalm 38, D, Judgement of Solomon (f. 43ᵛ); Psalm 51, Q, Doeg beheading the priests (f. 51ᵛ); Psalm 52, D, Temptation of Christ (f. 52); Psalm 68, S, Christ between Peter and Paul with a man in the water below between two devils (f. 60ᵛ); Psalm 80, E, Musicians (f. 71ᵛ); Psalm 97, C, Nativity (f. 82); Psalm 101, D, Ecclesia holding a chalice and Host before Christ (f. 83); Psalm 109, D, the Trinity (f. 93). There are fourteen historiated initials to the Canticles, the Pater Noster and the Apostles' and Athanasian Creeds (see also no. 23): Confitebor, Martyrdom of Isaiah (f. 116); Ego dixi, Isaiah with the sick Hezekiah (f. 116ᵛ); Exultavit cor meum, Hannah standing (f. 117); Cantemus domino, Moses holding the tablets of the Law (f. 117ᵛ); Domine audivi, Habakkuk standing (f. 118ᵛ); Audite celi, Moses seated with a scroll (f. 119ᵛ); Te Deum, St. Ambrose (f. 122); Benedicite, the Three Hebrews in the Fiery Furnace (f. 122ᵛ); Benedictus, Zacharias standing (f. 123ᵛ); Magnificat, the Virgin seated (f. 124); Nunc Dimittis, Simeon standing (f. 124); Gloria, Annunciation to the Shepherds (f. 124ᵛ); Pater Noster, Christ blessing (f. 124ᵛ); Apostles' Creed, the Virgin and the Apostles (f. 124ᵛ); Athanasian Creed, ornamental (f. 125); Litany, ornamental (f. 126ᵛ) and also for the initials of the prayers of the Litany. There is an historiated initial of the standing Virgin for a prayer to her (f. 130ᵛ). From f. 132 there is a decline in the quality of both the script and the illumination. In this section are small ornamental initials containing busts or heads to the Office of the Dead, the Psalter of the Virgin and the Hours

of the Virgin. There is the rare feature of an ornamental pattern of foreedge painting which perhaps is contemporary with the production of the manuscript. The artist of all but the poorly decorated final section is Hand B of the Munich Psalter (no. 23), with possibly an assistant working on some of the minor decoration. This is the artist's main work and most probably was done shortly after the Munich Psalter. Some writers have linked this Psalter with London, British Library MS Royal I. D. X (no. 28), but the two works are by distinctly different artists. Although perhaps a single workshop is involved it is best to consider two branches, one grouped around the Munich Psalter and the other around the Imola Psalter (no. 26).

The iconography of the New Testament scenes and the Canticles is close to that of the Munich Psalter. The added head of Christ on f. 2 is the image supposedly impressed on the handkerchief of St. Veronica who wiped Christ's face on the way to Calvary. This devotional image occurs in several mid century English manuscripts (e.g. nos. 88, 95, 111, 126 and a Missal, Paris, Bibl. Arsenal 135). These are all connected with the type of image where the shoulders are shown and not merely the head. The example in the Arundel Psalter may be stylistically the earliest of the group which would make it the earliest extant picture of the Veronica head in Western art. The version known to these English artists is close to the mosaic icon of a bust of Christ once set in middle of the apse of S. Giovanni in Laterano in Rome. The Veronica image was later frequently placed in devotional manuscripts as the recitation of a prayer before it was connected with an indulgence. In contrast with the Munich Psalter there are historiated initials at all liturgical divisions of the Psalter as was to become normal for luxury Psalters. The occurrence of the Hours of the Virgin Mary is unusual so early in the century whereas from c. 1220 it becomes more frequent (e.g. nos. 35, 36, 118) and eventually becomes an independent book (e.g. nos. 73, 158, 161, 185).

The text of the Calendar points strongly to Oxford having all three feasts of St. Frideswide whose relics were at the Augustinian priory there (12th Feb., 15th May, 19th October). In the Hours section there is a collect for Frideswide supporting the Oxford connection, and Augustinian involvement is suggested by Augustine heading the Confessors in the Litany. There are two other Augustinian manuscripts with minor decoration by the same artists (a Psalter, London, British Library MS Harley 2905 and a Missal for Lesnes, London, Victoria and Albert Museum, MS L. 404-1916).

As the historiated initials show influence from the Imola Psalter group a later date than the Munich Psalter and post-1204 seems certain (see no. 26).

PROVENANCE: S. Heveningham (f. 1). On the same leaf is recorded 'This book was bought of Capt. Bee by Mr. Simon Fox for the Rt. Honble. Henry Howard. 23rd. of March 1658'. The manuscripts of the Howard family, Earls of Arundel, were acquired by the British Museum in 1831.

LITERATURE: A. Haseloff, *Eine thüringisch-sächsische Malerschule des 13. Jahrhunderts*, Strasbourg, 1897 (repr. 1979), 160; C. Wordsworth, H. Littlehales, *The Old Service Books of the English Church*, London, 1904, 111; British Museum, *Reproductions*, III, pl. XVI; Herbert, *Illuminated Manuscripts*, 179; J. A. Herbert, 'A Psalter in the British Museum (Royal MS I. D. X)', *Walpole Society*, III, 1913-14, 49; British Museum, *Schools of Illumination*, pt. II, London, 1915, pl. 8; Millar, I, 45, pl. 66; Saunders, *English Illumination*, I, 57; Boeckler, *Abendländische Miniaturen*, 93ff.; Swarzenski, *Handschriften XIII Jh.*, 93 n. 28, 155 n. 3; Haseloff, *Psalterillustration*, 14 ff., Tab. 2; Tristram, *Wall Painting*, 230; R. Bernheimer, 'The Martyrdom of Isaiah', *Art Bulletin*, 34, 1952, 23, fig. 10; Boase, *English Art*, 280, pl. 91a; O. Pächt, 'The Avignon Diptych and its eastern ancestry', *Essays in Honor of E. Panofsky*, Princeton, 1961, 405, pl. 32, fig. 21; Rickert, *Painting in Britain*, 98 ff., pl. 98A; Deuchler, *Ingeborgpsalter*, 8 n. 22, 43, 78, 92 n. 66, 164 n. 284; Turner, 'Manuscript Illumination', 136; H. B. Graham, 'The Munich Psalter', *The Year 1200: a Symposium*, New York, Metropolitan Museum of Art, 1975, 302; Watson, *Dated Manuscripts*, no. 448, pl. 126.

EXHIBITED: New York, Metropolitan Museum, *The Year 1200*, 1970, no. 260.

25. Liverpool, City Libraries MS f. 091. PSA
Psalms with Gloss
395 × 258 mm., ff. 258.
c. 1200-10. (?) Winchester *Ills. 96, 97, 104*

Although this is a glossed psalter essentially intended for scholarly study it has a system of decoration appropriate to a liturgical Psalter. There are ten historiated initials at the normal liturgical divisions: Psalm 1, B, Tree of Jesse (f. 1); Psalm 26, D, Anointing of David (f. 43); Psalm 38, D, Judgement of Solomon (f. 69ᵛ); Psalm 51, Q, Doeg beheading priests of Nob (f. 91); Psalm 52, D, Temptation of Christ (f. 92ᵛ); Psalm 68, S, Jonah thrown to the whale (f. 117ᵛ); Psalm 80, E, Jacob wrestling with the angel (f. 145ᵛ); Psalm 97, C, Annunciation to the Shepherds (f. 170); Psalm 101, D, Ecclesia before Christ (f. 173); Psalm 109, D, Trinity (Gnadenstuhl type) (f. 192ᵛ). The first of the Canticles, Confitebor, has a large ornamental initial (f. 251).

The iconography of the psalm initials links this book with nos. 24, 26, 27. The style is connected to nos. 26 and 27 although it seems earlier and more related to French models like the Manerius Bible (Paris, Bibliothèque Ste. Geneviève MSS 8-10). This connection may suggest that there is a French element in the stylistic sources of the group whose main work is the Imola Psalter (no. 26) under which entry the problem of style is more fully discussed.

The suggestion of a Winchester provenance has been made only in view of the link with the Imola Psalter.

26. Imola, Biblioteca Comunale MS 100
Psalter (Imola Psalter)
287 × 210 mm., ff. 209 (partly in Roman numeration)
After 1204. (?) Winchester *Ills. 93, 101, 102*

Although lacking a series of prefatory miniatures this is one of the most sumptuous of all early 13th-century English Psalters. The Calendar is decorated with roundels of the Labours of the Months and Signs of the Zodiac: January, a man drinking from a horn (p. IV); February, a man warming himself by the fire (p. V); March, a man digging (p. VI); April, a seated man (p. VII); May, a man riding (p. VIII); June, a man weeding (p. IX); July, a man scything (p. X); August, a man cutting corn (p. XI); September, a man picking grapes (p. XII); October, a man sowing (p. XIII); November, a man killing pigs (p. XIV); December, a man feasting (p. XV).

At the beginning of the Psalter text is a full-page miniature with busts in roundels against a burnished gold ground representing the descendants of St. Anne (p. XX). Then follows (p. XXI) a full-page B for the first psalm containing a Tree of Jesse and scenes in roundels in the frame: David killing the bear, Anointing of David, David slinging at Goliath, David beheading Goliath, David harping before Saul, David writing the psalms, David as King. The first verses of Psalm 1 are set in large gold capitals against red and blue grounds with white rinceaux as a framed fully illuminated page. Small illuminated initials mostly ornamental but occasionally containing grotesques are at the beginning of each psalm and for the Canticles. The nine historiated initials at the liturgical divisions are exceptionally large with finely burnished gold grounds: Psalm 26, D, Anointing of David (p. 48); Psalm 38, D, Judgement of Solomon (p. 80); Psalm 51, Q, Doeg slaughtering the priests (p. 107); Psalm 52, D, Temptation of Christ (p. 109); Psalm 68, S, Jonah thrown to the whale (p. 137); Psalm 80, E, Jacob's dream and his wrestling with the angel (p. 174); Psalm 97, C, Annunciation to the Shepherds (p. 207); Psalm 101, D, Ecclesia holding a chalice before Christ (p. 211);

Psalm 109, D, Coronation of the Virgin (p. 243). All the decoration is by the same artist.

This is the highest quality book of a group of Psalters (nos. 25, 27, 28, 29) having close links with the Munich Psalter workshop. It is odd that such a luxury manuscript should lack a preliminary set of miniatures and it has been suggested that such a set has been lost. There is an affinity with the initial and text page layout of the Ingeborg Psalter (Chantilly, Musée Condé MS 1695) and possibly some similar model perhaps of late 12th-century Winchester origin was used for both. Some of the figures in the Imola Psalter have a fullness of form and naturalness of drapery suggesting such a source. If Winchester was one element in its stylistic origins then Northern France was another, and again the complex inter-relationships of the 'Channel style' around 1200 are evident.

A rare subject for illustration is the genealogy of St. Anne who, according to legend, had three husbands including one called Salome. This Salome was normally considered as female, being one of the three Maries who stood at the foot of the Cross, and a controversy arose concerning the theory of the three husbands of Anne. The matter was particularly debated in 12th-century England and the inclusion of the miniature suggests its owner was a supporter of the Salome legend.

There are only ornamental and not historiated initials to the Canticles, a feature which distinguishes the Imola Psalter group from the Munich Psalter group even though workshop collaboration subsequently occurs between the two groups.

A chronological list of major events (p. XVII–XVIII) in the same hand as the main text ends with the death of Eleanor of Aquitaine in 1204 so the Psalter must postdate that year.

The Calendar is probably Augustinian of the Winchester diocese: Edburga (15th June), Hedda (7th July), Grimbald (8th July), Edburga (18th July), Ethelwold (1st August), Transl. Birinus (4th September), Transl. Ethelwold (10th September), Transl. Augustine (11th October), Judoc (13th December). The very specific Winchester features suggest the possibility of a Winchester Benedictine Calendar (the Nunnaminster?) to which the translation of Augustine has been added as an Augustinian feature. The Litany is indisputably Amesbury-Fontevrault with St. Melor whose relics were at Amesbury third among the Martyrs and a number of West French entries characteristic of Fontevrault. The nunnery of Amesbury was of the Order of Fontevrault whose houses had a community of brothers attached to that of the nuns. The nuns followed the Benedictine rule but the brothers seem to have followed the Augustinian. If the Imola Psalter was made for a nun of Amesbury this situation might explain the Augustinian element. Amesbury was however in the diocese of Salisbury not Winchester and the Winchester text features support the suggestion that stylistic elements come from there. The added obit of Margaret de Quincey *'priorissa nostra'* in a 13th-century hand on 15th July confirm ownership by a religious community, but it has not

been possible to discover whether any other documents reveal a prioress of this name at Amesbury. The Winchester connections suggest the possibility that the workshop began there before moving to Oxford (see no. 28).

PROVENANCE: Unfortunately in a medieval inscription of ownership (p. III) by a Benedictine monastery dedicated to the Assumption the name of the place is illegible. John Parke, priest of the Savoy Hospital, London (p. I), 16th century. William Rogers (p. I) who was son-in-law of St. Thomas More. An inscription on the flyleaf ending THO.M. might suggest actual ownership by Thomas More but this is not in his handwriting. Frances Pulton (p. III). It has been suggested the Psalter may have reached Imola as a gift from the Old Pretender when he visited the Bishop of Imola in 1717. It came to the Biblioteca Comunale from the convent of S. Francesco. In 1858 Panizzi, the librarian of the British Museum, visited Imola and attempted to acquire the book for the collection (his visit is recorded on the flyleaf).

LITERATURE: R. Galli, *I manoscritti e gli incunaboli della Biblioteca comunale d'Imola*, Imola, 1894, LXXXIV-V; D. Fava, *Tesori delle Biblioteche d'Italia: Emilia e Romagna*, Milan, 1932, 34, fig. 16; Swarzenski, *Handschriften XIII Jh.*, 101 n. 2; Haseloff, *Psalterillustration*, 14 ff., Tab. 2, pls. 1, 2; R. Galli, 'Un prezioso salterio della Biblioteca Comunale d'Imola', *Accademie e Biblioteche d'Italia*, XV, 1940-1, 325-38; Morison, *'Black-Letter' Text*, 33; Boase, *English Art*, 282-4; Rickert, *Miniatura*, II, pls. I, II; Rickert, *Painting in Britain*, 98, pls. 96B, 99A; S. Mitchell, *Medieval Manuscript Painting*, London, 1965, pls. 88, 89; Deuchler, *Ingeborgpsalter*, 34, 43; Turner, 'Manuscript Illumination', 136; Ragusa, 'Lyre Psalter', 273 n. 25; H. B. Graham 'The Munich Psalter', *The Year 1200: a Symposium*, New York, Metropolitan Museum of Art, 1975, 302; N. J. Morgan, 'Notes on the Post-Conquest Calendar, Litany and Martyrology of the Cathedral Priory of Winchester with a consideration of Winchester Diocese Calendars of the Pre-Sarum period', *The Vanishing Past: Medieval Studies presented to Christopher Hohler*, ed. A. Borg, A. Martindale, BAR, Oxford, 1981, 133, 153, 157, 167 nn. 67, 72, 74, 168 nn. 80, 83, 169 n. 90, 170 nn. 103, 109, 110.

EXHIBITED: Rome, Palazzo di Venezia, *Mostra Storica Nazionale della Miniatura*, 1954, no. 463.

27. Oxford, Bodleian Library MS Liturg. 407
Psalter and Hymnal
140 × 100 mm., ff. 255
c. 1210. (?) Winchester *Ills. 94, 95*

This Psalter is unusually small for its time and is an early example of a growing fashion for smaller books. It has ten historiated initials with burnished gold grounds at the liturgical divisions and small ornamental initials for each Psalm: Psalm 1, B (full page), David fighting a lion or bear, David harping

(f. 9ᵛ); Psalm 26, D, Anointing of David (f. 40); Psalm 38, D, Judgement of Solomon (f. 59ᵛ); Psalm 51, Q, Doeg beheading Ahimelech (f. 76ᵛ); Psalm 52, D, David harping before Saul (f. 77ᵛ); Psalm 68, S, Jonah thrown into the whale (f. 94ᵛ); Psalm 80, E, Jacob wrestling with the angel (f. 117ᵛ); Psalm 97, C, the Virgin and Child (f. 137); Psalm 101, D, Ecclesia with a chalice kneeling before Christ (f. 140); Psalm 109, D, Christ seated blessing (f. 159).
The iconography of the psalm initials and the style of the painting are close to nos. 26 and 28. The Calendar (later adapted to Franciscan use in the 14th century) is very close to that of the Imola Psalter (no. 26) with the same Winchester features. An intended Amesbury ownership is suggested by the inclusion, highly graded in blue, of the 1st October feast of St. Melor whose relics were at Amesbury.

PROVENANCE: Amesbury Priory on the basis of the feast of St. Melor in the calendar. At some time before the early 14th century it must have passed into Franciscan hands as evidenced by the careful modification of the Calendar and the added Hymnal. 'frere Usebius Joublet' is a 17th-century inscription on f. 1. Purchased by the Bodleian Library in 1873 from the Revd. John C. Jackson.

LITERATURE: Frere, *Bibliotheca Musico-Liturgica*, no. 178; S.C., V, no. 29071; Boase, *English Art*, 280 n. 3; Ker, *Medieval Libraries*, 3; Rickert, *Painting in Britain*, 98, 99-100, 102; Pfaff, *New Liturgical Feasts*, 24, 123; Turner, 'Manuscript Illumination', 136; Pächt and Alexander, III, no. 360, pl. XXXI; H. B. Graham, 'The Munich Psalter', *The Year 1200: a Symposium*, New York, Metropolitan Museum of Art, 1975, 302; N. J. Morgan, 'Notes on the Post-Conquest Calendar, Litany and Martyrology of the Cathedral Priory of Winchester with a consideration of Winchester Diocese Calendars of the Pre-Sarum period', *The Vanishing Past: Medieval Studies presented to Christopher Hohler*, ed. A. Borg, A. Martindale, BAR, Oxford, 1981, 153, 157, 167 nn. 67, 72, 74, 168 nn. 80, 83, 169 n. 90, 170 nn. 103, 109, 110.

28. London, British Library MS Royal I. D. X.
Psalter
345 × 235 mm, ff. 139
c. 1210. Oxford *Ills. 99, 100, 103, 105; figs. 2, 6, 11*

The Psalter opens with sixteen full-page miniatures divided into two registers. One half of each has a burnished gold ground and the other half a coloured ground: 1. Annunciation, 2. Visitation (f. 1); 3. Nativity, 4. Annunciation to the Shepherds (f. 1ᵛ); 5. The Magi before Herod, 6. Adoration of the Magi (f. 2); 7. Dream of the Magi, 8. The Presentation in the Temple (f. 2ᵛ); 9. Flight into Egypt, 10. Massacre of the Innocents (f. 3); 11. Baptism, 12. Wedding at Cana (f. 3ᵛ); 13. Transfiguration, 14. Raising of Lazarus (f. 4); 15. Meal at the house of Lazarus, 16. Entry into Jerusalem (f. 4ᵛ); 17. The Last Supper, 18. The Washing of the feet (f. 5)

19. The Betrayal, 20, Denial of Peter by the fire, Christ before the High Priest (f. 5ᵛ); 21. The Flagellation, 22. Judas returns the money and hangs himself (f. 6); 23. The Crucifixion, 24. The Deposition (f. 6ᵛ); 25. Holy Women at the Tomb, 26. Descent into Hell (f. 7); 27. Christ's disappearance from the meal at Emmaus, 28. Doubting of Thomas (f. 7ᵛ); 29. Ascension, 30. Pentecost (f. 8); 31. Christ in Majesty surrounded by the Evangelist symbols (f. 8ᵛ).

Then follows the Calendar illustrated by roundels showing the Labours of the Months and Signs of the Zodiac: January, a man drinking from a horn (f. 9); February, a man warming himself by the fire (f. 9ᵛ); March, a man digging (f. 10); April, a seated man holding a flower (f. 10ᵛ); May, a man riding with a falcon (f. 11); June, a man scything (f. 11ᵛ); July, a man weeding a cornfield (f. 12); August, a man cutting corn (f. 12ᵛ); September, two men treading grapes (f. 13); October, a man sowing seeds (f. 13ᵛ); November, a man killing a pig (f. 14); December, three men feasting (f. 14ᵛ).

The Psalter text begins on f. 16 with a half-page B for Psalm 1 having tight concentric coils inhabited by white and blue lions. In the corners of the frame are four medallions: David fighting the lion, David harping, Saul threatening with a spear, David. Each psalm has a fully illuminated initial with the use of burnished gold, some being purely ornamental, others having figures or grotesque animals. There are red and blue ink line endings ornamented with animals, fish and heads. The psalms of the liturgical divisions have nine large historiated initials: Psalm 26, D, Anointing of David (f. 32); Psalm 38, D, Judgement of Solomon (f. 42ᵛ); Psalm 51, Q, David slays Goliath (f. 52); Psalm 52, D, Temptation of Christ (f. 52ᵛ); Psalm 68, S, the bust of Christ above a man in the water between two devils (f. 62); Psalm 80, E, Jacob wrestling with the angel (f. 74ᵛ); Psalm 97, C, the bust of the Virgin and Child (f. 86); Psalm 101, D, Ecclesia kneeling before a standing Christ holding a chalice (f. 87ᵛ); Psalm 109, D, God the Father seated with God the Son (f. 98).

This is the first manuscript connected with the Imola Psalter style where a link with Oxford and the Munich Psalter workshop becomes absolutely clear. One proof of this is that the Psalm 68 initial has the unusual feature of two devils which occurs in no. 24. In support of an Oxford link the Calendar has two of the feasts of St. Frideswide (12th Feb., 19th Oct.), but a textual model from the diocese of Winchester is still suggested by the feasts of Judoc, Edburga, Grimbald and Birinus (9th Jan., 15th June, 8th July and 3rd Dec.). Frideswide is invoked among the Virgins in the Litany and in general the liturgical evidence suggests an intended destination in the region of Oxford.

The style of the painter is well shown in the full-page miniatures. The figures are more carefully drawn with subtler and weaker modelling and in paler colours than in the work of the Munich Psalter workshop. Certain affinities in facial type and colour with the Westminster Psalter (no. 2) suggests the artist may have known similar work. The figures

still have some monumentality but are rather flat with a tendency to angularity in pose. If the miniature cycle reflects a similar model to the Ingeborg Psalter (Chantilly, Musée Condé MS 1695) as some writers have suggested, then the figure style could be described as having gone through a process of desiccation. This move away from the fullness and plasticity of form of the Transitional period is a general tendency in English painting of the second decade of the 13th century.

PROVENANCE: E.H. is inscribed on f. 15ᵛ in a 16th-century hand. The Royal collection into which the book passed became part of the British Museum in 1757.

LITERATURE: A. Haseloff, *Eine thüringisch-sächsische Malerschule des 13. Jahrhunderts*, Strasbourg, 1897 (repr. 1979), 160; Haseloff, 'Miniature', 320; Vitzthum, *Pariser Miniaturmalerei*, 16; British Museum, *Reproductions*, III, pl. XIV; Herbert, *Illuminated Manuscripts*, 176–9, pl. 21; J. A. Herbert, 'A Psalter in the British Museum (Royal MS I. D. X)', *Walpole Society*, III, 1913–14, 47–56, pls.; British Museum, *Schools of Illumination*, pt. II, pls. 6, 7; Warner and Gilson, I, 18, pl. 13; Millar, I, 45, pls. 64, 65; Saunders, *English Illumination*, I, 55–6, II, pls. 58c, 61, 62; Boeckler, *Abendländische Miniaturen*, 93ff.,; Swarzenski, *Handschriften XIII Jh.*, 85 n. 3; Haseloff, *Psalterillustration*, 14 ff., Tab. 2; Morison, *'Black-Letter' Text*, 34; Tristram, *Wall Painting*, 230; Boase, *English Art*, 280, pls. 91b, c; Rickert, *Miniatura*, II, pl. 4; Rickert, *Painting in Britain*, 98–9, pl. 99 B; Deuchler, *Ingeborgpsalter*, 8 n. 22, 37, 39, 164 n. 284; Turner, 'Manuscript Illumination', 136; R. Mellinkoff, *The Horned Moses in Medieval Art and Thought*, London, 1970, 70, fig. 71; G. Schiller, *Ikonographie der christlichen Kunst*, III. I, Gütersloh, 1971, fig. 311; H. B. Graham, 'The Munich Psalter', *The Year 1200: a Symposium*, New York, Metropolitan Museum of Art, 1975, 302; Watson, *Dated Manuscripts*, no. 857, pl. 127; N. J. Morgan, 'Notes on the Post-Conquest Calendar, Litany and Martyrology of the Cathedral Priory of Winchester with a consideration of Winchester Diocese calendars of the Pre-Sarum period', *The Vanishing Past: Medieval Studies presented to Christopher Hohler*, ed. A. Borg, A. Martindale, BAR, Oxford, 1981, 157, 167 nn. 65, 67, 74.

EXHIBITED: New York, Metropolitan Museum, *The Year 1200*, 1970, no. 261; Brussels, 1973, no. 41, pl. 23.

29. Edinburgh, National Library MS 10000 (olim 3141)

Psalter (Iona Psalter)
289 × 195 mm., ff. 152
c. 1210. Oxford *Ills. 98, 106*

The book is sparsely decorated but is a product of the highest quality. There are eight large ornamental and historiated initials to the psalms of the liturgical divisions: Psalm 1, B, a full-page painting in a frame

with four medallions of David harping and three musicians (f. 7); Psalm 26, D, ornamental (f. 25); Psalm 38, D, ornamental (f. 37); Psalm 68, S, ornamental (f. 58); Psalm 80, E, ornamental (f. 72ᵛ); Psalm 97, C, David harping (f. 85ᵛ); Psalm 101, D, ornamental (f. 88); Psalm 109 D, ornamental (f. 100ᵛ). In the margins of some pages are pen drawings in blue and red of grotesque animals. The line endings in blue and red ink have grotesques and decorative patterns.

The book was evidently intended for a Scottish Augustinian patron as suggested by certain feasts in the Calendar (9th Jan., Felanus, 4th Mar., Kieran, 7th Apr., Finan, 11th Oct., Transl. Augustine) but combined with Oxford features (12th Feb., Frideswide, 19th Oct., Frideswide). A full assessment of the Calendar is difficult because some of the gold and other entries have not been completed. Another saint venerated at Iona, Columba, has been written in stylus on June 9th presumably for intended writing in gold. The Litany confirms both the Scottish and Oxford connections having saints particularly associated with Iona (Columba, Bethine, Adamnan, Odran) and Frideswide. As Augustine heads the Confessors and some prayers are in the female gender an intended destination for the Augustinian nunnery of Iona seems certain. The Oxford elements suggest the Psalter was produced there in view of the strong stylistic connection with no. 28.

PROVENANCE: The Augustinian nunnery of Iona on the evidence of the Calendar and Litany. C. K. Norrie, who sold it in 1905. C. W. Dyson Perrins, sold after his death in 1960 and acquired by the National Library of Scotland.

LITERATURE: G. F. Warner, *Descriptive catalogue of illuminated manuscripts in the Library of C. W. Dyson Perrins*, Oxford, 1920, no. 3, 9–11, pl. III; Millar, I, 119; Nordenfalk, 'Psalterillustration', 116; Morison, *'Black-Letter' Text*, 33; D. McRoberts, *Catalogue of Scottish Medieval Liturgical Books and Fragments*, Glasgow, 1953, no. 9; Rickert, *Painting in Britain*, 98; *Sotheby Sale Catalogue*, 29th November 1960, Lot 101, pl. 4.

EXHIBITED: B.F.A.C., *Illuminated Manuscripts*, 1908, no. 33, pl. 32; Brussels, Bibliothèque Royale, *Trésors des Bibliothèques d'Écosse*, 1963, no. 8, pls. 4, 5.

30. New York, Pierpont Morgan Library MS M. 43

Psalter (Huntingfield Psalter)
315 × 230 mm., ff. 165
c. 1210–20. (?) Oxford *Ills. 107, 109, 113*

The Calendar (ff. 1–6ᵛ) has ornamental initials for the Kalends. Then follows (ff. 7–26ᵛ) a series of 40 full-page miniatures divided into two or four compartments with the scenes set against rectangular panels of gold, blue or pink-brown in alternating colours in the background. The series was once more extensive, there being a leaf removed after f. 14ᵛ, perhaps a gathering lacking after f. 22ᵛ, and the first folio of the cycle missing. The pictures are of the Old and New Testaments and of Martyrdoms of Saints: 1. Creation of the Sun and Moon, 2. Creation of Eve (f. 7); 3. Adam and Eve Eating the Forbidden Fruit, 4. Expulsion from Paradise (f. 7ᵛ); 5. Offering of Cain and Abel, 6. Murder of Abel (f. 8); 7. God reproaches Cain, Lamech shoots Cain, 8. Building of the Ark (f. 8ᵛ); 9. The dove comes to Noah, 10. Noah's drunkenness (f. 9); 11. Building of the Tower of Babel, 12. Abraham fighting the four kings (f. 9ᵛ); 13. Melchisedech offers bread and wine to Abraham, 14. Abraham adores the three Angels (f. 10); 15. Lot entertains the two Angels, 16. Destruction of Sodom and Gomorrah (f. 10ᵛ); 17. Sacrifice of Abraham, 18. Meeting of Rebeccah and Isaac (f. 11); 19. Jacob obtains Isaac's blessing, 20. Esau comes to Isaac (f. 11ᵛ); 21. Jacob wrestling with the Angel, 22. Jacob sends his sons to buy corn in Egypt (f. 12); 23. Joseph flees from Potiphar's wife, 24. Joseph interpreting the dream of the Butler and Baker (f. 12ᵛ); 25. Moses and the Burning Bush, 26. Moses and the Israelites crossing the Red Sea (f. 13); 27. The Israelites pick up the armour and weapons of the drowned army of Pharaoh, 28. Moses given the Tablets of the Law (f. 13ᵛ); 29. Moses striking down the Golden Calf, 30. The walls of Jericho fall at the sounding of the trumpet (f. 14); 31. Jephthah's daughter with a harp meets Jephthah at the door of his house, 32. Jephthah fulfils his vow by killing his daughter (f. 14ᵛ); 33. Elkanah with his wives Hannah and Peninnah, 34. Hannah and Elkanah kneel before Eli (f. 15); 35. Birth of Samuel, 36. Presentation of Samuel in the Temple (f. 15ᵛ); 37. Samuel anointing Saul, 38. Saul speaking to Samuel (f. 16); 39. Anointing of David, 40. David fighting Goliath (f. 16ᵛ); 41. David cutting off the head of Goliath, 42. Death of Saul and Jonathan (f. 17); 43. Absalom hanging by his hair from the tree, 44. Death of Absalom (f. 17ᵛ).

45. Annunciation to Zacharias, 46. Birth of John the Baptist (f. 18); 47. Zacharias writing the name John, 48. Annunciation to the Virgin Mary (f. 18ᵛ); 49. The Visitation, 50. The Nativity (f. 19); 51. Annunciation to the Shepherds, 52. Magi before Herod (f. 19ᵛ); 53. Massacre of the Innocents, 54. The Baptism (f. 20); 55. The first two Temptations of Christ, 56. The third Temptation of Christ (f. 20ᵛ); 57. Death of Lazarus, Lazarus in Abraham's bosom, 58. Death of Dives, Dives in Hell (f. 21); 59. Raising of Lazarus, 60. Entry into Jerusalem (f. 21ᵛ); 61. Judas receiving the pieces of silver from the chief priests, 62. The Last Supper (f. 22); 63. The Washing of the Feet, 64. The Betrayal (f. 22ᵛ); [at this point there must have been another gathering to complete the Passion sequence]; 65. Christ rising from the Tomb, 66. The Holy Women at the Tomb (f. 23); 67. Descent into Hell, 68. 'Noli me tangere' (f. 23ᵛ); 69. Martyrdom of St. Stephen, 70. Martyrdom of St. Laurence, 71. Martyrdom of St. Vincent (?), 72. Martyrdom of St. Hippolytus (?) (f. 24);

73. Martyrdom of St. Thomas of Canterbury, 74. Martyrdom of St. Edmund, 75. Martyrdom of a saint who carries his own head (St. Clarus has been suggested by James although his cult was exceedingly limited in England), 76. Martyrdom of St. Alban (?) (f. 24ᵛ); 77. Martyrdom of St. Peter, 78. Martyrdom of St. Paul, 79. Martyrdom of St. Andrew, 80. Martyrdom of St. James (f. 25); 81. Death of St. John the Evangelist, 82. Martyrdom of St. Matthew, 83. Martyrdom of St. Simon, 84. Martyrdom of St. Bartholomew (f. 25ᵛ); 85. St. Martin and the beggar, 86. St. Nicholas restores to life the three boys in the tub, 87. St. Benedict and St. Maurus, 88. St. Placidus saved from drowning (f. 26); 89. The three Maries, 90. St. Mary Magdalen speaking to a seated group, 91. Beheading of a female saint, perhaps St. Catherine (f. 26ᵛ).

Then follows the Psalter text beginning with a full-page miniature for the initial B of the first psalm (f. 27ᵛ). The B is filled with a Tree of Jesse and a roundel of David harping in the stem. It is a very elaborate Tree of Jesse containing twelve Prophets in addition to the direct line of Jesse. The frame has eight vesica-shaped medallions at the corners and in the middle of the sides. At the centre at the top is the Coronation of the Virgin and over the remaining medallions and border bars is represented the Last Judgement (Apostles, Saints, Cherubim and at the bottom the Devil in Hell). On the opposite page (f. 28) are the opening lines of the psalm in bands of gold capitals against alternate blue and pale brown grounds. Ornamental initials to all the psalms contain either figures, foliage ornament or grotesques. The line endings are fully painted and gilded with ornamental patterns, fish and dragons. The majority of the pages at the liturgical divisions of the Psalter have been removed but two remain: Psalm 68, S, Jonah thrown to the whale, Jonah coming out of the whale (f. 97); Psalm 109, D, Christ seated blessing (f. 156). Both have the opening words of the psalms set in large gold capitals illuminated as bands against pink and blue with white rinceaux patterns. From some of the psalm initials (e.g. f. 74ᵛ) extensions come out into the border ending in large triangular areas filled with ornament. The text ends in the middle of Psalm 118 at verse 113.

There are two main artists, one painting the main cycle of miniatures and the Beatus page, and another the scenes of the saints and the initials to Psalms 68, 109. The artist of the Old and New Testament scenes probably develops in part out of the style of the Oxford workshop (particularly no. 28) but derives certain features from the Leiden Psalter workshop (nos. 14-16). The figure compositions are animated in narrative with much use of gesture and glance to create this effect, as well as internal dark line in the folds to enhance the impression of lively narrative. The view expressed by Boase on the clumsy character of the drawing is difficult to justify. The artist is at a transitional stage between the monumental forms of c. 1200 and the energetic figure style of William de Brailes (see nos. 71-4) who must have studied in the Huntingfield Psalter workshop early in his career.

The cycle of Old Testament scenes (titles in French have been added by a c. 1300 hand) is related in some unusual features to that of the Munich Psalter (e.g. the Isaac and Joseph scenes). This connection combined with the link with de Brailes suggest an Oxford location for the workshop. Closely related in style are a Glossed Psalter (no. 31) and the Lothian Bible (no. 32) and the question of provenance is further discussed in their entries.

The series of pictures of the martyrdoms of saints four to a page is unusual. This arrangement is found in a Picture Book of the early 13th century perhaps from the North French abbey of St. Bertin (The Hague, Royal Library MS 76 F. 5). This Picture Book has many close links both stylistic and iconographic with English art and might be by an English artist deriving from the workshop of the Leiden Psalter (no. 14) or by a Frenchman influenced by such a style. The artist of the martyrdoms of the saints in the Huntingfield Psalter differs from his collaborator in using different colour combinations and more black drawing lines for the draperies and details of his figures.

The Huntingfield Psalter has been given a late 12th-century dating in some of the literature perhaps because its Calendar lacks the 29th December feast of St. Thomas Becket which is found in most English calendars by the end of the century. The Calendar offers no obvious indications of location and there is no litany. The ownership by the Huntingfield family is indicated by added 13th-century obits in the Calendar. The Roger de Huntingfield (19th June) could be either the man of that name who died in 1204 or 1252-57. A kneeling lady with a girl or young man depicted in the initial to Psalm 50 (f. 81) might possibly be the original owner.

PROVENANCE: A member of the Huntingfield family owned the book in the 13th century as evidenced by the family obits on June 9th and 19th. William Morris purchased the book in 1895 (his inscription of ownership on f. i). Richard Bennett (his bookplate). J. Pierpont Morgan acquired the book in 1902 and his private library eventually became incorporated as a public reference library of the State of New York.

LITERATURE: B. Quaritch, *Facsimiles of Illustrations in Biblical and Liturgical Manuscripts*, London, 1892, 10-11, pls. 8-12; Maunde Thompson, 'Notes', 219; *A Catalogue of the Early Printed Books and Manuscripts collected by Richard Bennett*, Guildford, 1900, no. 647; M. R. James, *Catalogue of Manuscripts and Early Printed Books from the Libraries of William Morris, Richard Bennett, Bertram 4th Earl of Ashburnham and other sources, now forming portion of the Library of J. Pierpont Morgan*, London, 1906, no. 16 with pls.; Herbert, *Illuminated Manuscripts*, 141; G. F. Laking, *A Record of European Armour and Arms*, London, 1920, I, 68-70, figs. 84, 85; Millar, I, 41, pl. 59b; A. Watson, *The early iconography of the Tree of Jesse*, Oxford, 1934, 109-10, pl. XXII; Swarzenski, *Handschriften XIII Jh.*, 92 n. 11, 158 n. 4; Haseloff, *Psalterillustration,*

8 ff., Tab. 1; M. Schapiro, 'Cain's Jaw-bone that did the first murder', *Art Bulletin*, 24, 1942, 205, fig. 2; Boase, *English Art*, 281, pl. 87; J. H. Plummer, *The Lothian Morgan Bible*, Ph.D. Dissertation, Columbia University, 1953, 47, pl. 14; Rickert, *Miniatura*, II, pl. 1; G. Henderson, 'Cain's Jaw-bone', *J.W.C.I.*, XXIV, 1961, 112 n. 26; G. Henderson, 'Late Antique influences on some English medieval illustrations of Genesis', *J.W.C.I.*, XXV, 1962, 192; Rickert, *Painting in Britain*, 97, 234; *Survey*, III, 114.

EXHIBITED: London, Society of Antiquaries, *English Medieval Paintings*, 1896, no. 5; B.F.A.C., *Illuminated Manuscripts*, 1908, no. 36, pl. 35; London, 1930, no. 27; New York, Pierpont Morgan Library, *The Written Word*, 1944–45, 30; New York Pierpont Morgan Library, *William Morris and the Art of the Book*, 1976, 101, no. 18, pl. 10.

31. Oxford, Bodleian Library MS Bodley 284
Psalter with gloss of Alexander Neckham
410 × 300 mm., ff. 307 +iii
c. 1210–20. (?) Oxford *Ill. 110*

Although this is a glossed psalter intended for scholarly study rather than liturgical use there are ten historiated initials at the liturgical divisions: Psalm 1, B, the Virgin and Child, David harping (f. 1); Psalm 26, D, Anointing of David (f. 53); Psalm 38, D, Solomon seated holding a sword (f. 94); Psalm 51, Q, David slinging at Goliath (f. 132); Psalm 52, D, Temptation of Christ (f. 133); Psalm 68, S, bust of Christ above with a man in the water with a devil below (f. 168); Psalm 80, E, Jacob wrestling with the angel (f. 196); Psalm 96, C, Samson carrying the gates of Gaza (f. 223ᵛ); Psalm 101, D, Ecclesia kneeling holding a chalice (f. 226); Psalm 109, D, Christ seated blessing (f. 242ᵛ). All the initials have burnished gold grounds. Occasionally (e.g. f. 132) from the pen initials come elaborate feathery extensions in red and blue ink forming vertical and horizontal border bars.
In style this book is related to the Huntingfield Psalter and the Lothian Bible (nos. 30, and 32). The iconography of the psalm initials is derived as abbreviated versions from Oxford manuscripts such as nos. 24 and 28. The subject for Psalm 97 of Samson carrying the gates of Gaza is unusual and also occurs in a contemporary Psalter from the parish church of St. Helen, Worcester (Exeter, Cath. Lib. MS. 3508). The later marks of ownership by the Augustinian Abbey of Cirencester suggests a link with the Oxfordshire/Worcestershire region which is supported by the evidence of the decoration. It is difficult to be certain whether the book was produced at Oxford or possibly Cirencester itself. In the 12th century these glossed texts were associated with monastic scriptoria but perhaps in the 13th century lay production in the towns may have been responsible for them. The commentary on the Psalms and Athanasian Creed is by Alexander Neckham (1157–1217) who was Abbot of Cirencester.

PROVENANCE: 'Cirencestrie' is written in several places in a late 14th-century hand (e.g. f. iii). Henry VIII, it was part of the Old Royal Library. Presented to the Bodleian Library by Charles Howard, Earl of Nottingham in 1604.

LITERATURE: *S.C.*, I, no. 2339; Ker, *Medieval Libraries*, 52; N. M. Haring, 'Commentaries on the Pseudo-Athanasian Creed', *Medieval Studies*, 34, 1972, 215, 220, 241; Bennett, *Thesis*, 108 n. 2; Pächt and Alexander, III, no. 359 pl. XXX; N. J. Morgan, 'Psalter illustration for the Diocese of Worcester in the 13th century', *Medieval Art and Architecture at Worcester Cathedral, British Archaeological Association Conference Transactions* (1975), London, 1978, 91–2, pl. XVIII A.

32. New York, Pierpont Morgan Library MS M. 791
Bible (The Lothian Bible)
470 × 320 mm., ff. 395
c. 1220. (?) St. Albans or Oxford *Ills. 108, 112*

The Lothian Bible is the most elaborately decorated English Bible of the 13th century, with a full-page frontispiece to Genesis and 66 historiated initials, many containing a series of scenes, to almost every book of the Bible. Some of these initials are on separate pieces of vellum pasted in, but several have been removed. The decoration begins with initials for the two Prologues: ornamental, with a bishop blessing in the centre (f. 1); a seated scribe, probably St. Jerome (f. 2ᵛ). The GENESIS frontispiece is a framed full-page miniature with a burnished gold ground: at the top is the Trinity in a quatrefoil surrounded by nine groups of busts of angels; below, the Holy Spirit passing over the Waters, the Fall of the Rebel Angels and the Rivers of Paradise; in the bottom zone are six Creation scenes set in roundels which are surrounded by concentric coils of foliage: God creates seven angels, Creation of the Firmament, Creation of the Earth, Creation of the Sun, Moon and Trees, Creation of the Birds and Beasts, Creation of Eve (f. 4ᵛ). A large initial I, also at the beginning of the text of GENESIS, which was pasted in on a separate piece of vellum, has been removed. The opening verses of GENESIS are in large capitals set in bands of alternating colours of white and red rinceaux on blue and pink grounds.
Several initials have been cut out or the pasted on pieces of vellum have been removed. The following remain: NUMBERS, God's command to Moses to number the people, Moses numbers the people, Destruction by earthquake of the men of Korah, Moses and Aaron speak to the people, Balak sends a message to Balaam, the Angel of the Lord before Balaam on the ass (f. 36ᵛ); DEUTERONOMY, Moses speaks to the people, God speaks to Moses, God tells Moses he will die before crossing into the Promised Land, the Crossing of the Jordan, the Burial of Moses (f. 48); JOSHUA, the Siege of Jericho, the Ark carried behind the trumpeters (f. 58ᵛ); JUDGES,

Annunciation of the Birth of Samson, the sacrifice of Manoah, (?) Samson with his father and mother, Samson fighting the lion (f. 66); RUTH, ornamental (f. 73); KINGS I, Presentation of Samuel in the Temple (f. 74ᵛ); a large ornamental initial (f. 75); KINGS III, Nathan and Bathsheba before David, Solomon riding on David's mule, Coronation of Solomon, Bathsheba pleads for Adonijah before Solomon, the death of Adonijah, the Judgement of Solomon (f. 93); CHRONICLES I, II, ornamental with tight concentric coils (ff. 112, 120ᵛ); ESDRAS I, mostly removed, but a scene of men building survives at the bottom (f. 131ᵛ); NEHEMIAH, Nehemiah standing holding a book (f. 136); ESDRAS II, ornamental with five seated figures in the stem (f. 138ᵛ); PROLOGUES TO TOBIT, Jerome in discussion with two bishops, Tobias standing (f. 142ᵛ); TOBIT, the Burial of the Dead, the blind Tobit instructs Tobias, Tobias bids farewell as he leaves with the Angel, Tobias instructed by the Angel to take the fish out of the river (f. 142ᵛ); JUDITH, Nebuchadnezzar sends Holofernes to war, the soldiers of Holofernes, the besieged city of Bethuliah, Judith comes before Holofernes, Judith beheading Holofernes, Judith brings the head of Holofernes back to Bethuliah (f. 145ᵛ); ESTHER, the Feast of Assuerus, Assuerus consults the wise men, Assuerus decrees that husbands should be rulers over wives, Esther and the virgins summoned, Esther brought to the bed of Assuerus, Assuerus chooses Esther as wife, the marriage feast for Esther, Mordecai set on the king's horse, Haman on the gibbet (f. 150); MACCABEES I, Antiochus (or Mattathias) with his soldiers (f. 153ᵛ); MACCABEES II, ornamental (f. 163).

The Psalter has a double text, Gallican and Hebrew, thus requiring two initials for each psalm: Psalm 1, David harping with musicians, the armed David stands before Saul, David and Goliath (f. 170); Psalm 26, ornamental (f. 175ᵛ); Psalm 38, ornamental (f. 179); Psalm 51, the pasted in initial has been removed (f. 182ᵛ); Psalm 52, ornamental (f. 182ᵛ); Psalm 68, ornamental (f. 186); Psalm 80, ornamental (f. 190ᵛ); Psalm 97, ornamental (f. 194ᵛ); Psalm 101, a group of kneeling figures representing the humble poor, Christ surrounded by the symbols of the Evangelists (f. 195); Psalm 109, God the Son, God the Father blessing (f. 199).

Then follows: PREFACE TO ISAIAH, Isaiah writing (f. 209ᵛ); ISAIAH, the Martyrdom of Isaiah (f. 209ᵛ); JEREMIAH, the prophet standing (f. 224); BARUCH, the prophet seated writing (f. 243); EZEKIEL, God handing a roll to the sleeping Ezekiel among the sleeping captives by the river Chebar, the people of Israel, God commands Ezekiel to eat the roll, Ezekiel prophesying to the Israelites (f. 245ᵛ); PROLOGUE TO DANIEL, bust of Daniel (f. 260ᵛ); DANIEL, Nebuchadnezzar dreams of the great image, Nebuchadnezzar consults the magicians and astrologers, he orders the worship of the image when the music sounds, the three Hebrews in the fiery furnace (f. 261); JOEL, the prophet seated (f. 270); HABAKKUK, the prophet seated (f. 275ᵛ); SOPHONIAS, the prophet seated (f. 276); HAGGAI, ornamental (f. 277); MALACHI, the prophet seated

(f. 279ᵛ); JOB, Job's flocks, the slaughter of Job's servants by the Chaldeans, Job comforted by his three friends, Job on the dungheap discussing with the friends and his wife, the Devil before God (f. 281); PROVERBS, Solomon crowned by a personification of Wisdom (f. 288); ECCLESIASTES, Solomon instructing Rehoboam (f. 294ᵛ); SONG OF SONGS, Solomon and the Bride (f. 296ᵛ); WISDOM, Solomon teaching (f. 298); ECCLESIASTICUS, Jesus ben Sirach points to the heavens (f. 302ᵛ).

PROLOGUE TO THE NEW TESTAMENT, bust of St. Jerome (f. 316); MATTHEW, Tree of Jesse, Matthew writing (f. 318); MARK, Mark seated, the Calming of the Storm, Healing of the Possessed Man, Healing of the Blind Man (f. 327ᵛ); LUKE, Baptism of Christ, Luke seated (f. 333ᵛ); JOHN, John seated, John in the cauldron of boiling oil, Raising of Lazarus (f. 343ᵛ); ACTS, the Ascension (f. 351); PETER I, Peter teaching (f. 363); PETER II, ornamental (f. 364); JOHN I, John seated writing (f. 365); JOHN II, III, ornamental (f. 366); APOCALYPSE, John's vision of Christ with the sword in his mouth (f. 367); ROMANS, Paul seated (f. 372ᵛ); CORINTHIANS I, II, GALATIANS, EPHESIANS, Paul seated (ff. 376ᵛ, 380, 383, 384); PHILIPPIANS, ornamental (f. 385ᵛ); THESSALONIANS I, Paul standing (f. 386ᵛ); THESSALONIANS II, ornamental (f. 387); COLOSSIANS, Paul seated (f. 387ᵛ); TIMOTHY I, bust of Paul (f. 388ᵛ); TIMOTHY II, ornamental containing a head of Paul (f. 389ᵛ); TITUS, PHILEMON, Paul seated (f. 390ᵛ); HEBREWS, ornamental (f. 391); LAODICEANS, bust of Paul (f. 393ᵛ). In the large initials (e.g. Numbers, Deuteronomy) the different scenes are set in medallions with foliage coils in between. All the initials have highly burnished gold grounds. Small ornamental gilded initials occur for the Prologues to the various books. The figure style is characterised by angularity and blockiness of forms. There is little suppleness in the poses and a tendency to stereotyped formulae of composition. The move away from the more monumental and natural figure styles of the years around 1200 is typical of the second and third decades of the 13th century.

The initials have elaborate frame systems extending into the margin to incorporate the several figure medallions which illustrate some of the books. Foliate rinceaux are extensively used to subdivide and fill spaces within these frames. The use of the separate pieces of vellum pasted in for many of the initials may be because the artists needed smoother vellum for their painting. It may alternatively be the result of some situation in the process of book production in connection with division of labour between artists and scribes.

The exceptionally detailed narrative illustrations for some of the initials (e.g. Esther and Judith) imply the knowledge of a large cycle of Old Testament pictures. Certain details of iconography perhaps suggest dependence on an Anglo-Saxon prototype of the 11th century (Henderson), or a model related to the Spanish 11th-century Bibles of Roda and Farfa (Godwin).

The very unusual iconography of the Trinity on

the Genesis page has the torsoes of God Father and Son set on one body. This may derive from Anglo-Saxon versions of the Trinity such as that in the Psalter, London, British Library MS Harley 603 (*Survey*, II, no. 64, pl. 210). Some of these iconographic motifs probably came through a more recent intermediary. An example would be the Judith and Esther scenes which are similar to the subjects in the Munich Psalter (no. 23).

The text of the Bible, having many unusual features, has been compared to St. Albans examples (e.g. *Survey*, III, no. 91) of the second half of the 12th century (Plummer, Bennett). This link, combined with the very faint St. Albans 14th-century press-mark which some have deciphered on f. 6, suggests the possibility of production at the Abbey. The theological complexity of some of the iconography (e.g. the Genesis page) suggests production for a learned patron.

The figure style is close to the second artist of the Huntingfield Psalter (no. 30), but is more refined in execution. If it is in fact the same artist he evidently took much more care over his work in the Lothian Bible. There are also links in style and iconography with the later Oxford workshop of William de Brailes (e.g. nos. 71, 74). These parallels and the iconographic similarities with the Munich Psalter suggest a possible Oxford origin for the artists, even if the evidence suggests that the text may have been written at St. Albans.

PROVENANCE: Perhaps at the Benedictine Abbey of St. Albans in the 14th century if the very faint mark on f. 6 can be accepted as a St. Albans pressmark. (?) John Dee, 1578; the date and the delta sign indicating his ownership on the gold ground on f. 4ᵛ. 'Magister Saunders' in a 17th-century hand in the margin on f. 228ᵛ. Brian Twyne (*c.* 1579–1644), the Oxford antiquary, has been read as possibly one of the names on an offset on f.a. The family of the Marquesses of Lothian had acquired the Bible by 1819 when the Duke of Wellington signed his name on f. 1 on a visit to the Lothian home, Blickling Hall. The manuscript was put up for sale in 1932, was bought by Philip Hofer and given by him in 1935 to the Pierpont Morgan Library.

LITERATURE: Swarzenski, 'Unknown Bible Pictures', 63; A. Heimann, 'Trinitas Creator Mundi', *J.W.C.I.*, II, 1938, 49 n. 4, pl. 7c; F. G. Godwin, 'The Judith illustration of the Hortus Deliciarum', *Gazette des Beaux Arts*, 36, 1949, 45; J. H. Plummer, *The Lothian Morgan Bible*, Ph.D. Dissertation, Columbia University, 1953; Millar, 'Fresh Materials', 288; Rickert, *Miniatura*, II, pl. 7; Rickert, *Painting in Britain*, 94, 233, pl. 94; W. von den Steinen, *Homo Caelestis*, Munich, 1965, I, 274–5, II, col. pl. preceding pl. 239; Brieger, *English Art*, 79–80, pls. 20, 22b; Henderson, 'Studies', II, 128 n. 65; L. Ayres, 'A Tanner manuscript in the Bodleian Library and some notes on English painting of the late twelfth century', *J.W.C.I.*, XXXII, 1969, 49–50; W. Braunfels, 'Dreifaltigkeit', *Lexikon der christlichen Ikonographie*, I, col. 534; Bennett, *Thesis*,

88 n. 2, 91, 95, 107–8, 131, 169, 182–4; Zahlten, *Creatio Mundi*, 68, 108, 125, 161, 262, figs. 116, 231, 233.

EXHIBITED: New York, Pierpont Morgan Library, *The Written Word*, 1944–45, 32; New York, Pierpont Morgan Library, *The First Quarter Century of the Pierpont Morgan Library*, 1949, no. 24, pl. 12; New York, Pierpont Morgan Library, *Liturgical Manuscripts*, 1964, no. 45; New York, Pierpont Morgan Library, *Mediaeval and Renaissance Manuscripts*, 1974, no. 16; New York, Metropolitan Museum, *The Year 1200*, 1970, no. 262.

33. Oxford, Bodleian Library MS Ashmole 1525
Psalter and Hymnal
305 × 208 mm., ff. 186
c. 1210–20. Canterbury *Ills. 114–118*

This elaborately decorated book has been much mutilated having several pages missing and many of the illuminations cut out. A major loss is all the pages that had the large initials of the liturgical divisions. The decoration begins with Labours of the Months (many cut out) Sand igns of the Zodiac of the Calendar in tinted drawing and of rather average quality: March, a man hoeing (f. 2); April, a man holding two leafy branches (f. 2ᵛ); September, a man with a scythe and bundles of corn (f. 4); October, a man sowing (f. 4ᵛ). Each psalm is accompanied by a collect, a rare feature, and both psalms and collects have decorative initials, the psalms all being historiated.

Seventy-six of these historiated initials remain: Psalm 2, a king seated at a lectern (f. 6); Psalm 4, a king standing before an altar on which is a reliquary shrine (f. 7); Psalm 5, kneeling king below a bust of Christ (f. 7ᵛ); Psalm 6, kneeling king (f. 8ᵛ); Psalm 8, Massacre of the Innocents (f. 10); Psalm 9, a king beheading a man (f. 10ᵛ); Psalm 10, standing man (f. 12); Psalm 11, bust of Christ above a crowned woman holding a chalice (f. 12ᵛ); Psalm 14, man presenting a book to a king (f. 13); Psalm 15, a woman kneels at the feet of Christ (f. 13ᵛ); Psalm 16, God the Father welcomes Christ rising from the tomb (f. 14); Psalm 17 v. 26 (a monastic division), Temptation of Eve, Annunciation (f. 15); Psalm 18, bust of Christ above a monk and a woman (f. 16ᵛ); Psalm 23, head of Christ above a crowned woman (Ecclesia) holding a chalice (f. 19ᵛ); Psalm 26, the large initial was evidently pasted in on a separate piece of vellum which has become detached (f. 21); Psalm 27, a man kneeling before an altar (f. 22); Psalm 28, man and woman presenting a lamb on an altar (f. 22ᵛ); Psalm 29, hand of God above a bishop and king (f. 23); Psalm 30, Christ standing (f. 24); Psalm 32, ornamental (f. 26ᵛ); Psalm 34, ornamental (f. 28ᵛ); Psalm 37, man kneeling before an altar (f. 31ᵛ); Psalm 39, bust of Christ above Ecclesia holding a chalice and Host (f. 32ᵛ); Psalm 40, man handing out loaves from a basket to a group (f. 33ᵛ); Psalm 43, bust of God above a group of figures (f. 35ᵛ); Psalm 45, bust of God above clerics with palms

(f. 37ᵛ); Psalm 47, the Lord in the city of God (f. 38ᵛ); Psalm 48, Moses with the Tablets of the Law (f. 39); Psalm 49, Christ as judge displays his wounds (f. 40); Psalm 50, David gazes at Bathsheba (f. 41); Psalm 54, Christ prays to his Father (f. 42); Psalm 56, a king sitting in judgement (f. 44); Psalm 57, Israelites worshipping the Golden Calf (f. 45); Psalm 58, men disputing with a king above a man and woman (f. 45ᵛ); Psalm 59, men besieging a town (f. 46ᵛ); Psalm 60, men praying to God beside Ecclesia with a chalice (f. 47ᵛ); Psalm 61, two kings disputing (f. 48); Psalm 62, a woman giving round objects, perhaps loaves, to a man (f. 48ᵛ); Psalm 63, Christ and angels above the Betrayal (f. 49ᵛ); Psalm 66, a king and his people praying to God (f. 52); Psalm 69, two monks disputing (f. 55ᵛ); Psalm 73, God brandishes a sword (f. 59ᵛ); Psalm 74, a group of figures (f. 60ᵛ); Psalm 76, Synagogue (f. 61); Psalm 77, Moses with the Tablets of the Law (f. 62); Psalm 78, a man stabbing another (f. 65ᵛ); Psalm 79, an archer (f. 66ᵛ); Psalm 80, a space left for an initial to be pasted has been later filled with an ornamental E (f. 67); Psalm 81, Christ standing between two priests (f. 67ᵛ); Psalm 82, bust of God sending fire from heaven upon a group of figures (f. 68); Psalm 83, a crowned woman before Christ (f. 69); Psalm 84, God blessing a king (f. 70); Psalm 86, a king sitting in a city (f. 71ᵛ); Psalm 87, God above a physician attending a sick king (f. 72); Psalm 88, a King before God (f. 73); Psalm 89, a saint praying (f. 75ᵛ); Psalm 90, a man before Christ treading on the lion and the serpent (f. 76ᵛ); Psalm 91, God blessing a female crowned saint (f. 77ᵛ); Psalm 92, Christ seated holding a book (f. 78); Psalm 93, God with a sword above a king and a man with an axe (f. 78ᵛ); Psalm 94, two priests before an altar (f. 79ᵛ); Psalm 95, David harping with a musician (f. 80ᵛ); Psalm 96, a king above a ring of flames (f. 81); Psalm 98, God and angels above people praying (f. 82); Psalm 100, a female figure standing before a seated Christ (f. 82ᵛ); Psalm 102, Christ praying (f. 84); Psalm 103, God creating the sun and moon (f. 85); Psalm 105, a man before a seated king (f. 88); Psalm 106, Descent into Hell (f. 90); Psalm 108, Flagellation of Christ, Judas hanging himself (f. 92ᵛ); Psalm 112, the three Hebrews in the furnace (f. 94); Psalm 114, God above Christ between two devils (f. 95ᵛ); Psalm 115, Christ as priest raising a chalice above an altar (f. 96); Psalm 118, an angel holding a sword with a knight in armour (f. 98); Psalm 119, a king harping before an altar (f. 108ᵛ).

In a few cases there are preparatory sketches for the historiated initials in the margins (e.g. ff. 33ᵛ, 37ᵛ, 39). The remaining initials to psalms and collects are mostly fully illuminated in gold and colours, and contain ornament, birds, animals, and grotesques. From f. 74 onwards parts of the book show that its decoration was completed in the early 14th century. From f. 141ᵛ both script and decoration are completely 14th century (the text being the monastic Canticles and Hymnal). The ornamental decoration of this part has some resemblance to the earliest work of the Ormesby Psalter (Oxford, Bodleian Library MS Douce 366).

This is a unique attempt in English 13th-century illumination to provide historiated initials to almost all the psalms. There are a few contemporary French examples (Haseloff, *Psalterillustration*, 33 ff.) and in some subjects they agree with Bodl. Ashmole 1525. The subjects of each initial usually refer to some verse of the psalm and further research may elucidate the many subjects, possibly Old Testament scenes, which have not been identified.

The figure style but not the foliage ornament is close to another Psalter of very similar size also made at Canterbury (no. 34). On the evidence of calendars the Ashmole Psalter was made for St. Augustine's Abbey whereas no. 34 was made for the Cathedral Priory. Probably secular illuminators were involved although the books might have been written out in the monastic scriptorium. The figure style of the Ashmole Psalter makes much more use of linear fold patterns than the Cathedral Priory Psalter. The stylistic connections are discussed in the entry for no. 34.

The Calendar is of St. Augustine's Abbey (Wormald) but the Litany is of the Cathedral Priory. The text of the Psalter is unusual in having Collects for each psalm. This feature also occurs in no. 34 and the same series is found in two early 14th-century English manuscripts, the Tickhill Psalter (New York, Public Library MS Spencer 26) and the Ormesby Psalter (Oxford, Bodleian Library MS Douce 366). Although the Canterbury location of the text is certain, there is some doubt as to whether Christ Church or St. Augustine's was the intended destination in view of the conflicting evidence of the Calendar and Litany. There may be some reflection of the situation when King John exiled the monks of Christ Church and transferred some of the monks from St. Augustine's to the Cathedral Priory.

PROVENANCE: Canterbury, St. Augustine's Abbey, on the evidence of the Calendar. By the early 14th century the book belonged to Christ Church for a Hymnal of the use of that house was added then. Various obits added in the Calendar probably when at Christ Church and include Thomas Golstone who was prior in the 16th century. Robert Bedingfield (16th century) written on flyleaf at end. Elias Ashmole (1617–92) gave his collection of manuscripts to Oxford University in 1677. In 1860 these were transferred from the Ashmolean to the Bodleian Library.

LITERATURE: W. H. Black, *Catalogue of the manuscripts bequeathed unto the University of Oxford by Elias Ashmole*, Oxford, 1845, cols. 1436–7; Frere, *Bibliotheca Musico-liturgica*, no. 172; F. A. Gasquet, E. Bishop, *The Bosworth Psalter*, London, 1908, 122 n. 1; S. C. Cockerell, M. R. James, *Two East Anglian Psalters at the Bodleian Library*, Oxford, Roxburghe Club, 1926, 25 n. 2; Wormald, *Kalendars*, I, 47; D. D. Egbert, *The Tickhill Psalter and related manuscripts*, New York, 1940, 12; L. Brou, *Psalter Collects*, H.B.S., LXXXIII, 1949, 57 (wrongly numbered as 155); Ker, *Medieval Libraries*, 37; H. Gneuss, *Hymnar und Hymnen im*

Englischen Mittelalter, Tübingen, 1968, 241, 250; Pfaff, *New Liturgical Feasts*, 23; Pächt and Alexander, III, no. 355, pl. XXX; P. M. Korhammer, 'The origin of the Bosworth Psalter', *Anglo-Saxon England*, 2, 1973, 180; M. Korhammer, *Die monastischen Cantica im Mittelalter*, Munich, 1976, 5, 12 n. 8, 24, 119, 121; M. H. Caviness, 'Conflicts between Regnum and Sacerdotium as reflected in a Canterbury Psalter of c. 1215', *Art Bulletin*, 61, 1979, 52–4, figs. 20, 22, 24, 26, 28, 31.

EXHIBITED: Oxford, Bodleian Library, *Latin Liturgical Manuscripts*, no. 45, pl. XIV.

34. Paris, Bibliothèque Nationale MS lat. 770
Psalter (Little Canterbury Psalter)
292 × 198 mm., ff. 249
c. 1210–20. Canterbury, Christ Church

Ills. 119–121

There are eleven miniatures on gold grounds and ornamental foliage initials at the liturgical divisions of the Psalter: Psalm 1, B, a full-page framed miniature with an unusual form of Tree of Jesse having the Virgin and Child surrounded by anthropozoomorphic Evangelists, Kings, Rivers of Paradise and Prophets in the frame (f. 11ᵛ); Psalm 21, two square miniatures of the Flagellation and Way of the Cross (f. 32ᵛ); Psalm 26, Saul threatening David, D, ornamental (f. 38ᵛ); Psalm 38, Saul plotting the death of David, D, ornamental (f. 55); Psalm 51, the Entombment and Crucifixion, Q, ornamental (f. 70ᵛ); Psalm 52, Ahimelech gives to David the hallowed bread and the sword of Goliath, Doeg kills Ahimelech and the priests of Nob, D, ornamental (f. 71ᵛ); Psalm 68, Saul's suicide, the Amalekite tells David of Saul's death, S, ornamental (f. 87ᵛ); Psalm 80, Crowning of David, Joab's defeat of Abner, E, ornamental (f. 105ᵛ); Psalm 97, the Emperor Julian and Maurice Tiberius as types of avaricious and evil rulers, the burial of Julian struck down by heaven for his evil ways, C, ornamental (f. 124); Psalm 101, Resurrection, 'Noli me tangere', D, ornamental (f. 127); Psalm 109, the Trinity (f. 142); D, ornamental (f. 143ᵛ).

The iconographic programme is unusual and has been explained as presenting a political allegory on the evil and avaricious policy of King John towards the Church. The monks of Christ Church Canterbury for whom this Psalter was probably made had good reason to hate the King. John had refused to recognise Stephen Langton as Archbishop, supported as candidate by the Pope and the monks; this resulted in the Papal interdict on England (1208–13) and the King's revenge on the monks by imposing exile on them. The veiled pictorial allegory with evil rulers like Saul and the Emperor Julian personifying King John is a subtle comment on the politics of the time. At the beginning of the new reign of Henry III it was significant that the wall paintings on the vaults of the Trinity Chapel at Canterbury represented good kings of England affirming belief in just rule. The Christological subjects at Psalms 51, 101 reflect

an old Anglo-Saxon tradition (e.g. *Survey*, II, no. 80). It is unusual for Psalm 21 to be singled out for decoration with subjects of the Passion. The opening words of this psalm and several verses refer to the events of the Crucifixion and it was read for private devotion. It is often included in later Books of Hours as a Psalm of the Passion.

The format of the illustrations in rectangular frames rather than as historiated initials is rare. It is paralleled for some psalms in the Psalter, Paris, Bibliothèque Ste. Geneviève 1273, illustrated by a French artist, having a Rochester-type Litany and an added St. Bertin Calendar.

The figure style is characterised by lively poses conveyed by the outline but not supported by internal drawing. The paint is applied thickly with little modelling giving a rather flat effect. The apparent incompatibility between the drawing and painting style has led to a suggestion that there may have been underdrawings by the artist of a Peter of Poitiers manuscript (no. 43c) whose sensitivity was lost by overpainting. This theory is not wholly convincing for although the outline styles and facial types are related they are not quite identical.

There are two artists working on the 'Little Canterbury Psalter' (so-called to distinguish it from no. 1). The lively poses, where figures have thin legs, are related to the Miracles of Becket depicted in stained glass in the Trinity Chapel at Canterbury. The thick painting, use of colour and heavy dark outline derive from earlier work at Canterbury by one of the artists (e.g. f. 15ᵛ) working on the 'Great Canterbury Psalter' (no. 1). A contrast with this earlier work is the complete lack of colour modelling of the faces. The ornament of the initials is of a foliage type which is dry and flat, far removed from the fleshier forms predominant around 1200.

The Calendar is basically of Christ Church Canterbury but was modified by a contemporary hand for Cluniac use. Perhaps there was a change in intended destination at the time of the preparation of the manuscript. The Litany is however of Christ Church use. As for no. 33, the liturgical evidence might suggest the book was made during the exile of the Christ Church monks, for Faversham (founded from Cluniac Bermondsey but independent of Cluny itself). Some monks from Faversham were transferred by the King to the Cathedral Priory; this brought about close associations between the two places at the time. During the 13th century the book passed into lay hands as suggested by an added secular text 'Les jours perilleux' and the obit of a member of the d'Estouteville family added to the calendar on 11th October.

PROVENANCE: Christ Church Priory, Canterbury, on the evidence of the calendar. A Cluniac house (unidentified). The d'Estouteville family owned the book before the end of the 13th century. Colbert (1619–83), whose arms are on the cover, who was a descendant of the d'Estouteville family. Colbert's books entered the French Royal collection in 1732 and this collection eventually became part of the Bibliothèque Nationale.

LITERATURE: P. Meyer, 'Bribes de littérature anglo-normande, IV: Les jours perilleux', *Jahrbuch für romanische und englische Literatur*, VII, 1866, 47–51; L. Delisle, 'Livres d'Images destinés à l'instruction religieuse et aux exercices de piété des Laïques', *Histoire Littéraire de la France*, XXXI, 1893, 275–6; F. A. Gasquet, E. Bishop, *The Bosworth Psalter*, London, 1908, 69 ff; Wormald, *Kalendars*, I, 64; Nordenfalk, 'Psalterillustration', 117; D. D. Egbert, *The Tickhill Psalter and related manuscripts*, New York, 1940, 12; V. Leroquais, *Les psautiers manuscrits des bibliothèques publiques de France*, Mâcon, 1940–1, no. 294; L. Brou, *Psalter Collects*, H.B.S., LXXXIII, 1949, 55; Ker, *Medieval Libraries*, 39; B. Woledge, H. P. Clive, *Répertoire des plus anciens textes en prose française*, Geneva, 1964, 81; Pfaff, *New Liturgical Feasts*, 105; M. H. Caviness, 'A lost cycle of Canterbury paintings of 1220', *Antiquaries Journal*, LIV, 71, pl. XXII c; M. H. Caviness, *The Early Stained Glass of Canterbury Cathedral*, Princeton, 1977, 47, 69, 97, 130, 154, figs. 98, 126, 192; W. H. Monroe, 'A Roll-manuscript of Peter of Poitiers' Compendium', *Bulletin of the Cleveland Museum of Art*, LXV, 1978, 104, figs. 15, 16; M. H. Caviness, 'Conflicts between Regnum and Sacerdotium as reflected in a Canterbury Psalter of ca. 1215', *Art Bulletin*, 61, 1979, 38 ff., figs. 1, 3, 4, 6–8, 11, 12, 14, 17, 19, 21, 23, 25, 27, 29, 37.

35. Berlin, Kupferstichkabinett MS 78. A. 8

Psalter and Hours of the Virgin (Margrete Skulesdatter's Psalter)

286 × 195 mm., ff. 158

c. 1210–20. (?) London *Ills. 122, 123, 130*

The Calendar is decorated with the Labours of the Months in rectangular frames and the Signs of the Zodiac in roundels: January, a man feasting (f. 1ᵛ); February, a man warming himself by the fire (f. 2); March, a man pruning a tree (f. 2ᵛ); April, a standing woman holding flowers (f. 3); May, a man falconing (f. 3ᵛ); June, a man raking (f. 4); July, a man scything (f. 4ᵛ); August, a man reaping (f. 5); September, a man gathering grapes (f. 5ᵛ); October, a man threshing corn (f. 6); November, grazing pigs (f. 6ᵛ); December, slaughter of a pig (f. 7).

A series of seven full-page miniatures painted only on one side of the vellum precedes the Psalter text. The paintings are in dull browns, greens and blues with highly burnished gold grounds. Each miniature is divided into two registers: Annunciation, Nativity (f. 8ᵛ); Annunciation to Shepherds, Adoration (f. 9ᵛ); Presentation, Baptism (f. 10ᵛ); Temptation of Christ, Raising of Lazarus (f. 11ᵛ); Entry into Jerusalem, Washing of the Feet (f. 12ᵛ); Last Supper, Betrayal (f. 13ᵛ); Crucifixion, Deposition (f. 14).

There are ten large historiated initials at the liturgical divisions and small ornamental initials to all other psalms. These initials have dragon extensions into the margins with pen flourishes coming out of their mouths. The historiated initials are: Psalm 1, a full-page framed B containing the Coronation of the Virgin and David harping with a musician (f. 14ᵛ); Psalm 26, D, Crowning of David or Solomon (f. 32ᵛ); Psalm 38, D, Judgement of Solomon (f. 44); Psalm 51, Q, Doeg murdering the priests (f. 53); Psalm 52, D, Musicians (f. 53ᵛ); Psalm 68, S, Jonah thrown to the whale and coming out of the whale (f. 67); Psalm 80, E, at top a bust of Christ in a mandorla between two musicians, below, Jacob's dream and his wrestling with the angel (f. 80); Psalm 97, C, Annunciation to the Shepherds (f. 92); Psalm 101, D, a young man, King and Queen kneeling before Christ (f. 93ᵛ); Psalm 109, D, the Trinity (f. 104ᵛ).

This is an early example of the combination of the Psalter text with the Hours of the Virgin. At the beginning of the Hours is a historiated initial of the Virgin and Child (f. 143).

The style is characterised by blocky figure forms with hook-like black lines delineating the folds. The faces are bland and expressionless without any modelling. The colours are very distinctive with brown, green, yellow, blue and gold predominating. The facial type and certain static and truncated poses suggest a possible idiosyncratic derivation from the Huntingfield Psalter, Oxford workshop (nos. 30–32). From the textual evidence of the two manuscripts closely related to the Berlin Psalter (nos. 36, 37), the workshop may have links with London.

The exceptionally large historiated initials occupying almost half the page for Psalms 51, 101 suggest a predominant tradition of a three-part division of the Psalter on to which the smaller initials of the eight-part liturgical division have been grafted. The historiated initials have several subjects in common with earlier 13th-century Oxford manuscripts (e.g. nos. 24, 28) which supports the stylistic evidence of some derivation from Oxford illumination.

The text model suggests an Augustinian house possibly having some link with Hartland in Devon which possessed the relics of St. Nectan. This is inferred from the presence in the Calendar of the feasts of Nectan (17th June), Octave of Augustine (4th Sept.), Translation Augustine (11th Oct.), and in the Litany Augustine being listed second among the Confessors and Sidwell (relics at Exeter) invoked among the Virgins. The very rare entry of St. Osyth of Aylesbury (3rd June) usually points to some link with the Oxford region which may result from the connections already mentioned in respect of style and iconography. The one clear conclusion that can be made from the text analysis is that the Augustinian canons were in some way involved.

The Psalter was very possibly intended for a royal owner as suggested by the group kneeling before Christ in the initial to Psalm 101 where donor portraits are often placed (13th-century instances are to be found in nos. 51 and 166). By the middle of the 13th century it had come into the possession of a member of the Norwegian royal family as the obits of the kings and archbishops of Norway added to the Calendar show. The last of these to die was

Duke Skuli (23rd May) in 1240. He was the father of Margrete Skulesdatter, the queen of Haakon Haakonson, and it has been suggested she was the owner. If this theory is acceptable it must have been passed to her son Haakon and on his death in 1257 to his wife Rikissa. Rikissa had entered in the calendar the obits of her parents and she is the first certain owner of the book. The original King, Queen and their son (if these figures in Psalm 101 in any way imply ownership) for whom the Psalter may have been prepared could possibly be King John of England, Queen Isabella and their son Henry, later Henry III. Presumably as the queen is represented at the head of the group she is the intended owner. The theory that the book was made for Margrete Skulesdatter, who was identified as the queen with her son in this initial, cannot be upheld. Her son was not born until the 1230s which would be a date too advanced on grounds of style.

The cover was added when the manuscript was in Germany in the mid 14th century and has miniatures set under translucid horn.

PROVENANCE: (?) Margrete Skulesdatter, queen of Norway (1225–70). Probably given to her son Haakon the Younger (d. 1257). It passed to his wife Rikissa on his death and she had added the obits of her husband (30th April) and mother, the Duchess Ingeborg of Sweden (17th June), and an added prayer in the female gender mentions these (f. 158v). Some writers have interpreted the evidence of these obits to suggest it belonged to the 14th-century Duchess Eufemia of Mecklenburg. It was acquired in the mid 14th century by a Heinrich von Itzendorp as a note records his donation of it to the Benedictine nunnery of Buxtehude. It entered the Berlin Library in 1835 from the collection of Karl Ferdinand Friedrich von Nagler (1770-1846).

LITERATURE: E. Jørgensen, 'Meddelelse om et Psalterium, som fordum var i norsk Eje', (Dansk) Historisk Tidskrift, III/4, 1910-12, 219 ff.; Kunst og Kultur, 1914-15, 138-140 with pls.; H. Fett, Norges Malerkunst i Middelalderen, Kristiana, 1917, 6, 38, with figs.; P. Wescher, Beschreibendes Verzeichnis der Miniaturen des Kupferstichkabinetts der Staatliche Museen Berlin, Leipzig, 1931, 46-8, figs. 37-8; Haseloff, Psalterillustration, 14 ff., Tab. 2; A. Filip Liljeholm, 'Drottning Rikissa Birgersdotters Andaktsbok', Nordisk Tidskrift och Bibliotheksväsen, 45, 1958, 130 ff., figs. 1, 2; P. Bloch, 'Bemerkungen zu zwei Psalterien in Berlin und Cambridge', Berliner Museen, N.F. 9, 1959, 6-12, figs. 1, 2, 5, 6; Brieger, English Art, 82; Rickert, Painting in Britain, 98, 100-1, 234 n. 35; T. Gad, 'Psalter', Kulturhistoriskt Lexikon för nordisk medeltid, XIII, 1968, 586-7; Ragusa, 'Lyre Psalter', 275 n. 36; P. Verdier, Le Couronnement de la Vierge, Paris, 1980, 100; J. S. Golob, The Glossed Psalter of Robert de Lindesey, Ph.D., Cambridge, 1981, 31-45, passim.

EXHIBITED: Oslo, Universitets Oldsaksamling, Middelalderkunst fra Norge i andre Land, 1972, no. 2, fig. 2; Berlin, Staatlichen Museen, Berlin-Dahlem,

Zimelien: Abendländische Handschriften des Mittelalters aus den Sammlungen der Stiftung Preussischer Kulturbesitz Berlin, 1976, no. 184; Berlin, Staatsbibliothek Preussischer Kulturbesitz, Das Christliche Gebetbuch im Mittelalter, 1980, no. 11.

36. Cambridge, St. John's College MS D. 6
Psalter with Gloss and Hours of the Virgin
275 × 183 mm., ff. 180+v
c. 1210–20. (?) London Ills. 124, 125, 131

This is a sister book to no. 35. The Calendar only has roundels with the Signs of the Zodiac without any illustrations of the Labours of the Months. The Hours of the Virgin precede the Psalter and have at the beginning a large historiated initial of the seated Virgin and Child (f. 18). The colours of this and all the illuminations are brown, green, pale yellow and blue with burnished gold grounds. Small minor initials to the sections of the Hours are in gold, green and brown.

A set of four full-page framed miniatures against burnished gold grounds precedes the Psalter text. They are painted only on one side of the vellum and are divided into two registers: Annunciation to the Shepherds, Magi before Herod (f. 27v); Adoration of the Magi, Massacre of the Innocents (f. 28v); Presentation, Baptism (f. 29v); Entry into Jerusalem, Betrayal (f. 30v). At the liturgical divisions are historiated initials and minor decorative initials to the other Psalms. The line endings in blue and red ink are purely ornamental. The ten historiated initials are: Psalm 1, a full-page B with tight concentric coil ornament, David harping and corner roundels of Musicians and Prophets (f. 31v); Psalm 26, D, Crowning of David or Solomon (f. 50v); Psalm 38, D, Judgement of Solomon (f. 63); Psalm 51, Q, Slaughter of the priests of Nob (f. 74v); Psalm 52, D, David as harpist with another musician (f. 75); Psalm 68, S, Jonah thrown to the whale, Jonah coming out of the whale (f. 87); Psalm 80, E, bust of Christ in a mandorla flanked by two musicians, below, Jacob's dream and his wrestling with the angel (f. 102); Psalm 97, C, Annunciation to the Shepherds (f. 116); Psalm 101, D, a crowned woman (Ecclesia?) with an attendant kneeling before Christ (f. 118); Psalm 109, D, Coronation of the Virgin (Ecclesia), (f. 132).

The style is identical to no. 35 and the books are probably by the same artist. The iconography of the Life of Christ scenes and the psalm initials differ slightly between the two psalters. The texts differ in that the St. John's copy has both an interlinear and marginal gloss.

A now erased inscription of ownership on the flyleaf has been read as 'Psalterium Abbatis Roberti de Lindeseye'. Robert de Lindesey was Abbot of Peterborough (1214–22) and is recorded (S. Gunton, The History of the Church of Peterburgh, London, 1686, 29) as owning two Psalters, one glossed and one without a gloss. The other Psalter also survives

with its inscription of ownership still readable (no. 47) but is by a completely different artist.

The liturgical evidence suggests that the book was not intended for Peterborough destination. The Calendar has some characteristics of the diocese of London (30th April, Erkenwald, 7th October, Osyth, 11th October, Ethelburga) with those of Erkenwald and Ethelburga highly graded in red. The occurrence of St. Olaf (29th July) is unusual. The origin of the Litany is unclear but Nicholas has a double invocation among the Confessors and Ethelburga is listed among the Virgins.

The crowned woman in the initial to Psalm 101 may be the original owner rather than Ecclesia as it is not usual for an attendant to be present in the scene of Ecclesia before Christ. A possible intended owner would be Isabella, the queen of King John. The subsequent ownership by Robert de Lindesey means that the production of the book must antedate his death in 1222.

On f. 1 is marked a price of 20 shillings probably at a date in the 13th century; this is presumably the cost of the book.

PROVENANCE: Robert de Lindesey, Abbot of Peterborough (d. 1222). Thomas Maksey if a 15th-century note of his name on the front flyleaf can be taken to imply ownership. Frater Rogerus Birde, monachus, 1533, an inscription on the back flyleaf. William Crashaw (1572–1626). Given to St. John's College by Thomas Wriothesley, Earl of Southampton, in 1635.

LITERATURE: James, *Catalogue*, no. 81; Miller, I, 120; Saunders, *English Illumination*, I, 66, II, pl. 69; Haseloff, *Psalterillustration*, 14 ff., Tab. 2; B. Dickens, 'The Cult of St. Olave in the British Isles', *Saga Book of the Viking Society*, 12, 1937–45, 65 n. 1; P. Bloch, 'Bemerkungen zu zwei Psalterien in Berlin und Cambridge', *Berliner Museen*, N.F. 9, 1959, 8 ff., figs. 3, 4, 7, 8; Baltrušaitis, *Reveils et Prodiges*, 140, fig. 26; Ker, *Medieval Libraries*, 151; Rickert, *Painting in Britain*, 98, 100; Turner, *Early Gothic*, 12; Brieger, *English Art*, 82; J. S. Golob, *The Glossed Psalter of Robert de Lindesey*, Ph.D., Cambridge, 1981.

EXHIBITED: B.F.A.C., *Illuminated Manuscripts*, 1908, no. 34, pl. 33; Brussels, 1973, no. 43.

37. London, British Library MS Lansdowne 420
Psalter
308 × 220 mm., ff. 156
c. 1220–30. (?) London *Ills. 126–129*

The Calendar pages are set within a thin frame of gold (as in no. 7) and have medallions with gold grounds illustrating the Labours of the Months and Signs of the Zodiac: January, a man feasting (f. 2); February, a man warming himself by the fire (f. 2ᵛ); March, a man pruning a tree (f. 3); April, a man holding two foliage sprays (f. 3ᵛ); May, a man hawking (f. 4); June, a man cutting out weeds (f. 4ᵛ);

July and August page lacking; September, a man gathering fruit (f. 5); October, a man threshing (f. 5ᵛ); November, a man tending pigs (f. 6); December, a man slaughtering a pig (f. 6ᵛ).

Then follows a series of eleven full-page framed miniatures with two scenes to a page set in roundels. The gold grounds have small punched star decorations and the predominant colours in the painting are carmine red and bright blue. The scenes illustrated are: Annunciation, Visitation (f. 7); Nativity, Annunciation to the Shepherds (f. 7ᵛ); Journey of the Magi, Magi before Herod (f. 8); Adoration, Dream of the Magi (f. 8ᵛ); Death of Herod, Coronation of Archelaus, Joseph's Dream and Flight into Egypt (f. 9); Christ teaching, Joseph advised by the angel to return from Egypt, the return from Egypt, a scene with people seated at table (f. 9ᵛ); Baptism, Temptations of Christ (f. 10); Raising of Lazarus, Entry into Jerusalem (f. 10ᵛ); Washing of the Feet, Last Supper (f. 11); Betrayal, Mocking of Christ (f. 11ᵛ); David harping with a musician (f. 12).

There is a full-page B for the first psalm with animal musicians and in the corner medallions seated prophets, and in the side medallions David harping and a man with an ape on a chain (f. 12ᵛ). For each psalm there is an illuminated initial with figure busts, fish and grotesques in brown, green and yellow wash. The line endings are in red and blue ink with fish, hands, heads and ornamental patterns. Pen flourishes with large fish extend into the borders and occasionally isolated dragons, fish or grotesque heads are drawn in the margin. All the pages with historiated initials at the liturgical divisions have been removed except for Psalm 38, D, Judgement of Solomon (f. 47ᵛ).

Although the figure style is the same as for the two preceding Psalters (nos. 35, 36) the colour of the prefatory miniatures dominated by red and blue is quite different. The dull palette of blue, brown, green and yellow which characterises the other books does occur in the psalm initials. The choice of a new format with the prefatory miniatures set in circular frames is another innovation. Both the colour and the circular frame format may derive from contemporary French Psalters. The format of these frames is found in the Psalter of Blanche of Castile (Paris, Bibl. Arsenal MS 1186) and in certain Psalters of the Bible Moralisée workshop (e.g. Paris, Bibl. Nat. MS nouv. acq. lat. 1392). The date of these manuscripts is unlikely to be much before 1225. If this theory of French influence on the Lansdowne Psalter is accepted then it would be rather later in date than nos. 35, 36. Another new feature which may also derive from France is a characteristic stamp pattern for punching gold grounds which also occurs in the Ingeborg Psalter (Chantilly, Musée Condé MS 1695), although this is also found earlier in England in works like no. 13. The older literature unconvincingly linked the style with the early 13th-century Oxford group of manuscripts (nos. 24, 28) and equally unconvincingly interpreted liturgical evidence to suggest a Chester provenance. The Calendar indisputably points to

the diocese of London (24th April, Mellitus, 30th April, Erkenwald, 20th May, Ethelbert, 7th October, Osyth, 11th October, Ethelburga, 14th November, Translation of Erkenwald) both Erkenwald feasts and that of Ethelburga of Barking being in red. The Litany is unspecific. The London evidence of the Calendar combined with that from no. 36 suggests the workshop may have been based there.

PROVENANCE: On May 24th in the Calendar is added the obit of David Hulse of Norbury, Cheshire, who died in 1436. An inscription on the flyleaf records ownership by Lord Somers (1651–1716), Joseph Jekyll (1663–1738) and James West (d. 1772). William Petty, Marquess of Lansdowne (1737–1807) acquired the manuscript and his collection was purchased by the British Museum in 1807.

LITERATURE: Herbert, *Illuminated Manuscripts*, 179–80; E. Jørgensen, 'Meddelelse om et Psalterium, som fordum var i norsk Eje', (*Dansk*) *Historisk Tidskrift*, III/4, 1910–2, 223; J. A. Herbert, 'A Psalter in the British Museum (Royal MS I.D.X)', *Walpole Society*, III, 1913–14, 49; Millar, I, 119; Saunders, *English Illumination*, I, 55, 57; Rickert, *Miniatura*, II, pl. 5; Rickert, *Painting in Britain*, 98, 100, pl. 96A; Deuchler, *Ingeborgpsalter*, 164 n. 284; J. Smits van Waesberghe, *Musikerziehung, Lehre und Theorie der Musik in Mittelalter*, Leipzig, 1969, 52; M. S. Frinta, 'Punchmarks in the Ingeborg Psalter', *The Year 1200: a Symposium, New York, Metropolitan Museum of Art*, 1975, 253, fig. 4; J. S. Golob, *The Glossed Psalter of Robert de Lindesey*, Ph.D., Cambridge, 1981, 46–52, passim.

38. Cambridge, Corpus Christi College MS 75
Psalter with Gloss
422 × 285 mm., ff. 280
c. 1220. (?) East Anglia *Ills. 132, 133*

Although this is not a liturgical Psalter but one with a scholarly commentary it is illustrated by ten historiated initials with burnished gold grounds at the liturgical divisions: Psalm 1, B, ornamental with very tight concentric coils populated by white-red lions (f. 2ᵛ); Psalm 26, D, 'Noli me tangere' (f. 44ᵛ); Psalm 38, D, Judgement of Solomon (f. 71ᵛ); Psalm 51, Q, Noah's drunkenness (f. 94); Psalm 52, D, Balaam on his ass with the Angel (f. 95); Psalm 68, S, Jonah thrown to the whale, Jonah out of the whale (f. 122); Psalm 80, E, a nude figure above a seated figure with a scroll (f. 154); Psalm 97, C, Annunciation to the Shepherds (f. 180ᵛ); Psalm 101, D, a youth and a man kneeling before a city (f. 184ᵛ); Psalm 109, D, Annunciation (f. 208). There are ten small illuminated initials to the gloss preceding the psalms at the divisions (ff. 1, 44, 71, 93ᵛ, 95, 121ᵛ, 154, 180ᵛ, 184ᵛ, 208).
The figures are attenuated and are lively in pose, an effect enhanced by much internal drawing of fold patterns in black. The faces are modelled in a characteristic ruddy way. Another odd technique is the use

of a chalk-green colour with folds drawn in pink for some of the draperies.
This work has no connection with the Glossed Gospels, Cambridge, Trinity College MS. B. 5. 3 (no. 3) as James suggested, but the style may be a linearised small-scale version of some *c.* 1200 model (Ayres). The iconography of some of the initials (e.g. Psalms 26, 51, 109) is quite unlike other contemporary English Psalters and may be a result of some tradition for illumination of the glossed text. James linked the book to St. Albans on the basis of script but in the absence of any detailed study of this oft-mentioned 'St. Albans script' such an attribution should be viewed with caution. The same artists decorated a liturgical Psalter (no. 39) and the arguments for a possible production in the East Anglia region are discussed in that entry.

PROVENANCE: Matthew Parker, Archbishop of Canterbury from 1559 to 1575 bequeathed his books to Corpus Christi College in 1574. This manuscript is listed in the inventory of the bequest annotated by his son John Parker in 1593.

LITERATURE: James, *Catalogue*, no. 75; Nordenfalk, 'Psalterillustration', 116; Brieger, *English Art*, 85, pl. 26 a; L. M. Ayres, 'A Tanner manuscript in the Bodleian Library and some notes on English painting of the late twelfth century', *J.W.C.I.*, XXXII, 1969, 48–9, pl. 7b; Ragusa, 'Lyre Psalter', 273 n. 25.

EXHIBITED: Cambridge, Corpus Christi College, *Matthew Parker's Legacy*, 1975, no. 24, pl. 24.

39. London, British Library MS Lansdowne 431
Psalter
332 × 225 mm., ff. 130
c. 1220–30. (?) East Anglia *Ills. 134, 135*

The Calendar has roundels with the Labours of the Months and Signs of the Zodiac on blue and pink grounds: January, a Janus headed man holding cups (f. 4); February, a man warming himself by the fire (f. 4ᵛ); March, a seated man (f. 5); April, a man pruning a bush (f. 5ᵛ); May, a man falconing (f. 6); June, a man scything (f. 6ᵛ); July, a man cutting corn (f. 7); August, a man threshing (f. 7ᵛ); September, a man picking grapes (f. 8); October, a man grazing pigs (f. 8ᵛ); November, slaughtering of pigs (f. 9); December, two men feasting (f. 9ᵛ).
A large, regrettably slightly damaged, framed B for Psalm 1 occupies two thirds of the page (f. 11). The initial is filled with very tight concentric coils populated with lions, rabbits, squirrels and nude and clothed men fighting. Around the B are the four symbols of the Evangelists, two standing prophets with scrolls, David and Goliath, a juggler and a man with an ape. There are medallions in the frame containing Ecclesia, Synagoga, David harping, a musician, St. Paul and Moses.

Eight large initials with gold grounds mark the liturgical divisions: Psalm 26, D, ornamental (f. 26); Psalm 38, D, Judgement of Solomon (f. 35ᵛ); Psalm 51, Q, Doeg slaughters the priests of Nob, David fighting Goliath on the extension to the initial (f. 43ᵛ); Psalm 52, D, Temptation of Christ (f. 44); Psalm 68, S, Jonah thrown to the whale, Jonah out of the whale (f. 53); Psalm 80, E, four seated musicians (f. 64ᵛ); Psalm 97, C, the Annunciation to the Shepherds (f. 74ᵛ); Psalm 109, D, Coronation of Ecclesia (f. 85). The first of the Canticles, Confitebor, has a large ornamental initial (f. 105ᵛ).

The lesser psalm initials are in gold or blue with blue, green and brown wash infills, and the line endings are ornamental designs in red and blue penwork.

The figure style is a later version of that of the Glossed Psalter discussed in the previous entry (no. 38). The fold style has become more fluid than in the earlier work but in other aspects such as the ruddy facial modelling there is little change. This latter feature and other general aspects of figure style may derive from the Lindesey Psalter group (nos. 45–7). In a very general way the style is similar to the initials of the Psalter, Cambridge, Trinity College MS B. 11. 4 (no. 51). The subjects depicted in the initials of the psalm divisions in contrast to the artist's earlier product (no. 38) are much more usual, and Haseloff linked them with the group of Psalters which have some connections with Oxford (nos. 24, 25, 26, 28).

The Calendar and Litany suggest the Psalter was intended for an Augustinian house in East Anglia. The Calendar has been said (Rickert) to be of Barnwell, near Cambridge, and there are certainly several entries in common with the accurate Barnwell Calendar in the *Liber Memorandum* (London, British Library MS Harley 3601). These are Oswald (28th Feb.), Erkenwald (30th Apr.), John of Beverley (7th May), Leutfred (21st June), Sexburga (6th July), Withburga (8th July), Olaf (29th July), Inv. Alban (2nd Aug.), Radegund (13th Aug.), Osyth (7th Oct.), Translation of Augustine (11th Oct.), Translation of Etheldreda (17th Oct.). The characteristic East Anglian entries are Sexburga, Withburga, Translation of Etheldreda (relics at Ely), on the 29th April the Translation of St. Edmund (not in Harley 3601) whose relics were at Bury, Olaf who was the dedicatory saint of the Augustinian priory of Herringfleet (Suffolk), and Osyth whose relics were at the Augustinian nunnery of Chich (Essex). In spite of these connections with the Barnwell calendar, in general there is not sufficient similarity definitely to suggest production for that house. A particular omission is the feast of dedication of the priory on 21st April. The evidence does however point to an East Anglian destination and this is supported in the Litany in which Olaf, Withburga and Sexburga are invocations sufficiently unusual to be of significance.

The inclusion of the Office of the Dead and the Commendation of the Soul in the text is an early example of a feature which later in the 13th century becomes quite normal in Psalters.

The absence of the feast of the Translation of St.

Thomas of Canterbury in the Calendar has suggested to some a pre-1220 date for the Psalter, but the absence of a feast is never a firm means of dating.

PROVENANCE: (?) An Augustinian house in East Anglia, possibly Barnwell. Soon after its production the Psalter passed to a Precentor 'E' of Chichester Cathedral as suggested by the added obits of Bishop Ranulf (d. 1224) on 15th September and of the Precentor's father John (24th Apr.) and mother Avicia (26th Sept.). A now erased 15th-century inscription on f. 11 has apparently been read according to a note on the flyleaf as an invocation to pray for the souls of John Howard and his wife Alice. This is perhaps the John Howard (d. 1426) whose brass was once at Stoke-by-Nayland (Suffolk), and whose wife was Alice Tendring. On f. 2 a 1543 inscription to pray for the soul of Thomas Broune, a Mercer of Bury St. Edmunds. Thomas Hird's inscription of ownership on the flyleaf. The bookplate has the arms of William Petty, Marquess of Lansdowne (1737–1807). His collection of manuscripts was purchased by the British Museum in 1807.

LITERATURE: H. N. Humphreys, *The Illuminated Books of the Middle Ages*, London, 1849, pl. 11; A. Haseloff, *Eine thüringisch-sächsische Malerschule des 13. Jahrhunderts*, Strasbourg, 1897 (repr. 1979), 235; C. Wordsworth, H. Littlehales, *The Old Service Books of the English Church*, London, 1904, 111–12; Millar, I, 119; Haseloff, *Psalterillustration*, 11, 14 ff., Tab. 2; Rickert, *Painting in Britain*, 98, 101; Brieger, *English Art*, 85.

40. London, British Library MS Harley 5102
Psalter
310 × 230 mm., ff. 139
c. 1220. (?) East Midlands *Ills. 136–140*

A series of five full-page framed miniatures in two registers with gold and red grounds, and painted on one side of leaves blank on the verso, have been bound into the Psalter: the Burial of St. Thomas of Canterbury (f. 17); Martyrdom of St. Thomas of Canterbury (f. 32); Sacrifice of Isaac, two seated bishops (f. 68); Saints Peter and Paul standing, two seated saints (f. 118); Peter walking on the water, Christ speaking to the Apostles (f. 129). These miniatures are quite distinct in style from the rest of the illumination in the book.

The Psalter has a parallel French translation up to f. 23 where it breaks off. Nine large ornamental and historiated initials with gold grounds having punch dot designs mark the liturgical divisions: Psalm 1, a full-page framed B on a blue patterned ground having tight coil foliage in the initial (f. 1); Psalm 26, D, the Anointing of David (f. 23ᵛ); Psalm 38, D, ornamental (f. 37ᵛ); Psalm 51, Q, Saul ordering Doeg to slay the priests, on the tail of the initial an ape shooting an arrow at a hybrid creature (f. 49); Psalm 52, D, a king in a tower with two women

standing on either side (f. 49ᵛ); Psalm 68, S, God above a man in the water (f. 61); Psalm 80, E, David harping with three musicians (f. 77ᵛ); Psalm 97, C, ornamental (f. 90ᵛ); Psalm 109, D, the Trinity above two kings (f. 104). All the other psalms have illuminated ornamental initials, some containing animals in grotesque situations and occasionally figures. There are very simple ornamental penwork line endings.

This Psalter has been dated in the late 12th century in much of the literature, probably on account of the style of the full-page miniatures. These are, however, additions and are either by a very archaic artist or have been re-used from an earlier book. The figures are flat and wooden in pose with stylised patterned folds. The origins of this style are not clear and it has been suggested that the artist may not be English (Rickert). His figure style certainly in a general way is part of the 'Channel style' of the late 12th century when Anglo-French interrelationships are so predominant. If, as seems likely, these miniatures are re-used leaves of the late 12th century, then the representations of the Martyrdom and Burial of St. Thomas of Canterbury are very early examples of these subjects.

The Psalter itself is probably of the early 1220s, the figure style of the historiated initials having a general similarity to no. 39. The figures are, however, more sophisticated in pose and modelling and there is no direct influence between the two. The punch dot design on the gold contrasts with the plain gold of no. 39. This feature was used earlier in no. 15 from the North Midlands workshop of the Leiden Psalter (no. 14) and in the Ashmole Bestiary (no. 19) also having a Midlands provenance. In the absence of any Calendar or Litany to provide liturgical evidence for provenance these rather vague parallels for style and technique have led to an East Midlands attribution for this manuscript, but only as a tentative suggestion. The description (Rickert) of the Psalter as a sister manuscript to British Library MS Lansdowne 420 (no. 37) is difficult to understand as there seems to be no obvious connection between the two.

The inclusion of animals and grotesques in the initial is a significant step towards their eventual appearance in the borders later in the century. Many of the animals are in narrative situations parodying human activities. Examples are the ram musician on f. 50 or a fox with bag and stick on f. 75ᵛ.

PROVENANCE: Various names have been written on the miniatures, initials and in the margins, all probably of 16th-century date: Peter Coffin (f. 54), Rafe Couche, Cateryn Newell (f. 118), and Dene Grenwell (f. 10ᵛ). These have the appearance of 'graffiti' and probably do not provide any direct evidence of ownership. The book was acquired by Robert (1661–1724) or Edward (1689–1741) Harley. The Harley manuscripts were acquired by the British Museum in 1753.

LITERATURE: S. Berger, *La Bible française au Moyen Age*, Paris, 1884, 402–3; Herbert, *Illuminated Manuscripts*, 141; G. F. Laking, *A Record of European Armour and Arms*, London, 1920, I, 114, fig. 140; Millar, I, 118; Saunders, *English Illumination*, I, 53, II, pls. 34b, c, 35, 58b; British Museum, *Reproductions*, IV, pl. XV; T. Borenius, *St. Thomas Becket in Art*, London, 1932, 92, 100, pl. XXXVII; Haseloff, *Psalterillustration*, 8 ff., 13, Tab. 1; H. W. Janson, *Apes and Ape Lore in the Middle Ages and the Renaissance*, London, 1952, 52, 70 n. 108, pl. IXb; Boase, *English Art*, 288; B. Woledge, H. P. Clive, *Répertoire des plus anciens textes en prose française*, Geneva, 1964, 98; Rickert, *Painting in Britain*, 98, 100, 234; E. Brayer, A.-M. Bouly de Lesdain, 'Les prières usuelles annexées aux anciennes traductions françaises du Psautier', *Bulletin d'Information de l'Institut de Recherches des Textes*, 15, 1967–8, 73; C. E. Wright, *Fontes Harleiani*, London, 1972, 107, 117, 171, 251; H. Waddams, *Saint Thomas Becket 1170–1970*, London, 1969, pls. on 15, 19; *Survey*, III, 116.

EXHIBITED: London, British Museum, *Illuminated Manuscripts and Bindings of Manuscripts exhibited in the Grenville Library*, 1923, no. 20.

41. London, British Library MS Cotton Claudius B. VI

Chronicle of Abingdon
315 × 216 mm., ff. 202
c. 1220. Abingdon Abbey *Ill. 111*

At the beginning of the text a mid 15th-century miniature of a battle scene (f. 3) has been added. The Chronicle is illustrated by nineteen small rectangular miniatures inserted in the text depicting the Kings and Queens of England: Ini, King of Wessex (f. 6); Cynewulf, King of Wessex (f. 9ᵛ); Egbert, King of Wessex (f. 12); Ethelbald, King of Wessex (f. 13); Queen Ethelswith, Queen Aelfleda (f. 14); Athelstan (f. 18); Edred (f. 33ᵛ); Eadwig (f. 43); Edgar (f. 63); Edward the Martyr (f. 85ᵛ); Ethelred the Unready (f. 87ᵛ); Canute (f. 106); Harthacanute (f. 108ᵛ); Edward the Confessor (f. 109ᵛ); William I (f. 119ᵛ); William II (f. 124); Henry II (f. 169ᵛ); Richard I (f. 176ᵛ). Some leaves are perhaps lacking as this series is incomplete.

The seated figures in various postures are set against burnished gold grounds. The style derives from that of the Oxford workshop of the Huntingfield Psalter (no. 30). In the Abingdon Chronicle the figures are more lively and there is much more use of line in the folds, both features suggesting a slightly later date than the Huntingfield Psalter. As Abingdon is near Oxford it is to be expected that the artists working for the Abbey should have a connection with the leading illuminators' workshop operating in that region.

The dating of the chronicle to the late 13th century (Davies) is quite unacceptable in view of the style of the illuminations which are unlikely to be later than the 1220s or 30s. The text is a revised version of an

early 13th-century copy of the Chronicle (London, British Library MS Cotton Claudius C. IX).

PROVENANCE: The Benedictine Abbey of Abingdon. Thomas Allen (1540–1632). Sir Robert Cotton (1571–1631). Presented to the Nation by his grandson, Sir John Cotton, in 1700 as part of his Library. The collection was incorporated in the British Museum in 1753.

LITERATURE: T. F. Dibdin, *The Bibliographical Decameron*, London, 1817, I, lxxx–lxxxii; J. Stevenson, *Chronicon Monasterii de Abingdon*, 2 vols., *Rolls Series*, 1858, I, xv–xvi, frontispiece pl. (full edition of text); Hardy, *Descriptive Catalogue*, II, 470–1; F. M. Stenton, *The Early History of the Abbey of Abingdon*, Reading, 1913, 1–5; G. R. C. Davies, *Medieval Cartularies of Great Britain*, London, 1958, 2; Ker, *Medieval Libraries*, 3; Brieger, *English Art*, 138 n. 1; Munby, *Connoisseurs*, 74; A. G. Watson, 'Thomas Allen of Oxford and his manuscripts', in ed. M. B. Parkes, A. G. Watson, *Medieval Scribes, Manuscripts and Libraries. Essays presented to N. R. Ker*, London, 1978, 284 n. 26, 299, 309.

42. Oxford, St John's College MS 61
Bestiary
295 × 207 mm., ff. 103
c. 1220. (?) York *Ills. 14; 6 p. 8*

The Bestiary text is illustrated by framed fully-painted miniatures with either burnished gold grounds with punch dots or fully-painted blue, pink or red grounds. The first miniature is full page divided into four scenes: Creation of the Birds and Animals, Creation of Eve, Temptation of Adam and Eve, Expulsion from Paradise (f. 1v). Then follows a full-page miniature of Adam naming the animals (f. 2). The Bestiary text begins with an ornamental initial on f. 2v followed by the series of 94 pictures of the creatures: Lion, a full-page miniature divided into three registers (f. 3v); Tiger (f. 5v); Leopard, Panther (f. 6v); Antelope (f. 8v); Unicorn (f. 9); Lynx (f. 10); Griffin, Elephant (f. 10v); Beaver (f. 12v); Ibex (f. 13); Hyena (f. 13v); Bonnacon (f. 14v); Ape (f. 15); Satyr (f. 15v); Stag (f. 16); Goat (f. 17); Wild Goats (f. 18); Monoceros, Bear (f. 18v); Leucrota (f. 19v); Parandrus, Fox (f. 20); Yale, Wolf (f. 21); Dog (f. 23v); Sheep (f. 25v); Ram (f. 26); Lamb, He-Goat (f. 26v); Camel (f. 27); Dromedary (f. 28); Donkey, Wild Ass (f. 28v); Horse (f. 29v); Cat, Mouse, Weasel (f. 32v); Mole (f. 33); Hedgehog (f. 33v); Ants (f. 34); Vultures (f. 37); Cranes (f. 37v); Parrot (f. 38v); Caladrius (f. 39); Stork (f. 40); Swan (f. 40v); Ibis (f. 41); Ostrich (f. 41v); Coot (f. 42); Halcyon (f. 42v); Phoenix (f. 43); Phoenix emerging from flames (f. 43v); Cinnamolgus (f. 45); Ercinea, Hoopoe (f. 45v); Pelican (f. 46); Owl (f. 46v); Siren (f. 47); Partridge, two scenes (ff. 47v, 48); Magpie (f. 49); Hawk (f. 49v); Nightingale, Bat (f. 50); Raven (f. 50v); Crow (f. 51); Dove (f. 51v); Turtle-doves (f. 52v); Swallow (f. 53v); Quail (f. 54v); Peacock, Hoopoe (f. 55); Cockerel (f. 55v); Duck (f. 56); Bees (f. 57); Perindeus Tree (f. 59v); Dragon (f. 61); Basilisk (f. 62); Viper (f. 62v); Asp (f. 64v); Scitalis (f. 65v); Amphisbaena, Hydrus (f. 66); Boas, Jaculus, Siren serpent (f. 67); Seps, Lizard (f. 67v); Salamander (f. 68); Saura, Stellio (f. 68v); a Snake shedding its skin (f. 69v); Fire Stones (f. 103v). The last picture has an inscription of ownership by the Benedictine priory of Holy Trinity, York, incorporated as part of the miniature.

This book is based on a luxury copy of *c.* 1200 of the class that James called the Second Family. There is still some attempt to achieve the painterly modelling of the faces and on the bodies of the beasts which must have been in a mature form in the model. This model must have been of the style of the Aberdeen or Ashmole Bestiaries (nos. 17, 19). The gold grounds are heavily burnished to give a luxurious appearance. The figure painting is not however of the highest standard and there is a dry linearism and stiffness of pose transforming the more vigorous style used as a model. The iconography of this fully-painted model was perhaps very similar to that of the drawings in the Cambridge Bestiary (no. 21). In many features and in the sequence of pictures, the St. John's Bestiary is linked with that manuscript. Ultimately this iconography derives from the Leningrad Bestiary (no. 11) which represents a transitional phase between the First and Second Families of Bestiaries (McCulloch). The four scenes of f. 1v were probably not in the model, for, although Creation scenes occur in earlier Bestiaries, the Temptation and Expulsion scenes do not. Several pages are missing as recorded in an 1816 inscription on f. 1.

The ownership by Holy Trinity priory, York, and the iconographic links with the Lincoln region Cambridge Bestiary suggests a Lincolnshire or Yorkshire provenance. The inscription of ownership seems contemporary since it is part of the pictorial composition on f. 103v, and the production may have been in York itself.

PROVENANCE: Holy Trinity priory, York, an alien Benedictine house, as evidenced by a large contemporary inscription included in the miniature on f. 103v. Given by William Paddy to St. John's College in 1634 (f. 3).

LITERATURE: T. F. Dibdin, *The Bibliographica Decameron*, London, 1817, I, lxxxiv; Coxe, *Catalogue*, St. John's, 17; Druce, 'Elephant', 35, pl. V; Druce, 'Medieval Bestiaries I', 64, 81, pl. XVI; Druce, 'Medieval Bestiaries II', 36, 43, 46, 60, pls. II, VII; Millar, I, 117; James, *Bestiary*, 18, 53, suppl. pls. 17, 18; A. Watson, *The early iconography of the Tree of Jesse*, London, 1934, 49; Saxl and Meier, III, 412; Baltrušaitis, *Reveils et Prodiges*, 131, fig. 19C; McCulloch, *Bestiaries*, 36 passim; Ker, *Medieval Libraries*, 218; K. Varty, *Reynard the Fox*, Leicester, 1967, 152; Munby, *Connoisseurs*, 74; Einhorn, *Spiritalis Unicornis*, 79, 278, 338; M. B. Freeman, *The Unicorn Tapestries*, New York, 1976, 72, fig. 89.

43 (a), (b), (c), PETER OF RIGA, 'DE OPERIBUS
SEPTEM DIERUM' AND PETER OF POITIERS,
'COMPENDIUM HISTORIAE IN GENEALOGIA
CHRISTI'.

These works of Peter of Riga and Peter of Poitiers
are abbreviated versions of Biblical history and
genealogy probably intended for a readership in less
exalted scholarly circles than those frequented by
their authors. Peter of Poitiers was Chancellor of the
University of Paris (1193–1205) and his contempo-
rary, Peter of Riga (d. 1209) was a canon of St. Denis.
The illustrated versions of their works pose a prob-
lem because in spite of the Parisian origin of the
texts the large majority of copies seem to be English.
The illustrated Peter of Poitiers Genealogy was
particularly popular in 13th-century England (e.g.
nos. 90, 177) and it has only been possible to include
a few copies in this volume, of which these three are
the earliest. Another problem is the appearance of
this text in both book and roll form. The simplest
explanation of the use of the roll is that genealogies
were throughout the Middle Ages often presented in
this form. These rolls are vertical rather than hori-
zontal as in the Guthlac and Velletri Rolls (nos. 22,
and 155). The text exists in various versions: (i)
standard form, e.g. nos. 43(a) and (c), (ii) with
interpolations from Petrus Comestor's Historia
Scholastica, (iii) as part of a universal chronicle,
e.g. nos. 43(b), 90.
All the 13th-century copies have illustrations in
tinted drawing. The three included in this entry
show different styles in this technique which was so
widespread in England during the first half of the
century. The highest quality drawing is in the copy
in Cambridge, no. 43(a). There is no evidence of
provenance and the style is not specific enough to
suggest an exact location. The British Library copy,
no. 43(b), is related in iconography but is in a dif-
ferent drawing style with more sketchy use of line.
The Cleveland copy, no. 43(c), has been linked
(Monroe) with Canterbury manuscripts (e.g. nos.
33, and 34) and to the stained glass depicting the
miracles of St. Thomas in the Corona of the Cathed-
ral. Certainly general resemblances support this con-
clusion although until the wider context of develop-
ments in small-scale tinted drawings of the pre-
1250 period has been closely studied, the attribution
can only be tentative. The setting of drawings
against coloured rather than plain grounds occurs in
contemporary works such as the Psalter, Cambridge,
Trinity College MS B. 11. 4 (no. 51) and a Bible
in Manchester (no. 58).

**43 (a). Cambridge, Corpus Christi College
MS 83 ff. 1–7**
Peter of Riga, De operibus septem dierum
Peter of Poitiers, Compendium Historiae in
Genealogia Christi
381 × 240 mm.
c. 1220. *Ills. 141, 142*

The first of the two texts illustrated is by Peter of
Riga (d. 1209), a canon first at Rheims and later at
St. Denis. It is concerned with a historical and
allegorical exposition of the days of Creation and has
roundels with drawings tinted in brown, green and
pink: God Creator standing holding an orb, God
creating Light, God creating the Firmament, Crea-
tion of the Earth (f. 1); Creation of the Sun and
Moon, Creation of the Birds and Fishes, Creation of
Adam, Creation of Eve (f. 1ᵛ). Drawings by the same
artist in roundels and quatrefoils illustrate Peter of
Poitiers' genealogy of the ancestry of Christ (ff.
2–6ᵛ): Adam and Eve (f. 2); Noah (f. 2ᵛ); Terah,
Abraham, Isaac (f. 3); Jacob (f. 3ᵛ); Esrom, Aram,
Naason (f. 4); Solomon, Saul (f. 4ᵛ); a gap follows;
Amasias (f. 5); Josias (f. 5ᵛ); Azor (f. 6ᵛ); Eliud,
Joseph, and as a contemporary ruler, Julius Caesar
(f. 7); the Virgin Mary, Christ in the crib, the
Baptism, the Crucifixion (f. 7ᵛ).

PROVENANCE: Bequeathed to the College by
Matthew Parker (1504–75), Archbishop of Canter-
bury (1559–75).

LITERATURE: James, *Catalogue*, no. 83; P. S. Moore,
The Works of Peter of Poitiers, Notre Dame, 1936,
101, 108; W. Monroe, 'A Roll-Manuscript of Peter
of Poitiers' Compendium', *Bulletin of the Cleveland
Museum of Art*, LXV, 1978, 97 ff., figs. 6, 7.

**43 (b). London, British Library MS Cotton
Faustina B. VII, ff. 41–71**
Universal Chronicle incorporating
Peter of Riga, De operibus septem dierum and
Peter of Poitiers, Compendium Historiae in Genea-
logia Christi
258 × 175 mm.
1208–16. *Ill. 143*

The illustrations are similar to no. 43 (a) and are
also as tinted drawings framed in medallions: God
between Angels, the Fall of the Rebel Angels,
Creation of Light, Creation of the Firmament,
Creation of the Earth (f. 44); Creation of the Sun
and Moon, the Birds and Fishes, Adam, Eve, God
resting on the seventh day (f. 44ᵛ). At this point the
Peter of Riga text ends and the Peter of Poitiers
Genealogy (which, because it is part of a universal
chronicle, includes portraits of rulers) illustrated
in a similar manner begins: the Temptation (f. 45);
Noah (f. 45ᵛ); Terah, Abraham (f. 46); Aaron, Moses
(f. 47); Saul (f. 47ᵛ); David harping, Solomon (f.
48); Benadad, King of Syria (f. 48ᵛ); Phul, King of
Assyria (f. 49); Merodach, son of the King of
Babylon (f. 49ᵛ); Darius, King of Persia (f. 50);
Alexander the Great (f. 50ᵛ); Joseph, Julius Caesar
(f. 51); the Virgin Mary, Christ in the Crib, Christ
bust, the Crucifixion (f. 51ᵛ); St. Peter (f. 52ᵛ);
Lucius, King of Britain (f. 53ᵛ); Constantine (f. 56);
Faramund, King of France (f. 57); Clodoveus, King
of France (f. 58); Augustine, Gregory the Great
(f. 59); Pipin, Charlemagne (f. 62); Alfred the Great

(f. 63); William the Conqueror (f. 67); Pope Innocent III (f. 69). On f. 43ᵛ before the text begins is a triangular diagram of the Trinity incorporating the Crucifixion. The date of the text must be between 1208 (accession of Otto IV) and 1216 when Pope Innocent III, described as living, died. On f. 69ᵛ an entry for the year 1215 is in a fresh hand.

PROVENANCE: Sir Robert Cotton (1571–1631). Presented by his grandson, Sir John Cotton, to the Nation in 1700 and incorporated in the British Museum in 1753.

LITERATURE: W. de Gray Birch, *Early Drawings and Illuminations in the British Museum*, London, 1879, 6; W. Monroe, 'A Roll-Manuscript of Peter of Poitiers' Compendium', *Bulletin of the Cleveland Museum of Art*, LXV, 1978, 97 ff., figs. 5, 8; Watson, *Dated Manuscripts*, no. 530, pl. 118.

43 (c). Cleveland, Museum of Art CMA 73.5
Peter of Poitiers, Compendium Historiae in Genealogia Christi
2810 × 220 mm. (a roll)
c. 1220. (?) Canterbury *Ill. 144*

This version of Peter of Poitiers' Genealogy is in the form of a roll. Many later manuscripts of the text are in this form (e.g. no. 177, part 2) which was probably a format associated with genealogies. The illustrations are drawings in medallions in most cases set against coloured grounds. The top part of the roll is missing and the scenes begin with the Temptation and Adam digging. Then follow: Cain killing Abel, Noah tending vines, Abraham, Moses, David, Zedekiah, Alexander the Great, Christ blessing, the Crucifixion, a seven branched candlestick. The last illustration often occurs at the beginning or end of the Peter of Poitiers Genealogy and is accompanied (in this case cut off) by a text on the symbolic associations of the candlestick.

PROVENANCE: In the 18th century the roll belonged to a cleric of Anglesey. Purchased for the Cleveland Museum of Art after its appearance in a Sotheby Sale in 1972.

LITERATURE: Sotheby Sale Catalogue, 10th July 1972, lot 20, pl.; W. Monroe, 'A Roll-Manuscript of Peter of Poitiers' Compendium', *Bulletin of the Cleveland Museum of Art*, LXV, 1978, 92 ff., figs. 1 (a)–(d), 3, 4, 9, 12.

44. Cambridge, University Library MS Dd. 8. 12
Bible
376 × 252 mm., ff. 469
c. 1210–20. (?) North Midlands *Ill. 145*

Although only one initial of this Bible is historiated, the work of this and of the ornamental initials is of the highest quality. The illuminated Genesis initial (f. 12) is of the whole height of the page and has scenes in seven roundels on burnished gold grounds with punched star designs: God creates Heaven and Earth, God separating the Earth and Sea, Creation of the Trees, Creation of the Sun and Moon, Creation of the Birds and Fishes, Creation of Eve, God seated resting on the seventh day. All the other books have ornamental initials in gold with palmette infills not fully illuminated.

The colours in the Genesis initial are very bright with painterly modelling of the draperies and faces of the figures. This style suggests a source in North Midlands works like the Ashmole Bestiary (no. 19). The suggestion (Brieger) that the style is close to the Lothian Bible is not convincing as in that manuscript the colours are more subdued and the figures more stolid in pose. Also the punched designs on the gold are not characteristic of the Lothian Bible workshop.

PROVENANCE: No evidence of ownership.

LITERATURE: *A Catalogue of Manuscripts preserved in the Library of the University of Cambridge*, 1, Cambridge, 1856, 341; Brieger, *English Art*, 80, pl. 21b; Bennett, *Thesis*, 88 n. 2, 92, 318; Zahlten, *Creatio Mundi*, 61, 128, 250, fig. 87.

EXHIBITED: London, Victoria and Albert Museum, *The Bible in British Art*, 1977, no. 10.

45. Cambridge, Fitzwilliam Museum MS 12
Psalter
310 × 198 mm., ff. 236
Shortly after 1220. (?) Peterborough *Ills. 147–149*

There is no figure decoration in the Calendar and the first illumination is a full-page Crucifixion on a highly burnished gold ground having incised patterns (f. 12). The liturgical divisions of the Psalms have eight historiated or ornamental initials also on gold grounds with incised patterns set in frames with a pink or blue diaper background: Psalm 1, B, Christ holding a chalice and blessing above two standing crowned women holding flowers and books, perhaps personifications of Mercy and Truth (f. 12ᵛ); Psalm 26, D, ornamental (f. 41ᵛ); Psalm 38, D, ornamental (f. 60ᵛ); Psalm 51, Q, ornamental (f. 77); Psalm 52, D, David slinging at Goliath (f. 78); Psalm 68 is lacking; Psalm 80, E, ornamental foliage containing a lion fighting a bull and a man fighting a lion (f. 116); Psalm 101, D, a Benedictine monk and abbot before an altar (f. 139ᵛ); Psalm 109, D, Christ seated blessing (f. 159). The other psalm initials have ornamental foliage in wash colours with occasional touches of gold. There are ornamental line endings in red, blue, brown and gold but these are only in the first four pages (ff. 13–14) and their execution was not completed. Occasionally pen flourishes in red and blue and green extend from the initials into the border.

The workshop which illuminated this Psalter and nos. 46, and 47 has the most refined and high quality artists of the period around 1220. Their style and its possible sources is fully discussed under no. 47 which is their most elaborate product. The Crucifixion miniature in the Fitzwilliam Psalter is remarkable for the bareness of its composition allowing for much space around the figures. The poses of the Virgin and St. John are contemplative, both looking away from the pitiful thin body of Christ. Such Crucifixion groups in painting were probably influenced by those in wood sculpture set on the Rood screens in churches. All English examples were destroyed at the Reformation but their appearance can to some extent be reconstructed from contemporary Norwegian examples under English influence (Andersson).

The lack of a complete series of historiated initials for the psalms of the liturgical divisions is unusul for a Psalter produced in the third decade of the century. Equally unusual are the subjects chosen for those few that are historiated, and this suggests the artist came from a background unconnected with the earlier 13th–century workshops producing Psalters (e.g. nos. 24–28, 35–37).

A notable feature is the variety of patterns incised or punch dotted on the gold grounds. The background to this technique and its significance for the origins of the artist is discussed under no. 47.

The Calendar and Litany of the Psalter are of the Benedictine Abbey of Peterborough (see Sandler, 154–61, for collation of Peterborough texts). For some reason the entry specifically characteristic of the Benedictines, of the Octave of the Translation of Benedict (18th July), has been erased. The Translation of St. Thomas of Canterbury (7th July) and the feast of St. Hugh of Lincoln (17th November), both instituted in 1220, are in the original hand of the Calendar which may imply that it was written after 1220. Both, however, seem to have been written as corrections after the main text of the Calendar had been written out. The entry for St. Hugh had to be written over an erased blue inscription concerning the sun coming into Sagittarius. The arguments for the Fitzwilliam Psalter being earlier than no. 47 are given under the entry for the latter. Since the second Psalter is before 1222 the Fitzwilliam Psalter can perhaps be dated 1220–2. The picture of an abbot in the initial for Psalm 101 implies ownership by the then Abbot of Peterborough, Robert de Lindesey. He is definitely recorded as owning two Psalters one glossed and one unglossed (S. Gunton, *History of the Church of Peterburgh*, London, 1686, 29) and these seem to be nos. 36 and 47.

PROVENANCE: An abbot of the Benedictine Abbey of Peterborough as evidenced by the figure in the initial for Psalm 101 and the Calendar and Litany of Peterborough. A later hand has added the obit on 21st May of Fulk Bassett, Bishop of London (1244–59). Richard, Viscount Fitzwilliam (1745–1816) acquired the manuscript in 1808 (f. 1) and his collection was bequeathed to the University of Cambridge in 1816.

LITERATURE: W. G. Searle, *The Illuminated Manuscripts in the Library of the Fitzwilliam Museum*, Cambridge, 1876, 141–2; James, *Catalogue*, 22–3, pl. II; Haseloff, 'Miniature', 346; Vitzthum, *Pariser Miniaturmalerei*, 16; Lindblom, *Peinture Gothique*, 125, 126; Millar, I, 48, pls. 71, 72; Saunders, *English Illumination*, I, 60, 63, II, pls. 63, 64; Frere, *Bibliotheca Musico-Liturgica*, no. 1000; Swarzenski, *Handschriften XIII Jh*, 75, 135 n. 5; Haseloff, *Psalterillustration*, 14 ff., Tab. 2; Andersson, *English Influence*, 202 n. 3, 261; F. Nordström, 'Peterborough, Lincoln and the Science of Robert Grosseteste', *Art Bulletin*, 37, 1955, 242, fig. 3; Ker, *Medieval Libraries*, 151; Rickert, *Painting in Britain*, 102; Turner, *Early Gothic*, 10–11; Brieger, *English Art*, 83–4, pl. 26b; Munby, *Connoisseurs*, 79; L. F. Sandler, *The Peterborough Psalter in Brussels and other Fenland Manuscripts*, London, 1974, 109, 136, 140, 154–61.

EXHIBITED: Cambridge, Fitzwilliam Museum, *Illuminated Manuscripts in the Fitzwilliam Museum*, 1966, no. 27, pl. 6.

46. London, British Library MS Cotton Vespasian A. I, f. 1

Single leaf from a Psalter
230 × 170 mm.
c. 1220. (?) Peterborough *Ills. 150, 154; fig. 3*

This single leaf, now mounted separately, was inserted into an 8th-century Psalter (*Survey*, I, no. 29) probably in the 17th century when both were in the possession of Sir Robert Cotton (d. 1631). The original Beatus page of the Psalter had been lost between 1418 and 1566. On the recto of the leaf is a framed miniature with a plain gold background of Christ in Majesty surrounded by the symbols of the Evangelists holding scrolls. The verso has a large ornamental B for Psalm 1. The initial is filled with tightly coiled foliage with lions, birds, nude figures and a man in the coils. David is seated harping at the centre of the stem. In the frame there are eight medallions with the following subjects: personifications of the Church and the Synagogue, Saints Peter and Paul, standing prophets holding scrolls, a bust of Christ holding a book, Christ of the Resurrection stepping out of the tomb.

The Christ in Majesty figure is close to the smaller figure in the initial to Psalm 109 of the Fitzwilliam Psalter (no. 45) and is by the same artist. The Beatus page is by a quite different artist whose figures lack modelling in both the draperies and the faces and are less substantial in their forms. Linear patterns in black delineate the folds and the painting technique is less refined. This work has parallels with a similar dry linearism which is found particularly in the Stockholm Psalter artist (nos. 64–68) working in the following decade.

PROVENANCE: Sir Robert Cotton (1571–1631) acquired the 8th-century Psalter in 1599. This single

leaf was probably inserted by him. The manuscripts of Sir Robert were presented by his grandson, Sir John Cotton, to the Nation in 1700 and incorporated in the British Museum in 1753.

LITERATURE: Haseloff, 'Miniature', 346; British Museum, *Reproductions*, III, pl. XV; Lindblom, *Peinture Gothique*, 125–6; Millar, I, 48, 120; Saunders, *English Illumination*, I, 60; L. Edwards, 'Some English examples of the medieval representation of Church and Synagogue', *Transactions of the Jewish Historical Society of England*, 18, 1958, 74; Rickert, *Painting in Britain*, 101; Turner, *Early Gothic*, 10, pl. 1; D. H. Turner, *Illuminated Manuscripts exhibited in the Grenville Library*, London, 1967, no. 13; Brieger, *English Art*, 83; D. H. Wright, *The Vespasian Psalter*, Copenhagen, 1967, 34; *Survey*, I, no. 29.

47. London, Society of Antiquaries MS 59
Psalter (The Psalter of Robert de Lindesey)
240 × 155 mm., ff. 256.
Before 1222. (?) Peterborough

Ills. 151, 156–159; fig. 7

The Psalter text is preceded by a series of prayers added in the early 14th century. The Calendar (ff. 26–31ᵛ) is simply decorated with ornamental initials for the Kalends. The main illustrations in two distinct styles are three pages of framed tinted drawings (ff. 33–34), two fully-painted framed miniatures (ff. 35ᵛ, 36), and by the same artist eight fully painted initials to the liturgical divisions of the Psalter. The drawings have tinting in brown and green with occasional touches of red. The frame is divided into two registers: Annunciation, Nativity (f. 33); the Betrayal, Christ before Pilate (f. 33ᵛ); the Crucifixion, Holy Women at the Tomb (f. 34). The main painted decoration has burnished gold grounds with delicate incised patterned designs: the Crucifixion with a foliate cross, medallions in the frame containing personifications of the Church and Synagogue, St. Peter, Moses, two prophets (f. 35ᵛ); Christ in Majesty with medallions in the frame of the symbols of the Evangelists holding scrolls, and a man and woman holding books (f. 36). The B of Psalm 1 is a full-page illumination with the initial set against a dark blue and red diaper ground filled with concentric tight coils inhabited with white-red lions, squirrels and rabbits (f. 38ᵛ). In the frame are medallions with seated figures of Isaiah, Jeremiah, Ezekiel, Daniel, David harping, other figures of musicians. The initials to the liturgical divisions have burnished gold grounds with punch dot designs: Psalm 26, D, Anointing of David (f. 64ᵛ); Psalm 38, D, Ahimelech gives the hallowed bread and Goliath's sword to David (f. 81); Psalm 51, Q, an armed man on a horse attacked by a lion (f. 96ᵛ); Psalm 52, D, David and Goliath (f. 97ᵛ); Psalm 68, S, Jonah going into the whale, Jonah coming out of the whale (f. 113ᵛ); Psalm 80, E, Jacob wrestling with the angel (f. 132ᵛ); no historiated initials for Psalms 97, 101;

Psalm 109, D, Christ seated blessing (f. 169). The initials to the other psalms are in blue, red, brown and green wash. Some of the psalms are subdivided into two parts according to Benedictine usage and have a decorative initial at the division.

There are two artists, the painter of the full paintings and the artist of the tinted drawings. In the fully painted work by the first artist the figure style combines painterly and linear features. In his full-page Crucifixion most of the fold systems of the draperies are produced by modelling effects with little use of black lines. Other figures however, such as David in the Psalm 52, are almost like tinted drawings in which all the emphasis is placed on the drawing line. The painterly aspects and the careful modelling of the faces in brown and white paint are stylistic features deriving from the *c.* 1200 period. The emphasis on linear folds in some of the figures points towards the reassertion of linearism in the context of a mannered figure style which is to predominate in English manuscript illumination for the next forty years. The poses of figures are mannered in an elegant suave way unlike the abstract mannerism of Romanesque art.

The tinted drawings by the second artist, in contrast, are in a style in which the poses are mannered and stylised more in the Romanesque sense with rigid block-like fold patterns. These figures are however well composed in a vivacious narrative context and the artist is by no means inferior even if his work is, by contrast with his collaborator, rather archaic. The painter of the work in full painting is the same artist who decorates the Fitzwilliam Psalter (no. 45) and the Christ in Majesty of the British Library leaf (no. 46). The Fitzwilliam Psalter seems the earlier work even though in the Crucifixion page perhaps the modern linear style is more evident. It has the archaic feature of ornamental initials for most of the liturgical divisions whereas there is a full series of the historiated initials in the Society of Antiquaries Psalter. Also in this latter Psalter in the Crucifixion the more elaborate tooled patterns on the gold and the more complicated and compressed composition seem more developed features.

The dating of the two Psalters suggests these changes take place in the short period of time 1220–2. Abbot Robert de Lindesey, the owner of the Society of Antiquaries Psalter according to the 14th-century inscription on f. iii, died in 1222. The additions to the Calendar in a near contemporary hand of the feasts of the Translation of St. Thomas of Canterbury (7th July) which took place in 1220, the Transfiguration (26th July) and Hugh of Lincoln (17 November) support his ownership because he gave money to ensure the celebration 'in cappis' of these feasts. This evidently refers to the copes worn by the monks on great feast days.

The stylistic origins of the important chief painter are complex. His techniques of gold grounds with incised patterns, painterly modelling of draperies and faces, and use of colour, suggest a debt to North Midlands and Northern manuscripts, e.g. nos. 12 (a), 17, 18, 19, 40, 44. There are also some similarities of facial type and composition (e.g. the Christ

in Majesty of no. 46) with the Westminster Psalter (no. 2) and the St. Albans Glossed Gospels (no. 3). Probably the artist of the Peterborough Psalters travelled widely while formulating his style, and on the basis of the artistic connections suggested he could have been predominantly involved with Benedictine patrons. The artist of the tinted drawings is even harder to locate and there is no obvious background to his style.

The iconography of the Crucifixion (f. 35ᵛ) with the cross sprouting foliage also probably occurred in wood sculpture as evidenced by near contemporary Norwegian Crucifixions probably based on English models (Andersson). The tree symbolism of the cross with its association with resurrection and life is expressed in the hymns sung during the ceremony of the Adoration of the Cross on Good Friday. The Psalm initial iconography is beginning to show the influence of established systems of illustration, although the scenes for Psalms 38, 51 are unique in English 13th-century examples.

PROVENANCE: Robert de Lindesey, Abbot of Peterborough (1214–22) as evidenced by a 14th-century inscription on f. iii 'Psalterium Roberti de Lindeseye abbatis', and the Peterborough Calendar and Litany. The obliterated signature on f. iv is of the antiquary, Smart Lethieuiller (d. 1760). The bookplate of the Revd. Charles Lyttleton (1714–68), Bishop of Carlisle (1762–8). He bequeathed this manuscript and a Flemish Psalter (MS. 1) to the Society of Antiquaries of which he was President.

LITERATURE: H. Shaw, *A Handbook of the Art of Illumination as practised during the Middle Ages*, London, 1866, 17, pl.; Maunde Thompson, 'Notes', 219; Haseloff, 'Miniature', 346, fig. 259; Vitzthum, *Pariser Miniaturmalerei*, 16; Herbert, *Illuminated Manuscripts*, 180–1, pl. XXII; Lindblom, *Peinture Gothique*, 125, 126, pl. 44; *New Pal. Soc.*, II, pl. 128; Millar, I, 47, pls. 69, 70; Saunders, *English Illumination*, 60; Haseloff, *Psalterillustration*, 14 ff., 44, Tab. 2; Morison, '*Black-Letter*' *Text*, 33; Tristram, *Wall Painting*, 38, 41, 172, 370, suppl. pls. 20, 34; Andersson, *English Influence*, 164, 191, 261, 287, fig. 150; F. Nordström, 'Peterborough, Lincoln and the Science of Robert Grosseteste', *Art Bulletin*, 37, 1955, 253; L. Edwards, 'Some English examples of the medieval representation of Church and Synagogue', *Transactions of the Jewish Historical Society of England*, 18, 1958, 74; Rickert, *Miniatura*, II, pl. 10; Schapiro, 'Glazier Psalter', 187, 188; Ker, *Medieval Libraries*, 151; Rickert, *Painting in Britain*, 102, pl. 104; Turner, *Early Gothic*, 10; A. Martindale, *Gothic Art*, London, 1967, 74, pl. 51; Brieger, *English Art*, 82–3, pl. 24; Ker, *Medieval Manuscripts*, I, 302–3; Henderson, 'Studies', I, 79; Henderson, 'Studies', II, 109 n. 10; F. Wormald, 'Anniversary Address', *Antiquaries Journal*, XLIX, 1969, 199–201; R. Mellinkoff, *The Horned Moses in Medieval Art and Thought*, London, 1970, 127, fig. 116; L. F. Sandler, *The Peterborough Psalter in Brussels and other Fenland Manuscripts*, London, 1974, 109, 122, 136, 139, 140, 154–61; J. Alexander,

'The Middle-Ages', in ed. D. Piper, *The Genius of British Painting*, London, 1975, 35 with fig.; M. Korhammer, *Die monastischen Cantica im Mittelalter*, Munich, 1976, 12 n. 8, 22–3, 119–23, 146; R. Marks, N. Morgan, *The Golden Age of English Manuscript Painting, 1200–1500*, New York, 1981, pls. 3, 4.

EXHIBITED: London, Society of Antiquaries, *English Medieval Paintings*, 1896, no. 6; B.F.A.C., *Illuminated Manuscripts*, 1908, no. 37, pl. 36; London, Royal Academy, *British Primitives*, 1923, no. 102; London, 1930, no. 124; B.F.A.C., *British Medieval Art*, 1939, no. 28; Paris, Musée du Louvre, *L'Europe Gothique*, 1968, no. 235, pl. 72; Brussels, 1973, no. 44; London, British Library, *The Benedictines in Britain*, 1980, no. 48, 31, pl. 14.

48. London, Lambeth Palace Library MS 563
Psalter and Hymnal
104 × 78 mm., ff. 157
c. 1220. (?) St. Neots

Ills. 152, 153, 155; p. 41

This very small Psalter is simply decorated with ten historiated and ornamental initials with gold grounds at the liturgical divisions: Psalm 1, B, full page, David harping with four musicians (f. 20); Psalm 26, D, Anointing of David (f. 35); Psalm 38, D, David pointing to his mouth (f. 44ᵛ); Psalm 51, Q, David and Goliath (f. 53); Psalm 52, D, the fool before a cleric (f. 53ᵛ); Psalm 68, S, Jonah thrown to the whale (f. 62ᵛ); Psalm 80, E, ornamental (f. 73ᵛ); Psalm 97, C, ornamental (f. 85ᵛ); Psalm 101, D, a man kneeling before an altar (f. 87ᵛ); Psalm 109, D, the Creation of Eve (f. 100).

The figure style is flat with fairly large figures which, however, have little sense of volume conveyed in the folds of the draperies. The faces have bland expressions with little modelling. A similar facial type and figure is found in a set of drawings of psalm initials in a model book from Lyre Abbey in Normandy (Evreux, Bibl. Mun. MS. 4) which also has some resemblances in iconography and ornament (Ayres). The style is rather isolated in England and in view of St. Neots being a cell of the Norman Abbey of Bec there may be some influence from Normandy. The older literature has suggested parallels with the Robert de Lindesey Psalter (no. 47), St. Albans work and the Oxford workshop of William de Brailes, but none of these seem to have any convincing resemblance.

The Calendar is of the Benedictine priory of St. Neots in Huntingdonshire, and special hymns to St. Neot have been added to the Hymnal. The Psalter was definitely intended for a monk as the special series of Canticles for monastic use are included in the text. The very unusual subjects for some of the historiated initials (e.g. Psalm 109) and the lack of a full series (Psalms 80, 97 are ornamental) suggests the artist was outside the influence of contemporary workshops producing Psalters. Possibly this rather isolated manuscript was made at St. Neots itself.

PROVENANCE: Benedictine priory of St. Neots, a cell of the Norman Abbey of Bec, on the evidence of the Calendar. The R. B. initials on the 16th-century binding are those of Richard Bancroft, Archbishop of Canterbury (1604–10), whose manuscripts were bequeathed to his successors in the See.

LITERATURE: Frere, *Bibliotheca Musico-Liturgica*, no. 5; E. G. Millar, 'Les principaux manuscrits à peintures du Lambeth Palace à Londres', *B.S.F.R.M.P.*, 1924, 35–8, pls. XIII a-d; Millar, I, 121; James, *Catalogue*, 772–6; Haseloff, *Psalter-illustration*, 61 ff., Tab. 16; Wormald, *Kalendars*, II, 105; Ker, *Medieval Libraries*, 170; Rickert, *Painting in Britain*, 98, 101; Brieger, *English Art*, 85; L. M. Ayres, 'Problems of sources for the iconography of the Lyre drawings', *Speculum*, LXIX, 1974, 64–5, fig. 4; M. Korhammer, *Die monastischen Cantica im Mittelalter*, Munich, 1976, 22, 119, 121.

49. Oxford, Magdalen College MS 100
Psalter
335 × 220 mm., ff. 220
c. 1220–30. (?) Worcester *Ills. 163–166*

The historiated initials with gold backgrounds and dragon stems for the liturgical divisions of the Psalter have been pasted in on separate pieces of vellum. In some cases these have been removed and only four survive: Psalm 26, D, David between the lion and the bear (f. 34); Psalm 38, D, a group of men before a seated figure pointing to his mouth (f. 49); Psalm 97, C, three Benedictine monks chanting before an altar on which is a chalice (f. 114ᵛ); Psalm 109, D, the Trinity above the scene of Pentecost (f. 134). There are red, blue and green painted initials to the other psalms. Occasionally pen flourishes extend from the text into the border, but there are no line endings.

The figures are angular in form with alert poses. The folds of the draperies are indicated by elaborate systems of lines which do however enhance the position of the limbs and do not form abstract patterns. The faces, heads and feet are quite elaborately modelled in brown and white paint. Apart from the heavy modelling of the faces, this style is a move away from the solid figure forms of c. 1200 to the angular poses with linearity of drapery folds which are to be the characteristics of the English Early Gothic style. The sources for this figure style of the Magdalen Psalter artist and for his unusual use of colour are not clear, but his background may be linked to that of the artist of the Glazier Psalter (no. 50).

The iconography of Psalm 26 is very rare but David with the lion did occur for this psalm in the mid 12th-century Lambeth Bible (*Survey*, III, no. 70), and David with both lion and bear occur for Psalm 1 in the slightly later Winchester Bible (*Survey*, III, no. 83). Very similar iconography with the unusual feature of David spearing the bear is found in the model book from Lyre Abbey (Evreux, Bibl. Mun. MS 4). This parallel with a French manuscript and

the subjects used for Psalms 38, 97 (unusual in England c. 1220 although commonly adopted later) suggests a French influence on the iconography. The particular compositions for Psalms 38 and 97 were copied later in the century in the Psalter for Evesham Abbey (no. 111).

The Calendar and Litany are of the use of the Benedictine priory of the Cathedral of Worcester (compare the text of the Antiphonary of Worcester, Worcester, Cath. Lib. MS F. 160). Two corrections contemporary with the main text of the Calendar and by a slightly different hand are the Dedication of Worcester Cathedral (7th June) and the Translation of St. Wulfstan (14th June, which is in fact the Octave of the Translation). Both these events took place on June 7th, 1218 and if the entries are additions rather than corrections then the text would antedate 1218; yet this date seems perhaps a little early for the style of the initials. As they are pasted in on separate pieces of vellum they could just possibly have been added later. The Worcester provenance is confirmed by the fragments from a Gradual later bound in as flyleaves. These came from a Worcester Cathedral manuscript and have now been returned (Worcester, Cathedral Library, MS Add. 68). In the mid 13th century the Psalter was in the possession of Prior Richard (1242–52) who had the obits of his parents entered in the Calendar on 3rd June and 28th October.

PROVENANCE: The Benedictine Cathedral Priory of Worcester as evidenced by the Calendar and Litany. The added obits in the Calendar suggest it belonged to Prior R., probably Richard (1242–52). A note of 1533 (f. 220) records the book had been given (presumably to Magdalen College) by John Stanley in 1395.

LITERATURE: Coxe, *Catalogue*, II, Magdalen, 54; Frere, *Bibliotheca Musico-Liturgica*, no. 494; C. H. Turner, *Early Worcester Manuscripts*, Oxford, 1916, lxiii; Boase, *English Art*, 290; Ker, *Medieval Libraries*, 210; Rickert, *Painting in Britain*, 101; L. M. Ayres, 'A Tanner manuscript in the Bodleian Library and some notes on English painting of the late twelfth century', *J.W.C.I.*, XXXII, 1969, 49, pl. 8 b, d; Pfaff, *New Liturgical Feasts*, 107; L. M. Ayres, 'Problems of sources for the iconography of the Lyre drawings', *Speculum*, 49, 1974, 63–4, figs. 1, 2; N. J. Morgan, 'Psalter illustration for the Diocese of Worcester in the 13th Century', *Medieval Art and Architecture at Worcester Cathedral*, British Archaeological Association Conference Transactions, London, 1978, 92–4, pl. XVIII C.

EXHIBITED: Brussels, 1973, no. 42.

50. New York, Pierpont Morgan Library MS Glazier 25
Psalter (The Glazier Psalter)
330 × 220 mm., ff. 182
c. 1220–30. (?) London
 Ills. 160–162; colour frontispiece; figs. 4, 10

There are six full-page framed miniatures before the Psalter text. The figures are set against plain burnished gold panels set on coloured grounds: the Annunciation (f. 1ᵛ); the seated Virgin and Child (f. 2); the Crucifixion (f. 2ᵛ); Christ in Majesty surrounded by the symbols of the Evangelists (f. 3); David harping before Saul (f. 3ᵛ); the Coronation of David (f. 4). The elaborate full-page B for Psalm 1 is set in a frame containing figure medallions (f. 5ᵛ). The initial is filled with rows of tight concentric coils in which are entangled huntsmen, hounds, stags and small nude men. There are ten medallions in the frame depicting David threatened by Saul, musicians, tumblers and David fighting the lion. Psalm 2 has a fully illuminated ornamental initial but all other psalms, except those at the liturgical divisions, have initials in gold with colour wash foliage initials in green, grey, yellow and occasionally blue and red. The line endings are in red and blue penwork as ornamental patterns and occasionally dragons. The nine liturgical division initials are: Psalm 26, D, ornamental (f. 28ᵛ); Psalm 38, D, ornamental (f. 43); Psalm 51, Q, ornamental (f. 56); Psalm 52, D, ornamental (f. 57); Psalm 68, S, ornamental (f. 70ᵛ); Psalm 80, E, ornamental (f. 88); Psalm 97, C, ornamental (f. 104ᵛ); Psalm 101, D, Christ seated between two angels above three kneeling men (f. 107); Psalm 109, D, the Trinity (f. 121ᵛ). The ornamental initials have the same wiry concentric coils as in the B for Psalm 1 and they are occasionally populated by white lions and monkeys. Thin sinuous dragons form the tails of these initials and they are very similar to those in the Magdalen Psalter (no. 49). The opening words of the liturgical division psalms are in gold capitals against pale blue, pale brown or red-pink grounds.

The Psalter appeared in a sale in 1953 and has been one of the most important additions to our knowledge of English 13th-century illumination in recent years. The figure style is characterised by angular forms with a tendency toward attenuation of limbs and elaborate troughed systems of drapery usually emphasised in black drawing line. Rinceaux and hatched designs in white are intended as ornamental highlights to the folds and a characteristic grey and white with touches of brown-pink is used for modelling faces, hands and feet. Some subjects of the full-page miniatures (e.g. the Annunciation and Christ in Majesty) may have been derived from the Westminster Psalter (no. 2). They are by comparison very revealing of the stylistic change which had taken place since the Transitional period around 1200. The Glazier Psalter is the first example with large-scale miniatures of the style which can truly be called Early Gothic and which will achieve maturity in the work of the 1240s, and 50s by the Sarum Master (nos. 99–103, Part 2) and his contemporaries (nos. 107–12, Part 2). The Glazier Psalter artist himself or a very closely related collaborator worked on a Psalter (no. 51) and a Bestiary (no. 53).

The full-page miniatures are conceived as diptychs devoted to the Virgin, Christ and David. The scenes facing each other show these figures in situations of humility on the left and glory on the right. The choice of the Coronation of David as a full-page miniature possibly suggests some interest in the contemporary debate on the meaning of the rite of anointing in the Coronation ceremony. Pope Innocent III had decreed that this in no way conferred power on the King in any way analogous to that conferred on a priest at his ordination. The miniature in the Glazier Psalter is only of the Coronation (i.e. the conferring of worldly power on the King), in contrast to other examples such as that in the Rutland Psalter (no. 112, Part 2) which also emphasise the anointing. The choice of the first David scene does perhaps suggest some knowledge of the Coronation Ordo in which a prayer contrasts David's humility with the evil thinking of Saul.

The absence of historiated initials for most of the liturgical division psalms is unusual for the period and may support the conclusion from the full-page miniatures that some late 12th-century model like the Westminster Psalter was used. Only in the 13th century does a complete series of historiated initials become the norm.

The likely production in London has been suggested on the basis of dependence on the Westminster Psalter and the same style used in no. 51 whose Calendar has clear London features. Another piece of supporting evidence is the closeness of the text (recognised by Plummer) to an earlier London product, Cambridge, St. John's, MS D. 6 (no. 36).

The Litany in the Glazier Psalter is unspecific but has the very odd feature of a double invocation for St. Silvester. It has been tentatively suggested (Schapiro) that this may imply the intended ownership of Silvester of Everdon who was keeper of the great seal in 1244 and later Bishop of Carlisle (1246–54).

PROVENANCE: André Hachette, his bookplate. Purchased from the sale of his manuscripts in 1953 by William Glazier, his bookplate. After Mr. Glazier's death in 1962 his manuscripts were placed in the custody of the Pierpont Morgan Library by the Trustees of the Glazier Collection.

LITERATURE: W. S. Glazier, 'A Collection of Illuminated Manuscripts', *The Book Collector*, VI, 1957, 364–5, with pl.; Schapiro, 'Glazier Psalter', 179–89, pls. 19–23; F. Wormald, 'Notes on the Glazier Psalter', *J.W.C.I.*, XXIII, 1960, 307–8; Rickert, *Painting in Britain*, 101; Brieger, *English Art*, 150, pl. 51; E. J. Beer, 'Gotische Buchmalerei: Literaturbericht', *Zeitschrift für Kunstgeschichte*, 30, 1967, 94–5; J. Plummer, *The Glazier Collection of Illuminated Manuscripts*, New York, 1968, no. 25, pls. 1, 4; L. M. Ayres, 'A Tanner manuscript in the Bodleian Library and some notes on English painting of the late twelfth century', *J.W.C.I.*, XXXII, 1969, 49; H. Helsinger, 'Images on the Beatus page of some medieval Psalters', *Art Bulletin*, 53, 1971, 168, fig. 11; M. Remnant, *Musical Instruments of the West*, London, 1978, fig. 5; M. Schapiro, *Late Antique, Early Christian and Medieval Art. Selected Papers*, London, 1980, 329–54.

51. Cambridge, Trinity College MS B. 11. 4
Psalter
285 × 200 mm., ff. 181
c. 1220–30. London *Ills. 167–174; fig. 12*

The illumination of this richly decorated Psalter begins in the Calendar which has the Labours of the Months and the Signs of the Zodiac in roundels against gilded grounds: January, a man drinking from a horn (f. 1); February, a man warming himself by the fire (f. 1ᵛ); March, men digging and sowing seed (f. 2); April, a man seated between two trees (f. 2ᵛ); May, a man and woman falconing (f. 3); June, a man weeding (f. 3ᵛ); July, men scything and raking (f. 4); August, men threshing and binding corn (f. 4ᵛ); September, picking and treading grapes (f. 5); October, a man grazing pigs (f. 5ᵛ); November, men slaughtering a pig (f. 6); December, a man feasting (f. 6ᵛ).

Then follow ten full-page pictures, perhaps part of a larger series, which have been bound out of order (the correct order should be ff. 10, 10ᵛ, 7, 7ᵛ, 8, 8ᵛ, 9, 9ᵛ, 11, 11ᵛ). The illustrations are drawings with light overall colour washes and blue and pink painted backgrounds. The first eight are divided into six square parts and have scenes of the Old and New Testaments: 1. Abraham offered bread and wine by Melchisedech, 2. Abraham entertains the angels, 3. Destruction of Sodom and Gomorrah, 4. Sacrifice of Isaac, 5. Isaac's meeting with Rebecca, 6. Isaac blessing Jacob (f. 10); 7. Esau brings food to Isaac, 8. Jacob's Dream, 9. Jacob wrestling with the Angel, 10. Jacob sends Joseph to his brothers, 11. Joseph taken out of the well and sold to the Ishmaelites, 12. the Ishmaelites bring Joseph to Potiphar (f. 10ᵛ); 13. Joseph fleeing from Potiphar's wife, 14. Joseph in prison with Pharaoh's Butler and Baker, 15. the Butler brings the cup to Pharaoh and the Baker is hanged, 16. Joseph interpreting Pharaoh's dream, 17. Joseph riding in his chariot by the granaries of Egypt, 18. Joseph's brothers charged with the theft of the cup (f. 7); 19. Jacob is persuaded to send Benjamin to Egypt, 20. Joseph's brothers and Benjamin stand accused of the theft of the cup, 21. Joseph's farewell to Benjamin, 22. Jacob comes to Egypt with his family, 23. Jacob's family before Pharaoh, 24. Jacob blessing Ephraim and Manasseh (f. 7ᵛ); 25. Dream of the Magi, 26. Massacre of the Innocents, 27. Flight into Egypt, 28. Presentation in the Temple, 29. Baptism, 30. Transfiguration (f. 8); 31. Entry into Jerusalem, 32. Last Supper, 33. Judas receiving the tribute money, 34. Gethsemane, 35. the Betrayal, 36. Peter's Denial and the Mocking of Christ (f. 8ᵛ); 37. the Flagellation, 38. Way of the Cross, 39. the Crucifixion, 40. the Deposition, 41. Anointing of Christ's body, 42. Holy Women at the Tomb (f. 9); 43. Descent into Hell, 44. 'Noli me tangere', 45. Supper at Emmaus, 46. Doubting of Thomas, 47. Ascension, 48. Pente-

cost (f. 9ᵛ). The remaining two pictures have a full-page Last Judgement (f. 11) and in twelve compartments, the Torments of Hell (f. 11ᵛ).

There are nine historiated initials to the liturgical divisions with burnished gold grounds having a punched rosette design. Psalm 1, lacking; Psalm 26, D, Anointing of David (f. 37); Psalm 38, D, Judgement of Solomon (f. 52); Psalm 51, Q, Doeg killing Ahimelech (f. 65); Psalm 52, D, Saul's suicide (f. 65ᵛ); Psalm 68, S, the Crucifixion and the Holy Women at the Tomb (f. 79); Psalm 80, Christ with musicians above Jacob's dream and Jacob wrestling with the angel (f. 96); Psalm 97, C, Annunciation to the Shepherds (f. 110ᵛ); Psalm 101, D, Christ Judge with Angels holding the Instruments of the Passion above an Abbess and a nun kneeling at an altar (f. 113ᵛ); Psalm 109, the Trinity (Gnadenstuhl type with the Jewish derived motif of a plain quatrefoil in place of the head of God the Father) with the Abbess and nun kneeling beside (f. 130).

The text pages are elaborately decorated with each Psalm having a fully illuminated initial, some containing animals or figures (e.g. the Virgin and Child on f. 157ᵛ), and each verse begins with a small illuminated initial. In addition the line endings are fully painted and gilded up to f. 78, some being filled with men, animals, fish and grotesques, others with ornamental patterns. Their iconographic repertoire is identical to that which in the second half of the century occurs as free forms on the border bars, e.g. the Cuerden Psalter, New York, Pierpont Morgan, MS 756 (no. 162, Part 2). From ff. 79–133 the designs of the line endings have been erased, but they are resumed from f. 133ᵛ in a coarse style without the use of gold.

The fully painted work in the historiated initials is close to the Glazier Psalter (no. 50) and is probably the work of the same artist. The style is characterised under that entry. The use of rosettes punched on the gold ground is a feature not occurring in the Glazier Psalter but they are found in an earlier Psalter of London provenance (no. 37).

The drawings of the Old and New Testament scenes are a more elegant version of a style of a contemporary London region Psalter (no. 52). The attenuated figures with angular gestures and mincing poses are best paralleled in the stained-glass windows of the Miracles of Becket in the Corona of Canterbury Cathedral. The same energy of narrative composition and expressive use of gesture occurs in both, and of all contemporary manuscript illumination these scenes come closest to stained-glass style. There is a slight difference in technique used for the Last Judgement scenes which have fuller painting with modelling of faces and bodies rather than the light colour washes used for the other scenes.

The iconography of these narrative scenes and of the Last Judgement is dependent on the cycle of the Munich Psalter (no. 23). Similar rare scenes (e.g. the Joseph sequence, Judas receiving the tribute money) occur and either the Munich Psalter itself or the same model must have been known to the artist. The division of the page into a grid incorporating a large number of scenes is a system deriving

from the 12th century (e.g. no. 1 and its forerunners).

The historiated initials show similar dependence for their subjects on works of the years around 1200 (e.g. nos. 25, 26), but some (Psalms 68, 101) have very unusual subjects. The Crucifixion is however used for Psalm 68 in an early 13th-century example (no. 18) and the Last Judgement for Psalm 109 in the Madrid Psalter (no. 120, Part 2).

The Calendar is Augustinian (4th Sept, Octave Augustine) of the London diocese with a few entries of Winchester saints. The characteristic London (compare the St. Paul's Calendar in W. Sparrow Simpson, *Documents illustrating the History of St. Paul's Cathedral*, Camden Society, 1880, 61–73) entries are: Mellitus (24th Apr.), Erkenwald (30th Apr.), Erasmus (3rd June), Silas (13th July), Philibert (20th Aug.), Genesius (25th Aug.), Osyth (7th Oct.), Ethelburga (11th Oct.), Translation of Erkenwald (14th Nov.). The characteristic Winchester (compare those cited for no. 26) entries are: Edburga (15th June), Grimbald (7th July), Edburga (18th July), Translation of Birinus (4th Sept.), Birinus (3rd Dec.), Judoc (13th Dec.). These Winchester saints seem in no way specific enough to suggest adaptation of a London Calendar for any specific religious house in the Winchester diocese although the high colour grading given to both Edburga feasts may point to the Nunnaminster where her relics rested. The main liturgical and stylistic evidence suggest London production for the manuscript but with the use of iconographic models from manuscripts perhaps produced at Oxford or Winchester.

The abbess in Psalms 101 and 109 was presumably the intended owner. There is no firm evidence to presume, as has been done by some writers (e.g. Saunders), that she was a nun of St. Mary's Winchester (The Nunnaminster). The habits of the two representations in fact differ and in Psalm 101 she is wearing a white undergarment which in both cases is also worn by the accompanying nun. This may be the habit of an Augustinian nun and perhaps there has been some misunderstanding by the artist concerning the religious order of the patron. Alternatively two different ladies were intended, although this presents a problem for the two large Augustinian houses in London (Clerkenwell, Halliwell) were ruled by prioresses who would presumably not be depicted with the pastoral staff of an abbess (the earliest Augustinian nunnery to be ruled by an abbess was Lacock in 1239). If the Winchester saints in the Calendar can be taken as suggesting adaptation for a Winchester region Benedictine abbess (the figure in Psalm 109 has a Benedictine habit) then the abbess of the Nunnaminster is certainly a likely candidate.

PROVENANCE: A 14th-century note in French on f. 36ᵛ gives the information that the Psalter was loaned by Dame Ida de Ralegh to Walter Hone, Abbot of New(n)ham during his lifetime and was then to pass to Dame Johane de Roches, a nun of the Benedictine Abbey of St. Mary, Winchester. Walter Hone was confirmed Abbot of the Cistercian house of Newnham (Devon) in 1338. Ida de Ralegh was wife of Sir John de Ralegh of Beaudeport (Devon) and she is mentioned as living in 1346. The Psalter was probably the *Psalterium cum picturis* listed in the 1614 catalogue of the books belonging to Trinity College (contained in MS R. 17. 8).

LITERATURE: James, *Catalogue*, no. 243; Haseloff, 'Miniature', 320; *New Pal. Soc.*, I, pls. 214–16; Millar, I, 46–7, 51, pl. 68; Saunders, *English Illumination*, I, 66; Frere, *Bibliotheca Musico-Liturgica*, II, 157; Haseloff, *Psalterillustration*, 61 ff., Tab. 16; Swarzenski, 'Unknown Bible Pictures', 64, 65; J. Plummer, 'The Glazier Collection', *Burlington Magazine*, 101, 1959, 194; Schapiro, 'Glazier Psalter', 188; Baltrušaitis, *Reveils et Prodiges*, 140, 144 fig. 30, 281 fig. 12; G. Henderson, 'Late Antique Influences in some English Medieval illustrations of Genesis', *J.W.C.I.*, XXV, 1962, 177; Rickert, *Painting in Britain*, 98, 99, 101; Henderson, 'Studies', I, 79; Henderson, 'Studies', II, 119; Brieger, *English Art*, 61, 92–94, pls. 23b, 25; Deuchler, *Ingeborgpsalter*, 65; P. Z. Blum, 'The Middle English Romance 'Iacob and Iosef' and the Joseph cycle of the Salisbury Chapter House', *Gesta*, VIII, 1969, 25 n. 58; N. J. Morgan, 'Gothic Manuscripts in England', *The Book through Five Thousand years*, ed. H. D. L. Vervliet, Brussels, 1972, pl. 120; M. H. Caviness, *The Early Stained Glass of Canterbury Cathedral*, Princeton, 1977, 81, 90, 125, fig. 168; N. J. Morgan, 'Notes on the Post-Conquest Calendar, Litany and Martyrology of the Cathedral Priory of Winchester with a consideration of Winchester Diocese Calendars of the Pre-Sarum period', *The Vanishing Past: Medieval Studies presented to Christopher Hohler*, ed. A. Borg, A. Martindale, BAR, Oxford, 1981, 157, 167 nn. 67, 74, 168 n. 80.

EXHIBITED: B.F.A.C., *Illuminated Manuscripts*, 1908, no. 38, pl. 37; London, 1930, no. 120; Brussels, 1973, no. 45.

52. Cambridge, Emmanuel College MS 252 (3.3.21) ff. 1–12ᵛ
Psalter fragment
266 × 184 mm., ff. 12
c. 1220–30. London *Ills. 175–178; fig. 8*

Twelve leaves from a Psalter having the Calendar, prefatory miniatures, and the initial B to Psalm 1, have been bound in at the end of a 15th-century copy of Eusebius, *De Morte Hieronymi*. The Calendar has simple decoration with gold used for the Kalends initials. The ten prefatory pictures are framed with the frame divided into two, and are drawings tinted with blue, green, yellow-brown and orange-pink: Annunciation, Visitation (f. 7); Nativity, Annunciation to the Shepherds (f. 7ᵛ); Journey of the Magi, Magi before Herod (f. 8); Adoration of the Magi, Dream of the Magi (f. 8ᵛ); Flight into Egypt, Massacre of the Innocents (f. 9); Presentation in the Temple, the Baptism (f. 9ᵛ); Marriage

at Cana, Raising of Lazarus (f. 10); Temptations of Christ (f. 10v); Entry into Jerusalem, Washing of the feet (f. 11); the Last Supper, the Betrayal (f. 11v). The page on f. 10 has been partly cut away.

The initial B to Psalm 1 is a full-page fully painted miniature with use of burnished gold (f. 12v). The page is very damaged but the subjects are clearly visible: the Tree of Jesse is in the B and in the frame are corner medallions containing personifications of of the Church and the Synagogue, David slinging at Goliath, David beheading Goliath. No text pages of the Psalter survive.

The drawing style is a more freely executed and larger scale version of that of the artist of the Old and New Testament scenes of the previous entry (no. 51). The technique however is different and is proper tinted drawing as opposed to the overall colour washes of no. 51. The Beatus page was fully painted and is by a different artist who is perhaps the same person as the artist of the historiated initials of no. 51. Some of the best preserved figures show close links with the style of these initials, and where the under-drawing is visible, it also reveals a drawing style very similar to no. 51. The inevitable conclusion is that both Psalters are products of the same workshop.

Although it has long been realised that the Calendar is of the London region, the fact that it is of the Benedictine Abbey of Chertsey has not been mentioned. The characteristic Chertsey (compare Wormald, *Kalendars*, I, 81–93) entries are: Austraberta (10th Feb.), Erkenwald (30th Apr.), Oct. Erkenwald (7th May), Simeon (1st June), Edburga (15th June), Sexburga (6th July), Hedda (7th July), Oct. Benedict (18th July), Ethelwold (2nd Aug.), Aidan, written Anianus (31st Aug.), Translation Birinus (4th Sept.), the two brothers Ewald (3rd Oct.), Ethelburga (11th Oct.), Feast of the Relics (24th Oct.). The Octave for Benedict on 18th July confirms the Calendar is Benedictine. The grading of nine lessons (a Benedictine Calendar would have twelve) given beside some feasts is a modification for another patron. This Chertsey Calendar gives support to the London location for this workshop of illuminators which has already been suggested for no. 51.

PROVENANCE: The Benedictine Abbey of Chertsey on the evidence of the Calendar. Later perhaps belonged to the Augustinian Priory of Holy Trinity, Aldgate, as the obit of the prior of that house, John Bradwell (*c.* 1513) has been added (30th June). Also on 7th Jan. there is a 15th-century obit of Prior Roger, as well as an added 16th-century obit of Beatrice Tyrill (4th June). The manuscript was given to Emmanuel College by the Greek scholar and antiquary, Joshua Barnes (1654–1712), as recorded on f. 1.

LITERATURE: James, *Catalogue*, no. 252; Millar, I, 119; Frere, *Bibliotheca Musico-Liturgica*, II, 129; Boase, *English Art*, 284; Rickert, *Miniatura*, I, pl. 59; J. Plummer, 'The Glazier Collection', *Burlington Magazine*, 101, 1959, 194; Schapiro,

'Glazier Psalter', 189; Ker, *Medieval Libraries*, 123; Rickert, *Painting in Britain*, 234 n. 24; Henderson, 'Studies', I, 79.

EXHIBITED: B.F.A.C., *Illuminated Manuscripts*, 1908, no. 35, pl. 34; London, 1930, no. 118, pl. 26.

53. Cambridge, University Library MS Kk. 4. 25
Bestiary and other texts
285 × 198 mm., ff. 134
c. 1230. London *Ills. 179–184; fig. 9*

This book contains a miscellany of texts. Those accompanied by illustrations are a letter of Alexander the Great to Aristotle concerning the wonders of India (ff. 19–25), a treatise on the Nature of the Angels (ff. 47v–51), a Bestiary (ff. 51v–104v) and a Lapidary (ff. 110–120v).

There are occasional drawings and paintings as illustrations to the various texts some almost filling the page. The drawings are tinted in green and brown with crowns, haloes and other details gilded. The green is occasionally used as an overall wash over the drapery area. The drawings are mostly unframed except for a number in the Bestiary section which like the paintings in that part have frames. The four largest drawings are in the sections of the Alexander and Nature of Angels texts: Alexander seated in the pose of authority (f. 18v); a tracing from the Annunciation on the following leaf (f. 47); the Annunciation (f. 47v); Raphael healing Tobit's blindness (f. 48); an unfinished drawing of St. Michael fighting the dragon (f. 50v).

The Bestiary section with 180 illustrations is fully painted up to f. 70v and then tinted or overall colour wash drawings are used: Twelve-footed people, Antipod, the rest of the page is torn away (f. 52); the Bragmanni (f. 52v); Ox (f. 57v); Buffalo, Bulls (f. 58); Sheep and Rams with a shepherd holding a Lamb (f. 58v); Horse (f. 59); Mule (f. 60v); Camel (f. 61); Dromedary, Stag (f. 61v); Stags swimming in a river (f. 62); Fallow-deer (f. 62v); Wild Goat (f. 63); Wild Boar attacked by dogs (f. 63v); Leopard, Lynx (f. 65); Panther (f. 65v); Bear (f. 66); Unicorn (f. 66v); Monoceros (f. 67); Tiger, Griffin (f. 67v); Manticora (f. 69v); Parandrus, Yale (f. 70); Apes (f. 70v); Fox (f. 71); Wolf, Hyena (f. 71v); Jason decapitated, Jason's dog pines beside his dead master, King Lysimachus joined by his dog at his funeral pyre (f. 73); a dog identifies a criminal (f. 73v); Hare, Porcupine (f. 74); Rabbit, Badger, Cat, Mouse, Weasel (f. 74v); Mole, Dormouse, Squirrel (f. 75); Hedgehog, Ants (f. 75v); Hydra (f. 76); Gorgons (f. 76v); Sirens (f. 77); Hippocentaur, Onocentaur (f. 77v); Eagle, Vulture (f. 79v); Cranes, Stork (f. 80); Swan, Bucio (?Bittern), Heron, Ibis (f. 80v); Ibis (f. 81); Rainbow (sic!), Ostrich, Coot (f. 81v); Halcyon, Phoenix (f. 82); Phoenix (f. 82v); Caladrius, Shearwater (f. 83); Ercinea, Coot, Quail, Heron (f. 83v); Duck, Parrot, Pelican (f. 84); Hoopoe, Merops, Hawk, Kite, Partridge (f. 84v); Cinnamol-

gus, Hoopoe (f. 85); Magpie, Jackdaw, Cuckoo, Raven, Crow (f. 85ᵛ); Jackdaw, Bats, Owl (f. 86); Eagle-Owl, Nightingale, Turtle-dove, Dove, Lark (f. 86ᵛ); Crow, Swallow, Blackbird (f. 87); Sparrow, Thrush, Finch, Ficedula, Snipe, Peacock, Cock (f. 87ᵛ); Perindeus Tree (f. 88ᵛ); a walrus-like Whale (f. 89); Whale (f. 89ᵛ); Dolphin (f. 90); Pike, Red Mullet, Grey Mullet, Sword-fish, Serra, Sole, Melanurus, Scorpion (f. 90ᵛ); Squatus, Barbel, Tench, Herring, Eels, Lamprey (f. 91); a crab-like Polypus, a lobster-like Crab, Conch (f. 91ᵛ); Oysters, Mussels, Whelks, Clams, Ycinus (?), Fungia (?), Cantleche (?), Starfish (f. 92); Seal, Hippopotamus (f. 92ᵛ); Anguis, Coluber (f. 93); Dragon, Basilisk (f. 93ᵛ); Viper (f. 94); Asp, Dipsas, Prester, Hypnale (f. 94ᵛ); Emorroris, Seps, Cerastes, Scitalis, Amphisbaena (f. 95); Boas, Jaculus, Hydrus, Celidros, Rinatrix, Siren-serpent, Centris (f. 95ᵛ); Parzas, Cetula, Ophites, Centipede, Lizard, Toad, Salamander (f. 96); Saura, Stellio, serpent shedding its skin (f. 96ᵛ); Worm, Spider, Leech (f. 97ᵛ); Scorpion, Caterpillar (f. 98); Centipede, Snail, Silk-worm, Maggots (f. 98ᵛ); Bees with bee-keeper (f. 99); Fire Stones (f. 101ᵛ); the seated author, Isidore, represented as a king (f. 113ᵛ); the scribe Marbod, author of the Lapidary (f. 120ᵛ); an unfinished drawing of a scribe (f. 126ᵛ).

The fully painted part of the Bestiary is in a vigorous and free style with monumental forms which possibly suggest some connection with a model in wall painting. Bestiary subjects did occur in the wall paintings of the 1237 decoration of the Painted Chamber in the Palace of Westminster. The backgrounds to the various creatures are sometimes a plain colour and in other cases a rudimentary ground plane or landscape features are included. Some animals are depicted in a genre scene as for instance the shepherd holding a lamb, which is included in the Sheep and Rams illustration (f. 58ᵛ) or the hunting scene used for the Wild Boar (f. 63ᵛ).

The drawings with either tinting or overall colour washes are stylistically of great importance. Those of Alexander and the Angels (ff. 18ᵛ, 47ᵛ, 48, 50ᵛ) are large in scale and are an equivalent in drawing to the style of the full-page miniatures in the Glazier Psalter (no. 50). The Alexander has a pose and fold style close to the David in the Coronation scene in the Glazier Psalter. The pose with one leg put up horizontally, with the foot resting on the knee, is commonly found in English art c. 1220–70 in connection with rulers in a role of authority. There is a similar stylistic closeness of the Annunciation scenes in the Psalter and Bestiary. Some of the drawings have very detailed systems of troughed folds (e.g. Raphael healing Tobit) which is a direct precursor of the Westminster drawing style of the mid century (no. 95, Part 2). Such complicated troughed folds and rather angular poses are characteristic of the sculpture in Westminster Abbey in the wall arcades of the radiating chapels, the angels in the South Transept spandrels and the Annunciation group in the Chapter House. These parallels as well as those with the Glazier Psalter suggest this is a London style. The attribution of the drawings by

some writers to St. Albans and the viewing of them as precursors of the style of Matthew Paris is unconvincing (see further discussion no. 95, Part 2). The general stylistic parallels with the late 12th-century stained glass at Canterbury (Caviness) suggest the origins of this troughed fold drawing style may be in the years around 1200.

The very full series of Bestiary illustrations (several of which defy identification as actual creatures) were classified by James as of the Third Family. The same set is found in the nearly contemporary Fitzwilliam Bestiary (no. 55) and later in the century in the Westminster Bestiary (no. 172, Part 2). A particular characteristic of the Third Family are the opening pictures (damaged in this copy) of Isidore's treatise on the Fabulous Nations of the World.

PROVENANCE: No evidence.

LITERATURE: *A Catalogue of Manuscripts preserved in the Library of the University of Cambridge*, 3, Cambridge, 1858, 670–3; A. Goldschmidt, *Der Albanipsalter in Hildesheim*, Berlin, 1895, 45; Druce, 'Abnormal forms', 135, 172; Druce, 'Serra', 25; Druce, 'Medieval Bestiaries, II', 39, 66, pl. XI; James, *Bestiary*, 23, 54; F. Wormald, 'Paintings in Westminster Abbey and contemporary paintings', *Proceedings of the British Academy*, XXXV, 1949, 164; Saxl and Meier, III, 419, pl. III, fig. 7; J. Plummer, 'The Glazier Collection', *Burlington Magazine*, 101, 1959, 194; Schapiro, 'Glazier Psalter', 183, 189; Rickert, *Miniatura*, II, pl. 14; McCulloch, *Bestiaries*, 39, 188; Rickert, *Painting in Britain*, 108; Swarzenski, *Monuments*, fig. 545; Brieger, *English Art*, 149–50, pls. 41b, 50; L. M. Ayres, 'A Tanner manuscript in the Bodleian Library and some notes on English painting of the late twelfth century', *J.W.C.I.*, XXXII, 1969, 49; K. Weitzmann, *Illustrations in Roll and Codex*, Princeton, 1970, 139, fig. 121; Turner, 'Manuscript Illumination', figs. 188, 189; Bennett, *Thesis*, 159; Einhorn, *Spiritalis Unicornis*, 81, 279, 339, fig. 26; M. Caviness, 'The Canterbury Jesse Window', *The Year 1200: a Symposium, New York, Metropolitan Museum of Art*, 1975, 378–9, fig. 17; M. B. Freeman, *The Unicorn Tapestries*, New York, 1976, 89, fig. 114; M. H. Caviness, *The early stained glass of Canterbury Cathedral*, Princeton, 1977, 73, fig. 132; Yapp, 'Birds', 319; J. B. Friedman, *The Monstrous Races*, Cambridge, 1981, 11–13, 47, 242 n. 53, figs. 4, 6.

54. Oxford, Bodleian Library MS Bodley 602, ff. 1–66
Bestiary
240 × 175 mm., ff. 66
c. 1230. Southern England *Ills. 190, 191*

The text is illustrated by 87 unframed fully painted drawings set in various positions in the text: Lion, three scenes (f. 1ᵛ); Antelope (f. 3); Fire Stones (f. 3ᵛ); Serra (f. 4); Caladrius (f. 5); Pelican (f. 5ᵛ); Owl (f. 6); Eagle (f. 6ᵛ); Phoenix (f. 7); Phoenix

rising from the flames (f. 7ᵛ); Hoopoe (f. 8); Ants (f. 9); Sirens, Onocentaurs (f. 10); Hedgehog (f. 11); Ibis (f. 11ᵛ); Fox (f. 12ᵛ); two antelope or deer seemingly unconnected with the text (f. 13ᵛ); Unicorn (f. 14); Beaver (f. 15); Hyena (f. 16); Hydrus (f. 16ᵛ); Hydrus (f. 17); Goat (f. 17ᵛ); Wild Ass (f. 18); Apes (f. 18ᵛ); Coot (f. 19ᵛ); Panther (ff. 20, 21ᵛ); Dragon (f. 22); Whale (f. 22ᵛ); Partridge (f. 23ᵛ); Weasel (f. 24); Asp (f. 24ᵛ); Ostrich (f. 25); Turtledoves (f. 26); Stag (f. 26ᵛ); Salamander (f. 27ᵛ); Doves (f. 28); Perindeus Tree (f. 29); Elephant (ff. 30, 30ᵛ); Amos with the goats (f. 32); Fire Stones (ff. 32ᵛ, 33ᵛ); Mermecolion (f. 34); Isidore as author (f. 36); various types of dove (ff. 37, 38ᵛ, 39, 39ᵛ, 40, 40ᵛ, 41); Eagle (f. 41ᵛ); the Winds and points of the Compass (f. 42); head of Christ (for Auster), head of the Devil (for Aquilo), Hawk (f. 42ᵛ); various Hawks (ff. 43ᵛ, 44, 44ᵛ); the Sparrow and Dove (f. 44ᵛ); Palm Tree (f. 45); a man holding a palm branch and shield (f. 45ᵛ); a man wrestling with the Devil (f. 46); a kneeling cleric in a circle with four doves at the cardinal points (f. 46ᵛ); Cedar (f. 47); birds resting in the Cedar (f. 48); Sparrow (f. 48ᵛ); other forms of Sparrow (ff. 49, 49ᵛ); the cleansing of the Leper with the two sparrows, Leviticus, Chap. XIV (f. 50); the Pelican feeding its young (f. 50); Nictorax (f. 51); Raven (f. 51ᵛ); Cockerel (f. 53ᵛ); Ostrich (f. 55ᵛ); Vulture (f. 59); Cranes (f. 60); Kite (f. 61); Swallow (f. 61ᵛ); Storks (f. 62ᵛ); Blackbird (f. 63); Owl (f. 64); Jackdaw (f. 64ᵛ); Geese (f. 65ᵛ).

These drawings are painted in very bright colours of brown, blue, green and a very unusual carmine pink. The technique is almost like full painting with occasional use of white highlighting, but the black drawing lines are usually strongly superimposed. This style is a freer more robust version of the London drawing styles seen in nos. 52, 53 and the manuscript may have been produced in a place not far removed from London. The bright colours used and the lack of any relation to the early style of Matthew Paris contradict the suggestion (Pächt and Alexander) that it was perhaps produced at St. Albans.

The series of subjects has been classified (McCulloch) as a sub-group of the First Family of Bestiaries. It is a type which is found in English illustrated versions in the 12th century (*Survey*, III, nos. 36, 104) which set the format of drawings lacking frames. It is exceptional in the 13th century but there is one related example, Oxford, Bodl. Douce 167, ff. 1-12. The artist of Bodley 602 is remarkable for his stereotyped drawings of the birds. His successful drawing of the eagle is repeated with little variation for several other birds.

PROVENANCE: William Thecher canon of the Augustinian priory of Newark (Surrey) gave the book to John Ross, canon of the same house, as is recorded on f. 13ᵛ. The texts (ff. 67-171) bound together with the Bestiary have a 15th-century ownership inscription of the Benedictine priory of Hatfield Regis (Essex). The volume was presented to the Bodleian Library by Sir George More in 1604.

LITERATURE: Druce, 'Yale', 177; Druce, 'Caladrius', 408; Druce, 'Abnormal forms', 172; Druce, 'Serra', 25, 26; *S.C.*, I, no. 2393; James, *Bestiary*, 9, 10-11, 52, suppl. pls. 7, 8; F. Saxl, R. Wittkower, *British Art and the Mediterranean*, London, 1948, pl. 29. 4; Bodleian Picture Book, *English Rural Life*, figs. 3b, 10d, 20b, 21b; Saxl and Meier, III, 312, pl. II, fig. 4; C. R. Dodwell, *The Canterbury School of Illumination*, Cambridge, 1954, 72, pl. 43d; Baltrušaitis, *Reveils et Prodiges*, 132, fig. 20A; McCulloch, *Bestiaries*, 29, passim; Ker, *Medieval Libraries*, 96, 133; K. Varty, *Reynard the Fox*, Leicester, 1967, 151; Klingender, *Animals in art*, 386, fig. 218a; Pächt and Alexander, III, no. 371, pl. XXXII; Einhorn, *Spiritalis Unicornis*, 80, 81, 335, fig. 80; W. O. Hassall, 'Bestiaires d'Oxford', *Les dossiers de l'archéologie*, 16, 1976, 75, 79.

55. Cambridge, Fitzwilliam Museum MS 254
Bestiary
266 × 174 mm., ff. ii + 46 + iii
c. 1220-30. (?) London region *Ills. 185-189*

The 143 illustrations are unframed, set against the plain vellum and lightly painted: Sciopod, Pigmy, Bragmanni (f. 1); Map of the World (f. 1ᵛ); a very mutilated scene of Adam naming the animals (f. 2); Ox (f. 4ᵛ); Buffalo (f. 5); Sheep and Rams with a shepherd (f. 5ᵛ); He-Goat, Pig (f. 6); Ass, Wild Ass (f. 6ᵛ); Horse (f. 7); Mule (f. 8ᵛ); Camel (f. 9); Dromedary (f. 9ᵛ); Stags, Stags swimming in a river (f. 10); Fallow-deer, Wild Goat (f. 11); Wild Boar attacked by dogs (f. 11ᵛ); Lion being hunted (f. 14); Lion with lioness and cubs (f. 14ᵛ); Androcles and the Lion (f. 15); Leopard (f. 15ᵛ); Lynx, Panther (f. 16); Bear (f. 16ᵛ); Unicorn (f. 17); Monoceros (f. 17ᵛ); Manticora, Parandrus (f. 18); Yale, Apes (f. 18ᵛ); Beaver (f. 19); Wolf (f. 19ᵛ); Fox, Hyena (f. 20ᵛ); Bonnacon (f. 21); Ibex, Dog (f. 21ᵛ); Hare (f. 22); Porcupine, Rabbit, Badger, Cat, Mouse (f. 22ᵛ); Mole, Squirrel (f. 23); Hedgehog, Ants (f. 23ᵛ); Crocodile (f. 24); Otter (f. 24ᵛ); Eagles (f. 25ᵛ); Crane, Stork (f. 26); Swan, Bittern, Heron, Ibis (f. 26ᵛ); Phoenix, Caladrius (f. 27); Ostrich, Ercinea, Coot, Halcyon (f. 27ᵛ); Shearwater, Quail, Heron, Duck, Parrot (f. 28); Pelican, Hoopoe, Hawk (f. 28ᵛ); Partridge (f. 29); Magpie, Cuckoo, Raven (f. 29ᵛ); Jackdaw, Bats, Owl (f. 30); Eagle-Owl, Nightingale, Turtle-dove, Dove (f. 30ᵛ); Swallow, Lark, Blackbird (f. 31); Peacock, Cock (f. 31ᵛ); a walrus-like Whale (f. 32ᵛ); Whale (f. 33); Dolphin (f. 33ᵛ); Pike, Red Mullet, Grey Mullet, Swordfish, Serra (f. 34); Melanurus, Barbel, Tench, Eel, Lamprey (f. 34ᵛ); Polypus, Crab, Conch (f. 35); Oysters, Mussels, Whelks, Clams, Cantleche, Starfish (f. 35ᵛ); Seal (f. 36); Anguis (f. 36ᵛ); Dragon, Basilisk (f. 37); Viper (f. 37ᵛ); Asp, Dipsas, Prester (f. 38); Cerastes, Scitalis, Amphisbaena (f. 38ᵛ); Boas, Jaculus, Hydrus, Rinatrix, Siren-serpent, Cerula (f. 39); Lizard, Toad, Salamander, Saura (f. 39ᵛ); Stellio, serpent shedding its skin (f. 40); Worm, Spider, Leech (f. 41); Scorpion (f. 41ᵛ);

Snail, Frog (f. 42); Bees with bee-keeper (f. 42ᵛ); Cerberus (f. 44ᵛ).

Most of the creatures are lightly painted overall, rather than tinted, although proper tinted drawing technique is occasionally used. The animals and figures are in vigorous poses and it is regrettable that the manuscript has been badly preserved. The figure style is related to the London style of nos. 52, 53 and is either a provincial derivation or possibly a precursor of that style. A later hand has done marginal drawings copying the illustrations on ff. 8ᵛ, 9, and some heads and an angel on ff. 12ᵛ, 13.

The unusual series of pictures was classified as the Third Family by James and is close in sequence and iconography to nos. 53 and 172, Part 2. There is the same tendency to make scenes incorporating genre elements, as in no. 53, with almost identical compositions.

The Map of the World is of the Crates type, named after its classical prototype, the Crates globe. The world is divided into two semicircular zones separated and surrounded by sea. It is a relatively rare form of world map probably because it implied the existence of the Antipodes which was disputed by the Church.

PROVENANCE: Edward Smith left the book to his friend Timothy Colmore of Durham who gave it in 1809 to Chr. Fulthorpe (ff. i, 1). The Earl of Ashburnham (1797–1878)—Appendix no. CLXXVIII. Acquired by the Fitzwilliam Museum from the sale of the Ashburnham collection in 1899.

LITERATURE: Druce, 'Serra', 22 n. 2, 25, fig. 3; Druce, 'Medieval Bestiaries, II', 50; James, *Bestiary*, 23; F. Wormald, P. M. Giles, 'A handlist of additional manuscripts in the Fitzwilliam Museum', *Transactions of the Cambridge Bibliographical Society*, 5, 1951, 200, no. 14; McCulloch, *Bestiaries*, 39, 98, 129 n. 82, 151, 174, 192; Einhorn, *Spiritalis Unicornis*, 80, 81, 339, fig. 83.

56. London, British Library MS Egerton 2849

Obituary Roll of Lucy, prioress of Hedingham
After 1226. (?) Hedingham (Essex) *Ill. 202*

This roll of 208 mm. width has a picture section of 305 mm. in height with three framed scenes in drawing tinted green and pink, with the top and bottom scenes against a pale yellow ground: at the top the Crucifixion and the seated Virgin and Child; in the middle two angels taking up in a napkin the the soul of Lucy, prioress of the Benedictine nunnery of Hedingham (Essex); at the bottom the conclusion of the funeral rites, the absolution of the prioress round whose bier stand a priest, clerics holding cross, censer, holy water bucket and asperge, and four nuns.

A large ornamental initial U tinted in brown, green and red begins the text of the letter of Prioress Agnes; further down the roll is an initial T in similar style.

The text begins with a letter from Agnes, Prioress of Hedingham, asking for prayers for the soul of her predecessor Lucy. Lucy de Vere was foundress and first prioress of the nunnery. The roll was sent around to 122 religious houses in the southern half of England, each writing an answer to the request for prayers. The letter of Agnes is in book hand, but most of the entries by the religious houses are in charter hand.

The style of the drawings is a rougher version of the London style (nos. 52, 53, 55) and may well suggest it is a provincial derivant of the Essex region in the neighbourhood of Hedingham. It has been suggested (Lethaby) that the style is close to the earliest Crucifixion of the wall paintings of that subject in the nave of St. Albans. The resemblance is however only in very general characteristics.

The Cambridge Franciscans who were established there in 1226 made in entry on the roll and thus provide an approximate post 1226 date. The length of time the roll took to circulate around the 122 religious houses is of course a matter for speculation, and may have been a matter of years.

PROVENANCE: The Benedictine nunnery of Castle Hedingham (Essex). In the 17th century owned by the de Vere family, Earls of Oxford, as recorded in a note by Thomas Astley attached to the manuscript. It was acquired by the British Museum in 1903.

LITERATURE: J. Weever, *Funeral Monuments*, London, 1767, 370; *New Pal. Soc.*, I, pl. 21; W. H. St. John Hope, *The Obituary Roll of John Islip*, *Vetusta Monumenta*, VII, 1906, pt. IV, 3–4, pls. XV, XVI; *Catalogue of Additions to the Manuscripts in the British Museum in the years* 1900–1905, London 1907, 390; W. R. Lethaby, 'English Primitives, I', *Burlington Magazine*, 29, 1916, 190 ff., pl. 2; Tristram, *Wall Painting*, 326, 331, pl. 154; Schapiro, 'Glazier Psalter', 189; Brieger, *English Art*, 169; J. Plummer, *The Glazier Collection of Illuminated Manuscripts*, New York, 1968, 22; Watson, *Dated Manuscripts*, no. 613, pl. 134.

EXHIBITED: London, British Library, *The Benedictines in Britain*, 1980, no. 51, 32, pl. 16.

57. London, British Library MS Harley Charter 83. A. 37

Single leaf from a Missal
280 × 185 mm.
c. 1220–30. *Ill. 203*

The blank reverse of this leaf from a Missal was used for a 14th-century charter. The subject of the Crucifixion which is depicted on the other side is frequently found in Missals facing the text of the Canon Prayer. This example is a full-page framed drawing with the figures of Christ, the Virgin and St. John tinted in green and a pink-brown with the frame in green.

The style is characterised by forceful poses and elaborate linear systems of folds. In a general sense it is similar to work in the Glazier Psalter (no. 50), in particular the figure of the Angel in the Annunciation miniature.

At the top of the drawing a later hand has written 'Missale parochia Pirton' which suggest it was a Missal belonging to Pirton (Worcestershire) church. It is a rare survival of an illustrated page from an English Missal of this period as the few other examples lack figure decoration.

PROVENANCE: The church of St. John Baptist, Pirton (Worcestershire) as evidenced by a 14th-century inscription above the drawing and on the reverse a 14th-century charter concerned with rights of pasturage.

LITERATURE: W. de Gray Birch, *Early Drawings and Illuminations in the British Museum*, London, 1879, 6.

58. Manchester, John Rylands Library MS lat. 140
Bible
308 × 208 mm., ff. iii +314
c. 1220-40 *Ills. 199, 200*

This Bible is exceptional in having framed scenes in the margins rather than historiated initials at the beginning of most of the books with coloured drawings against coloured grounds. The figures are tinted or have overall colour wash in brown and green, and occasionally blue, and are set against blue or brown-pink grounds. The subject matter of many of the scenes is not clear, much is repetitive and in general quite apart from usual systems of Bible illustration. The 68 scenes are as follows: PROLOGUE, Jerome writing (f. 1); GENESIS, Creation of Eve (f. 2ᵛ); EXODUS, the killing of the Hebrew children (f. 13ᵛ); EXODUS, Chapter XV, a seated man holding a book (f. 17); LEVITICUS, a sacrificial offering of an animal (f. 23); NUMBERS, God speaking to Moses (f. 29ᵛ); DEUTERONOMY, Moses speaks to the Israelites (f. 39); PROLOGUE TO JOSHUA, Joshua standing (f. 48); JOSHUA, Joshua standing (f. 48ᵛ); JUDGES, (?) the death of Joshua (f. 54ᵛ); RUTH, Elimelech and Naomi (f. 60); KINGS I, II, a standing man (ff. 61, 68ᵛ); KINGS III, IV, a standing king (ff. 74ᵛ, 82ᵛ); CHRONICLES I, a standing man (f. 90); CHRONICLES II, a seated man (f. 96ᵛ); JOB, Job standing (f. 105ᵛ); JOB, Chapter XXXII, Job standing (f. 110); ISAIAH, Isaiah standing (f. 112); JEREMIAH, Jeremiah standing (f. 124ᵛ); LAMENTATIONS, Jeremiah lamenting (f. 139); EZEKIEL, Ezekiel writing (f. 142); DANIEL, Daniel standing (f. 156); PROVERBS, Solomon teaching (f. 161); ECCLESIASTES, Ecclesia holding a chalice (f. 166); WISDOM, Solomon seated (f. 168ᵛ); ECCLESIASTICUS, Solomon standing (f. 172ᵛ). The books of the minor prophets all have a standing figure holding a scroll: HOSEA (f. 182); JOEL (f. 183ᵛ); AMOS (f.

184); ABDIAS, (f. 185); JONAH (f. 185ᵛ); MICAH (f. 186); NAUM (f. 186ᵛ); HABAKKUK (f. 187); SOPHONIAS (f. 187ᵛ); HAGGAI (f. 188); MALACHI (f. 190). Then follow: ESDRAS I, Esdras standing (f. 190ᵛ); NEHEMIAH, Nehemiah standing (f. 193); NEHEMIAH, Chapter VII v. 70, a man giving coins to the treasury of Jerusalem (f. 194ᵛ); TOBIT, Tobit giving money to the poor (f. 196); ESTHER, Assuerus rebuking Vashti (f. 201ᵛ); MACCABEES I, a battle scene (f. 204ᵛ); MATTHEW, the Angel (f. 218); MARK, the Lion (f. 225); LUKE, the Bull (f. 229ᵛ); JOHN, the Eagle (f. 237ᵛ); ACTS, a large picture of the Ascension (f. 243); ROMANS, a large picture of Paul standing (f. 250ᵛ). The remaining Epistles of Paul and those of James, Peter and John all have standing figures of their authors: CORINTHIANS I (f. 253ᵛ); CORINTHIANS II (f. 256ᵛ); GALATIANS (f. 258); EPHESIANS (f. 259); PHILIPPIANS (f. 260); COLOSSIANS (f. 261); THESSALONIANS I (f. 261ᵛ); THESSALONIANS II (f. 262); TIMOTHY I (f. 262ᵛ); TIMOTHY II (f. 263); TITUS (f. 264); PHILEMON (f. 264); JAMES (f. 267); PETER I (f. 268); PETER II (f. 268ᵛ); JOHN I (f. 269). The illustration ends with the figure of St. John writing for the APOCALYPSE (f. 270ᵛ).

The drawing style is difficult to parallel exactly and very probably the manuscript was produced at an isolated centre. There is a preference for elongation of figure forms and rather stiff poses. Usually the figures are coloured with overall wash rather than tinting, and in this feature and general aspects of style there is a similarity to the Anselm manuscript (no. 60) which is of the same period.

The simplicity of the iconography and unusual format of scenes in the margins suggests production at a centre where models of more complex Bible iconography in historiated initials were not available. Odd features in the order of the books and in the texts of their prologues also suggest a lack of contact with the emerging centres of Bible production such as Oxford and Paris.

PROVENANCE: The 26th Earl of Crawford (1847-1913). His collection of manuscripts was purchased in 1901 by Mrs. Enriqueta Augustina Rylands for the library she had founded in memory of her husband, John Rylands.

LITERATURE: M. R. James, *A descriptive catalogue of the Latin manuscripts in the John Rylands Library at Manchester*, Manchester, 1921, 246-8, pls. 162-3.

59 (a), (b). GIRALDUS CAMBRENSIS, TOPOGRAPHIA HIBERNICA, EXPUGNATIO HIBERNICA, ITINERARIUM KAMBRIAE

59 (a). London, British Library MS Royal 13. B. VIII
Giraldus Cambrensis, Topographia Hibernica, Expugnatio Hibernica, Itinerarium Kambriae
275 × 195 mm., ff. 147
c. 1220. *Ills. 192, 196, 197*

The text of the *Topographia Hibernica*, a description of Ireland by the priest Giraldus Cambrensis (1145–1223), has 45 marginal illustrations in tinted drawing of the creatures, habits of the people and wonders of Ireland: a Crane, Barnacle Geese (f. 8ᵛ); Cormorant (f. 9); Kingfisher, Stork (f. 9ᵛ); Crow (f. 10); Stag, Hare, Badger, Beaver (f. 10ᵛ); Weasel, two snakes, Mole (f. 11); Spider, Fox, Wolf (f. 11ᵛ); ornamental initial (f. 13ᵛ); the fish with three gold teeth found at Carlingford in Ulster, Deer (f. 16ᵛ); the legend of the wolf that talked with the priest of Ulster (ff. 17ᵛ, 18); the bearded woman of Limerick, the man-ox of Wicklow (f. 19); the cow-stag of Chester, the woman of Connaught making love with a goat, Joanna of Paris making love with a lion, an Irish cockerel (f. 19ᵛ); St. Kevin and the blackbird (f. 20); the legend of the bear of St. Firmin of Uzès (f. 20ᵛ); the teals of St. Colman (f. 21); the rats of Ferneginan, the wandering bell of Mactalewus (f. 21ᵛ); the tame falcon of Kildare, the miraculously written Gospels of Kildare (f. 22); a leaping salmon (f. 23); the miraculous speaking crucifix of Dublin, the archer who crossed the hedge of St. Brigid and blew on her fire (f. 23ᵛ); an Irish musician playing the harp (f. 26); the Irish use of the axe (ff. 27ᵛ, 28); the killing of the mare in Tirconnell, the bath in the stew of mare's meat and the eating of it (f. 28ᵛ); men of Connaught in a coracle, an Irishman riding bare-chested on a horse (f. 29); bell and crozier reliquaries, the priest Bernard blowing the horn of St. Brendan (f. 30); a maimed cripple using wooden blocks to walk with (f. 30ᵛ). Nine ornamental pen initials tinted in green, brown, blue and yellow are on ff. 1, 3ᵛ, 34ᵛ, 37, 38, 54ᵛ, 73ᵛ, 74ᵛ, 90ᵛ. These initials are the only decoration to the other two works by Giraldus, the *Expugnatio Hibernica* (ff. 34ᵛ–74) and the *Itinerarium Kambriae* (ff. 74ᵛ–100ᵛ).

The lively drawings have colour washes in brown, green and yellow with occasional use of blue and red. Very possibly the original versions of the subjects were sketches by Giraldus himself in his no longer extant autograph copy. Perhaps an illustrated version was made when he was in Lincoln (1192–8) as there are elements in the drawing style having affinities with work in the Leningrad Bestiary (no. 11) produced in the Lincoln region at that time. The use of marginal drawings is a precursor of the system used later by Matthew Paris in illustrating his Chronicles. The style of the drawing is difficult to locate to any particular region and there is no reason to assume that later ownership by St. Augustine's Canterbury provides evidence of production there.

The choice of curious anecdotal subjects for illustration is again a precursor of Matthew Paris's liking for similarly bizarre incidents for his sketches. Giraldus gave public readings of his text in Oxford and one can imagine that the narration of some of these events would have provided great entertainment for his audience.

The author came from an aristocratic Welsh family, entered the priesthood and had an obsessive ambition which was never achieved to become Bishop of St. Davids. He visited Ireland with Prince John in 1185 and wrote shortly afterwards the account of the country, the *Topographia Hibernica*. The first version was finished shortly after 1188 but this copy is a third revised version which Giraldus prepared. Some writers (Flower, Boase) have dated this manuscript *c.* 1200 which may be a little early. The style of the drawings could possibly be of that date particularly if they derive features from models in the *c.* 1190 autograph copy. But they have general parallels with works *c.* 1220 like the Fitzwilliam Bestiary (no. 55) and it is likely the manuscript is of around that date.

PROVENANCE: The Benedictine Abbey of St. Augustine, Canterbury: '*Liber sancti Augustini extra muros Cantuarie*' is inscribed on f. 147. It is listed as no. 906 in a 15th-century catalogue of the Library of St. Augustine's (James). The manuscript appears in the 1666 catalogue of the Royal Library which passed into the British Museum in 1757.

LITERATURE: J. F. Dimock, *Giraldus Cambrensis Opera*, Rolls Series, V, 1867, xx–xxii, xxxii–xxxiv, 1-202, 207–404, VI, 1868, x–xi, xvii, xxiv, 9–152; M. R. James, *The Ancient Libraries of Canterbury and Dover*, Cambridge, 1903, 294, 518; Warner and Gilson, 94–5, pl. 79; R. Flower, 'Manuscripts of Irish interest in the British Museum', *Analecta Hibernica*, 2, 1931, 311–2; U. T. Holmes, 'Gerald, the naturalist', *Speculum*, 11, 1936, 110 ff; Boase, *English Art*, 197, pl. 31e; O. Pächt, 'A cycle of English frescoes in Spain', *Burlington Magazine*, 103, 1961, 170 n. 25; Ker, *Medieval Libraries*, 45; Klingender, *Animals in art*, 395, fig. 228; A. Gransden, 'Realistic observation in twelfth-century England', *Speculum*, 47, 1972, 48 ff., figs. 2, 3, 5; A. Gransden, *Historical Writing in England c. 550 to c. 1307*, London, 1974, 245 n. 224, 365, pl. VIII; Yapp, 'Birds', 320.

59 (b). Dublin, National Library, MS 700

Giraldus Cambrensis, Topographia
Hibernica, Expugnatio Hibernica
278 × 182 mm., ff. 99
c. 1220. *Ills. 193–195, 198*

This second copy of Giraldus Cambrensis texts is also illustrated with 45 marginal tinted drawings with occasional details in gold and silver and in addition on f. 48 a full-page map of Europe. Both the texts have marginal illustrations although there are very few for the *Expugnatio Hibernica*. Those for the *Topographia Hibernica* are close in iconography to no. 59 (a). They are as follows: Cormorant (f. 11ᵛ); Kingfisher (f. 12); Crow (f. 13); Marten, Badger, Beaver (f. 13ᵛ); Weasel, Mole (f. 14); Wolf, Fox, Spider, Leech, Lizard (f. 14ᵛ); the legend of the wolf that talked with the priest of Ulster (f. 23); the bearded woman of Limerick (f. 24ᵛ); the man-ox of

Wicklow, the woman of Connaught making love with a goat, the cow-stag of Chester (f. 25); Joanna of Paris making love with a lion, an Irish cockerel (f. 25ᵛ); St. Kevin and the blackbird (f. 26); the bear of St. Firmin of Uzès (f. 26ᵛ); the teals of St. Colman (f. 27ᵛ); the rats of Ferneginan, the wandering bell of Mactalewus (f. 28); the tame falcon of Kildare (f. 28ᵛ); the miraculously written Gospels of Kildare (f. 29); a leaping salmon (f. 29ᵛ); the archer who crossed the hedge of St. Brigid and blew on her fire (f. 31); an Irish musician playing the harp (f. 36); the Irish use of the axe (f. 39); the killing of the mare of Tirconnell, the bath in the stew of mare's meat and the eating of it (f. 39ᵛ); men of Connaught in a coracle, an Irishman riding (f. 40); the priest Bernard blowing the horn of St. Brendan (f. 42); a maimed cripple using wooden blocks to walk with (f. 42ᵛ); a full-page map of Europe (f. 48).

Then follow the series of drawings to the *Expugnatio Hibernica*: a man with an axe (f. 56); men drawing swords (f. 64ᵛ); man drawing sword (f. 71); a seated king (f. 72); men drawing swords (ff. 77ᵛ; 78ᵛ); a man holding a vial (f. 81); man drawing sword (f. 84ᵛ). There are twelve large ornamental pen initials with tinted foliate ornament on ff. 1, 2ᵛ, 3, 5, 17, 32, 49, 50, 52, 53, 73ᵛ, 95ᵛ. Some of these have long pen flourishes in red and blue extending into the margin.

The marginal illustrations are tinted in brown and green and often with overall colour washes. The style is similar to no. 59 (a) and doubtless the same pictorial model is being used. This second copy is possibly from the same workshop but a slightly later product.

The map does not seem to have received any detailed attention in the literature. It is a schematic depiction of Europe including the British Isles and Iceland. The contours of the countries are very regular without the detailed indentations of the coastlines found later in the Matthew Paris maps (nos. 88, 91–3). The schematic representations of cities are similar to those later used by Matthew Paris and such earlier maps must have been used by him in planning his more detailed versions.

PROVENANCE: An inscription on f. 99 records that Walter Mybbe gave the book to the Vicars Choral of Hereford in 1438. John N..... (illegible) of Gloucester owned it in the 18th century (f. 1). On the pastedown of the front cover is recorded the purchase in 1831 by Sir Thomas Phillips (1792–1872) from Mr. Strong, a bookseller of Bristol. The volume was purchased for the National Library of Ireland after it appeared in a Sotheby sale (July 1st, 1946, Lot 5).

LITERATURE: J. J. O'Meara, *The first version of the Topography of Ireland by Giraldus Cambrensis*, Dundalk, 1951, 7, pls. opp. 34, 50, 90, 98; Boase, *English Art*, 197; Ker, *Medieval Libraries*, 99; A. Gransden, 'Realistic observation in twelfth century England', *Speculum*, 47, 1972, 48 ff.

60. London, British Library MS Cotton Cleopatra C. XI

Anselm, De similitudinibus (ff. 2–48ᵛ),
Treatises on the faculties of the mind and on science (ff. 70–7ᵛ)
201 × 147 mm.
c. 1220–30. *Ill. 201*

The text of St. Anselm (1033–1109) is a treatise on virtues and vices. The first part, illustrated by a series of allegories, is concerned with the forms of self-will and the rewards and punishments of obedience and disobedience. This incorporates sections 1–71 (ff. 2–20). The second part, sections 72–146 (ff. 20ᵛ–37), is concerned with virtues and vices within monastic life and the gifts of the Holy Spirit. The work has been described (Southern) as an attempt at a systematic study of the psychology of religious life. It is extraordinary that a set of 60 illustrations placed in the margins should have been conceived for such a text full of abstract ideas. These illustrations single out a figure or object mentioned which lends itself to visual presentation. The numbers in brackets refer to the sections of the explanatory text printed in Southern, *Memorials of St. Anselm* or the *Patrologia Latina* (Vol. 159, 605–708) for certain addition material: (Southern 5), a framed picture of six standing figures of God, Voluntas (as an angel), the Devil, a peasant, a woman and an adulterer (f. 2ᵛ); (Southern 9), a woman standing by a spring (f. 3ᵛ); (Southern 19), a woman standing with two heads (f. 5); (Southern 20), three busts in a building symbolising the pleasures of the mind (f. 5ᵛ); (Southern 37), an adulterous queen standing between two figures (f. 8ᵛ); (Southern 38), a woman standing by a dragon symbolising a poisonous herb (f. 9); (Southern 40), a woman between two figures approached by a dog symbolising the various senses (f. 9ᵛ); (Southern 41), a mill with a millstream wheel (f. 10); (Southern 42), two carpenters (f. 10ᵛ); (PL Cap. 44), the city of Jerusalem (f. 11ᵛ); (Southern 46), Christ blessing, a king sitting in judgement (f. 12); (Southern 50), two women symbolising beauty and ugliness (f. 13ᵛ); (Southern 51), one man with a light load, another with a heavy load, symbolising agility and ponderousness (f. 13ᵛ); (Southern 52), a man fighting a lion, another turning away, symbolising strength and weakness (f. 14); (Southern 53), a lord and lady and a peasant digging, symbolising liberty and servitude (f. 14ᵛ); (Southern 54), one man seated on a stool, another man in bed, symbolising health and sickness (f. 15); (Southern 59), a scholar in dispute with a man wielding a club, symbolising wisdom and foolishness (f. 16); (PL Cap. 61), a man disputing with an angel (f. 17); (Southern 62), two women embracing, symbolising friendship (f. 17ᵛ); (Southern 63), a woman pulling another's hair, symbolising discord (f. 18); (Southern 71), one man harping, another clasping his hands in grief, symbolising joy and sadness (f. 20); (Southern 73), God seated with a man beside him (f. 20ᵛ); (Southern 74), a man disputing with the Devil (f. 21); (Southern 75), God in discussion with a king (f. 21ᵛ); (Southern 76), a king seated before a town

and a castle (f. 22); (Southern 77), a sick monk and a flask of medicine (f. 22ᵛ); (Southern 78), a black monk conversing with a white monk (f. 23); (Southern 79), a black monk in conversation with an angel (f. 23); (Southern 80), God in conversation with an Emperor (f. 23ᵛ); (Southern 83), a sinful monk conversing with a layman (f. 25); (Southern 84), a monk seated by a tree (f. 25ᵛ); (Southern 87), a servant girl between two women (f. 26); (Southern 88), a man and woman embracing (f. 26); (Southern 90), a seated monk holding a coin (f. 26ᵛ); (Southern 93), a monk being given a tonsure (f. 27ᵛ); (Southern 97), a monk seated by a gardener (f. 28); (Southern 101–8), a man at confession (f. 29); (PL Cap. 112), two sisters in conversation (f. 31); (Southern 119), a dying man with his soul coming out of his side (f. 32ᵛ); (Southern 128), a sheep, an ox and a dog (f. 34ᵛ); (Southern 130), a doctor holding a flask (f. 35); (Southern 136), Solomon standing (f. 35ᵛ); (Southern 138), a man and woman symbolising pride and humility (f. 36); (Southern 146), a man cutting down a tree (f. 37); (PL Cap. 147), a figure with two heads (f. 37); (PL Cap. 150), a man meditating (f. 37ᵛ); (PL Cap. 154), a harpist (f. 38); (PL Cap. 155), a devil behind two men (f. 38); (PL Cap. 156), a poor man and a man with long hair (f. 38ᵛ); (PL Cap. 158), a seated man (f. 39); (PL Cap. 167), two figures with the Holy Ghost (f. 40); (PL Cap. 168), God pointing to a star (f. 40); (PL Cap. 177), the Devil conversing with a novice (f. 41ᵛ); (PL Cap. 178), two figures planting trees (f. 41ᵛ); (PL Cap. 179), a goldsmith at work (f. 42); (PL Cap. 184), the Devil with hunting horn and hounds pursuing a naked man and woman (f. 42ᵛ); (PL Cap. 189), a hare (f. 43ᵛ); (PL Cap. 190) a small bird (f. 43ᵛ); (PL Cap. 192), a man lying dead (f. 44); (?) St. Ambrose (f. 48ᵛ).

The treatises on the faculties of the mind and on science are illustrated by three diagrams with figure personifications: the Arts and the Sciences (f. 72ᵛ); the Virtues (f. 75); a schema of the Christian faith with scenes of the Virgin and Child, the Church and Synagogue, the Crucifixion and various actions of Christ (f. 77ᵛ).

These drawings are painted or tinted in green, brown, grey and yellow. They were probably executed at the Cistercian Abbey of Dore (Herefordshire) whose ownership is attested by a 16th-century inscription. The production at Dore is suggested because a later version of the drawing style but having brighter colouring is found in a 1244 dated copy of Bede (London, British Library MS Egerton 3088) which also belonged to the Abbey. Production of illustrated books at monastic centres was by the 1220s relatively rare, and the Anselm text perhaps provides an interesting document of the sort of work which was specifically designed for a monastic readership.

PROVENANCE: The Cistercian Abbey of Dore (Herefordshire) as evidenced by a 16th-century inscription on f. 2: 'Liber abbathie de Dore. J. Exon.'. Sir Robert Cotton (1571–1631), and from his grandson Sir John Cotton it was presented with the Cotton Library to the Nation in 1700. Incorporated into the British Museum in 1753.

LITERATURE: W. de Gray Birch, *Early Drawings and Illuminations in the British Museum*, London, 1879, 6; M. R. James, *Abbeys*, London, 1925, col. pl. facing page 6; Millar, I, 121; Ker, *Medieval Libraries*, 58; R. W. Southern, *Memorials of St. Anselm*, London, 1969, 38, 297 (an edition of a purer form of the text).

61. Private Collection

Life of St. Thomas of Canterbury
300 × 220 mm., ff. 4
c. 1230–40. (?) London

Ills. 206–208

These four leaves with eight pictures are all that remains from an illustrated life of St. Thomas Becket in French verse. Framed tinted drawings are placed at the head of the text which is partly in two columns and partly in three. In all cases except f. 3ᵛ the illustration extends across all the columns of the text with in some cases the frame subdivided to include two scenes: Henry II expelling the friends and relations of Thomas, Thomas at Pontigny lying ill from too much fasting (f. 1); the parting of Thomas and Pope Alexander III (f. 1ᵛ); Thomas pronounces sentence of excommunication on his enemies, he appears before Henry II and Louis VII of France (f. 2); he parts from the two kings (f. 2ᵛ); Henry's son crowned by the Archbishop of York, the Coronation banquet (f. 3); Thomas and Pope Alexander told of the Coronation (f. 3ᵛ); Thomas on his departure for England is warned of danger by Milo, chaplain to the Count of Boulogne (f. 4); Thomas lands at Sandwich (f. 4ᵛ). The rubric titles above the drawings are the result of the drawings being placed at the head of the page away from the passage of text they illustrate. Two contemporary illustrated copies of Romances (nos. 81, 82) show the older system in which the illustration is placed within the text.

The attribution of the authorship and illustration of this Life of Thomas to Matthew Paris is controversial. In Matthew's autograph copy of the Life of Alban (no. 85) is a note in his own handwriting mentioning that he had copied (he uses the word *transtuli* which could also be interpreted to mean translated) and illustrated a book about St. Thomas the Martyr and St. Edward. This statement could either mean that he copied out the Life from another exemplar or that he translated it into French from a Latin version. This manuscript however is not the Life of Thomas mentioned by Matthew for it is neither in his handwriting nor are the illustrations by him. This can be clearly seen by comparison with his autograph copy of the Life of St. Alban (no. 85). The figures in the Thomas are more angular in form and jerky in pose, the lines are not so rounded in the fold patterns, and the facial types have a smaller

range of expressions than in the work of Matthew. The drawing style has features in common with the Life of St. Guthlac (no. 22) and more particularly with London work of the 1220s such as the drawings in the Psalter in Emmanuel College Cambridge (no. 52).

It has been stated (Legge, Vaughan) that the leaves are of similar size to the Lives of St. Alban (no. 85) and Edward (no. 123) but the dimensions are not particularly close. However, the placing of the illustration in a rectangular frame at the head of the column of the text is an arrangement found in all three books and also Matthew Paris's Lives of the Offas (no. 87). But it is a system of illustration commonly used in the period also for the illustrated Apocalypses, and there is no reason to attribute its invention to Matthew Paris. The wrong assertion of similarity of size and the equally wrong assertion of similarity of style with the works connected with Matthew Paris has led to the generally accepted opinion that this Life of Thomas was a St. Albans product copying an original by Matthew Paris. The authorship of the text by Matthew is controversial yet possible, but the evidence for the production of this surviving Life of St. Thomas at St. Albans is not very strong. The drawing style derives from London works like the Emmanuel Psalter (no. 52) and is quite distinct from that of Matthew Paris (no. 85) and his assistants (no. 86). If Matthew's statement about the Life of St. Thomas means that he copied out the text from an earlier version and provided illustrations then the manuscript he used might well have been similar to the fragment which we are considering. This complex problem of the links between the work of Matthew Paris and that of London artists is discussed further under nos. 81, 82, 95, 123. Because of the early date suggested by its drawing style the Life of Thomas is a key work in the consideration of this problem and paradoxically has not received much attention in the literature.

PROVENANCE: Acquired by Jacques Goethals-Vercruysse (d. 1838) who collected books from Courtrai and Flanders during the period following the French Revolution. The manuscript has remained in the possession of the Goethals family.

LITERATURE: P. Meyer, *Fragments d'une vie de Saint Thomas de Cantorbéry*, Paris, 1885 (facsimile); James, *Estoire de Saint Aedward*, 18, 28; James, 'Matthew Paris', 3; Millar I, 59, 123; Saunders, *English Illumination*, I, 78; T. Borenius, *St. Thomas Becket in Art*, London, 1932, 41 ff., 53, 66, 105 n. 1, pls. XI, XII; M. D. Legge, *Anglo-Norman in the Cloisters*, Edinburgh, 1950, 26; Vaughan, *Matthew Paris*, 168 ff., 178, 207, 221–2; Henderson, 'Studies', I, 79 ff; H. Waddams, *Saint Thomas Becket 1170–1970*, London 1969, figs. on 11, 13, 14.

EXHIBITED: Courtrai, *Gewijde Kunst te Kortrijk*, 1953, no. 149.

62. London, Lincoln's Inn MS Hale 123
Bible
240 × 158 mm., ff. 395
c. 1230–40. *Ills. 212, 213*

This Bible has been much mutilated by the cutting out of many leaves. Each book has a historiated or ornamental initial on a burnished gold ground with punched dot designs. The PROLOGUES have ornamental initials (ff. 1, 3) and then follows the GENESIS initial (f. 3ᵛ) which is divided into multiple small compartments. In the centre, reading from bottom to top, are: the Crucifixion, seven Creation scenes, Annunciation, Visitation, Nativity, Adoration of the Magi, Flight into Egypt, Presentation in the Temple, (?) Christ teaching in the Temple. At the sides of this central series are, reading from bottom to top: God's instructions to Adam and Eve, the Temptation, God's rebuke to Adam and Eve, Expulsion from Paradise, Adam digging, Eve spinning, Offerings of Cain and Abel, Murder of Abel, Lamech shooting Cain, Entry into Jerusalem, Betrayal, Arrest of Christ, Christ before Pilate, Mocking of Christ, Flagellation, Way of the Cross, Crucifixion, Entombment, Christ stepping out of the tomb, Ascension, Pentecost. At the very top of the initial at each side is a black habited monk writing. The surviving 32 initials to the other books are: EXODUS, the baby Moses saved by being set afloat on the Nile (f. 19ᵛ); LEVITICUS, Moses given the Tablets of the Law (f. 32ᵛ); NUMBERS, Moses seated between two men (f. 41); RUTH, Elimelech and Naomi (f. 77ᵛ); KINGS II, Saul's suicide (f. 90); KINGS III, the dying David with Abishag (f. 99); KINGS IV, Ascension of Elijah (f. 109); CHRONICLES II, Solomon directs the building of the Temple (f. 127ᵛ); NEHEMIAH, ornamental (f. 140ᵛ); ESDRAS III, a sacrificial offering of an animal (f. 145); TOBIT, Tobit burying the dead (f. 149ᵛ); ESTHER, ornamental (f. 155).

The Psalter has a dual text; Psalm I, Ahimelech gives Goliath's sword to David, Jonathan shooting arrows (Kings I, Chapter XX, vv. 35–7), Coronation of David, David harping with a musician (f. 168); Psalm 26, God blesses David's eyes, Anointing of David (f. 174); Psalm 38, the Devil beside a man in bed, two men holding a bowl above a reclining man (f. 178); Psalm 51, David and Goliath, David beheading Goliath (f. 182); Psalm 52, the Fool, the Fool pointing to his mouth (f. 182); Psalm 68, Jonah coming out of the whale, Jonah on the whale's back (f. 186); Psalm 97, monks singing, a priest celebrating Mass (f. 194ᵛ); Psalm 101, a monk praying at an altar and a shrine (f. 195ᵛ); Psalm 109, God the Father and God the Son (f. 200); PROLOGUE TO PROVERBS, a large ornamental initial (f. 211); PROVERBS, Solomon teaching (f. 211); ECCLESIASTES, Solomon teaching (f. 218ᵛ); PROLOGUE TO JEREMIAH, ornamental (f. 255); JEREMIAH, the stoning of Jeremiah (f. 255); LAMENTATIONS, Jeremiah lamenting (f. 275); ZACHARIAH, ornamental (f. 303ᵛ); GALATIANS, Paul preaching and writing (f. 363); HEBREWS, Paul teaching (f. 364ᵛ); PETER II, ornamental (f. 377ᵛ); JOHN I, ornamental (f. 378).

The figures are in lively vigorous poses but have a block-like rigidity of form. The folds are delineated with strong thick and thin black lines, and there is some attempt at modelling in colour with white highlights or hatching. This style has many analogies with that of William de Brailes and his assistants (nos. 69–74) and the artist probably has some links with that workshop. The origins of his style are probably from London works of *c.* 1220 (e.g. no. 36) in which blockiness of figures and the same technique of drawing thick and thin black fold lines is found. The artist of the Bible who is working over a decade later has, however, more movement in the figures and fluidity in the fold patterns.

The subjects of the historiated initials at this early stage of 13th-century Bible illustration show no clearly established pattern. As in many English Bibles of the period there are two textual versions of the Psalter (in this case the Hebrew and the Gallican) with, at the liturgical divisions, historiated initials for both versions.

The (?) Benedictine monks in the initials to Genesis and Psalms 97 and 101 suggest the Bible was either produced at or destined for some religious house.

PROVENANCE: Matthew Hale (1609–76), the judge, bequeathed his collection of manuscripts to Lincoln's Inn.

LITERATURE: Ker, *Medieval Manuscripts*, I, 132; Bennett, *Thesis*, 48, 88 n. 2, 103, 108, 140 n. 1, 169, 175 n. 1, 184, 270, 327.

63. London, British Library MS Burney 3
Bible (The Bible of Robert de Bello)
275 × 200 mm., ff. 513 +v
c. 1230–40. (?) Canterbury *Ills. 219–222*

This richly decorated Bible belonged to Robert de Bello, Abbot of St. Augustine's Canterbury (1224–53). There are historiated initials with gold grounds to almost all the books and ornamental initials to their prologues: JEROME'S PROLOGUE, Jerome writing, the sending of the text to Pope Damasus, a bar border terminating in a peacock (f. 2); PROLOGUE TO GENESIS, ornamental (f. 4ᵛ). A very large initial I begins GENESIS having scenes of the Creation in intersecting roundels and having a horizontal extension with six medallions against foliage coils of the main events in Genesis: at the top the Angels and below the Fall of the Rebel Angels beside the Creation of the Firmament, Creation of the Earth and Seas, Creation of the Trees, Creation of the Sun and Moon, Creation of the Beasts and Fishes, Creation of Eve, the Trinity (Seventh Day), God's instructions to Adam and Eve, the Temptation, God's rebuke to Adam and Eve, the Expulsion from Paradise, Adam digging and Eve spinning and suckling Cain, the dove comes to Noah in the Ark, the Building of the Tower of Babel, Abraham and

Isaac on the way to the sacrifice, the Sacrifice of Abraham (f. 5ᵛ).

Then follow for the remaining books 73 smaller initials: EXODUS, the Crossing of the Red Sea (f. 27ᵛ); LEVITICUS, a sacrificial offering of an animal (f. 45ᵛ); NUMBERS, Moses speaks to the Israelites (f. 57ᵛ); DEUTERONOMY, Moses given the tablets of the Law (f. 75); JOSHUA, a scene of circumcision (f. 90); JUDGES, (?) Judah speaks to the Israelites (f. 101); RUTH, Elimelech, Naomi and their sons go to Moab (f. 112ᵛ); KINGS I, Anointing of David (f. 115); KINGS II, Saul's suicide, the Amalekite before David (f. 130); KINGS III, David's charge to Solomon, Solomon directs the building of the Temple (f. 142ᵛ); KINGS IV, the siege of a city (f. 156ᵛ); CHRONICLES I, the descendants of Adam (f. 170); CHRONICLES II, Solomon praying at Gibeon (f. 181ᵛ); ESDRAS I, the building of the Temple (f. 197ᵛ); ESDRAS II, Nehemiah kneeling before Jerusalem (f. 201ᵛ); TOBIT, Tobias and Raphael depart from Tobit (f. 207ᵛ); JUDITH, Judith beheading Holofernes (f. 212); ESTHER, Assuerus and Esther, the hanging of Haman (f. 217ᵛ); JOB, Job on the dungheap (f. 223ᵛ); PROLOGUE TO PROVERBS, a man gives a book to two bishops (f. 234); PROVERBS, Solomon (as cleric) instructing Rehoboam (f. 234); ECCLESIASTES, Solomon teaching (f. 243ᵛ); SONG OF SONGS, the Bridegroom embracing the Bride (f. 246ᵛ); WISDOM, Solomon teaching (f. 248ᵛ); ECCLESIASTICUS, Jesus ben Sirach pointing up to Heaven and down to Hell (f. 255ᵛ); ISAIAH, Isaiah with a woman (f. 274ᵛ); JEREMIAH, in error the Martyrdom of Isaiah was depicted (f. 295ᵛ); LAMENTATIONS, Jeremiah lamenting before Jerusalem (f. 320); BARUCH, Baruch before Josiah (f. 322ᵛ); EZEKIEL, Ezekiel's vision (f. 326); DANIEL, Daniel feeds the dragon of Babylon (f. 348); HOSEA, God speaks to Hosea (f. 357); JOEL, men blow trumpets before Joel (f. 360); AMOS, Amos with (?) a trowel (f. 362); ABDIAS, Abdias prophesies to the people of Edom (f. 364ᵛ); JONAH, Jonah coming out of the whale (f. 365ᵛ); MICAH, Micah standing (f. 366); NAHUM, Nahum standing (f. 368ᵛ); HABAKKUK, Habakkuk brings food to Daniel in the lion's den (f. 369ᵛ); SOPHONIAS, Sophonias standing (f. 371); HAGGAI, Haggai instructs the building of the Temple (f. 372); ZACHARIAH, a vision of Zachariah (f. 373); MALACHI, an angel speaks to Malachi (f. 376ᵛ); MACCABEES I, the worshipping of an idol, a battle scene (f. 378); MACCABEES II, a group of figures debating, the beheading of Nicanor (f. 392).

Then follows the New Testament: PROLOGUE, two men in discussion (f. 402); MATTHEW, Tree of Jesse (f. 402); MARK, Mark standing (f. 416); LUKE, Luke with the head of a bull, Zacharias censing the altar (f. 425); JOHN, John with the head of an eagle, John asleep against Christ's chest, the Woman in Adultery brought before Christ, the Marriage at Cana (f. 440); ACTS, Luke writing (f. 451ᵛ); JAMES, James standing (f. 467); PETER I, Peter sending the letter, the Arrest of Peter (f. 468ᵛ); PETER II, Peter teaching (f. 470); JOHN I, John teaching (f. 471); JOHN II, John sending the letter (f. 473); JOHN III, Peter and

John (f. 473); JUDE, Jude with two followers (f. 473ᵛ); ROMANS, Paul sending a letter (f. 474); CORINTHIANS I, Paul sending a letter (f. 480); CORINTHIANS II, Paul seated (f. 485ᵛ); GALATIANS, Paul writing (f. 489ᵛ); EPHESIANS, Paul in prison (f. 491); PHILIPPIANS, Paul in prison (f. 493); COLOSSIANS, Paul sending a letter (f. 494ᵛ); THESSALONIANS I, Paul teaching (f. 496); THESSALONIANS II, Paul writing (f. 497); TIMOTHY I, Paul teaching Timothy (f. 498); TIMOTHY II, Paul writing (f. 499ᵛ); TITUS, Paul and Titus (f. 500ᵛ); PHILEMON, Paul sending the letter (f. 501ᵛ); HEBREWS, Paul teaching (f. 501ᵛ); APOCALYPSE, John writing (f. 506ᵛ).

Several of these initials have extended stems, sometimes incorporating dragons, which form bars in the margin ending in blocks of ornament. This is an early example of the bar border which later in the century eventually completely frames the text. Angular blocks of ornament also extend from the initials themselves into the borders. Some initials have pen flourishes which penetrate into the margin and this is another feature which points to future developments.

The figure style is characterised by a dry linearism in which black fold patterns are set on uniformly painted colour grounds with no modelling by shading. The same linearism is found in the treatment of the faces. Minor differences of style between the initials suggest that more than one artist worked on the book. The dryness of the style is however compensated by a liveliness of narrative composition and alertness of the figure poses.

This workshop is rather isolated in terms of the figure work but the ornamental leaf forms and the extension bars with blocks of ornament have parallels with contemporary work of the de Brailes workshop (e.g. the Bibles nos. 69, 70). The dry linear figure style could evolve from Canterbury work in manuscripts of the second decade of the century (no. 33) or the stained glass in the Trinity Chapel of the Cathedral. Also the figure of Adam digging on f. 5ᵛ has the unusual feature of him wearing a fleece as in the late 12th-century stained glass in the genealogy series. These Canterbury parallels would give support to the idea of the production of the Bible at that centre which would be very plausible in view of the contemporary ownership by Robert de Bello, Abbot of St. Augustine's. Production at Canterbury has indeed been assumed by some (Millar) but it is by no means certain and there are ornamental and iconographic links with the Lothian Bible (no. 32) which is unlikely to be a Canterbury product. Examples of these links would be in the Genesis initial (f. 5ᵛ) the composition of scenes in roundels surrounded by foliate coils, the Dove's wings touching the cheeks of the other two persons of the Trinity, and the unusual scene of the Fall of the Rebel Angels. Without detailed investigation of these connections with the Lothian Bible and also with work deriving from it in manuscripts of the de Brailes workshop no definite attribution can be made of production of the Bible at Canterbury.

The book must date from the time of Robert de Bello's abbacy (1224–53) as his name has been incorporated below the illuminated peacock on f. 2. Many have dated it late in this period but a date in the 1230s would seem more likely in view of the stylistic and ornamental connections.

PROVENANCE: Robert de Bello, Abbot of the Benedictine Abbey of St. Augustine, Canterbury (1224–53): contemporary inscriptions on ff. 1ᵛ, 2. On the flyleaf at the end, ownership of the 16th and 17th century is recorded. Sir Anthony St. Leger (1496–1559), also on f. 180ᵛ, who was an agent of Thomas Cromwell in suppressing the Abbeys. Edward Drayner was given the Bible by Sir Anthony and he gave it to John Buckridge, Bishop of Rochester and later Ely (1562–1631). The Bishop gave it to Roger Twysden, the antiquary (1597–1672) in 1631. A note (17th century) records the loan of the book to Laurence Sadler. Finally the Bible came into the possession of Charles Burney (1757–1817) whose library was acquired by the British Museum in 1818.

LITERATURE: *Pal. Soc.*, I, pls. 73, 74; M. R. James, *The Ancient Libraries of Canterbury and Dover*, Cambridge, 1903, lxxxix, 197 (no. 10), 515; British Museum, *Reproductions*, I, pl. XI; Herbert, *Illuminated Manuscripts*, 182; E. Maunde Thompson, *An Introduction to Greek and Latin Palaeography*, Oxford, 1912, 450–1; Millar, I, 51–2, pl. 76; A. de Laborde, *La Bible Moralisée illustré*, Paris, 1911–27, V, 8–9, pl. 790; Saunders, *English Illumination*, I, 72–3, II, pl. 75; A. Watson, *The early iconography of the Tree of Jesse*, London, 1934, 48 n. 1; Swarzenski, *Handschriften XIII Jh.*, 17, 92 n. 11, 93 n. 32, 94 n. 45, 103 n. 22; H. Swarzenski, 'Quellen zum deutschen Andachtsbild', *Zeitschrift für Kunstgeschichte*, 4, 1935, 142, fig. 2; Morison, '*Black-Letter' Text*, 34; B. Rackham, *The Ancient Glass of Canterbury Cathedral*, London, 1949, 12, 28, 31; Tristram, *Wall Painting*, 267, 278, pl. 129; J. H. Plummer, *The Lothian Morgan Bible*, Ph.D. Dissertation, Columbia University, 1953, 60, 61, 76; O. Pächt, 'The illustrations of St. Anselm's Prayers and Meditations', *J.W.C.I.*, XIX, 1956, 79, pl. 21d; Rickert, *Miniatura*, II, pl. 6; Ker, *Medieval Libraries*, 43; Turner, *Early Gothic*, 12, pl. 2; Rickert, *Painting in Britain*, 103, pl. 100; Brieger, *English Art*, 81–2, 177, pl. 21a, c; Deuchler, *Ingeborgpsalter*, 172 n. 317; E. S. Greenhill, 'The Group of Christ and St. John as Author Portrait: Literary Sources, Pictorial Parallels', *Festschrift B. Bischoff*, Stuttgart, 1971, 407, 412, pl. 20; Bennett, *Thesis*, 53–4, 109, 134, 140 n. 1, 261, 270; M. H. Caviness, *The early stained glass of Canterbury Cathedral*, Princeton, 1977, 47, 90, 97, 113; J. J. G. Alexander, *The Decorated Letter*, New York, 1978, pl. 28; Zahlten, *Creatio Mundi*, 62, 108, 112, 120, 125, 126, 145, 165, 256, figs. 96, 195; Yapp, 'Birds', 321; P. Barnet, 'A Pair of Thirteenth Century Bibles: The Ruskin Bible at Yale and the Scripps Bible in the Detroit Institute of Arts', *Yale University Library Gazette*, 55, 1980, 11; P. Verdier, *Le Couronnement de la Vierge*, Paris, 1980, 83, 101.

EXHIBITED: London, British Museum, *Illuminated Manuscripts and Bindings of Manuscripts exhibited in the Grenville Library*, 1923, no. 21.

64. London, British Library MS Royal 12. F. XIII

Bestiary and Lapidary
298 × 214 mm., ff. 152
c. 1230. South-East England *Ills. 209–211*

The Bestiary text is illustrated with 55 framed miniatures having plain gold grounds at the end of the passage of text describing the animal: ornamental initial B (f. 3); Lion being hunted (f. 3ᵛ); Lion with other animals (f. 4); Lion with cubs (f. 5); a full-page miniature in two registers, people before the Lion, the Lion before the cockerel (f. 5ᵛ); Tiger (f. 6ᵛ); Leopard (f. 7); Panther (f. 9); Antelope (f. 9ᵛ); Unicorn (f. 10ᵛ); Lynx, Griffin (f. 11); a full-page miniature in two registers, men fighting from a howdah on the Elephant's back, the raising of the fallen Elephant (f. 11ᵛ); Elephants (f. 13ᵛ); Beaver (f. 14); Ibex (f. 14ᵛ); Hyena (f. 15ᵛ); Bonnacon (f. 16); Ape (f. 17); Satyr (f. 17ᵛ); Stags (f. 19); Wild Goats (f. 20); Wild Goats grazing (f. 20ᵛ); Monoceros (f. 21); Bear (f. 22ᵛ); Leucrota (f. 23); Crocodile (f. 24); Manticora (f. 24ᵛ); Parandrus (f. 25); Fox feigning death and carrying off a bird (f. 26ᵛ); Yale (f. 27); Wolf, the man who had lost his speech (f. 29); Dogs (f. 29ᵛ); King Garamantes and his dogs (f. 30ᵛ); a dog identifies a murderer (f. 33); Adam naming the animals (f. 34ᵛ); Sheep (f. 35); Ram, Lamb (f. 35ᵛ); He-Goat (f. 36); Boars, Bullocks (f. 36ᵛ); Oxen (f. 37ᵛ); Camel (f. 38); Dromedary (f. 38ᵛ); Ass (f. 39); Wild Ass (f. 39ᵛ); Horse (f. 42ᵛ); Cat (f. 43); Mouse (f. 43ᵛ); Weasel (f. 44); Mole (f. 44ᵛ); Hedgehog (f. 45); various birds (f. 47ᵛ); Eagles (f. 49); Vulture (f. 50). At this point the illustration ceases, with only blank spaces being left in the text for the remainder of the book.

This is the most extensive piece of work by an artist who also decorates two Bibles (nos. 65, 66), a Medical text (no. 67) and a Psalter (no. 68). In the Psalter he is assisted in a very minor way by the Oxford illuminator, William de Brailes. His work is characterised by bright strong colours (including a characteristic carmine red) flatly applied with the drapery folds strongly delineated in black. The figures are tall and thin and their faces have little modelling. The strong black outlines and fold lines are always precisely drawn and this is one of the finest Bestiaries of the period.

The series of illustrations are of the Second Family as classified by James but it is one of the members of that family with a very individual series of illustrations. Many additions to the Bestiary text derive from the Pantheologus of Peter of Cornwall (a canon of the Priory of Holy Trinity, Aldgate) which is a treatise containing a substantial section dealing with material similar to that found in Bestiaries. Some of the iconography is most unusual and particularly rare is the scene of the man who had lost his speech when looked at by a wolf (f. 29). The man is shown restoring his voice by taking off his clothes and striking two stones together.

The style of the artist is a continuation of that existing *c.* 1220 at Canterbury as evident in the Psalter made for St. Augustine's (no. 33). The Bestiary was owned by a Benedictine Abbey in Kent, Rochester, which had close connections with Canterbury and provides supporting evidence for the artist originating from this area. The only other one of his works to have evidence of provenance is the Psalter, which has a London calendar. It seems likely that the artist both originated and worked in the South-East of England.

PROVENANCE: The Benedictine Cathedral Priory of Rochester as evidenced by the inscription '*Liber de claustro Roffensis R. precentoris*' on f. 3. It is noted on f. 150 that it was repaired by Brother John of Malling, possibly the man of that name who is mentioned in the records of 1387. On f. 151ᵛ are the names of William Grybbons and Thomas Aston. It is not certain when it passed into the Royal Collection which became part of the British Museum in 1757.

LITERATURE: M. F. Mann, 'Eine altfranzösische Prosaversion des Lapidarius Marbods', *Romanische Forschungen*, II, 1886, 363 ff.; G. C. Druce, 'The Symbolism of the Goat on the Norman Font at Thames Ditton', *Surrey Archaeological Collections*, XXI, 1908, 110; P. Meyer, 'Les plus anciens lapidaires français', *Romania*, XXXVIII, 1909, 267–85; Druce, 'Crocodile', 315, 316, 317, 320; Druce, 'Amphisbaena', 290; Druce, 'Yale', 177, 191, 192, pl. IX; Druce, 'Caladrius', 384, 385, 390; Druce, 'Elephant', 10, 42, pls. II, III, VII; Druce, 'Serra', 21 n. 1; Druce, 'Medieval Bestiaries, I', 51, 64, pl. X; Druce, 'Medieval Bestiaries, II', 45, 52, 60, 62, 73, pls. VI, IX; Warner and Gilson, II, 64–5, pl. 75; P. Studer, J. Evans, *Anglo-Norman Lapidaries*, Paris, 1924, 5; Millar, I, 119; Saunders, *English Illumination*, I, 48, II, pl. 53; James, *Bestiary*, 16, 53, suppl. pl. 11; D. J. A. Ross, 'A lost painting in Henry III's palace at Westminster', *J. W. C. I.*, XVI, 1953, 160, pl. 22a; H. Buchthal, *Miniature Painting in the Latin Kingdom of Jerusalem*, Oxford, 1957, 76, pls. 151d, f; McCulloch, *Bestiaries*, 37, 74 n. 15, 188, 189; B. Woledge, H. P. Clive, *Répertoire des plus anciens textes en prose française*, Geneva, 1964, 78; Ker, *Medieval Libraries*, 163; Klingender, *Animals in art*, 392, 396, figs. 222, 229b, 230, 231; B. Rowland, *Animals with Human Faces*, Knoxville, 1973, figs. on 7, 50, 77, 102, 118, 153; Einhorn, *Spiritalis Unicornis*, 79, 278, 337, fig. 82; M. B. Freeman, *The Unicorn Tapestries*, New York, 1976, 45, fig. 42; X. Muratova, 'Adam donne leurs noms aux animaux', *Studi Medievali*, XVIII.II, 1977, 378, pl. XI; P. L. Armitage, J. A. Goodall, 'Medieval horned and polled sheep: the archaeological and iconographic evidence', *Antiquaries Journal*, LVII, 1977, 76, 77; O. Mazal, *Buchkunst der Romanik*, Graz, 1978, 91, col. pl. 52.

EXHIBITED: London, British Library, *The Benedictines in Britain*, 1980, no. 99, 66, pl. 45.

65. Cambridge, University Library MS Ee. 2.23

Bible

335 × 212 mm., ff. 394

c. 1230–40. *Ills. 216–218*

This is one of the best preserved and most completely illustrated of all English Bibles of the first half of the 13th century. There are 62 historiated initials with burnished gold grounds to most of the books although that for Genesis is lacking: EXODUS, Moses given the Tablets of the Law (f. 17ᵛ); LEVITICUS, a sacrificial offering of an animal (f. 30ᵛ); DEUTERONOMY, Moses and the Israelites before the Ark (f. 51); JOSHUA, God speaks to Joshua (f. 62); JUDGES, Ehud kills Eglon (f. 69ᵛ); RUTH, ornamental (f. 77ᵛ); KINGS I, Elkanah seated with Hannah and Peninnah (f. 79ᵛ); KINGS III, David in bed between Abishag and (?) Bathsheba (f. 98); CHRONICLES I, the descendants of Adam (f. 117ᵛ); CHRONICLES II, a soldier speaking to a group (f. 126); ESDRAS I, ornamental (f. 136ᵛ); ESDRAS II, an angel appears to (?) Esdras (f. 139ᵛ); ESDRAS III, a sacrificial offering of an animal (f. 143ᵛ); TOBIT, Tobias before Tobit (f. 148); ESTHER, ornamental (f. 154); JOB, Job on the dungheap (f. 158).

Psalm I, Christ blessing, David harping (f. 165ᵛ); Psalm 26, Judgement of Solomon (f. 168ᵛ); Psalm 38, two men in discussion (f. 170); Psalm 52, Saul's suicide (f. 172); Psalm 68, Jonah thrown to the whale (f. 173ᵛ); Psalm 80, Jacob wrestling with the angel (f. 175ᵛ); Psalm 97, Annunciation to the shepherds (f. 177ᵛ); Psalm 109, the Trinity (f. 179ᵛ); PROVERBS, Solomon teaching (f. 185ᵛ); ECCLESIASTES, Solomon seated (f. 192ᵛ); SONG OF SONGS, Ecclesia standing (f. 195); WISDOM, a female personification of Wisdom (f. 196ᵛ); ECCLESIASTICUS, Solomon standing (f. 201ᵛ); ISAIAH, two men with sickles (f. 215ᵛ); JEREMIAH, the stoning of Jeremiah (f. 232); LAMENTATIONS, Jeremiah lamenting (f. 250ᵛ); BARUCH, Baruch prophesying (f. 252ᵛ); EZEKIEL, Ezekiel's vision (f. 254ᵛ); DANIEL, Daniel in the lion's den (f. 272); HOSEA, Hosea with Gomer (f. 279); JOEL, Joel seated (f. 281ᵛ); AMOS, Amos prophesies the destruction of Jerusalem by fire (f. 282ᵛ); ABDIAS, God speaks to Abdias (f. 284ᵛ); JONAH, Jonah comes out of the whale (f. 285); MICAH, Micah prophesying (f. 285ᵛ); NAUM, Naum prophesies before Nineveh (f. 287ᵛ); HABAKKUK, Habakkuk seated by a flock of sheep (f. 288); SOPHONIAS, an angel speaks to Sophonias (f. 289); HAGGAI, ornamental (f. 290); ZACHARIAH, ornamental (f. 290ᵛ); MACCABEES II, the delivery of the letter to the Jews of Egypt (f. 304ᵛ); MATTHEW, Tree of Jesse (f. 312ᵛ); MARK, Mark writing (f. 323ᵛ); LUKE, Luke writing (f. 330ᵛ); JOHN, John standing (f. 342ᵛ); PROLOGUE TO ROMANS, Paul preaching (f. 351ᵛ); ROMANS, Paul preaching (f. 352ᵛ); CORINTHIANS I, Paul teaching (f. 357); GALATIANS, Paul speaking to a Bishop (f. 363); EPHESIANS, Paul disputing (f. 364ᵛ); PHILIPPIANS, Paul handing a letter to a Bishop (f. 366); COLOSSIANS, Paul speaking to a Bishop (f. 367); THESSALONIANS I, Paul robing a cleric (f. 368); THESSALONIANS II, Paul handing a letter to a Bishop (f. 369); TIMOTHY I, Paul giving communion (f. 369ᵛ); TIMOTHY II, an angel appears to Paul in prison (f. 370ᵛ); TITUS, Paul and Titus (f. 371); PHILEMON, Paul and Philemon (f. 371ᵛ); HEBREWS, the Nativity of Christ (f. 372); APOCALYPSE, John writing (f. 385ᵛ).

The figure style is a small-scale version of that of no. 64 and it is work by the same artist. The iconography of the Psalm initials shows subjects characteristic of English Psalter illustration such as those for Psalms 52, 80, 97. It is difficult to say whether the other historiated initials in the Bible show specifically English traditions because as yet there has been no systematic iconographic study of contemporary work in North France.

No obvious evidence suggests a place of production of this Bible and the smaller one (no. 66) by the same artist. A Bible, Paris, Bibl. Nat. MS lat. 10431 (see p. 126 for further mention) contains at the end of the text the Canon Prayer of the Mass with illumination by the same hand (e.g. f. 348). A Calendar contained in this manuscript may on further analysis provide evidence for localisation although it does not point clearly to any particular provenance.

PROVENANCE: A religious house as the original owner is suggested by a note on f. 255 referring to the use of the Bible for reading in the refectory. Sir Thomas Knyvett (c. 1539–1618), as a note on f. 1 cites it as MS 11 in the Knyvett Collection. His collection passed eventually to John Moore, Bishop of Ely (1707–14). Bishop Moore's Library was purchased by George I and presented to Cambridge University.

LITERATURE: *A Catalogue of Manuscripts preserved in the Library of the University of Cambridge*, 2, Cambridge, 1857, 40; D. J. McKitterick, *The Library of Sir Thomas Knyvett of Ashwellthorpe c. 1539–1618*, Cambridge, 1978, 158.

66. Peterborough, Cathedral Library MS 10

Bible

128 × 90 mm., ff. 351

c. 1230–40. *Ills. 214, 215*

This is a smaller version of no. 65 and is partly by the same artist. It is interesting that in many cases different subjects are used for the historiated initials of the two Bibles even though they seem to be products of the same workshop. The state of preservation of this smaller Bible is less good and much of the text is missing.

In its original state all the books had illuminated initials on gold grounds. The following 41 survive: GENESIS, God the Creator seated, Creation of the Sun and Moon, of the Trees, of the Birds and Beasts, of Adam, of Eve, the Expulsion from Paradise (f. 1); EXODUS, Crossing of the Red Sea (f. 13); LEVITICUS, Moses and the Israelites before the Ark (f. 29ᵛ); NUMBERS, God speaks to Moses (f. 37ᵛ); DEUTERONOMY, Moses speaks to the Israelites

(f. 50); RUTH, Ruth standing (f. 63ᵛ); KINGS I, Elkanah seated with Hannah and Peninnah (f. 66); KINGS II, the Amalekite before David (f. 77ᵛ); KINGS III, David with Abishag and (?) Bathsheba (f. 87); KINGS IV, an angel appears to three men (f. 98); CHRONICLES I, the descendants of Adam (f. 108); CHRONICLES II, Solomon teaching (f. 117); ESDRAS I, Cyrus standing (f. 129); ESDRAS II, the siege of a city (f. 132ᵛ); ESTHER, Assuerus standing (f. 135); TOBIAS, the blinding of Tobit (f. 140); Psalm 38, two men in discussion, very damaged (f. 159); Psalm 52, Saul's suicide (f. 161); Psalm 68, Jonah thrown to the whale (f. 163); Psalm 80, Jacob's ladder and Jacob wrestling with the angel (f. 166); Psalm 119, a king kneeling at an altar (f. 171); ECCLESIASTES, Solomon instructing Rehoboam (f. 180); WISDOM, a female personification of Wisdom (f. 182ᵛ); ISAIAH, Isaiah writing (f. 202); JEREMIAH, Jeremiah disputing (f. 219ᵛ); LAMENTATIONS, Jeremiah lamenting (f. 238ᵛ); BARUCH, Baruch writing (f. 240ᵛ); EZEKIEL, Ezekiel holding (?) a bone (f. 243); HOSEA, God speaks to Hosea (f. 267ᵛ); JOEL, Joel prophesying (f. 270); ABDIAS, an angel appears to Abdias (f. 272ᵛ); HABAKKUK, Habakkuk with a disciple (f. 274ᵛ); ZACHARIAH, ornamental (f. 275ᵛ); MACCABEES I, soldiers (f. 278ᵛ); MATTHEW, Matthew writing (f. 296); CORINTHIANS I, Paul preaching (f. 338ᵛ); CORINTHIANS II, Christ appears to Paul (f. 342ᵛ); GALATIANS, Christ appears to Paul (f. 345ᵛ); EPHESIANS, Christ appears to the sick Paul (f. 347); PHILIPPIANS, Paul baptising (f. 348ᵛ); COLOSSIANS, the care of the sick (f. 350); TIMOTHY I, the stoning of Paul (f. 351ᵛ).

The artist of almost all the initials in this Bible was long ago recognised by Cockerell as the main artist of the Stockholm Psalter (no. 68). This Psalter had formerly belonged to Cockerell and he records on the fly-leaf that he had taken it to Peterborough to compare side by side with the Bible. The Bible is the smallest scale example of this artist's work and this results in a necessarily rather more schematic figure style. He uses the same characteristic colours, in particular a bright red, as are found in his other works (see no. 64 for discussion).

The very small size of the book is comparable with the de Brailes Bible (no. 69) and is typical of the 'portable Bible' which was already being produced in large numbers in Paris.

PROVENANCE: No evidence of medieval ownership or of when it entered the Peterborough Library.

LITERATURE: Cockerell, *W. de Brailes*, 14 n. 1; Brieger, *English Art*, 85 n. 2; Bennett, *Thesis*, Appendices I, A, B, C.

67. Turin, Biblioteca Nazionale MS L. IV. 25
(burnt in the fire of 1904)
Various Medical texts
287 × 114 mm., ff. 202
c. 1230–40. South East England *Ills. 204, 205*

No full description exists of this manuscript before its destruction in the disastrous fire at the Turin Library in 1904. There were two large miniatures on gold grounds: the seated Virgin with the Child (f. 5ᵛ); the Crucifixion (f. 10). Four historiated initials also with gold grounds were at the beginning of the various medical treatises contained in the manuscript: a seated physician holding up a urine bottle for inspection (f. 11); Hippocrates instructing a pupil (f. 28ᵛ); the presentation of a book to a cleric (f. 43); (?) Christ healing the sick (f. 56).

The two surviving photographs of the manuscript are of the large miniatures of the Crucifixion and the Virgin and Child. They are, as far as one can tell from the inadequate reproductions, the work of the artist of the Rochester Bestiary (no. 64) and the Stockholm Psalter (no. 68). In these figures, larger than normally found in the work of the artist, full advantage is taken of the opportunity for more complicated fold patterns. In the figure of the Virgin in the Crucifixion the tense pose of her tall thin figure is enhanced by the nervous fold lines. A smaller Crucifixion miniature by the same artist is found in a Bible containing the Canon Prayer of the Mass (Paris, Bibl. Nat. MS lat. 10431, f. 348).

The subjects of these large miniatures are not of course related to the main section of medical texts but are attached to prayers to the Virgin and Christ on the Cross.

PROVENANCE: No evidence.

LITERATURE: P. Giacosa, *Magistrum salernitani nondum editi*, Turin, 1901, 427–30, figs. opp. 428, pl. 3.

68. Stockholm, National Museum B. 2010
Psalter
180 × 134 mm., ff. 159
c. 1230–40. (?) London *Ills. 223–225; fig. 13*

The Calendar preceding the Psalter has scenes of the Labours of the Months in rectangular panels and of the Zodiac in roundels, both having burnished gold grounds: January, a man feasting (f. 2); February, a man warming himself by the fire (f. 2ᵛ); March, a man pruning a tree (f. 3); April, a man holding flowers (f. 3ᵛ); May, a man on a horse holding a falcon (f. 4); June, a man raking (f. 4ᵛ); July, a man scything (f. 5); August, a man cutting corn (f. 5ᵛ); September, a man picking fruit (f. 6); October, a man sowing (f. 6ᵛ); November, a man threshing corn (f. 7); December, torn away, but two pigs heads surviving suggest the scene was the slaughter of pigs (f. 7ᵛ). The decorative page at the beginning of Psalm 1 is missing but eight historiated initials on burnished gold grounds exist for all other initials of the liturgical divisions: Psalm 26, D, Judgement of Solomon (f. 28ᵛ); Psalm 38, D, a man pointing to his mouth with a young man standing beside (f. 42); Psalm 51, Q, Doeg slaying the priests (f. 53ᵛ); Psalm 52, D, Saul's suicide (f. 54); Psalm 68, S, Jonah thrown to

the whale, Jonah coming out of the whale (f. 66); Psalm 80, E, Jacob wrestling with the angel (f. 81ᵛ); Psalm 97, C, Annunciation to the Shepherds (f. 95ᵛ); Psalm 109, D, the Trinity (f. 111).

On almost every page elaborate pen flourishes in red, blue and gold extend into the margin. These are often combined with dragon extensions coming from the main initials and terminating in blocks of ornament. There are decorative line endings in pen-work and colour wash, some purely ornamental, others formed of fish and bird's heads. Additional page decoration are birds, animals and grotesques placed free in the upper and lower margins. Also in the margins on many pages are coats of arms as shields which apart from the one on f. 124ᵛ appear to be contemporary with the illumination. The abundance of heraldic decoration is very rare at such an early date and this Psalter seems to be the first example. It is also, together with the shields in the manuscripts of Matthew Paris, the earliest series of shields in any form of English art. The selection of arms offers no obvious indication of the original patron but the Butler arms added later in the 13th century on f. 124ᵛ may suggest subsequent owner-ship by a member of that family.

There are two main artists and five assistant decorators. The Calendar medallions and all the historiated initials except that of Psalm 109 are by the artist of the Rochester Bestiary (no. 64). The Psalm 109 initial and the ornamental border on that page are by the Oxford illuminator William de Brailes (see nos. 69–74 for stylistic discussion). The casual involvement of de Brailes in the production of the book suggests he worked for a short period with this workshop while away from Oxford. The other artists are all decorators (their work is analysed in detail in Cockerell, *W. de Brailes*, 13). The artist of the historiated initials helps these decorators by executing some of the bas-de-page animals and grotesques (e.g. ff. 48, 57, 136).

The Calendar is indisputably of the London diocese. Characteristic entries are: Mellitus (24th Apr.), Erkenwald (30th Apr.), Ethelbert (20th May), Erasmus (3rd June), Silas (13th July), Philibert (20th Aug.), Genesius (25th Aug.), Osyth (7th Oct.), Ethelburga (11th Oct.), Translation of Erkenwald (14th Nov.). Both the feasts of Erkenwald and those of Mellitus and Ethelbert (all three venerated at St. Paul's) are in the highest grading colour of blue, and Ethelburga of Barking is in red. The Litany has, however, a Peterborough element as the three Peter-borough saints Kyneburga, Kyneswitha and Tibba are invoked at the end of the list of Virgins. St. Oswald, the relic of whose arm was possessed by Peterborough, is almost at the bottom of the list of Martyrs, and SS. Ethelwold, Aidan and Botulph (venerated at Peterborough) end the list of Confessors. The Litany is in fact merely an adaptation, possibly for a Peterborough patron, and is in no sense a proper Peterborough Litany (see for comparison L. F. Sandler, *The Peterborough Psalter in Brussels*, London, 1974, 161) as has been stated in the literature (Cockerell).

The decorative line endings incorporating fish, the pen flourishes and the free bas-de-page features all have precursors in a London Psalter (no. 37). These connections combined with the London Calendar suggest possibly the book was made in London where the artist of the Rochester Bestiary joined with artists trained in the capital. In a minor way the group was assisted by a casual visitor from Oxford, William de Brailes.

The pen flourishes on the pages with historiated initials form partial borders for the text. This is an early example of the interest in forming borders which is to develop fully in the second half of the century. There are parallels to this use of pen flour-ishes in French manuscripts of the period c. 1220–40: e.g. the Psalters, Manchester, John Rylands Library, MS lat. 22; Paris, Bibl. Nat. MS lat. 1073A; Philadelphia, Free Library, Lewis Coll., MS E. 185.

PROVENANCE: A member of the Butler family in the second half of the 13th century as suggested by the addition of their arms on f. 124ᵛ. On the flyleaf is a 14th-century inscription of ownership by Edith Corf, prioress of the Cistercian nunnery of Tarrant Keynes, Dorset, at some time during the second half of the century. The inscription states that the Psalter is to be left to one of the chantries at the nunnery on her death. On May 29th in the Calendar is added the obit of one of her relations John Corf (fl. 1346–82). In the late 19th century it belonged to a Mr. Whittaker of Hastings (Sussex). It was acquired by Sydney Cockerell in 1909. Major Roland Abbey obtained the book from him in 1956. It was acquired for the National Museum Stockholm after it was sold at Sotheby's in 1970.

LITERATURE: Millar, I, 49, 120; Cockerell, *W. de Brailes*, 2, 3, 11–5, pl. XIV; Haseloff, *Psalterillustra-tion*, 61, Tab. 16; G. Pollard, 'William de Brailes', *Bodleian Library Record*, V, 1955, 203–4; Rickert, *Painting in Britain*, 104, pl. 103C; Brieger, *English Art*, 85–6, 92; *Sotheby Sale Catalogue*, 1st December, 1970, lot 2867, pls. 8, 9; P. Reuterswärd, 'En Hand-skrift av William de Brailes och hans Verkstad i Oxford', *Kontakt med Nationalmuseum*, 1971, 7–15 with figs; C. Nordenfalk, *Bokmålningar från medeltid och renässans i Nationalmusei samlingar*, Stockholm, 1979, 42–7, figs. 39–50, pl. V.

EXHIBITED: London, 1930, no. 151; B.F.A.C., *British Medieval Art*, 1939, no. 33; London, Nation-al Book League, *Treasures from Private Libraries in England*, 1965, no. 39.

69. Oxford, Bodleian Library MS lat. bibl. e. 7
Bible and Select Masses
167 × 116 mm., ff. 440
c. 1234–40. Oxford *Ills. 226, 227*

There are historiated or ornamental initials with gold grounds to the books of the Bible. In view of the small size of the book these initials inevitably con-

tain scenes of a schematic and unimaginative type. An unusual feature is a framed miniature against a blue ground of Moses blessed by God at the end of the Prologue to the Pentateuch (f. 4ᵛ). The 67 decorated initials are: PROLOGUE, ornamental (f. 2); GENESIS, in medallions the Creation of the Firmament, the Earth and the Waters, the Trees, the Sun and Moon, the Fishes, Adam, the Crucifixion (f. 5); EXODUS, ornamental (f. 21); LEVITICUS, God speaks to Moses (f. 34ᵛ); NUMBERS, God speaks to Moses (f. 44); DEUTERONOMY, Moses speaks to the Israelites (f. 57ᵛ); JOSHUA, Joshua speaks to the Israelites (f. 69); JUDGES, Samson fighting the lion (f. 77); RUTH, ornamental (f. 85ᵛ); KINGS I, Saul seated (f. 86ᵛ); KINGS II, David seated (f. 98); KINGS III, ornamental (f. 107); KINGS IV, Ahaziah seated (f. 117ᵛ); CHRONICLES I, a seated man (f. 128); CHRONICLES II, Solomon seated (f. 137); ESDRAS I, NEHEMIAH, TOBIT, ornamental (ff. 148ᵛ, 151ᵛ, 156ᵛ); JUDITH, Judith praying (f. 159ᵛ); ESTHER, ornamental (f. 164); JOB, the Devil before God (f. 168ᵛ); Psalm I, David harping (f. 176ᵛ); Psalm 26, David praying (f. 180ᵛ); Psalm 38, David pointing to his mouth (f. 183); Psalm 51, David and Goliath (f. 184ᵛ); Psalm 52, David lamenting (f. 185); Psalm 68, Jonah coming out of the whale (f. 187); Psalm 80, Jacob wrestling with the angel (f. 189ᵛ); Psalm 97, clerics singing at a lectern (f. 191ᵛ); Psalm 101, David praying (f. 192); Psalm 109, God seated blessing (f. 194).

Following the Psalter a section of the text (ff. 199–204) has the Canon Prayer and various Mass Propers (compare no. 77) including one for the feast of St. Dominic, canonised 1234 (f. 204). An addition in nearly contemporary hand is the Mass for the Translation of Dominic. Then the Bible text resumes: PROVERBS, Solomon seated (f. 208); ECCLESIASTES, ornamental (f. 214ᵛ); SONG OF SONGS, the Bridegroom embracing the Bride (f. 217); WISDOM, Solomon seated (f. 218ᵛ); ECCLESIASTICUS, Solomon seated (f. 223ᵛ); ISAIAH, God appears to Isaiah (f. 237); JEREMIAH, Jeremiah seated (f. 251ᵛ); LAMENTATIONS, Jeremiah lamenting (f. 269); BARUCH, Baruch writing (f. 270ᵛ); EZEKIEL, Ezekiel standing (f. 273); DANIEL, Daniel in the lion's den (f. 289); HOSEA, God speaks to Hosea (f. 295ᵛ); JOEL, God appears to Joel (f. 297ᵛ); AMOS, bust of Amos (f. 298ᵛ); ABDIAS, Abdias sleeping (f. 300); JONAH, Jonah coming out of the whale (f. 300ᵛ); MICAH, NAHUM, ornamental (ff. 301, 302); HABAKKUK, Habakkuk points to heaven (f. 302ᵛ); SOPHONIAS, HAGGAI, ZACHARIAS, MALACHI, ornamental (ff. 303ᵛ, 304, 304ᵛ, 307); MACCABEES I, two soldiers (f. 307ᵛ); MACCABEES II, MATTHEW, MARK, LUKE, JOHN, ornamental (ff. 318, 325ᵛ, 336, 343, 354ᵛ); ROMANS, Paul falling from his horse (f. 363ᵛ). The majority of the other epistles have ornamental initials except : EPHESIANS, Paul seated (f. 375ᵛ); PETER I, Peter standing (f. 397ᵛ); JOHN I, John standing (f. 399ᵛ); JOHN II, III, John preaching (f. 400ᵛ); JUDE, Jude standing (f. 400ᵛ); APOCALYPSE, John writing (f. 401).

This is the best known of the several Bibles by William de Brailes and his workshop. Almost all the illumination is by de Brailes excepting the miniature of Moses on f. 4ᵛ and the initials on ff. 400ᵛ, 401. This second artist worked on the New College Psalter (no. 74) on ff. 44ᵛ, 49ᵛ and 52ᵛ. The figure style of de Brailes in this Bible is that of the early phase of his career and is further discussed under nos. 71–3.

The use of angular blocks of ornament attached to the initials or to bar or dragon extensions (e.g. ff. 159ᵛ, 180ᵛ) are features which derive from the Lothian Bible (no. 32). They are used sparingly at this early stage of de Brailes work, but later he makes more elaborate and inventive use of them.

One of the major problems in the study of de Brailes is to distinguish his work from that of other artists belonging to the workshop. Some of these assistants have a style very close to that of de Brailes and most of these artists probably derive out of the workshop of the Lothian Bible and the Huntingfield Psalter (no. 30). The workshop produced several Bibles with the illumination partly by de Brailes himself. The main examples are: London, Gray's Inn MS 24, Oxford, Bodleian Library MS Laud Lat. 13, Oxford, Christ Church MS 105, Oxford, Merton College MS 7, Perth Museum, Philadelphia, Free Library MS Lewis 29.

The Oxford location of the de Brailes workshop is discussed in the Introduction (pp. 4, 15). The Bible in Christ Church provides additional evidence for on f. 164ᵛ it has an Oxford Calendar contemporary with the text. This contains the 12th February and 19th October feasts of Frideswide (relics at Oxford) both highly graded in red. As the only other English saints in red are the much more common feasts of Alban, Translation of Thomas of Canterbury, Mildred and Edmund the Martyr, the singling out of the Frideswide feasts point to a patron of the Oxford region. as the intended owner.

The Bible described in this entry has some textual evidence for patron and date. The inclusion of the Mass for St. Dominic in the Missal section (ff. 199–204) as the only mass of the Sanctoral, and the addition on the same page of the Mass for the Translation of Dominic, suggests the Bible belonged to a Dominican. The author of the entry on the Bible for the Sotheby sale catalogue put forward interesting arguments for a date before 1233–4 on the basis of the addition of the mass for the Translation of Dominic and the use of *beatus* rather than *sanctus* for the mass for Dominic (i.e. implying this was before his canonisation in 1234). However the Mass Proper for Dominic, as is the case for many saints, refers to him as *beatus*. Also there is no evidence that masses for Dominic were celebrated until his formal canonisation so the evidence rather suggests a post-1234 date for the Bible.

In the 14th century the book was evidently in the possession of a religious house for it is annotated for reading 'in refectorio'.

PROVENANCE: Perhaps a Dominican of the Oxford priory as suggested by the Dominican masses on f. 204. Later in the 15th century it was in the Rhineland or Flanders where it was given by Prior Johannes

Linden to friar Nicholas Boheler of Spira (Speyer in the Rhineland or Spiere in Flanders). This information, now very illegible, is recorded on ff. 438ᵛ, 440ᵛ. In 1647 it was presented by Isabella Fernandes to the Sodality of the Immaculate Conception in Antwerp (f. 1). Alfred Pfeiffer, his bookplate. C. W. Dyson Perrins purchased it from the bookseller Olschki in 1915. Sold at Sotheby's in 1959 and again in 1976 when it was acquired by the Bodleian Library.

LITERATURE: G. Warner, *Descriptive Catalogue of Illuminated Manuscripts in the Library of C. W. Dyson Perrins*, London, 1920, no. 5, 25–7, pl. VI; Millar, I, 49, 50 n. 1, 51; Saunders, *English Illumination*, I, 61; Cockerell, *W. de Brailes*, 4, 25–6, pl. XX e–k; Nordenfalk, 'Psalterillustration', 117; G. Pollard, 'William de Brailes', *Bodleian Library Record*, V, 1955, 204; Rickert, *Painting in Britain*, 104; Brieger, *English Art*, 81, 86 n. 2, 90; Bennett, *Thesis*, 48; *Sotheby Sale Catalogue*, 5th July 1976, lot 81, with pls; 'Notable Accessions. Western Manuscripts', *Bodleian Library Record*, IX, 1973–8, 357–8.

EXHIBITED: London, Victoria and Albert Museum, *The Bible in British Art*, 1977, no. 11; Oxford, Bodleian Library, *Manuscripts at Oxford: an exhibition in memory of Richard William Hunt*, 1980, no. XVI, 5.

70. Cambridge, Gonville and Caius College MS 350/567
Bible
245 × 175 mm., ff. 359 (misnumbered 369)
c. 1230–40. Oxford *Ills. 228–231*

This is a larger Bible by the same workshop as no. 69. There are illuminated initials to each book, mostly historiated, with gold grounds occasionally having a punch dot design. From most of these initials there are extensions either as angular blocks of ornamental leaf forms or dragons or foliate stems terminating in triangular blocks of ornament. The 79 initials are as follows: PROLOGUES, Jerome writing (f. 1); ornamental (f. 2ᵛ); GENESIS, God's instructions to Adam and Eve, Noah's ark on the waters, the Sacrifice of Isaac, Moses given the Tablets of the Law, the Crucifixion (f. 3); EXODUS, Moses with flocks of sheep (f. 18); LEVITICUS, God speaking to Moses (f. 30); NUMBERS, God speaking to Moses (f. 37ᵛ); DEUTERONOMY, Moses speaks to the Israelites (f. 48ᵛ); JOSHUA, Joshua speaks to the Israelites (f. 58ᵛ); JUDGES, Samson fighting the lion (f. 65ᵛ); RUTH, Boaz with Ruth gleaning in the cornfield (f. 73); KINGS I, Elkanah and Hannah praying in the Temple (f. 74ᵛ); KINGS II, David and Goliath (f. 85); KINGS III, Solomon seated (f. 92ᵛ); KINGS IV, Ascension of Elijah (f. 102ᵛ); CHRONICLES I, a bust of a man (f. 111ᵛ); CHRONICLES II, Solomon praying at Gibeon (f. 119ᵛ); ESDRAS I, three standing figures (f. 130ᵛ); ESDRAS II, Nehemiah before Artaxerxes (f. 133);

ESDRAS III, Esdras seated (f. 137); TOBIT, Tobias and Raphael (f. 141); JUDITH, Judith carrying the head of Holofernes (f. 144); ESTHER, Assuerus and Esther (f. 147ᵛ); JOB, Job on the dungheap (f. 152). Psalm I, David harping (f. 159); Psalm 26, Anointing of David (f. 161ᵛ); Psalm 38, David pointing to his mouth (f. 163); Psalm 51, Saul's suicide (f. 165); Psalm 68, ornamental (f. 166ᵛ); Psalm 80, Jacob wrestling with the angel (f. 168ᵛ); Psalm 97, clerics singing (f. 170ᵛ); Psalm 109, God seated blessing (f. 172ᵛ); PROVERBS, Solomon teaching Rehoboam (f. 176ᵛ); ECCLESIASTES, Solomon teaching (f. 182ᵛ); SONG OF SONGS, the Bridegroom embracing the Bride (f. 184ᵛ); WISDOM, Solomon seated (f. 185ᵛ); ECCLESIASTICUS, Jesus ben Sirach seated (f. 190); ISAIAH, an angel appears to Isaiah (f. 201ᵛ); JEREMIAH, Jeremiah pointing to Jerusalem (f. 214ᵛ); LAMENTATIONS, Jeremiah lamenting (f. 229ᵛ); BARUCH, Baruch preaching (f. 231); EZEKIEL, Ezekiel preaching (f. 233); DANIEL, Daniel in the lion's den (f. 247ᵛ); HOSEA, Hosea with Gomer (f. 253ᵛ); JOEL, Joel preaching (f. 256); AMOS, Amos with his flocks (f. 256ᵛ); ABDIAS, Abdias in discussion (f. 258ᵛ); JONAH, Jonah coming out of the whale (f. 259); MICAH, Micah praying (f. 259ᵛ); NAHUM, Nahum prophesies before Nineveh (f. 260ᵛ); HABAKKUK, Habakkuk writing (f. 261ᵛ); SOPHONIAS, Sophonias censes the Temple (f. 262); HAGGAI, Haggai standing (f. 263); ZACHARIAH, God speaks to Zachariah (f. 263ᵛ); MALACHI, Malachi writing (f. 266); MACCABEES I, soldiers (f. 267); MACCABEES II, the idolatry of Antiochus (f. 275ᵛ). MATTHEW, Matthew seated (f. 283); MARK, Mark seated (f. 293). The foliation 'jumps' ten folios at this point by mistake in numeration. LUKE, Luke seated (f. 309ᵛ); JOHN, John seated (f. 320); ROMANS, Paul falling from his horse (f. 328); CORINTHIANS I, Paul seated (f. 332); CORINTHIANS II, Paul disputing (f. 335ᵛ); GALATIANS, Paul preaching (f. 338); EPHESIANS, Paul seated (f. 339ᵛ); PHILIPPIANS, Paul writing (f. 340ᵛ); COLOSSIANS, Paul preaching (f. 341ᵛ); THESSALONIANS I, Paul in prison (f. 342ᵛ); THESSALONIANS II, Paul standing (f. 343); TIMOTHY I, Paul seated (f. 343ᵛ); TIMOTHY II, Paul preaching (f. 344ᵛ); TITUS, Paul and Titus (f. 345ᵛ); PHILEMON, Paul standing (f. 346); HEBREWS, Paul standing with Peter (f. 346); ACTS, Pentecost (f. 349); PETER I, Peter standing (f. 360ᵛ); PETER II, Peter standing (f. 361ᵛ); JOHN I, John preaching (f. 362); JOHN II, III, John standing (ff. 363, 363ᵛ); APOCALYPSE, Christ blessing (f. 364).

This fine Bible was first recognised by Adelaide Bennett as the work of William de Brailes' workshop; it is their most elaborate surviving example of Bible illustration. Characteristic of the workshop is a preference for subdued colours of dark and light blue, brown and pink with thick black outlines and drapery lines. The larger size of this Bible allows larger initials which give the opportunity for more elaborate figure composition. The figures are in forceful poses and in narrative scenes they convey by gesture and glance the sense of energetic dialogue. As in the Bodleian Bible (no. 69) angular blocks containing

ornamental foliage extend from the initials or from the terminations of foliate or dragon extensions. These are, however, restrained compared with later works of the workshop (e.g. nos. 73, 74).

PROVENANCE: 'Master Rawson gentilman and merser of London' is written in a 16th-century hand on f. 369ᵛ. On f. 369 is a scribbled name, perhaps 'Will. Bucknam'. John Gostlin, Master of Gonville and Caius College (1619–27) gave the book to the College in 1627 as is recorded on the flyleaf.

LITERATURE: James, *Catalogue*, no. 350 (567); Bennett, *Thesis*, 48, 126, 162, 273 n. 1, 287.

71. Baltimore, Walters Art Gallery MS 106 and Paris, Collection Wildenstein, Musée Marmottan

Single leaves perhaps from a Psalter
135 × 98 mm., ff. 24 (Baltimore) +7 (Collection Wildenstein)
c. 1230–40. Oxford *Ills. 232–235*

The Baltimore section has 24 single leaves bound together, some illustrated only on one side of the leaf, others on both sides. They contain part of an Old and New Testament cycle with missing sections some of which are preserved as seven single leaves in the Wildenstein collection (placed in square brackets): 1. God creates the Firmament and divides the Earth from the Waters (f. 1); [2. Creation of Eve, 3. God clothes Adam and Eve, 4. Expulsion from Paradise]; 5. Noah's Ark (f. 2); 6. the Flood (f. 3); [7. Abraham entertains the angels, 8. Lot entertains the angels]; 9. Lot's departure from Sodom (f. 4); 10. Moses and the Plague of Frogs (f. 5); [11. Moses and the Plague of Flies]; 12. Moses and the Plague of the Cattle (f. 6); 13. the Plague of Hail and Thunder (f. 7); 14. the Plague of Darkness (f. 8); 15. the Plague of Locusts (f. 9); 16. the Crossing of the Red Sea (f. 10); 17. Pharaoh's army drowned in the Red Sea (f. 11ᵛ); 18. Moses striking the rock for water (f. 12); 19. the Worship of the Golden Calf and breaking of the Tablets of the Law (f. 13); 20. Jacob sends Joseph to visit his brothers at Shechem (f. 14); [21. Joseph sold to the Ishmaelites]; 22. Potiphar's wife accuses Joseph (f. 15); 23. Joseph's cup found in Benjamin's sack, 24. the meeting of Jacob and Joseph (f. 16); 25. Hannah prays for a son and is blessed by Eli, 26. Birth of Samuel (f. 17); 27. Samuel serves the priests with meat, 28. Presentation of Samuel in the Temple (f. 17ᵛ); 29. Ruth meets Boaz while gleaning in the fields, 30. Ruth at the feet of Boaz (f. 18); 31. Boaz makes a pact with his kinsman who takes off his shoe as witness of the agreement, 32. Birth of Obed (f. 18ᵛ); 33. The Stoning of Achan, 34. the Capture of the City of Hai (f. 19); 35. the Gibeonites make peace, 36. the attackers of Gibeon killed by hail (f. 19ᵛ). This ends the Old Testament sequence and all that remain are very few scenes of a New Testament cycle: Peter saved from the water (f. 20); Ascension (f. 21ᵛ); Pentecost (f. 22ᵛ); Last Judgement (f. 23). The last scene, the Fall of Lucifer and the Rebel Angels (f. 24) should in fact have been at the beginning of the Old Testament series. The scenes of the Old Testament have descriptive *tituli* in French.

Although all these pictures have been ascribed to William de Brailes there are differences of figure style and in the techniques used for modelling the faces which suggest that some are by other members of the workshop. The division of the hands in the workshop which would involve a detailed systematic analysis of all their works is beyond the scope of this study. The liveliness of narrative composition characteristic of all artists of the group is always apparent. The series of paintings may once have prefaced a Psalter of similar small dimensions to the de Brailes Hours (no. 73). The choice of very unusual Old Testament scenes (e.g. the various plagues of Egypt, Boaz making a pact with his kinsman) suggests knowledge of a very detailed Old Testament cycle. The surviving single leaves probably are only a small portion of a larger series. Several of the rare scenes are paralleled in the Munich Psalter (no. 23) and the Huntingfield Psalter (no. 30). Both these works were perhaps produced in Oxford and as the de Brailes workshop seems to have operated in Oxford presumably the large cycle was still available in some form there. The figure style has none of the more elegant poses which later appear in the workshop (e.g. no. 74) and probably represents its middle phase.

PROVENANCE: The loose leaves were bought in the late 19th century by the dealer Gruel in Paris and bound together with some French ivories incorporated in the binding (this information is given in a letter from S. C. Cockerell to Dorothy Miner of the Walters Art Gallery, 17th October 1937). This made up book was acquired by Henry Walters in 1906 and his collection formed the basis of the Museum he founded in Baltimore. The other leaves in the Wildenstein collection were perhaps also part of the group of leaves acquired by Gruel.

LITERATURE: Swarzenski, 'Unknown Bible Pictures', 55 ff., figs. 1–11, 13–28; E. Millar, 'Additional Miniatures by W. de Brailes', *Journal of the Walters Art Gallery*, 2, 1939, 106 ff., figs. 1–7; Millar, 'Fresh Materials', 288, fig. 234; G. Pollard, 'William de Brailes', *Bodleian Library Record*, V, 1955, 205; Rickert, *Miniatura*, II, pl. 8; G. Henderson, 'Late Antique influences in some English Medieval illustrations of Genesis', *J.W.C.I.*, XXV, 1962, 192–4; Rickert, *Painting in Britain*, 104, 235 n. 52, pl. 103B; Brieger, *English Art*, 86 n. 2, 89–90, pl. 28; *La Collection Wildenstein*, Musée Marmottan, Paris, 1980, nos. 113, 114 with plates.

EXHIBITED: Baltimore, Walters Art Gallery, *Illuminated Books of the Middle Ages and Renaissance*, 1949, no. 41, pl. XXI; Cleveland, Museum of Art, *Twelve Masterpieces of Medieval and Renaissance Book Illumination*, 1964, no. 5; Notre Dame, University Art Gallery, *Medieval Art 1060–1550: Dorothy Miner Memorial*, 1974, no. 6.

72(a). Cambridge, Fitzwilliam Museum MS 330
255 × 175 mm. with minor variations between the
leaves *Ills. 237, 238*

72(b). New York, Pierpont Morgan Library
MS M. 913
215 × 143 mm.
Single leaves from a Psalter
c. 1230–40. Oxford *Ill. 236*

There are six leaves in the Fitzwilliam Museum and
one in the Pierpont Morgan Library. As one has
the opening words of Psalm 1 they must have been
part of a prefatory series to a Psalter. There must
have been more pictures now lost because both the
Old and New Testament scenes are parts of cycles.
The leaves in the Fitzwilliam Museum are: 1. The
Fall of the Rebel Angels and within the frame round-
els having seated figures of Virtues and Vices: Char-
ity, Humility, Patience, Avarice, Pride, Anger; 2. Six
scenes from Genesis in vesica shaped medallions:
God clothing Adam and Eve, Adam digging and
Eve spinning, the Offerings of Cain and Abel, Cain
slaying Abel, God's rebuke to Cain, Lamech shoot-
ing Cain, and in medallions in the frame are God
rebuking Adam and Eve, Adam and Eve clothed
and dejected after the Fall, Enoch and Seth, the
sons of Adam and Eve; 3. The Last Judgement with
Christ Judge trampling on the Lion and Dragon,
Angels with Instruments of the Passion, the Virgin
and Apostles, and the separation of the Blessed from
the Damned; 4. The Wheel of Fortune with Fortune
seated in the centre turning the spokes, and the rise
and fall of a man from childhood to death in sixteen
roundels and semicircles in the outer frame, and
eight semicircles of the legend of Theophilus in the
inner frame: Theophilus rejecting the bishopric of
Adana, Theophilus laments his state of poverty, he
sells his soul to the Devil, he is made rich by the
Devil, he prays to the Virgin, the Virgin gets the
bond back from the Devil, the Virgin returns the
bond to Theophilus, Death of Theophilus; 5. In
large vesica frames the seated figures of Christ bless-
ing, trampling on the lion and the basilisk, and David
harping, and within the frame in roundels the four
symbols of the Evangelists and two musicians;
6. The Tree of Jesse with four roundels containing
musicians in the frame. This last page must have
immediately preceded the Psalter text as the first
verse of Psalm I is written in capital letters immed-
iately above the sleeping Jesse.
The leaf in the Pierpont Morgan Library has scenes
of the childhood of Christ set in vesica-shaped
medallions in a similar arrangement to the page of
Old Testament scenes: the Magi before Herod and
his advisors, Adoration of the Magi, Massacre of
the Innocents, Flight into the Egypt, and in the frame
are medallions of two eagles and the prophets Hosea,
Habakkuk, Jeremiah and Isaiah holding scrolls. In
between the medallions are squirrels, lions, cockerels.
The backgrounds to these miniatures are of burnished
gold sometimes having an incised diaper pattern
and punched dots. The medallions of the Old Testa-
ment scenes are set against a background of foliage

scrolls. A predominant characteristic of the compo-
sitions are systems of medallions and semicircles
analogous to work in contemporary stained glass
windows (e.g. Canterbury, Lincoln) and in wall
paintings such as Romsey (Hampshire) and Brook
(Kent).
The blockiness of the figure forms suggests the early
or middle phase of the workshop comparable to the
Baltimore/Paris series of single leaves (no. 71). Some
of the seated figures show clear links with the Hunt-
ingfield Psalter (no. 30) and it is likely that an artist
who had worked on that book joined the de Brailes
workshop. The same stylistic differences occur be-
tween the Fitzwilliam/New York leaves as in those in
Baltimore and Paris suggesting the involvement of
several artists. These leaves are much larger than
the Baltimore/Paris series and show the style of the
workshop in its most monumental aspect. They have
been considerably cut down and the original size
of the Psalter of which they were part must have been
only slightly smaller than the very large New College
Psalter (no. 74).
There are several unusual scenes in the iconography.
The Fall of the Rebel Angels is paralleled in the
Baltimore leaves (no. 71), in the Bible of Robert de
Bello (no. 63) and in the Lothian Bible (no. 32).
Very rare is the scene of God clothing Adam and
Eve which also occurs on one of the Wildenstain
leaves (no. 71). Another feature in common with
another product of the workshop is the unusual
inclusion of the Death of Theophilus in the Theo-
philus series which occurs in the Hours (no. 73).
The Wheel of Fortune is rarely found in manuscript
painting but occurs in contemporary wall painting
in Rochester Cathedral and in two lost works exe-
cuted under Henry III's patronage, the King's Hall
at Winchester (1235-6) and the Palace of Clarendon
(1247).
This is the first work to bear the signature of W. de
Brailes which occurs by the suppliant figure in the
Last Judgement scene. It must be assumed that this
whole miniature is by him and it is much larger in
scale than the other works having his signature. This
miniature is thus fundamental as a starting point for
attributing other illuminations to him. As suggested
by documentary evidence (see Introduction) he was
definitely working in Oxford from before 1238 until
after 1252. The style of the Last Judgement leaf
suggests a date early in this period.

PROVENANCE: **(a)** Jean-Baptiste-Joseph Barrois,
Deputy for Lille (1784–1855). Acquired by the 4th
Earl of Ashburnham in 1849. Sold at Sotheby's
10–14th June 1901 passing first to George C.
Thomas of Philadelphia and then Dr. A. S. W.
Rosenbach of New York. Bought by Sir Alfred
Chester Beatty from Dr. Rosenbach in 1920.
Purchased for the Fitzwilliam Museum with the aid
of the National Art Collections Fund in 1932.
(b) The leaf was found in an extra-illustrated edition
of Thomas Dibdin's, *The Bibliographical Decameron*.
This belonged to Mrs. Walter P. Bliss who sold it
to Mr. John F. Fleming. Acquired for the Pierpont
Morgan Library in 1963.

LITERATURE: **(a)** Millar, I, 49, 94, pl. 75; E. G. Millar, *The Library of A. Chester Beatty: a descriptive catalogue of the Western Manuscripts*, Oxford, 1927, I, 122–6, pls. LXXXIX–XCI; Cockerell, *W. de Brailes*, 3, 15–8, pls. XV–XVII; A. C. Fryer, 'Theophilus the Penitent as represented in art', *Archaeological Journal*, 92, 1935, 300, 307, 318, pl. IX; Swarzenski, 'Unknown Bible Pictures', 61, 63, figs. 12, 29; Tristram, *Wall Painting*, 191; F. Wormald, P. M. Giles, 'A Handlist of Additional Manuscripts in the Fitzwilliam Museum', *Transactions of the Cambridge Bibliographical Society*, 5, 1972, 308, no. 125; J. Plummer, *The Lothian Morgan Bible*, Ph.D. Dissertation, Columbia University, 1953, 61; G. Pollard, 'William de Brailes', *Bodleian Library Record*, V, 1955, 204; G. Henderson, 'Cain's Jaw-bone', *J.W.C.I.*, XXIV, 1961, 112 n. 26; Rickert, *Painting in Britain*, 104, 105, pls. 102, 103A; Brieger, *English Art*, 37, 86–8, pl. 22a; E. Kitzinger, 'World Map and Fortune's Wheel: a medieval mosaic floor in Turin', in ed. W. E. Kleinbauer, *The Art of Byzantium and the Medieval West: selected studies by E. Kitzinger*, Bloomington, 1976, 347 n. 134; M. Remnant, *Musical Instruments of the West*, London, 1978, fig. 37.
(b) F. B. Adams, J. Plummer, 'A newly discovered miniature by W. de Brailes', *Thirteenth Report to the Fellows of the Pierpont Morgan Library*, 1963–64, 11–13, with pl.; R. Marks, N. Morgan, *The Golden Age of English Manuscript Painting 1200–1500*, New York, 1981, pl. 5.

EXHIBITED: **(a)** London, Royal Academy of Arts, *Exhibition of British Primitive Paintings*, 1923, no. 104; London, 1930, nos. 145–50, pl. 34; B.F.A.C., *British Medieval Art*, 1939, no. 135; Cambridge, Fitzwilliam Museum, *Illuminated Manuscripts in the Fitzwilliam Museum*, 1966, no. 29.
(b) Notre Dame, University Art Gallery, *Medieval Art 1060–1550: Dorothy Miner Memorial*, 1974, no. 5, pl. 5.

73. London, British Library MS Add. 49999
Book of Hours
150 × 123 mm., ff. 105 +vi
c. 1240. Oxford *Ills. 241–247*

This is the earliest fully illustrated example in English art of a Book of Hours. The text contains the Hours of the Virgin Mary, the Penitential Psalms, the Litany and the Gradual Psalms. The decoration is very extensive and originally each of the Hours of the Virgin had a full-page frontispiece, but some have been removed. All major sections of the text have historiated initials with dragons and ornamental foliage blocks extending from them into the margin. The decoration begins with a full-page miniature at the beginning of Matins with four roundels in a frame with the scenes set against burnished gold having a diaper pattern: the Betrayal, the Flagellation, Peter's first denial and the Mocking of Christ, the Jews spit on Christ and Peter's denial by the fire.

In the margin by the final scene the cock is crowing and Peter is weeping (f. 1). In the Matins text there are historiated initials of the Life of the Virgin on grounds of plain burnished gold, and in the Lauds text initials of the Life of Christ: Joachim's offering at the Temple is rejected, Anna is reproached for her barrenness by a servant woman (f. 1v); Annunciation to Joachim with the shepherds (f. 3v); Annunciation to Anna (f. 4); Meeting of Joachim and Anna (f. 5v); Birth of the Virgin (f. 7v); Presentation of the Virgin in the Temple (f. 9); the men of the House of David with their rods and that of Joseph blossoming (f. 9v); Marriage of Joseph and the Virgin (f. 10v); the Annunciation (f. 11); the Visitation, Joseph's Dream (f. 13v); Annunciation to the Shepherds, Nativity (f. 14v); Presentation in the Temple (f. 15); the Magi before Herod (f. 16v); Herod with his Advisors (f. 17v); Adoration of the Magi (f. 19v); Dream of the Magi (f. 21); Return journey of the Magi (f. 23); Massacre of the Innocents (f. 23v); Flight into Egypt (f. 24); the seated Virgin and Child (f. 26).

Then follow the initials to the memoriae to the Holy Ghost, the Cross and the saints which end Lauds: Pentecost (f. 27); Crucifixion (f. 27v); Martyrdom of St. Laurence, an initial of much larger size than the others on an inserted page (f. 28); St. Catherine laid in her tomb by angels (f. 29); St. Margaret coming out of the dragon (f. 29v); for All Saints there are individual groups of the Virgin Mary and the Angels, Apostles, Martyrs, Confessors, Virgins (f. 30); Christ seated blessing (f. 30v). Prime begins with a full-page miniature with four vesica-shaped medallions set against a ground of foliate ornament: Christ before Annas, Christ before Caiaphas, Christ before Pilate, Christ before Herod (f. 32).

Then begin a series of historiated initials of the legend of Theophilus which continues through Prime, Terce and part of Sext: Theophilus refuses the offer of a bishopric (f. 32v); Theophilus in poverty (f. 33); he makes a pact with the Devil (f. 34); Theophilus restored to his position seated richly dressed (f. 36); he prays to the Virgin to release him from his pact with the Devil (f. 38). Then follows a full-page miniature at the beginning of Terce with four vesica shaped medallions set against an ornamental background: Christ's second appearance before Pilate spread over two medallions, Pilate washes his hands, the Jews take Christ away (f. 39). Then the Theophilus scenes continue in the historiated initials: Theophilus kneels before the Virgin (f. 39v); the Virgin retrieves the bond from the Devil (f. 40v); the Virgin gives the bond back to Theophilus (f. 41v); Theophilus burns the bond on a fire (f. 42v); a portrait of the artist W. de Brailes (f. 43).

The frontispiece to Sext has the usual system of four medallions with figure scenes: Christ says to the Jew: 'you will remain until I return' (the legend of the Wandering Jew), the Way of the Cross, Christ stripped of his robe, Christ and a man with a winged cap holding hammer and nails stand by the Cross (f. 43v). Then the historiated initials continue with the Theophilus legend and begin the series of the story of the priest who only knew one mass, that of

the Virgin Mary: Theophilus lying dead in his tomb with the Virgin lifting up his soul (f. 44); the priest who could only chant the Mass of the Virgin kneeling at an altar (f. 44ᵛ); St. Thomas of Canterbury suspending the priest (f. 45ᵛ); the priest appeals to St. Thomas (f. 46ᵛ); W. de Brailes praying (f. 47). There is a full-page miniature before None: the Crucifixion with the two thieves, the surrounding crowd and the giving of the sponge; below, two vesica-shaped medallions of the Crucifixion with the Virgin and St. John, and of the spearing of Christ's side by the short-sighted Longinus (f. 47ᵛ). The remaining full-page miniatures have been removed and all the subsequent decoration in the sections for None, Vespers and Compline is in the historiated initials: the priest appeals for the second time to St. Thomas (f. 48); the Virgin puts a hair shirt on St. Thomas (f. 49); the priest travels across the sea in a boat (f. 49ᵛ); he appeals for a third time to St. Thomas (f. 50ᵛ); the priest prays to the Virgin (f. 53); he goes on another boat journey (f. 54); the priest tells St. Thomas that the Virgin has told him about the hair shirt (f. 54ᵛ); St. Thomas, kneeling to ask forgiveness, reinstates the priest to his position (f. 55ᵛ); the priest celebrating the Mass of the Virgin (f. 56); the priest lying dead in a tomb with the Virgin holding up his soul (f. 58); three singing clerics for the initial of the Vespers hymn, Ave Maris Stella (f. 58); the Annunciation to the Virgin of her approaching death (f. 59); the Apostles come to the Virgin to hear of her approaching death (f. 60); a large vertical and horizontal border section containing the Death of the Virgin, her Funeral Procession with the Jew touching the bier, the Burial of the Virgin, an angel takes her soul up to heaven, the Coronation of the Virgin (f. 61); the nine Jews struck blind for mocking the Virgin's funeral (f. 61ᵛ); one of the Jews converted by St. Peter and restored to sight by the funeral pall of the Virgin (f. 62ᵛ); the converted Jew restores the sight of another of the Jews with the pall (f. 63); the pall has no effect on the blindness of one who refuses to believe in Christ (f. 63ᵛ); a woman, possibly the owner of the Hours, kneeling in prayer (f. 64ᵛ).

The Penitential Psalms have initials illustrating David's sin against Uriah the Hittite and his penitence: Nathan reproves David for the death of Uriah (f. 66); an angel appears to the penitent David half buried in the ground (f. 67ᵛ); David praying (f. 69); David as a penitent struck with rods by a priest (f. 72); the woman, perhaps the owner of the Hours, in prayer (f. 75); David in prayer (ff. 78, 79). The Litany has an initial of Christ seated in judgement (f. 81) and for the Collects there are figures of a woman (ff. 87ᵛ, 88), and a cleric (f. 88ᵛ) in prayer. The Gradual Psalms have the stories of Susanna and of the man who gave a chalice to the church of St. Laurence: Susanna praying (f. 90); Susanna brought to judgement (f. 90ᵛ); Daniel questions the first elder (f. 91ᵛ); the second elder questioned (f. 92ᵛ); judgement passed on the two elders (f. 93); the two elders being burnt on a large fire (f. 94); Susanna praying in thanks for her deliverance (f. 95); Susanna lying dead with her soul being taken up to heaven by two angels (f. 96); the burgess

places the chalice on the altar of the church of St. Laurence (f. 97ᵛ); the burgess on his deathbed (f. 98); St. Michael and the Devil, who has been heavily thumbed, disputing over the soul of the burgess (f. 98ᵛ); a recluse has a vision of the dispute over the soul (f. 100ᵛ); St. Laurence intercedes by placing the chalice given to his church on the scales of judgement on the side of the burgess's good deeds (f. 101); two angels carry the soul of the burgess up to heaven (f. 101ᵛ). On ff. 38ᵛ, 39ᵛ, 64, 96ᵛ are purely ornamental initials.

In addition to the decoration of the historiated and ornamental initials there are ornamental extensions from these initials and on most pages feathery pen-work ornaments extending into the margin. Ornamental line endings in red, blue and gold also occur. This is unquestionably the most important of all the early illuminated Books of Hours. This text, used for private devotional reading, had earlier been attached to the Psalter (e.g. nos. 24, 35, 36) and had seldom received any decoration save for one or two historiated initials. From the mid 13th century more elaborate illustration begins and this trend culminates in the richly illuminated Hours of the 14th and 15th centuries. This Hours by the de Brailes workshop is by far the most extensively decorated of any Hours of the early phase of this development and it is an invaluable document of the devotional sentiment of the period. The illustrations reflect, better than any other manuscript of the time, the piety of a devout member of the laity; emphasis on the events of Christ's Passion, on the life and miracles of the Virgin, and on her intercessory power as well as that of the saints for the salvation of the soul.

As the Hours are primarily devotions to the Virgin Mary it is no surprise to find many historiated initials devoted to her life and miracles. Before each of the Hours the full-page miniatures are, however, devoted to a detailed series of scenes of the Passion of Christ. The other historiated initials have scenes of the lives of the Saints for the prayers to them, the sin and penitence of David for the Penitential Psalms, the stories of Susanna and of the burgess who gave a chalice to the Church of St. Laurence for the Gradual Psalms. The very large initial of the Martyrdom of St. Laurence and the story of the burgess saved from Hell through his gift of a chalice to a church of St. Laurence suggest the owner had a special devotion to that saint or a connection with a church dedicated to him. Unusual features of the iconography are: (i) the elaborate narrative version of the Crucifixion on f. 47ᵛ which also once occurred in the now destroyed wall paintings of Winterbourne Dauntsey (Hampshire), (ii) the very full series of scenes of miracles of the Virgin, (iii) the Susanna scenes which also occur in the Munich Psalter (no. 23), (iv) the scene from the legend of the Wandering Jew (f. 43ᵛ). This last is so rare that a more extended comment is required. The legend is of a Jew who had struck Christ as he left the Judgement Hall and who received the admonition 'you will remain until I return'. This was interpreted as meaning that the man would not die but would remain living and wandering the world until the Second Coming of

Christ (A. S. Rappaport, *Mediaeval Legends of Christ*, London, 1934, 235 ff.). The legend was popular in England since the visit of an Armenian bishop in 1228 who had told the story to the monks of St. Albans. Roger of Wendover incorporated it into his *Flores Historiarum* (before 1236) and it is found later in Matthew Paris's *Chronica Maiora* where an illustration also occurs (no. 88).

Two features suggest that this Book of Hours is the product of a relatively late phase of the de Brailes workshop. The figures have less exaggerated forceful poses, excepting in some of the Passion scenes, and some show more supple and relaxed forms than the blocky types of the earlier works. The second feature is the use of pen flourishes, ornamental blocks and bars partly to frame the text which points to future developments in the New College Psalter (no. 74). The use of these pen flourishes to form horizontal bars in the lower margin may be an influence resulting from de Brailes' partial acquaintance with the workshop of the Stockholm Psalter (no. 68) in which manuscript he painted the decoration of one page. The other artists of the Stockholm Psalter are independent from the de Brailes workshoip and have a great liking for feathery pen flourish extensions. In the de Brailes Hours the use of solid borders in the inner margin with a horizontal panel attached in the lower border (f. 61), is a new feature showing the same intention partially to frame the text as the ornamental blocks and pen flourishes. The characteristically subdued colours of the workshop are still used; pale blue, orange, pale pink and white predominating.

The signature of W. de Brailes is on ff. 43, 47 with the important phrase 'qui me depeint' on f. 43 which proves he was in fact an artist and not merely a scribe or a non-participating director of the workshop. As he is tonsured he presumably was in some form of minor orders but certainly not a priest because the records reveal that he was married to a woman called Celena. Beside the pictures and historiated initials in the Hours are rubrics in French describing the scenes. They are not in the same hand as the script of the text and may be by one of the illuminators, perhaps de Brailes himself.

The manuscript lacks a calendar but does have a Litany. The Litany is however not at all specific and the only significant feature seems to be the invocation of St. Frideswide among the Virgins. This would be expected in view of the Oxford location of the de Brailes workshop. The use of the Hours has often been described as Sarum but there are several differences from that text as it occurs in the 14th century in its developed form. These could be explained by the likelihood of the text being still in a variable form at such an early period of its development. The small size of the book combined with the use of a disproportionately large script characterises two other early English Books of Hours (Yale, University Library MS Marston 22, London, British Library MS Add. 33385). The Yale manuscript is sparsely decorated and must be nearly contemporary with the de Brailes Hours.

The owner of the book was presumably the woman depicted in prayer on ff. 64ᵛ, 75, 87ᵛ, 88. Some almost contemporary additions in French were probably made for her. These include prayers to the Virgin and the Saints, and prayers for certain friars, Richard of Newark (Nottinghamshire), Bartholomew of Grimston (Leicestershire), and Richard of Westey (?) with whom the owner was evidently well acquainted.

PROVENANCE: J. Rosenthal, Munich, who sold it to C. W. Dyson Perrins in 1906. Acquired by the British Museum in 1959.

LITERATURE: G. Warner, *Descriptive Catalogue of Illuminated Manuscripts in the Library of C. W. Dyson Perrins*, Oxford, 1920, 11–25, pls. IV–VI; Millar, I, 49, 50, 94, pls. 73, 74; Saunders, *English Illumination*, I, 61, II, pl. 65a; Cockerell, *W. de Brailes*, 3, 18–25, pls. XVIII–XX; T. Borenius, *St. Thomas Becket in Art*, London, 1932, 42; Morison, '*Black-Letter*' *Text*, 21, fig. XXV; Swarzenski, *Handschriften XIII Jh.*, 128 n. 7, 133 n. 3; A. C. Fryer, 'Theophilus the penitent as represented in art', *Archaeological Journal*, 92, 1935, 295, 307, 319; Swarzenski, 'Unknown Bible Pictures', 63; Tristram, *Wall Painting*, 191, 221; G. Pollard, 'William de Brailes', *Bodleian Library Record*, V, 1955, 204; Baltrušaitis, *Reveils et prodiges*, 148, fig. 35A, 152, fig. 37A; T. J. Brown, G. M. Meredith-Owens, D. H. Turner, 'Manuscripts from the Dyson Perrins Collection', *British Museum Quarterly*, XXIII, 1960–61, 30–1, pl. XVIIa; G. Pollard, 'The construction of English twelfth century bindings', *The Library*, XVII, 1962, 3, 16; Rickert, *Painting in Britain*, 104; Turner, *Early Gothic*, 13, pl. 3; British Museum, *Reproductions*, V, pl. VIII; J. Lafontaine-Dosogne, *Iconographie de l'Enfance de la Vierge dans l'Empire Byzantin et en Occident*, II, Brussels, 1965, 47, 64, 70, 75, 79, 88, 163; D. H. Turner, *Illuminated Manuscripts exhibited in the Grenville Library*, London, 1967, 27; Brieger, *English Art*, 88–9, 210; J. Harthan, *Books of Hours*, London, 1977, 13; J. Backhouse, *The Illuminated Manuscript*, Oxford, 1979, pl. 27; C. M. Baker, *The early development of the illustrated Book of Hours in England c. 1240–1350*, Ph.D. East Anglia, 1981, passim.

EXHIBITED: B.F.A.C., *Illuminated Manuscripts*, 1908, no. 58, pl. 52; London, Royal Academy of Arts, *Exhibition of British Primitive Paintings*, 1923, no. 103; London, 1930, no. 153; B.F.A.C., *British Medieval Art*, 1939, no. 30.

74. Oxford, New College MS 322
Psalter
350 × 250 mm., ff. 162
c. 1240–50. Oxford
Ills. 239, 240 (colour), 248, 249; figs. 14, 15

This Psalter is the largest and most elaborate extant work from the de Brailes workshop. Although there are no full-page prefatory miniatures there is an

abundance of historiated initials and decorative ornament. The text opens with the Calendar which has illuminations of the Labours of the Months and Signs of the Zodiac in roundels against plain highly burnished gold grounds: January, a three-headed man drinking (f. 1); February, a man taking his shoe off by the fire (f. 1ᵛ); March, a man digging (f. 2); April, a seated man holding two flowers (f. 2ᵛ); May, a man falconing (f. 3); June, a man weeding (f. 3ᵛ); July, a man scything (f. 4); August, a man cutting corn (f. 4ᵛ); September, a man picking fruit (f. 5); October, a man sowing (f. 5ᵛ); November, a man slaughtering a pig (f. 6); December, a man placing loaves in an oven (f. 6ᵛ).

The Psalter text begins with a full page framed B for Psalm 1 containing a Tree of Jesse (f. 7). Nearly every psalm initial and also those for the Canticles contain figures standing, seated, pointing or holding scrolls or books, occasionally identifiable as Christ or a prophet. Bars, often formed of dragons' bodies, extend down from some of the initials turning to form horizontals in the bottom margin. Often these fillings of the lower margins are pen flourishes in red, blue and gold. There are ornamental line endings drawn in red, blue and gold, and in one section (ff. 113–22ᵛ) they are fully illuminated. The nine historiated initials at the main liturgical divisions are: Psalm 26, D (pasted in on a separate piece of vellum), David harping before Saul (f. 28); Psalm 38, D, (pasted in on a separate piece of vellum), Judgement of Solomon (f. 41ᵛ); Psalm 51, Q (pasted in on a separate piece of vellum), David and Goliath (f. 54); Psalm 52, D (pasted in on a separate piece of a vellum), Temptation of Christ (f. 54ᵛ); Psalm 68, S, Jonah praying to Christ on his exit from the whale, Jonah thrown to the whale (f. 67); Psalm 80, E, Jacob wrestling with the angel, Jacob's Dream (f. 82ᵛ); Psalm 97, C, Annunciation to the Shepherds, the Nativity (f. 97); Psalm 101, D, Christ blessing, David gazing at Bathsheba, Nathan reproves David, the penitent David buried up to his waist in the sand praying (f. 99); Psalm 109, Gnadenstuhl type Trinity (f. 113).

This is the most developed example of the art of the de Brailes workshop. It seems to be an attempt to rival in luxury contemporary Psalters such as those of the Sarum Master's workshop (nos. 99, 101). The full illumination with figures for nearly every psalm initial, and the profusion of line endings, dragon extensions and pen flourishes, is almost the maximum amount of decoration that can be given to the text pages of a Psalter. Comparable systems with figure initials for every Psalm occur in only three other English 13th-century Psalters (nos. 33, 99, 162).

The figure style has become more elegant and the colours, predominantly blue and red-pink, are different from the duller palette of the earlier products of the workshop. The opening words of each psalm of the liturgical divisions are in gold capitals against patterned ornamental grounds. Several artists work on the book, one close to a hand in the much earlier Lothian Bible (no. 32).

Earlier Oxford products such as the Psalter (no. 24) and the Huntingfield Psalter (no. 30) could have provided models for some features of this luxury layout. What is completely new is the integration of the illumination with the text page by a subtle balance between the initials, border extensions, pen flourishes, penwork of the line endings and the main text. The dragons which extend from the initials to form horizontal or vertical border bars ending in blocks of ornament are often counterbalanced by similar extensions as pen flourishes. The section ff. 113–22ᵛ is decorated in a rather different manner. Here there are fully illuminated line endings containing animals, birds and fish. Similar creatures occur as bas-de-page with pen flourishes coming out of their mouths. The ornamental repertoire in this section suggests the influence from the workshop of the Stockholm Psalter (no. 68) in which de Brailes seemed to have worked for a short period.

The iconography of the Psalm initials is completely in the English tradition having such characteristic subjects as the Jacob scenes for Psalm 80 and the Annunciation to the Shepherds for Psalm 97. The scenes of David's sin and penitence in the Psalm 101 initial recall the same subjects used for the Penitential Psalms in the de Brailes Hours (no. 73). As the Psalm 101 initial often has the figures of the owner of the Psalter it is likely that the owner identified himself as a penitent with the example of David. A link with the sources of the de Brailes workshop is evident in the Tree of Jesse in the Beatus initial whose iconography and composition derives from the Huntingfield Psalter (no. 30) from which the style of some artists of the group originates.

This is the only manuscript completely by the de Brailes workshop to have a Calendar. The inclusion of the feast of St. Francis (4th Oct.) in the original hand definitely dates the manuscript after 1228, the year he was canonised. There are two additions of Dominican saints: Dominic (5th Aug.), Peter of Verona (28th April) and four of English saints: Edmund of Abingdon (16th Nov.), Richard of Chichester (3rd Apr.), Translation of Etheldreda (17th Oct.) and Hugh (17th Nov.). Although the first four were canonised at dates possibly contemporary with the production of the manuscript their absence from the original Calendar cannot be used to provide a *terminus ante* for the dating of the text (see Introduction p. 33 for comment). The basic Calendar in the original hand is of the diocese of Winchester having Edburga (15th June), Hedda (7th July), Grimbald (8th July), Translation Birinus (4th Sept.), Ethelfleda (23rd Oct.) and Birinus (3rd Dec.). The inclusion also of the feasts of Erkenwald (30th Apr.) and Ethelbert (20th May), both of whose relics were at St. Paul's, suggests the Calendar may be of that part of the diocese of Winchester bordering on London. The limits of the Winchester diocese were only some twenty miles distant from Oxford where the de Brailes workshop was almost certainly based. It is hardly surprising that they should produce a manuscript for a patron connected with a region so close to their centre of operation.

The Litany is rather a muddled text, with certain elements deriving from Christ Church, Canterbury (Salvus, Adrian, Fursey) but lacking a number of

more important Canterbury saints including St. Thomas. It would be rash to make any conclusions from what, to all appearances, is a rather impure text.

The New College Psalter is the final product of de Brailes and his workshop. He is last mentioned in Oxford records in 1252 and thus a date c. 1240–50 has been proposed.

PROVENANCE: Various 14th-century obits have been added to the Calendar: Mary de Brewese (21st Mar. 1323), Hugh le Marny (28th Nov. 1334), Johanna de Wokingdone (7th May 1335). A 17th-century inscription on the paste-down records the book as a gift to the College of a Mr. Howell. This is Henry Howell who matriculated in 1675. He was son of Thomas Howell, Bishop of Bristol, and the manuscript was given to the College in 1693.

LITERATURE: Coxe, *Catalogue*, I, New College, 115; Millar, I, 49; Cockerell, *W. de Brailes*, 2, 7–11, pls. II–XIII; Swarzenski, *Handschriften XIII Jh.*, 18, fig. 10; Haseloff, *Psalterillustration*, 61 ff. Tab. 16; Swarzenski, 'Unknown Bible Pictures', 63; Tristram, *Wall Painting*, 191; J. Plummer, *The Lothian Morgan Bible*, Ph.D. Dissertation, Columbia University, 1953, 16, 48, pl. 15; G. Pollard, 'William de Brailes', *Bodleian Library Record*, V, 1955, 203; Rickert, *Miniatura*, II, pl. 9; Rickert, *Painting in Britain*, 104, 105; Brieger, *English Art*, 90–2, pl. 27; Ragusa, 'Lyre Psalter', 274 n. 27; R. W. Hunt, 'The Medieval Library' in *New College Oxford 1379–1979*, J. Buxton, P. Williams, eds., Oxford, 1979, 339; N. J. Morgan, 'Notes on the Post-Conquest Calendar, Litany and Martyrology of the Cathedral Priory of Winchester with a consideration of Winchester Diocese Calendars of the Pre-Sarum period', *The Vanishing Past: Medieval Studies presented to Christopher Hohler*, ed. A. Borg, A. Martindale, BAR, Oxford, 1981, 157, 167 nn. 67, 72, 168 nn. 80, 86.

EXHIBITED: B.F.A.C., *Illuminated Manuscripts*, 1908, no. 59, pl. 53; London, 1930, no. 152; B.F.A.C., *British Medieval Art*, 1939, no. 31.

75. Oxford, Bodleian Library MS Auct. D. 4. 8
Bible
208 × 138 mm., ff. 708
c. 1240–50. (?) East Anglia *Ills. 252–255*

This Bible has historiated initials to almost all the books on burnished gold grounds with punched dot patterns, 81 in all: PROLOGUES, a brown habited figure (f. 13); ornamental (f. 16); GENESIS, Creation of the Firmament, of the Earth and Sea, of the Trees, of the Sun and Moon, of the Birds and Animals, of Eve, God resting on the seventh day, Expulsion from Paradise, the Crucifixion, Last Judgement (f. 17); EXODUS, the baby Moses saved from death by being set afloat on the Nile (f. 39ᵛ); LEVITICUS, Moses sacrificing at an altar (f. 61); NUMBERS, Balaam on the ass (f. 75ᵛ); DEUTERONOMY, Burial

of Moses (f. 96); JOSHUA, Siege of Jericho (f. 115); JUDGES, Destruction of Jerusalem (f. 127ᵛ); RUTH, Elimelech, Naomi and their sons go to Moab (f. 141ᵛ); KINGS I, Presentation of Samuel in the Temple (f. 144); KINGS II, the Amalekite before David (f. 163); KINGS III, Solomon riding on David's mule (f. 178); KINGS IV, Ascension of Elijah (f. 194ᵛ); CHRONICLES I, Descendants of Adam (f. 211ᵛ); CHRONICLES II, Solomon directs the building of the Temple (f. 226); ESDRAS I, ornamental (f. 246); NEHEMIAH, ornamental (f. 251ᵛ); ESDRAS II, Josias speaks to the Levites (f. 259); ESDRAS III, a man bringing a cup to two seated kings (f. 260ᵛ); ESDRAS IV, V, ornamental (ff. 269, 278); TOBIT, Tobit gives Tobias the debt of Gabael (f. 280ᵛ); JUDITH, Judith beheading Holofernes (f. 286); ESTHER, Assuerus and Esther (f. 293); JOB, Job on the dungheap (f. 300ᵛ).

Psalm I, David harping (f. 315); Psalm 26, David pointing to his eye (f. 319ᵛ); Psalm 38, David pointing to his mouth (f. 323); Psalm 51, David and Goliath (f. 325ᵛ); Psalm 68, Jonah coming out of the whale (f. 329); Psalm 80, David playing a viol (f. 333); Psalm 101, a cleric praying (f. 336ᵛ); Psalm 109, God seated blessing (f. 339ᵛ); PROVERBS, Solomon instructing Rehoboam (f. 349); ECCLESIASTES, Solomon teaching (f. 360); SONG OF SONGS, Ecclesia and Synagoga before Solomon (f. 364ᵛ); WISDOM, Solomon seated (f. 366ᵛ); ECCLESIASTICUS, Jesus ben Sirach seated reading (f. 374ᵛ); ISAIAH, Martyrdom of Isaiah (f. 397); JEREMIAH, God speaks to Jeremiah (f. 424ᵛ); LAMENTATIONS, Jeremiah lamenting (f. 454); BARUCH, Jeremiah dictating to Baruch (f. 457); EZEKIEL, Ezekiel seated (f. 460ᵛ); DANIEL, Daniel in the lion's den (f. 487ᵛ); HOSEA, God speaks to Hosea (f. 498); JOEL, Joel teaching (f. 502); AMOS, Amos with his flocks (f. 503ᵛ); ABDIAS, the prophets eating bread (f. 506); JONAH, Jonah coming out of the whale (f. 506ᵛ); MICAH, Micah prophesies before Hezekiah (f. 507ᵛ); NAHUM, Nahum prophesies before Nineveh (f. 510); HABAKKUK, God speaks to Habakkuk (f. 511); SOPHONIAS, God speaks to Sophonias (f. 512ᵛ); HAGGAI, Haggai instructs the building of the Temple (f. 513ᵛ); ZACHARIAH, Zachariah prophesying (f. 514ᵛ); MALACHI, Malachi prophesying (f. 519); MACCABEES I, the Death of Alexander (f. 520ᵛ); MACCABEES II, a battle scene (f. 537ᵛ).

MATTHEW, Matthew writing (f. 549); MARK, Mark with the head of a lion seated writing (f. 566); LUKE, Luke with the head of a bull seated writing (f. 577ᵛ); JOHN, John with the head of an eagle seated writing (f. 596ᵛ); ACTS, the Apostles dictating to Luke (f. 609ᵛ); JAMES, James seated (f. 627); PETER I, Peter in prison speaking to a man (f. 628ᵛ); PETER II, Peter seated (f. 630ᵛ); JOHN I, John in the cauldron of boiling oil (f. 631ᵛ); JOHN II, John drinking from the poisoned cup (f. 633); JOHN III, John seated in his tomb (f. 633ᵛ); ROMANS, Paul preaching (f. 634); CORINTHIANS I, Paul falls from his horse (f. 640ᵛ); CORINTHIANS II, Paul disputing (f. 646ᵛ); GALATIANS, the feeding of the sick (f. 651); EPHESIANS, Paul baptising (f. 653); PHILIPPIANS, Paul preaching (f. 655ᵛ); COLOSSIANS, Paul let down in

a basket from the walls of Damascus (f. 657); THESSALONIANS I, the beating of Paul (f. 658ᵛ); THESSALONIANS II, Paul bitten by the viper (f. 660); TIMOTHY I, Paul blessing Timothy as a Bishop (f. 661); TIMOTHY II, Paul in discussion with Timothy (f. 662ᵛ); TITUS, Paul dictating to a scribe (f. 664); PHILEMON, Paul preaching (f. 664ᵛ); HEBREWS, the beheading of Paul (f. 665); APOCALYPSE, the Last Supper with John sleeping on Christ's chest (f. 670); INDEX TO THE HEBREW NAMES, ornamental (f. 679). There are illuminated ornamental initials to the prologues of most of the books.

The figure style is characterised by lively poses and facial expressions with particular prominence given to the eyes. The faces are strongly modelled giving a ruddy effect. A prominent feature is the extensive use of punch dot patterns on the burnished gold grounds. The technique of facial modelling may derive from works perhaps localisable in East Anglia (nos. 38, 39) and the punch dot designs from East Midland works (e.g. no. 40). A contemporary work to the Bible showing a rather coarse version of the figure style is a Book of Hours (Yale, University Library MS Marston 22). In the Memoria in Lauds of this Book of Hours prominence is given to Edmund the Martyr (relics at Bury) suggesting that the text may be of East Anglian origin. As the Bible was in the late 13th century in the possession of a Norwich man and all the artistic connections are East Anglian it was probably produced in that region. On the basis of present knowledge no definite centre can be suggested.

Unlike most of the other small English 13th-century Bibles which have suffered mutilation this copy has all its illuminated initials remaining in an excellent state of preservation. An unusual feature of the iconography is the series of scenes of the lives of John and Paul spread over the initials to their epistles.

PROVENANCE: Given to the library of the Benedictine Cathedral Priory of Norwich by Master Richard de Felningham, a Norwich bailiff mentioned in the records in 1294 (f. 13). The 14th-century pressmark E. xliii is of the Cathedral Library. Henry Fowler, rector of Minchinhampton (Gloucestershire) owned the Bible in 1610 (ff. 1, 12). Thomas, Lord Windsor of Stanwell, 1626 (ff. 2, 12). Sir Christopher Hatton, 1605–70 (f. 1). Robert Scot acquired many of Hatton's manuscripts which he sold to the Bodleian Library in 1671.

LITERATURE: S. C. Cockerell, M. R. James, *Two East Anglian Psalters at the Bodleian Library*, Roxburghe Club, 1926, 21; *S.C.*, II, no. 4086; N. R. Ker, 'Medieval manuscripts from Norwich Cathedral Priory', *Transactions of the Cambridge Bibliographical Society*, I, 1949, 14; Bodleian Picture Book, *English Illumination of the thirteenth and fourteenth centuries*, pl. 8b, c; Ker, *Medieval Libraries*, 138; Bennett, *Thesis*, 181 n. 2, 287 n. 1; Pächt and Alexander, III, no. 444, pl. XL.

76. London, British Library MS Harley 4751

Bestiary
307 × 233 mm., ff. 74
c. 1230–40. (?) Salisbury *Ills. 263–266; p. 38*

This is a less luxurious version of no. 98 and slightly earlier in style. The 106 miniatures have no gold and use rather drab colours. They are set in the text in rectangular or circular frames with panels set in the background. The pictures of the Lion at the beginning of the text are missing and the series begins with the scene of the capture of the Lioness (f. 2ᵛ). Then follows: Tiger (f. 3ᵛ); Panther (f. 4); Antelope (f. 5ᵛ); Leopard (f. 6); Unicorn (f. 6ᵛ); Lynx (f. 7); Griffin (f. 7ᵛ); Elephant (f. 8); Beaver (f. 9ᵛ); Ibex, Hyena (f. 10); Bonnacon, Apes (f. 11); Satyrs (f. 11ᵛ); Stags (f. 12); Reindeer (f. 13ᵛ); Goats (f. 14); Wild Goats (f. 14ᵛ); Monoceros (f. 15); Bear (f. f. 15ᵛ); Leucrota (f. 16ᵛ); Sheep (f. 17ᵛ); Ram (f. 18); Lambs (f. 18ᵛ); Goat kids (f. 19); He-Goat (f. 19ᵛ); Sow (f. 20); Wild Boar (f. 21); Bullock (f. 21ᵛ); Ox (f. 22); Buffalo (f. 22ᵛ); Cow (f. 23); Calf (f. 23ᵛ); Camel (f. 24); Donkey (f. 25); Wild Ass (f. 26); Dromedary (f. 26ᵛ); Horse (f. 27); Mule (f. 29); Badger (f. 30); Cats, Mice (f. 30ᵛ); Weasel, Mole (f. 31); Dormouse, Hedgehog (f. 31ᵛ); Ants (f. 32); Frogs (f. 33); Salamander (f. 33ᵛ); Eagles (f. 35ᵛ); Barnacle Geese (f. 36); Ospreys or Cormorants (f. 37); Kingfishers (f. 37ᵛ); Coots (f. 38); Vultures (f. 38ᵛ); Cranes (f. 39); Parrot (f. 39ᵛ); Caladrius (f. 40); Stork (f. 40ᵛ); Herons (f. 41); Swan (f. 41ᵛ); Ibis (f. 42); Ostriches (f. 42ᵛ); Coot (f. 43); Jackdaws (f. 43); Halcyon (f. 44ᵛ); Phoenix (f. 45); Pelicans (f. 46); Owls (f. 46ᵛ); Eagle Owl (f. 47); Sirens (f. 47ᵛ); Partridge (f. 48); Magpie (f. 48ᵛ); Hawk (f. 49); Bat, Nightingale (f. 50); Raven (f. 50ᵛ); Crow (f. 51); Dove (f. 51ᵛ); Turtle-doves (f. 52); Swallow (f. 52ᵛ); Quails (f. 53); Geese (f. 54); Peacock, Owl (f. 54ᵛ); Hoopoe (f. 55); Cock, Hens (f. 55ᵛ); Ducks (f. 56); Sparrows (f. 56ᵛ); Dragon (f. 58ᵛ); Basilisk (f. 59); Viper (f. 60); Asp (f. 61); Scitalis, Amphisbaena (f. 62); Hydrus (f. 62ᵛ); Boas, Jaculus, Siren serpent (f. 63); Seps, Dipsa, Lizard (f. 63ᵛ); snake shedding its skin (f. 64); Scorpion (f. 65); Coluber (f. 65ᵛ); types of fish (f. 68); Whale (f. 69). There is a fully painted ornamental initial B on f. 1.

This is an expanded version of the Second Family of Bestiaries as classified by James. Additional passages of text were incorporated from Rabanus Maurus, the Pantheologus of Peter of Cornwall and the Topographia Hibernica of Giraldus Cambrensis. The Barnacle Geese section is for example an interpolation from Giraldus Cambrensis. The basic series of pictures derives from early 13th-century examples like the Cambridge Bestiary (no. 21) but with additional figures and genre elements included in the scenes.

The figures are tall and thin with troughed fold draperies which often terminate in flying folds. The energetic poses and this fold style result in lively compositions. This is enhanced by the figures, animals and foliage tree forms overlapping the edges of the frames as if they were being forced out by the energy of the composition. The fold style is a fuller version of that of the Cambridge Bestiary (no. 21)

and additional substance is given to the figures by the use of colour. As the iconography has connections with the Cambridge manuscript presumably a similar Bestiary was used as a model. A further development of the style of the Harleian Bestiary occurs in a companion book (no. 98) painted in a richer manner.

Both these Bestiaries (nos. 76, 98) have been dated by most writers to a period contemporary with the Cambridge Bestiary in the years around 1200. The script, facial types, fuller folds and elaboration of the iconography however suggest that a date in the second quarter of the 13th century is more likely. The Harleian Bestiary is the earlier in style and no. 98 is a development which is a direct precursor of the style of the Sarum Master (see no. 98 for discussion) who operated at Salisbury. In view of this possibly the Harleian Bestiary was produced in that region. The compositions suggest, in their expansiveness, an influence from a more monumental composition in wall painting. A series of Bestiary pictures were done in 1237 for the Painted Chamber at Westminster Palace. There are affinities of style with contemporary wall paintings of the Life of Christ at Ashampstead (Berkshire). Further stylistic parallels particularly relevant to provenance are the roundels of the Labours of the Months in the choir vault at Salisbury. These were, however, completely repainted in 1870 and can only with caution be accepted as replicas of the originals.

PROVENANCE: Several names have been written in the book in the 16th and 17th centuries which do not necessarily imply ownership: John Bollocke (f. 34ᵛ), Richard Bowen (f. 69ᵛ), John Burd (f. 53), Edward Griffith (f. 70ᵛ), Edward, Lord Herbert (f. 65ᵛ), Edmund Maddock (f. 72ᵛ), Abraham Millard (f. 43ᵛ), Thomas Newcombe (f. 69ᵛ), James Solbrery (f. 58). The name of Lord Herbert (1583–1648) has by it 'his hand witnesse ye same'. The book was acquired by Robert (1661–1724) or Edward (1689–1741) Harley. The Harley manuscripts went to the British Museum in 1753.

LITERATURE: J. Strutt, *A Complete View of the Dress and Habits of the People of England*, London, 1796, I, pl. LIII; British Museum, *Reproductions*, III, pl. XIII; G. C. Druce, 'The Symbolism of the Goat on the Norman Font of Thames Ditton', *Surrey Archaeological Collections*, XXI, 1908, 110, 111, and pl.; Druce, 'Crocodile', 320, 329, 333, 335, pls. III, XV; Druce, 'Amphisbaena', 286, 289, 291, pls. IV, VI; Druce, 'Yale', 191; Herbert, *Illuminated Manuscripts*, 187; Druce, 'Caladrius', 385, 401, 407, pl. III; Druce, 'Abnormal forms', 159 n. 1, 175, pl. X; Druce, 'Serra', 21 n. 1; Druce, 'Medieval Bestiaries, I', 44, 47, 55, 59, 63, pls. VI, VIII, X, XII, XV; Druce, 'Elephant', 33, 35, 42, pls. V, VI; Druce, 'Medieval Bestiaries, II', 36, 40, 44, 46, 55, 59, 72, 77, pls. V, VII, XII; Millar, I, 38, 39, 88, pl. 56; Saunders, *English Illumination*, I, 47, II, pl. 51a; James, *Bestiary*, 15–16, 53, suppl. pls. 12, 13; G. C. Druce, 'The Sow and Pigs', *Archaeologia Cantiana*, XLVI, 1934, 3–6, pl. III; R. Wittkower, 'The Marvels of the East', *J.W.C.I.*, V, 1942, 191, pl. 48b; H. W. Janson, *Apes and Ape Lore in the Middle Ages and the Renaissance*, London, 1952, 330, 348 n. 19; Saxl and Meier, III, 190; Boase, *English Art*, 295; Rickert, *Miniatura*, I, pl. 55; Baltrušaitis, *Reveils et prodiges*, 131, fig. 19B; O. Pächt, 'A cycle of English frescoes in Spain', *Burlington Magazine*, 103, 1961, 170, fig. 4; McCulloch, *Bestiaries*, 36, passim; Rickert, *Painting in Britain*, 88; Turner, 'Manuscript Illumination', fig. 164; Klingender, *Animals in art*, 387, 394–6, figs. 213, 218c, (wrongly titled), 220a, 225, 226, 227; C. E. Wright, *Fontes Harleiani*, London, 1972, 75, 78, 87, 172, 187, 231, 240, 251, 308; B. Rowland, *Animals with Human Faces*, Knoxville, 1973, fig. on 117; I. Schachar, *The 'Judensau'*, London, 1974, 4–5, 7, 8, pl. 1b; Einhorn, *Spiritalis Unicornis*, 80, 81, 277, 337; P. L. Armitage, J. A. Goodall, 'Medieval horned and polled sheep: the archaeological and iconographic evidence', *Antiquaries Journal*, LVII, 1977, 77; B. Rowland, *Birds with Human Souls*, Knoxville, 1978, fig. on 29; Yapp, 'Birds', 316, 319, 320, 324.

EXHIBITED: London, British Museum, *British Heraldry*, 1978, no. 51, pl.

77. San Marino (California), Huntington Library, MS HM 26061

Bible and Select Masses
215 × 150 mm., ff. 381
c. 1240. *Ills. 250, 251*

The illumination consists of one full-page miniature and numerous decorative initials, seven of which are historiated, the rest either painted with vine motifs or having ornamental penwork. The full-page miniature is a Crucifixion facing the Canon of the Mass (f. 178ᵛ). The historiated initials are as follows: PROLOGUE, a monk writing (f. 22); GENESIS, the first Six Days of Creation in medallions followed by the Crucifixion (f. 24); Psalm 1, B, David Playing the Harp (f. 166); MATTHEW, the Evangelist (f. 284); MARK, the Evangelist and symbol (f. 292); LUKE, the Evangelist and symbol (f. 297); and JOHN, the Evangelist (?) and symbol (f. 305ᵛ). In the Genesis initial, the fifth Day of Creation is omitted but the sixth appears in two medallions illustrating the Creation of the Animals and the Shaping (?) of Adam. The first three evangelists are seated at lecterns and writing. For the last Gospel, the head of a bearded man, possibly John, and the eagle are represented. The manuscript has several unusual features. Most prominent is the insertion after Psalms as in the contemporary de Brailes Bible (no. 69) of an abbreviated missal (ff. 179–191ᵛ) written in a contemporary hand and containing prefaces, the canon, votive masses, and occasional prayers, of which one is introduced by '*pro fratribus congregationis*' (f. 180ᵛ). Shortly after its completion, the manuscript was extensively annotated, possibly by its first owner with several systems of index and cross-reference. The most noteworthy is the appearance of Grosse-

teste's concordantial signs in Parables; others, such as concordances to the Gospels or to Gregory's *Moralia in Job*, are more common. In the 14th century, lection tables corresponding to Sarum usage as well as other materials were added to the codex ff. 1–21).

The fine Crucifixion miniature is of the type found in the two Peterborough Psalters (nos. 45, 47) and is especially similar to that in the Cambridge, Fitzwilliam Museum MS 12. The similarities extend from the general pictorial conception and iconography to details of Christ's anatomy and the facial features of the Virgin and John. In the Bible, however, the cross and all figures are brought forward and enlarged, drapery folds are more metallic and angular, actions are more restrained, and the figures are more sharply set off from the dark blue background by their cooler colours. The effect is one of increased severity and monumentality. These mature Early Gothic characteristics suggest a date in the 1230s or later; similar traits begin to appear in the David miniatures of the Glazier Psalter (no. 50). In view of the date, the use of an early model like the Peterborough Psalter is surprising; it may have been deliberate, for a similar reversion is again the case in the initials where a few figures show characteristics from the early 13th century 'Channel School' (e.g. London, Brit. Libr., MS. Add. 15452 f. 101ᵛ).

The manuscript is most closely related to another Bible in Paris (Bibl. Nat., MS. lat. 10431) which also contains an abbreviated missal. Although its style appears to be slightly earlier, the prayers and votive masses as well as the codicological features are so similar to the San Marino manuscript that the two manuscripts appear to have been produced in the same atelier. Neither manuscript can be securely localised, but the Calendar of the Paris manuscript points to a Cistercian house in England and to a date between 1235 and 1246 (St. Elizabeth and St. Lambert are both included but the latter is not yet commemorated with twelve lessons). The prayers and indexing systems of the San Marino Bible suggest an owner who used the manuscript to facilitate liturgical and exegetical work, perhaps a canon with close ties to the Franciscans in Oxford or London.

PROVENANCE: Mrs. Stanley H. Burchell; given to the Huntington Library in 1935.

LITERATURE: *Huntington Library Quarterly*, XVII, No. 1 (Nov. 1953), 90. H. Stahl is preparing a detailed article on the MS.

EXHIBITED: San Marino, Huntington Library, *Aspects of Medieval England; Manuscripts for Research in the Huntington Library*, 1972, no. 34.

78. Cambridge, Trinity College MS 0.1.20
ff. 240–99ᵛ
Roger of Salerno, Chirurgia
197 × 152 mm.
c. 1230–40. *Ills. 256–261*

This medical treatise is a French version of Roger of Salerno's work on surgery. Up to f. 273 (the MS has been refoliated since it was catalogued by James) there are 50 drawings in the bottom margin of the various operations and medical practices described in the text. Many are plain drawings but others are tinted in yellow, brown and green. One exception, by a different artist, is a painted historiated initial at the beginning of the text of a man with a bandaged head kneeling before a doctor (f. 240). The marginal drawings which follow are: a man with a wounded head examined by a doctor, assistants with pestles and mortars preparing medicines (f. 240); the doctor directing preparation of ointments for wounds (f. 241ᵛ); examination of the extent of a head wound (f. 242); a doctor applying a scalpel and forceps to the head of a man (f. 242ᵛ); further examination of a head injury (f. 243); a pointed instrument applied to the head (f. 243ᵛ); a doctor instructing production of a medicine (f. 244); examination of a man in bed (f. 245ᵛ); forceps applied to the head (f. 246); preparation of 'pudre rouge' (f. 246ᵛ); examination of the mouth in connection with a nose wound (f. 247ᵛ); extraction of an arrow from a man's head (f. 248); extraction of an arrow from the back (f. 248ᵛ); ointment applied to a man's head (f. 249ᵛ); preparation of medicines (f. 250); an operation on the head (f. 251ᵛ); a scalpel applied to the head (f. 252); another head operation (f. 252ᵛ); pouring liquid through a funnel into a man's ear (f. 253); examination of a patient's stomach (f. 254); treatment of a neck wound (f. 254ᵛ); preparation of medicines (f. 255); a man with eye trouble asking help from a doctor (f. 255ᵛ); ointment applied to the eyes (f. 256); a man asking help from a doctor (f. 257ᵛ); a cautery operation on a facial fistula (f. 258); a doctor examining a man's nose (f. 258ᵛ); the doctor instructing his assistants in the preparation of medicines (f. 259); two operations for a polypus on the nose (f. 259ᵛ); further treatment of a polypus on the nose (f. 260); examination of a bandaged nose (f. 260ᵛ); preparation of medicines (f. 261); a man with eye trouble treated by a doctor (f. 262); examination of a bandaged mouth (f. 262ᵛ); a man inhaling over a cauldron, a man with impetigo consulting a doctor (f. 263); the doctor examines the man with impetigo (f. 264); the doctor and his assistants preparing medicines (f. 265); an operation on the ear (f. 265ᵛ); liquid poured through a funnel into the ear (f. 266); the doctor stitching a wound in the neck (f. 266ᵛ); examination of a throat wound (f. 267); a man pointing to his stomach turns away from a doctor (f. 268); preparation of medicines (f. 269); examination of the throat (f. 269ᵛ); examination of a man's face (f. 270ᵛ); a throat operation (f. 271); preparation of medicines (f. 272); an operation on the shoulder (f. 273). Apart from a crude 14th-century sketch on f. 273ᵛ the drawings cease at this point.

The treatise on surgery was written by Roger of Salerno during the third quarter of the 12th century. The translation into Anglo-Norman French in this manuscript has been considered (Meyer, Ross) to be the work of an Englishman. The work is divided

into sections dealing with wounds and diseases of the head, of the nose and throat, of the arms and abdomen and finally of the legs and feet. Many details are concerned with the preparation of medicines and ointments. The illustrations only extend as far as the beginning of the third section on the arms and abdomen. They are the earliest extensive series of pictures of the French version of the text. Later in the century there is a more extensively illustrated example made in France (London, British Library MS Sloane 1977).

The figure style is characterised by the liveliness of poses and facial glances. There is an attempt to convey the nature of the patient's complaint by the pose or features of the body, and also to give some psychological expression to the faces. The drawing style makes use of many fine thin lines in the draperies and is difficult to parallel exactly. In a general sense such drawing with an emphasis on multiple folds is characteristic of certain London region drawings (nos. 53, 95). Features similar to the drawing style of the Cambridge Bestriary (no. 21) suggest that this medical manuscript could have been made at an earlier date than the proposed c. 1230–40.

PROVENANCE: Thomas Gale (d. 1702). His manuscripts were presented to Trinity College by his son Roger Gale in 1738.

LITERATURE: James, *Catalogue*, no. 1044, pl. XVI; P. Meyer, 'Les manuscrits français de Cambridge', *Romania*, 32, 1903, 75–95; K. Sudhoff, 'Beiträge zur Geschichte der Chirurgie im Mittelalter', *Studien zur Geschichte der Medizin*, X, 1914, 33–42, pls. V–VII; D. J. A. Ross, *Some thirteenth century French versions of the Chirurgia of Roger of Salerno*, Ph.D. Dissertation, London, 1940, 15–272; L. MacKinney, *Medical Illustrations in Medieval Manuscripts*, London, 1965, 71–2 (wrongly cited as a St. John's MS), fig. 71; Randall, *Images*, 37, 194, 197; R. Herrlinger, *History of Medical Illustration from Antiquity to A.D. 1600*, London, 1970, 34.

EXHIBITED: B.F.A.C., *Illuminated Manuscripts*, 1908, no. 78, pl. 67.

79. Liverpool, Merseyside County Museum MS Mayer 12017
Universal Chronicle incorporating Peter of Poitiers, Compendium Historiae in Genealogia Christi
c. 1230–40. *Ill. 262*

This is a roll of 210 mm. width. The illustrations to this roll are drawings, 18 in all, tinted in green, blue and red set in most cases in roundels against fully-painted panelled grounds. There are red and green ornamental borders at the edges for the length of part of the roll. The illustrations begin with a circular diagram of the twelve tribes of Judah but without figural representation. Then follows: the Seven-branched Candlestick, God the Creator

blessing, the Temptation of Adam and Eve, Noah and his family putting the birds and animals in the Ark, Sacrifice of Isaac, David harping, Zedekiah with the Babylonians slaying the people of Jerusalem, the Nativity, Crucifixion, Resurrection, Ascension, a rectangular miniature having two sections one with Christ seated amongst the Apostles and the other the Emperor Augustus. The Chronicle continues after the time of Christ with a series of roundels of Popes and contemporary rulers: Pope Silvester, Constantine the Great, Pope Gregory the Great, Emperor Heraclius, Pope Leo III, Charlemagne.

The figures have angular poses, vivacious facial expressions and many fine linear folds in the draperies. This style and the unusual use of colour is difficult to parallel, although the multiple line folds have some affinities with the medical manuscript discussed in the previous entry (no. 78). The tinted drawings of the roll are mostly set against blue grounds with pink panels which combined with the red and green ornamental borders result in an unusually bright effect for a manuscript of this text (compare the dull colours used in the examples in no. 43).

PROVENANCE: The antiquary Joseph Mayer (1803–86) gave his collection of manuscripts and antiquities to the Corporation of Liverpool in 1867.

LITERATURE: C. T. Gatty, *Catalogue of Medieval and Later Antiquities contained in the Mayer Museum*, Liverpool, 1883, no. 6, pl. II.

EXHIBITED: Manchester, Whitworth Art Gallery, *Medieval and Early Renaissance Treasures in the North West*, 1976, no. 14.

80. London, British Library MS Harley 3244 ff. 27–71ᵛ
Peraldus, Liber de Vitiis,
Bestiary
278 × 172 mm.
After 1235. *Ills. 267–270*

The Bestiary section is preceded by Peraldus's treatise on the Vices which has a set of four preliminary pictures in tinted drawing: a Dominican friar kneeling before Christ blessing (f. 27); a symbolic diagram showing a knight on horseback with a shield having a device symbolic of the Trinity, crowned by an angel, with seven doves before him symbolising the gifts of the Holy Spirit, confronting a page of devils representing the Vices (ff. 27ᵛ, 28); a six-winged Seraph standing on a seven-headed dragon (f. 28ᵛ).

Then follows the treatise on the Vices, and the Bestiary begins on f. 36. It has 132 framed illustrations with drawings lightly painted in brown, orange, blue and green: Lion (f. 36); Tiger (f. 36ᵛ); Leopard, Panther (f. 37); Antelope, Unicorn (f. 38); Lynx, Griffin (f. 38ᵛ); Elephant (f. 39); the female

Elephant in the water when about to give birth is menaced by the Dragon (f. 39ᵛ); Beaver (f. 40); Ibex, Hyena (f. 40ᵛ); the Lioness with the Crocote she has produced through mating with the Hyena, Bonnacon, Apes (f. 41); Satyrs, Stag (f. 41ᵛ); Goats (f. 42); Goats, Monoceros, Bears (f. 42ᵛ); Crocodile (f. 43); Manticora, Parandus, Fox (f. 43ᵛ); Yale, Wolf (f. 44); Dogs (f. 44ᵛ); Dog with a shepherd, Dogs hunting, Dog identifying a murderer and howling by its dead master (f. 45); Dogs attacking the gaoler and dragging him to King Garamantes (f. 45ᵛ); Adam naming the animals (f. 46); Sheep, Ram, Lamb, He-Goat (f. 46ᵛ); Wild Boar, Bull, Ox (f. 47); Camel (f. 47ᵛ); Dromedary, Ass (f. 48); Wild Ass, Horses (f. 48ᵛ); Cat, Mouse, Weasel, Mole, Hedgehog (f. 49ᵛ); Ants (f. 50); a general picture of birds, Eagle (f. 50ᵛ); Vulture (f. 51); Cranes, Parrot (f. 51ᵛ); Caladrius, Stork, Swan (f. 52); Ibis (f. 52ᵛ); Ostrich, Coot, Halcyon (f. 53); two scenes of the Phoenix (f. 53ᵛ); Cinnamolgus, Ercinea (f. 54); Hoopoes, Pelican, Owl (f. 54ᵛ); Siren, two scenes of the Partridge (f. 55); Magpie, Hawk, Nightingale, Bat (f. 55ᵛ); Raven, Crow, Doves (f. 56); Turtle Doves, Swallow (f. 56ᵛ); Quail, Peacock, Hoopoe, Cockerel (f. 57); Duck, Bees (f. 57ᵛ); Bees, Perindeus Tree (f. 58ᵛ); Anguis, Dragon (f. 59); Basilisk, Regulus, (f. 59ᵛ); Fire Stones (f. 60); Whale (f. 60ᵛ); Amos seated with a whale in the water before him, Whale (f. 61); Asp, Scitalis (f. 61ᵛ); Amphisbaena, Hydrus (f. 62); Boas, Jaculus, Siren-serpent, Seps, Lizard (f. 62ᵛ); Salamander, Saura, Stellio (f. 63); a snake shedding its skin (f. 63ᵛ); Worms, Spiders, Centipede, Scorpion (f. 64); Scorpions, Jonah coming out of the whale (f. 64ᵛ); Whale, Serra (f. 65); Dolphins, Sea Pig, Scorpion (f. 65ᵛ); Crocodile, Red Mullet, Grey Mullet (f. 66); Eels, Lamprey (f. 66ᵛ); Crabs (f. 67); Conch shells, Mussels, Frog (f. 67ᵛ). The Bestiary is followed by a Lapidary which is not illustrated.

A number of texts are bound together with the Bestiary including some aids for preaching comprising a series of exempla and the *Ars Predicandi* of Richard of Thetford. The compilation, which also includes a moral treatise, the *Liber Poenitentialis* of Alain de Lille, seems to have been made for the Dominican kneeling before Christ on f. 27 and the Bestiary presumably was included to provide additional ideas for his sermons. The use of such material was characteristic of the lively preaching of the friars which attracted such large crowds (G. R. Owst, *Literature and Pulpit in Medieval England*, Oxford, 1966, 195–207).

The drawings are lightly painted mostly with overall colour wash rather than tinting and are set against a plain background. The style, which is difficult to parallel precisely in other works, is vigorous with strong poses for both figures and animals. Heavy black outlines emphasise the silhouette effect against the plain grounds. The style has been condemned as primitive (Saunders) but it is only by comparison with the very refined contemporary works of the Sarum Master or the Westminster artists that such a judgement could be accepted. Many 13th-century English Bestiaries are beyond doubt low quality art (e.g.

Oxford, Bodleian Library MS e. Mus. 136), but Harley 3244 is certainly of much higher rank than such books.

The iconography, rubrics and inscriptions of both the Bestiary subjects and the Virtues and Vices pictures are very unusual (e.g. the gaoler of King Garamantes dragged before him, Adam as a naked figure naming the animals). The Bestiary scenes are a variant of the Second Family series and have been linked (McCulloch) with a late 13th-century example (Paris, Bibliothèque Nationale MS Lat. 3630). Some subjects are interpolated from the Third Family. The scene of the knight representing the Virtues setting out to do battle against the Vices is a 13th-century reinterpretation of the early medieval Psychomachia in which a battle was represented between personifications of the Virtues and Vices. The date of the book depends on whether the compilation of texts were made at the same time or later bound together. In spite of differences of script the general appearance suggests it is a contemporary compilation. One of the texts, the *Templum Domini* of Robert Grosseteste was written after 1235 which would give a *terminus post* for the whole book.

PROVENANCE: The unnamed Dominican friar represented on f. 27. Richard Edwards owned the book in the 17th century (f. 1). Later acquired by Robert (1661-1724) or Edward (1689-1741) Harley. The Harley manuscripts came to the British Museum in 1753.

LITERATURE: G. C. Druce, 'The Symbolism of the Goat on the Norman Font of Thames Ditton', *Surrey Archaeological Collections*, XXI, 1908, 110; Druce, 'Crocodile', 313, 314, 315, 323, 324, 333, 335, pls. III, V, XVI; Druce, 'Amphisbaena', 290, 291, pl. IV; Druce, 'Yale', 177, 178, 191; Druce, 'Caladrius', 401, 409, pl. V; Druce, 'Abnormal forms', 157, 175, fig. 5; Druce, 'Serra', 21 n. 1, 25, fig. 2; Druce, 'Elephant', 5, 11; Druce, 'Medieval Bestiaries, I', 47, 73, 78, 81, pls. III, XV; Druce, Medieval Bestiaries, II', 36, 45, 50, 74; Saunders, *English Illumination*, I, 48, II, pl. 51b; James, *Bestiary*, 17, 53, suppl. pl. 19; S. Harrison Thomson, *The Writings of Robert Grosseteste*, Cambridge, 1940, 139; Saxl and Meier, III, 161; McCulloch, *Bestiaries*, 36, passim; D. J. A. Ross, 'A lost painting in Henry III's palace at Westminster', *J.W.C.I.*, VI, 1953, 160, pl. 22c; W. George, 'The Yale', *J.W.C.I.*, XXXI, 1968, 424, pl. 92g; M. Evans, 'Tugenden und Laster', *Lexikon der christlichen Ikonographie*, IV, 1972, col. 382, fig. 3; C. E. Wright, *Fontes Harleiani*, London, 1972, 143; B. Rowland, *Animals with Human Faces*, Knoxville, 1973, figs. on 3, 30, 125; Einhorn, *Spiritalis Unicornis*, 79, 278, 337, fig. 24; P. L. Armitage, J. A. Goodall, 'Medieval horned and polled sheep: the archaeological and iconographic evidence', *Antiquaries Journal*, LVII, 1977, 77; X. Muratova, 'Adam donne leurs noms aux animaux', *Studi Medievali*, XVIII.II, 1977, 377; B. Rowland, *Birds with Human Souls*. Knoxville, 1978, figs. on 72, 179; M. W. Evans, forthcoming article, *J.W.C.I.*

81. Cambridge, Trinity College MS O.9.34
Thomas of Kent, Roman de toute chevalerie
280 × 195 mm., ff. 46
c. 1240–50. *Ills. 271–274*

This is one of the very few English illustrated copies of a secular romance to survive from the period. The text in Anglo-Norman is a poem on the life and travels of Alexander written by a certain Thomas of Kent in the second half of the 12th century. The text is much concerned with the military exploits of Alexander and with the marvels seen on his travels in the East. Only about half the original manuscript exists (46 out of a probable 96 folios). The text in two columns is illustrated with 152 framed tinted drawings in green, brown, blue and red with rubricated titles each of one column width set in various parts of the columns corresponding to the divisions of the text (described in detail by James). The complete work must have contained about 300 pictures as suggested by a *c.* 1300 copy (Paris, Bibl. Nat. MS fr. 24364) which has 311, and by a 14th-century copy without illustrations but containing 297 picture titles (Durham, Cathedral Library MS C. IV. 27B). Fine large penwork initials in red and blue are set at the divisions of the text.

The figure style is characterised by jerky angular poses with alert faces and expressive gestures of hands and fingers. The tinting is applied in rather a mechanical way to the contours and fold lines without being used to convey a sense of volume in the figure. The style has been likened to that of Matthew Paris but such angular figures are in no way similar to his style and all that they have in common is the technique of tinted drawing. A more likely source for the style is the Life of St. Thomas (no. 61) which has similar angular jerky poses. A London provenance has been tentatively suggested for this style but the Romance of Alexander is not sufficiently close to attribute its production also to London. The link with St. Albans and Matthew Paris has been constantly stated in the literature since James made the suggestion when he catalogued the manuscript. It has been realised (Ross) that such subjects as Alexander in bed with Queen Candace and various naked figures have been represented with a lack of inhibition unlikely for a monastic illustrator and more plausible as the product of a lay artist. The main argument against production at St. Albans is however that the figure style and head type is unlike anything with definite St. Albans provenance.

The Romance of Alexander was also depicted in monumental paintings of the time at Henry III's Palace at Clarendon where there was an Alexander chamber first mentioned in 1247 and in the 1252 paintings of Alexander scenes in the Queen's chamber at Nottingham Castle.

PROVENANCE: Thomas Gale (d. 1702). His manuscripts were presented to Trinity College by his son Roger Gale in 1738.

LITERATURE: James, *Catalogue*, no. 1446, pl. XV; J. Weynand, *Der Roman de toute chevalerie des Thomas von Kent*, Bonn, 1911; Millar, I, 125; M. D. Legge, *Anglo-Norman in the Cloisters*, Edinburgh, 1950, 38, 114; B. Foster, 'The Roman de toute chevalerie: its date and author', *French Studies*, IX, 1955, 154-8; D. J. A. Ross, 'Discussions: Thomas of Kent', *French Studies*, IX, 1955, 350-1; D. J. A. Ross, *Alexander Historiatus: a guide to medieval illustrated Alexander Literature*, London, 1963, 25; M. D. Legge, *Anglo-Norman Literature and its background*, Oxford, 1963, 106; Ker, *Medieval Libraries*, 166; Brieger, *English Art*, 132; D. J. A. Ross, 'A thirteenth century Anglo-Norman workshop illustrating secular literary manuscripts', *Mélanges offerts à Rita Lejeune*, Gembloux, 1969, 690 ff., fig. 2; B. Foster, I. Short, *The Anglo-Norman Alexander (Le Roman de toute chevalerie) by Thomas of Kent*, Anglo-Norman Text Society, 29–31, 1976 (edition of the text); *Anglo Norman Text Society*, 32–3, 1977, 2, 10–12, 18 ff., 70 (commentary).

EXHIBITED: B.F.A.C., *Illuminated Manuscripts*, 1908, no. 79, pl. 68; London, 1930, no. 127; Brussels, 1973, no. 50.

82. London, British Library MS Lansdowne 782
Chanson d'Aspremont
234 × 160 mm., ff. 38
c. 1240–50. *Ill. 275*

This is another illustrated copy of a secular text produced by the workshop of no. 81. The Chanson d'Aspremont, written at the time of the Third Crusade, is a version of the Legend of Roland. The text in two columns has 45 framed illustrations of variable size and shape, some of two column width, some of one, and some spreading into the margins. Six additional pictures have been cut out and in general the manuscript is in a damaged state. The pictures are drawings tinted in green and brown with occasional touches of red and grey-blue.

Most of the drawing in this book is of inferior quality compared to the work in the *Roman de toute chevalerie*. Small differences of figure style, manner of tinting and scale of composition suggests that two or three artists were involved. The work in the section ff. 3v–17 comes closest to the *Roman de toute chevalerie* and definitely points to production by an artist of the same workshop. The other drawings, occasionally almost crude, suggest very sketchy rapid execution. Such relatively rough work used to illustrate secular manuscripts is in glaring contrast to the extreme luxury of contemporary liturgical texts. The connection of this manuscript with Matthew Paris and the School of St. Albans has been made by most writers but, as for no. 81, there is little stylistic similarity except the use of the same tinted drawing technique. There is no reason even to assume that the drawings derived from a model produced at St. Albans.

On the basis of a very similar text being used as a model for the Norwegian Karlamagnus Saga, it has been suggested by de Mandach that such a text could

have reached Norway at the time of Matthew Paris's visit to Haakon V in 1248. If the artistic link with St. Albans is rejected then this theory is very much weakened. The close political connections between England and Norway in the 13th century of course provide many possible means through which a text could be transmitted to Haakon V (d. 1263) for whom the Karlamagnus Saga was written.

PROVENANCE: William Petty, Marquess of Lansdowne (1737–1807). His collection was purchased by the British Museum in 1807.

LITERATURE: H. L. D. Ward, *Catalogue of Romances, British Museum*, London, 1883, I, 600–2; R. Lejeune, J. Stiennon, *The Legend of Roland in the Middle Ages*, London, 1971, (translation of the French edition, Brussels, 1966), 210–12, pl. XIX, figs. 163–9; D. J. A. Ross, 'A thirteenth century Anglo-Norman workshop illustrating secular literary manuscripts', *Mélanges offerts à Rita Lejeune*, Gembloux, 1969, 689 ff., fig. 1; A. de Mandach, *Chanson d'Aspremont*, Geneva, 1975, 25 ff.

83. London, Public Record Office MS (E36) 266

The Black Book of the Exchequer
270 × 155 mm., ff. 104
c. 1240–50. (?) London *Ills. 276–278*

The volume is illustrated by nine plain drawings without tinting. First are the symbols of the Evangelists in roundels: Eagle, Bull (f. 8); Angel (f. 8ᵛ); Lion (f. 9). Then follows a series of figures under architectural canopies: Christ seated blessing (f. 9ᵛ); the Virgin and Child seated (f. 10); St. Thomas of Canterbury (f. 10ᵛ); St. Michael spearing the dragon (f. 11); the Crucifixion (f. 17ᵛ).
The text contains official memoranda compiled by the Officers of the Exchequer and a treatise on the constitution and practice of the Exchequer. A Calendar at the beginning (ff. 2–7ᵛ) seems to be a later addition. There are also oaths for various officers and the Evangelist symbols which are accompanied by texts from their Gospels were probably used in connection with administering these and other oaths. The reason for the inclusion of the drawings of Christ, the Virgin and the saints is not clear.
The drawing style is characterised by the use of many troughed drapery folds, elongated figures and rather weak outlines. It is no more than routine work and the importance of the book lies more in its textual contents and function.

PROVENANCE: The records of the Exchequer were kept at Westminster Abbey throughout the later Middle Ages and for a period after the Reformation. From the 16th century they were transferred between various depositories and eventually in the second half of the 19th century found a resting-place in the newly built Public Record Office.

LITERATURE: M. S. Giuseppi, *A guide to the manuscripts preserved in the Public Record Office*, London, 1923, I, 210; Public Record Office, *Museum Catalogue*, London, 1974, 23.

84. Cambridge, University Library MS Gg. 6.42, ff. 5, 5ᵛ

Alexander Neckham, various works
182 × 140 mm.
c. 1240–50. *Ills. 280, 281*

A single leaf inserted into the book (ff. 5, 5ᵛ) has two framed drawings tinted in pale brown and pink with touches of red: St. Francis bearing the stigmata standing with another friar (f. 5); two standing friars, perhaps Dominicans (f. 5ᵛ). Some rather crude marginal drawings and borders occur in the text with some grotesque animal heads in red and blue pen (e.g. ff. 3, 9, 21ᵛ, 29ᵛ, 40ᵛ, 72) resembling those in the Carrow Psalter (no. 118, Part 2).
The facial types, and the use of tinting to give three-dimensional substance to the drawing convincingly, are close to the early style of Matthew Paris as seen in the Life of St. Alban (no. 85). The drawing is however rather more fussy in use of line and also there is a lack of green or blue in the tinting, which are the colours much used by Matthew Paris. These differences apart, the artist does have sufficient link with the St. Albans drawings to suggest he was directly acquainted with Matthew's work. On the basis of this contact a date in the 1240s has been suggested. These two drawings are perhaps the earliest representations of the friars in English manuscripts. The Dominicans had first come to England in 1221 and the Franciscans in 1224.

PROVENANCE: A Franciscan (?) owner in the 13th century. On f. 2ᵛ an inscription of ownership of Maurice Gyffard. Also on f. 2ᵛ is a note asking for the prayers of Cirencester.

LITERATURE: *A Catalogue of the Manuscripts preserved in the Library of the University of Cambridge*, III, Cambridge, 1858, 231–4; Little, *Franciscan History and Legend*, 41, 64, pl. 7; Brieger, *English Art*, 143 n. 3.

85. Dublin, Trinity College MS 177 (E.I.40)

Life of St. Alban and other works relating to the Abbey of St. Albans
242 × 165 mm., ff. 77
c. 1240–50. St. Albans *Ills. 279, 282–285*

The parts of the manuscript which have illustrations are the Lives of St. Alban and St. Amphibalus (ff. 29–50), the visit of Saints Germanus and Lupus to Britain (ff. 51–55), the Invention and Translation of the relics of St. Alban, and the foundation of the Abbey of St. Albans by King Offa (ff. 55ᵛ–63). There are 54 remaining framed tinted drawings set

at the head of a two column text (occasionally over only one column) occupying almost half the page. Some were on separate pieces of vellum pasted in and these have been removed (ff. 40ᵛ, 42ᵛ, 43, 45ᵛ, 48ᵛ, 49ᵛ, 50ᵛ, 51ᵛ). In addition to the illustrations to the text there is a mutilated drawing of the Virgin and Child (f. 2ᵛ).

The main series of illustrations (some out of order through misbinding are placed in brackets) are as follows: 1. Amphibalus telling Alban of the life of Christ (f. 29ᵛ); 2. Alban dreams about Christ's life (f. 30ᵛ); 3. Alban watches Amphibalus kneeling before the Cross (f. 31); 4. Alban kneels before Amphibalus and is baptised (f. 31ᵛ); 5. a Saracen watching the baptism reports to the Roman Governor (f. 32); 6. Alban exchanges clothes with Amphibalus (f. 33); 7. he is attacked by the pagans (f. 33ᵛ); 8. he is arrested (f. 34); 9. the pagans try to force Alban to worship an idol (f. 34ᵛ); 10. the scourging of Alban (f. 35); 11. Alban is imprisoned and during his imprisonment the country suffers a drought (f. 35ᵛ); 12. Alban on his way to his martyrdom saves men from drowning by his prayers (f. 36); 13. the witnessing of this miracle converts the soldier Heraclius to Christianity and he is beaten by the pagans (f. 37); 14. Alban's prayers cause springs to flow (f. 37ᵛ); 15. the Beheading of Alban (f. 38); 16. Heraclius mocked for taking Alban's head (f. 38ᵛ); [17. the Burial of Alban (f. 47); 18. Heraclius is tortured (f. 47ᵛ); 19. the Beheading of Heraclius (f. 46); 20. Angels and fire from heaven descend on the place of Alban's tomb (f. 46ᵛ);] 21. Christian converts leave Verulamium for Wales to find Amphibalus (f. 39); 22. Amphibalus baptising (f. 40); 23. Soldiers discover Amphibalus baptising (f. 41); 24. Soldiers massacre the Christian converts (f. 41ᵛ); 25. an eagle and a wolf guard the dead bodies of the martyrs (f. 42); 26. the lamentations over the massacre (f. 43ᵛ); 27. Martyrdom of Amphibalus (f. 45); 28. a battle between Christians and pagans, and the removal of the body of Amphibalus (f. 48); 29. Devils attack the killers of Amphibalus (f. 49); 30. the conversion, penance and baptism of the inhabitants of Verulamium (f. 50); 31. Bishops Germanus and Lupus sent to Britain to deal with the Pelagian heresy (f. 51); 32. Genevieve vows chastity before Bishop Germanus (f. 52); 33. Germanus bids Genevieve farewell (f. 52ᵛ); 34. Germanus and Lupus embark on a boat for Britain (f. 53); 35. the two bishops land in Britain (f. 53ᵛ); 36. they worship at Alban's tomb and pray for assistance against the Pelagians (f. 54); 37. the bishops dispute with the Pelagians (f. 54ᵛ); 38. the bishops return home, Germanus carrying a reliquary containing dust stained with Alban's blood (f. 55); 39. King Offa of Mercia setting out on an expedition (f. 55ᵛ); 40. Offa's victory over King Boernred (f. 56); 41. an angel appears to the sleeping Offa (f. 56ᵛ); 42. a stream of gold fire falls from heaven to signify the place of Alban's grave (f. 57); 43. Offa goes to see the place where the miracle of the fire occurred (f. 57ᵛ); 44. the fire descends from heaven again (f. 58); 45. Offa in consultation with three bishops (f. 58ᵛ); 46. Offa directs a search for Alban's tomb (f. 59);

47. Offa directs the building of St. Alban's church (f. 59ᵛ); 48. a continuation of the previous scene (f. 60); 49. Willegod invested by Offa as the first abbot of St. Albans (f. 60ᵛ); 50. the monks before the shrine of St. Alban (f. 61); 51. Offa and four bishops in procession on St. Alban's feast day (f. 61ᵛ); 52. Offa landing in England on his return from Rome (f. 62); 53. Offa's horse, squire and attendants (f. 62ᵛ); 54. the continuation of the previous scene with Offa presenting a gift to a monk at an altar (f. 63).

The attribution of the text of the lives of Alban and Amphibalus and all the illustrations in the book to the hand of Matthew Paris has in the past been a controversial issue. Vaughan's authoritative arguments for attributing the handwriting of the text to Matthew has led recent opinion to accept almost everything in the manuscript as his work. The drawings are close in style to some of those in the *Chronica Maiora* (no. 88) which can indisputably be attributed to Matthew. Only the tinting and gilding from f. 51 onwards seem to be by another hand. Gold is not used in the earlier part of the manuscript, nor in other works by Matthew. The combined evidence of script and drawing style leaves little doubt that this book can be considered as an autograph copy of Matthew Paris.

The late 14th-century chronicler Thomas of Walsingham had recorded (ed. H. T. Riley, *Amundesham's Annales, Rolls Series*, 1870–1, II, 303) that Matthew Paris had written and illustrated the lives of Saints Alban and Amphibalus. Although much of Thomas of Walsingham's account of Matthew's artistic talents is exaggerated it seems that this particular attribution can be taken at face value. The source of the life of Alban is a Latin version by William of St Albans which Matthew 'translates' into Anglo-Norman French. The poem is written in a metre of laisses of alexandrines which differs from the octosyllabic couplets used in the two almost contemporary illustrated Anglo-Norman lives of saints (nos. 61, 123). The French titles to the illustrations, possibly by a different scribe, are however in octosyllabic couplets. The text is in two columns in contrast to the other two lives of saints for which there are three columns. After f. 50 the text is in Latin and is not related to the picture above but contains miscellaneous material relating to Alban. The pictures still however have French titles describing their contents. It seems that the illustrations may have originated as a system in which the width of the illustration corresponded to the column of the text (as in no. 81). In placing such illustrations together in a single frame the impression given is that although some of the pictures correspond to a two column text, others show that the illustrator was aware of the three column text arrangement.

The figures completely fill the height of the frame and the compositions often give a compressed effect although figures do often overlap the edge of the frame counteracting this. The scale of the drawings is much larger than in most of Matthew Paris's other work and this series of illustrations represents his art in its most elaborate form. The figures are

substantial in form, some even quite bulky, with a tendency to squatness and roundness of contour. There is a great range of facial types with varied expressions, some characterised by wide-eyed surprised looks. The origins of this style seem to be in works of *c.* 1200 possibly associated with St. Albans (nos. 2, 3) which have the same compactness of figure forms. Very probably there was much work of this period at St. Albans available for Matthew to study. The metalworker, Walter of Colchester (d. 1248), who was a monk at St. Albans may have had a style of this type, and it is significant that he made a series of scenes of the life of St. Alban for a beam set around the high altar of the Abbey.

The Life of St. Alban, being the largest-scale work of Matthew, is the most important for the consideration of his style and consequently the controversial dating is particularly relevant. The controversy is between an early date in the 1230s and the view of it as a mature work of *c.* 1250 or even later. The script has been described (Vaughan) as a more finished, neater and careful hand than that used by Matthew in his late works and it has been argued that this suggests an early date. The late date has been proposed (Wormald) because the drawings seem more developed than those by Matthew in the Lives of the Offas (no. 87a) which from textual evidence can be seen as completed by *c.* 1250. Other arguments for dating have been based on comparisons with the other two contemporary lives of saints illustrated by tinted drawings (nos. 61, 123, Part 2). Neither of these is either illustrated by or in the handwriting of Matthew Paris, although possibly the Life of St. Edward (no. 123) was copying an original by him. Even in this latter case unless it is assumed that the later artist directly copied Matthew's original the copy cannot be used to provide evidence for his style or arrangement of pictures in relation to text. The dating from stylistic comparison with the *c.* 1250 Lives of the Offas suggests that the more sensitive and finished work in the Life of Alban may be an advance in style. It could however reflect merely that more care and trouble was taken over the latter manuscript, rather than suggesting a later date. Also since the Offas drawings lack tinting they tend to suffer by comparison. The Virgin and Child in the last part of the *Chronica Maiora* (no. 92) which is tinted and datable in the 1250s can be compared with some of the work in the Alban. In conclusion the stylistic evidence does argue for a date nearer 1250 than 1240. To counteract the early dating of the script it could be argued that the writing is more carefully done than in the Chronicles because of the special nature of the text as an illustrated life of the patron saint of the Abbey.

A number of highly important notes at the beginning of the manuscript (ff. 2, 2ᵛ) are fundamental evidence for Matthew Paris's involvement in the production of Illustrated Lives of Saints. These are in translation: (i) 'If you please you can keep this book until Easter', (ii) 'G, please send to the Lady Countess of Arundel, Isabel, that she is to send you the book about St. Thomas the Martyr and St. Edward which I translated (or copied) and illustrated, and which

the Lady Countess of Cornwall may keep until Whitsuntide', (iii) a set of verses descriptive of the Labours of the Months, (iv) 'In the Countess of Winchester's book let there be a pair of images on each page thus' – and a list of verses follow descriptive of SS. James the Great, John, Andrew, Thomas, Martin, Nicholas, Alban, Amphibalus, Leonard, Giles, Joachim, Anne and Bartholomew. All these notes are in Matthew Paris's handwriting and leave no doubt that he lent books to aristocratic patrons, see notes (i) and (ii). Note (ii) does not make it clear whether Matthew was the original author and illustrator of the Lives of SS. Thomas and Edward for the word *'transtuli'* could mean 'copied' rather than 'translated'. For both the extant copies of these lives (nos. 61, 123) I have argued that he perhaps was not the original author and artist. Notes (iii) and (iv) may suggest Matthew was taking an order for an illuminated book to instruct a scribe and artist and does not necessarily imply that he himself would execute the images for the Countess of Winchester's book. It is very likely that ecclesiastics were the intermediaries in providing illustrated books (in this case a Psalter is probably intended) for aristocratic patrons and would give instructions to lay artists and scribes concerning matters of iconography and text. A Psalter probably produced at St. Albans (no. 86) has pictures of saints and gives an indication of the sort of book intended for the Countess of Winchester. The interpretation of these notes is crucial in assessing the role of Matthew Paris in mid 13th-century book illustration. Most writers have followed M. R. James in interpreting them in a way in which they proved the monk to be a leading artist of the period with considerable influence on the style and format of illustration of Lives of the Saints. The perceptive comments and analysis of Vaughan and Henderson have modified the view of Matthew Paris's art and his role must now be viewed as secondary to that of several artists whose names have not been recorded and who also worked in the technique of tinted drawing (nos. 53, 61, and part 2, 95, 103, 107-9, 122-5, 131). Matthew is a talented amateur whose work contrasts with the professional, but not necessarily any the more interesting, work of these contemporaries. The misunderstanding of his position is a typical case of art historians overvaluing the few artists whose names have come down to us and attributing too many works and too much influence to them. The role of anonymous figures, as in this case, is often more important.

These reservations should not be interpreted to mean that Matthew Paris was not involved at all in the writing and illustrating of Saints' Lives in Anglo-Norman. His authorship of the Alban seems almost beyond dispute and the authorship of the Lives of SS. Thomas and Edward remains a possibility but is far less certain (see further discussion under nos. 61, 123). A Life of St. Edmund of Abingdon (Welbeck Abbey, Coll. Duke of Portland, MS I.C.I. – on deposit in the British Library MS Loan 29/61) is dedicated to Isabel de Warenne, Countess of Arundel. Its author is named as 'Maheu' and convincing arguments have been put forward

(Lawrence) that it is a translation by Matthew Paris from a version in Latin. The extant manuscript is a 14th-century copy of the original. Thomas of Walsingham at a later period recorded that Matthew wrote and illustrated a Life of St. Edmund. Isabel, Countess of Arundel, might have come into contact with St. Albans through an intermediary at Wymondham Priory of which she was patroness and which was a dependency of St. Albans.

In monumental painting and metalwork there is evidence of collaboration between monks and lay artists at St. Albans (see R. E. Swartout, *The Monastic Craftsman*, Cambridge, 1932, 42–6) and there may have been a similar situation in the production of illustrated books and texts in Anglo-Norman. The lengthy discussion given to this problem has attempted to present the evidence for the Lives of the Saints which are, however, only one aspect of the controversial 'School of St. Albans'.

PROVENANCE: The Benedictine Abbey of St. Albans is indicated by a note on f. 3: '*Hic est liber ecclesie sancti albani anglorum prothomartiris de armariolo A*'. James Ussher (1581–1656), Archbishop of Armagh (1625–56). His library was brought to Dublin by the officers of Cromwell's army and purchased by the state. It was first kept in Dublin Castle and later in 1661 presented by Charles II to Trinity College.

LITERATURE: Hardy, *Descriptive Catalogue*, I, 8, 14–18; R. Atkinson, *Vie de Seint Auban*, London, 1876; H. Suchier, *Über die Matthäus Paris zugeschriebene 'Vie de Seint Auban'*, Halle, 1876; E. Uhlemann, 'Über die anglo-normannische Vie de Seint Auban', *Romanische Studien*, IV, 1880, 543–626; James, *Estoire de St. Aedward*, 18–22, 27–8, 35–6, 63–70, 75, with 11 plates; W. R. L. Lowe, E. F. Jacob, M. R. James, *Illustrations to the Life of St. Alban in Trin. Coll. Dublin MS. E.1.40*, Oxford, 1924 (facsimile); James, 'Matthew Paris', 2; Millar, I, 58, 99, pl. 89a; Saunders, English Illumination, I, 78; C. C. Oman, 'The Goldsmiths at St. Albans Abbey during the 12th and 13th centuries', *Transactions of the St. Albans and Hertfordshire Architectural and Archaeological Society*, 1932, 219, pl. 1; F. Wormald, 'More Matthew Paris Drawings', *Walpole Society*, 31, 1942–3, 112; M. D. Legge, *Anglo-Norman in the Cloisters*, Edinburgh, 1950, 21 ff.; Vaughan, 'Handwriting', 376, 388, 390, pl. XVIa; J. Plummer, *The Lothian Morgan Bible*, Ph.D. Dissertation, Columbia University, 1953, 50; Freyhan, 'Joachism', 232, 238, pl. 52a; Vaughan, 'Matthew Paris', 168 ff., 221, 227–8, pl. VIII; C. H. Lawrence, *St. Edmund of Abingdon*, Oxford, 1960, 70–1; M. D. Legge, *Anglo-Norman Literature and its background*, Oxford, 1963, 268–9; Ker, *Medieval Libraries*, 166; N. Denholm-Young, *Handwriting in England and Wales*, Cardiff, 1964, 52–3; Turner, 'Evesham Psalter', 35; Rickert, *Painting in Britain*, 108 ff., pl. 111A; Henderson, 'Studies', I, 73 ff., pls. 1a, b, 2a, 4a; H. S. London, T. D. Tremlett, *Rolls of Arms, Henry III, Aspilogia*, II, London, 1967, 85–6; Brieger, *English Art*, 151–2, pl. 48;

A. R. Harden, *La Vie de Seint Auban, Anglo-Norman Text Society*, 19, 1968 (edition of the text); M. W. Evans, *Medieval Drawings*, London, 1969, pl. 54; H. Farmer, 'Alban von England', *Lexikon der christlichen Ikonographie*, V, 1973, col. 67; A. Gransden, *Historical Writing in England c. 550 to c. 1307*, London, 1974, 358; S. Patterson, 'An attempt to identify Matthew Paris as a flourisher', *The Library*, XXXII, 1977, 367–70; R. Marks, N. Morgan, *The Golden Age of English Manuscript Painting 1200–1500*, New York, 1981, pls. 6, 7.

EXHIBITED: London, 1930, no. 123, pl. 27.

86. London, British Library MS Royal 2.B.VI
Psalter
280 × 195 mm., ff. 163
After 1246. St. Albans *Ills. 286–291*

A series of nine full-page framed illustrations precedes the Psalter text. These are drawings tinted in green, pale yellow, red and blue, and all excepting the last are in two registers: Annunciation, Nativity (f. 8); Annunciation to the Shepherds, Adoration (f. 8�v); Presentation, Flagellation (f. 9); Crucifixion, Holy Women at the Tomb (f. 9�v); Ascension, Martyrdom of St. Edmund (f. 10); Martyrdoms of Saints Alban and Amphibalus (f. 10�v); seated figures of St. John Baptist, St. John Evangelist and two Bishop saints (f. 11); seated figures of St. Edward the Confessor, another royal male saint perhaps Edward the Martyr, St. Catherine, a female saint holding a sword and scourge (f. 11�v); the seated Virgin and Child (f. 12�v). All are set against the plain vellum ground excepting f. 12�v where the figures are under an arch against a blue ground. There are ten ornamental initials at the psalm divisions formed of plain gold scrolls against blue and pink grounds: Psalm 1, B (f. 13�v); Psalm 26, D (f. 33); Psalm 38, D (f. 45�v); Psalm 51, Q (f. 56�v); Psalm 52, D (f. 57�v); Psalm 68, S (f. 69); Psalm 80, E (f. 83�v); Psalm 97, C (f. 97); Psalm 101, D (f. 98�v); Psalm 109, D (f. 111�v). There are very simple ornamental line endings in blue and red ink.

The importance of this manuscript is that it is the only mid 13th-century illustrated liturgical manuscript indisputably intended for St. Albans use. Both the Calendar (Wormald) and Litany (compare London, British Library MS Royal 2.A.X of which it is an updated version) are of St. Albans use and some of the Benedictine psalm divisions have slightly larger initials (e.g. on ff. 25�v, 43�v). The Psalter was certainly in the possession of a monk of St. Albans (see Provenance) and its use by a Benedictine is indicated by the notes that the *Gloria Patri* should be sung at the Benedictine psalm divisions (e.g. on ff. 68, 80, 108�v).

The illustrations are not by Matthew Paris and are rather weakly drawn in both the faces and drapery lines. The full-page picture of the Virgin and Child (f. 12�v) is better work. The style comes closest to some of the sketchier marginal drawings in the

Chronica Maiora and it seems likely that the artist worked in close collaboration with Matthew Paris. Whether he was a monk or layman it is impossible to say. There is some possibility that in this Psalter we have the early work of the artist who later illustrated two Apocalypses with tinted drawings (nos. 124, 125, part 2). The ornamental initials at the main psalm divisions are very plain and are difficult to parallel. In these simple initials and in the use of tinted drawing for the prefatory pictures this Psalter stands apart from other Psalters of the mid century. This isolation from the work of lay Psalter production and the closeness of the drawing style to Matthew Paris suggest it is an indigenous product of the Abbey of St. Albans. The inclusion of the rare scene of the Martyrdom of St. Amphibalus whose relics were at St. Albans supports this. Also the iconographic type and setting of the Virgin and Child drawing is close to the wall painting of the same subject on the fifth pier from the west on the north side of the nave at St. Albans.

The gift of the Psalter to the Abbey by the monk John of Dalling is recorded on f. 1 with the information that this was with permission of Abbot John of Hertford (1235-60) and that John of Dalling could have the use of it during his lifetime. A note in the same hand has a prayer that the soul of John of Dalling should rest in peace. The personal ownership of the books by monks and the recorded gift to the monastery is quite commonly found.

As St. Edmund of Abingdon (canonised 1246) is in both the Calendar and Litany in the original hand the book must postdate 1246. Abbot John died in 1260 and if the note of f. 1 was written during John of Dalling's lifetime as seems likely then the book can be dated 1246-60.

PROVENANCE: John of Dalling, monk of the Benedictine Abbey of St. Albans as recorded on f. 1. On his death it passed to the Abbey and was kept in a cupboard in the choir as is recorded in a later note on f. 1. On the front flyleaf 'Robarthus Gyles' (16th century). John Theyer's (1597-1673) ownership is recorded on f. 163ᵛ, and c. 1678 it was purchased for the Royal collection after the Theyer sale in which it was no. 10. It passed with the other Royal manuscripts to the British Museum in 1757.

LITERATURE: F. Madden, *Matthaei Parisiensis, Historia Anglorum*, III, *Rolls Series*, London, 1869, xlviii n. 4; Hardy, *Descriptive Catalogue*, III, lxii-iii, lxviii; W. de Gray Birch, *Early Drawings and Illuminations in the British Museum*, London, 1879, xviii, pl. X; A. Goldschmidt, *Der Albanipsalter in Hildesheim*, Berlin, 1895, 29, 45; W. H. St. John Hope, *English Altars, Alcuin Club Collections*, I, 1899, pl. IV, fig. 1; James, *Estoire de St. Aedward*, 34; Warner and Gilson, I, 41-2, pl. 23; Millar, I, 124; Saunders, *English Illumination*, I, 79; Wormald, *Kalendars*, I, 31; Vaughan, *Matthew Paris*, 205, 224 ff., pl. IX; Ker, *Medieval Libraries*, 167; Brieger, *English Art*, 173, 220; Deuchler, *Ingeborgpsalter*, 8 n. 22; Pfaff, *New Liturgical Feasts*, 23 n. 1; S. Patterson, 'An attempt to identify Matthew Paris as

a flourisher', *The Library*, XXXII, 1977, 368-70; R. W. Hunt, 'The Library of the Abbey of St. Albans', in *Medieval Scribes, Manuscripts and Libraries. Essays presented to N. R. Ker* ed. M. B. Parkes, A. G. Watson, London, 1978, 259 n. 40; Watson, *Dated Manuscripts*, no. 861, pl. 142.

87. London, British Library MS Cotton Nero D.I

(a) Matthew Paris, Lives of the Offas, Gesta Abbatum Sancti Albani, Liber Additamentorum
350 × 235 mm., ff. 202
c. 1250-59. St. Albans *Ills. 292-294*
(b) An added drawing of the vision of Christ among the candlesticks (f. 156) *Ill. 297*

(a) There are three separate texts contained in the volume and all are illustrated by drawings. The first section (ff. 2-25) is the lives of King Offa of the Angles (5th century) and King Offa of Mercia (8th century). These two kings were of particular interest to St. Albans because the first Offa had promised to found a monastery but this promise was only fulfilled by his namesake three centuries later, who after discovering the relics of St. Alban founded a Benedictine establishment at St. Albans. The second text (ff. 30-73) is Matthew Paris's part of the Abbey's chronicle, the *Gesta Abbatum Sancti Albani*, a chronicle concerned with internal affairs of the monastery. The third section (ff. 74-202), the *Liber Additamentorum* is a miscellaneous collection of documentary material compiled by Matthew Paris for use in his chronicles, and supplemented with additional material in the 14th century. The title *Liber Additamentorum* has been used by some to describe the whole volume and not only this last section.

The Lives of the Offas was only partly illustrated at the time when its text was written and the drawings from f. 5ᵛ were continued in the early 14th century. The seven 13th-century illustrations are framed and set at the head of a two-columned text: King Warmund and his blind and dumb son Offa with the nobleman Riganus attempting to persuade the King to abdicate (f. 2); Offa praying, Offa restored to sight and speech stands before Warmund (f. 2ᵛ); the knighting and arming of Offa (f. 3); Offa and his men in battle (f. 3ᵛ); another battle scene showing Offa killing the son of Riganus (f. 4); the burial and lament over the slaughtered rebels (f. 4ᵛ); Offa returns to Warmund, Offa receiving homage (f. 5). From f. 3ᵛ the drawings are not fully completed with some figures lacking internal drawing of the folds.

The *Gesta Abbatum* has seventeen small busts or seated figures of the various Abbots set in frames against coloured grounds (ff. 30, 30ᵛ, 31, 31ᵛ, 32, 32ᵛ, 33, 33ᵛ, 34ᵛ, 36ᵛ, 37, 40ᵛ, 48ᵛ, 50, 53, 57, 64).

The *Liber Additamentorum* has a few drawings set in the text or the margins: the Bulla of the Master of the Hospitallers (f. 122); the gems, rings and cameos

in the treasury of St. Albans (ff. 146, 146ᵛ); the Martyrdom of St. Alban (f. 149); an added leaf discussed in section **(b)** of the apocalyptic vision of Christ standing among the candlesticks (f. 156); a copy of the seated man on f. 111ᵛ of the late 12th century Glossed Gospels (no. 3) is on f. 156ᵛ; the Elephant sent by St. Louis to Henry III with an added detail of its trunk (f. 169ᵛ); rows of painted shields (ff. 171, 171ᵛ); the itinerary from London to Apulia (ff. 183ᵛ, 184); a bird, perhaps a pheasant (f. 185); a rough sketch map of the four main Roman roads of England (f. 187ᵛ).

The writing and compilation of the various parts of the manuscript took place over a number of years (detailed analysis in Vaughan, *Matthew Paris*). Most of the first two sections were perhaps written before 1250 or around that date. Matthew Paris refers to the pre-1235 part of his *Gesta Abbatum* (i.e. ff. 30–63) in his *Historia Anglorum* (no. 92) which was begun in 1250. The Lives of the Offas seems also to have been written by 1250 because at the end of its text (f. 24ᵛ) is the statement 'the deeds of all the abbots from Offa until 1250 are described in this book'. The documents comprising the *Liber Additamentorum* date variously from 1244–59. It seems that at some time between 1251 and 1253 Matthew Paris conceived the idea of making a book out of these miscellaneous documents. This evidence for the dating of the texts gives a date for the drawings. All except for the f. 64 drawing in the *Gesta Abbatum* and a few drawings in the *Liber Additamentorum* are of the *c.* 1250 period. The Elephant in particular must be after 1255 for it was in that year that the creature arrived in England as a gift from St. Louis to Henry III.

In the past a controversy raged as to the amount of the work in Matthew's own handwriting (Madden, Hardy, Luard). This problem has now been resolved by Vaughan's detailed study which has revealed that all apart from some twenty pages in the *Liber Additamentorum* section are in the chronicler's own hand.

Some controversy has also existed about Matthew's contribution to the drawings and some have doubted in particular whether the Offa scenes are by his hand. These Offa drawings lack tinting and so suffer by comparison with his other works. The rounded contours, fold patterns and facial types of ff. 2–4ᵛ, do however resemble the drawings in the Life of St. Alban (no. 85) and the Bernardus Silvestris text (no. 89) and the treatment of narrative is also characteristic of Matthew's personal style. A tendency to include more fold lines and fussier edges to the draperies suggest his drawing was by *c.* 1250 influenced by that of contemporary professional artists (e.g. nos. 95, 103, Part 2) to a greater extent than in the Life of Alban. The drawing on f. 5 is not by Matthew but seems to be contemporary with his work. The arrangement of these Offa illustrations as rectangular framed miniatures set above the text is the same as in the Life of St. Alban (no. 85) and the intention was obviously to make a similarly extensive series of pictures, but for some reason Matthew had to abandon the work. The trailing scrolls bearing

texts (e.g. f. 2) do not occur in the Life of St. Alban and are a feature perhaps derived from contemporary Apocalypse illustration (e.g. nos. 103, 122, Part 2). They had been used in a small way in the Life of St. Thomas of Canterbury (no. 61).

The other illustrations in the volume, except the full-page picture of the Elephant, are of the small-scale type found in the margins of Matthew's chronicles (nos. 88, 92). They are all by Matthew himself except for some of the Abbots in the *Gesta Abbatum* (e.g. f. 53) which are by a less able hand.

Other interests of the chronicler are evident in the pages devoted to shields of arms (seen also in the margins of nos. 88, 92) and to the itinerary from London to Apulia (also in nos. 88, 92). The shields seem to have been copied from a roll of arms since they are arranged in a definite order. A date 1244–5 has been argued for them (Tremlett) which gives them the distinction of being the earliest extant English roll of arms.

(b) *The added drawing of the vision of Christ among the Candlesticks* (f. 156).

As this is an inserted leaf with rather special features it is best considered apart from the rest of the manuscript. It shows the vision (Revelation, I, v. 13–16) of Christ standing with a two-edged sword in his mouth amidst seven candlesticks. This is as a drawing with slight shading in pale brown wash. The page has been cut down as part of the halo and one of the candlesticks have been cut off. The drawing has the inscription 'This is the work of Brother William of the Order of Minors, companion of St. Francis, second in that Order, holy in conversation, English by birth'. On the reverse of the leaf is written 'let nothing more be written on this page lest the picture be damaged and the parchment being transparent it can be seen better if held up to the light'.

The Brother William referred to may be the Franciscan William of England who was still living in Italy in 1239 (Little, 1943) rather than a Brother William said to have died in 1232 and to have been buried in the church of St. Francis at Assisi.

It is very possible that this drawing is a copy rather than the original by Brother William. Some of the ink line lacks firmness and suggests careful copying although perhaps this feature should be seen as an attempt by another hand to work up Brother William's drawing. The style is quite different from any drawing by Matthew Paris or any of his contemporaries. The closest parallels for the style are found in the early 13th century French Psalter of Queen Ingeborg (Chantilly, Musée Condé MS 1695). This style persisted in France into the 1220s and 1230s (e.g. the God Creator of the *Bible Moralisée*, Vienna, Österr. Nationalbibl. 2554) and perhaps Brother William's art derived from such sources. The monumentality of the figure suggests the influence of a style more suitable for wall painting. The iconography shows an interest in illustration of the Apocalypse of which the earliest extant examples in English manuscripts date from the 1240s (e.g. nos. 97, 103). It has been suggested (Klingender) that a Franciscan interest in this text may have led

to its popularity in the mid 13th century in English illumination.

Matthew Paris seems to have been particularly interested in Brother William because he made a drawing of him in the *Chronica Maiora* for the year 1224 (no. 88, MS 16, f. 71).

PROVENANCE: On f. 2 is a donor inscription in the handwriting of Matthew Paris: '*Hunc librum dedit Frater Matthaeus Deo et ecclesiae Sancti Albani. Quem qui abstulerit vel titulum deleverit anathema (sit). Anima eiusdem Matthaei et animae omnium defunctorum requiescant in pace.*'. Sir Robert Cotton (1571–1631); his signature is on f. 162. Presented to the Nation by Sir John Cotton in 1700 as part of his Library. The collection was incorporated in the British Museum in 1753.

LITERATURE: **(a)** W. Wats, *Vitae duorum Offarum*, London, 1639; F. Madden, 'On the knowledge possessed by Europeans of the Elephant in the 13th century', *The Graphic and Historical Illustrator*, ed. E. W. Brayley, London, 1834, 335, 352; F. Madden, *Matthaei Parisiensis, Historia Anglorum*, III, *Rolls Series*, London, 1869, xlviii–ix; Hardy, *Descriptive Catalogue*, I, 27, 498–9, III, xlviii, l, liv–v, lx, lxi, lxxii, cxxviii–cxxx, 141–3, 155–6, pls. I–V; O. Göschen (Pusikan), 'Wappen aus den Werken des Matthias von Paris', *Vierteljahrsschrift für Heraldik, Sphragistik und Genealogie*, IX, 1881, 107–51, 2 col. pls.; H. Luard, *Matthew Paris, Chronica Maiora*, VI, *Rolls Series*, London, 1882, vii–xii, 1–523; E. Maunde Thompson, *English Illuminated Manuscripts*, London, 1895, 41–2, pl. 13; K. Miller, *Mappae Mundi. Die ältesten Weltkarten*, Stuttgart, 1895–8, III, 70, 83–4, 85–90, figs. 25, 28; C. R. Beazley, *The Dawn of Modern Geography*, London, 1901, II, 638–40; O. Barron, 'Pictures of English Dress in the Thirteenth Century', *The Ancestor*, V, 1903, 99–115; Lindblom, *Peinture Gothique*, 130, fig. 34; W. R. Lethaby, 'English Primitives, V', *Burlington Magazine*, 31, 1917, 46–7; James, *Estoire de St. Aedward*, 27, 30–1; C. Jenkins, *The Monastic Chronicler and the Early School of St. Albans*, London, 1922, 67–77; Millar, I, 57–8, 98–9, pl. 88a, b; Saunders, *English Illumination*, I, 77–8, II, pls. 81, 82; James, 'Matthew Paris', 2, 21 ff., pls. XXI–XXVI; C. C. Oman, 'The Jewels of St. Albans Abbey', *Burlington Magazine*, 57, 1930, 81–2 with pls.; C. C. Oman, 'The Goldsmiths at St. Albans Abbey during the 12th and 13th centuries', *Transactions of the St. Albans and Hertfordshire Architectural and Archaeological Society*, 1932, 224, pls. 2, 3; F. M. Powicke, 'Notes on the compilation of the Chronica Majora of Matthew Paris', *Modern Philology*, XXXVIII, 1941, 310–14; 'The compilation of the Chronica Majora of Matthew Paris', *Proceedings of the British Academy*, XXX, 1944, 152–7; A. R. Wagner, *A Catalogue of English Medieval Rolls of Arms, Aspilogia*, I, London, 1950, 1–2, pl. I; Vaughan, 'Handwriting', 376, passim, pls. XV(a), XVII(d); J. Plummer, *The Lothian Morgan Bible*, Ph.D. Dissertation, Columbia University, 1953, 13, 51, pl. 22; G. B. Parks, *The English*

Traveler to Italy, Rome, 1954, 180–4, fig. 7; Vaughan, *Matthew Paris*, 42 ff., 48, 85, 89–90, 230–2, 250–3; Turner, 'Evesham Psalter', 35; Ker, *Medieval Libraries*, 166; Turner, *Early Gothic*, 17, pl. 6; Rickert, *Painting in Britain*, 110, 237 n. 81; Henderson, 'Studies', II, 115; Brieger, *English Art*, 142 ff., 152, pl. 49a; H. S. London, T. D. Tremlett, *Rolls of Arms, Henry III, Aspilogia*, II, London, 1967, 3–9, 36–57, 79, pl. II; M. W. Evans, *Medieval Drawings*, London, 1969, pl. 53; J. C. Higgitt, 'The Roman background to Medieval England,' *Journal of the British Archaeological Association*, 36, 1973, 12, pl. III. 1, 2; W. Cahn, 'St. Albans and the Channel Style in England', *The Year 1200: a Symposium*, New York, *Metropolitan Museum of Art*, 1975, 188, fig. 3; S. Patterson, 'An attempt to identify Matthew Paris as a flourisher', *The Library*, XXXII, 1977, 367–70; R. W. Hunt, 'The Library of the Abbey of St. Albans', in *Medieval Scribes, Manuscripts and Libraries. Essays presented to N. R. Ker*, ed. M. B. Parkes, A. G. Watson, London, 1978, 265 n. 76, 266 n. 79; Watson, *Dated Manuscripts*, no. 542, pls. 143–4.

EXHIBITED: London, British Museum, *British Heraldry*, 1978, no. 6, with col. pl.

LITERATURE: **(b)** J. Gage Rokewode, *An Account of the Painted Chamber in the Royal Palace at Westminster*, London, 1842, 26; A. G. Little, 'Brother William of England, companion of St. Francis and some Franciscan drawings in the Matthew Paris Manuscripts, *Collectanea Franciscana*, I, 1914, 1–8; W. R. Lethaby, 'English Primitives', V, *Burlington Magazine*, 31, 1917, 51–2, pl. B; Millar, I, 58; British Museum, *Reproductions*, IV, pl. XVIII; T. Borenius, E. W. Tristram, *English Medieval Painting*, Florence, 1927 (repr. New York, 1976), 13, pl. 27; Saunders, *English Illumination*, I, 75; Little, *Franciscan History and Legend*, 37–9, pl. 1; A. G. Little, 'Brother William of England, companion of St. Francis and some Franciscan drawings in the Matthew Paris manuscripts', *Franciscan Papers, Lists and Documents*, Manchester, 1943, 19–24, pl. IV; Tristram, *Wall Painting*, 321–3, suppl. pl. 51; F. D. Klingender, 'St. Francis and the birds of the Apocalypse', *J.W.C.I*, XVI, 1953, 16, pl. 1c; Vaughan, *Matthew Paris*, 223; Turner, *Early Gothic*, 18, pl. 8; Brieger, *English Art*, 161, pl. 155a; M. W. Evans, *Medieval Drawings*, London, 1969, pl. 55; J. Alexander, 'The Middle Ages', in ed. D. Piper, *The Genius of British Painting*, London, 1975, 35 with fig.

EXHIBITED: London, Royal Academy of Arts, *Exhibition of British Primitive Paintings*, 1923, no. 105.

88. Cambridge, Corpus Christi College MSS 26, 16

Matthew Paris, Chronica Maiora pts. I, II
I, MS 26, 362 × 244 mm., ff. vi +141 +iii
II, MS 16, 362 × 248 mm., ff. v +281
c. 1240–53 and later. St. Albans

Ills. 295, 296, 302, 307

I, MS 26. This is the first volume of the chronicle of Matthew Paris called the *Chronica Maiora* and covers the period from the Creation to 1188. The second volume is MS 16 and the third part is contained in no. 92. The text of this first section is illustrated with marginal drawings tinted in green, brown, pale yellow and blue with touches of red. The foliation has been changed since the early descriptions of the manuscript (Luard, James).

Before the chronicle begins there are six leaves of prefatory illustrated material: an itinerary from London to Apulia illustrated with schematic depictions of cities and ending with a map of Southern Italy (ff. i–iii); a map of the Holy Land (ff. iii verso–iv); a genealogy of the Kings of England with a bust of Alfred (f. iv verso); a Paschal Table with foliate ornament (f. v); a Calendar of St. Albans set in a system of columns (f. vi and verso).

The 25 marginal drawings in the chronicle are: Brutus sacrificing to Diana (f. 4); Lear and his three daughters (f. 6); Alexander the Great (f. 12ᵛ); Cassibelaunus (f. 14ᵛ); the Nativity of Christ (f. 15ᵛ); Journey of the Magi (f. 16ᵛ); the Crucifixion (f. 18); Stoning of Stephen (f. 18ᵛ); the Virgin (f. 20); a bust of Merlin (f. 33ᵛ); Mohammed, who was devoured by swine, with a pig (f. 44); Offa as king and as monk (f. 53); Martyrdom of St. Alban (f. 58ᵛ); Offa directing the search for Alban's remains (f. 59); a bust of Alfred (f. 65); a fight on horseback between Edmund Ironside and Canute (f. 80ᵛ); a rough sketch, probably a later addition, of the fight between the dwarf Mimekan and the giant Rodogan (f. 83); two Templars on a horse, the hospital in London founded by Queen Matilda (f. 110ᵛ); the wreck of the White Ship (f. 111ᵛ); a bust of King David of Scotland (f. 117ᵛ); the baptism of the Sultan of Iconium by the Patriarch of Antioch (f. 127ᵛ); Martyrdom of St. Thomas of Canterbury (f. 132); the destruction of the walls of Leicester after the revolt of 1173 (f. 133); busts of King William of Scotland and a hooded Scotsman (f. 134); the search for the relics of St. Amphibalus (f. 135ᵛ); the capture of the relic of the True Cross by Saladin (f. 140). The births, accessions and deaths of leading figures are indicated by shields, crowns, mitres and croziers which are inverted to indicate death.

At the end of the chronicle text is a leaf with large drawings tinted in a particularly painterly way to enhance modelling: a head of the Virgin with the Child, a head of Christ from a Crucifixion or Man of Sorrows, the Veronica head of Christ (f. vii). On the verso of this leaf is a rectangular framed Map of the World.

II, MS 16. The chronicle covering the period 1189–1253 is continued in this volume. As for MS 26 the foliation has been changed since the early catalogue descriptions although this has been done imperfectly and there are two leaves numbered f. 150.

There are some prefatory leaves with illustrations: a fragmentary itinerary from London to Apulia with schematic drawings of cities (f. ii); fragmentary map of the Holy Land (f. ii verso); a genealogy of the English kings with a drawing of Alfred speaking to a group (f. iii); William I (f. iii verso); the Elephant sent by St. Louis to Henry III shown with its keeper (f. iv); fragmentary map of the Holy Land (f. v); fragmentary map of the British Isles (f. v verso).

The 75 marginal drawings in the chronicle are: the death of Saladin (f. 13ᵛ); a pillory (f. 25ᵛ); a Franciscan friar (f. 30); the Interdict symbolised by a tied bell (f. 31ᵛ); Battle of Bouvines (f. 41); Shipwreck of Hugh de Boves (f. 46ᵛ); Bishops at the Lateran Council of 1215 (f. 47ᵛ); oppression of the people under King John (f. 48ᵛ); the landing of Louis of France in England (f. 50ᵛ); the Veronica head of Christ pasted in on a separate piece of vellum (f. 53ᵛ); the dream of the stone falling on Falco de Breauté who had robbed St. Albans (f. 54); the siege of Lincoln (f. 55ᵛ); the sea battle on St. Bartholomew's day 1217 (f. 56); the kings of England and France embracing (f. 56ᵛ); the death of Saphadin (f. 57ᵛ); Battle of Damietta (f. 58ᵛ); Siege of Damietta (f. 59ᵛ); the second crowning of Henry III (f. 60); a lion killed by Hugo de Neville in the Holy Land (f. 61ᵛ); men wrestling at the riot on St. James's day 1222 (f. 62); the relic of the True Cross at Bromholm (f. 63); the hanging of men at Bedford Castle (f. 64); the devil and the chaste maid of Burgundy (f. 65ᵛ); symbolic picture for the death of Falco de Breauté from a poisoned fish (f. 68ᵛ); St Francis preaching to the birds and receiving the stigmata (f. 70ᵛ); Brother William the Franciscan (f. 71); Christ bearing the cross speaks to the Wandering Jew (f. 74ᵛ); symbolic picture of a town and gown riot in Paris (f. 75); the gold bulla of the Emperor Frederick II (f. 76ᵛ); Henry III's journey to Brittany in 1230 (f. 79ᵛ); a man threshing as a symbol of the plunder of the barns at Wingham in 1232 (f. 82); the knight who spared his father's murderer on Good Friday (f. 82ᵛ); a horseback fight between William Mareschall and Baldwin of Guines (f. 88); the house built in London for converted Jews (f. 89); William Mareschall on horseback (f. 91ᵛ); the priest carrying a crucifix who was helped by Earl Hubert of Kent (f. 93ᵛ); death of William of Trumpington, Abbot of St. Albans (f. 95ᵛ); purses symbolising the extortion of the usurers of Cahors (f. 98); Henry III's wedding with Eleanor of Provence (f. 99); the ecclesiastical Council of London (f. 109); Germanus of Constantinople angry at the discord between the Greek and Latin churches (f. 112); seals of the Emperor Frederick II (f. 127); death of Llewellyn, Prince of Wales (f. 133); defeat of the French at Gaza (ff. 134ᵛ, 135); Earl Richard of Cornwall sailing to Jerusalem (f. 137); the treaty between the Count of Brittany and Nazir (f. 139ᵛ); the Crown of Thorns brought to Paris in 1240 (f. 140ᵛ); four whales fighting (f. 141); St. Louis displaying the relics of the True Cross and the Crown of Thorns (f. 142ᵛ); the ravages of the Tartars (f. 145); a sea fight between the Pisans and the Genoese (f. 147); Gilbert Mareschall falling from his horse (f. 148ᵛ); the prisoners of the Saracens are released (f. 149); female Saracen jugglers at the Court of Frederick II (f. 150).

At this point the new foliation ceases and f. 150 (old foliation) is repeated on the next leaf. The

illustrations following are: the Shrine of St. Edward the Confessor (f. 150); an elephant with musicians on its back at the reception of Richard of Cornwall in Cremona (f. 151ᵛ); Earl Richard returning to England by boat (f. 153ᵛ); Henry III sailing to Royan in 1242 (f. 155); William de Marisco dragged behind a horse (f. 155ᵛ); the French troops in Poitou die of the plague (f. 159ᵛ); a boat symbolising the 1242 flooding of the Thames (f. 160ᵛ); Henry III embarking from a boat on his return from France in 1243 (f. 163ᵛ); the cannibal habits and tortures of the Tartars (f. 166); Griffin, son of Prince Llewellyn, attempting to escape from the Tower of London (f. 169); the battle between the Christians and the Kharismians and the loss of Jerusalem (f. 170ᵛ); the escape to Genoa of Pope Innocent IV in disguise (f. 177); Engelram of Coucy crossing a river on horseback (f. 177ᵛ); St. Louis is revived from sickness by being touched with the True Cross (f. 182); the death of Herbert Fitzmatthew (f. 183ᵛ); a stag's head symbolising the inquisition of the royal forests by Robert Passelewe, the church of Westminster which in that year, 1245, was being rebuilt (f. 186); the Council of Lyons (f. 186ᵛ); the fort of Gannoc (f. 194ᵛ); the procession of the relics of the Holy Blood in 1247 from St. Paul's to Westminster (f. 215); a crossbill symbolising the destruction of fruit in 1251 by an invasion of crossbills (f. 252). Five large ornamental foliage initials with colour wash occur on ff. 132ᵛ, 153, 161, 167ᵛ, 208ᵛ. As in the first volume shields, crowns, mitres and crosiers are used to indicate births and deaths. The shields for both volumes are catalogued by London and Tremlett (*Aspilogia, II*) but with the old foliation.

Although the composition of the chronicle is by Matthew Paris not all is written in his own handwriting. MS 26 is mainly written by another scribe excepting the preliminary six leaves, the three leaves at the end and many additions to the text, all being in the hand of Matthew. The second volume is almost entirely in the chronicler's own handwriting. The marginal illustrations in both volumes are all by Matthew Paris excepting perhaps those on ff. 14ᵛ, 15ᵛ, 18 of MS 26, and even these seem to be quite possibly by his hand. The differences in style in these drawings can certainly be explained by the time period over which the text was written, and also because some are intentionally more sketchy than others. In most cases the drawings seem to have been done when the text pages were written out which was over a considerable period of time. This is suggested by some of the rubrics and titles being written over the drawings (e.g. f. 133), and the penetration of some of the drawings into the text columns where the scribe has deliberately left a space for their insertion (e.g. ff. 127, 134ᵛ).

The dating of the text is based mainly on the evidence for the second volume. This was in progress by *c.* 1245 and the annals up to 1250 were completed early in 1251 (Vaughan). The 1251–3 section was probably completed in 1253. The evidence for the date of the first volume is less sure but *c.* 1240–5 is the most likely period. From this evidence it can be deduced that all the marginal illustrations excepting

the single one in the 1251–3 section can be dated in the period *c.* 1240–51. Most of the prefatory sections lack any textual evidence for dating. The Elephant in MS 16 must however have been done after the animal's arrival in England in 1255, and the Itinerary can be dated *c.* 1253 (Parks).

The importance of these chronicle volumes for the study of Matthew Paris's art is that they present the range of his personal drawing style over a relatively well dated period. The first conclusion that can be made is that his style does not greatly change over this period. Such changes as do occur are due to the greater finish and care taken over some drawings both in the way the lines are drawn and in the application of the tinting colours. These small scale, often sketchy, marginal figures are in the tradition of chronicle and didactic text illustration (e.g. nos. 59, 60 and the Henry of Huntingdon, *Historia Anglorum*, Baltimore, Walters Art Gallery MS. 793). The style shows in sketchier form the same characteristics as have been described for Matthew's large scale drawings in the Life of St. Alban and the Lives of the Offas (nos. 85, 87). In the full-page drawing of the heads (MS 26, f. vii) and in the Elephant with its keeper (MS 16, f. iv) his larger scale work is evident. The heads suggest some derivation from monumental painting such as that which still exists in the nave of St. Albans and at Windsor.

The choice and range of subjects illustrated shows a marked taste for the anecdotal and idiosyncratic (James, 'Matthew Paris', explains the stories behind some of the subjects). Although there are precedents of illustration in marginal drawings nothing before in English art prepares the way for such an inventive series of subjects. Matthew's strong personal style evident in his chronicle writing is equally expressed in his individual selection and presentation of subject matter. It is near contemporary history which is given the fullest attention. For the period up to 1235 Matthew had depended heavily on the chronicle of his predecessor at St. Albans, Roger of Wendover, but from that date on the composition is entirely his own work. Although much of the text is concerned with the history of England, a good deal of space is devoted to European affairs.

Some of the subject matter is of major iconographic importance. The scenes of the life of St. Francis are very early examples, for the Saint had only been canonised in 1228. The drawing of the legend of the Wandering Jew (see no. 73) is set beside the account of the Armenian bishop who had told this legend to the monks of St. Albans in 1228. The two pictures of the Veronica head of Christ (MS 26, f. vii; MS 16, f. 53ᵛ) are of great importance for they are, with the possible exception of the added picture in no. 24, the earliest examples of the subject in European art. The cult of the Holy Face in the West was centred around the relic of the handkerchief of St. Veronica kept in St. Peter's, Rome. The pictorial type in Matthew Paris's chronicle shows a head and shoulders representation and not as in most later examples only the face. This was evidently the version of the icon (which perhaps was a cover to the actual relic) known in mid 13th-century England which also

occurs in nos. 24, 95, 111. This type was probably based on a prototype from Rome such as the Christ bust in the triumphal arch mosaic in S. Giovanni in Laterano. In MS 16 the picture is set beside the description of the 1216 procession of the relic of the Veronica in Rome.

Matthew Paris seems to have been particularly interested in cartography. His itineraries and map of the British Isles are discussed under nos. 92, 93, but his only map of the world (copied later in London, British Library, Cotton Nero D.V) is in MS 26. In Matthew's handwriting is written on it 'This is a reduced copy of the world maps of Master Robert Melkeley and Waltham (Abbey). The King's world map which is in his chamber at Westminster is most accurately copied in Matthew Paris's Ordinal' (this Ordinal has not survived). The world map in MS 26 is rectangular in form and has some points in common in the textual inscriptions with the 13th century map once at Ebstorf (destroyed in the Second World War) by the Englishman Gervase of Tilbury.

PROVENANCE: Matthew Paris gave these volumes of his *Chronica Maiora* to his own Abbey of St. Albans. MS 16 has the inscription '*Hunc librum dedit frater Matthaeus Parisius Deo (et ecclesiae sancti Albani). Anima fratris Matthaei et animae omnium defunctorum requiescant in pace. Amen*' (f. 1). After the Reformation this volume was in the hands of Robert Talbot, prebendary of Norwich (1547–58) who has written a note on f. 245ᵛ. Matthew Parker (1504-75), Archbishop of Canterbury (1559–75) obtained it from Sir Henry Sidney (1529–86). Parker obtained MS 26 from Edward Anglionby of Balsall Temple (Warwicks.) whose signature is on f. ix. The Archbishop bequeathed his manuscripts to Corpus Christi College.

LITERATURE: R. Gough, *British Topography*, London, 1780, I, 64–6, pl. III; F. Madden, *Matthaei Parisiensis, Historia Anglorum*, I, *Rolls Series*, London, 1866, liv–lxi, III, London, 1869, xxv ff., xlviii–li; Hardy, *Descriptive Catalogue*, III, 117–9, xlv, liv–v, lx, lxxiii–iv, cxxxii–iii, pls. X–XVI; H. R. Luard, *Matthew Paris, Chronica Maiora*, 7 vols., *Rolls Series*, London, 1872–74; H. Michelant, G. Raynaud, *Itinéraires à Jérusalem, Société de l'Orient Latin, Série Géographique*, III, Paris, 1882, 123–139; K. Pearson, *Die Fronica*, Strasbourg, 1887, 12, 51–4, 96–7, pls. II, III; K. Miller, *Mappae Mundi. Die ältesten Weltkarten*, Stuttgart, 1895–8, III, 69, 71–82, 85, 91–2, figs. 20, 21, 32; C. R. Beazley, *The Dawn of Modern Geography*, London, 1901, II, 585, 638–40; J. C. Wall, *Relics of the Passion*, London, 1910, 154–8; James, *Catalogue*, nos. 26, 16; A. G. Little, 'Brother William of England, companion of St. Francis and some Franciscan Drawings in the Matthew Paris manuscripts', *Collectanea Franciscana*, I, 1914, 1 ff., figs. I–III; Lindblom, *Peinture Gothique*, 130; W. R. Lethaby, 'English Primitives, V', *Burlington Magazine*, 31, 1917, 45–6; James, *Estoire de St. Aedward*, 29, 31; C. Jenkins, *The Monastic Chronicler and the Early School of St. Albans*, London, 1922, 63, 79–90; Millar, I, 57, 122; Saunders, *English Illumination*, I, 76–7, II, pl. 79; James, 'Matthew Paris', 2, 3–17, pls. V–XVIII, XXIX; J. P. Gilson, *Four Maps of Great Britain designed by Matthew Paris*, London, 1928, 3–11, pl. B; J. B. Mitchell, 'Early Maps of Great Britain. I. The Matthew Paris Maps', *The Geographical Journal*, 81, 1933, 28–34 with pl.; Prince Youssouf Kamal, *Monumenta Cartographica Africae et Aegypti*, III. 5, Leiden, 1935, ff. 1000, 1002; Swarzenski, *Handschriften XIII Jh.*, 112 n. 11, 117, 128 n. 9; Little, *Franciscan History and Legend*, 66, pl. 8; F. Wormald, 'The Rood of Bromholm', *J.W.C.I.*, I, 1937–8, 32, pl. 6c; F. M. Powicke, 'Notes on the Compilation of the Chronica Majora of Matthew Paris', *Modern Philology*, XXXVIII, 1941, 305–17; A. G. Little, 'Brother William of England, companion of St. Francis and some Franciscan drawings in the Matthew Paris manuscripts', *Franciscan Papers, Lists and Documents*, Manchester, 1943, 16–18, figs. I–III; V. H. Galbraith, *Roger of Wendover and Matthew Paris*, Glasgow, 1944, 23–24, 26 ff.; F. M. Powicke, 'The Compilation of the Chronica Majora of Matthew Paris', *Proceedings of the British Academy*, XXX, 1944, 147–60; S. Corbin, 'Les Offices de la Sainte Face', *Bulletin des Études Portugaises*, 11, 1947, 27–9; A. R. Wagner, *Catalogue of English Medieval Rolls of Arms, Aspilogia*, I, 1950, 2, 3; Vaughan, 'Handwriting', 377, passim; F. D. Klingender 'St. Francis and the birds of the Apocalypse', *J.W.C.I.*, XVI, 1953, 13–18, pl. 1b; Saxl and Meier, III, 420; G. B. Parks, *The English Traveler to Italy*, Rome, 1954, 180–4; Vaughan, *Matthew Paris*, 1, passim, pls. II, III, VI, VII, Xb, XIII, XIV, XVI, XVIII, XXIa; O. Pächt, 'The "Avignon Diptych" and its Eastern Ancestry', *Essays in Honor of Erwin Panofsky*, New York, 1961, 405–9; Ker, *Medieval Libraries*, 165; S. Ringbom, *Icon to Narrative*, Åbo, 1965, 70; Turner, 'Evesham Psalter', 35–6; M. Destombes, *Mappemondes, A.D. 1200–1500*, Amsterdam, 1964, 246, no. 54. 1; Rickert, *Painting in Britain*, 108–9, 236, pls. 112, 114a; R. Foreville, 'L'iconographie du XIIe concile oecuménique', *Mélanges, R. Crozet*, II, Poitiers, 1966, 1121; Henderson, 'Studies', I, 71–3; H. S. London, T. D. Tremlett, *Rolls of Arms, Henry III, Aspilogia*, II, London, 1967, 57–74, pl. I; Brieger, *English Art*, 136–45, 147, pls. 44a, b, c, 45, b, c, 46, 52b; A-D. von den Brincken, 'Mappa Mundi und Chronographia', *Deutsches Archiv für Erforschung des Mittelalters*, 24, 1968, 147–8, 160, 162–7; A. Gransden, *Historical Writing in England c. 550 to c. 1307*, London, 1974, 356 ff., pl. X; S. Patterson, 'An attempt to identify Matthew Paris as a flourisher', *The Library*, XXXII, 1977, 367–70; E. Breitenbach, 'The Tree of Bigamy and the Veronica image of St. Peter's', *Museum Studies*, 9, 1978, 35, fig. 5; K. Gould, *The Psalter and Hours of Yolande of Soissons*, Cambridge, 1978, 86, 92–4, pl. 64; Yapp, 'Birds', 319, 326.

EXHIBITED: Cambridge, Corpus Christi College, *Matthew Parker's Legacy*, 1975, 13, pls. 20–2.

89. Oxford, Bodleian Library MS Ashmole 304

Bernardus Silvestris, Liber Experimentarius and other Fortune-telling tracts
176 × 128 mm., ff. 72 +ii (double numbering of ff. 33, 56)
c. 1250–55. St. Albans *Ills. 299, 300*

The texts are illustrated by marginal and framed tinted drawings: a half-page illustration of Euclid holding a sphere and telescope, Herman Contractus of Reichenau holding an astrolabe (f. 2ᵛ); marginal drawing of the Seven Towers of the Planets (f. 3ᵛ); full-page illustration of Plato standing behind the seated Socrates (f. 31ᵛ). Then follow a series of thirteen tables and circular diagrams decorated with foliage, fruit, animals, birds and symbolic representations of cities: the Sphere of Spices (f. 33a verso); the Sphere of Flowers (f. 33b); the Spheres of Fruit (ff. 33b verso, 34); Sphere of the Beasts (f. 34ᵛ); Spheres of Birds (ff. 35, 35ᵛ, 36); Spheres of Cities (ff. 36ᵛ, 37, 37ᵛ, 38, 38ᵛ). A full-page framed drawing of Pythagoras writing (f. 42) is followed by a series of birds two to a page (ff. 43ᵛ–52). The last illustration is a framed drawing occupying about one third of the page with the heads of the twelve sons of Jacob (f. 52ᵛ).

This book is a collection of work for fortune-telling and reveals an unusual side of Matthew Paris's interests. The whole manuscript is in his handwriting except for ff. 53–5ᵛ on which only the rubrics are written by him. The illustrations are all by his hand but some are lacking and can be reconstructed through later copies (no. 186, Part 2 and a 14th-century version in Oxford, Bodleian Library MS Digby 46). These fortune-telling books are generally called Books of Fate and derived from Arabic sources. The birds in the section ff. 43ᵛ–52 indicate this, for they have many Arabic names. The method of divination is by geomancy in which a series of questions is presented to which there is a series of answers arranged in systems of diagrams. The texts are the *Liber Experimentarius* of Bernardus Silvestris (12th-century) and the Prognostics of Socrates and Pythagoras (these two pagan philosophers were viewed in the Middle Ages as sages and soothsayers). The groups of answers are distinguished by the names of various so-called Judges. The inclusion of the twelve Jewish patriarchs gave a supposed biblical authority to an activity which was condemned by many churchmen of the time.

The illustrations are of the various pagan philosophers mentioned in the text and of the various diagrams used in the fortune-telling. There is no textual evidence for dating but the style of the drawing suggests comparison with the large drawings in the Lives of the Offas (no. 87) and the Chronicle of John of Wallingford (no. 91) and this connection gives a possible date *c.* 1250–55.

PROVENANCE: Thomas West in 1602 (inscription on ff. 1, 67ᵛ). On f. 1 Edward Lluyd (1660–1709) has written that the book was 'ex dono' of Vaughan, a scholar of Brasenose. It was transferred from the Ashmolean to the Bodleian Library in 1860.

LITERATURE: W. H. Black, *Catalogue of the manuscripts bequeathed unto the University of Oxford by Elias Ashmole*, Oxford, 1845, 214–5; C. H. Haskins, *Studies in the History of Medieval Science*, Cambridge, 1924, 53, 136; L. Brandin, 'Les prognostica du manuscrit MS Ashmole 304', *Studies in Romance Languages and Literatures presented to L. E. Kastner*, Cambridge, 1932, 57–67; L. Thorndike, *History of Magic*, II, London, 1923, 112, 114–8; F. Wormald, 'More Matthew Paris Drawings', *Walpole Society*, 31, 1942–3, 109 ff., pls. XXVII, XXVIII; F. Saxl, R. Wittkower, *British Art and the Mediterranean*, London, 1948, pl. 29.5; Vaughan, 'Handwriting', 390–1, pl. XVIb; Saxl and Meier, III, 287, pl. LV, fig. 141, pl. LVI, figs. 144, 145; T. C. Skeat, 'An early medieval Book of Fate, the "Sortes XII Patriarcharum",' *Medieval and Renaissance Studies*, III, 1954, 42, 48–9; Bodleian Picture Book, *English Illumination of the thirteenth and fourteenth centuries*, Oxford, 1954, 5, pl. 2a; Vaughan, *Matthew Paris*, 207, 230, 257–8, pls. XIVf, XXIb; M. B. Savorelli, 'Un Manuale di Geomanzia presentato da Bernardo Silvestre da Tours: L'Experimentarius', *Rivista critica di Storia della Filosofia*, XIV, 1959, 302, 312–42; Rickert, *Miniatura*, II, pl. 15; P. Volkelt, 'Die Philosopher Bildnisse in der Commentari ad Opera Aristotelis des Cod. Cus. 187', *Mitteilungen und Forschungen der Cusanusgesellschaft*, 3, 1963, 210; Ker, *Medieval Libraries*, 168; Rickert, *Painting in Britain*, 109; Brieger, *English Art*, 147–8, pl. 43; Pächt and Alexander, III, no. 437, pl. XXXVIII; J. D. Udovitch, 'Three Astronomers in a thirteenth century Psalter', *Marsyas*, 17, 1975, 83 n. 13; A. G. and W. O. Hassall, *Treasures from the Bodleian Library*, London, 1976, 73 ff., pl. 16; S. Patterson, 'An attempt to identify Matthew Paris as a flourisher', *The Library*, XXXII, 1977, 367–70; C. S. F. Burnett, 'What is the Experimentarius of Bernardus Silvestris?', *Archives d'Histoire doctrinale et littéraire du Moyen Age*, 1977, 101–2.

EXHIBITED: Brussels, 1973, no. 47, pl. 25; Oxford, Bodleian Library, *The Benedictines and the Book*, 1980, no. 53.

90. Eton, College Library MS 96

Peter of Poitiers, Compendium veteris testamenti and Universal Chronicle
472 × 344 mm., ff. 25
c. 1245–54. (?) St. Albans *Ill. 300*

This very large book has drawings tinted with blue, brown and green illustrating a diagrammatic presentation of history from the Creation to 1245. Most of these illustrations are in roundels and there are numerous characterised heads or small seated or standing figures of the persons mentioned. The following are the more elaborate larger scenes: God Creator blessing in a mandorla held by Angels, the Temptation of Adam and Eve, the Expulsion from Paradise (f. 2); Noah, his family and the animals in the Ark (f. 2ᵛ); Anointing of David (f. 4); Habakkuk

transported by an angel to Daniel (f. 7); Judith beheading Holofernes, a plan of Jerusalem (f. 7ᵛ); Esther and Mordecai talking to Haman (f. 8); Alexander seated (f. 8ᵛ); the part containing the scenes of the Life of Christ has been cut out; Galen inspecting a urine vessel (f. 12); St. Paul the Hermit (f. 12); St. Nicholas (f. 12ᵛ); Martyrdom of St. Thomas of Canterbury (f. 23); St. Dominic (f. 23ᵛ); St. Francis preaching to the birds with Brother John seated beside (f. 24).

The genealogy of Christ of Peter of Poitiers (the text up to f. 9ᵛ) was often expanded by the addition of a universal chronicle (e.g. no. 43b). The text of the chronicle in this manuscript extends to 1245. Since the number of years of the reign of Pope Innocent IV has not been inserted and his death was in 1254, a date c. 1245–54 is suggested for the production of the book. Certain events mentioned in the text and the iconography of some of the drawings (e.g. SS. Thomas of Canterbury, Francis) suggest derivation from Matthew Paris's *Chronica Maiora*. This has led to the suggestion that it was produced at St. Albans. Neither the script nor the illustration are by Matthew Paris although the style of the drawing is in a general way similar to his, but with an increase of fold-lines and angularity of poses resembling the Westminster drawings (no. 95, part 2). Parts of the text show a particular interest in Glastonbury Abbey which implies a source of the text, intended destination or, even possibly, production at that place.

PROVENANCE: (?) The Benedictine Abbey of Glastonbury. Elizabeth Flovern, William Hardine are names written in a 16th or 17th century hand on ff. 7ᵛ, 25. (?)The Cathedral of Worcester since it fits the description given for no. 342 in the 17th-century catalogue of Patrick Young. It is not known by what means the manuscript entered the Eton Library.

LITERATURE: James, *Catalogue*, no. 96; T. Borenius, 'Some further aspects of the iconography of Thomas Becket', *Archaeologia*, LXXXIII, 1933, 183, pl. XLIX, fig. 3; P. S. Moore, *The works of Peter of Poitiers*, Notre Dame, 1936, 99, 108, 112, 114, 115, 116; Little, *Franciscan History and Legend*, 71, pl. 11; Tristram, *Wall Painting*, 352; F. D. Klingender, 'St. Francis and the Birds of the Apocalypse', *J.W.C.I.*, XVI, 1953, 16; Vaughan, *Matthew Paris*, 225; Ker, *Medieval Libraries*, 206; Brieger, *English Art*, 143 n. 3; Ker, *Medieval Manuscripts*, II, 707–8; W. H. Monroe, 'A Roll-Manuscript of Peter of Poitiers' Compendium', *Bulletin of the Cleveland Museum of Art*, LXV, 1978, 106 n. 14, 107 n. 25; Yapp, 'Birds', 326.

91. London, British Library MS Cotton Julius D.VII

John of Wallingford, Miscellaneous writings
188 × 130 mm., ff. 134
c. 1247–58, St. Albans and Wymondham *Ill. 301*

The various historical texts contained in the volume are not illustrated but six drawings appear in the prefatory and added material. On. f. 3ᵛ is a shield diagram symbolic of the Trinity with the Crucifixion in the centre with two devils shooting arrows at it (compare the diagram of the knight in no. 80 and the allegory of the penitent on f. 53 of no. 126, part 2). A framed drawing depicts the monk, John of Wallingford, seated at a lectern reading the Psalter (f. 42ᵛ). Another framed drawing on f.60ᵛ has the figure of Christ seated crowned holding a chalice, trampling on the lion and the dragon and surrounded by twelve crowns. Less important illustrations are a crowned head in the margin of f. 92ᵛ and a drawing of an elephant on f. 114. On f. 46 is the important map of climate zones, and a map of the British Isles which was once folded and spread over ff. 50–3 has now been removed and mounted separately. The figure drawings are tinted in pale brown, green and pink.

John of Wallingford is not the compiler of the first chronicle of this collection (ff. 10–33), but almost all the text of the rest of the volume is in his handwriting and of his composition. He became a monk at Wallingford in 1231, moved to St. Albans in 1246–7 where he became infirmarer (i.e. the monk in charge of the infirmary) c. 1250. The final year of his life was spent at Wymondham, a cell of St. Albans, where he died in 1258. His chronicle (ff. 61–110) covers the period from the age of Hengist and Horsa in the fifth century up to 1258. This work is highly derivative from Matthew Paris's chronicles.

The portrait of John of Wallingford is by Matthew Paris and the inscription is in his handwriting. This inscription describes John as 'one time' infirmarer, an office which he is known still to have held in 1253. Since he left St. Albans in 1257, the drawing can be dated 1253–7. The map of the British Isles (discussed in the entry for no. 93) is also by Matthew Paris and has certain place names added by John of Wallingford who folded it into four parts so that it could be fitted into the small format of his chronicle. The Christ in Majesty drawing is almost certainly also by Matthew Paris. The iconographic type with Christ holding the chalice occurs in a wall painting on the west wall of the chancel arch at St Albans (now partly covered by a fifteenth century painting). Other examples of the type are found in two Psalters (nos. 45, 101, Part 2).

These two framed drawings being of the period 1253–7 show little development from Matthew Paris's earlier works. They are, with the drawings of Henry III's elephant (nos. 87, 88) and, if they are by his hand, the kings in the *Abbreviatio Chronicorum* (no. 93), his last works done shortly before his death in 1259.

The poorly drawn elephant on f. 114 is derived from Matthew Paris's version in the *Liber Additamentorum* and is probably by the hand of John of Wallingford. The diagrammatic map of the climate zones (f. 46) is also by his hand. It has been argued (von den Brincken) that it derives from a no longer extant example by Matthew Paris. Matthew certainly knew about climate zones as is made evident by a diagram

he made in his manuscript of William of Conches (Cambridge, Corpus Christi MS 385, p. 178).

PROVENANCE: John of Wallingford as evidenced by inscriptions of his name on ff. 1ᵛ, 112ᵛ. It passed to the Benedictine priory of Wymondham when John died there in 1258. In the 16th century the book was evidently at St. Albans when it belonged to the monk Thomas Kyngesbury who gave it to John Conyngesby. On f. 1 is the inscription 'Constat Iohanni Conyngesby ex dono magistri Kyngesbury'. John Conyngesby's name is also on f. 61. In the late 16th century it was in the possession of the Howard family: on f. 46 is written 'my good Lorde of Arundel' (i.e. St. Philip Howard, 1557–95). Sir Robert Cotton (1571–1631). Presented to the Nation by Sir John Cotton in 1700 as part of his library. The collection was incorporated in the British Museum in 1753.

LITERATURE: F. Madden, 'On the knowledge possessed by Europeans of the Elephant in the thirteenth century', *The Graphic and Historical Illustrator*, ed. E. W. Brayley, London, 1834, 335; Hardy, *Descriptive Catalogue*, I, 30, 625–6; F. Madden, *Matthaei Parisiensis, Historia Anglorum*, III, *Rolls Series*, London, 1869, xlviii n. 4; F. Liebermann, *Monumenta Germaniae Historica, Scriptorum*, XXVIII, 1888, 505–11; K. Miller, *Mappae Mundi. Die ältesten Weltkarten*, Stuttgart, 1895–8, III, 74; H. M. Bannister, 'Signs in Calendarial Tables', *Mélanges offerts a M. Émile Chatelain*, Paris, 1910, 148; Druce, 'Elephant', I; James, *Estoire de St. Aedward*, 22, 31, 32, 34; Millar, I, 124; James, 'Matthew Paris', 2, 26, pl. XXX; J. P. Gilson, *Four Maps of Great Britain designed by Matthew Paris*, London, 1928, 3–11, pl. C; J. B. Mitchell, 'Early Maps of Great Britain. I. The Matthew Paris Maps', *The Geographical Journal*, 81, 1933, 28–34, with pl.; Prince Youssouf Kamal, *Monumenta Cartographica Africae et Aegypti*, III. 4, Leiden, 1935, f. 922; Swarzenski, *Handschriften XIII Jh.*, 135 n. 5; Wormald, *Kalendars*, I, 32; Tristram, *Wall Painting*, 329; Vaughan, 'Handwriting', 392; Vaughan, *Matthew Paris*, 116, 220, 229–30, 238, 243, 255, 256; R. Vaughan, *The Chronicle attributed to John of Wallingford, Camden Miscellany*, 21, 1958; R. Vaughan, 'The Chronicle of John of Wallingford', *English Historical Review*, 73, 1958, 70 ff.; Ker, *Medieval Libraries*, 166; M. Destombes, *Mappemondes, A.D. 1200–1500*, Amsterdam, 1964, 168, no. 49.7; L. Bagrow, *History of Cartography*, rev. ed., ed. R. A. Skelton, London, 1964, 143, col. pl. B. (wrongly titled as Brit. Lib., Cotton Claudius D.VI); Brieger, *English Art*, 147, 148; A-D. von den Brincken, 'Mappa Mundi und Chronographia', *Deutsches Archiv für Erforschung des Mittelalters*, 24, 1968, 148–9, 160, 162–7; Pfaff, *New Liturgical Feasts*, 23; A-D. von den Brincken, 'Ut describeretur Universus Orbis–Zur Universalkartographie des Mittelalters', *Miscellanea Medievalia*, 7, 1970, 276, fig. 5; A-D. von den Brincken, 'Die Klimatenkarte in der Chronik des Johann von Wallingford – ein Werk des Matthaeus Parisiensis?', *Westfalen*, 51, 1973, 47–56; A-D. von den Brincken, 'Die Kugelgestalt der Erde in der Kartographie des Mittelalters', *Archiv für Kulturgeschichte*, 58, 1976, 94; S. Patterson, 'An attempt to identify Matthew Paris as a flourisher', *The Library*, XXXII, 1977, 367–70; R. W. Hunt, 'The Library of the Abbey of St. Albans', in *Medieval Scribes, Manuscripts and Libraries. Essays presented to N. R. Ker*, ed. M. B. Parkes, A. G. Watson, London 1978, 268 n. 90.

92. London, British Library MS Royal 14.C.VII

Matthew Paris, Historia Anglorum (Chronica Minora) and Chronica Maiora pt. III
358 × 250 mm., ff. 232 +ii
1250–9. St. Albans　　*Ills. 304, 305; colour pl. p. 29*

This volume contains from f. 9ᵛ to f. 156ᵛ an abbreviated history of England from the Norman Conquest to 1253, the *Historia Anglorum* (sometimes called the *Chronica Minora*), and the final part (1254–9) of Matthew Paris's full chronicle, the *Chronica Maiora* (ff. 157–218ᵛ). A much later hand (ff. 219–231) continues the chronicle from 1259–72. The foliation has been changed several times. As in other volumes of his chronicles there is a prefatory section of miscellaneous illustrated material: an itinerary from London to Apulia (ff. 2–4); a map of the Holy Land (ff. 4ᵛ–5); a map of the British Isles (f. 5ᵛ). These maps have now been mounted separately between sheets of perspex. They are decorated with small symbolic towns tinted in blue, green and pink, with gold, blue and pink columns separating the sections of the itinerary. Then follows a large framed drawing of the seated Virgin and Child with Matthew Paris kneeling before them (f. 6), a Calendar of St. Albans (ff. 7–8) and directly preceding the text a series of tinted drawings of the seated kings of England. These kings hold models of churches and are set against strongly coloured red and blue grounds: William I, William II, Henry I, Stephen (f. 8ᵛ); Henry II, Richard I, John, Henry III (f. 9).

The 32 marginal drawings illustrating the *Historia Anglorum* are rather fewer than in the earlier chronicle volumes (no. 88) and most are more sketchy: two Templars seated on a horse (f. 42ᵛ); the discovery of the relics of St. Amphibalus (f. 68); the birth of Henry III (f. 90); two bells being pulled to symbolise the relaxation of the Interdict (f. 94); Henry III sailing to Brittany (f. 116ᵛ); Richard, Archbishop of Canterbury (d. 1231), an attempt to rob his grave (f. 117ᵛ); a man threshing, symbolising the plunder of barns at Wingham (f. 118); Hubert de Burgh kneeling at an altar (f. 119); the house for converted Jews in London (f. 121); a hospital at Oxford founded by Henry III (f. 121ᵛ); St. Edmund of Abingdon blessed by Roger, Bishop of London (f. 122); St. Edmund brings about the reconciliation of Gilbert Mareschall and Henry III (f. 122ᵛ); Frederick II's marriage to Isabella of England (f. 123ᵛ); Henry III's marriage to Eleanor of Provence (f. 124ᵛ); the 1237 ecclesiastical Council

of London (f. 126); the death of the Soldan of Babylon (f. 127v); Henry III blessed by God (f. 128); death of Isabella, Countess of Cornwall (f. 129v); Henry III returning in 1243 by sea from Gascony (f. 134v); Griffin attempting to escape from the Tower of London (f. 136); St. Louis lying sick receiving a cross from the Bishop of Paris (f. 137v); the birth of Prince Edmund in 1245 (f. 138); Westminster Abbey and the shrine of St. Edward (f. 138v); the Council of Lyons (f. 138v); the Ascension of Christ symbolising the gift of the relic of his footprint to Westminster Abbey (f. 146); a dove flying up to the hand of God alluding to the defeat of the Christians and capture of St. Louis (f. 148v). The remaining six sketches are very insignificant (ff. 167, 167v, 181, 181v, 182) excepting the last which shows Matthew Paris on his deathbed (f. 218v). As in the other volumes of the *Chronica Maiora* marginal shields, crosiers and mitres, upright or inverted, indicate births, appointments and deaths of knights and bishops.

There are two large ornamental foliage initials in tinted drawing on ff. 10, 170.

Both the texts in this volume are well dated. In the text of the *Historia Anglorum* Matthew Paris tells us that he began the work in 1250. The final part of it was still being written in 1255 because the text shows awareness of the death of Pope Innocent IV who died in December 1254. These pieces of evidence suggest a date 1250–5 for the work. The third part of the *Chronica Maiora* covers the years 1254–9, the final year being that of Matthew Paris's death.

All the text of both parts of the volume up to f. 209 except ff. 154v–6v is in Matthew's handwriting. All the illustration is by him except of course the picture of his death on f. 218v and perhaps the mitres on ff. 210–18. The full-page drawings of the kings of England seem to have been intended as a preface to the *Historia Anglorum* text and are thus dateable 1250–5. The same date can be given to the marginal illustrations in that section of the text. There is less certainty about the dating of the itineraries (perhaps post 1253), maps and Virgin and Child drawing. These could have been made at any time between 1250 and 1259.

The *Historia Anglorum* is an abbreviated and edited version of the *Chronica Maiora* with a more exclusive emphasis on the events of English history. The marginal drawings in some cases (e.g. ff. 42v, 134v, 136) repeat the subjects of the *Chronica Maiora*. The style is sketchier and suggests hasty execution. As the drawings almost entirely peter out in the final part of the *Chronica Maiora* (i.e. f. 157 onwards) very probably Matthew Paris was no longer able to devote time to such illustrative embellishment.

The large-scale drawings of the seated kings of England and the Virgin and Child are important examples of the more elaborate drawing style of Matthew Paris. The figure of the Virgin is the most monumental in conception of all his works and can be compared to a panel painting of St. Peter (Oslo, Universitets Oldsakssamling) which has been attributed to him. This much damaged painting was possibly brought to Norway when Matthew visited

the country in 1248 to reform the monastery of St. Benet Holm. In comparison with the earlier large scale drawings in the Life of St. Alban (no. 85) there are more fold lines and complicated edges to the draperies in the figures of the Virgin and the seated kings. This tendency was however evident in some of the drawings in the latter part of the Alban and in the Lives of the Offas (no. 87). It is a stylistic feature very probably due to the influence of London work (e.g. no. 95, Part 2) but this tendency for complicated linear fold patterns also occurs elsewhere (e.g. no. 103).

The Map of the Holy Land is more elaborate than that of the first two parts of the *Chronica Maiora* (no. 88) but is of identical type. The map of the British Isles is the most basic in form of the four versions in the Matthew Paris manuscripts. It preserves the archaic aspects of the original model from which these maps derived and on which basis some were elaborated and improved (see further discussion under no. 93).

PROVENANCE: On f. 6v in the handwriting of Matthew Paris is the record of the donation of the book to St. Albans: '*Hunc librum dedit frater Matthaeus Parisiensis. . . Anima Matthaei et animae omnium fidelium defunctorum requiescant in pace. Amen*'. The St. Albans' pressmark A. 19 is on f. 1. In the 15th century the book had passed into the hands of Humphrey, Duke of Gloucester (1391–1447) for on f. 231 was a now erased inscription '*Ceste livre est a moy Homffrey Duc de Gloucestre*'. Later in the century it belonged to John Russell, Bishop of Lincoln (1480–94). An inscription on f. 1 states that if the book can be proved to have belonged to St. Albans the Bishop will view it as a loan from the monks but otherwise he bequeaths it to New College, Oxford. In the 16th century it was acquired by Henry Fitzalan, Earl of Arundel (1511–80). His library passed to John, Lord Lumley (1534–1609) whose name is on f.1 and whose manuscripts were purchased by James I. The Royal Library became part of the British Museum in 1757.

LITERATURE: R. Gough, *British Topography*, London, 1780, I, 61–4, pl. II; J. Strutt, *A Complete View of the Dress and Habits of the People of England*, London, 1796, I, pl. LXIV; E. F. Jomard, *Les Monuments de la Géographie*, Paris, 1858–62, pls. 39–41; F. Madden, *Matthaei Parisiensis, Historia Anglorum*, I, Rolls Series, London, 1866, xxxviii ff.; Hardy, *Descriptive Catalogue*, III, 133–6, 153–5, l, lx, lxxi, lxxiii, lxxvi, cxxvi-vii, cxxx–cxxxi, pls. VII, VIII, XIX; *Pal. Soc.*, I, pl. 218; H. Michelant, G. Raynaud, *Itinéraires à Jérusalem, Société de l'Orient Latin, Série Géographique*, III, Paris, 1882, 123–39; A. Goldschmidt, *Der Albanipsalter in Hildesheim*, Berlin, 1895, 44; K. Miller, *Mappae Mundi. Die ältesten Weltkarten*, Stuttgart, 1895–8, III, 69, 73–82, 84–90, 90–4, figs. 22, 27, 29, 30, 31; C. R. Beazley, *The Dawn of Modern Geography*, London, 1901, II, 638–40, pls. on 588, 590; Haseloff, 'Miniature', 346, fig. 260; F. Hauptmann, 'Die Wappen in der Historia Minor des Matthaeus

Parisiensis', *Jahrbuch der K.K. Heraldischen Gesell-schaft 'Adler'*, N. F. 19, 1909, 20–55, pls. 1–6; Herbert, *Illuminated Manuscripts*, 185; British Museum, *Schools of Illumination*, pt. II, London, 1915, pl. 10; Lindblom, *Peinture Gothique*, 129, 130, pls. 45, 46; W. R. Lethaby, 'English Primitives, V', *Burlington Magazine*, 31, 1917, 45, 47–8; James, *Estoire de St. Aedward*, 29–30, 31; Warner and Gilson, II, 135–6, pls. 83, 84; Millar, I, 57, 58, 98, pl. 87; James, 'Matthew Paris', 2, 18–21, frontis-piece, pls. XIX–XXI; T. Borenius, E. W. Tristram, *English Medieval Painting*, Florence, 1927 (repr. New York, 1976), 9, pl. 18; British Museum, *Reproductions*, IV, pl. XVII; J. P. Gilson, *Four Maps of Great Britain designed by Matthew Paris*, London, 1928, 3–11, pl. D; Saunders, *English Illumination*, I, 76, 78, II, pl. 80; J. B. Mitchell, 'Early Maps of Great Britain. I. The Matthew Paris Maps', *The Geographical Journal*, 81, 1933, 28–34, with pl.; Prince Youssouf Kamal, *Monumenta Cartographica Africae et Aegypti*, III. 5, Leiden, 1935, f. 1001; Wormald, *Kalendars*, I, 32; V. Lasa-reff, 'Studies in the Iconography of the Virgin', *Art Bulletin*, 20, 1938, 37; F. M. Powicke, 'Notes on the compilation of the Chronica Majora of Matthew Paris', *Modern Philology*, XXXVIII, 1941, 312–17; V. H. Galbraith, *Roger of Wendover and Matthew Paris*, Glasgow, 1944, 24, 28–30; F. M. Powicke, 'The compilation of the Chronica Majora of Matthew Paris', *Proceedings of the British Academy*, XXX, 1944, 153–60; Tristram, *Wall Painting*, 156, 302, 303, 319, 334, 381, suppl. pl. 51a; A. R. Wagner, *A Catalogue of English Medieval Rolls of Arms*, *Aspilogia*, I, London, 1950, 1; J. Plummer, *The Lothian Morgan Bible*, Ph.D. Dissertation, Colum-bia, 1953, 50; G. B. Parks, *The English Traveler to Italy*, Rome, 1954, 180–4, figs. 8a, b; Vaughan, 'Handwriting', 376, passim, pls. XVIIb, XIXh; Vaughan, *Matthew Paris*, passim, pls. I, V, XI, XII; Rickert, *Miniatura*, II, pl. 16; Turner, 'Evesham Psalter', 35–6; Ker, *Medieval Libraries*, 167; N. Denholm-Young, *Handwriting in England and Wales*, Cardiff, 1964, 51–2, pl. 12; L. Bagrow, *History of Cartography*, rev. ed., ed. R. A. Skelton, London, 1964, 143, pl. XX (wrongly titled as British Library, Cotton Nero D. V.); Turner, *Early Gothic*, 16, pl. 5; Rickert, *Painting in Britain*, 108–9, 203, pl. 110; H. S. London, T. D. Tremlett, *Rolls of Arms Henry III*, *Aspilogia*, II, London, 1967, 11–36, 77–9; A. Martindale, *Gothic Art*, London, 1967, 78, pl. 55; Brieger, *English Art*, 136 ff., pls. 42, 45a; S. Harrison Thomson, *Latin Bookhands of the Later Middle Ages 1100–1500*, Cambridge, 1969, no. 92; Pfaff, *New Liturgical Feasts*, 23; F. Deuchler, *Gothic Art*, London, 1973, 136, fig. 170; A. Grandsen, *Historical Writing in England c. 550 to c. 1307*, London, 1974, 356 ff., pl. IX; S. Patterson, 'An attempt to identify Matthew Paris as a flourisher', *The Library*, XXXII, 1977, 367–370; Watson, *Dated Manuscripts*, no. 893, pl. 145.

EXHIBITED: London, Royal Academy of Arts, *Exhibition of British Primitive Paintings*, 1923, no. 106; London, British Museum, *British Heraldry*, 1978,
no. 7, pl.; London, British Library, *The Benedic-tines in Britain*, 1980, no. 88, 77, col. pl. IV.

93. London, British Library MS Cotton Claudius D.VI, ff. 2–94
Matthew Paris, Abbreviatio Chronicorum Angliae
322 × 214 mm.
c. 1255–9. St. Albans *Ill. 306; fig. 18*

This concise chronicle was compiled by Matthew Paris as an abbreviation with some alterations of the *Historia Anglorum* (no. 92) and the *Chronica Maiora* (nos. 88, 92) to cover the period 1066–1255. The illustrations are restricted to some drawings of seated kings and a genealogy with busts of kings. The thirty-three seated kings tinted in green, orange, pale blue and pale yellow are set against blue and pink-red grounds. The first, King Offa, is set in a roundel beside a diagram representing the seven kingdoms of the Anglo-Saxon heptarchy (f. 5v). The remaining thirty-two kings are set in framed pictures with four kings to a page set under arches (ff. 6–9v). They are arranged as an abbreviated genealogical series from the legendary Brutus, great-grandson of Aeneas and first king of Britain, up to Henry III. In the 17th century Sir Robert Cotton wrote in the names of the kings following original inscriptions once in the border but almost completely cut off by a subsequent rebinding. On ff. 10v–11v there is a genealogy of the kings from Alfred to Harold with some busts in roundels. The text of the chronicle is set in two columns between painted vertical bands. A map of England and Scotland on a single folio (f. 12v) is now mounted separately.

The seated figures of kings are modelled on those at the beginning of the *Historia Anglorum* of which originally there must have been a similar extensive series. The figures in the *Abbreviatio Chronicorum* are less refined in style and some of the drawing is sketchy almost to the point of crudeness. This could be explained either by hasty execution or that some or all might be by another hand than that of Matthew Paris. The sketchiness of fold lines and faces how-ever resembles some of the drawings in the margins of the *Chronica Maiora* which are indisputably by Matthew. It seems quite possible that he did almost all the drawings of the kings but that they were drawn quickly without much care.

The extensive series of figures of kings is the most elaborate surviving genealogy of the period. Some of the kings are given some distinguishing features as for example John, an unpopular figure in historical writings of the time, with his crown falling off. Seated figures of the kings of England had been included in the Chronicle of Abingdon (no. 41) but not as a genealogical series. During the 13th century there is a rise in interest in illustrated genealogies as evidenced by the interest in illustrated versions of Peter of Poitiers' genealogy and its elaboration as a Universal chronicle with genealogical information (e.g. nos. 43b, 79, 90). An illustrated genealogy of *c.* 1250 accompanies the text of Geoffrey of Mon-

mouth's *Prophecies of Merlin* (Princeton, University Library MS 57) and the 1246 wall paintings in the King's lower chamber at Clarendon Palace were painted with heads of kings and queens. In Edward I's reign illustrated genealogies of kings often occur in roll form (e.g. Oxford, Bodleian Library MS Bodley Rolls 3).

The text of ff. 5ᵛ, 10ᵛ-11ᵛ, 12, 13-91 is in the handwriting of Matthew Paris and he has inserted some marginal notes on the other pages. The sources he has used from his other chronicles suggest this version was compiled between 1255 and his death in 1259. The drawings are therefore his last works.

The map of the British Isles is the most elaborate and best preserved example of the four versions by Matthew Paris (the others in nos. 88, 91, 92). The script and drawings of the schematic towns, trees and mountains are completely characteristic of his personal style. The sea is coloured green, the rivers blue or red and the inscriptions in red or black. The date of this map is not necessarily the same as that of the text of the main manuscript as it is on a single folio and could possibly have been executed before 1255. Mitchell proposed a scheme of interrelationships between the four Matthew Paris maps of Britain. The example in the *Abbreviatio Chronicorum* is of the same type as in nos. 88, 91 and is the most finished version of the three showing an increased knowledge of the geography of Scotland. The map is arranged around an axis of a North/South itinerary from Dover to Newcastle.

Matthew Paris seems to have had a particular interest in cartography. Presumably lost maps provided him with information to enable him to gradually elaborate his earlier versions. In the case of his world map (in no. 88) it is recorded that it derived from monumental examples in wall painting but there is no definite evidence that there were maps of Britain in that form which could have served as models. Vaughan has suggested that these single maps of Britain were personal creations of Matthew Paris and it is very plausible that their creation was another aspect of his nationalistic view of contemporary events. Whatever the case may be these maps are of prime importance as the first examples of the detailed cartography of Britain.

PROVENANCE: The Benedictine Abbey of St. Albans: '*hic est liber Sci. Albani*' is on f. 101 in a 14th century hand. Also there is a St. Albans calendar on ff. 218-9. Richard Hutton (early 16th-century inscription on f. 9ᵛ). John Stow (1525-1605) might have owned the manuscript because extracts occur from it in his *Collectanea*. Sir Robert Cotton (1571-1631): his signature on f. 6. Presented to the Nation by Sir John Cotton in 1700 as part of his library. The collection was incorporated in the British Museum in 1753.

LITERATURE: R. Gough, *British Topography*, London, 1780, 66-71, pl. IV; F. Madden, *Matthaei Parisiensis, Historia Anglorum, III, Rolls Series*, London, 1869, 155-348; Hardy, *Descriptive Catalogue*, III, 140-1, 194, lxxv-vi, cxxxiv, pl. XX;

K. Miller, *Mappae Mundi. Die ältesten Weltkarten*, Stuttgart, 1895-8, III, 70, 73-83, figs. 23, 24; C. R. Beazley, *The Dawn of Modern Geography*, London, 1901, II, 638-40, pl. on 584; Herbert, *Illuminated Manuscripts*, 185; Millar, I, 123; J. P. Gilson, *Four Maps of Great Britain designed by Matthew Paris*, London, 1928, 3-11, pl. A; J. B. Mitchell, 'Early Maps of Great Britain. I. The Matthew Paris Maps', *The Geographical Journal*, 81, 1933, 28-34, with pl.; Wormald, *Kalendars*, I, 32; W. Rosien, *Die Ebstorfer Weltkarte*, Hannover, 1952, 29, pl. 6; Vaughan, 'Handwriting', 390, pl. XVIIc; Vaughan, *Matthew Paris*, 36 ff., 113-14, 219, 223, 231-2; Ker, *Medieval Libraries*, 166; H. S. London, T. D. Tremlett, *Rolls of Arms, Henry III, Aspilogia*, II, London, 1967, 75-6; Brieger, *English Art*, 137 n. 2, 145 n. 1, 147; Pfaff, *New Liturgical Feasts*, 23; W. H. Monroe, 'A Roll-Manuscript of Peter of Poitiers' Compendium', *Bulletin of the Cleveland Museum of Art*, LXV, 1978, 107 n. 25; S. Patterson, 'An attempt to identify Matthew Paris as a flourisher', *The Library*, XXXII, 1977, 367-70; Watson, *Dated Manuscripts*, no. 520, pl. 152.

EXHIBITED: London, British Library, *The Benedictines in Britain*, 1980, no. 85, 77-8, pl. 50.

94. London, British Library MS Cotton Claudius B. VII ff. 223ᵛ-34ᵛ
Geoffrey of Monmouth, Prophecies of Merlin with interlinear commentary
318 × 222 mm.
c. 1250 *Ill. 298*

This is the only part of a miscellany of secular texts to receive illustration. There is one drawing set under an architectural canopy showing the young Merlin before King Vortigern (f. 224) and it is tinted in pale-brown, green and grey-blue. The scene illustrates the boy Merlin prophesying before Vortigern concerning two dragons who are shown below beside a pool. This illustrates the introductory section of the text (f. 223ᵛ) which describes this event and precedes the text of the prophecies themselves.

The figures are thinner and more angular than in the work of Matthew Paris. Such a style derives from drawings connected with London (e.g. no. 51). A similar tradition seems to be the source of work associated with Westminster and Court patronage in the 1250s which will be discussed in the second part of this Survey volume (nos. 95, 96). The drawing in the Prophecies of Merlin probably dates from around the middle of the century or possibly earlier.

There were depictions of subject matter from Arthurian legend in the palaces and castles of the period. Textual records mention an 'Arthur's Hall' and 'Guinevere's Chamber' in Dover Castle.

The text of the Prophecies of Merlin was part of Geoffrey of Monmouth's History of the Kings of Britain completed *c.* 1136. The inclusion of the Prophecies in a miscellaneous collection of texts

shows the particular interest in this section of Geoffrey's History. The prophecies are presented in terms of animals and birds, and they were constantly mentioned by chroniclers and writers throughout the later Middle Ages as referring to the political issues of their time. The interlinear commentary in this example makes such connections. Matthew Paris in his *Chronica Maiora* for example refers to Henry III's avarice in the veiled terms of the prophecy of Merlin concerning the lynx. The interest in political prophecy is an aspect of the general interest in the 13th century in prophecy, of which another aspect is the eschatological prophecy in connection with the text of the Apocalypse (see the second part of this Survey volume for discussion).

PROVENANCE: The possible ownership by Lichfield Cathedral suggested by Ward has been rejected by Ker. Sir Robert Cotton (1571–1631). Presented to the Nation by Sir John Cotton in 1700 as part of his library. The collection was incorporated in the British Museum in 1753.

LITERATURE: H. L. D. Ward, *Catalogue of Romances in the Department of Manuscripts in the British Museum*, London, 1883, I, 22–3, 193, 296, 303, 561–2; R. S. Loomis, *Arthurian Legends in Medieval Art*, New York, 1938, fig. 384; J. Hammer, 'A commentary on the Prophetia Merlini (Geoffrey of Monmouth's Historia Regum Britanniae, Book VII)', *Speculum*, 15, 1940, 409–31; Ker, *Medieval Libraries*, 115; Brieger, *English Art*, 133.

ILLUSTRATIONS

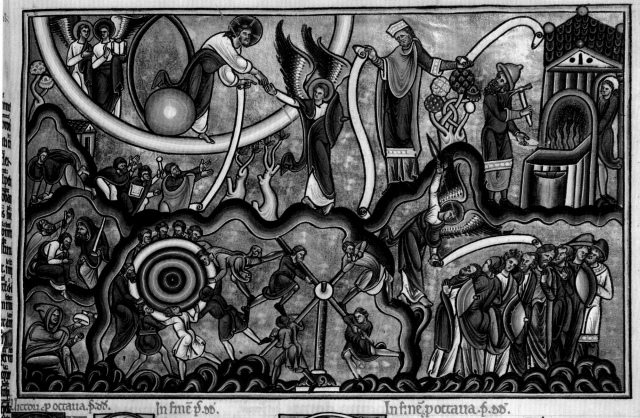

1. Psalm 11. Paris, Bibl. Nat., lat. 8846, f. 20 (cat. 1)

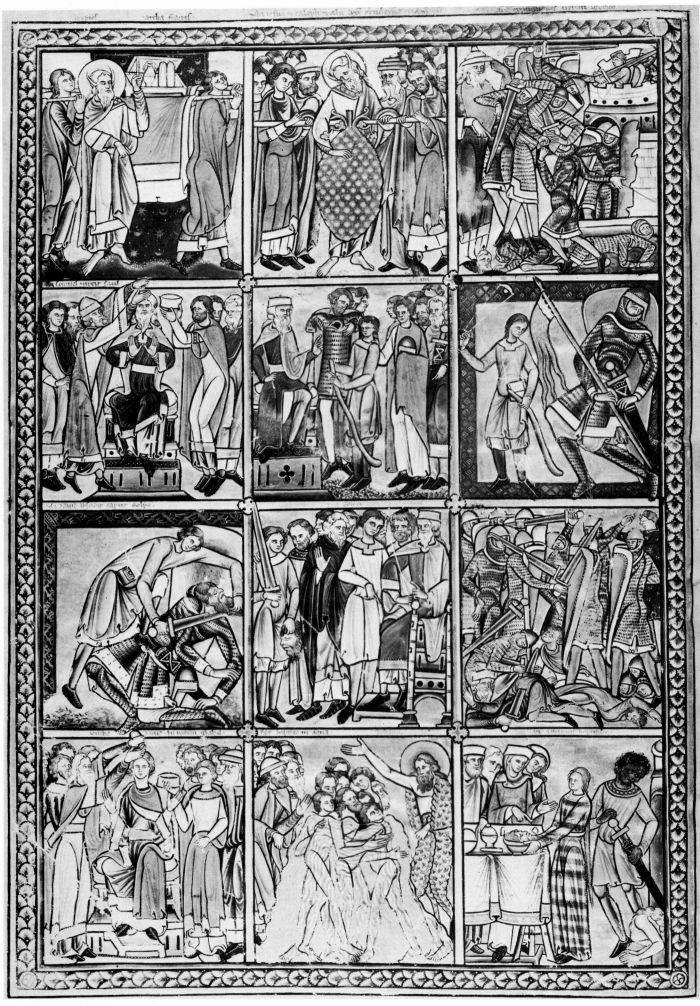

2. Old and New Testament scenes. Paris, Bibl. Nat., lat. 8846, f. 2ᵛ (cat. 1)

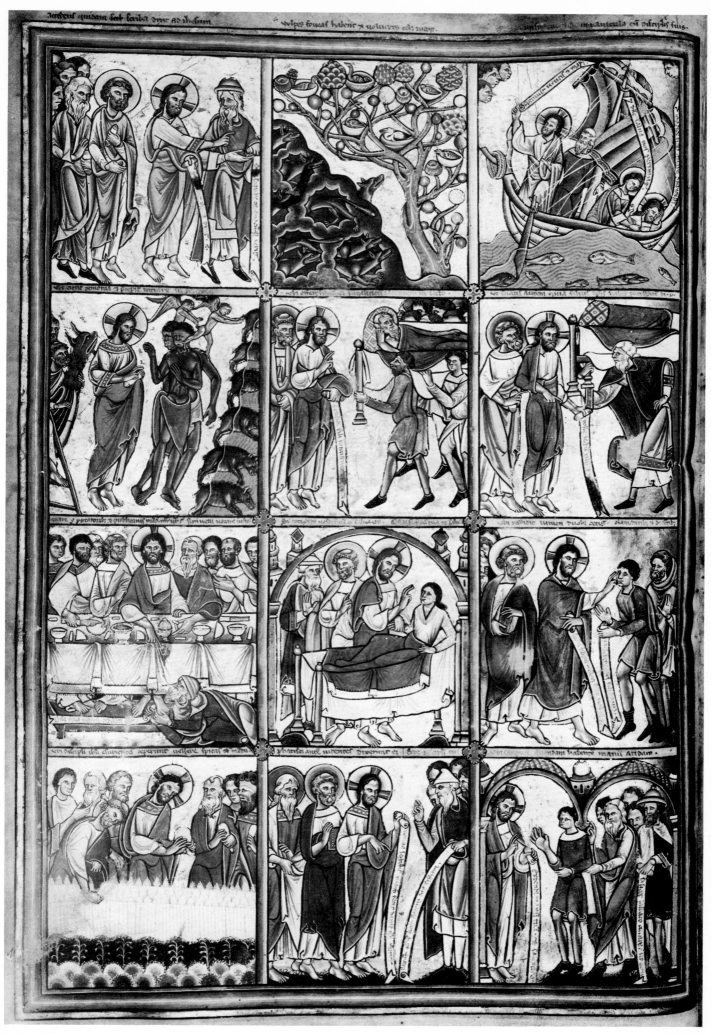

3. New Testament scenes. Paris, Bibl. Nat., lat. 8846, f. 3ᵛ (cat. 1)

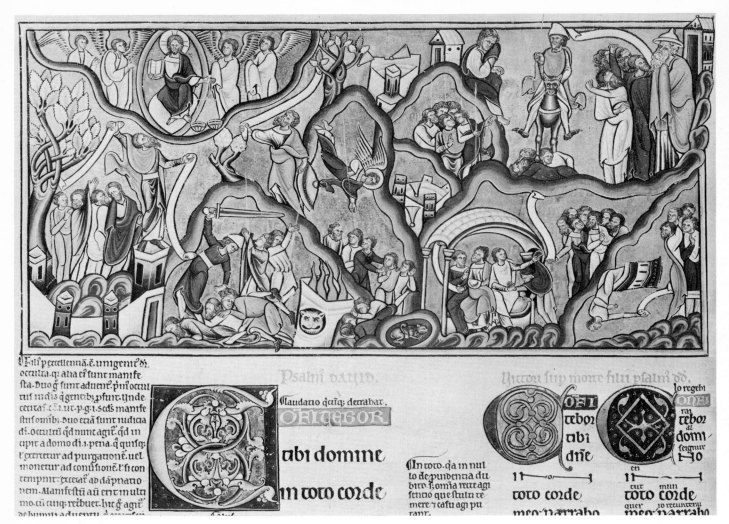

4. Psalm 9. Paris, Bibl. Nat., lat. 8846, f. 15ᵛ (cat. 1)

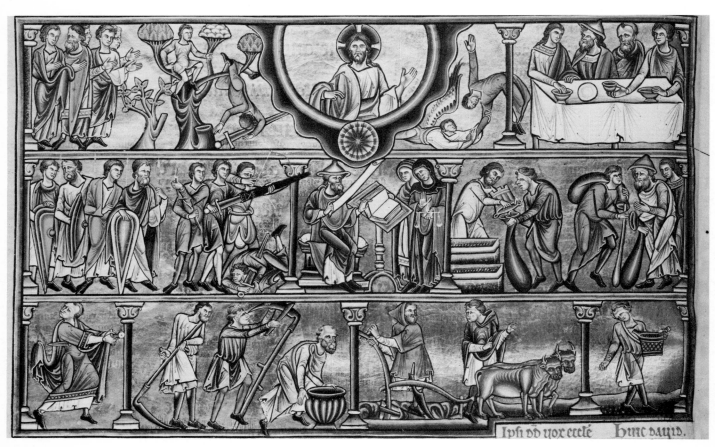

5. Psalm 36. Paris, Bibl. Nat., lat. 8846, f. 62ᵛ (cat. 1)

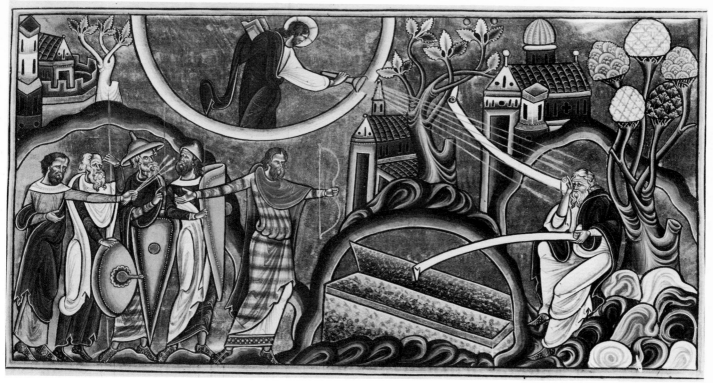

6. Psalm 12. Paris, Bibl. Nat., lat. 8846, f. 21 (cat. 1)

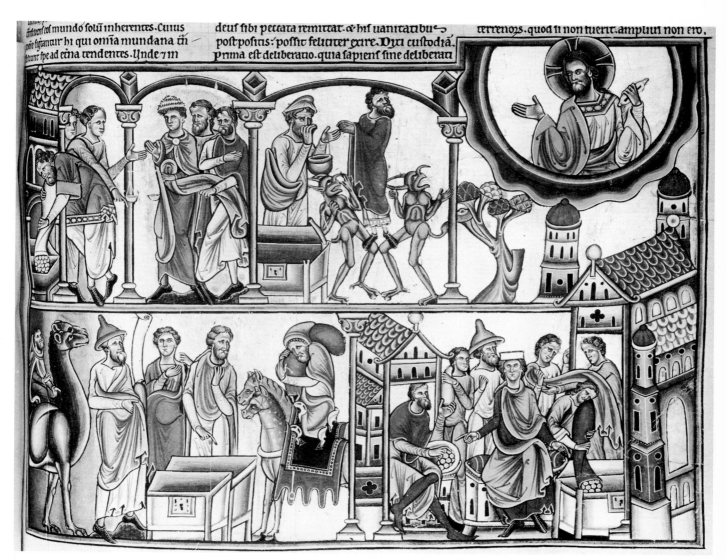

7. Psalm 38. Paris, Bibl. Nat., lat. 8846, f. 68 (cat. 1)

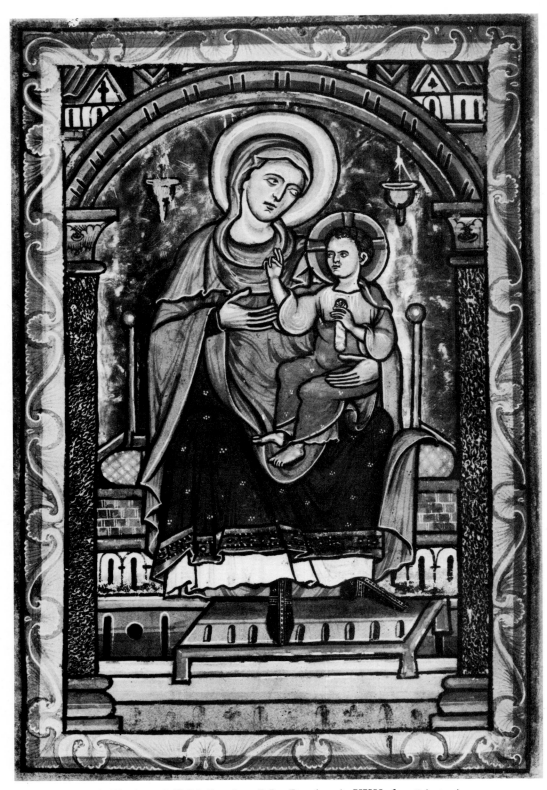

8. Virgin and Child. London, B.L., Royal 2. A. XXII, f. 13ᵛ (cat. 2)

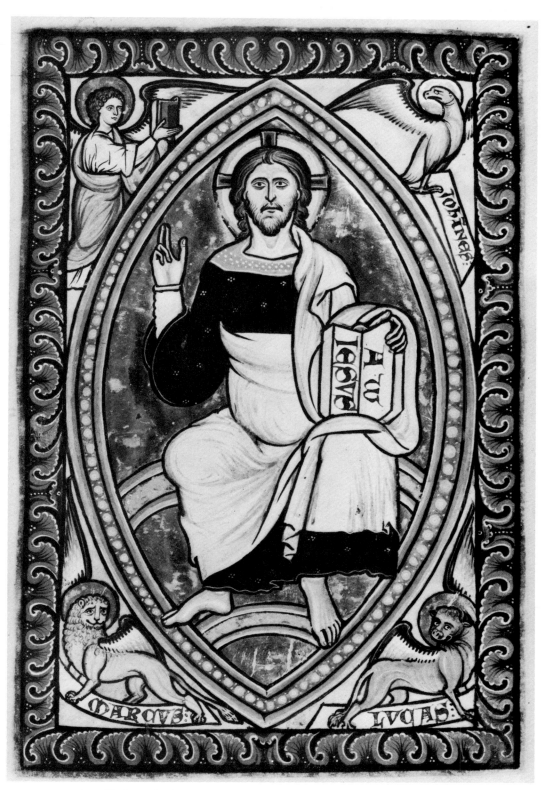

9. Christ in Majesty. London, B.L., Royal 2. A. XXII, f. 14 (cat. 2)

10. Psalm 1, Beatus initial. London, B.L.,
Royal 2. A. XXII, f. 15 (cat. 2)

11. Psalm 101, Monk kneeling before Christ. London, B.L.,
Royal 2. A. XXII, f. 116 (cat. 2)

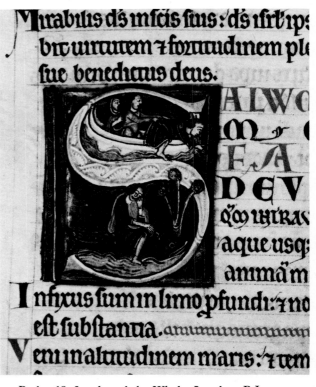

12. Psalm 68, Jonah and the Whale. London, B.L.,
Royal 2. A. XXII, f. 80ᵛ (cat. 2)

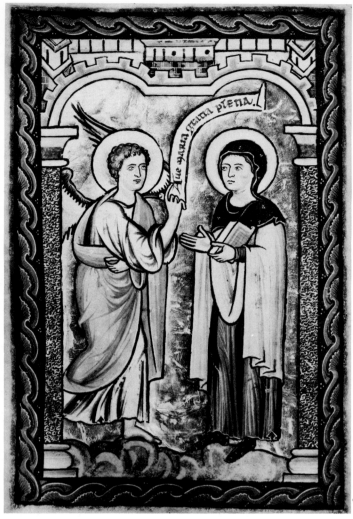

13. Annunciation. London, B.L., Royal 2. A. XXII, f. 12ᵛ (cat. 2)

14. Hugh of St. Victor teaching. Oxford, Bodl. Lib., Laud Misc. 409, f. 3ᵛ (cat. 4)

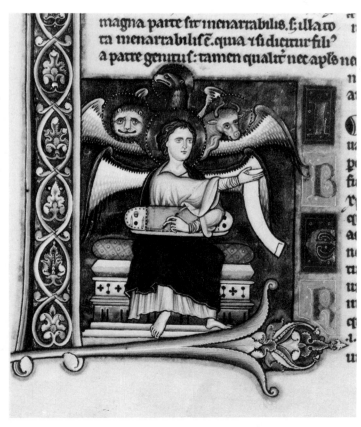

15. Initial L with Evangelist symbols. Cambridge, Trinity College, B. 5. 3, f. 4ᵛ (cat. 3)

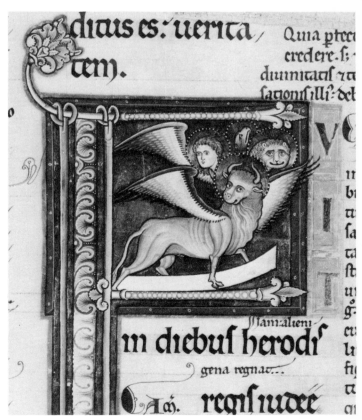

16. Initial F, the Bull of St. Luke. Cambridge, Trinity College, B. 5. 3, f. 111ᵛ (cat. 3)

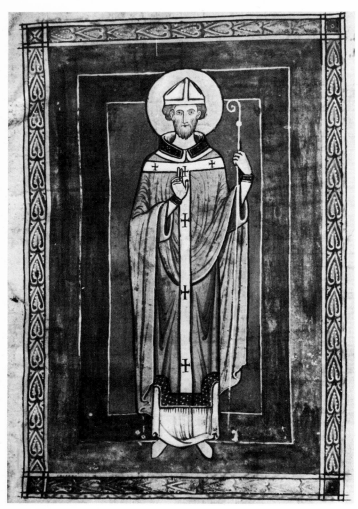

17. St. Dunstan (?). Cambridge,
Corpus Christi College, 161, f. 1 (cat. 5)

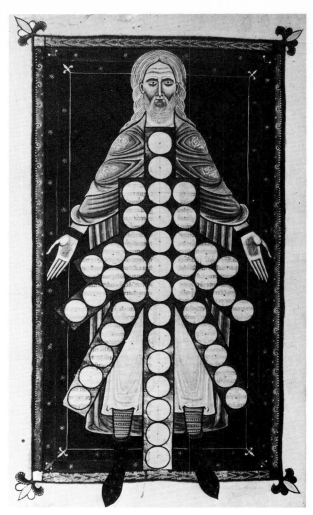

18. Tree of Consanguinity. Cambridge,
Corpus Christi College, 10, f. 330ᵛ (cat. 6)

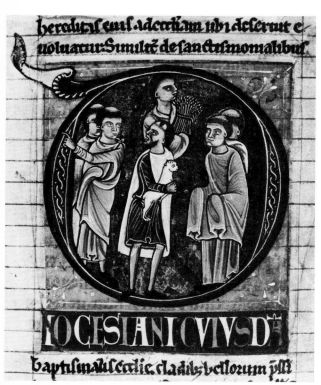

19. Causa XIII, Dispute over Church Tithes.
Cambridge, Corpus Christi College, 10, f. 181 (cat. 6)

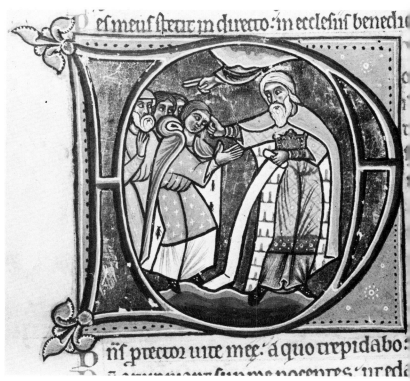

20. Psalm 26, Samuel anointing David. Cambridge,
Trinity College, B. 10. 9, f. 25ᵛ (cat. 7)

21. Psalm 101, ornamental initial D. Cambridge,
Trinity College, B. 10. 9, f. 78ᵛ (cat. 7)

22. Psalm 109, ornamental D. Oxford, Bodl. Lib.,
Auct. D. 2. 1, f. 164ᵛ (cat. 8)

23. Psalm 51, Ahitobel and Doeg before Saul.
Oxford, Bodl. Lib., Auct. D. 2. 1, f. 80 (cat. 8)

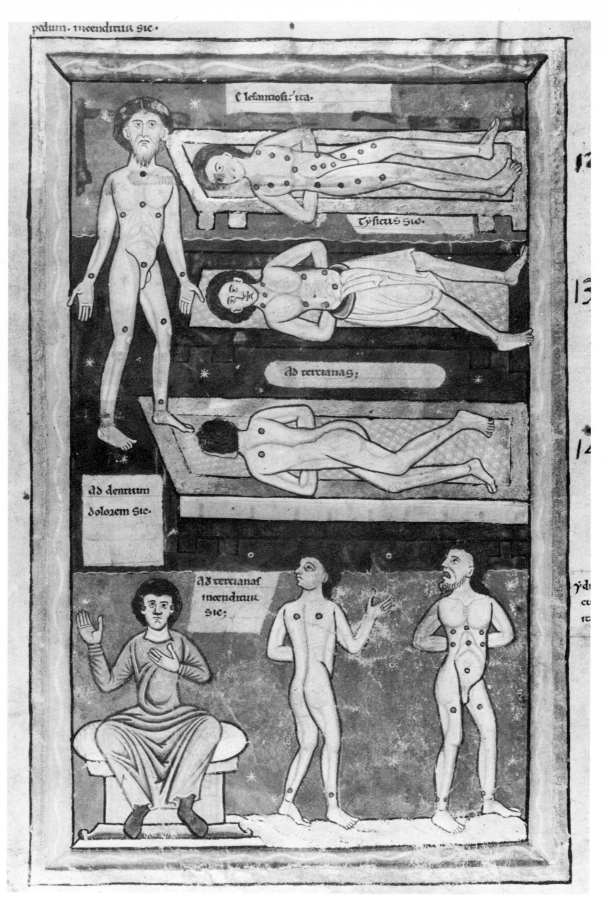

24. Cautery Points. Oxford, Bodl. Lib., Ashmole 1462, f. 9ᵛ (cat. 9)

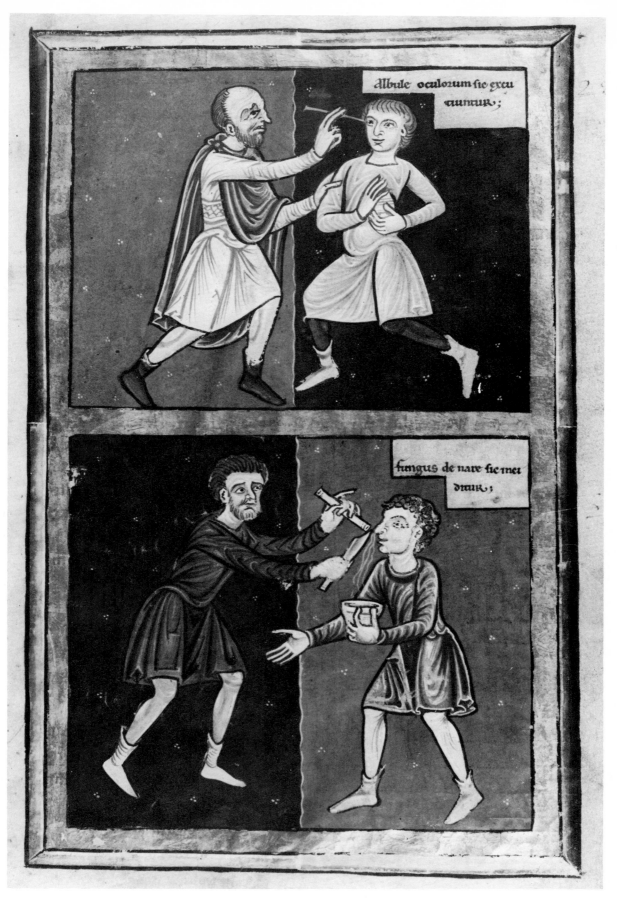

25. Operations for Cataract and Nasal Polyps. Oxford, Bodl. Lib., Ashmole 1462, f. 10 (**cat. 9**)

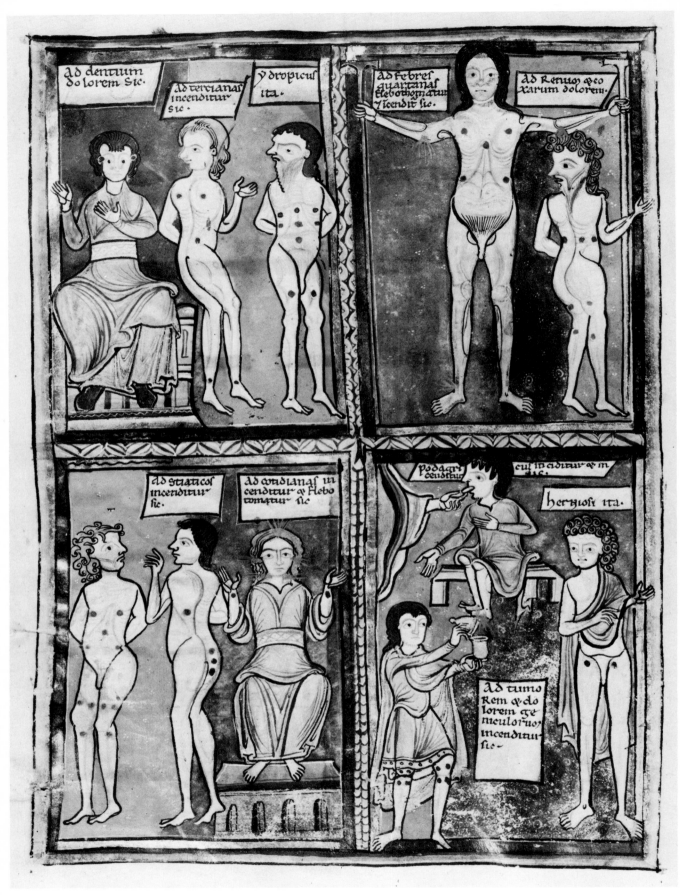

26. Cautery Points. London, B.L., Sloane 1975, f. 92ᵛ (cat. 10)

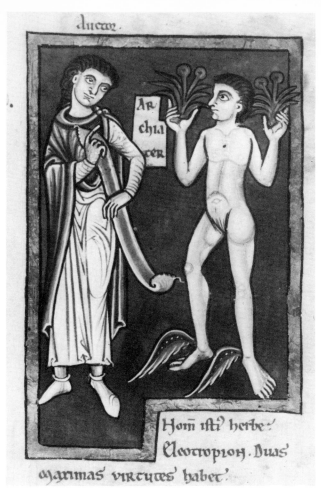

27. Mercury standing before Homer,
holding the herb Immolum. Oxford,
Bodl. Lib., Ashmole 1462, f. 26ᵛ (cat. 9)

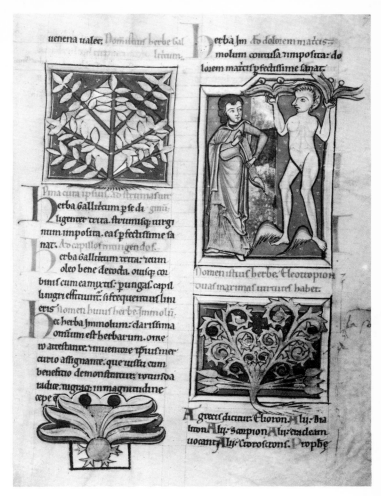

28. Gallitrichum, Mercury standing before Homer
holding the herb Immolum, Heliotropium. London,
B.L., Sloane 1975, f. 27 (cat. 10)

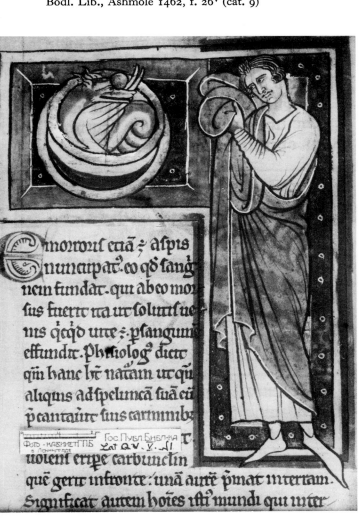

9. Emorroris. Leningrad, State Public Lib.,
at. Q. v. V. 1., f. 84 (cat. 11)

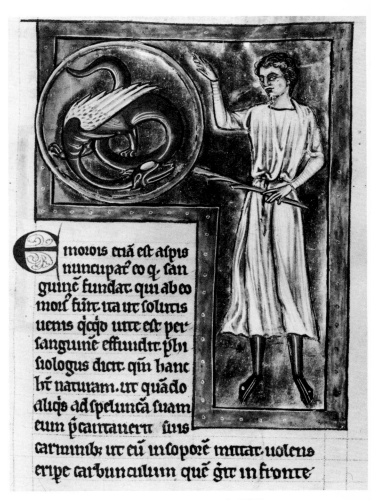

30. Emorroris. London, B.L., Royal 12. C. XIX,
f. 67 (cat. 13)

31. Apes. Leningrad, State Public Lib., Lat. Q. v. V. 1., f. 20ᵛ (cat. 11)

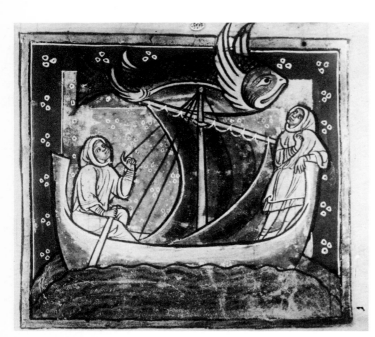

32–3. Serra; Crocodile. Leningrad, State Public Lib., Lat. Q. v. V. 1., ff. 70, 75 (cat. 11)

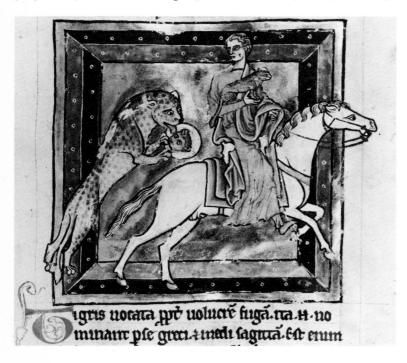

34. Tiger. London, B.L., Royal 12. C. XIX, f. 28 (cat. 13)

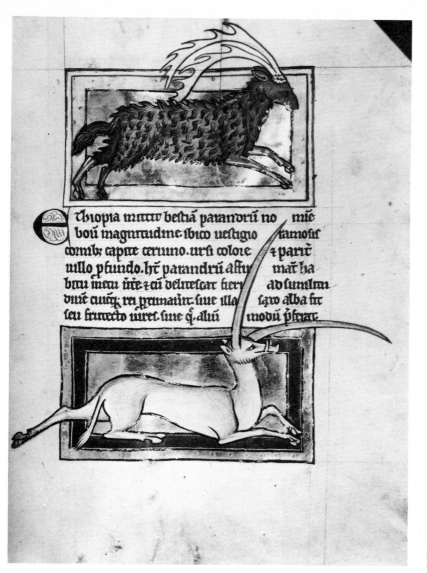

Ethiopia mittit bestiā parandrū no mīc̄
boū magnitudine. sbico uestigio ramosis
cornib; capite ceruino. ursī colore ⁊ parit
uillo pfundo. hr̄ parandrū astū mat̄ ha
bitu metu īste ⁊ cū delitescat hier̄ ad sumilū
dine cuiuq; rei puinalit. siue illa sqo alba sit
seu frutecto uiret. siue q̄ aliū modū pserat

35. Parandrus, Yale. London, B.L.,
Royal 12. C. XIX, f. 30 (cat. 13)

36. Unicorn. London, B.L., Royal 12. C. XIX,
f. 9ᵛ (cat. 13)

37. Caladrius. London, B.L., Royal 12. C. XIX,
f. 47ᵛ (cat. 13)

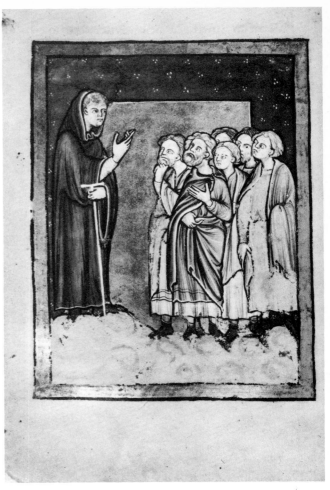

38. Ornamental initial D. London, B.L.,
Yates Thompson 26 (Add. 39943), f. 2ᵛ (cat. 12a)

39. Cuthbert preaching. London, B.L.,
Yates Thompson 26 (Add. 39943), f. 22ᵛ (cat. 12a)

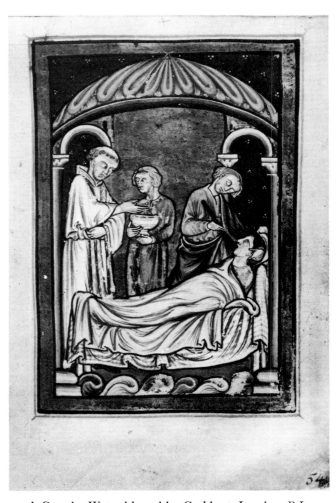

40. King Ecgfrid visits Cuthbert. London, B.L.,
Yates Thompson 26 (Add. 39943), f. 51 (cat. 12a)

41. A Cure by Water blessed by Cuthbert. London, B.L.,
Yates Thompson 26 (Add. 39943), f. 54 (cat. 12a)

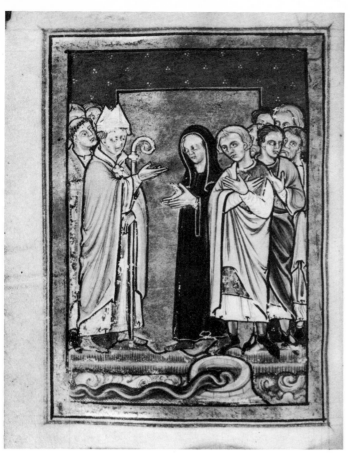

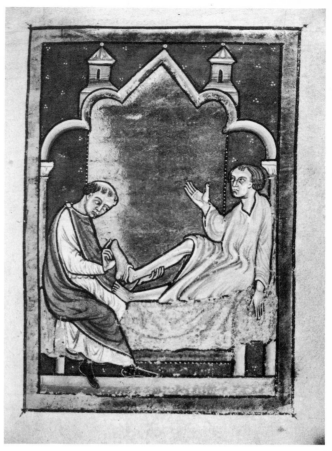

42. Cuthbert prophesies the Fate of Carlisle. London, B.L., Yates Thompson 26 (Add. 39943), f. 55ᵛ (cat. 12a)

43. A Paralytic cured by Cuthbert's Shoes. London, B.L., Yates Thompson 26 (Add. 39943), f. 80 (cat. 12a)

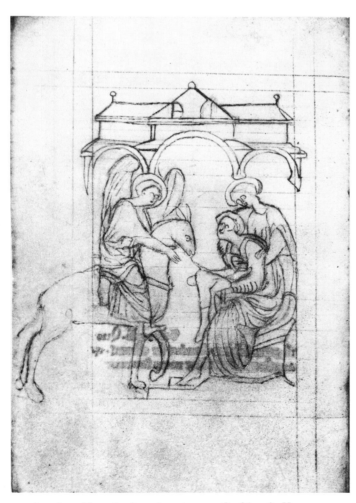

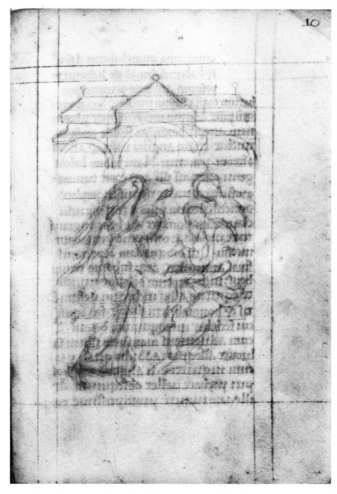

44. Angel on Horseback arrives to cure Cuthbert's Knee. Cambridge, Trinity College, o. 1. 64, f. 9ᵛ (cat. 12b)

45. Angel approaches Cuthbert to cure his Knee. Cambridge, Trinity College, o. 1. 64, f. 10 (cat. 12b)

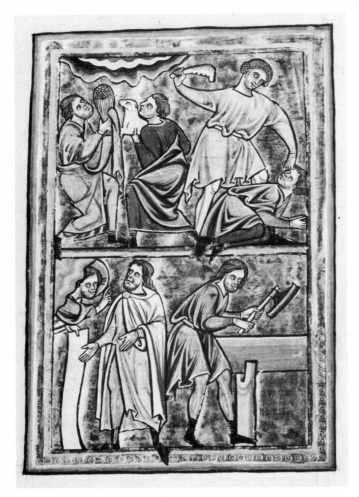

46. Cain and Abel, the Building of the Ark.
Leiden, Bibl. der Rijksuniversiteit,
lat. 76A, f. 10ᵛ (cat. 14)

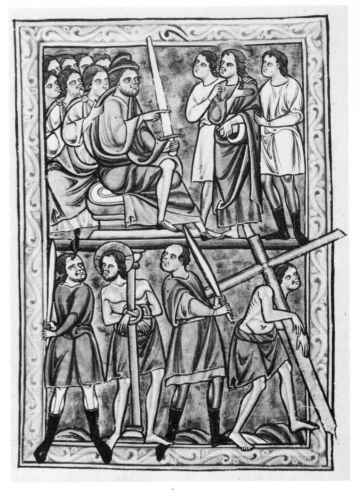

47. Christ before Pilate, Flagellation, Way of the Cross.
Leiden, Bibl. der Rijksuniversiteit,
lat. 76A, f. 24ᵛ (cat. 14)

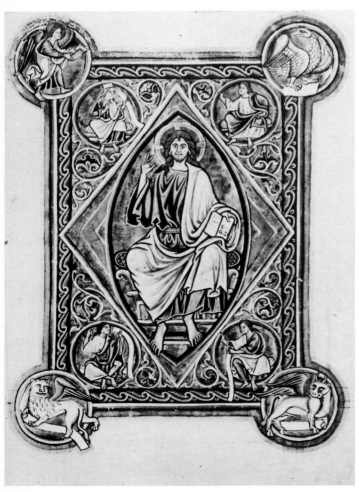

48. Christ in Majesty. Leiden, Bibl.
der Rijksuniversiteit, lat. 76A, f. 29 (cat. 14)

49. Psalm 1, Beatus initial. Leiden, Bibl.
der Rijksuniversiteit, lat. 76A, f. 30ᵛ (cat. 14)

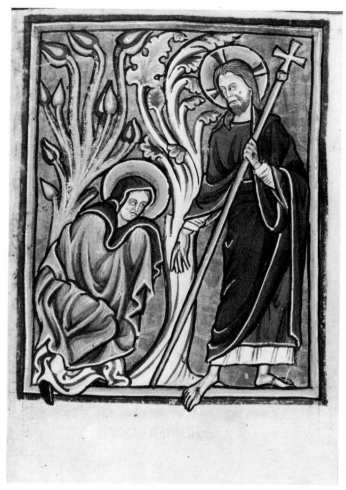

50. Noli me tangere. Private Collection,
f. 84 (cat. 16)

51. Visitation. Private Collection,
f. 28 (cat. 16)

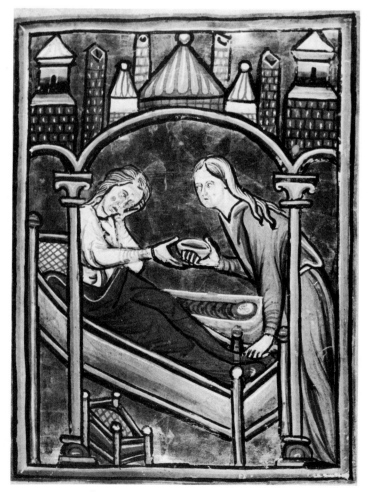

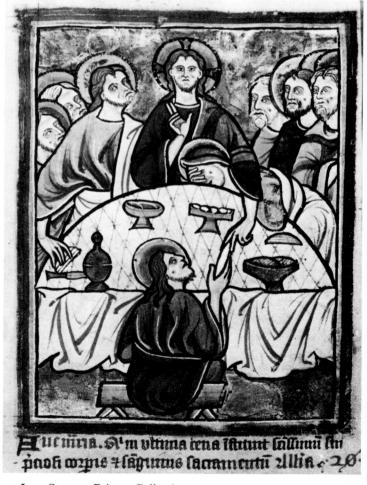

52. Nativity of the Virgin. Private Collection,
f. 21 (cat. 16)

53. Last Supper. Private Collection,
f. 63 (cat. 16)

54. Psalm 1, Beatus initial.
Cambridge, St. John's College,
K. 30, f. 7ᵛ (cat. 15)

55. Psalm 101, David harping with
three Musicians. Cambridge, St. John's College,
K. 30, f. 86 (cat. 15)

56–7. Initial C of Confitebor; Psalm 68, Crucifixion. London, B.L., Arundel 104, ff. 364ᵛ, 354 (cat. 18)

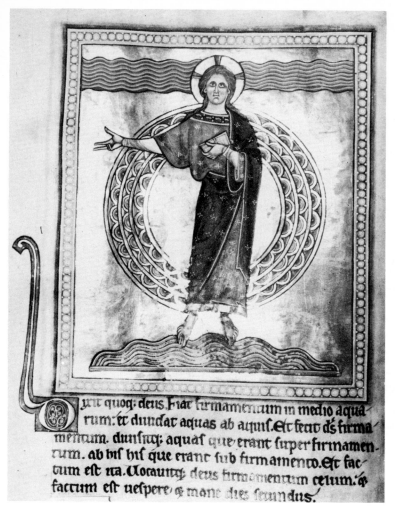

ᴜᴛ quoq: deus. Fɪᴀᴛ ꜰɪʀᴍᴀᴍᴇɴᴛᴜᴍ ɪɴ ᴍᴇᴅɪᴏ ᴀqᴜᴀ
ʀᴜᴍ: ᴇᴛ ᴅɪᴜɪᴅᴀᴛ ᴀqᴜᴀꜱ ᴀʙ ᴀqᴜɪꜱ. Eᴛ ꜰᴇᴄɪᴛ ᴅ̃ꜱ ꜰɪʀᴍᴀ
ᴍᴇɴᴛᴜᴍ. ᴅɪᴜɪꜱɪᴛqᴀ: ᴀqᴜᴀꜱ qᴜᴇ ᴇʀᴀɴᴛ ꜱᴜᴘᴇʀ ꜰɪʀᴍᴀᴍᴇɴ
ᴛᴜᴍ. ᴀʙ ʜɪꜱ ʜɪꜱ qᴜᴇ ᴇʀᴀɴᴛ ꜱᴜʙ ꜰɪʀᴍᴀᴍᴇɴᴛᴏ. Eᴛ ꜰᴀᴄ
ᴛᴜᴍ ᴇꜱᴛ ɪᴛᴀ. Uᴏᴄᴀᴜɪᴛq; ᴅᴇᴜꜱ ꜰɪʀᴍᴀᴍᴇɴᴛᴜᴍ ᴄᴇʟᴜᴍ: ᴇᴛ
ꜰᴀᴄᴛᴜᴍ ᴇꜱᴛ ᴜᴇꜱᴘᴇʀᴇ ᴇᴛ ᴍᴀɴᴇ ᴅɪᴇꜱ ꜱᴇᴄᴜɴᴅᴜꜱ.

58. Creation of the Waters and the Firmament.
Aberdeen, University Lib., 24, f. 1ᵛ (cat. 17)

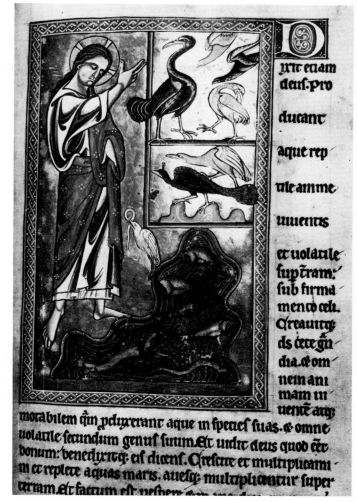

ᴜᴛ ᴇᴛɪᴀᴍ
ᴅᴇᴜꜱ. ᴘʀᴏ
ᴅᴜᴄᴀɴᴛ
ᴀqᴜᴇ ʀᴇᴘ
ᴛɪʟᴇ ᴀɴɪᴍᴇ
ᴜɪᴜᴇɴᴛɪꜱ
ᴇᴛ ᴜᴏʟᴀᴛɪʟᴇ
ꜱᴜᴘ ᴛ̃ʀᴀᴍ:
ꜱᴜʙ ꜰɪʀᴍᴀ
ᴍᴇɴᴛᴏ ᴄᴇʟɪ.
Cʀᴇᴀᴜɪᴛq;
ᴅꜱ ᴄᴇᴛᴇ gʀ
ᴅɪᴀ. ᴇᴛ ᴏᴍ
ɴᴇᴍ ᴀɴɪ
ᴍᴀᴍ ᴜɪ
ᴜᴇɴᴛᴇ ᴀᴛq;

ᴍᴏᴛᴀʙɪʟᴇᴍ q̃ɴ ᴘᴅᴜᴊᴇʀᴀɴᴛ ᴀqᴜᴇ ɪɴ ꜱᴘᴇᴄɪᴇꜱ ꜱᴜᴀꜱ. ᴇᴛ ᴏᴍɴᴇ
ᴜᴏʟᴀᴛɪʟᴇ ꜱᴇᴄᴜɴᴅᴜᴍ ɢᴇɴᴜꜱ ꜱᴜᴜᴍ. Eᴛ ᴜɪᴅɪᴛ ᴅᴇᴜꜱ qᴜᴏᴅ ᴇᴛ
ʙᴏɴᴜᴍ: ʙᴇɴᴇᴅɪᴊɪᴛqᴀ: ᴇꜱ ᴅɪᴄᴇɴꜱ. Cʀᴇꜱᴄɪᴛᴇ ᴇᴛ ᴍᴜʟᴛɪᴘʟɪᴄᴀᴍɪ
ɴɪ ᴇᴛ ʀᴇᴘʟᴇᴛᴇ ᴀqᴜᴀꜱ ᴍᴀʀɪꜱ. ᴀᴜɪᴇꜱq: ᴍᴜʟᴛɪᴘʟɪᴄᴇɴᴛᴜʀ ꜱᴜᴘᴇʀ
ᴛᴇʀʀᴀᴍ. Eᴛ ꜰᴀᴄᴛᴜᴍ ᴇꜱᴛ ᴜᴇꜱᴘᴇʀᴇ

59. Creation of the Birds and Fishes.
Aberdeen, University Lib., 24, f. 2 (cat. 17)

ᴜɪꜱ ꜱᴘᴇᴄɪᴇᴍ ꜰᴏʀᴍᴀᴍq: ʀᴇᴘᴀʀᴀᴛᴜʀ. Dᴏᴄᴇᴀᴛ ɴᴏꜱ g̃
ʜᴇᴄ ᴀᴜɪꜱ ᴜᴇʟ ᴇʀᴇᴍᴘʟᴏ ꜱᴜɪ ʀᴇꜱᴜʀʀᴇᴄᴛɪᴏɴᴇᴍ ᴄʀᴇᴅᴇʀᴇ
qᴜᴇ ᴇᴛ ꜱɪɴᴇ ᴇʀᴇᴍᴘʟᴏ ᴇᴛ ꜱɪɴᴇ ʀᴀᴛɪᴏɴɪꜱ ᴘᴄᴇᴘᴛɪᴏɴᴇ ɪᴘ
ꜱᴀ ꜱɪʙɪ ɪɴꜱɪɢɴɪᴀ ʀᴇꜱᴜʀʀᴇᴄᴛɪᴏɴɪꜱ ɪɴꜱᴛᴀᴜʀᴀᴛ. ᴇᴛ ᴜᴛɪq:
ᴀᴜɪꜱ ᴘᴘᴛ ʜᴏᴍɪɴᴇᴍ ꜱᴜɴᴛ ɴᴏɴ ʜᴏᴍᴏ ᴘᴘᴛᴀᴜᴇ.
Sɪᴄ ɪɢɪᴛᴜʀ ᴇʀᴇᴍᴘʟᴜᴍ ɴᴏʙ qᴜɪᴀ ᴀᴜᴄᴛᴏʀ ᴇᴛ ᴄʀᴇᴀᴛᴏʀ
 ᴀᴜɪᴜᴍ
 ꜱᴄᴏꜱ ꜱᴜᴏꜱ
 ɪᴍᴘᴘᴇ
 ᴄᴛᴜᴜᴍ ᴘɪ
 ʀᴇ ɴ̃ ᴘᴀꜱ
 ꜱᴜꜱ. ʀᴇꜱᴜʀ
 ɢᴇɴᴛᴇᴍ
 ᴇᴀᴍ ꜱᴜɪ
 ꜱᴇᴍɪɴᴇ
 ᴜᴏʟᴜɪᴛ
 ʀᴇᴘᴀʀᴀʀɪ.
 Q̃ꜱ ɢ̃ ʜᴜɪᴄ
 ᴀɴɴᴜɴᴛɪ
 ᴀᴛ ᴅɪᴇᴍ

ᴍᴏʀᴛɪꜱ ᴜᴛ ꜰᴀᴄɪᴀᴛ ꜱɪʙɪ ᴛʜᴇᴄᴀᴍ ᴇᴛ ɪᴍᴘʟᴇᴀᴛ ᴇᴀᴍ ʙᴏ
ɴɪꜱ ᴏᴅᴏʀɪʙ; ᴀᴛq: ɪɴɢʀᴇᴅɪᴀᴛᴜʀ ɪɴ ᴇᴀᴍ ᴇᴛ ᴍᴏʀɪᴀᴛ

60. Phoenix rising in Flames.
Aberdeen, University Lib., 24, f. 56 (cat. 17)

Sᴇᴅ ʜᴇᴄ ᴅᴏᴄᴇᴛ ᴍᴜʀᴇɴᴇ ᴇᴛ ᴜɪᴘᴇ ɴᴏɴ ɪᴜʀᴇ ɢᴇɴᴇʀɪꜱ: ꜱᴇᴅ ᴀʀᴅᴏʀᴇ
ʟɪʙɪᴅɪɴɪꜱ ᴇʀᴘᴇᴛɪᴜꜱ ᴀᴍᴘʟᴇʀᴜꜱ. Oʀꜱᴀᴛᴇ ᴏ̃ ᴜɪʀɪ q̃ ᴀʟɪᴇɴᴀᴍ ᴘᴍᴏ
ʟɪᴜʀᴇ qᴜᴇʀɪᴛ ᴜʀᴏʀᴇᴍ. Cᴜɪ ꜱᴇʀᴘᴇɴᴛᴜꜱ ꜱɪʙɪ ᴀꜱᴄɪꜱᴄᴇʀᴇ ᴄᴜᴘɪᴀᴛ ᴄᴏɴᴛᴜʙᴇʀ
ɴɪᴜᴍ. ᴄᴜɪ ᴇᴛɪᴀᴍ ᴄᴏᴍᴘᴀʀᴀɴᴅᴜꜱ ɪᴘᴇ ꜱᴇʀᴘᴇɴᴛɪ ꜱɪᴛ. Fᴇꜱᴛɪɴᴇᴛ ᴀᴅ
ᴜɪᴘᴀᴍ. qᴜᴇ ꜱᴇ ɪɴ ɢʀᴇᴍɪᴜᴍ ᴜʙɪ ɴᴏɴ ᴅɪʀᴇᴄᴛᴏ ᴛʀᴀᴍɪᴛᴇ ᴜᴇʀᴛᴀᴛɪꜱ.
ꜱ: ʟᴜʙʀɪᴄᴏ ᴅᴇᴍ ᴀᴍᴏʀɪꜱ ɪɴꜰᴜɴᴅᴜʀ Fᴇꜱᴛɪɴᴀᴛ ᴀᴅ ᴇᴀᴍ qᴜᴇ ᴜᴇɴᴇ
ɴᴜᴍ ꜱᴜᴜᴍ ʀᴇꜱᴜᴍɪᴛ ᴜᴛ ᴜɪᴘᴀ. Qᴜᴇ ꜰᴇʀᴛ ᴘᴀᴄᴛᴏ ᴄᴏɴɪᴜɴᴄᴛɪᴏɴɪꜱ
ᴍᴜɴᴇ: ᴜᴇɴᴇɴᴜ̃ qᴅ ᴜᴏᴍᴜᴇʀᴀᴛ ʀᴜʀ ʜᴀᴜʀɪʀᴇ. Dᴇ ᴀꜱᴘɪᴅᴇ.

ꜱᴘɪꜱ ᴜᴏᴄᴀᴛᴀ qᴜᴏᴅ ᴍᴏʀꜱᴜ ᴜᴇɴᴇɴᴀ ɪᴍᴍɪᴛᴛᴀᴛ ᴇᴛ ꜱᴘᴀʀɢɪᴛ. ɪᴏꜱ
ᴇɴɪᴍ ɢʀᴇᴄɪ ᴜᴇɴᴇɴᴜᴍ ᴅɪᴄᴜɴᴛ. ᴇᴛ ɪɴᴅᴇ ᴀꜱᴘɪꜱ qᴜᴏᴅ ᴍᴏʀꜱᴜ

61. Asp. Aberdeen, University Lib., 24,
f. 67ᵛ (cat. 17)

62. Adam naming the Animals. Oxford, Bodl. Lib., Ashmole 1511, f. 9 (cat. 19)

63. Lions. Oxford, Bodl. Lib., Ashmole 1511. f. 10 (cat. 19)

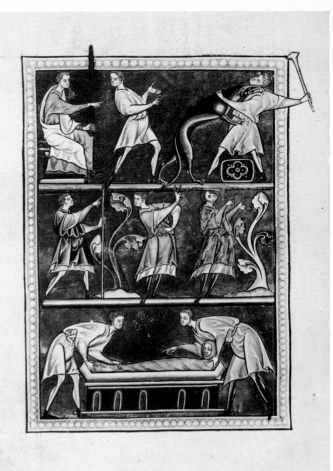

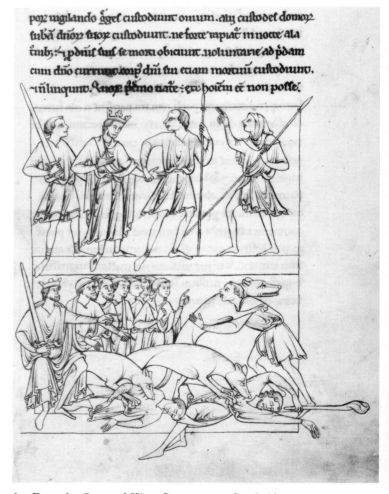

64. Dog, the Story of King Garamantes. Oxford,
Bodl. Lib., Ashmole 1511, f. 25ᵛ (cat. 19)

65. Dog, identification of a Murderer. Oxford,
Bodl. Lib., Ashmole 1511, f. 27ᵛ (cat. 19)

66. Lions. Cambridge, University Lib.,
Ii. 4. 26, f. 1 (cat. 21)

67. Dog, the Story of King Garamantes. Cambridge,
University Lib., Ii. 4. 26, f. 19 (cat. 21)

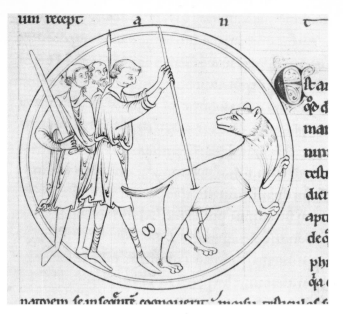

um recept a n t

natquem se infeatute coanouerit imate ethedate

68. Beaver. Cambridge, University Lib.,
Ii. 4. 26, f. 8ᵛ (cat. 21)

Teodrillus aciueo colore dictus. gignit in nilo flumi

69. Crocodile. Cambridge, University Lib.,
Ii. 4. 26, f. 15 (cat. 21)

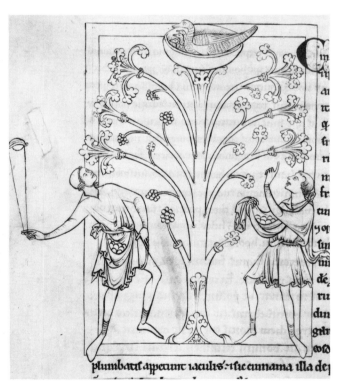

plumbaris apperunt iaculis: sie eunama illa de

70. Cinnamolgus. Cambridge, University Lib.,
Ii. 4. 26, f. 37ᵛ (cat. 21)

71. Hedgehog, man holding a Hedgehog.
Rome, Vatican, Bibl. Apostolica,
Reg. Lat. 258, f. 18ᵛ (cat. 20)

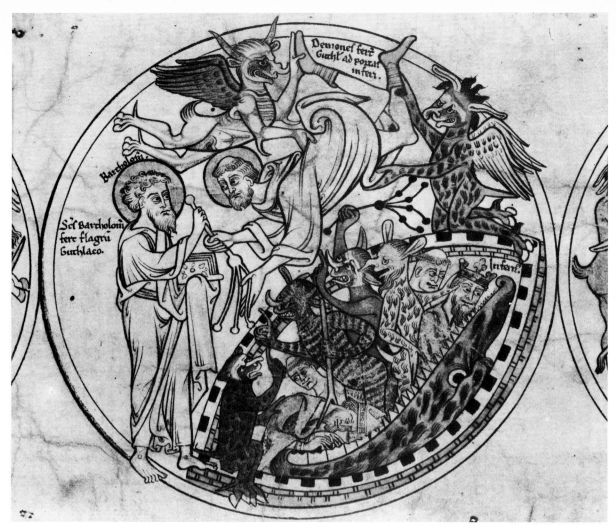

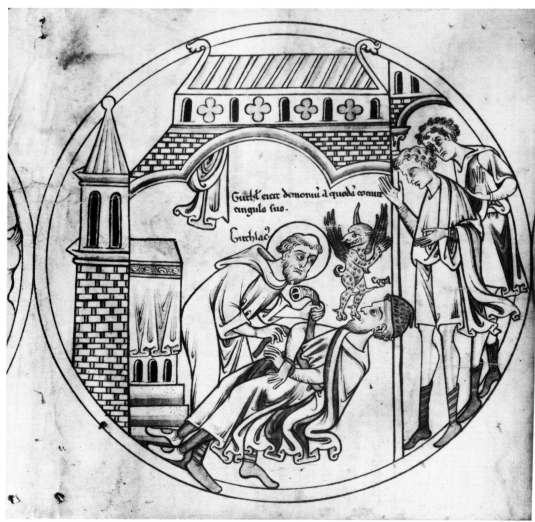

72–3. St. Bartholomew gives the Scourge to Guthlac. Guthlac casts a Demon out of Ecgga.
London, B.L., Harley Roll Y.6 (cat. 22)

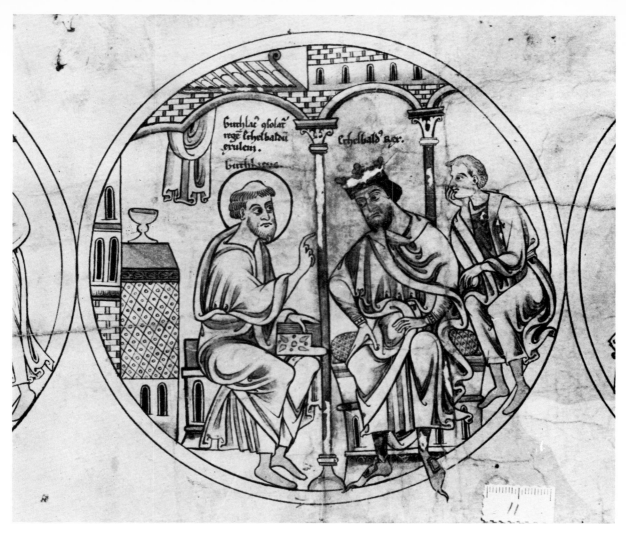

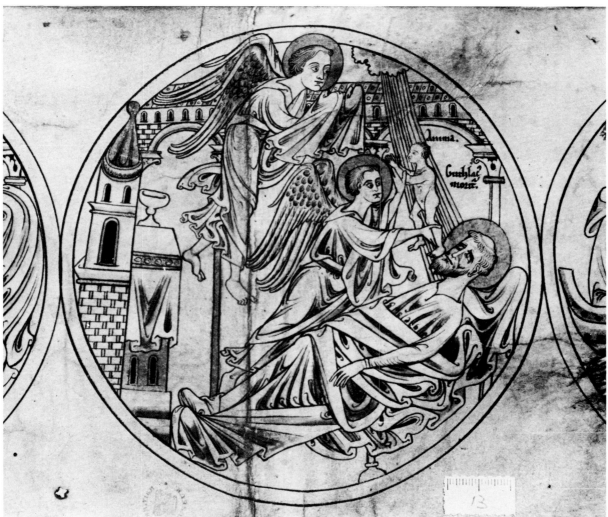

74–5. Ethelbald seeks the Counsel of Guthlac. Angels receive the Soul of the dying Guthlac.
London, B.L., Harley Roll Y.6 (cat. 22)

76. Scenes of Adam and Eve. Munich, Bayerische Staatsbibl., Clm. 835, f. 8ᵛ (cat. 23)

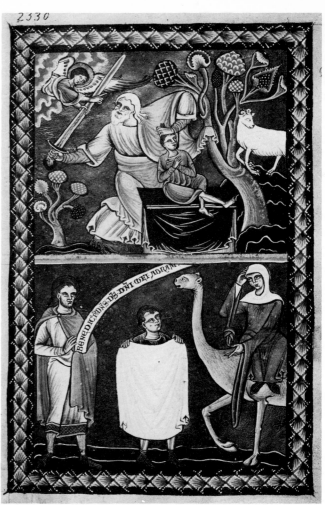

77. Sacrifice of Abraham, Isaac's meeting with Rebecca. Munich, Bayerische Staatsbibl., Clm. 835, f. 12 (cat. 23)

78. Joseph interprets Pharaoh's Dream, Joseph inspects the Granaries. Munich, Bayerische Staatsbibl., Clm. 835, f. 15 (cat. 23)

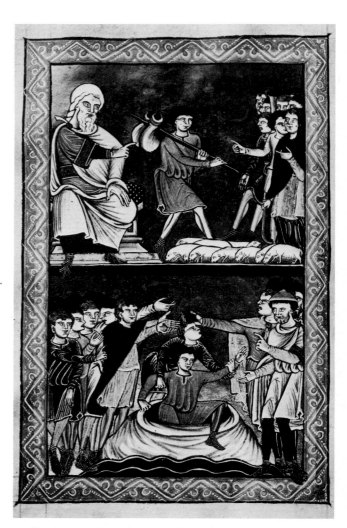

79. Jacob sends Joseph to visit his Brothers, Joseph taken from the Pit. Munich, Bayerische Staatsbibl., Clm. 835, f. 13ᵛ (cat. 23)

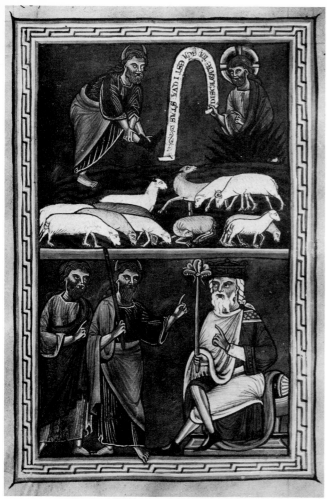

80. Moses and the Burning Bush, Moses and Aaron before
Pharaoh. Munich, Bayerische Staatsbibl. Clm. 835, f. 18 (cat. 23)

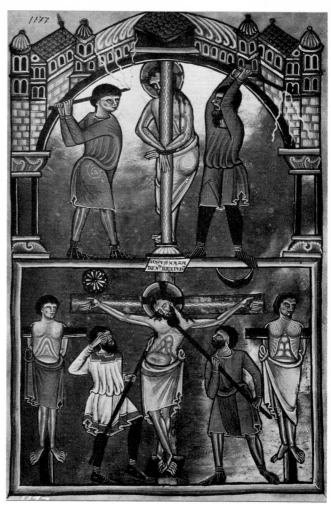

81. Flagellation, Crucifixion. Munich,
Bayerische Staatsbibl., Clm. 835, f. 26 (cat. 23)

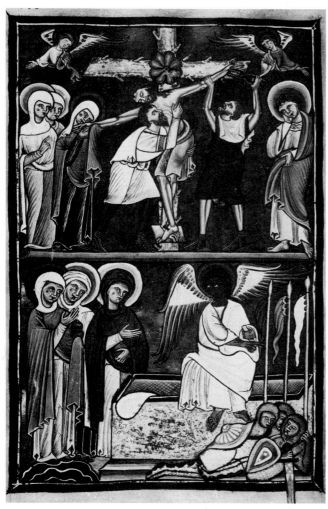

82. Deposition, Holy Women at the Tomb. Munich,
Bayerische Staatsbibl., Clm. 835, f. 26ᵛ (cat. 23)

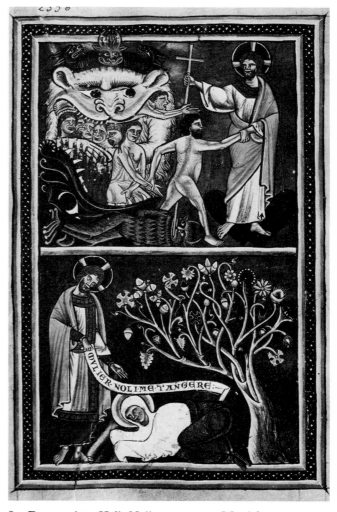

83. Descent into Hell, Noli me tangere. Munich,
Bayerische Staatsbibl., Clm. 835, f. 27 (cat. 23)

84. Psalm 148, the praise of God. Munich, Bayerische Staatsbibl.,
Clm. 835, f. 146ᵛ (cat. 23)

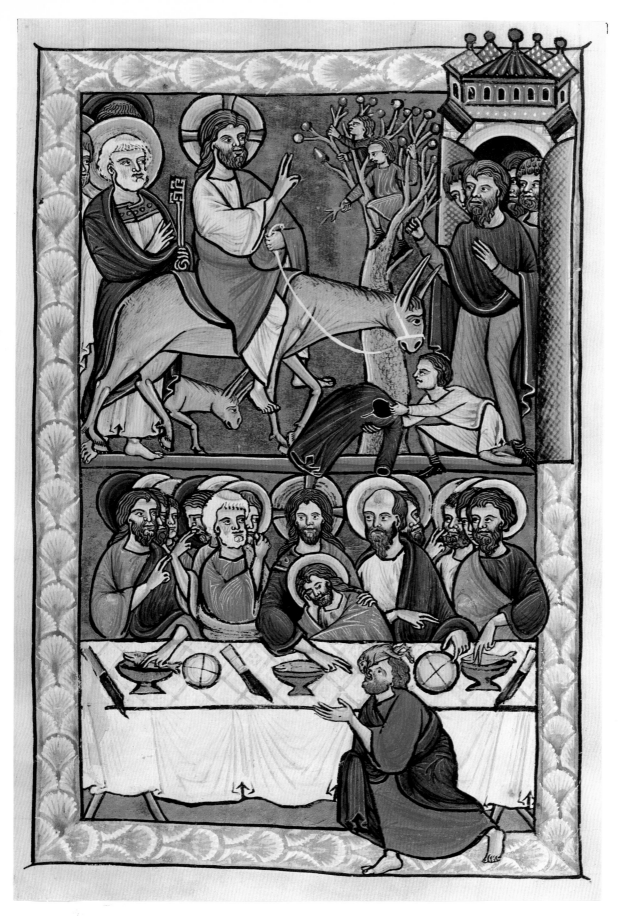

85. Entry into Jerusalem, Last Supper. Munich,
Bayerische Staatsbibl., Clm. 835, f. 24ᵛ (cat. 23)

86. Psalm 52, ornamental D. Munich,
Bayerische Staatsbibl., Clm. 835, f. 73 (cat. 23)

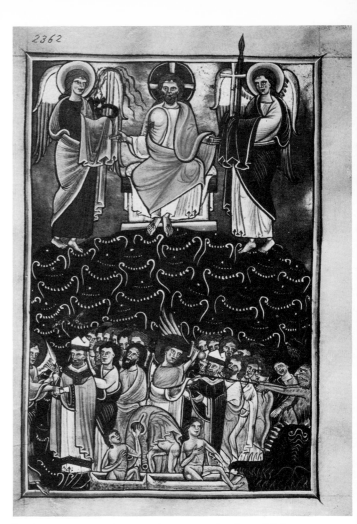

87. Last Judgement. Munich, Bayerische Staatsbibl.,
Clm. 835, f. 30 (cat. 23)

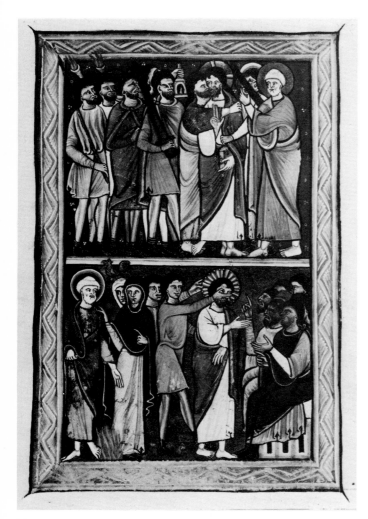

88. Betrayal, Peter's Denial and Trial of Christ.
London, B.L., Arundel 157, f. 9ᵛ (cat. 24)

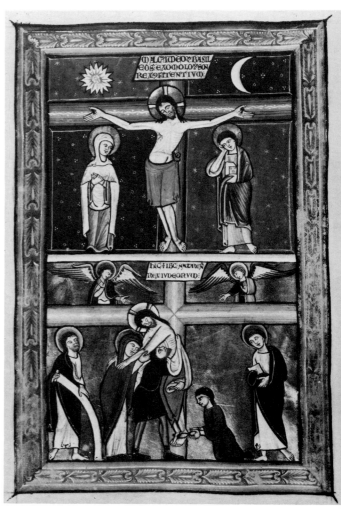

89. Crucifixion, Deposition. London, B.L.,
Arundel 157, f. 10ᵛ (cat. 24)

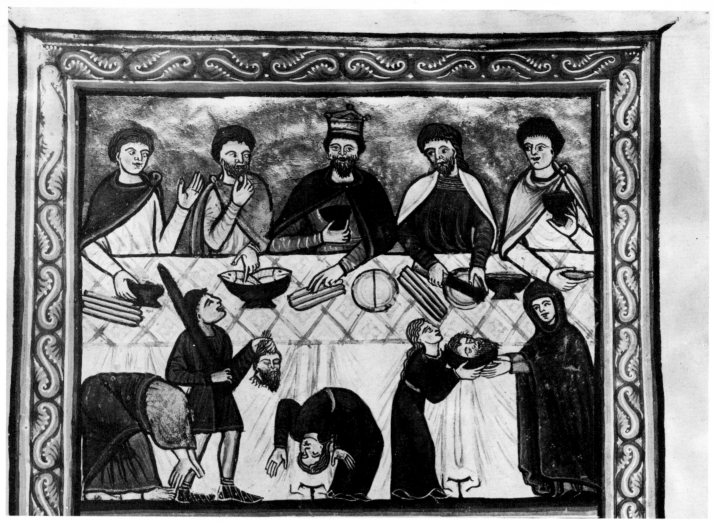

90. Herod's Feast, Beheading of John the Baptist.
London, B.L., Arundel 157, f. 7 (cat. 24)

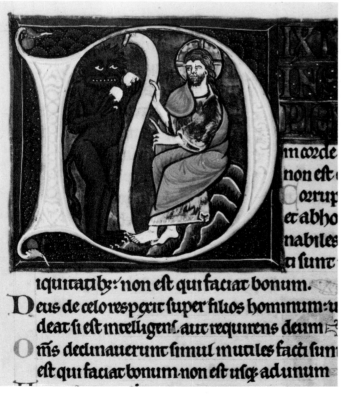

iquitatib;: non est qui faciat bonum.
Deus de celo respexit super filios hominum: u
deat si est intelligens. aut requirens deum
Omis declinauerunt simul inutiles facti sun
est qui faciat bonum non est usq; adunum

91. Psalm 52, Temptation of Christ. London, B.L.,
Arundel 157, f. 52 (cat. 24)

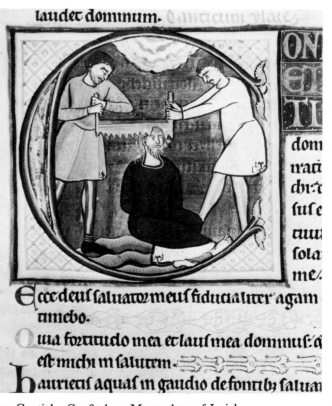

laudet dominum.

Ecce deus saluator meus fiducialiter agam
timebo.
Quia fortitudo mea et laus mea dominus: o
est michi in salutem.
haurietis aquas in gaudio de fontib; saluta

92. Canticle, Confitebor, Martyrdom of Isaiah.
London, B.L., Arundel 157, f. 116 (cat. 24)

93. Psalm 38, Judgement of Solomon.
Imola, Bibl. Comunale, 100, p. 80 (cat. 26)

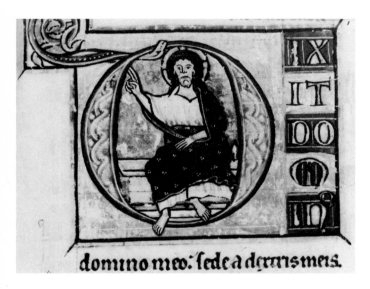

domino meo: sede a dextris meis.

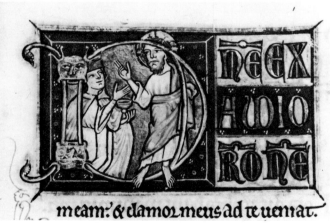

meam: & clamor meus ad te veniat.

94–5. Psalm 109, Christ seated blessing.
Psalm 101, Ecclesia kneels before Christ.
Oxford, Bodl. Lib., Liturg. 407, ff. 159,140 (cat. 27)

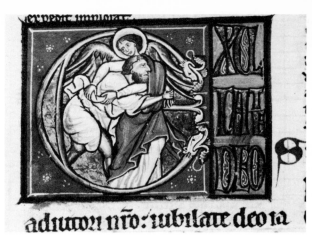

adiutori nro: iubilate deo ia

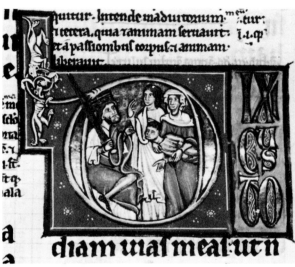

diam uiaf meaf ut n

96–7. Psalm 80, Jacob wrestling with the Angel.
Psalm 38, Judgement of Solomon. Liverpool,
City Lib., f. 091. PSA, ff. 145ᵛ, 69ᵛ (cat. 25)

peccatoris liberabit cos
lux orta ē iusto: & rectis c
etamini iusti in domino:
memorie sanctificatonis

tera eius: & brachium sa
orum fecit dominus saluta

98. Psalm 97, David harping. Edinburgh,
National Lib., 10000, f. 85ᵛ (cat. 29)

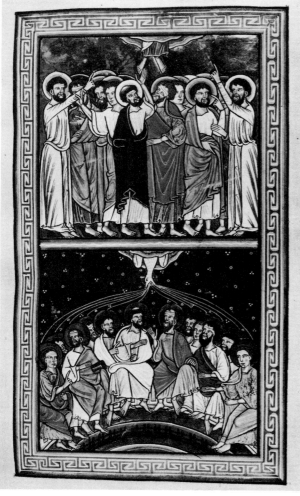

99. Ascension, Pentecost. London B.L.,
Royal 1. D. X., f. 8 (cat. 28)

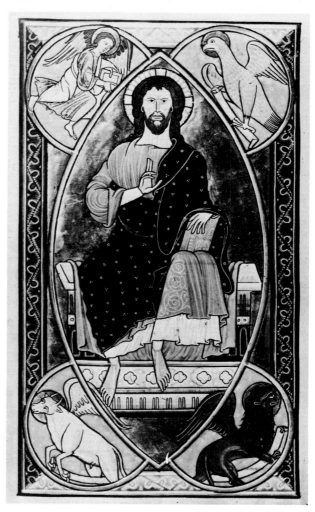

100. Christ in Majesty. London B.L.,
Royal 1. D. X., f. 8ᵛ (cat. 28)

101–2. Psalm 80, Jacob's Dream, Jacob and the Angel.
Psalm 97, Annunciation to the Shepherds.
Imola, Bibl. Comunale, 100, pp. 174, 207 (cat. 26)

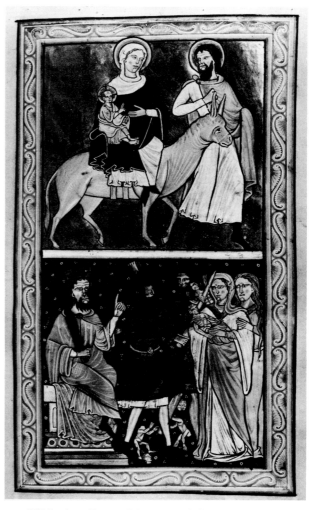

103. Flight into Egypt, Massacre of the Innocents.
London, B.L., Royal 1. D. X., f. 3 (cat. 28)

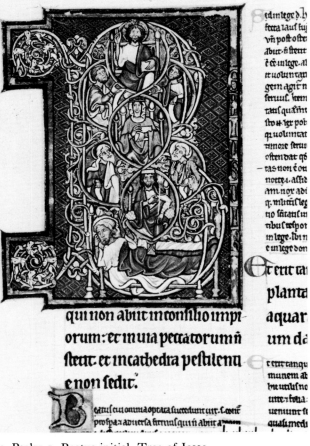

104. Psalm 1, Beatus initial, Tree of Jesse.
Liverpool, City Lib., f. 091. PSA, f. 1 (cat. 25)

105. Psalm 1, Beatus initial, London, B.L.,
Royal 1. D. X., f. 16 (cat. 28)

106. Psalm 1, Beatus initial. Edinburgh,
National Lib., 10000, f. 7 (cat. 29)

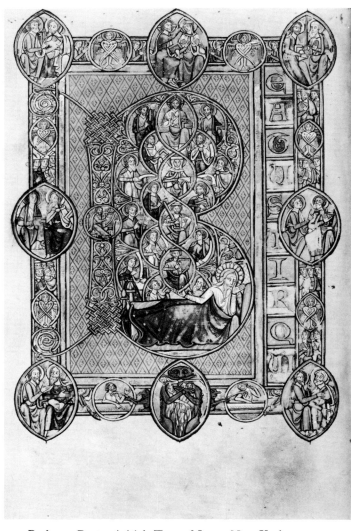

107. Psalm 1, Beatus initial, Tree of Jesse. New York,
Pierpont Morgan Lib., M. 43, f. 27ᵛ (cat. 30)

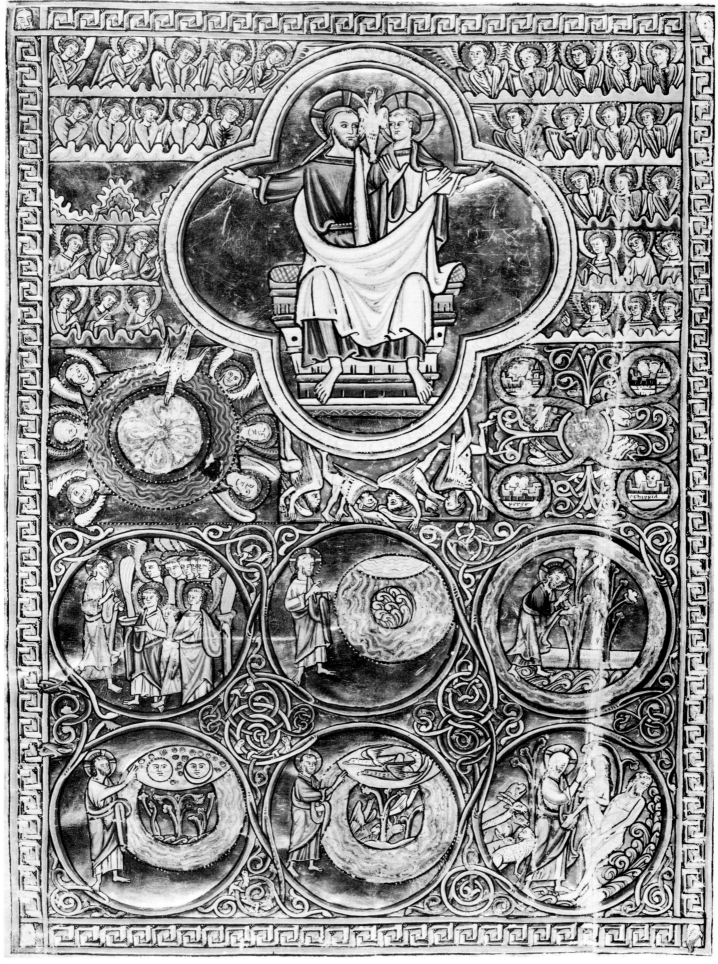

108. Creation Scenes. New York, Pierpont Morgan Lib., M 791, f. 4ᵛ (cat. 32)

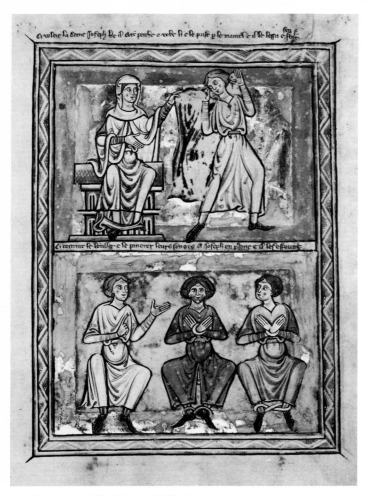

109. Joseph and Potiphar's Wife, Joseph
with the Butler and Baker. New York,
Pierpont Morgan Lib., M. 43, f. 12ᵛ (cat. 30)

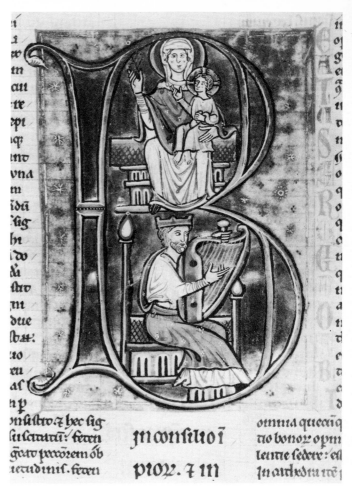

110. Psalm 1, Beatus initial, Virgin and Child,
David harping. Oxford, Bodl. Lib.,
Bodley 284, f. 1 (cat. 31)

111. Cynewulf King of Wessex. London, B.L.,
Cotton Claudius B. VI, f. 9ᵛ (cat. 41)

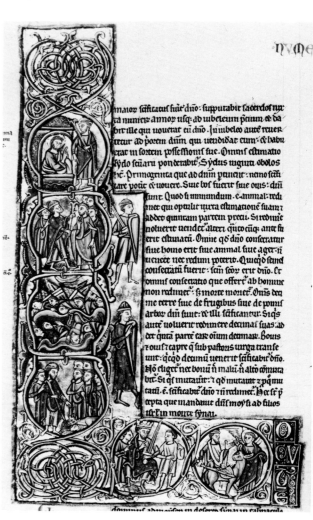

112. Old Testament Scenes. Initial to Numbers.
New York, Pierpont Morgan Lib., M. 791, f. 36ᵛ (cat. 32)

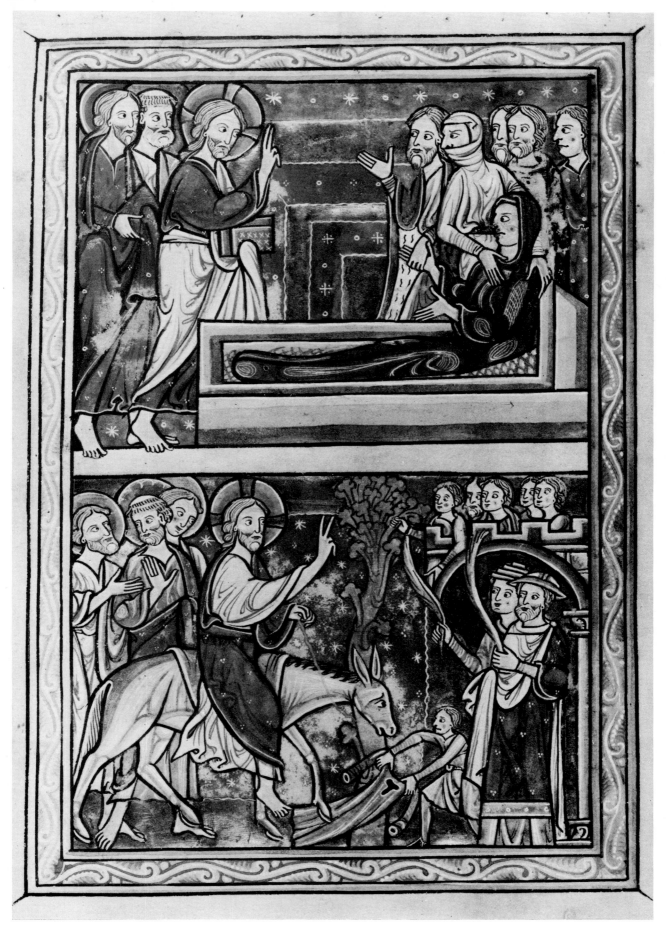

113. The Raising of Lazarus, Entry into Jerusalem.
New York, Pierpont Morgan Lib., M. 43, f. 21ᵛ (cat. 30)

114. Psalm 16, Resurrection of Christ. Oxford, Bodl. Lib., Ashmole 1525, f. 14 (cat. 33)

117. Initial to Collect for Psalm 16. Oxford, Bodl. Lib., Ashmole 1525, f. 14 (cat. 33)

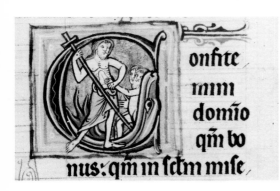

118. Psalm 56, King sitting in Judgement. Oxford, Bodl. Lib., Ashmole 1525, f. 44 (cat. 33)

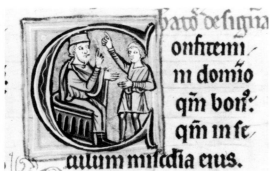

115–16. Psalm 106, Descent into Hell. Psalm 105, Man before a seated King. Oxford, Bodl. Lib., Ashmole 1525, ff. 90, 88 (cat. 33)

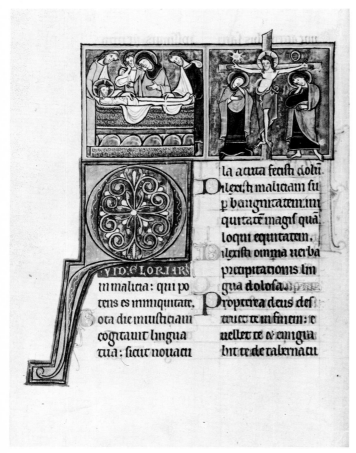

119. Psalm 51, Entombment, Crucifixion. Paris, Bibl. Nat., lat. 770, f. 70ᵛ (cat. 34)

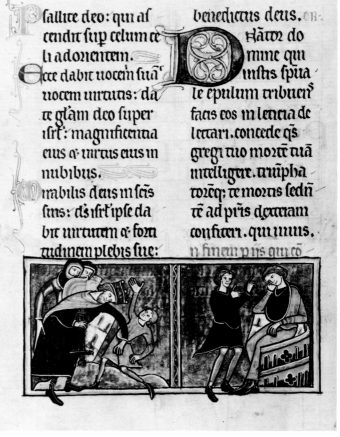

120. Psalm 68, Saul's Suicide, David told of Saul's Death. Paris, Bibl. Nat. lat. 770, f. 87ᵛ (cat. 34)

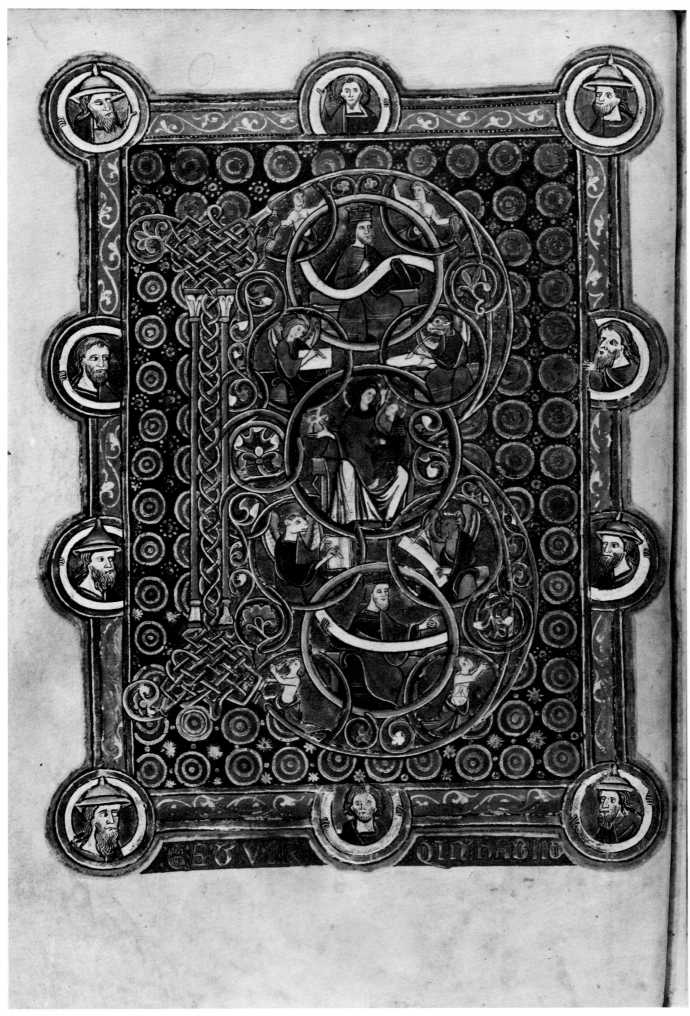

121. Psalm 1, Beatus initial. Paris, Bibl. Nat. lat. 770, f. 11ᵛ (cat. 34)

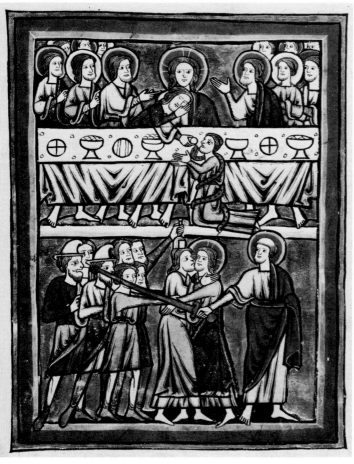

122. Last Supper, Betrayal. Berlin,
Kupferstichkabinett 78. A. 8, f. 13ᵛ (cat. 35)

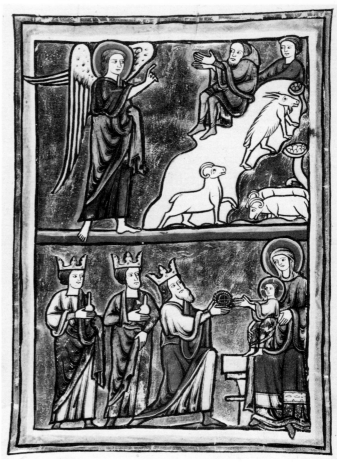

123. Annunciation to the Shepherds, Adoration of the Magi.
Berlin, Kupferstichkabinett 78. A. 8, f. 9ᵛ (cat. 35)

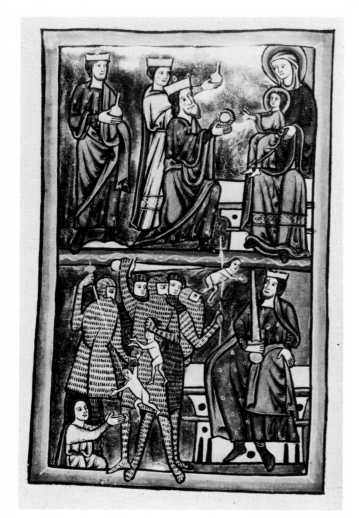

124. Adoration of the Magi, Massacre of the Innocents.
Cambridge, St. John's College, D. 6, f. 28ᵛ (cat. 36)

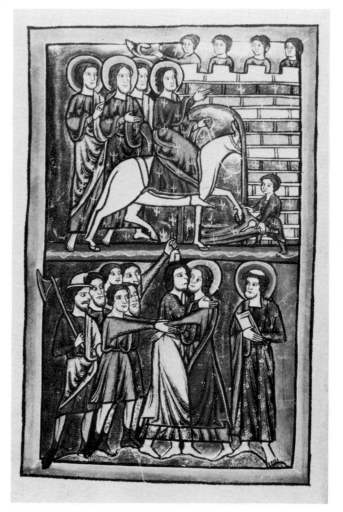

125. Entry into Jerusalem, Betrayal. Cambridge,
St. John's College, D. 6, f. 30ᵛ (cat. 36)

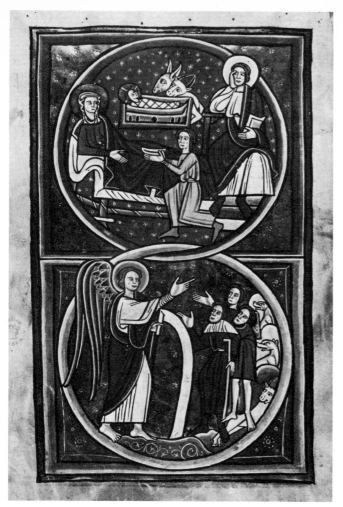

126. Nativity, Annunciation to the Shepherds.
London, B.L., Lansdowne 420, f. 7ᵛ (cat. 37)

127. Psalm 38, Judgement of Solomon. London, B.L.,
Lansdowne 420, f. 47ᵛ (cat. 37)

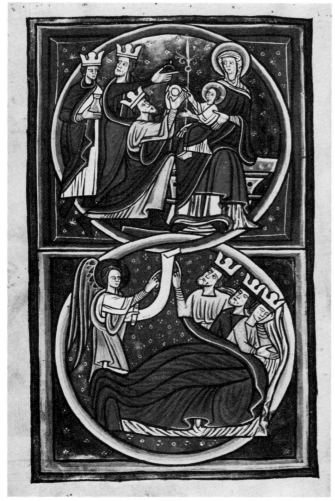

128. Adoration, Dream of the Magi. London, B.L.,
Lansdowne 420, f. 8ᵛ (cat. 37)

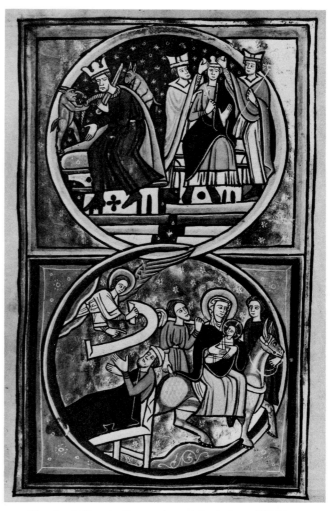

129. Death of Herod, Coronation of Archelaus, Flight
into Egypt. London, B.L., Lansdowne 420, f. 9 (cat. 37)

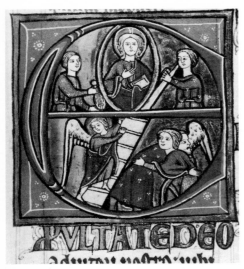

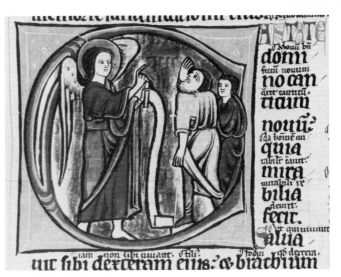

130. Psalm 80, Jacob's Dream. Berlin, Kupferstichkabinett 78. A. 8, f. 80 (cat. 35)

131. Psalm 97, Annunciation to the Shepherds. Cambridge, St. John's College, D. 6, f. 116 (cat. 36)

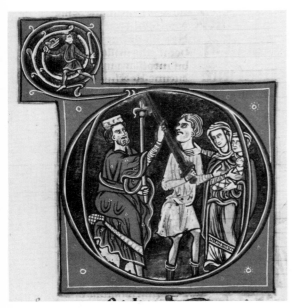

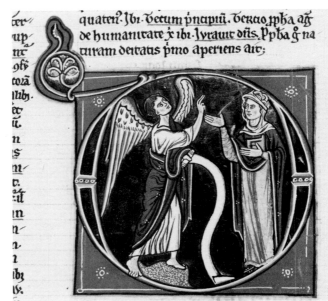

132–3. Psalm 38, Judgement of Solomon. Psalm 109, Annunciation. Cambridge, Corpus Christi College, 75, ff. 71ᵛ, 208 (cat. 38)

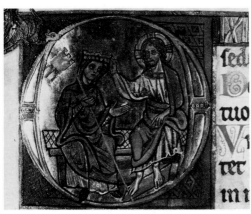

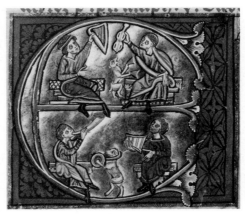

134–5. Psalm 109, Coronation of Ecclesia. Psalm 80, four seated Musicians. London, B.L., Lansdowne 431, ff. 85, 64ᵛ (cat. 39)

136. Psalm 80, David and Musicians. London, B.L., Harley 5102, f. 77ᵛ (cat. 40

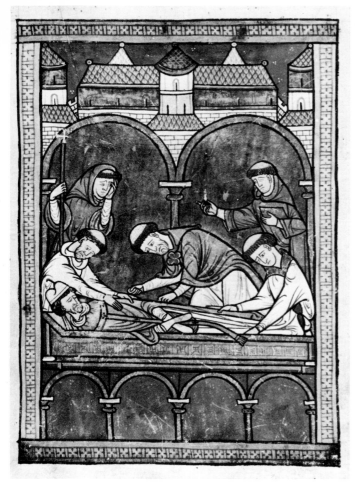

137. Burial of St. Thomas of Canterbury.
London, B.L., Harley 5102, f. 17 (cat. 40)

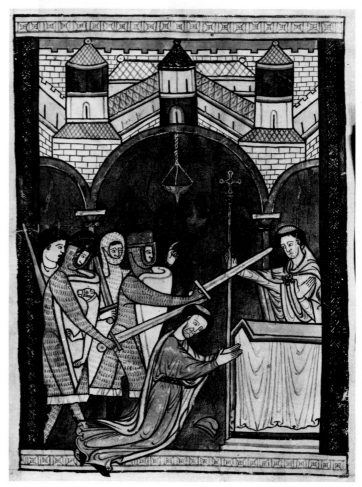

138. Martyrdom of St. Thomas of Canterbury.
London, B.L., Harley 5102, f. 32 (cat. 40)

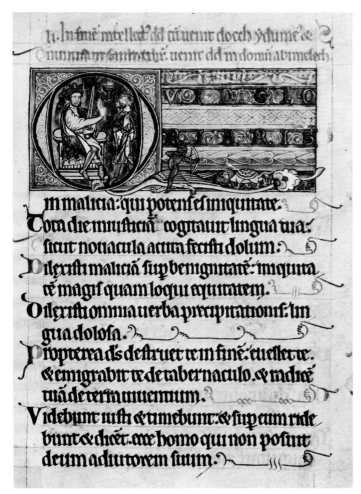

139. Psalm 51, Saul instructs Doeg. London,
B.L., Harley 5102, f. 49 (cat. 40)

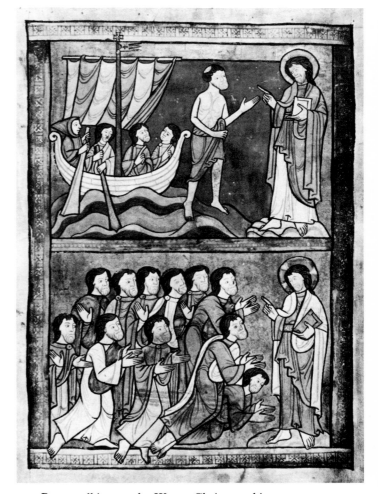

140. Peter walking on the Water, Christ speaking to
the Apostles. London, B.L., Harley 5102, f. 129 (cat. 40)

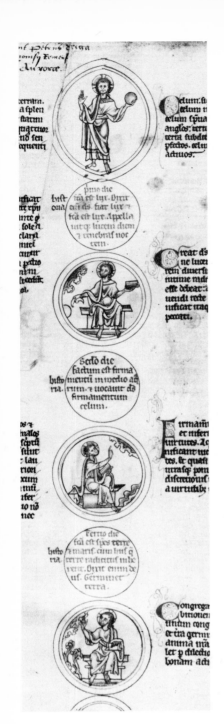

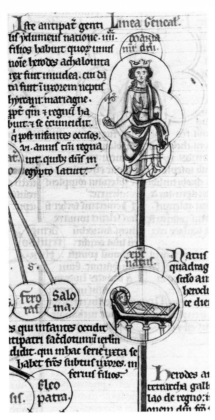

141–2. Creation Scenes.
The Virgin with Christ in the Crib.
Cambridge, Corpus Christi College,
83, ff. 1, 7ᵛ (cat. 43a)

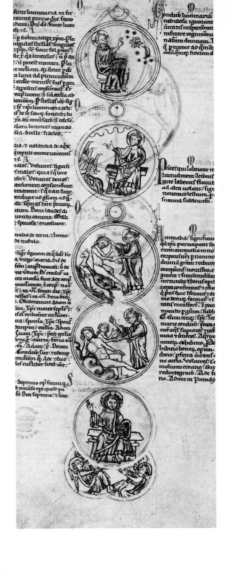

143. Creation Scenes. London,
B.L., Cotton Faustina B. VII,
f. 44ᵛ (cat. 43b)

144. Cain killing Abel. Cleveland,
Museum of Art, CMA 73.5, (cat. 43c)

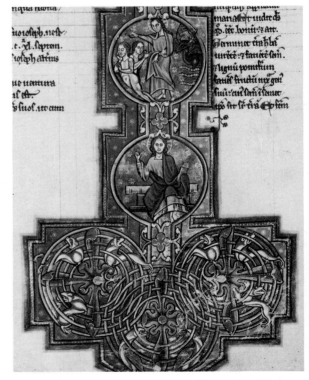

145. Creation Scenes. Cambridge, University Lib.,
Dd. 8. 12, f. 12 (cat. 44)

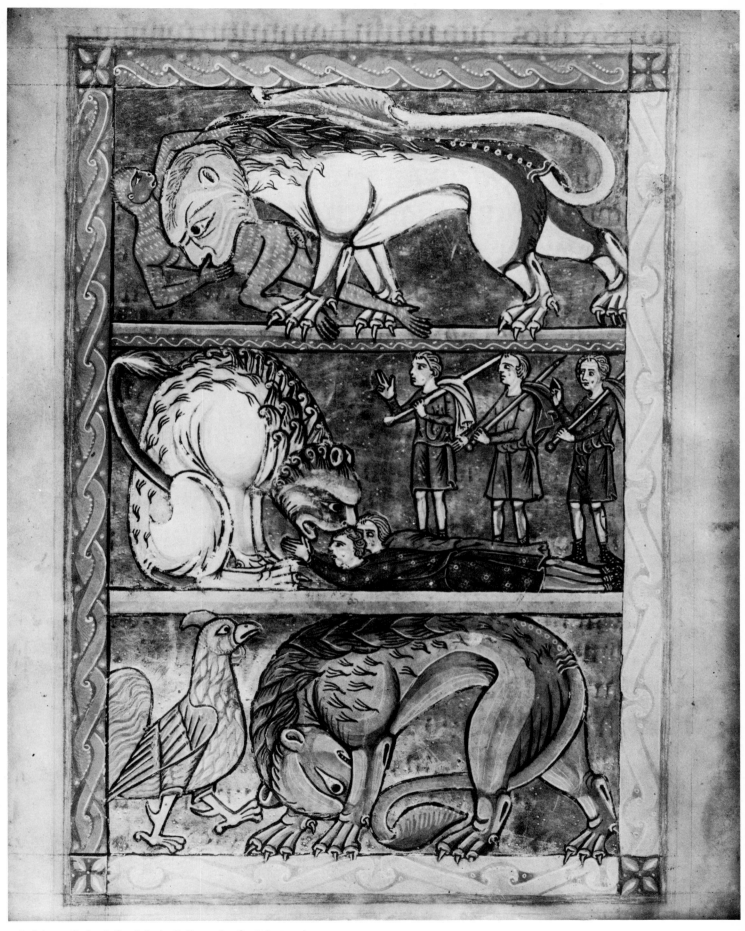

146. Lions. Oxford, St. John's College, 61, f. 3ᵛ (cat. 42)

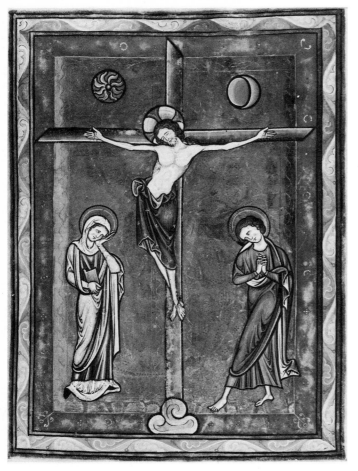

147. The Crucifixion. Cambridge,
Fitzwilliam Museum 12, f. 12 (cat. 45)

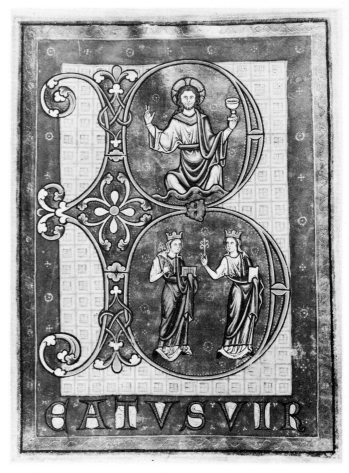

148. Psalm 1, Beatus initial. Cambridge,
Fitzwilliam Museum 12, f. 12ᵛ (cat. 45)

149. Psalm 101, Monk and abbot before an altar.
Cambridge, Fitzwilliam Museum 12, f. 139ᵛ (cat. 45)

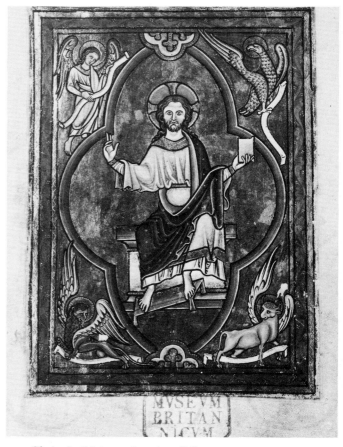

150. Christ in Majesty. London, B.L.,
Cotton Vespasian A. 1, f. 1 (cat. 46)

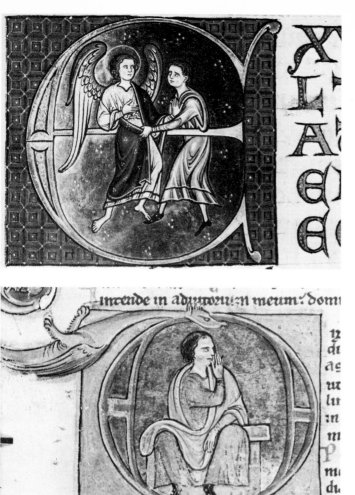

151. Psalm 80, Jacob and the Angel. London,
Society of Antiquaries 59, f. 132ᵛ (cat. 47)

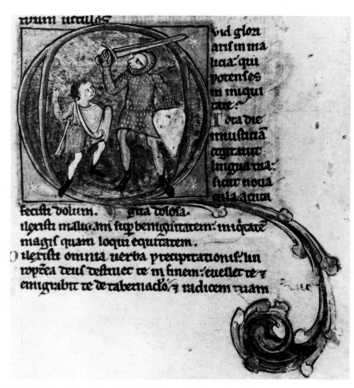

152–3. Psalm 38, David pointing to his Mouth. Psalm 51, David and Goliath. London, Lambeth Palace Lib., 563, ff. 44ᵛ, 53 (cat. 48)

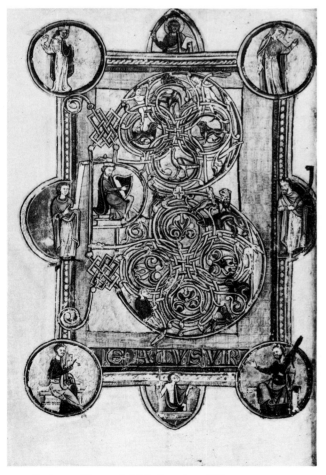

154. Psalm 1, Beatus initial. London, B.L.,
Cotton Vespasian A. 1, f. 1ᵛ (cat. 46)

155. Psalm 1, Beatus initial, David and Musicians.
London, Lambeth Palace Lib., 563, f. 20 (cat. 48)

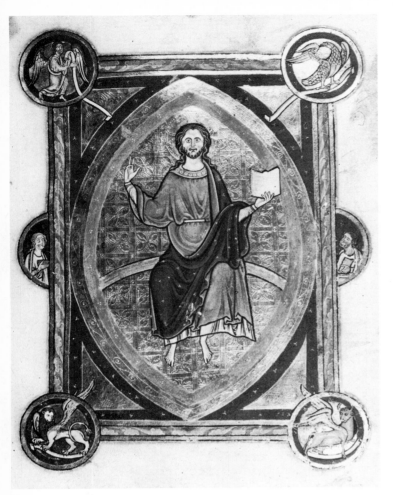

156. Christ in Majesty. London, Society
of Antiquaries 59, f. 36 (cat. 47)

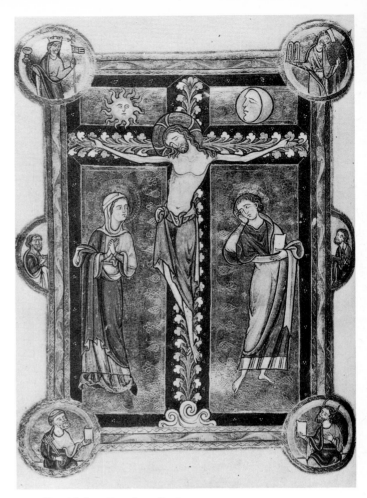

157. Crucifixion. London, Society
of Antiquaries 59, f. 35ᵛ (cat. 47)

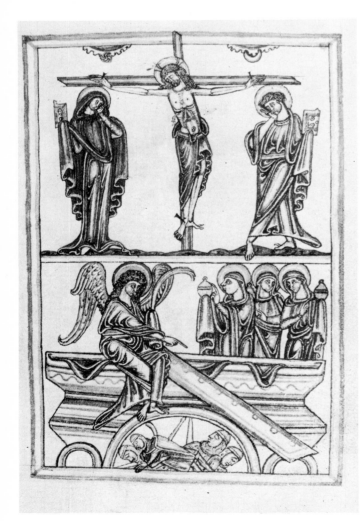

158. Crucifixion, Holy Women at Tomb. London,
Society of Antiquaries 59, f. 34 (cat. 47)

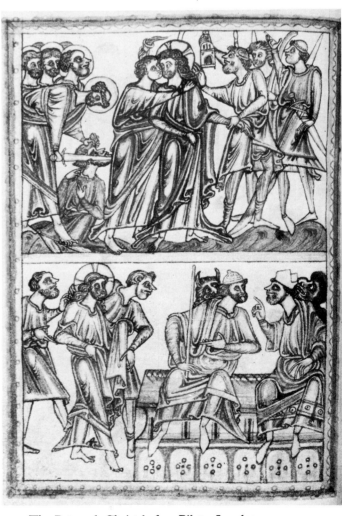

159. The Betrayal, Christ before Pilate. London,
Society of Antiquaries 59, f. 33ᵛ (cat. 47)

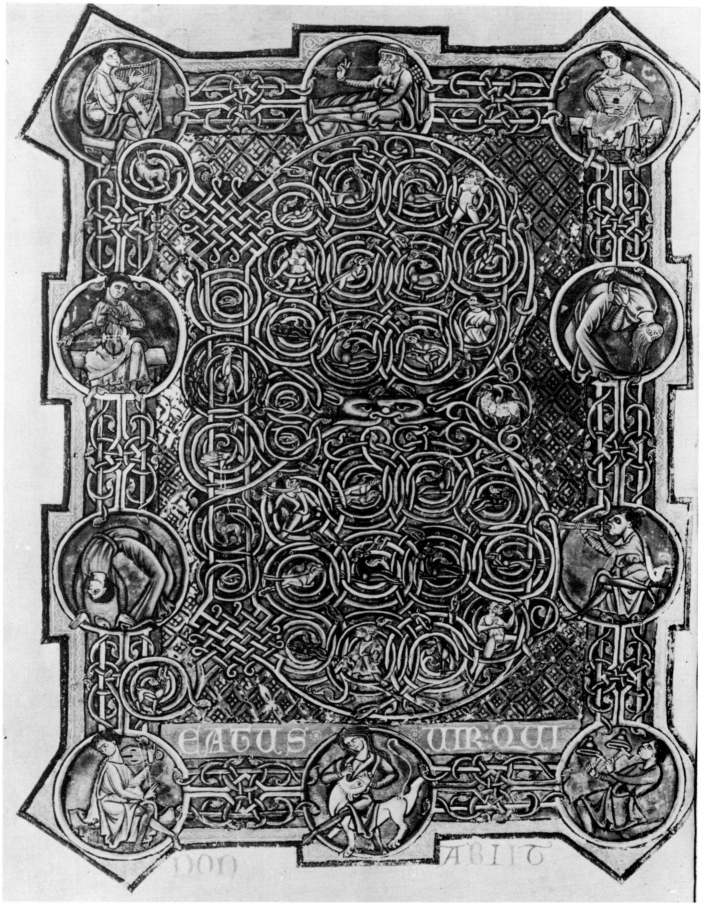

160. Psalm 1, Beatus initial. New York, Pierpont Morgan Lib., Glazier 25, f. 5ᵛ (cat. 50)

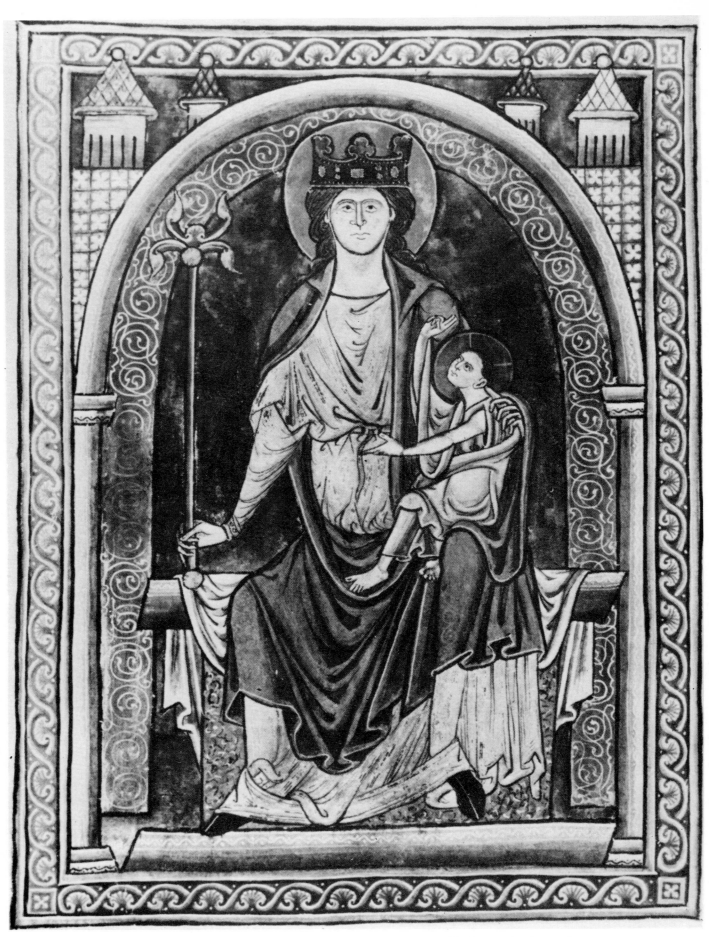

161. Virgin and Child. New York, Pierpont Morgan Lib., Glazier 25, f. 2 (cat. 50)

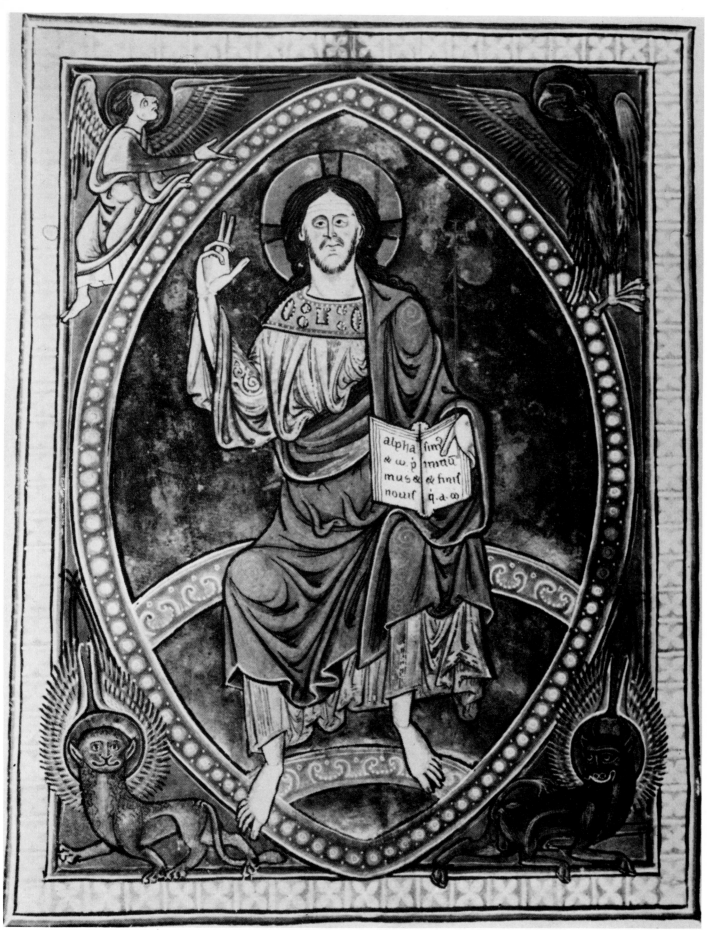

162. Christ in Majesty. New York, Pierpont Morgan Lib., Glazier 25, f. 3 (cat. 50)

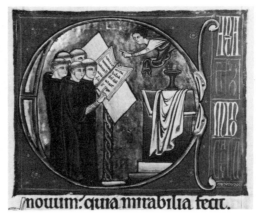

163–4. Psalm 26, David between the lion and the bear. Psalm 97, Monks chanting. Oxford, Magdalen College, 100, ff. 34, 114ᵛ (cat. 49)

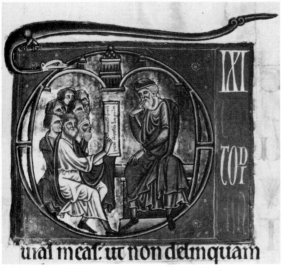

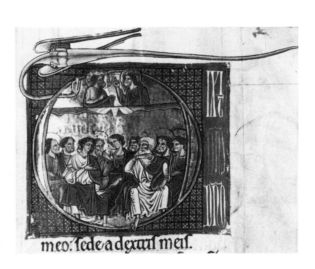

165–6. Psalm 38, Man pointing to mouth. Psalm 109, Trinity, Penteco Oxford, Magdalen College, ff. 49, 134 (cat. 49)

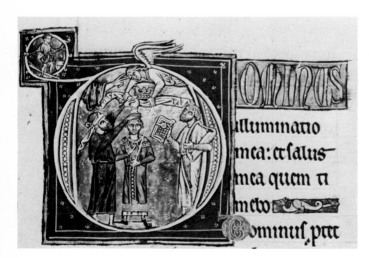

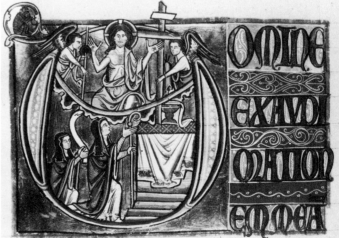

167–8. Psalm 26, Anointing of David. Psalm 38, Judgement of Solomon. Cambridge, Trinity College, B. 11. 4, ff. 37, 52 (cat. 51)

169–70. Psalm 97, Annunciation to the Shepherds. Psalm 101, Abbess before Christ Judge. Cambridge, Trinity College, B. 11. 4, f. 110ᵛ, 113ᵛ (cat. 51)

171. New Testament Scenes. Cambridge,
Trinity College, B. 11. 4, f. 9ᵛ (cat. 51)

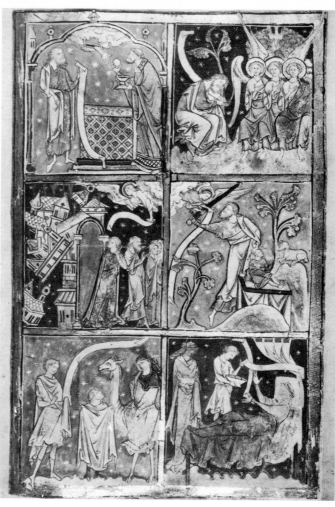

172. Old Testament Scenes. Cambridge, Trinity College,
B. 11. 4, f. 10 (cat. 51)

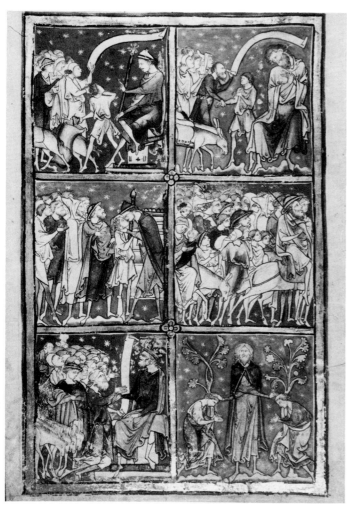

173. Old Testament Scenes. Cambridge, Trinity College,
B. 11. 4, f. 7ᵛ (cat. 51)

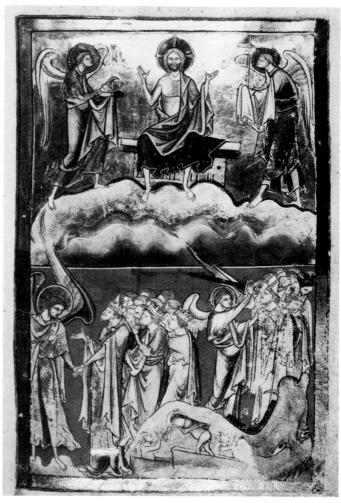

174. Last Judgement. Cambridge, Trinity College,
B. 11. 4, f. 11 (cat. 51)

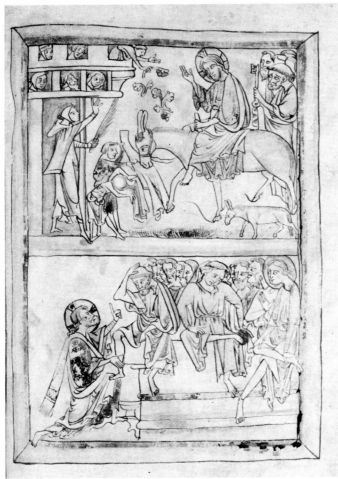

175. Entry into Jerusalem, Washing of the Feet. Cambridge, Emmanuel College, 252 (3.3.21), f. 11 (cat. 52)

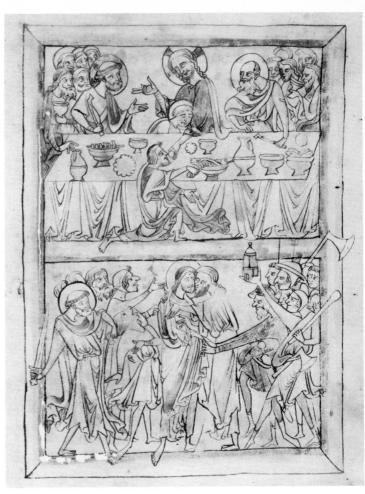

176. Last Supper, Betrayal. Cambridge, Emmanuel College, 252 (3.3.21), f. 11ᵛ (cat. 52)

177. Psalm 1, B, Tree of Jesse. Cambridge, Emmanuel College, 252 (3.3.21), f. 12ᵛ (cat. 52)

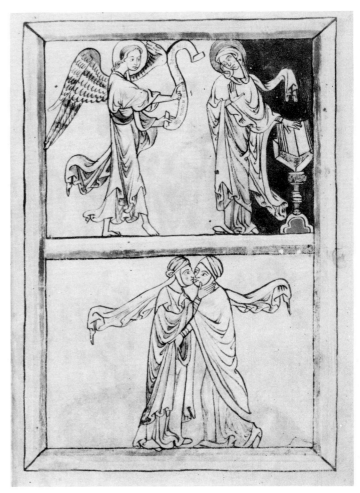

178. Annunciation, Visitation. Cambridge, Emmanuel College, 252 (3.3.21), f. 7 (cat. 52)

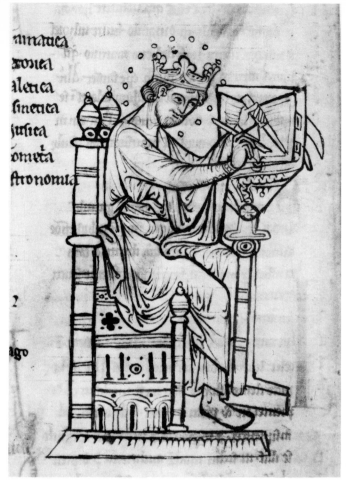

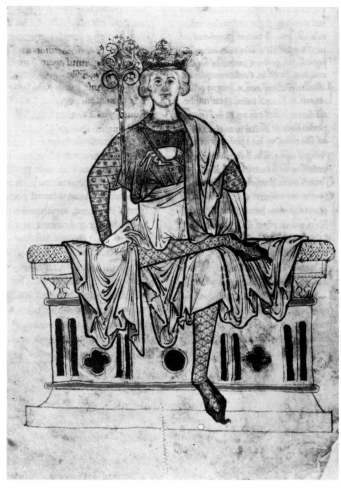

179. Seated Author, Isidore, represented as a King. Cambridge, University Lib., Kk. 4. 25, f. 113ᵛ (cat. 53)

180. Alexander. Cambridge, University Lib., Kk. 4. 25, f. 18ᵛ (cat. 53)

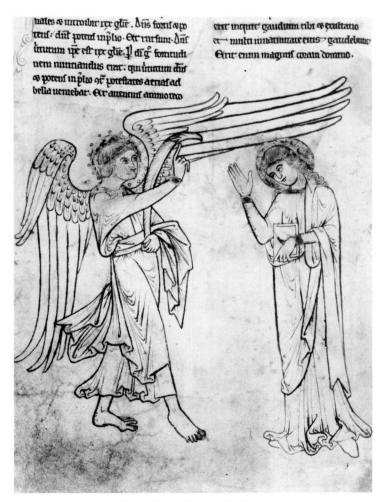

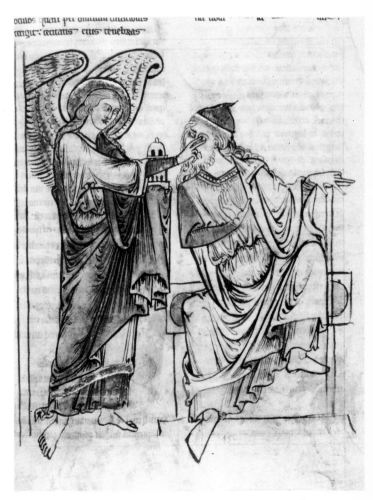

181. Annunciation. Cambridge, University Lib., Kk. 4. 25, f. 47ᵛ (cat. 53)

182. Raphael healing Tobit. Cambridge, University Lib., Kk. 4. 25, f. 48 (cat. 53)

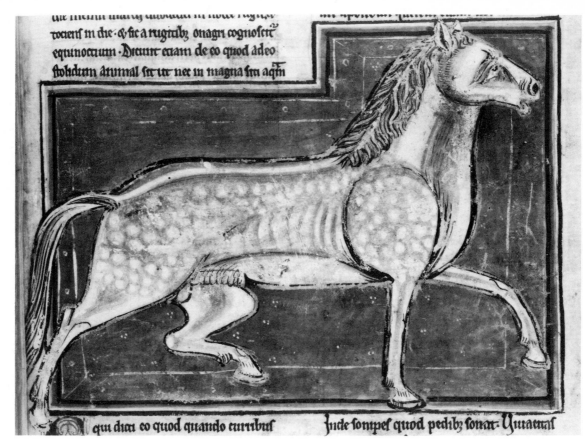

tie micmit mana abbudut in libie rugitet
tottens in die. et sic a rugiub onagri cognoseit
equinoctium. Dicunt etiam de eo quod adeo
stolidum animal sit ut nec in magna sui agm

...fpotioum quimi...

qui dicti eo quod quando turribus
Unde sonipes quod pedibz sonat. Iumentus

183. Horse. Cambridge, University Lib., Kk. 4. 25, f. 59 (cat. 53)

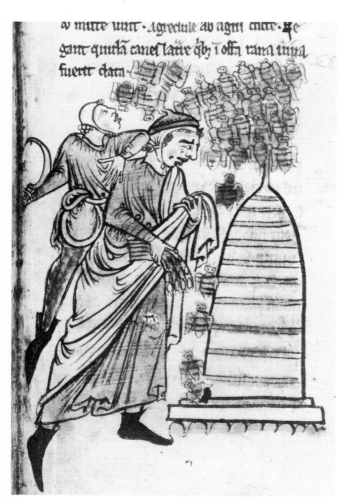

o mitte uut. Agrediule ab agm dicte. Se
gant quida canes latire qbz i offa rana iuua
fuert data.

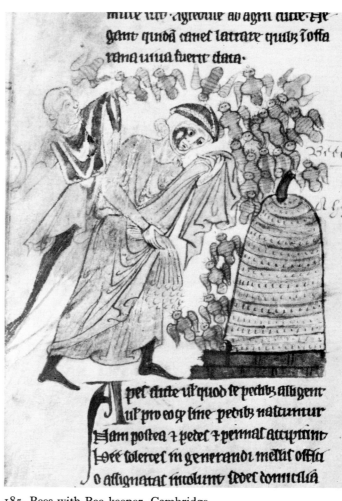

mitte uut. Agrediule ab agm dicte. He
gant quida canes latrare quibz i offa
rana uiua fuerit data.

Apes dicte ut quod se pedibz alligem
Uul pro eo qz sine pedibz natcuntur
Nam postea t pedes t pennas accipiunt
Sore solertes in generandi mellis officia
O assignatac incolunt sedes domicilia

184. Bees with Bee-keeper. Cambridge, University Lib.,
Kk. 4. 25, f. 99 (cat. 53)

185. Bees with Bee-keeper. Cambridge,
Fitzwilliam Museum 254, f. 42ᵛ (cat. 55)

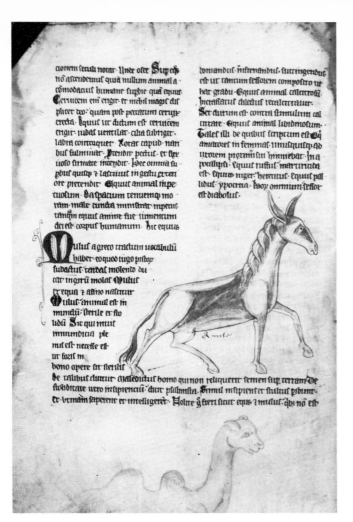

186. Mule. Cambridge, Fitzwilliam Museum
254, f. 8ᵛ (cat. 55)

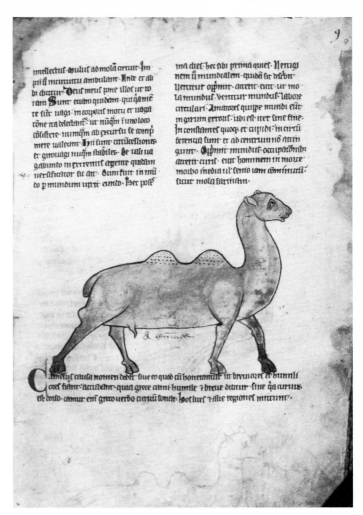

187. Camel. Cambridge, Fitzwilliam Museum
254, f. 9 (cat. 55)

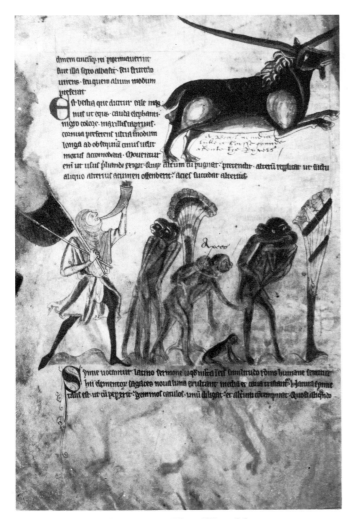

188. Yale, Apes. Cambridge, Fitzwilliam Museum
254, f. 18ᵛ (cat. 55)

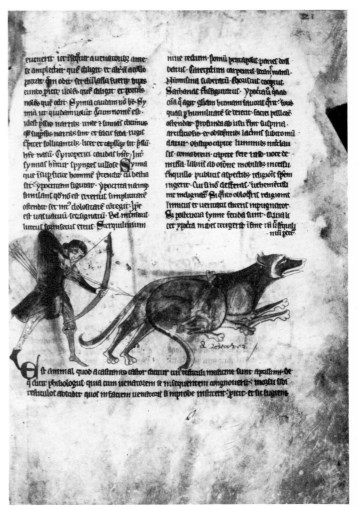

189. Beaver. Cambridge, Fitzwilliam Museum
254, f. 19 (cat. 55)

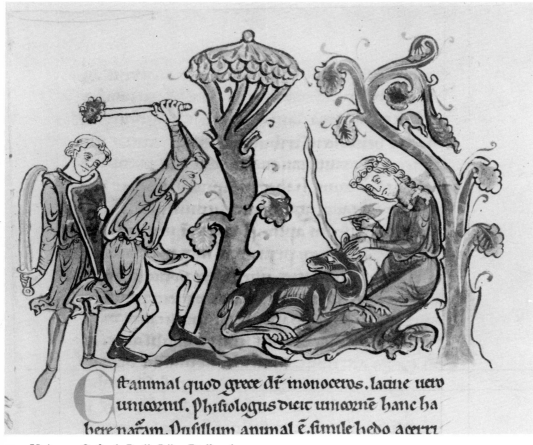

E ſt animal quod grece dr monoceros. latine uero
vnicoznis. phiſiologus dicit vnicoznē hanc ha
bere nacūam. Puſillum animal ē. ſimile hedo acerri

190. Unicorn. Oxford, Bodl. Lib., Bodley 602,
f. 14 (cat. 54)

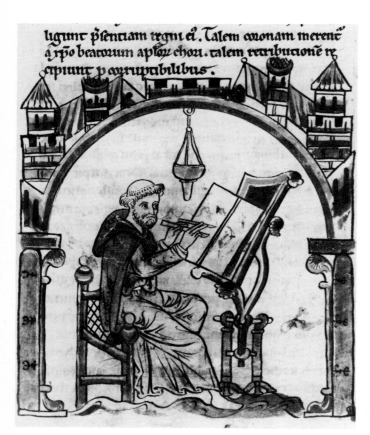

191. Isidore. Oxford, Bodl. Lib., Bodley 602,
f. 36 (cat. 54)

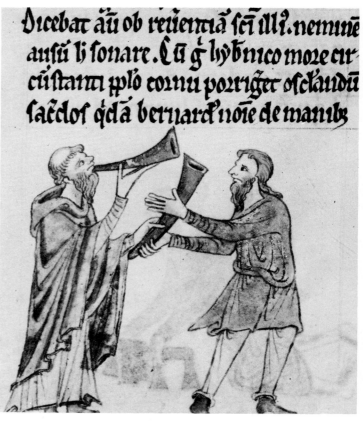

192. The Priest Bernard blowing the Horn of St. Brendan.
London, B.L., Royal 13. B. VIII, f. 30 (cat. 59a)

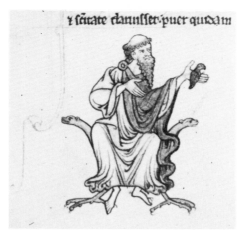

194. St. Kevin and the Blackbird.
Dublin, National Lib., 700,
f. 26 (cat. 59b)

193. The Irish use of the Axe.
Dublin, National Lib., 700,
f. 39 (cat. 59b)

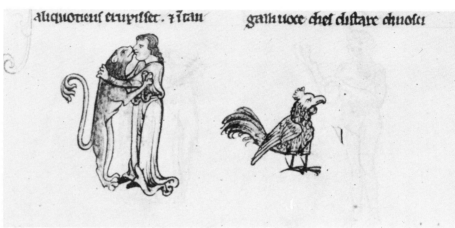

195. Joanna of Paris making love with a Lion;
an Irish cockerel. Dublin, National Lib., 700,
f. 25ᵛ (cat. 59b)

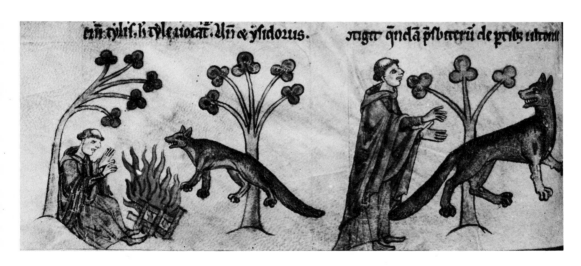

196. The Wolf
and the Priest of Ulster.
London, B.L., Royal 13. B. VIII,
f. 17ᵛ (cat. 59a)

197. The Wolf and the Priest of Ulster.
London, B. L., Royal 13. B. VIII,
f. 18 (cat. 59a)

198. The Wolf and the Priest of Ulster.
Dublin, National Lib., 700, f. 23 (cat. 59b)

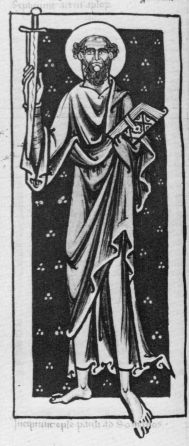

199. Ascension. Manchester, John Rylands Lib.,
Lat. 140, f. 243 (cat. 58)

200. St. Paul. Manchester, John Rylands Lib.,
Lat. 140, f. 250ᵛ (cat. 58)

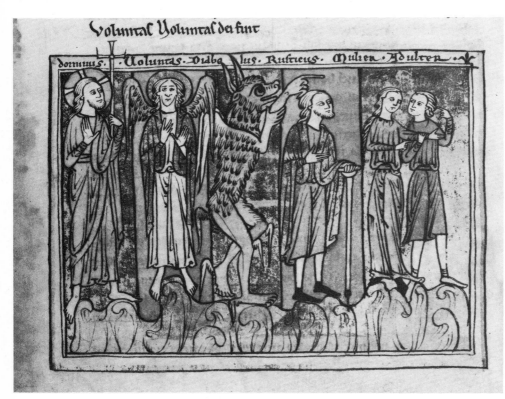

201. God, Voluntas, the Devil, Peasant, Woman and Adulterer.
London, B.L., Cotton, Cleopatra C. XI, f. 2ᵛ (cat. 60)

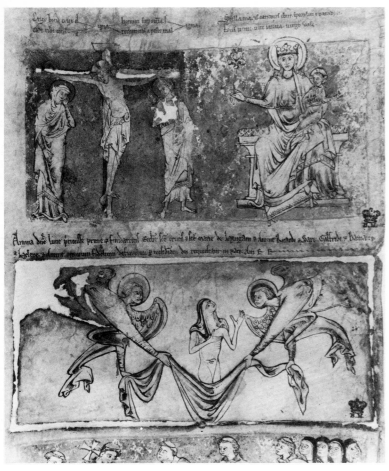

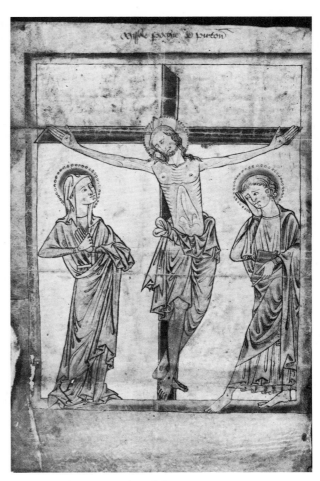

202. Crucifixion, Virgin and Child, Two Angels
lifting a Soul. London, B.L., Egerton 2849 (cat. 56)

203. Crucifixion. London, B.L.,
Harley Charter 83. A. 37 (cat. 57)

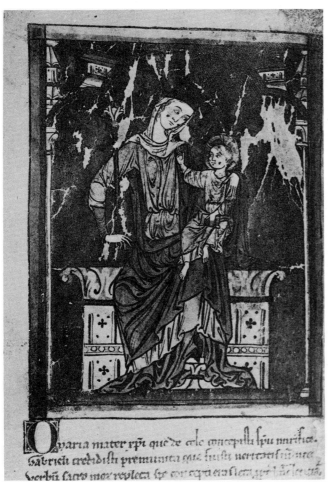

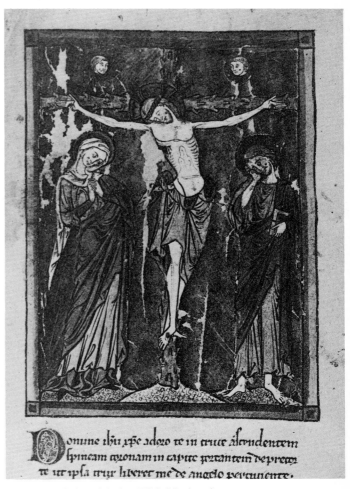

204. Virgin and Child. Turin, Bibl. Nazionale,
L. IV. 25, f. 5ᵛ (cat. 67)

205. Crucifixion. Turin, Bibl. Nazionale,
L. IV. 25, f. 10 (cat. 67)

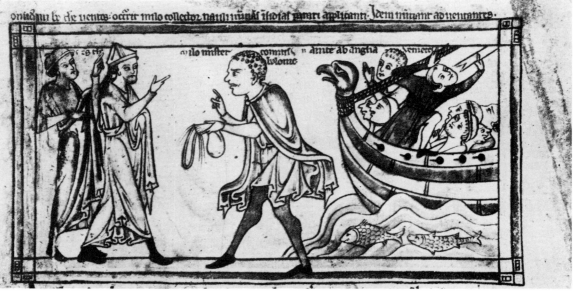

206–8. Parting of Thomas and Pope Alexander III. Thomas excommunicates his Enemies,
appears before Henry II and Louis VII. Thomas warned of Danger by Milo.
Private Collection, ff. 1ᵛ, 2, 4 (cat. 61)

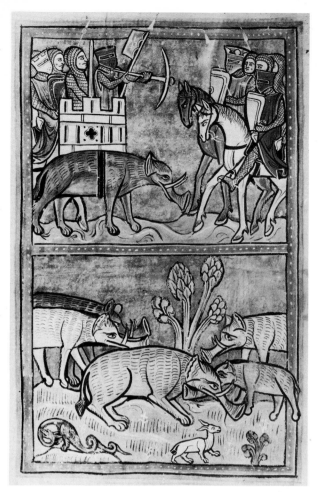

209. Elephants. London, B.L.,
Royal 12. F. XIII, f. 11ᵛ (cat. 64)

cum se liberare non potest· exclamat uoce magna
Audiens uenator uocem eius· uenit ⁊ occidit eum· Sic
⁊ tu homo qui studes sobrius ee et castus· ⁊ spualiter
uiuere· cui duo cornua sunt duo testamenta· per q́
poteris resecare ⁊ excidere omnia uicia· corporalia ⁊
spirtualia· Claue ab ebrietate· fle obligeris luxuria
⁊ uoluptate· ⁊ intersicaris a diabolo· limi eui et
mulieres apostatare faciunt homines a deo·

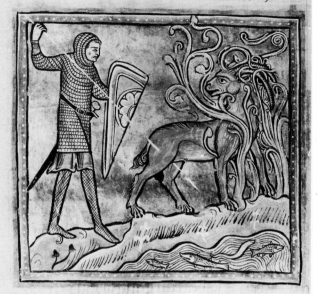

210. Antelope. London, B.L.,
Royal 12. F. XIII, f. 9ᵛ (cat. 64)

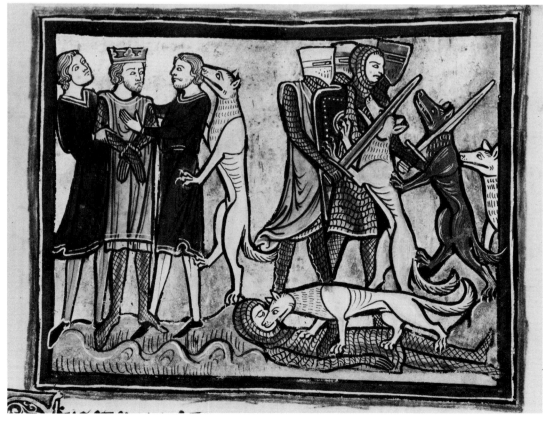

211. King Garamantes and his Dogs. London, B.L., Royal 12. F. XIII, f. 30ᵛ (cat. 64)

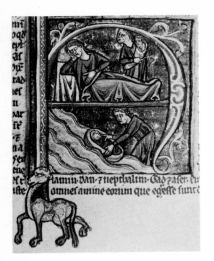

214–15. Crossing of Red Sea.
Solomon instructing Rehoboam.
Peterborough, Cathedral Lib.,
10, ff. 13, 180 (cat. 66)

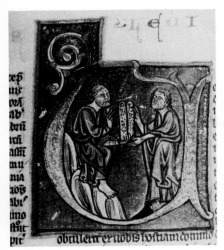

212–13. Birth of Moses; Moses set
afloat in the Nile. Moses given the
Tablets of the Law. London,
Lincoln's Inn, Hale 123,
ff. 19ᵛ, 32ᵛ (cat. 62)

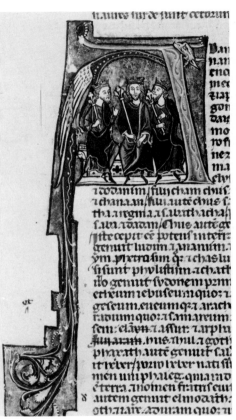

216. Descendants of Adam.
Cambridge, University Lib.,
Ee. 2. 23, f. 117ᵛ (cat. 65)

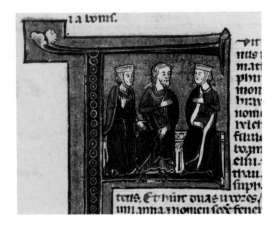

217–18. Job on the Dungheap.
Hannah, Elkanah and Peninnah. Cambridge,
University Lib., Ee. 2. 23, ff. 158, 79ᵛ (cat. 65)

219. New Testament Scenes. London, B.L.,
Burney 3, f. 440 (cat. 63)

220. Group of Figures debating, Beheading of Nicanor.
London, B.L., Burney 3, f. 392 (cat. 63)

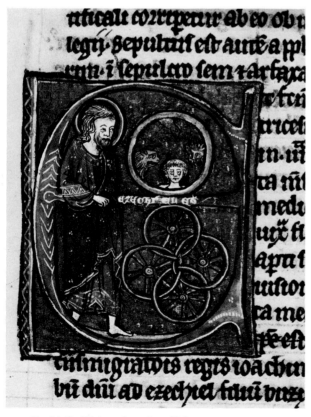

221. Ezekiel's Vision. London, B.L.,
Burney 3, f. 326 (cat. 63)

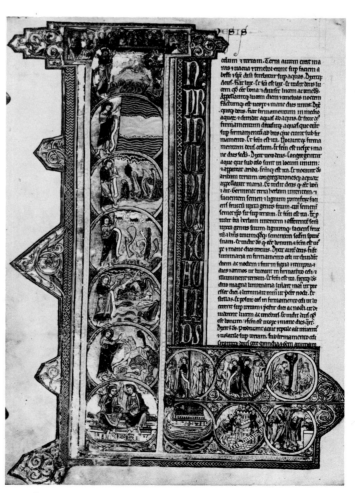

222. Genesis Scenes. London, B.L.,
Burney 3, f. 5ᵛ (cat. 63)

223. Psalm 26, Judgement of Solomon.
Stockholm, National Museum, B. 2010, f. 28ᵛ (cat. 68)

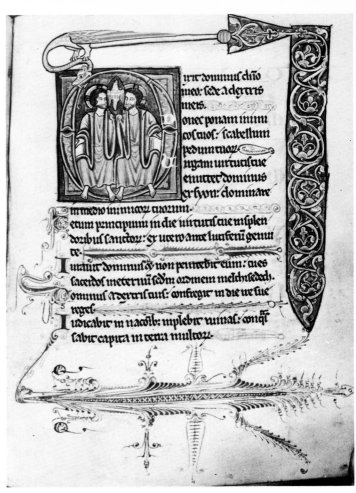

224. Psalm 109, Trinity. Stockholm,
National Museum, B. 2010, f. 111 (cat. 68)

225. Psalm 80, Jacob wrestling with Angel.
Stockholm, National Museum, B. 2010, f. 81ᵛ (cat. 68)

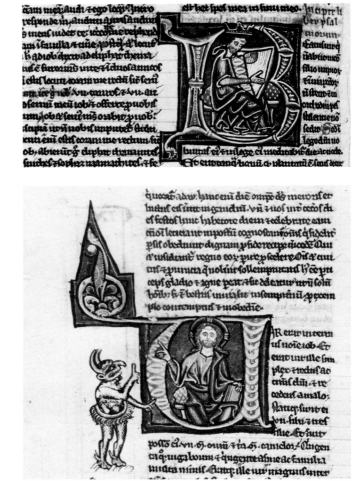

226–7. Psalm 1, Beatus Initial, David harping.
Job, Devil before God. Oxford, Bodl. Lib.,
Lat. bibl. e. 7, ff. 176ᵛ, 168ᵛ (cat. 69)

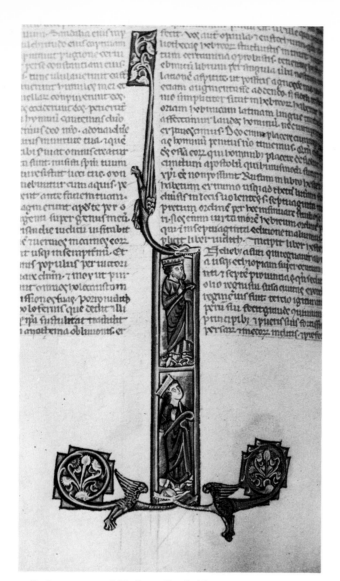

228. Assuerus and Esther. Cambridge,
Gonville and Caius College, 350/567, f. 147ᵛ (cat. 70)

229. Old Testament Scenes. Cambridge,
Gonville and Caius College, 350/567, f. 3 (cat. 70)

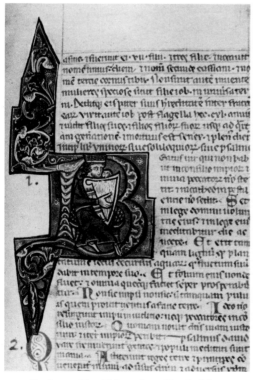

230. Psalm 1, David harping. Cambridge,
Gonville and Caius College, 350/567,
f. 159 (cat. 70)

231. Psalm 109, God seated blessing.
Cambridge, Gonville and Caius College,
350/567, f. 172ᵛ (cat. 70)

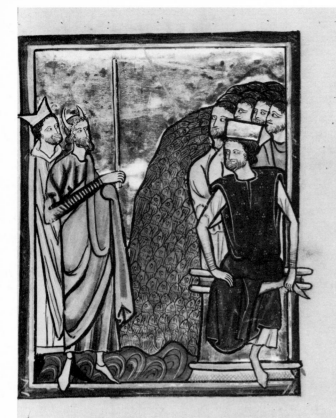

232. Moses and Plague of Frogs. Baltimore,
Walters Art Gallery, 106, f. 5 (cat. 71)

233. Moses draws Water from Rocks. Baltimore,
Walters Art Gallery, 106, f. 12 (cat. 71)

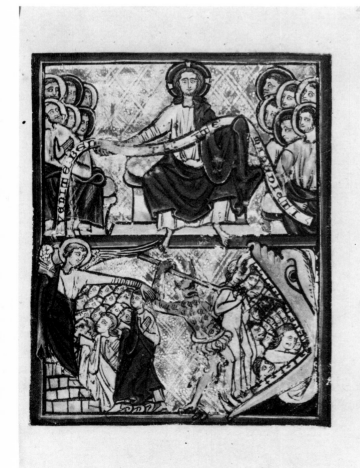

234. Last Judgement. Baltimore,
Walters Art Gallery, 106, f. 23 (cat. 71)

235. Fall of Lucifer. Baltimore,
Walters Art Gallery, 106, f. 24 (cat. 71)

236. Childhood of Christ. New York, Pierpont Morgan Lib., M. 913 (cat. 72b)

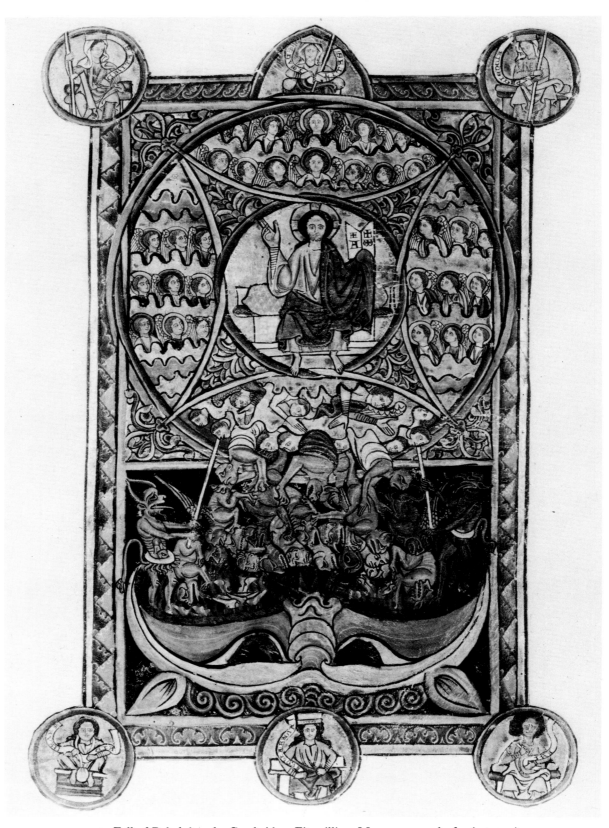

237. Fall of Rebel Angels. Cambridge, Fitzwilliam Museum, 330, leaf 1 (cat. 72a)

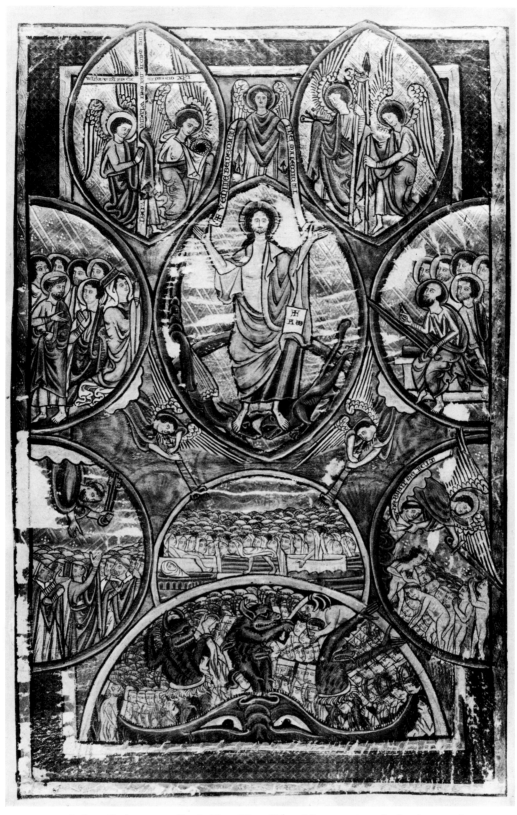

238. Last Judgement. Cambridge, Fitzwilliam Museum, 330, leaf 3 (cat. 72a)

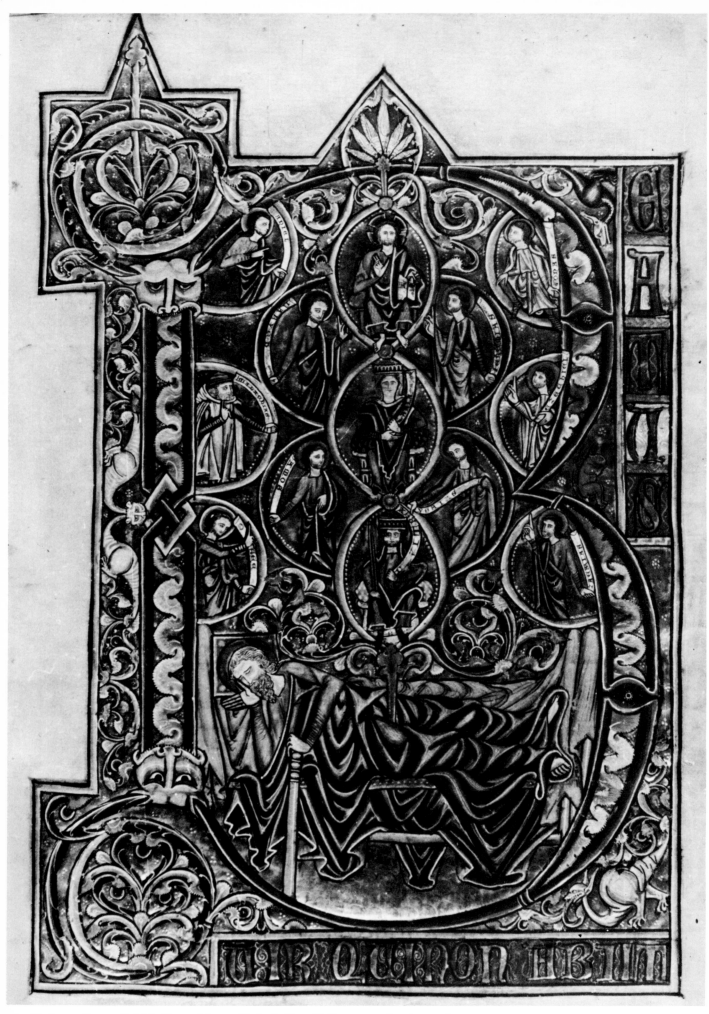

239. Psalm 1, Beatus Initial. Tree of Jesse. Oxford, New College, 322, f. 7 (cat. 74)

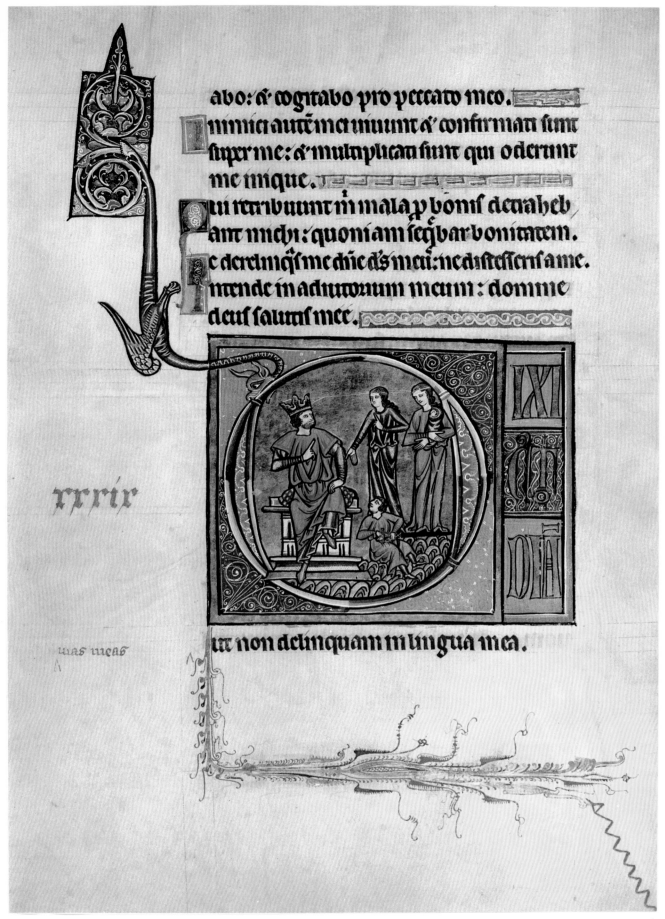

abo: & cogitabo pro peccato meo.

inimici autem mei vivunt & confirmati sunt super me: & multiplicati sunt qui oderunt me inique.

ui retribuunt mi mala p bonis detrahebant michi: quoniam sequebar bonitatem.

e derelinquas me dne ds meus: ne discesseris a me.

ntende in adiutorium meum: domine deus salutis mee.

rrrir

uias meas

ut non delinquam in lingua mea.

240. Psalm 38, Judgement of Solomon. Oxford, New College, 322, f. 41ᵛ (cat. 74)

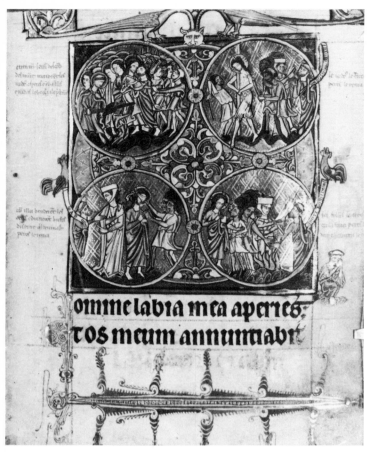

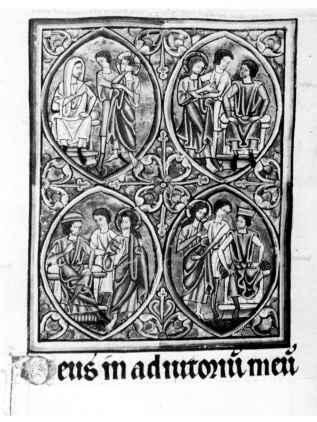

242. Trial of Christ. London,
B.L., Add. 49999, f. 32 (cat. 73)

241. Betrayal, Flagellation, Denial, Mocking of Christ.
London, B.L., Add. 49999, f. 1 (cat. 73)

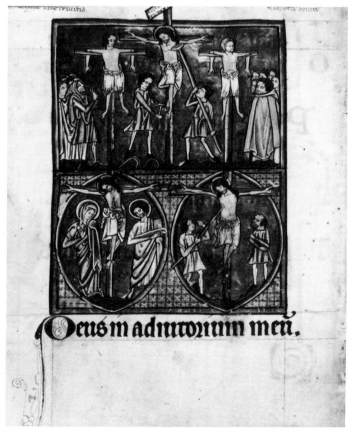

243. Crucifixion. London,
B.L., Add. 49999, f. 47ᵛ (cat. 73)

244. Priest appeals for Second Time to St. Thomas.
London, B.L., Add. 49999, f. 48 (cat. 73)

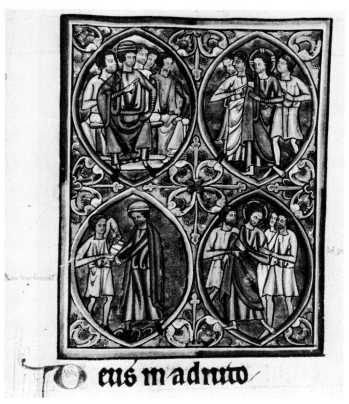

245. Trial of Christ. London,
B.L., Add. 49999, f. 39 (cat. 73)

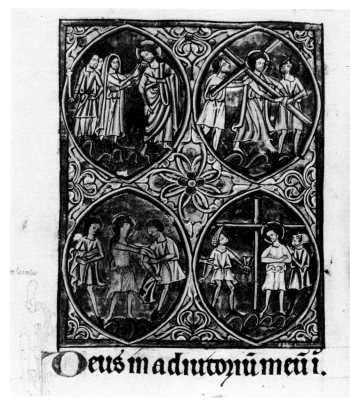

246. Passion Scenes. London, B.L.,
Add. 49999, f. 43ᵛ (cat. 73)

247. Theophilus makes a Pact with the Devil.
London, B.L., Add. 49999, f. 34 (cat. 73)

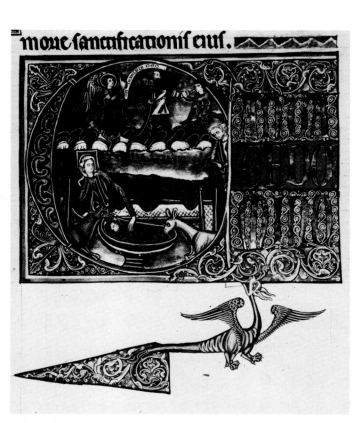

248. Psalm 97, Annunciation to Shepherds, Nativity.
Oxford, New College, 322, f. 97 (cat. 74)

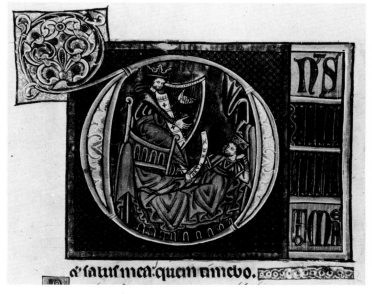

249. Psalm 26, David harping before Saul.
Oxford, New College, 322, f. 28 (cat. 74)

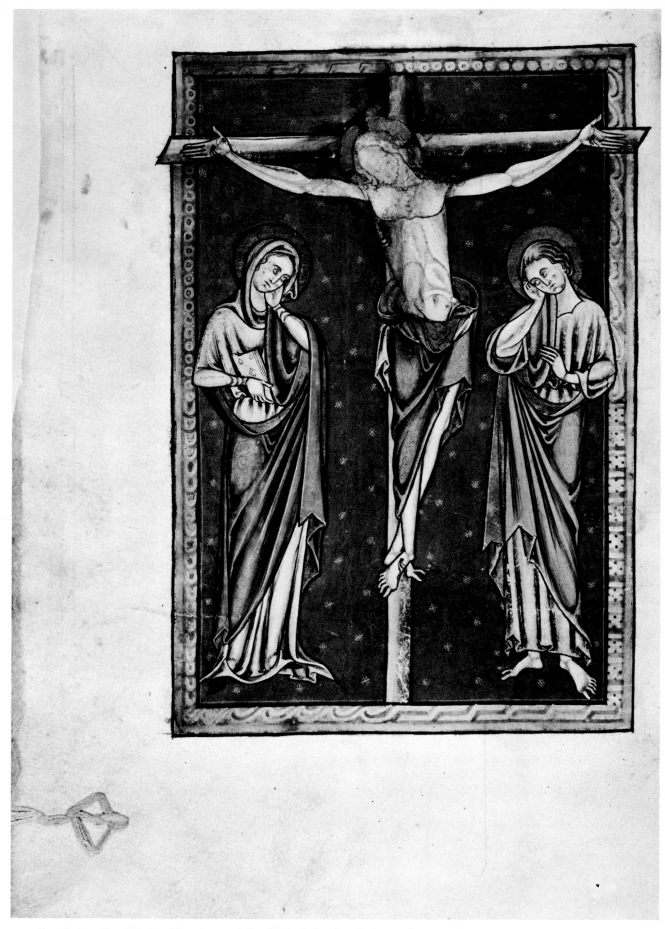

250. Crucifixion. San Marino, Huntington Lib., HM 26061, f. 178ᵛ (cat. 77)

251. David harping. San Marino, Huntington Lib.,
HM 26061, f. 166 (cat. 77)

252. David and the Amalekite. Oxford, Bodl. Lib.,
Auct. D. 4. 8, f. 163 (cat. 75)

253. Psalm 26, David pointing
to his Eye. Oxford, Bodl. Lib.,
Auct. D. 4. 8, f. 319ᵛ (cat. 75)

254. Josias speaks to the Levites.
Oxford, Bodl. Lib.,
Auct. D. 4. 8, f. 259 (cat. 75)

255. Psalm 109, God seated blessing.
Oxford, Bodl. Lib.,
Auct. D. 4, 8, f. 339ᵛ (cat. 75)

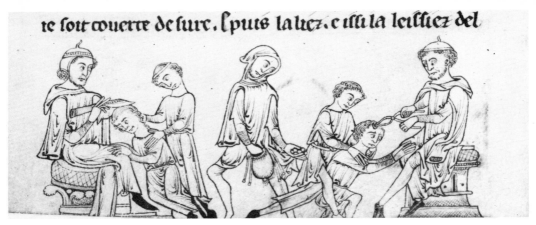

te foit couerre de fure. f puis la liez. e iffi la leiffiez del

256. Head Operation with Scalpel and Forceps. Cambridge, Trinity College, o. 1. 20, f. 242ᵛ (cat. 78)

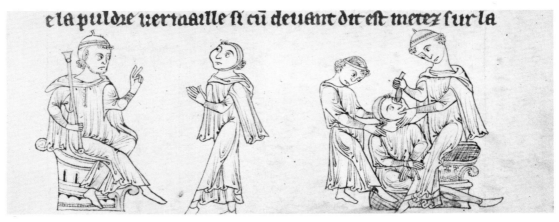

e la puldre uertaaille fi cu deuant dit est metez sur la

257. Treatment of an Eye Complaint. Cambridge, Trinity College, o. 1. 20, f. 262 (cat. 78)

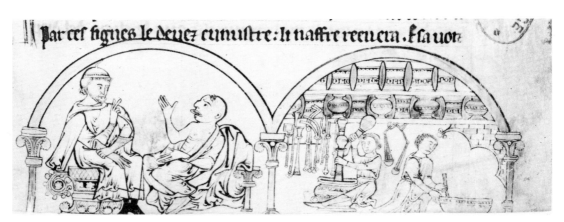

Par ces fignes le deuez cunuftre: li naffre receu eta. f fauor

258. Medical Examination, Assistants preparing Medicine. Cambridge, Trinity College, o. 1. 20, f. 240 (cat. 78)

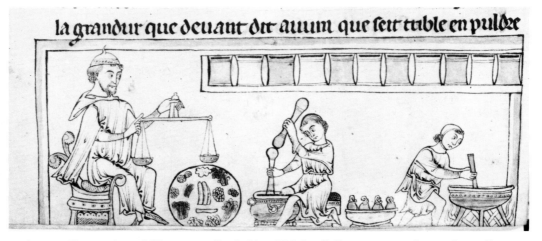

la grandur que deuant dit auum que feit truble en puldre

259. Preparation of Ointments. Cambridge, Trinity College, o. 1. 20, f. 241ᵛ (cat. 78)

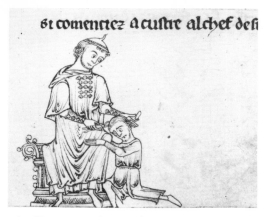

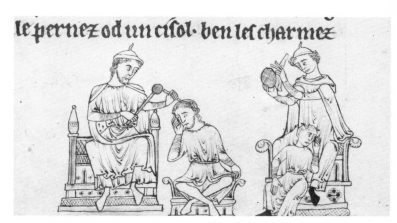

260. Forceps applied to the Head.
Cambridge, Trinity College,
o. 1. 20, f. 246 (cat. 78)

261. Operation on the Head.
Cambridge, Trinity College,
o. 1. 20, f. 251ᵛ (cat. 78)

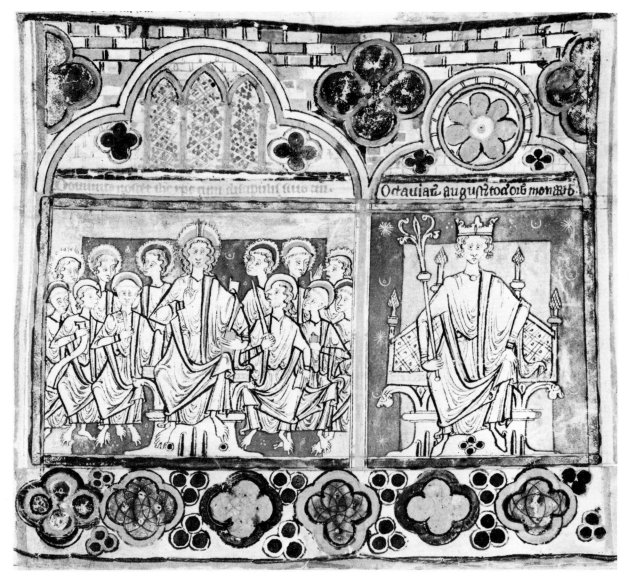

262. Christ with Apostles, Augustus.
Liverpool, Merseyside County Museum, Mayer 12017 (cat. 79)

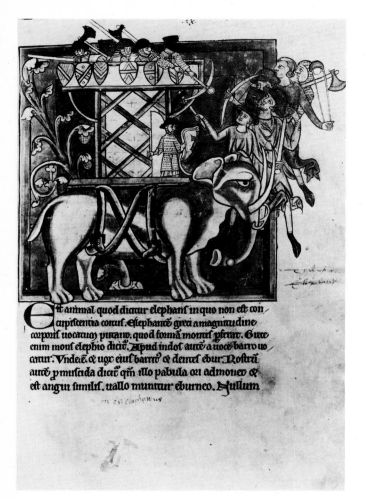

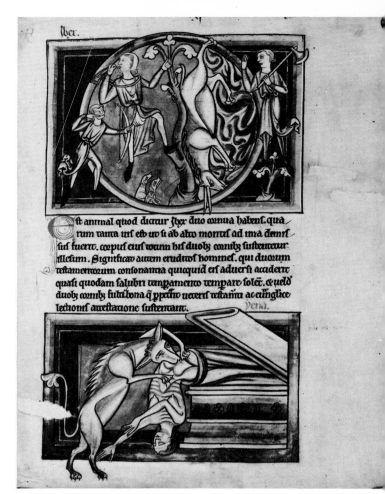

263. Elephant. London, B.L.,
Harley 4751, f. 8 (cat. 76)

264. Ibex, Hyena. London, B.L.,
Harley 4751, f. 10 (cat. 76)

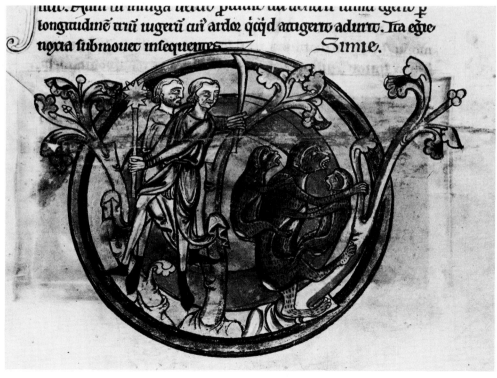

265. Apes. London, B.L., Harley 4751, f. 11 (cat. 76)

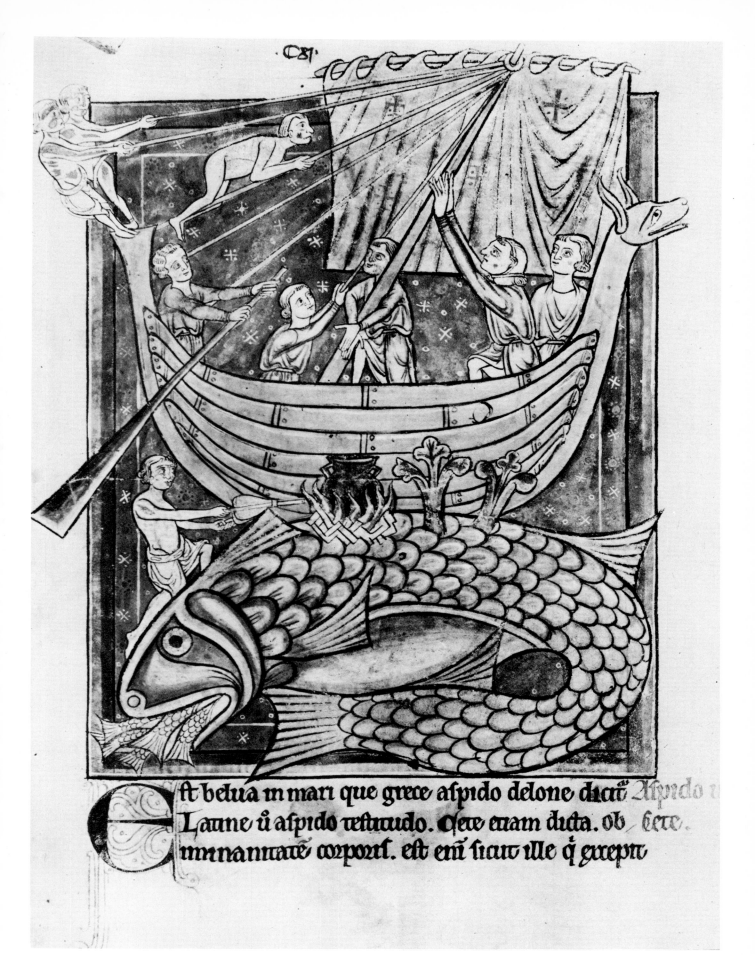

est belua in mari que grece aspido delone dicat̄. Aspido
Latine ū aspido testudo. Cete etiam dicta. ob ᵭᶜᵗᵉ.
ĩmanitatē corporis. est enī sicut ille q̄ excepit

266. Whale. London, B.L., Harley 4751, f. 69 (cat. 76)

267. Christ blessing Dominican Friar.
London, B.L., Harley 3244, f. 27 (cat. 80)

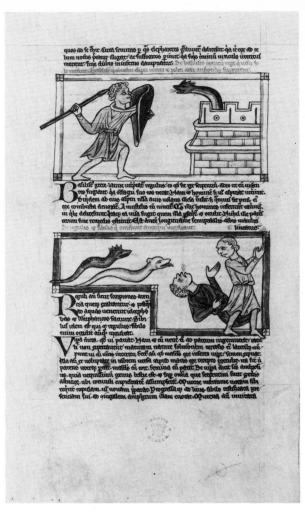

268. Basilisk, Regulus. London, B.L.,
Harley 3244, f. 59ᵛ (cat. 80)

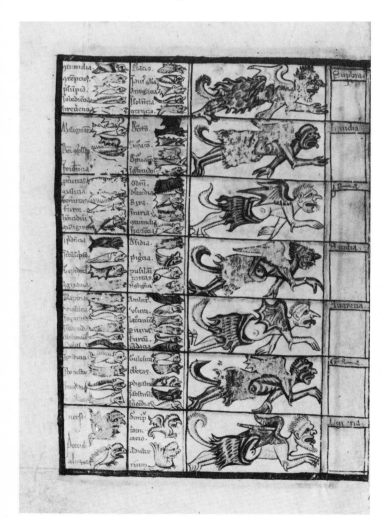

269. Vices. London, B.L.,
Harley 3244, f. 27ᵛ (cat. 80)

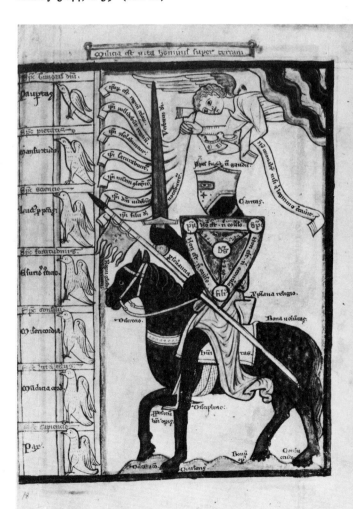

270. Knight confronting Vices.
London, B.L., Harley 3244, f. 28 (cat. 80)

271. Battle between Alexander and Darius Cambridge, Trinity College, o. 9. 34, f. 20 (cat. 81)

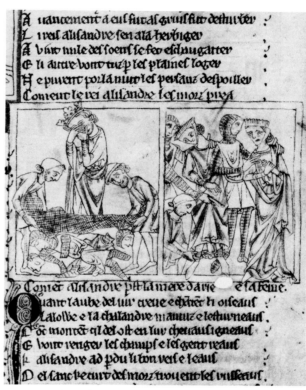

272–3. Darius with Messengers and Councillors. Alexander laments, Capture of the Women of Darius. Cambridge, Trinity College, o. 9. 34, ff. 8, 11ᵛ, (cat. 81)

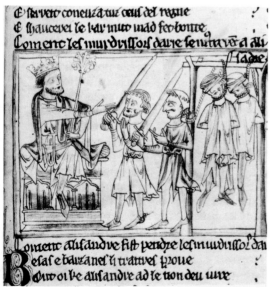

274. Alexander hangs the Murderers of Darius. Cambridge, Trinity College, o. 9. 34, ff. 22, (cat. 81)

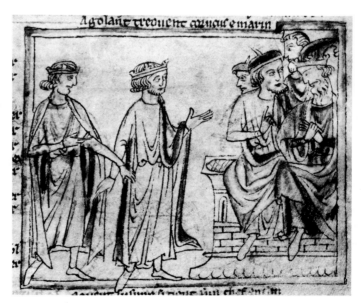

275. King Ulien and King Mandaquin before King Agolant. London, B.L., Lansdowne 782, f. 16 (cat. 82)

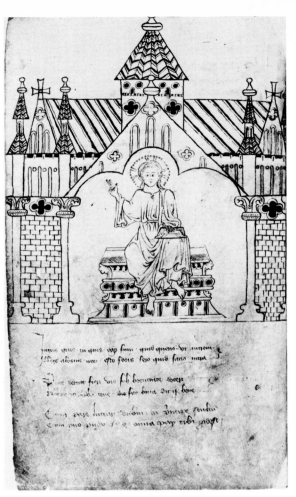

276. St. Michael spearing Dragon. London,
Public Record Office, (E36) 266, f. 11 (cat. 83)

277. Christ seated blessing. London,
Public Record Office, (E36) 266, f. 9ᵛ (cat. 83)

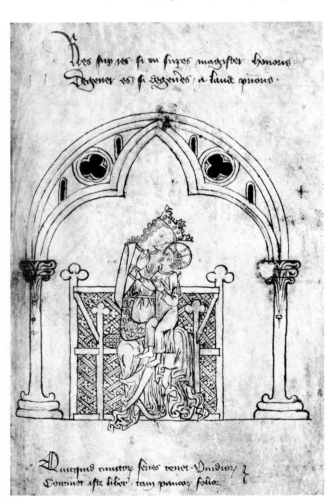

278. Virgin and Child. London,
Public Record Office, (E36) 266, f. 10 (cat. 83)

279. Virgin and Child. Dublin, Trinity College,
177 (E. 1. 40), f. 2ᵛ (cat. 85)

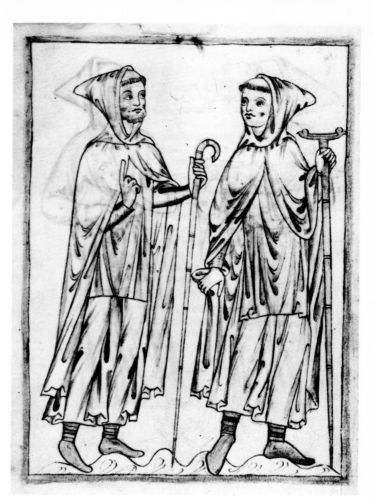

280. St. Francis bearing Stigmata, with Friar.
Cambridge, University Lib., Gg. 6. 42, f. 5 (cat. 84)

281. Two Friars. Cambridge, University Lib.,
Gg. 6. 42, f. 5ᵛ (cat. 84)

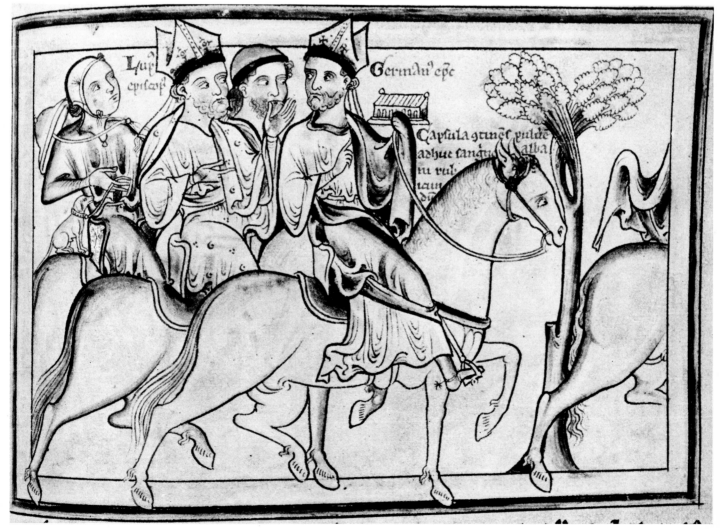

282. Bishops return Home, Germanus carrying Reliquary with St. Alban's Blood.
Dublin, Trinity College, 177 (E. 1. 40) f. 55 (cat. 85)

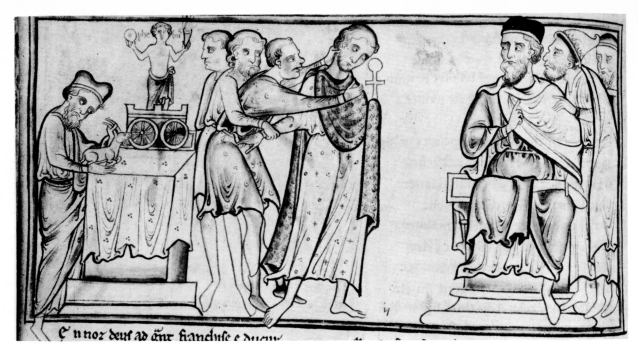

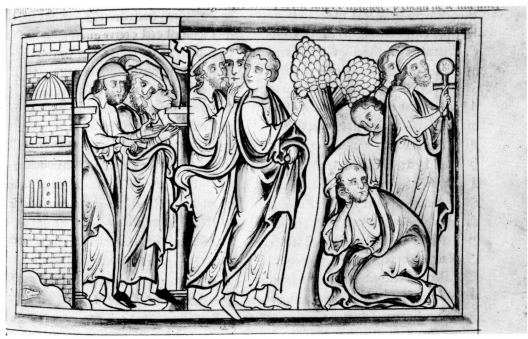

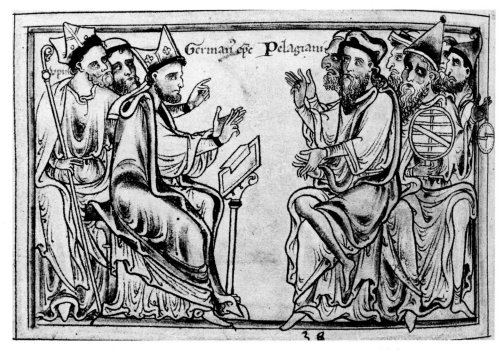

283–5. Pagans try to force St. Alban to worship an Idol.
Christian Converts leave Verulamium for Wales to find Amphibalus. Bishops dispute with Pelagians.
Dublin, Trinity College, 177 (E. I. 40), ff. 34ᵛ, 39, 54ᵛ (cat. 85)

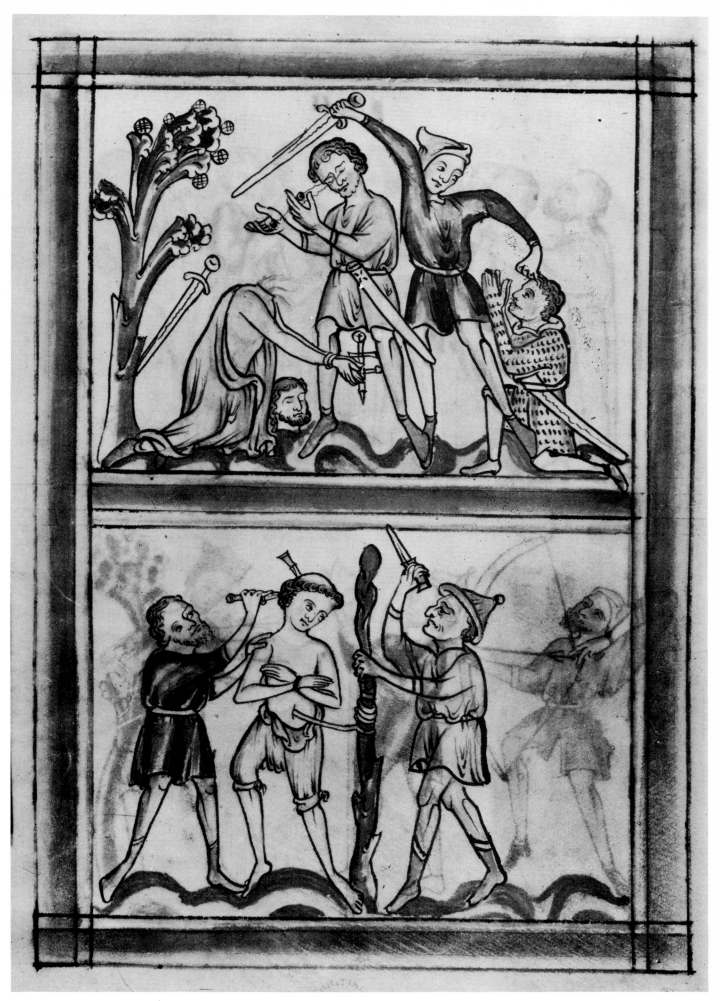

286. Martyrdoms of Saints Alban and Amphibalus. London, B.L., Royal 2. B. VI, f. 10ᵛ (cat. 86)

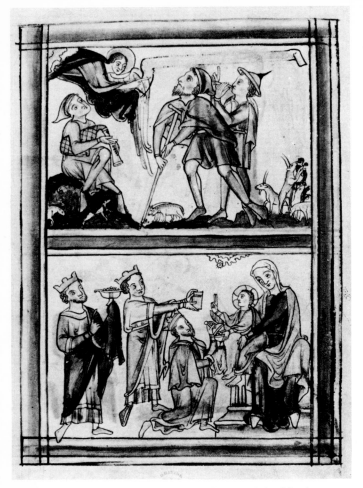

287. Annunciation to Shepherds, Adoration of the Magi. London, B.L., Royal 2. B. VI, f. 8ᵛ (cat. 86)

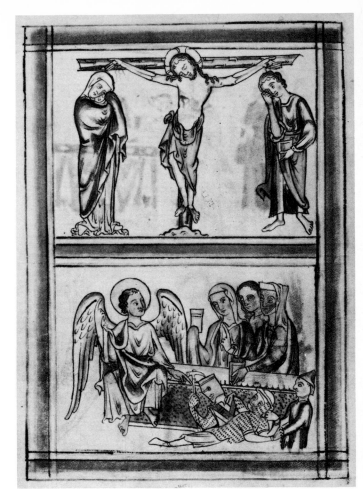

288. Crucifixion, Holy Women at Tomb. London, B.L., Royal 2. B. VI, f. 9ᵛ (cat. 86)

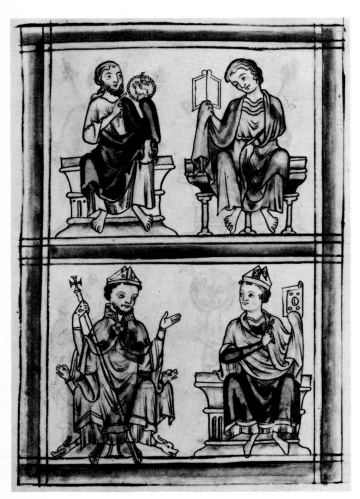

289. St. John the Baptist, St. John the Evangelist, Two Bishop Saints. London, B.L., Royal 2. B. VI, f. 11 (cat. 86)

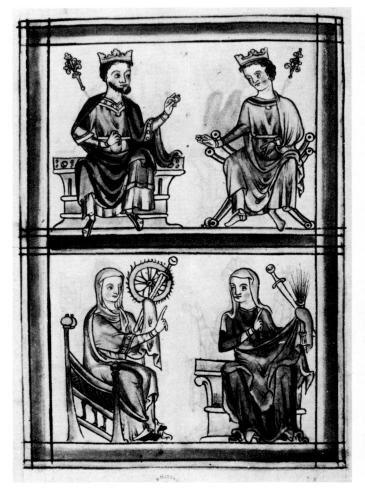

290. St. Edward the Confessor, St. Edward the Martyr(?), St. Catherine, Female Saint. London, B.L., Royal 2. B. VI, f. 11ᵛ (cat. 86)

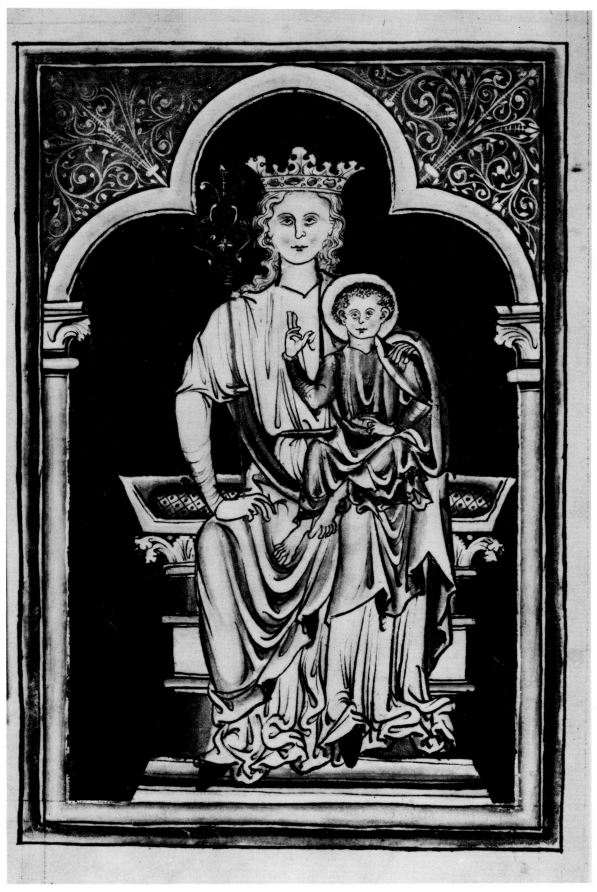

291. Virgin and Child. London, B.L., Royal 2. B. VI, f. 12ᵛ (cat. 86)

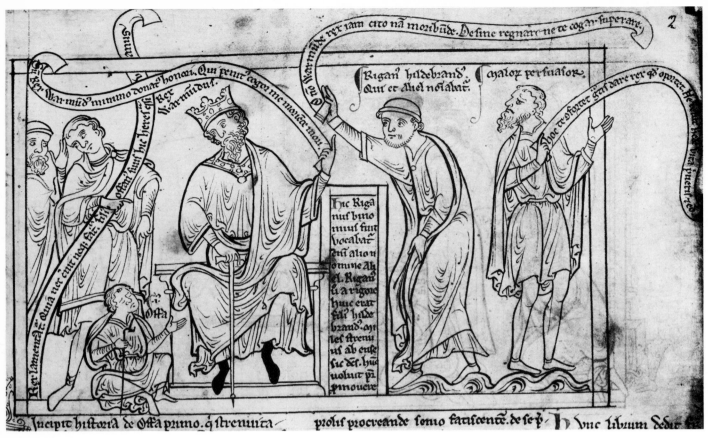

292. Scene from Life of Offa. London, B.L., Cotton Nero D. I, f. 2 (cat. 87a)

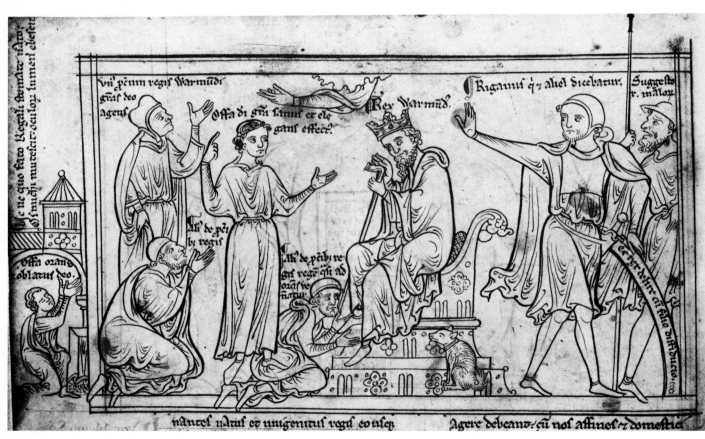

293. Scene from Life of Offa. London, B.L., Cotton Nero D. I, f. 2ᵛ (cat. 87a)

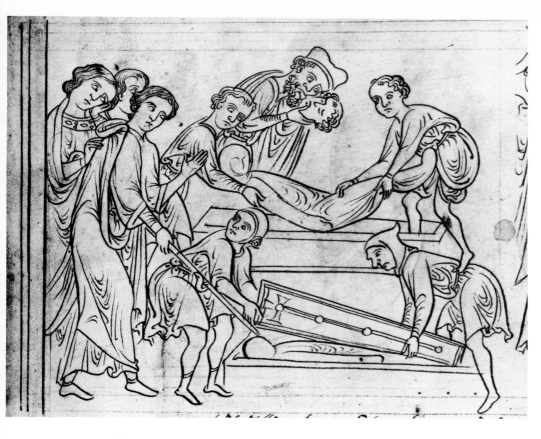

294. Scene from Life of Offa.
London, B.L., Cotton Nero D. I,
f. 4ᵛ (cat. 87a)

295–6. Capture of Relic of True Cross. Procession of Relics of Holy Blood.
Cambridge, Corpus Christi College, 26, f. 140; 16, f. 215 (cat. 88)

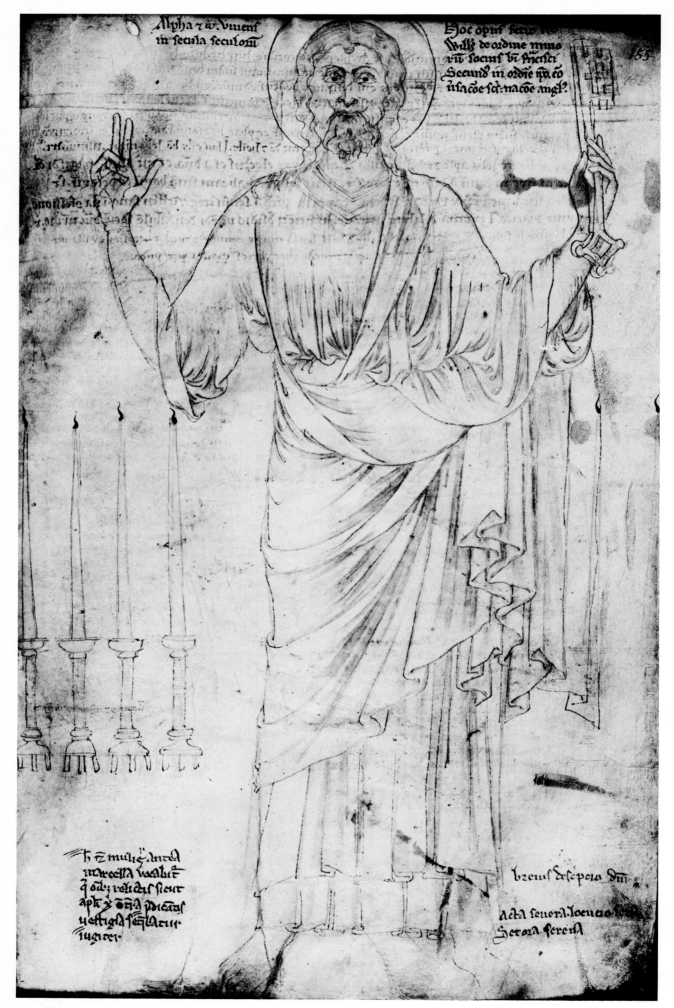

297. Christ among Candlesticks. London, B.L., Cotton Nero D. I, f. 156 (cat. 87b)

298. Merlin before King Vortigern. London, B.L., Cotton Claudius B. VII, f. 224 (cat. 94)

299. Euclid and Herman Contractus of Reichenau. Oxford, Bodl. Lib., Ashmole 304, f. 2ᵛ (cat. 89)

300. Pythagoras. Oxford, Bodl. Lib., Ashmole 304, f. 42 (cat. 89)

301. John of Wallingford. London, B.L., Cotton Julius D. VII, f. 42ᵛ (cat. 91)

302. Germanus of Constantinople. Cambridge, Corpus Christi College, 16, f. 112 (cat. 88)

303. Alexander the Great. Eton College Lib., 96, f. 8ᵛ (cat. 90)

304. Henry III. London, B.L., Royal 14. C. VII, f. 9 (cat. 92)

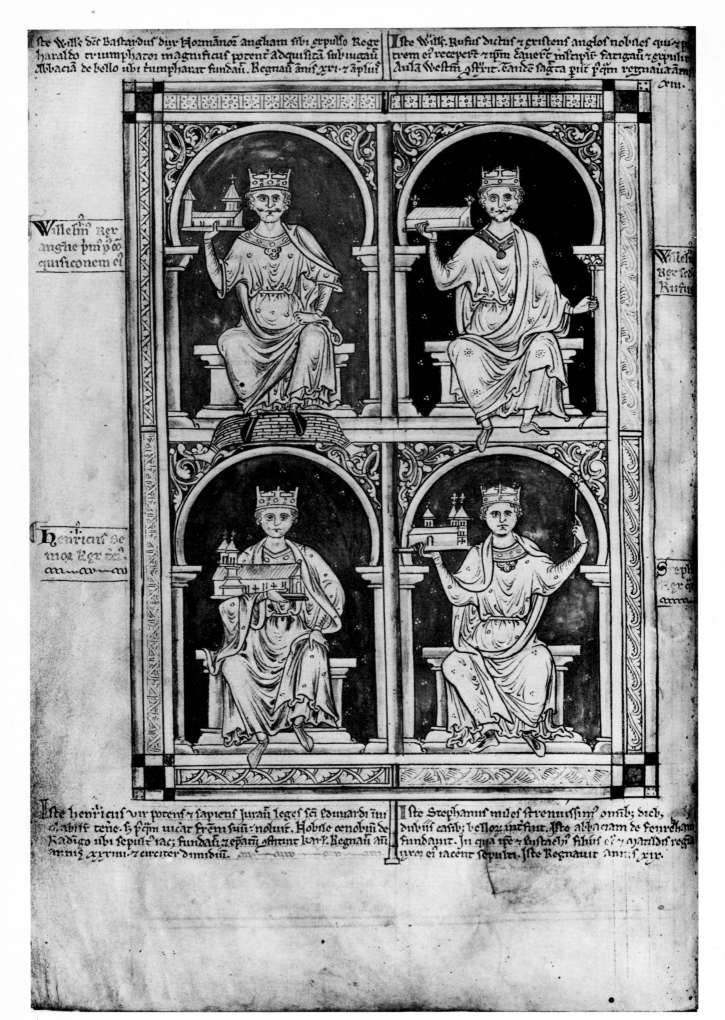

ste Wills dit Bastardus dux Horman̄oz angham sibi expulso Rege
haraldo triumphator magnificus potent̄ adquisita subiugaū
Abbaciā de bello ubi triumphavat fundaū. Regnaū ānıs xxı · ʒ aplıᵘ

Iste Wills. Rufus dictus ʒ cristens anglos nobiles qui p̄
trem ei receperr̄ nipm̄ equerr̄ misetpis̄ fatigau ʒ expuli
Aula Westm̄ ḡstrux̄. tande sagta puit f̄em regnauu ā m̄
cxıı.

Willelm̄ rex
anglie pm̄ p̄ co
quisiconem ei

Willelm̄
rex sed
Rufus

Henricus se
mor Rex t̄cī.
cxxxxuxx

Stephꜫ
Rex c̄
cxxx

Iste henricus uir potens ʒ sapiens iurau leges sc̄i edwardi iui
tabiliʒ tene. sʒ f̄em uicat f̄rem suū · noluit. Hobile cenobiū de
Radigo ubi sepultᵉ iace; fundati ʒ epatı ḡstrunt kart̄. Regnaū au
ānıs xxxuı · ʒ cırciter dimidiū.

Iste Stephanus miles strenuissim̄ omnib; dieb,
dubıı casib; bellor̄ intſuit. Iste abbaciam de feuersham
fundauit. In qua ıp̄e ʒ Eustachıᵘ filius eı̄ ʒ mathıldıs regı
ua uxor eı iacent sepulti. Iste Regnauit annıs xıx.

305. William I, William II, Henry I, Stephen. London, B.L., Royal 14. C. VII, f. 8ᵛ (cat. 92)

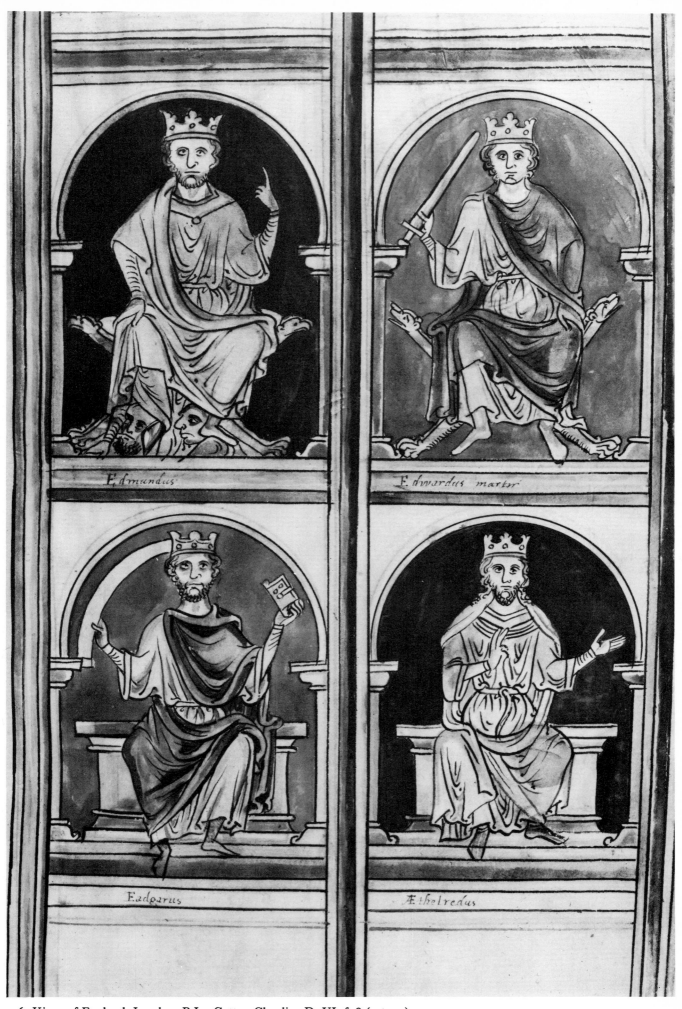

306. Kings of England. London, B.L., Cotton Claudius D. VI, f. 8 (cat. 93)

307. Virgin and Child, Two Heads of Christ.
Cambridge, Corpus Christi College, 26, f. vii (cat. 88)

INDEX

INDEX OF MANUSCRIPTS

References are to page numbers; figures in italics refer to illustrations and figures preceded by 'no.' refer to the numbered entry in the Catalogue of Manuscripts

St. Margaret. Paris, Bibl. Nat., fr. 19525, f. 141ᵛ

ANALYSIS OF MANUSCRIPTS IN THE CATALOGUE

I. TYPES OF BOOK

Astrological text: no. 89
Bestiaries: nos. 11, 13, 17, 19, 20, 21, 42, 53, 54, 55, 64, 76, 80
Bibles: nos. 32, 44, 58, 62, 63, 66, 69, 70, 75, 77
Bible Picture Books: nos. 16, 71
Chronicles: nos. 41, 43b, 79, 87, 88, 90, 91, 92, 93
Classical Authors:
 Pseudo-Apuleius: nos. 9, 10
 Pseudo-Dioscorides: nos. 9, 10
 Sextus Placitus: nos. 9, 10
Decretals: no. 6
Exchequer Book: no. 83
Fortune-telling text: no. 89
Glossed texts: nos. 3, 8, 25, 31, 36, 38
Gospels: no. 3
Herbals: nos. 9, 10
Hours of the Virgin Mary: nos. 24, 35, 36, 73
Hymnals: nos. 27, 33, 48
Lapidaries: nos. 20, 53, 64
Lives of Saints: nos. 5, 12a, 12b, 22, 61, 85
Maps: nos. 55, 59b, 87, 88, 91, 92, 93
Medical texts: nos. 9, 10, 67, 78
Medieval Authors:
 Alexander Neckham: nos. 31, 84
 Anselm, St.: no. 60

Bede, St.: nos. 12a, 12b
Bernardus Silvestris: no. 89
Geoffrey of Monmouth: no. 94
Giraldus Cambrensis: nos. 59a, 59b
Gratian: no. 6
Hugh of St. Victor: no. 4
John of Wallingford: no. 91
Matthew Paris: nos. 85, 87, 88, 92, 93
Guglielmus Peraldus: no. 80
Peter of Poitiers: nos. 43a, 43b, 43c, 79, 90
Peter of Riga: nos. 43a, 43b
Richard of St. Victor: no. 4
Robert Grosseteste: no. 80
Roger of Salerno: no. 78
Thomas of Kent: no. 81
Missals: nos. 57, 69, 77
Oath Book: no. 83
Obituary Roll: no. 56
Psalters: nos. 1, 2, 7, 8, 14, 15, 18, 23, 24, 25, 26, 27, 28, 29, 30, 31, 33, 34, 35, 36, 37, 38, 39, 40, 45, 46, 47, 48, 49, 50, 51, 52, 68, 72, 74, 86
Romances: nos. 81, 82, 94
Theological texts: nos. 4, 43a, 43b, 43c, 60, 79, 80, 84, 90
Topographical texts: nos. 59a, 59b

II. PLACES OF ORIGIN

Abingdon Abbey, Berkshire: no. 41
Canterbury: nos. 5(?), 33, 43c(?), 63(?)
 Christ Church: nos. 1, 34
Crowland Abbey, Lincolnshire: no. 22(?)
Durham Cathedral Priory: nos. 12a, 12b, 13(?)
East Anglia: nos. 38(?), 39(?), 75(?)
East Midlands: no. 40(?)
Faversham Abbey, Kent: no. 5(?)
Hedingham Priory, Essex: no. 56(?)
London: nos. 7, 35(?), 36(?), 37(?), 50(?), 51, 52, 53, 55(?), 61(?), 68(?), 83(?)
Northern England: nos. 9(?), 10(?), 14, 16
North Midlands: nos. 11, 15(?), 17(?), 18(?), 19(?), 20(?), 21(?), 44(?)

Oxford: nos. 23(?), 24, 28, 29, 30(?), 31(?), 32(?), 69, 70, 71, 72a, 72b, 73, 74
Peterborough Abbey, Huntingdonshire: nos. 45(?), 46(?), 47(?)
St. Albans Abbey, Hertfordshire: nos. 2(?), 3, 32(?), 85, 86, 87, 88, 89, 90(?), 91, 92, 93
St. Neots Priory, Huntingdonshire: no. 48(?)
Salisbury: no. 76(?)
South-East England: no. 64
Southern England: nos. 6, 54
West Midlands: no. 8(?)
Westminster Abbey: no. 2(?)
Winchester: nos. 25(?), 26(?), 27(?)
Worcester Cathedral Priory: no. 49(?)
Wymondham Priory, Norfolk: no. 91
York: no. 42(?)

III. ICONOGRAPHY

OLD TESTAMENT

Cross references are given where spellings of the Vulgate differ from the Authorised Version

Aaron and Moses before Pharaoh, no. 23; *80*
 and Moses number the people, no. 32; *112*
 and Moses speak to the people, no. 32; *112*
 and Moses in the Tabernacle, no. 23
 offers incense, no. 23
Abdias (see Obadiah)
Abel makes his offering to God, nos. 1, 14 ,23, 30, 62, 72; *46*
 murdered by Cain, nos. 1, 14, 23, 30, 43c, 62, 72; *46, 144*
Abishag, nos. 62, 65, 66
Abner defeated by Joab, no. 34
Abraham, nos. 43a, 43b, 43c
 his battle with the four kings, nos. 23, 30
 offered bread and wine by Melchisedech, nos. 1, 23, 30, 51; *172*
 receives the three angels, nos. 14, 23, 30, 51, 71; *172*
 God's promise to, no. 14
 with Hagar and Ishmael, no. 14
 journey with Isaac to the sacrifice, no. 63; *222*
 sacrifice of Isaac, nos. 1, 14, 23, 30, 40, 51, 63, 70, 79; *77, 172, 222, 229*
Absalom hanging by his hair from the tree, no. 30
 his death, no. 30
Achan, stoning of, no. 71
Achior, no. 23
Adam, no. 43a
 creation of, nos. 1, 43a, 43b, 66, 69, 77
 instructed by God, nos. 1, 14, 23, 62, 63, 70; *76, 222, 229*
 his temptation, nos. 1, 14, 23, 30, 42, 43b, 43c, 62, 63, 79, 90; *76, 222*
 reprimanded by God, nos. 14, 23, 62, 63, 72; *76, 222*
 clothed by God, nos. 71, 72
 expulsion from Paradise, nos. 1, 14, 23, 30, 42, 62, 63, 66, 71, 75, 90; *76, 222*
 digging, nos. 1, 14, 23, 43c, 62, 63, 72; *76, 222*
 naming the animals, nos. 11, 17, 19, 42, 55, 64, 80; *62*
 descendants of, nos. 63, 65, 66, 75; *216*
Adonijah (Adonias), death of, no. 32
Ahasuerus (see Assuerus)
Ahaziah, no. 69
Ahimelech gives the hallowed bread and sword of Goliath to David, nos. 23, 34, 47, 62
 killed by Doeg (see Doeg)
Ahitobel brought before Saul, no. 8; *23*
Amalekite tells David of Saul's death, nos. 34, 63, 66, 75; *120, 252*
Amasias (Amaziah), no. 43a
Ammonites shave David's servants, no. 23
Amos, nos. 11, 54, 58, 63, 69, 70, 75, 80
 prophesies destruction of Jerusalem by fire, no. 65
Angels, creation of, no. 32; *108*
 fall of the rebel, nos. 32, 43b, 63, 71, 72; *108, 222, 235, 237*
 received by Abraham, nos. 14, 23, 30, 51, 71; *172*
 received by Lot, nos. 30, 71
Animals, creation of, nos. 1, 11, 17, 19, 32, 42, 63, 66, 75, 77; *108, 222*
 named by Adam, nos. 11, 17, 19, 42, 55, 64, 80
Anointing of Saul, nos. 1, 30; *2*
 of David, nos. 1, 7, 23, 24, 25, 26, 27, 28, 30, 31, 40, 47, 48, 51, 62, 63, 70, 90
Antiochus Epiphanes, nos. 32, 70
Aram, no. 43a
Areuna (Araunah, Ornan), no. 23
Ark of the Israelites, Moses before, nos. 65, 66
 carrying of, nos. 1, 23, 32; *2*
 David walks harping before, no. 23

Ark of Noah, nos. 1, 30, 70, 71, 90; *229*
 building of, nos. 14, 30; *46*
Artaxerxes, king of Persia, no. 70
Assuerus (Ahasuerus), nos. 63, 66, 70, 75; *228*
 rebuking Vashti, no. 58
 series of scenes, nos. 23, 32
Azor, no. 43a
Babel, building of Tower of, nos. 23, 30, 63; *222*
Babylon, dragon of, no. 63
Baker of Pharaoh (see under Joseph)
Balaam on the ass, nos. 23, 32, 38, 75; *112*
Balak sends message to Balaam, no. 32; *112*
Baruch, nos. 32, 63, 65, 66, 69, 70, 75
Bathsheba gazed at by David, nos. 33, 74
 with David, nos. 65, 66
 with Nathan before David, no. 32
 intercedes with Solomon for Adonijah, no. 32
Battle scenes, nos. 58, 63, 75
Bear, fought by David, nos. 26, 27, 49
Belshazzar, series of scenes, no. 23
Benadad, king of Syria, no. 43b
Benjamin sent to Egypt by Jacob, nos. 23, 51; *173*
 accused of the theft of the cup, nos. 51, 71; *173*
 Joseph's farewell to, nos. 23, 51; *173*
Bethel, prophet of, no. 23
Birds, creation of, nos. 1, 14, 17, 19, 23, 32, 42, 43a, 43b, 44, 66, 75; *59, 108*
Boaz, nos. 23, 70, 71
Brazen Serpent, nos. 1, 23
Bride and Bridegroom (Song of Songs), nos. 63, 69, 70
Building of the Temple of Jerusalem by Cyrus, nos. 32, 63
Burning Bush, nos. 1, 23
Butler of Pharaoh (see under Joseph)
Cain suckled by Eve, no. 63
 makes his offering to God, nos. 1, 14, 23, 30, 62, 72; *46*
 murders Abel, nos. 1, 14, 23, 30, 43c, 62, 72; *46, 144*
 rebuked by God, nos. 1, 23, 30, 72
 shot by Lamech, nos. 23, 30, 62, 72
Candlestick, seven-branched, nos. 43c, 79
Circumcision, no. 63
Coronation of David, nos. 34, 35, 36, 50, 62
 of Solomon, no. 32
Cozbi, no. 23
Creation scenes, nos. 1, 11, 14, 17, 19, 23, 30, 32, 42, 43a, 43b, 44, 62, 63, 66, 69, 75; *58, 59, 108, 141, 143, 145, 222*
Cyrus, king of Persia, no. 66
Daniel, nos. 32, 47, 58
 his revelation, no. 23
 interprets Nebuchadnezzar's dream, no. 23
 story of Darius, no. 23
 in lion's den, nos. 23, 65, 69, 70, 75
 brought food by Habakkuk, nos. 63, 90
 story of Susanna, no. 23
 story of Belshazzar, no. 23
Darius, king of Persia, no. 43b
 series of scenes, no. 23
David, nos. 26, 43c, 69
 anointed by Samuel, nos. 1, 7, 23, 24, 25, 26, 27, 28, 30, 31, 40, 47, 48, 51, 62, 63, 70, 90; *2, 20, 167*
 harping before Saul, nos. 26, 27, 50, 74; *colour frontispiece, 249*
 fighting the bear, nos. 23, 24, 26, 27, 49; *163*
 fighting the lion, nos. 7, 23, 27, 28, 49, 50; *105, 160, 163*
 offered armour by Saul, no. 1; *2*
 stands armed before Saul, no. 32
 fighting Goliath, nos. 1, 23, 24, 26, 28, 30, 31, 32, 39, 45, 47, 48, 52, 62, 69, 70, 74, 75; *2, 153, 177*

NEW TESTAMENT AND THE SAINTS

NON-BIBLICAL

GENERAL INDEX

LIST OF MANUSCRIPTS CATALOGUED IN VOLUME FOUR

PART ONE

111. London, British Library MS Add. 44874, Psalter (The Evesham Psalter)

112. Belvoir Castle, Collection of the Duke of Rutland, Psalter (The Rutland Psalter)

113. Cleveland, Museum of Art Acc. 45. 132, Single leaf of Christ in Majesty

114. London, British Library MS Add. 28681, Psalter

115. Alnwick Castle, Collection of the Duke of Northumberland, Bestiary (The Alnwick Bestiary)

116. Oxford, Bodleian Library MS Laud Misc. 720, Giraldus Cambrensis, Topographia Hibernica

117. Oxford, Bodleian Library MS Ashmole 799, ff. 33–34v, Medical drawings

118. Baltimore, Walters Art Gallery MS 34, Psalter and Hours of the Virgin (The Carrow Psalter)

119. Hereford, Cathedral Library MS o. 7. 7, Decretals of Gregory IX

120. Madrid, Biblioteca Nacional MS 6422, Psalter

121. London, Public Record Office MS (E 36) 284, Abbreviated Domesday Book

122. New York, Pierpont Morgan Library MS M. 524, Apocalypse (The Morgan Apocalypse)

123. Cambridge, University Library MS Ee. 3. 59, Life of St. Edward the Confessor

124. Aachen, Ludwig Collection MS III. 1, Apocalypse (The Dyson Perrins Apocalypse)

125. London, British Library MS Add. 35166, Apocalypse

126. London, Lambeth Palace Library MS 209, Apocalypse (The Lambeth Apocalypse)

127. London, British Library MS Add. 42555, Apocalypse (The Abingdon Apocalypse)

128. Lisbon, Museu Calouste Gulbenkian L.A. 139, Apocalypse (The Gulbenkian Apocalypse)

129. Paris, Bibliothèque Nationale MS fr. 14969, Bestiary of Guillaume le Clerc

130. Oxford, Bodleian Library MS Rawlinson A. 384, Consanguinity Table

131. Oxford, Bodleian Library MS Auct. D. 4. 17, Apocalypse (The Bodleian Apocalypse)

132. (a) Moscow, Lenin Library MS И 1678

(b) Berlin, Kupferstichkabinett Inv. 1247, Single leaves from an Apocalypse

133. London, British Library MS Add. 54179, Psalter (The York Psalter)

134. London, Sion College MS Arc. L. 40. 2/L. 2, Psalter (The Psalter of Simon of Meopham)

135. London, British Library MS Add. 52778, Bible

136. Cambridge, Fitzwilliam Museum MS 85–1972, Bible fragment

137. Eton, College Library MS 177, Typological pictures and Apocalypse

138. Princeton, University Library MS Garrett 34, Psalter (The Tewkesbury Psalter)

139. Ripon, Cathedral Library MS 1, Bible

140. Preston, Harris Museum and Art Gallery, Psalter and Hymnal

141. London, British Library MS Add. 15749, Anselm, Meditations and Prayers

142. Oxford, All Souls College MS 2, Bible

143. New York, Pierpont Morgan Library MS Glazier 42, Bible

144. Cambridge, Trinity College MS R. 14. 9, Bestiary

145. London, British Library MS Harley 3487, Aristotle, various works

146. Oxford, Merton College MS 269, Averroes, Commentary on the Metaphysics of Aristotle

147. Durham, Cathedral Library MS A. II. 10, Psalter with Gloss

148. Cambridge, Jesus College MS Q. A. 11, Bible

149. Cambridge, Fitzwilliam Museum MS McClean 44, Psalter

150. Cambridge, Fitzwilliam Museum MS Marlay Add. I. 1916, Vegetius, De Re Militari

151. (a) London, British Library MS Add. 50000

(b) London, British Library MS Add. 54215, Psalter (The Oscott Psalter)

152. New York, Metropolitan Museum Acc. 22. 24. 1 (Rogers Fund), Psalter

153. Oxford, Bodleian Library MS Douce 180, Apocalypse (The Douce Apocalypse)

154. Paris, Bibliothèque Nationale MS lat. 10474, Apocalypse

155. Velletri, Museo Capitolare, Roll with scenes of the Passion and Resurrection

156. (a) Paris, Bibliothèque Nationale MS lat. 6323A, Aristotle, various works

(b) Rome, Biblioteca Apostolica Vaticana MS Urb. lat. 206, Aristotle, various works

(c) Paris, Bibliothèque Nationale MS lat. 6505, Averroes, Commentary on the Physics of Aristotle

157. Oxford, Bodleian Library MS Laud lat. 114, Psalter

158. London, British Library MS Add. 48985, Book of Hours (The Salvin Hours)

159. London, British Library MS Royal 1. D. I, Bible (The Bible of William of Devon)

160. Blackburn, Museum and Art Gallery MS 091. 21001, Psalter

161. London, British Library MS Egerton 1151, Book of Hours

162. New York, Pierpont Morgan Library MS M. 756, Psalter (The Cuerden Psalter)

163. Cambridge, Emmanuel College MS 116 (2. 1. 6), Bible

164. Oxford, Bodleian Library MS Auct. D. 1. 17, Bible

165. London, British Library MS Add. 21926, Psalter (The Grandison Psalter)

166. Venice, Biblioteca Marciana MS lat. I. 77, Psalter

167. London, British Library MS Add. 38116, Psalter (The Huth Psalter)

168. Cambridge, Sidney Sussex College MS 96, Bible

169. Cambridge, Corpus Christi College MS 49, Bible

170. London, British Library MS Add. 22493, Apocalypse fragment

171. Cambridge, Gonville and Caius College MS 384/604, Bestiary

172. London, Westminster Abbey Library MS 22, Bestiary

173 (a) Paris, Bibliothèque Nationale MS fr. 9574, Apocalypse

(b) London, Lambeth Palace Library MS 75, Apocalypse

174. Oxford, New College MS 358, Psalter